PRE-RAPHAELITES IN LOVE

GAY DALY

Pre-Raphaelites in Love

Ticknor & Fields • New York

1989

For information about permission to reproduce selections
from this book, write to Permissions, Ticknor & Fields,
52 Vanderbilt Avenue, New York, New York 10017.

Library of Congress Cataloging-in-Publication Data

Daly, Gay.
 Pre-Raphaelites in love / Gay Daly.
 p. cm.
 Bibliography: p.
 Includes index.
 ISBN 0-89919-450-8
 1. Preraphaelites — Great Britain — Relations with women.
 2. Preraphaelitism — Great Britain. 3. Painting, British.
 4. Painting, Modern — 19th century — Great Britain. I. Title.
 ND467.5.P7D34 1989 88-28172
 759.2 — dc19 CIP

PRINTED IN THE UNITED STATES OF AMERICA

P 10 9 8 7 6 5 4 3 2 1

Quotations from Diana Holman-Hunt's *My Grandfather, His Wives
and Loves* and *My Grandmothers and I,* copyright Diana Holman-
Hunt, are reproduced by permission of Curtis Brown Ltd.
The floral ornaments used in this book are adapted from designs by
Charles Ricketts in 1897. Courtesy of the Department of Printing
and Graphic Arts, Houghton Library, Harvard University.
The endpapers are reproduced from the wallpaper design "Marigold"
by William Morris in 1897. Courtesy of the Trustees of the Boston
Public Library, Fine Arts Department.
Book design by Ann Stewart.

For my father and mother,
Jack Musto Daly & Mary Prussia Daly

Acknowledgments

Many descendants and heirs of the Pre-Raphaelites have made this book possible by giving their kind permission to publish the letters of their ancestors. They have given much more along the way; they have invited me into their homes, shown me their pictures, answered my endless questions with grace and wit, and never let me down when I needed them. I thank Geoffroy Millais, Sir Ralph and Lady Millais, Diana Holman-Hunt, the late Harold Rossetti and his wife, Joan, Lance Thirkell, Mary Oliphant, Imogen Dennis, John Street, John Lamb, Lady Stow Hill, Celia Rooke, and Earl Baldwin of Bewdley.

I am also grateful to the museums and the individuals who generously gave their permission to reproduce the paintings, drawings, and photographs I have used as illustrations. I am indebted not only to the many libraries and museums that have kindly granted me permission to quote passages from letters and documents in their collections but also to the librarians and archivists who spent untold hours patiently locating letters, checking them in, signing them out; this is a quiet labor, which, however, I never took for granted. I thank the Beinecke Rare Book and Manuscript Library, Yale University; Bodleian Library, Oxford University; British Library; Brotherton Library, University of Leeds; Castle Howard, by kind permission of the Howard family; Cornell University Library; Delaware Art Museum; Fitzwilliam Museum; Houghton Library, Harvard University; Huntington Library; Pierpont Morgan Library; Princeton University Library; Harry Ransom Humanities Research Center,

University of Texas at Austin; Ruskin Galleries, Bembridge School; John Rylands Library; Society of Antiquaries; Tate Gallery; Victoria and Albert Museum. Thanks are also due to the Liverpool City Art Gallery, the Birmingham City Art Gallery and Museum, the Whitworth Art Gallery of the University of Manchester, and the University of British Columbia Library. I apologize for quotations untraced.

Over the years that I have worked on this book, I have benefited from the knowledge and insight of more scholars and friends than I could ever name here. I would especially like to thank for their help Mary Ellmann and her husband, the late Richard Ellmann; Mary Bennett; Mark Samuels Lasner; Virginia Surtees; Lady Rosalie Mander; Mary Lutyens; Ina Taylor; Jan Marsh; William Fredeman; David Thorburn; J. Hillis Miller; Ray Watkinson; the Honorary Secretary of the William Morris Society, Peter Preston; Patricia Allderidge; Michael Case; Michael Jaffe and Paul Woudhuysen; Rowland Elzea; Henry Boyd-Carpenter; J. S. Dearden; John Reilly; Susan Duval; Robert Kaiser; Robert Wagner; and Ilja Wachs. For their help with many complicated medical questions, I must mention Dr. John Joseph Lynch and Dr. Gerald Ginsberg, whose courtesy was unfailing and whose knowledge was invaluable.

There might well have been no book if dear friends in London had not allowed me to live with them for many months while I was working on my research. Katharine Phillips and Anthony Pye-Jeary shared not only their beautiful flat with me but also their humor, their charm, and their earthy common sense. I am so sorry that Kathy's father, Ian Phillips, who helped and delighted me by taking an interest in this project, will not be able to see it finished. My friends Diane and Esme Howard and Stephen and Jagna Wright also gave me places to stay along with kindness in abundance.

Frank Curtis and Clyde Taylor are respectively my lawyer and my agent, but they are also two of my most thoughtful readers. Their unflagging support for this book over many years has been a mainstay for me.

Katrina Kenison, my editor at Ticknor & Fields, gave me the deft, intelligent, and creative guidance that writers long for and rarely find. I might never have met Katrina if Thomas Mallon, another of her authors, had not introduced me to her. Tom's generosity stands out in my memory as one of the kindest things anyone has ever done for me. The editorial work of Janet Silver and Elizabeth Duvall has also improved this book in a hundred ways, large and small. Carol O'Brien

at Collins in London has offered fine editing as well as constant encouragement and much vital practical help over this last long year.

When I needed a research assistant but could not afford one, my mother, Mary Daly, devoted countless hours to reading and taking notes. I also want to thank some of the friends and family who read and discussed the book with me and who helped me to write it by their faith in the value of the work: Deborah Hudson, Brad Darrach, Joseph Viscomi, Paula Lieberman, Elisabeth Herz, Lila Nields, Mark and Laura Page, Brian and Jenifer Fallon, Barbara Petranek, Ellen Walsh, Jack Maguire, James Moser, Steven Mays, Maggie Mahar, Barbara Page, Joseph Woolfson, David Stang, Charles Hirshberg, James Altman, Ellen Schecter, Sadie Lovinger, Wendy Lucero, and John and Shelly Daly. Rachel Lovinger is my stepdaughter and also my friend. The first night I met her, when she was twelve, she asked me many thoughtful questions about my book, and I knew I could always count on her interest and sympathy.

There are no words sufficient to thank my husband, Jay Lovinger, who gave me the twin gifts of strength and happiness. We welcome our new daughter, Laura Woo Lovinger, who is about to arrive from Korea as I write these words.

Contents

List of Illustrations

A Note About Names

When I started writing this book, I was faced with a problem about how to name the principals. Should I call them by their surnames, which would accord them all, male and female, the maximum of dignity? Or would first names be more appropriate, since this was meant to be a personal history? As I read thousands of letters, which were the primary source for my story, I came to know them by the names they called each other. It gradually dawned on me that these were the names they would have recognized and responded to at this level of intimacy, and so these were the names that I should use. So William Morris and William Holman Hunt are called Morris and Hunt, just as they were by their closest friends, whereas Jane Morris, who was almost universally greeted as Jane or Janey, is called Jane. Rossetti and Burne-Jones were the wild cards; professionally they were referred to by their surnames, but friends as well as family called them Gabriel and Ned, so I do too.

Prologue

I WAS STILL a little girl, maybe nine or ten, when I started looking for the paintings of the big dreaming ladies with the masses of rippling, shimmering hair, black or red-gold. In museums, in glossy art books at the library, I searched for them, wondering just what the moody looks on their faces meant. All I knew for sure was that they were thinking about romance, about love, about the powerful and dramatic world that adults inhabit and little girls are shut out of. It was probably the sharp contrast of their looks with mine that attracted me in the beginning. My knobby knees and the parade of purplish black bruises raised on my shins by my brother made their perfect, dense white flesh, luminous skin, and long necks even more mysterious and desirable in my eyes. The lank strands that a sharp little friend had airily dismissed as so much "dishwater blonde" made me wistful before their yards of tumbling curls.

Later on I learned that these pictures, the work of the Pre-Raphaelites, were regarded by the aesthetes as embarrassing, fit only for greeting cards, and so I buried my fascination for a time, mortified by the gaucherie of my girlhood. But once I developed more confidence in my own interests, I went back to look at them again and found that they still compelled me. As records of what constituted beauty and desire in the last century, they still have the power to attract and to intrigue. Some are beautiful, others are disturbing, even repellent, but none is boring. Each is a psychological and aesthetic puzzle. One woman sits with eyes closed in a religious trance that seems to border on sexual ecstasy. Another, longing for an absent

lover, stretches like a languorous tiger, her voluptuous body wrapped in a dress of rich royal blue velvet that dominates the canvas, insisting that the viewer dwell on her curves. A third abides in a thoroughly conventional bourgeois sitting room of the period, crammed with fussy trinkets, a tapestry frame, a paisley shawl, a rosewood piano, but she sits in a young man's lap, wearing what looks to be a nightgown. What were these women doing in Victorian paintings? The suggestive poses, the intricate settings laden with symbols, above all their remarkable faces and bodies, left me with far more questions than answers, and the writing of this book grew out of the effort to answer those questions.

Once I started to work, I quickly realized that these images painted on canvas were the equivalent of our goddesses caught on celluloid; they were the Greta Garbos, the Hedy Lamarrs, the Ingrid Bergmans of Victorian England. These pictures were exhibited at the most important event in the British art world, the Royal Academy Exhibition held each spring in London, and during the twelve weeks of exhibition, thousands of people stood in line waiting to pay their shilling for admission just as we queue to buy tickets for a popular film. The art gossips, whispering among themselves, selected a "belle of the line," the most beautiful lady in paint, from the multitude on display. Many a rich man stood ready to write a fat check so that after the show closed he could take home one of the ladies in a frame. There he could hang her in his drawing room or study and spin out his own dreams about her at leisure. Some of the most coveted of these paintings were never exhibited because of the painter's insecurity, but news of them spread by word of mouth. Buyers schemed for an invitation to the artist's studio, and he made a fortune anyway.

Learning something about the public life of these images made me even more curious about what had inspired them. Had the pictures been painted from live models, or were they simply daydreams, crafted by sensual men trapped in the moral straitjackets of Victoria's England? A bit of detective work revealed that every one of them had been painted from a model, who had sat quietly in the studio holding a pose, sometimes till her back ached or her feet and hands fell asleep. The Pre-Raphaelites believed that every rose must be painted from a live flower, every face from an actual human being.

Because these artists were fascinated by women's beauty, they were always scouting for new models, in the street, in the drawing room, in church — searching for the faces and bodies that would fire their

fantasies. The women they painted came from almost every class and corner of London. Among their ranks were the spoiled, petted daughter of a solicitor, a hearty, motherly prostitute, a wily barmaid, and the daughter of a Methodist minister. This diversity is hardly surprising, since appearance was the criterion by which they were chosen and beauty is no respecter of class. (Conspicuous by its absence was the aristocracy; titled ladies appeared in these paintings only after the artists' reputations were secure and it became an honor rather than a gamble to be painted by them.)

When an artist spent days or sometimes months alone in the studio with his model, struggling to paint her face and perhaps her body, he was prone to fall in love; after all, his dream was coming alive. Sometimes the model responded eagerly; at other times she was dragged along, nervous and uncertain about where it was all leading. In a few cases the artist proposed marriage, hoping to seize hold of his dream and make it last a lifetime. Several of these marriages endured.

A painter had a unique advantage over other Victorian suitors in that he was able to spend a remarkable number of hours alone with his beloved, in the studio. This unusual privacy helped to fuel these relationships with an intensity, a concentration of feeling, that was hard to achieve in a drawing room where a watchful mother or sister sat nearby, working at her embroidery and stopping to pour out tea. These young artists did not, however, take advantage of their freedom; only rarely did they carry a model from the studio to the bedroom. They observed the discipline of chastity that their culture demanded of gentlemen and endeavored to conduct at least a facsimile of a conventional courtship. Solid sons of the middle class, they were usually not ready to abandon their beliefs for their desires. Sometimes years of agonizingly virtuous engagement passed while the artist tried to make enough money to marry and set up the comfortable household that he, his bride, and her mother assumed to be necessary.

The waiting was not all frustration, however; it also sustained the delightful period of pure romance. Love had time to unfold where now sex would intervene. Earnest young Victorian couples started out by using polite address, referring to each other as Mister Ruskin and Miss Gray. After months or years of such carefulness, the first use of a Christian name had a preciousness we cannot imagine. Kisses, touches, embraces were exciting beyond our comprehension.

Artists took special pleasure in this delay, because it gave them a chance to paint from the desire that bred romance, before the de-

mands of marriage and children threatened to crush its mystery. While they were brooding on the torment of chastity, they were frequently creating the greatest pictures they would ever paint. Few, if any, of these pictures are just portraits; rather, they are complex narratives, studded with clues and symbols that the Victorian audience, with its penchant for narrative painting, loved to decode. For us they are psychic histories that record the revelation of love and the fantasies that informed it.

<div align="center">❦❦❦</div>

We imagine that we have freed ourselves from the baggage of the Victorian world, and in some ways no doubt we have, but it has become clear to me that its myths of romance and marriage are still embedded in our consciousness and that they have great power over us — greater, in fact, when we refuse to acknowledge them. We may affect to have finished with such foolishness as romance, believing that we have substituted a healthy, forthright acknowledgment of the need for sex in our lives, but who among us does not long for the passion, the tenderness, the seduction that casual sex will never provide? Many of the wishes we have suppressed are nakedly revealed in these paintings, so that looking at them can be startling, as we see our secret desires writ a little too large. This fact goes a long way toward explaining why the Pre-Raphaelites' work was dismissed earlier in this century, when people were struggling to break the bonds of sexual repression. It may also explain why now, when the glamour of the sexual revolution has palled, interest in these paintings is renewed.

Romance as a motivation for middle-class marriage was little heard of before the nineteenth century; parents dictated choice of partner, and parents were practical, interested in property and social status. As the industrial revolution provided Britain with an unparalleled infusion of capital, however, the middle class, expanding at an extraordinary rate and buoyed up by its sudden affluence, set about seizing luxuries that had hitherto been the province of the aristocracy. Romance was one of these. The Pre-Raphaelite painters rode the crest of this wave, making a huge success by giving their newly rich middle-class male audience the raw materials for fantasy.

This was hardly the artists' original intention. The young men who formed the Pre-Raphaelite Brotherhood in 1848 meant to mount an aesthetic revolution that would change the history of painting forever,

but in this they failed; the Impressionists across the Channel superseded them within their lifetimes. What they did do was to plunder history, myth, and literature for stories of women who embodied desire, then offer them up as delicately ethereal or boldly sexual images, each seductive in its own fashion. In their paintings we witness the birth of bourgeois romance.

The institution of marriage was also being transformed in the Victorian era. As the industrial revolution drew people to the city, away from family and village, marriage became the haven to which a man could retreat when his day in the brutal working world was over. Nestled in the home were the wife and children, safe and cozy, waiting to greet their exhausted lord and master. As the world at large grew more menacing, the rewards and benisons of marriage were touted more loudly; the perfect wife was hailed as an "angel in the house," who could salve all her husband's wounds with a celestial balm. A generation of women tried to live up to that ideal.

We struggle to break that tradition, but most of us carry around more than a few of its remnants. Marriage is still the goal, the payoff, the ideal resolution for most of us; we dream of the one happy, lifelong relationship marked by fidelity, harmony, and perfect sympathy. Few of us achieve that ideal, yet we continue to yearn for it. Just as the Pre-Raphaelites did, we struggle to pour romance into the container of marriage, and we have enormous difficulty keeping it there.

Ultimately I realized that this book must be not simply about a group of women, or even about a group of artists and models; instead, it had to be about marriage, for it was through marriage that these men and women tried to realize in life the fantasies that gave rise to such extraordinary paintings. And so I have tried to look at what happened when the model became not only the stuff of dreams, a Beatrice or an Isolde who lived in the bell jar of the studio, but also the stuff of everyday life. Could the artist, now a husband, tolerate the discovery that his beloved had her own worries, aches and pains, temper? What happened to the muse when she started hiring servants, mending socks, embroidering by the fire, sharing a bed, bearing children? Was it possible to make a bridge to the mundane? The fall from romance to reality is always shocking; did the model's great beauty and the great expectations that it raised make the fall a longer one, the crash harder when it came?

On the surface, many of these marriages seemed happy and fulfilled. Was this merely an appearance, some cunning brand of Vic-

torian hypocrisy? Or did the Pre-Raphaelites view marriage differently, in some way that allowed them to find satisfaction where we would see only misery? Match these women and their motivations for marriage — economic necessity, desperation, civility, and romantic feeling — with the artists who longed to live out the extreme visions of romance embodied in their paintings, and today we would have a recipe for a series of quick divorces. However, four of these marriages lasted between thirty and forty years. Exquisite manners carried partners through much that we would not tolerate, but none of these unions was simply a bravura display of civility. In even the most deeply troubled, there was a profound connection between husband and wife, a bond of intimacy that held even when it cut most deeply.

At first I thought that it would be difficult to piece together the stories of the women who appear in Pre-Raphaelite paintings; after all, women have led hidden lives, and paintings are silent.[1] Instead, I discovered that people were often just as fascinated by these models as they were curious about the artists, and so reminiscences about the women were recorded alongside memories of the men. My principal source, however, has been letters written by and to my subjects.

No one will know us as we can know these Victorians; telephone calls are words cast into the wind. Then, everything was set down on paper, even the most casual invitation. Such wealth of material is a biographer's dream. Even though I was driven half mad at times by wretched handwriting and wished that someone had occasionally thrown out an invitation to dinner, I still felt privileged to be able to read immediate accounts of these women's thoughts, plans, hopes, dreams, and disappointments. There is a special pleasure, a sense of connection, in holding in one's own hands the same leaf of stationery that the letter writer picked up a hundred years ago as she pulled up a chair to the secretary in her sitting room, a sharpened quill and a pot of ink at her side. Letters yield a myriad of small, quiet clues that carry one beyond the words. The handwriting: Is it steady, shaky, dashed off? The letterhead: Was the correspondent writing from home or from a country house where she might have gone to spend the weekend with a lover?

There are frustrating gaps. Two of the Pre-Raphaelite models were virtually illiterate, and so their histories must be reconstructed carefully by sifting through letters and documents written about them,

a difficult task at best. Other letters were destroyed — by a guilty husband who made a hasty bonfire of his wife's correspondence, or by a wife who sat down in her old age and weeded out everything that she did not want her children or posterity to know. Despite these losses, however, the letters that remain give us a very full picture of these women's lives, spent in the shadow of great Victorian men. Naturally, many remarkable things were going on in that shadow, and my first goal in writing this book was to try to bring them into the light.

As one would expect, it is easier to document the lives of the artists. All five of the men whose stories I pursued — John Everett Millais, William Holman Hunt, Dante Gabriel Rossetti, Edward Burne-Jones, and William Morris — were recognized as major artists in their own lifetimes, indeed in their youth, and they all made substantial fortunes through the sale of their artwork. Their pictures made them dream merchants to their culture, the equivalent of filmmakers in our world, and they were rewarded as liberally as movie directors are today. Everybody wanted to know them and to preserve a record of their friendship; hence, conversations were recorded verbatim and memoirs abound. Literally thousands of their letters were hoarded, then bequeathed to children and grandchildren, who later sold them to manuscript archives, where they are reverently conserved today. So it seemed as if it would be possible to know these artists, insofar as it is possible to know anyone who lived in another century, another place, another cultural milieu.

Only gradually did I discover that the very celebrity that preserved this abundance made my task more difficult. These men were protected by family and friends, who wanted to control the version of their lives that was passed down to us, so an extramarital affair was swept under the rug, failures of generosity or sympathy were denied or glossed over, compulsive flirtation was rendered as endearing courtliness. At the other extreme, jealousy darkened some records. I have tried to read through the apologias, to scrape off the whitewash and find something closer to each man as he really was and not as those who loved him wished he had been.

The first task and the great joy of the feminist historian and biographer is to dig out the stories of women that have not been told or that have been distorted in the telling; the next challenge is to look again at the stories of famous men that may have been told before and to see them fresh, detecting where we may have been hoodwinked

by achievements and glamour. The Pre-Raphaelite artists were not only creative geniuses, they were, most of them, extraordinarily charming individuals, savagely funny, superb company, seductive to men and women alike. I have tried to get something of that charm down on paper, because it really existed and because it is fun to read about, but I have also tried to stand back and look at how it mystified those who came under its power.

During the eight years that I researched and wrote this book, I never once got bored. The eloquence of these men and women, their triumphs and failures, their humor, their selfishness, their griefs, their elusiveness, held me captive. Over that time my own life took a major turn as I fell in love with and married my own extraordinary husband. With this change, I found that although I was still fascinated by the paintings and the romances that lay behind them, the rhythms and crises that marked the Pre-Raphaelites' relationships began to grip me with a new intensity; even the minutiae of daily life, as children were born and bills piled up, compelled me. I make no special claim for greater understanding — I just hope that I have become more patient with all those who struggle within these pages to live in concert with another human being.

PRE-RAPHAELITES
IN LOVE

One

THE PRE-RAPHAELITE BROTHERHOOD

IN THE 1830s, the decade of Victoria's ascension to the throne, a handful of small boys were scribbling away, drawing tiny knights and rocking horses and sailing ships, filling up every scrap of paper that came their way and ruining more than one tablecloth with their remarkable productions. Drawing was a common pastime in those days, but for these children it was a vital means of expression, as needful as breathing — and before long they would use their extraordinary gifts to change the history of British painting.

Many parents mistake a lively, precocious child for a startling prodigy, but in the case of John Everett Millais the doting parents had good reason to prize their son's childish sketches. By the time he was seven he could take a walk on the Jersey beach near his home, and on returning to the house sit down and draw a perfect likeness of any face that had interested him as he walked along the strand. A slight boy, delicate in health, he was kept at home, where his mother taught him his lessons, with the exception of art, for which she engaged the best drawing master on the island.

His gift quickly asserted its authority. When he was nine, after his drawing master announced there was nothing more he could teach the boy, his parents took him to London. An introduction to Sir Martin Archer Shee, President of the Royal Academy, the governing body of the British art world, was secured. Family legend has it that when Shee heard the reason for their call he blurted out: "Better a chimney sweep than an artist!" But after he had looked at the boy's

portfolio, he changed his tack. Uncertain that so young a child could have produced such mature work, he set Johnny the task of drawing the fight of Hector and Achilles, right there in his study. Satisfied by the sketch, Shee "declared that it was the plain duty of the parents to fit the boy for the vocation for which Nature had evidently intended him."[1] After a brief stint at a preparatory academy, the child was admitted to the Royal Academy Schools as a probationer — at eleven, the youngest student ever enrolled. There he streaked ahead in his work.

While Johnny Millais was thriving in school and petted at home, another boy, William Holman Hunt, was living across London in the rough-and-tumble suburb of Haggerston, yearning to be an artist but fearful that the obstacles would prove insuperable. The principal road-block was his father, a timid, dogged man who himself had wanted to be an artist but had dutifully buried his dreams and become the manager of a draper's warehouse in Cheapside. Gradually Mr. Hunt had achieved a moderate success, to which he clung tightly, and he planned the same course for his son. He preached endlessly on the dangers of art and the virtues of business, but he tantalized the boy each Sunday by showing him, as a treat, the scrapbook of inexpensive prints of paintings that he had been collecting for years.

What Mr. Hunt failed to calculate was the indomitable will of his child. When the boy was twelve, his father put him to work as a clerk in an office, where he toiled six days a week. In every spare moment, though, he was drawing, and his father did allow him to attend classes in the evenings at the Mechanics' Institute. He also badgered his father into letting him take lessons from Henry Rogers, a successful portrait painter in the City of London. In his teens he painted three self-portraits, which show the round, earnest face of a boy with dark blond hair and a cute snub nose, a feature that remained the bane of his existence even in adulthood.

Hunt understood that he was locked in a battle of wills with his father. After four years' clerking, he decided he had to make a stand for art before it was too late. He quit his job, telling his father: "When I was twelve and a half I feel you would have been wrong, thinking as you did, to allow me to drift into a pursuit you thought objectionable. I am now sixteen and a half; if you kept me at business until I were twenty-one I should then become an artist with but a poor chance of accomplishing anything. I will not put the responsibility upon you now; I know the profession is a hard one, but I have made

up my mind to trust myself to it."[2] He determined to attend the Royal Academy Schools, which was the only direct road to success as a painter. He had no money with which to enroll in a preparatory school, which was the usual procedure, so he set himself to draw without guidance from the plaster casts of ancient Greek sculpture at the British Museum. To apply to the RAS, he would have to submit three finished drawings: an antique figure, an anatomical figure, and a drawing of the human skeleton.

In 1843 the young Hunt attended the annual prize giving at the Royal Academy Schools in order to get a glimpse of Millais, the prodigy so many art students were buzzing about. Six decades later he still remembered that December afternoon as a landmark in his life. He barely remarked the presence of J. M. W. Turner, the aged, crotchety recluse who towered over British painting, because he had eyes only for "the boy." In his autobiography he vividly recalled the moment when Millais was called to receive the silver medal: "Out of the press a slim lad with curly hair and white collar arose eagerly, and was handed from seat to seat till he descended into the arena, where, remembering his manners, he bowed, and approached the desk. As he returned, the applause was boisterous. . . . I had not until now seen either the boy of whom I had heard so much, or his drawings; I had formed so exalted an idea of both, that it would have been a pain to me had either fallen short of my standard. In the conception of a yet unknown living hero the image cherished becomes so dear that too often the reality is a disenchantment. It was not so in this case; the boy Millais was exactly what I had pictured him, and his work just as accomplished as I had thought it to be."[3] A dream was realized for Hunt in that moment: He now had the hero he wanted so badly.

Hunt's first application to the RAS was rejected. Thoroughly humiliated, he buckled down to another six months' study, determined to apply again at the next opportunity. More than fifty years later the second rejection still stung: "When I stood before the new list of probationers I had the bitterness of finding that my name was again absent."[4] His father seized on these rejections as proof that his son lacked talent. Instead of giving way, Hunt struck a bargain with his father. He would apply once more; if he failed a third time, he would go into business.

One day as Hunt was working away at the British Museum, his hero popped into sight. Millais was flying through the gallery when

suddenly he stopped and stood for a few minutes behind Hunt, watching him intently. Then he burst out, "I say . . . you ought to be at the Academy." Starved of hope, Hunt was thrilled to hear "the boy" voice his own thoughts. Millais continued in this happy vein: "You just send the drawing you are doing now, and you'll be in like a shot."

The charm worked: Hunt's next application was a success, just as Millais had predicted. Much of his time was wasted in grinding out small, conventional paintings, which he lamented as those "potboilers so necessary to keep the kitchen-range alight," and he envied the richer students, but he delighted in his acceptance by the esteemed Academy. Now he had many chances to observe "the boy" (who was only a year and a half younger than Hunt) at close quarters. He liked what he saw, but Millais's popularity made a barrier; Hunt would have died rather than appear to curry favor. Fortunately, Millais's forthright enthusiasm broke through his reserve. The first time he saw the new probationer he called out, "I told you so. I knew you'd soon be in."[5]

When Millais invited his new friend home to Gower Street to meet his family, Hunt could not help but be struck by the painful contrast with his own situation. The Millais family planned their days around the task of fostering Johnny's genius. Mrs. Millais sat in the studio and read to him while he painted. Mr. Millais, who played the violin, the flute, and two or three other instruments, was always willing to put on an impromptu concert to soothe his son at the easel. Both parents sat for their son, to save the expense of professional models. Mr. Millais built props; his wife researched costumes at the British Museum and then came home and stitched them up. Hunt saw that the boy's great self-confidence and his "most serviceable sanguine temperament" had grown like healthy weeds in such rich soil.[6] (By sixteen Millais had shot up over six feet, and with his cockatoo's crest of curly hair and his elegant, clean features, he made Hunt rueful with his beauty.)

The Millais family welcomed Hunt. On his first visit they repeated Johnny's praise of his work, and soon the lonely young man was warming himself at the fire of their encouragement. Admission to the RAS and his growing friendship with Millais started to ease Hunt's fears of failure and inadequacy, silencing that small, jeering voice in his head that whispered that his father might be right, that perhaps he had only a very minor talent. His luck continued to hold; even his father began to encourage him.

Hunt began to spend more and more time in Millais's studio, where the two discussed contemporary art, art history, and painting technique, as well as the strain of living with their ambitions. Hunt remembered: "Our increasing intimacy induced confidential talk whenever we met . . . and I found him . . . quite ready to re-examine settled views, even though they seemed to him at first above question."[7] Since Millais was the favorite of the Royal Academy, he could well have stuck with the formulas and methods that had brought him an early success. But the popular painters of the day bored him, and in Hunt he found a sympathetic ear.

Hunt was tremendously impressed by his friend's open-mindedness. In the twentieth century we have seen a dozen radically different styles of painting come and go, and rejection of established norms is a commonplace to us — although our belief that we have learned to accommodate continual upheaval may ultimately prove an illusion. But for Hunt and Millais, any departure from artistic tradition was nothing less than rebellion, and it was daring indeed.

English painting was in the doldrums. Constable was dead, and Turner was a frail old man. Every spring the walls of the Royal Academy Exhibition were lined with the same sort of dreary pictures, executed according to the same rigid set of rules. Hunt raged at the endless procession of painted figures who looked to him "not like sober live men, but pageant statues of waxwork. Knights were frowning and staring as none but hired supernumeraries could stare; the pious had vitreous tears on their reverential cheeks; innkeepers were ever round and red-faced; peasants had complexions of dainty pink; shepherdesses were facsimiled from Dresden-china toys; homely couples were ever reading a Family Bible to a circle of most exemplary children; all alike from king to plebeian were arrayed in clothes fresh from the bandbox."[8]

He and Millais longed to paint "live men" who expressed their own passions, but painters who didn't play by the Academy's rules had small chance of achieving fame or wealth. Both had an enormous drive to succeed, and they could see that it might be very hard to realize their ambitions if they painted according to their own values. The Royal Academy was a small world; there were just forty Royal Academicians and twenty junior Associates, who often passed years, even decades, waiting for an R.A. to die so that they might be elevated to the empyrean. Despite their impatience, Hunt and Millais never ruled out election for themselves. Once inside the Academy, they would be in a stronger position to work for reform. Besides, election

meant a steady stream of patrons, commissions, income, whereas failure to belong doomed an artist to endless struggle.

Sir Joshua Reynolds became the boys' bugaboo; between themselves, they referred to him as Sir Sloshua. The first President of the Royal Academy, founded in 1768, Reynolds had laid down codes that still held sway eighty years later, albeit in a decayed form. Blinded by youth, Hunt and Millais could not see that in Reynolds's day his ideas had been fresh and fruitful, a brilliant response to and shaping of the aesthetic of his culture. Since then, however, lesser talents had turned his guidelines into dogma. Hunt and Millais were right to fume: The rules being drummed into students' heads at the Royal Academy Schools were rigid, repressive, deadening. The objects in every picture had to be drawn with firm, solid outlines. Every composition had to make either an S or a triangle. All colors had to be subdued, every landscape brown in tone. Light and shadow had to be painted in a ratio of one to three or one to four. And all human figures had to be painted free of deformity, dressed in clean new clothes.

To young painters with heads full of brilliant and extraordinary pictures, these strictures added up to an aesthetic and emotional straitjacket. Living in a climate where sunlight was a precious commodity, they found the reign of brown a cruel joke. Hunt in particular worshiped light; he spent his life trying to catch the light exactly as he saw it. Later in his career he followed the sun to Egypt and Palestine, but at this point it seemed to him that he might never be able to paint it at all. He took as a personal affront the vogue for dark, murky renderings of "drooping branches of brown trees over a night-like sky, or a column with a curtain unnaturally arranged."[9]

Hunt saw himself as the leader in art, encouraging his companion to think delightfully dangerous thoughts, but Millais remained the leader in friendship. Hunt was hesitant to invite Millais to his studio in his family's new home in Holborn, but Millais pressed for an invitation. When Hunt finally showed Millais the large painting he had been laboring over, *Christ and the Two Maries,* he wondered aloud if he shouldn't abandon it in favor of a smaller picture that he could be sure to finish in time for the deadline for the Royal Academy Exhibition. According to Hunt, Millais responded by giving him "such hearty encouragement as to the character of the work that I was saved from the impatient conclusion tempting me that whatever I did was sure to fail."[10]

Hunt soon found himself confiding the secret of his Christ's re-

markable luminosity. He had learned the trick of painting on a wet white ground, a technique derived from fresco painting, in which the artist works directly on wet plaster. This method was a radical departure from the practice then in vogue of painting on a dry canvas coated with asphaltum, a tarry brown compound that muted all colors. The wet white ground was far more difficult to control. The artist had to prepare a small square of canvas each day by putting down a thin layer of white pigment mixed with a dab of varnish. It could be painted only once; if the hand faltered, the painter had to scrape out what he had done and start all over again. Even though one false touch could destroy a whole day's work, Hunt felt that this method brought so much light into the picture that it was well worth the risk.[11]

Flush with the certainty of youth, the two friends agreed that they knew where painting had gone wrong. To steer a fresh, straight, honest course, they decided, it was necessary to study and paint nature directly. Careful study of nature might rescue art from the utter artificiality into which it had fallen. Nature was, they believed, the only true source of inspiration, and if they could commit themselves to representing it faithfully, it would provide them with all that they needed to produce noble and beautiful works of art. Hunt believed that it was the responsibility of every artist to "make art a handmaid in the cause of justice and truth."[12]

Hunt found validation for their commitment to nature in Ruskin's *Modern Painters,* which he borrowed on a twenty-four-hour loan. Staying up all night, racing through the pages at top speed, Hunt experienced a shock of recognition. A hundred times, in a hundred different ways, Ruskin urged the artist to trust nature and forsake all else. "Of all its readers," Hunt declared, "none could have felt more strongly than myself that it was written expressly for him." Suddenly Hunt saw a door opening where he had long thought to find only a brick wall: "Up to that day I had been compelled to think that the sober modern world tolerated art only as a sort of vagabondish cleverness, that in England it was a disgrace, charitably modified in very exceptional cases, to have a professional passion for it."[13] He rushed to Gower Street to tell Millais about the man who believed as they did, who urged the artist to "go to Nature in all singleness of heart, and walk with her labouriously and trustingly."[14]

In fact Hunt's feeling about Ruskin was not unique; similar sentiments were echoed in the diaries and letters of many, many young Victorians. Ruskin fired the imagination of a generation; his passion-

ate commitment to art and the strong moral foundation on which that commitment rested offered young artists a justification for their own passionate intellectual intensity, an intensity frowned upon by their careful elders. Millais, who was never much of a reader, was one of the few who was not electrified by Ruskin's writing, but he was perfectly happy to soak in Hunt's excited account. His floods of nervous energy made it hard for him to sit still; the one place that he could bring his energy under control was in front of his easel.

In the spring of 1848 the two friends were scrambling to finish their pictures in time for the annual Royal Academy Exhibition. Pictures had to be delivered to the Academy in Trafalgar Square by midnight of Handing In Day, April 10; then the Hanging Committee, composed of several Royal Academicians, reviewed the several thousand submissions and chose somewhere between fifteen hundred and two thousand paintings to exhibit.* These were then hung in time for Varnishing Day, when the artists were allowed a morning to touch up their works. The exhibition was opened to the public on the first Monday in May.

Both Hunt and Millais desperately wanted their works to be chosen; there was virtually nowhere else to show and sell paintings. Galleries were few and far between and tended to deal in Old Masters and established painters. Dealers were a new phenomenon, just coming into their own; the art market as we know it was being born. Every dealer scouted the exhibition each spring; if he saw something he liked, he would go around to the artist's studio to talk and to see what else might be for sale. For the two young artists, selling their work was critical. From the time Millais was sixteen, his family depended on the income from his sales, and Hunt had to support himself to take the burden off his father.

As Handing In Day approached, the boys saw that they would have to work virtually around the clock if they were going to meet the deadline. Millais suggested that Hunt bring his canvas to Gower Street so they could make the final dash together. Long after everyone else in the Millais family had gone to sleep, they were up painting and talking, always talking. "We revealed all our innermost thoughts

*After the review, artists had to queue at the Royal Academy to ask the porter whether their works had been accepted. The porter was known for booming out a loud nay, so that rejection was often humiliatingly public. Notification by post was not instituted until 1875.

to each other, and used our conclusions to form ardent resolves for the future," Hunt recalled. "It is on quiet and confidential occasions such as this that burning convictions are tested and refined, and ours at this time were beaten upon the anvil of what experience we had already had. Here the scaling dross was shaken off, and the pure iron converted into tempered steel."[15]

By now they trusted each other so thoroughly that they could trade off and do bits of each other's painting. Millais's patience for churning out drapery to hide the nakedness of his *Cymon and Iphigenia* snapped, and he begged Hunt to relieve him: "Do, like a dear fellow, work out these folds for me; you shan't lose time, for I'll do one of the heads of your revellers [in his *Eve of St. Agnes*] for you."[16] They finished an hour before the midnight deadline, hustled their canvases into a hansom, and delivered them to the Academy, then staggered home to bed.

The painters took a brief holiday while the Hanging Committee sat in judgment on their work. Hunt's picture made the grade, but Millais's was rejected. Hunt admired his friend's stoicism: "He was exceedingly brave about the disappointment, and — as was characteristic with him throughout life on encountering any check to success — he was very reticent on the subject, and now he hid the picture away."[17]

Millais went to spend the summer with friends at Oxford, leaving Hunt to his own devices. One day at the exhibition he had a fateful encounter with an art student named Gabriel Charles Dante Rossetti, an appellation eventually slimmed down to Dante Gabriel Rossetti. According to Hunt, Rossetti "came up to me . . . loudly declaring that my picture of *The Eve of St. Agnes* was the best in the collection."[18] Hunt was a trifle embarrassed by this public display, but such praise was always the straight way to his heart, and within a few days Rossetti was in Hunt's studio.

The young man who had captured Hunt's suspicious heart so easily was the product of an extraordinary family living quietly in Charlotte Street, within walking distance of the Hunt and Millais families. The father was Gabriele Rossetti, an Italian revolutionary and poet who had fled his country in fear of his life and sought asylum in England. An impractical, dreamy man, he had had the good sense to marry Frances Polidori, a woman so stable and commonsensical that it seems as if the only impulsive act of her life was to marry her unworldly,

poor, and romantic suitor. If this is true, there is little evidence that she ever regretted her decision, and much evidence that the marriage was a happy one, if not a prosperous one.

The Rossettis had four children in four years: Maria, Gabriel, William, and Christina. Mr. Rossetti's post as professor of Italian at King's College paid only a meager honorarium of ten pounds a year, but the title attracted private students, whose shillings added up. As the years went by, however, Mr. Rossetti retreated into a series of intricate paranoid researches into a conspiracy that he found encoded in Dante's work, and many of the family's bills had to be paid by a wealthy patron who believed in the professor's genius and wrote him an occasional good-sized check. Even with this help, the family's annual income usually averaged between £220 and £280 — barely enough to maintain shabby gentility for a family of six.

Feeding and clothing her family as well as paying the rent on less than a pound a day required careful management, but Mrs. Rossetti succeeded in doing so without visiting a sense of strain on her children. They remembered home as a sunny place filled with love, encouragement, and a good deal of fun. The family was even able to keep a servant, since maids generally received between ten and twelve pounds a year plus room and board. Because Mrs. Rossetti did not cook and neither she nor her daughters sewed, her servant must have worked day and night. However, she was not one to leave the raising of her children to others.

A singularly well-educated woman who had been a governess before she married, Frances Rossetti took on the task of teaching her children at home. She gave them a solid grounding in reading critically and writing gracefully, assigning essays and drawing on the Bible, the *Confessions* of St. Augustine, and *The Pilgrim's Progress*. She leavened these texts with Homer, Shakespeare, and *Robinson Crusoe* and allowed her children to read the popular romance writers they clamored for: Walter Scott, Maria Edgeworth, Ann Radcliffe, and Maturin. The children learned Italian from their father, who chose to speak only his native language at home, although he could speak English.

Maria, William, Gabriel, and Christina created a world for themselves; they seemed to need no one but each other. From their earliest years they churned out poems and drawings and plays and journals at a great rate. Before she learned to write, Christina dictated her first poem and her first story to her mother. Gabriel drew constantly from the time he was four and soon declared his intention of becoming a

painter, a desire that his family honored. As teenagers, the four children played a competitive game called *bouts-rimés*, in which one sibling would make up and distribute a list of rhyming words, then all four would race against the clock to complete sonnets. (One of Christina's first efforts was completed in eight minutes.) To finish the game they would exchange verses and suggest improvements to each other; in this way they began to use each other as teachers and critics, sharpening their literary skills while playing. This fruitful collaboration never stopped; all their lives they encouraged, advised, edited, and read proof for each other, creating a network of mutual support that helps to explain the startling range of their achievements.

When Gabriel was nine, his parents decided that he and William should attend a proper school, and money for tuition was scratched together. Although Maria and Christina were left behind at home like so many Victorian sisters, they were encouraged to keep on with their studies, and first-rate tutors, screened by their mother, were brought in to supplement their lessons. When the boys began to study Greek at school, Maria insisted that she must learn it too, and she made quicker progress than her brothers, turning out a creditable translation of Hesiod. The girls patterned themselves after their mother; as a result, they passed their lives in study, reflection, and discussion.

If William and Gabriel had been free to choose, they too would have stayed at home, for school was boring; however, their daily trips across town educated them to realities of which their sisters remained ignorant. Hippolyte Taine, a French visitor to London in the 1840s and 1850s, was shocked by what he saw in those streets, which outstripped any horror he had seen in Paris: "I recall the lanes which open off Oxford Street, stifling alleys thick with human effluvia, troops of pale children crouching on filthy staircases; the street benches at London Bridge where all night whole families huddle close, heads hanging, shaking with cold; above all I recall Haymarket and the Strand at evening, where you cannot walk a hundred yards without knocking into twenty streetwalkers: some of them ask you for a glass of gin; others say, 'It's for my rent, mister.' The impression is not one of debauchery but of abject, miserable poverty. One is sickened and wounded by this deplorable procession in those monumental streets. It seemed as if I were watching a march past of dead women."[19]

Of the Rossetti children, Gabriel was the only rebel. At thirteen he left school to enter Sass's, the preparatory academy for the Royal

Academy Schools that Millais had already breezed through, but soon he was cutting classes and chafing at the tedious assignments, pronouncing them trivial and mechanical, death to the soul of an artist. By contrast, when William was fifteen he put away his dreams of becoming a doctor and took a job as a clerk in the Excise Office (renamed the Inland Revenue a few years later). Having suffered a series of strokes, Mr. Rossetti was now too ill to work, and the family was in dire need of the eighty pounds a year William earned. While William was shuttling back and forth to his office in Old Broad Street, Gabriel was drifting around the city, exploring and writing poetry when he should have been carefully crosshatching. This kind of behavior earned him a reputation as the family maverick, the scapegrace who worried and aggravated his parents. William's patience was also tried; he had almost unlimited sympathy for his brother, but years later he allowed himself to observe that Gabriel had then "cost something and earned nothing."[20]

Despite his lack of conventional training, Gabriel was admitted to the RAS in 1845, when he was seventeen. He soon found the disciplines of the Royal Academy as irksome and unrewarding as those at Sass's. A student was allowed ten years in which to complete the Academy course, progressing from the Antique to the Life to the Painting School, and most students spent two or three years in the Antique School before they passed on to the Life School. Even two years seemed an eternity to Gabriel, who found the exercise of drawing from plaster casts of Greek sculpture intolerable. In no time he was wandering about again, making pictures as they were thrown up by his imagination and turning to poetry when he was in the mood.

Eventually, though, Gabriel's aimlessness and lack of technique began to worry even him. He saw the merits of the medieval system of apprenticeship, which struck him as a direct, natural method of education, and he began to cast about for a gifted older painter who might become his master. He settled on Ford Madox Brown, whom he had not met but whose work he had seen and admired. Gabriel wrote him a letter praising his work so effusively that Brown, a taciturn fellow who had not yet had much success in impressing the art world in general — he was only twenty-six — suspected that the letter writer was mocking him. Legend has it that he paid a call on Rossetti armed with a stout stick, prepared to rap him over the head if necessary. But Gabriel's ample charm began to work its magic immediately, and before the interview was concluded Brown was

not only convinced of his sincerity but had agreed to take him on. The lessons were free, because Brown's pride would not let him charge, though he needed money badly. (Not until 1855 was he reduced to this expedient, at which time he noted in his diary: "Gave my first lesson for a guinea and am no longer a gentleman."[21])

Gabriel grew to love and respect Brown, but found it impossible to accommodate himself to the discipline that the more experienced painter tried to impose. He wanted to surge ahead and embark on large, beautiful, extravagant paintings. Instead, Brown set him "to fag at some still life."[22] A muddy, clumsy composition entitled *Bottles* survives as testimony to Gabriel's boredom and lack of skill.

It was just at this time that Gabriel met Hunt, in whom he saw a more pliable teacher. Hunt was as painstaking a technician as Brown, but, flattered by Gabriel's attention, he told him that although he would ordinarily recommend the same training that Brown prescribed, he could make an exception for so imaginative a being as Gabriel.

Hunt's confidence was bolstered further that summer when he sold his *Eve of St. Agnes* for seventy pounds, a small fortune in those days.* With this infusion of cash, he felt secure enough to move out of his parents' house and rent a studio in Cleveland Street, near Fitzroy Square. He intended to take the space alone, but Gabriel convinced him that he should work there too and share the expenses. Hunt was afraid of compromising his precious work hours, but Gabriel made life so exciting, so much fun, that he couldn't resist.

They did waste time, staying up late into the night to discuss everything under the sun. They discovered, among other things, a common passion for Keats, who was then little regarded or even read. Gabriel introduced Hunt to the poetry of Blake, whom he worshiped and almost no one else cared a whit about. The year before he had bought a notebook full of Blake's manuscripts and drawings from an attendant at the British Museum, who apparently wanted to get rid of it because it was not worth cataloguing. (Gabriel had been broke at the time, but fortunately William had been willing to lend him the necessary ten shillings.) He also showed Hunt his own poetry,

*Economists suggest that one of these pounds was worth about thirty of today's pounds, which would make Hunt's picture worth £2100, but in fact this figure is deceptively low, because so many products and services were valued at a rate that now seems astonishingly cheap. For example, a man's dress shirt could be had for less than a quarter of a pound, and a mansion in Cheyne Walk was let at a hundred pounds a year. So Hunt's prize bought a lot of freedom.

including the beginnings of a translation of the *Vita Nuova* by his beloved namesake, Dante. Hunt had also tried his hand at poetry, but was so abashed by the quality of Gabriel's work that he never wrote another line.

A steady stream of visitors descended on their new studio, at Gabriel's invitation, and Hunt got angry when time that could have been spent painting was frittered away in conversation. Nor did he find Gabriel a willing student; Gabriel resisted Hunt's admonitions to study perspective so resolutely that he never succeeded in getting a grasp on this fundamental tool. But Hunt found his friend's companionship so valuable that he forgave a host of small and large offenses. Together they discussed what they regarded as the laughable state of contemporary art, and Hunt confided the hope he shared with Millais of initiating a radical reform to bring painters back to the study of nature, the only true source of inspiration.

At Hunt's insistence the two young artists did sometimes settle down to work before their easels, and under his friend's tutelage Gabriel began his first painting in oil, an ambitious design called *The Girlhood of Mary Virgin*. To save the expense of professional models, Christina sat for the Virgin, bent over her embroidery frame, and Mrs. Rossetti posed for Saint Anne, the watchful mother at her side. For a time Gabriel wholeheartedly embraced Hunt's commitment to represent nature, and *Girlhood* shows evidence of an effort to paint simple, homely objects. But fidelity to nature went deeply against the grain of his imagination, and he rarely attempted it thereafter.

Gabriel decided that if he and Hunt were going to start a revolution in art, they should recruit comrades to mount the barricades. In no time he had three prospects under consideration. William was a natural lieutenant; trapped all day at his desk at the Inland Revenue, he was easily seduced into dreaming about a world in which he too could somehow afford to be a painter. He enrolled in a life drawing class in the evenings, and soon Hunt, who liked William very much, was looking with no little dismay at his "conscientious, although rigid, transcriptions of the nude."[23]

As a second candidate, Gabriel introduced his friend Thomas Woolner, a cocky, self-important young man who saw himself as a sculptor but who was scrambling to make a living as a carver of marble decorations. Gabriel found it an easy stretch to include sculpture in their program for reform; Hunt was less sure, but hesitated to voice his reservations.

Gabriel's third recruit was James Collinson, Christina Rossetti's suitor, whose dutiful picture *Charity Boy's Debut* had been well received at the Royal Academy the year before. Collinson was a less than stimulating companion: He suffered from narcolepsy, which meant he had a tendency to nod off in the middle of conversations.

The normally cautious Hunt was swept up in the fast current of Gabriel's enthusiasm. He introduced his other pupil, Frederic George Stephens, into the group. A handsome young fellow who had been lamed in a boyhood accident, Stephens was possessed of a small talent and a great deal of doggedness.

When Millais returned from his summer in the country, he was hurt to learn of the plans Hunt and Rossetti had been concocting. He was jealous of Hunt's tremendous excitement over his new friendship, and upset to discover that his private dreams and cherished ideas for reform had been shared with a host of strangers who were planning to style themselves as artists when in fact some of them didn't even know how to draw. He teased Hunt: "Where is your flock? I expected to see them behind you. Tell me all about it. I can't understand so far what you are after. Are you getting up a regiment to take the Academy by storm? I can quite see why Gabriel Rossetti, if he can paint, should join us, but I didn't know his brother was a painter. Tell me. And then there's Woolner. Collinson'll certainly make a stalwart leader of a forlorn hope, won't he? And Stephens, too! Does he paint? Is the notion really to be put in practice?"[24]

Hunt tried to explain, and succeeded in convincing Millais, who was in his own way as sociable as Rossetti, to meet his new friend and talk over the possibilities. One talk led to another, as Rossetti succeeded in charming Millais too — for the moment.

They found themselves in general agreement that painting had taken a disastrously wrong turn with Raphael. Raphael was a genius, but the virtues of his mannered formalism had been turned into appalling vices by a legion of painters after him. To put painting back on track, young artists would have to drop the aesthetic styles and judgments of the past three centuries and throw off the deadly hand of the Renaissance. They would need to return to the spirit of the early Italians who had worked with a simple, direct regard for nature, of artists such as Giotto, Fra Angelico, Orcagna, and Ghirlandaio, who had painted what they had seen with clarity, colors, and simplicity that were now dismissed as naive.

Hunt and his two companions met constantly in the evenings, after

the sun had set, when painting was no longer possible. In a month they felt they had hammered out their ideas, and Millais invited all potential members of the artistic revolution to his studio in Gower Street for an exploratory meeting.

<center>∾❦∾</center>

That meeting, in September 1848, the year of revolutions, marked the founding of the Pre-Raphaelite Brotherhood. Millais produced a set of engravings of the medieval frescoes in the Campo Santo, the burial ground, at Pisa, and handed them round for everyone's perusal. Through these clumsy line engravings of frescoes they had never seen, Hunt, Millais, and Rossetti were able to grasp the greatness of medieval art. (Actually, Hunt sensed their value immediately, but Rossetti laughed at them until Ford Madox Brown uged him to go back and look more closely.) None of the young men had ever had the opportunity to travel to see the originals of such work, and in 1848 the National Gallery had just 214 paintings in its collection. To be sure, these included many masterworks — eight Rubenses, seven Rembrandts, four Van Dycks, three Correggios, two Raphaels, and a Bellini — but the Bellini seems to have been the single picture painted by an Italian before Raphael. Their knowledge of the great works pre-dating Raphael was based on the few prints they had seen and on Ruskin's elaborate descriptions.

Millais was reassured to see that his engravings were received with an intelligent sympathy. Hunt held forth on the principles that would inform the group's work, explaining that he, Rossetti, and Millais had settled on "the Pre-Raphaelite Brotherhood" as a name, not because they would imitate the early Italian painters but because they would reclaim the innocence and purity that painting had had in those days. Collectively they would eschew convention and escape the burden of rules under which artists now labored; instead, they would turn to nature as their master, not to copy it slavishly but to render their own perceptions faithfully. At the same time they would commit themselves to painting themes that had moral value, that inspired those who saw their pictures to lead noble, decent lives.

Then Gabriel produced a curious document that he and Hunt had composed, and asked everyone to read it and affix his signature. The paper started off boldly: "We, the undersigned, declare that the following list of Immortals constitutes the whole of our Creed, and there exists no other Immortality than what is centred in their names

and in the names of their contemporaries, in whom this list is reflected." The Immortals fell into five categories. At Hunt's insistence, Jesus stood alone at the top. (Gabriel had wanted Shakespeare to have this spot.) Category two contained Shakespeare and the author of Job. Number three listed Homer, Dante, Chaucer, Leonardo, Goethe, Keats, Shelley, King Alfred, Landor, Thackeray, Washington, and Browning. Categories four and five were even more of a grab bag, ranging from Boccaccio to Mrs. Browning to Newton to Edgar Allan Poe. All seven of the assembled signed this paper to signify that they were the Pre-Raphaelite Brothers and agreed that henceforth they would inscribe their pictures with the initials PRB.

The Brothers decided to hold a monthly meeting to conduct business and to review works in progress; William was appointed secretary, and he began to keep a journal. The young men found that they thrived in one another's company, though, and before long they were getting together almost every night, devising theories not only about how to paint but about how to live. Very young and very earnest, they laid down prohibitions against drinking, smoking, and swearing, although they seem to have drunk the occasional glass of beer, and Woolner at least always had a pipe in his mouth. Nor were they above a giggle. When a group of them considered renting a house together in Chelsea, they planned to put a sign that read PRB on the door: Please Ring Bell to outsiders, Pre-Raphaelite Brotherhood to those in the know.

They did not restrict themselves to painting and sculpture. When Tennyson published *In Memoriam,* an elegy for his closest friend, Arthur Henry Hallam, William Rossetti arranged to get one of the very first copies to review. Everyone gathered at Gabriel's studio that evening, and when William arrived, brandishing the copy over his head in triumph, he passed it to Gabriel, who read the entire poem aloud — more than 2700 lines — while his friends sat listening intently. Friendship was the mainstay of their lives. Tennyson, already their hero, had spent fifteen years crafting this masterpiece from his grief for his friend Hallam, who had died at the age of twenty-two. These young men understood its greatness in the moment, and felt privileged to have heard it read in their intimate circle.

❧✦❧

None of the Brothers had much money; they were rich only in hopes and dreams. All seven came from the middle or lower middle class,

and only Millais and Collinson had grown up in any degree of comfort (Stephens's father was a minor functionary at the Tower, and Woolner's father was a letter carrier). They were intent on advancing both economically and socially, but they had certainly chosen a difficult route. Until the early part of the nineteenth century, painters were generally regarded as little better than tradesmen. The Royal Academy's prestige was a recent phenomenon, and because the Pre-Raphaelites' ideals clashed so profoundly with the Academy's rigid codes, their chances of admission to that august body were slim. Prosperity and recognition seemed elusive, and so they clung to each other for support.

Intense friendships between young men were common, not least because Victorians were under so much pressure to repress their sexuality. Certainly a man could not sleep with a woman who was not his wife — at least, he could not acknowledge that he did so; surreptitious visits to prostitutes were commonplace. A gentleman could not marry until he had sufficient income to support a wife in comfort, which meant hiring servants. It might be years before any member of the Brotherhood had the sort of income a wife required, so it was easier to steer away from romance or even from friendship with women. Even in the letters the Pre-Raphaelites wrote during this period, few women are mentioned, with the exception of mothers, sisters, and aunts. Instead, the young men threw themselves into their relationships with one another, forming passionate bonds that lasted, sometimes until death.

Gabriel Rossetti was the exception. He was already intensely aware of women, and they were drawn to his exotic Mediterranean looks: dark eyes ringed with shadows, hollow cheeks, and dark brown hair that curled softly onto his shoulders. In his teens he sketched prostitutes larking on the streets, and by the time he was twenty-one he had written a poem about a young man who spends a night with one: "Lazy laughing languid Jenny,/ Fond of a kiss and fond of a guinea." The poem is not about sex per se; it is a meditation on the painful, shameful life of a prostitute and the culpability of the men who prey on her. Gabriel had not yet visited a prostitute when he wrote this poem; there is about it the shock and revulsion of a pure young man speaking about something that he affects to understand but has not in fact experienced. Years later he wrote that Jenny came from a "world that I was then happy enough to be a stranger to."[25] However, in order to write the poem at all, he had certainly spent many hours imagining what the life of a prostitute was like.

Late-night expeditions took the Brothers to Tottenham Court Road and other quarters where prostitutes waited for customers. The boys were looking not for sex but for models, and they examined the face of each woman in the hope that she would prove exciting to paint. But when they found a promising beauty, courage generally failed them. Except for Gabriel, they could not bring themselves to ask a young woman if she would consider coming to the studio, so it seems unlikely that any of them had the nerve to venture out alone and pick up a woman for sex.

During the precious daylight hours, Millais, Hunt, and Rossetti worked hard at the paintings they hoped to exhibit in the spring of 1849. Millais was making his usual steady progress; his great achievement this year was *Lorenzo and Isabella,* an illustration of Keats's "Isabella." The picture has the gleaming jewel tones characteristic of the most beautiful Pre-Raphaelite work, as if it were a stained glass window rendered in paint. Using a wet white ground and a rich palette of rose, copper, gold, royal blue, and olive green, Millais portrayed the two tremulous lovers sitting amid a crowd at a banquet table, a difficult composition that he executed with a confidence remarkable in a painter just barely twenty. Lorenzo, an ascetic, slender fellow with a high forehead and curly blond hair (much like the painter), is drawing back from the woman at his side as if he fears to touch her. Isabella's thickly muscled brother sits across the table, cracking nuts and kicking a dog. In a nice bit of revenge that also suggests his own identification with Lorenzo, Millais used a bully who tormented him in his early years at the Royal Academy Schools as a model for this sinister character.

Hunt watched Millais in awe as he painted this picture: "Not an hour of his life had been lost to his purpose of being a painter. The need of groping after systems by philosophic research and deductions was superseded in him by a quick instinct which enabled him to pounce as an eagle upon the prize he searched for. Favoured and young as he was, he had passed through an early tempering which left him firmer in will than many men ever become. This steadfastness was softened by generous enthusiasm, a sweet reasonableness. . . . so that Rossetti . . . said that when he looked at Millais in full, his face was that of an angel."[26]

Hunt made good use of Millais's spirituality in his new picture, *Rienzi,* which illustrated a battlefield scene from Bulwer-Lytton's best-selling novel of the same name. The hero Rienzi holds his dying brother and shakes his fist at heaven, vowing revenge. Hunt drew

Millais for the sensitive young knight Adrian, who watches in anguish as the boy dies of his wound. As Hunt grew closer to Rossetti, he came to feel that this new comrade embodied the strength and mastery he needed for the figure of Rienzi, so he scraped out the hard work he had done using a paid model and painted Gabriel's face into the scene instead. (Not all of Gabriel's friends painted him in an epic mode; Brown put him into his *Lear and Cordelia* as the fool!)

Gabriel too seemed to be settling down to serious painting. If his interest was engaged, he could grow utterly absorbed. "When he had got fairly tangled in a new design," Hunt wrote, "he would refuse the attraction of home, meals, out-of-door engagements, or bed, and sit through the night, sleeping where he sat for hours at the time, recommencing his work when he woke. He ate whatever was at hand when hunger suggested, and when time came for bed on the second night he would ask me to leave him; in the morning I would find him still at his engrossing task."[27] When he was not working, he often sat in a rocking chair for hours without saying a word, perhaps meditating a poem.

Such utter concentration was broken by fits of frustration. Coping with a wriggling child model, for instance, reduced him to "storming wildly, overthrowing his tools and stamping about, until the poor child sobbed and screamed with fright." Gabriel realized he had gone too far and made a half-hearted attempt to comfort the girl, but she was too hysterical and just recoiled further.

After this blowup, Hunt decided to take matters in hand. He calmed Gabriel down and asked him to come outside for a talk. "In the shining wintry sun, on the broad walk of Regent's Park, [I] bade him consider the certain consequences of action such as his, and argued that indulging all his humours would be fatal to his prospects of becoming a painter. This he had an undoubted right to give up for himself, but he must not destroy my chance of getting my picture done, since its completion was a very vital matter to me. I added that his want of self-control affected my power of work more than he imagined." Apologetic, Gabriel promised to rein himself in, and, according to Hunt, he "held to his promise manfully."[28]

Hunt and Gabriel had a difficult relationship, since they were both sensitive, egotistic, and depressive. While they shared a studio they often grated on each other's nerves. Gabriel's worst offense, which still infuriated Hunt when he wrote about it fifty years later, was casually showing Hunt's unfinished paintings to strangers. Hunt showed

works in progress only to fellow painters, whom he could trust to see their potential. Displaying a fledgling picture to laymen who might condescend to it felt like a violation to him. He forgave Gabriel, however, because their relationship was a source of great consolation to him. Gabriel's abounding faith in Hunt's genius quieted his persistent fears.

Hunt was curiously silent about his own fits and the price they may have exacted from Gabriel. He was certainly subject to black moods, which appear to have crossed the border into psychosis on occasion and earned him a nickname, "the Mad." His granddaughter described these moods: "When in despair about his future or his work he would shut himself up in a poky bedroom above the studio and shiver with fear. He felt as if icy water were trickling down his spine. Alone in the dark, he raved, holding long noisy conversations with the Devil. . . . Like a man in a trance, he would wrestle with this terrifying beast — huge, snarling and covered with hair. When the monster moved in, Gabriel, much concerned, would drag Hunt down the attic stairs, scolding but affectionate. He would light the lamp and the stove, and comfort him with cups of coffee. He chafed his hands and coaxed the Mad back to sanity."[29]

Only once did Hunt acknowledge his dependence, in a letter to Gabriel: "Sometimes . . . when troubled or impatient, I am glad to call out to you, and I feel the comfort in your answer which a child feels in the fearful dark at knowing that he is not alone."[30]

<hr />

The first crack in the PRB appeared when Gabriel decided to show *The Girlhood of Mary Virgin* at the Free Exhibition in Hyde Park Corner rather than at the Royal Academy Exhibition, which was held slightly later. A far less prestigious venue, the Free Exhibition attracted Gabriel because he would not have to expose himself to the judgment of the aptly named Hanging Committee; one simply paid a fee for space.

Although they should have seen a lack of confidence, Hunt and Millais smelled treachery. They fancied that Gabriel was drawing attention to himself while deserting his friends, leaving them to run the gauntlet of the Academy alone. Millais's parents made matters worse by muttering that they had been leery of that sly Italian from the start.

Insult was added to injury when Hunt and Millais had to listen to

the critics praise *Girlhood* as the "precursor of a new school," which, as Hunt remarked drily, was "somewhat trying." Both he and Millais were incensed. They believed that they had brought Gabriel along, taught him how to paint, and filled him with their ideas. For Hunt this heralded precursor was nothing more than a "simple exercise" he had set his pupil.[31] Hunt was dramatizing a bit: Gabriel did lack technique, but he was a brilliant and gifted artist who had contributed his own ideas to the PRB. Hunt mounted his soapbox and accused Gabriel of the crime no true gentleman would ever commit: "not 'playing the game' fairly."[32]

Hunt and Millais knew that their works had been accepted for the Academy's exhibition, but they were nervous about where they would be hung. The exhibition rooms had extremely high ceilings, and hundreds of pictures ended up where viewers could barely make them out even if they craned their necks. A painter's worst fear was that his picture would be "skied," or shot up to the very top of the room, a placement that suggested the hangers' contempt. It was bad enough that pictures were hung with their frames practically touching each other.

When Varnishing Day finally arrived, Hunt and Millais found, to their great relief, that their paintings were placed side by side just above "the line," a wooden ledge eight feet eight inches above the floor. Paintings hung "on the line" — that is, with the top of their frames near the ledge — were at or close to eye level; they were accorded the best spots for viewing because the hangers judged them the finest works in the show.

The start of the Royal Academy Exhibition was marked each year by a series of ritualized events. Opening Day was the first Monday in May. On the preceding Thursday the Queen paid a private visit, and on Friday the Private View, a landmark of the London season, was held; everybody who was anybody received an invitation, and most put in an appearance, whether or not they were interested in painting.

All of this folderol was lost on Hunt and Millais in 1849. To their dismay, the crowds showed them no mercy, although a handful of painters stopped to compliment them on their work. According to Millais's son, *Lorenzo and Isabella* was treated as "a prime joke, only surpassing in absurdity Mr. Holman Hunt's *Rienzi*."[33] The artists felt humiliated but were relieved that the reviews were mild; some critics showed interest in what they perceived to be an intriguing experi-

ment. Although the Brothers had worked the initials PRB artfully into their canvases, no one noticed them, and for the moment the fact of the Brotherhood remained a secret.

Gabriel must have felt exquisitely uncomfortable in Hunt's studio at this time, because he suddenly decamped. Weeks later a servant appeared to collect his things and announced that he had ceased to pay his share of the rent. It is a measure of Hunt's love for Gabriel, and of Gabriel's charm, that their friendship survived what Hunt saw as a double betrayal — which did not mean that Hunt forgot it.

In some wise the two young men were reconciled, and they set out on a trip to France and Belgium. (Millais was invited along, but he was too busy to leave his easel.) This was a journey of discovery. They studied the pictures in the Louvre, and at Bruges they found new heroes among the Dutch painters, especially Hans Memling and the Van Eycks. In the work of these great artists they saw a validation of the Brotherhood's commitment to verisimilitude, and with the pride of youth they thought that they were rehabilitating forgotten geniuses. They didn't know that Charles Eastlake, who was about to be elected President of the Royal Academy, had made a similar journey in 1828, the year Rossetti was born, and had been electrified by the very same pictures.

When they returned home Gabriel began a new painting, once again using his sister Christina as the Virgin, in an Annunciation scene called *Ecce Ancilla Domini* ("Behold the Handmaid of the Lord"). Initially William sat for the Archangel Gabriel, but the artist had to give him up because his "malevolent expression" would not do.

Gabriel took a great deal of trouble with this picture, which taxed his skills to the limit. In the scene, the Virgin crouches on a bed in a white nightgown, her face even sadder and more remote than in *Girlhood*. The painter conveys her innocence by a brilliant use of warm whites; her white nightgown against white walls makes her dark, troubled face the focus of the picture, which has an almost Moorish feeling, definitely Mediterranean. The joy of the traditional Annunciation painting is missing; this Mary has been overwhelmed by the gravity of the angel's message.

To amuse and distract himself from the strain of painting, Gabriel came up with the idea of starting a Pre-Raphaelite magazine. This would provide him with a ready-made outlet for his poems; on days when the picture was going badly, he thought that maybe his career lay in poetry rather than in painting. He presented the idea at one of

the PRB's evening meetings, and everyone agreed to contribute something: an etching, an essay, a review, a poem. The name of the magazine did not come so easily; no fewer than sixty-five possibilities were taken under consideration, including *The Progressist, The Anti-Smudge, The Chariot, The Die, The Goad, The Ant,* and *Earnest Thoughts,* before they settled on *The Germ.* William was appointed editor, which meant that he did the lion's share of the work, rounding up the copy, getting it ready to go to the printer, proofreading galleys, mailing out complimentary copies, and trying to figure out how to sell it. The first issue, published in January 1850, was a commercial disaster; only two hundred of the seven hundred copies were sold, at a shilling apiece. (It did not help that the Brothers insisted on pronouncing "Germ" with a hard *g*, as in *girl*, which made potential buyers laugh.) Somehow Gabriel convinced the others that they should press on with a second issue. In all there were four issues before *The Germ* folded, and apparently it was the publisher, not the Brothers, who absorbed a loss of thirty pounds.

While Gabriel was floundering with his Annunciation and grinding out copy to fill *The Germ,* Millais and Hunt were also hard at work on religious subjects, which were highly salable. Hunt labored for months over *A Converted British Family Sheltering a Christian Priest from the Persecution of the Druids.* Victorian narrative paintings often carried such unwieldy titles, so viewers could recognize the story being depicted. This canvas presents a singularly unattractive huddle of half-naked Christians in various shades of streaky pink flesh, hiding implausibly inside a grass-covered lean-to while a few more Christians are being tortured in the immediate background.

Millais had embarked on *Christ in the House of His Parents,* a far more satisfying picture. He dressed the Holy Family in ragged work clothes rather than the rich royal robes of conventional religious art, and gave them the faces of tense, worried working people rather than placid angels. Mary and Joseph are comforting Jesus, bending over to look at a bloody cut on his palm that prefigures his wounds on the cross.

Millais put hundreds of hours into this work, and went to great lengths to achieve verisimilitude. He painted in a carpenter's shop, using the carpenter as the model for Joseph so he could paint precisely the muscles a carpenter develops. He slept in the shop to save travel time, and he did dozens of sketches of wood shavings to get them just right. The finished work is a simple, quiet scene painted with

directness and affection. When Hunt saw the finished canvas, he was stunned by its power.

As soon as these paintings were exhibited, the storm clouds that had been hanging over the PRB broke. Their secret was out; friends had gossiped to critics, decoding those mysterious initials for them; then the Brothers had gone public by publishing the short-lived *Germ*. Sarcasm and hostility greeted them on almost every side. "The leading journals denounced our works as iniquitous and infamous," Hunt recalled.[34]

When a Victorian gentleman sat down to write a review, he took the gloves off. Gabriel was attacked first, because for the second year in a row he exhibited at the Free Exhibition, renamed this year the National Institution. The *Athenaeum* critic tore into him: "What shall we say of a work . . . which we notice less for its merits than as an example of the perversion of talent. . . . We allude to the *Ecce Ancilla Domini* of Mr. D. G. Rossetti. Here a certain amount of talent is distorted from its legitimate course by a prominent crotchet. Ignoring all that has made the art great in the works of the greatest masters, the school to which Mr. Rossetti belongs would begin the work anew, and accompany the faltering steps of its earliest explorers. . . . do these crotchet-mongers propose that the art should begin and end there? The world will not be led to that deduction by such puerilities as the one before us, which with the affectation of having done a great thing is weakness itself. An unintelligent imitation of the mere technicalities of old Art — golden glories, fanciful scribblings on the frames, and other infantile absurdities — constitute all its claims. A certain expression in the eyes of the ill-drawn face of the Virgin affords a gleam of something high in intention — but it is still not the true inspiration. The face of the angel is insipidity itself."

Many in the art press felt threatened by the PRB, which they perceived as a conspiracy of immature painters intent on setting British painting back several centuries by rejecting, as this reviewer sniffed, "the Raphaels, Guidos and Titians, and all such small-beer daubers," and forcing the public to accept in their place incompetent imitations of medieval "saints squeezed out perfectly flat."

Millais caught the worst of it, no doubt because his painting was by far the strongest of the Pre-Raphaelite offerings and so the greatest threat to prevailing aesthetic standards. Furthermore, he had been the acknowledged pet of the Academy for more than ten years; it was as if they had nursed a viper in their bosom. The *Times* called his picture

"plainly revolting . . . with no conceivable omission of misery, of dirt and even disease"; the *Athenaeum* scourged it as "pictorial blasphemy"; *Blackwood's* reviled it as a "collection of splay feet, puffy joints and misshapen limbs." Even Charles Dickens was offended. In *Household Words,* his popular new magazine, he denounced Millais's Christ as a "hideous, wry-necked, blubbery, red-haired boy in a nightgown" and his Mary as a woman "so horrible in her ugliness that . . . she would stand out from the rest of her company as a monster in the vilest cabaret in France or the lowest gin-shop in England." Queen Victoria, unable to attend the exhibition, was so intrigued by the furor that she asked for the picture to be sent to her.

Hunt did not escape the critics' wrath either. The *Times* attacked his *Druids* as suffering from the "same intolerable pedantry" as Millais's painting, a remark that tickled Hunt more than it pained him, for he knew his friend's painting was brilliant. But the coldness of fellow painters did hurt him: "Not one complimented me in any way, but those I saw turned away as though I had committed a crime."[35] The canvas came home "unsold and uninquired for."[36]

Today it is hard to see why the Pre-Raphaelite Brotherhood so disturbed the critics and the viewing public. From this vantage, their work appears radiant, often fanciful, a definite change from what came before, but hardly revolutionary when set beside subsequent developments such as impressionism and cubism. Nonetheless, the shock and distress that many people felt on encountering a Pre-Raphaelite painting in 1850 were very real. In fact the Brothers were rejecting not Raphael so much as their own immediate forebears — Maclise, Eastlake, Leslie, Mulready, Horsley, and Landseer, Royal Academicians who were still on the scene and widely admired. Consequently, their peculiar pictures seemed disrespectful, so much boyish braggadocio.

Perhaps equally disturbing, the palette these painters chose — all those bright, startling colors that seemed lit from behind — jolted their audience. The value of light, the need for light in a painting is something we take for granted, but our comfort has been learned, first from the Pre-Raphaelites and then from the Impressionists. In 1850, looking at a Pre-Raphaelite work was for many people much like coming out of a long, dark tunnel and having a torch shone in their eyes.

Hunt, Millais, and Rossetti were discouraged by the avalanche of criticism. Millais retreated to Oxford to recuperate in the care of

friends, Thomas and Martha Combe, who lived just off the quadrangle of the Clarendon Press, which Thomas Combe had revivified. Both the Combes were immensely fond of Millais, and they were eager to fatten him up and entertain him while he painted in the countryside around the university. From Oxford he wrote to Hunt, questioning the PRB credo and their painstaking method of using a wet white ground: "I cannot help thinking we have been asses to have followed the principle of nature and commonsense, it is so disgustingly laborious and unremunerative."[37]

Reduced to cranking out potboilers once more, Hunt may have agreed with Millais secretly, but pride would never let him admit it. At one point he was so poor he could not afford stamps, a serious matter before the invention of the telephone. His dress clothes spent a lot of time at the pawnshop, and his work clothes grew hopelessly shabby. (Gabriel was equally broke, but it did not gnaw at him so desperately. He took life more easily than Hunt, called his pawnbroker "my uncle," and on July 1, 1850, wrote to his brother: "Just today you have put on the only pair of breeches in which it is possible for me to go to the opera tonight. Unless you *do* want them for yourself, I wish if possible you would manage to be at home by five, in order that we may make a transfer."[38])

Hunt was at his wits' end when Millais came to his rescue by finding a buyer for *Druids* at Oxford, a friend of the Combes' who agreed to pay Hunt 160 guineas, a good price.* One hundred and sixty guineas may not sound like much to us, but when the young painter Walter Crane sold his first small picture at the Royal Academy Exhibition of 1862 for five guineas, he was absolutely thrilled at the sale and quite happy with the sum he received. From the early days, Hunt and Millais were able to command good prices, despite their sense that they were being oppressed by a critical cabal. (Some buyers were more perspicacious than critics and ignored their venom.)

Since Hunt and Millais had no choice but to compete in the same limited market, Millais's gesture was particularly generous, and Hunt lavished him with praise: "He, regarding my welfare as dear to him as his own, again secured to me the opportunity of carrying on the contest with him, which, it will be seen, he continued to do until I

* Artists often insisted on being paid in guineas rather than pounds. It was understood that transactions between gentlemen were made in guineas, and artists were fighting for recognition as gentlemen. There was also a slight monetary advantage, since a guinea was worth twenty-one shillings and a pound only twenty.

had found my fair chance of making my effort by his side."[39] (During the next year Millais introduced Hunt to the Combes, which was the start of a precious lifelong friendship.)

Gabriel's response to the savaging of his Annunciation was to withdraw from competition almost entirely. For the moment he was distracted from his professional aggravations by a stunning model, a young woman who worked in a bonnet shop. Romance now pushed such tiresome subjects as exhibitions to the back of his mind, and after 1850 he showed his work only very occasionally, and then in venues where he felt protected, such as a private exhibition arranged by Ford Madox Brown for himself and his friends. Gabriel never submitted a single painting to the Royal Academy, which meant he cut himself off from virtually the only means of bringing his work to the attention of the buying public. As a consequence, he had to find his buyers by word of mouth — a singularly difficult way to make a living.

Despite his wavering, Millais renewed his commitment to Pre-Raphaelite principles, deciding to give them a thorough trial, and he and Hunt started fresh pictures for the exhibition of 1851. The subjects they took up this time were irreproachable, chosen from Shakespeare, Tennyson, Coventry Patmore, and the Bible. Hunt painted the last scene from *Two Gentlemen of Verona,* in which Valentine rescues Sylvia from the clutches of Proteus, in a calm, even decorous rendering. Millais readied three pictures this year. The most daring was *Mariana,* a sensuous interpretation of Tennyson's poem about a young woman who languishes at a moated grange, waiting for an absent lover. Rising from the table where she has worked too long over her embroidery, she stretches her whole body deliciously. Her catlike grace and velvety, form-fitting royal blue gown make her far more seductive than the long-suffering woman in the poem, and even though the critics scorned the painting, it was extremely popular among the women who attended the exhibition.

Once again the press turned on Hunt and Millais, with even greater vehemence. Hunt, with his flair for melodrama, observed that last year's "storm of abuse" had "turned into a hurricane."[40] It seemed as if each day brought more criticism. On May 7 the *Times* published a review that impugned the Brothers' pictures, their motives, and their association. With a bombastic flourish, the review began: "We cannot censure at present as amply or as strongly as we desire to do, that strange disorder of the mind or the eyes which continues to rage

with unabated absurdity among a class of juvenile artists who style themselves PRB." There was a great deal more in this vein, as well as a charge that the Royal Academy was spoiling these young men by hanging their disgraceful extravagances year after year. Their credo was dismissed as "that morbid infatuation which sacrifices truth, beauty, and genuine feeling to mere eccentricity" and which "deserves no quarter at the hands of the public." Their pictures were labeled "monkish follies" that "have no real claim to figure in any decent collection of English paintings."

Even history seemed to be conspiring against them. Pius IX had just restored the hierarchy of the Roman Catholic Church in Britain and created Nicholas Wiseman a cardinal and archbishop for Westminster, the first since the reign of Henry VIII. Fleet Street had jumped on this development and dubbed it the Papal Aggression, stirring up fears of Vatican belligerence. On Guy Fawkes Day, the pope and the new cardinal had been burned in effigy by furious crowds all over the country. The Pre-Raphaelites got caught in the crossfire, as their critics seized the chance to brand them not just bad boys but dangerous papists. As if calumny by the press were not sufficient, private citizens were moved to write and berate them. Reported Hunt: "The post brought nothing but anonymous insults."[41]

But the Brothers were most thoroughly alarmed when they learned that Sir Charles Eastlake had said privately that neither he nor the Hanging Committee would accept the PRB's outrageous pictures for exhibition after this year. In desperation Millais made a trip to Highgate to visit Coventry Patmore, whom he knew to be a good friend of the all-powerful critic John Ruskin. Patmore was fond of Millais and thought him a gifted artist, and he agreed to speak to Ruskin immediately. Ruskin loved a good scrap over aesthetic issues, so he fired off a letter to the *Times,* which appeared on May 13.

Hunt and Millais were floored by what they read. Not only did Ruskin like their work, he had taken the trouble to write a long, passionate defense of their intentions, dismissing their critics as casually as if they were flies on a horse's flank. To him, the Brothers' carefulness was a virtue rather than a defect: "There has been nothing in art so earnest or so complete as these pictures since the days of Albert Dürer. This I assert generally and fearlessly." He analyzed the works they had exhibited in detail, finding strengths and weaknesses, and concluded by predicting a brilliant future: "If they temper the courage and energy which they have shown in the adoption of their

system with patience and discretion in framing it, and if they do not suffer themselves to be driven by harsh or careless criticism into rejection of the ordinary means of obtaining influence over the minds of others, they may, as they gain experience, lay in our England the foundations of a school of art nobler than the world has seen for three hundred years."

Hunt and Millais were almost speechless with gratitude. They dithered over whether to send a thank-you letter, on the theory that it might seem to be toadying. Finally Hunt wrote to Patmore, asking what to do, and the poet wrote back telling him that Ruskin would not bite. They sent a letter to Ruskin from Millais's address in Gower Street and signed it with both their names. A genuine enthusiast, Ruskin did not stand on ceremony, and late in the afternoon of the day he received their note he paid a call at Millais's studio. He followed up with a second letter to the *Times,* equally laudatory, two weeks later; it was now clear that he was solidly in the Pre-Raphaelites' corner.

Ruskin's grandiloquence saved them. The next year the critics were far more circumspect. Where before they had seen nothing but ugliness and insult, they now saw talent and promise. They had realized that they were going to have to take these disturbing new paintings seriously. The Pre-Raphaelites were launched, and they would dominate British art for the rest of the century.

Two

DANTE
AND BEATRICE

Painting was the passion the Brothers shared in youth; soon another kind of passion drew them. Gabriel was the first to be seduced.

Scrambling to get enough copy to the printer to fill the first issue of *The Germ,* he sat down with paper and pen on the twentieth of December, 1849, in the tiny bedroom he shared with his brother and tried to unravel a thick knot of dreams and ideas that had been forming in his head. He worked through the day and night, and by dawn he had down most of a rambling, earnest tale he called "Hand and Soul," about a fictional painter named Chiaro dell' Erma, who was supposed to have lived and worked in thirteenth-century Pisa.

Chiaro is an ascetic and supremely talented youth who has dedicated himself to the sincere imitation of nature, a task to which he is well suited. He is so sensitive that sunsets and the "sight of stately persons" — that is, beautiful persons — make him feel faint. He himself is so lovely to look at that the fair sex cannot resist him: "Women loved Chiaro; for, in despite of the burthen of study, he was well-favoured and very manly in his walking; and seeing his face in front, there was a glory upon it, as upon the face of one who feels a light round his hair."

Like Gabriel, Chiaro is stymied in his quest for spiritual fulfillment. Fame came easily to him, but he quickly saw its hollowness. Then his faith failed him, and despair gnawed at his heart. When it dawns on him that he has begun to worship physical beauty, mistaking it for spiritual grace, he grows confused and sick of himself.

The young artist is saved by the sudden apparition of a beautiful woman, a spirit who has donned contemporary clothing in order to accomplish her mission. At once Chiaro knows that her hair is "the golden veil through which he beheld his dreams." In the next moment her words confirm his intuition that she is his spiritual twin: "I am an image, Chiaro, of thine own soul within thee." She counsels him to "seek thine own conscience (not thy mind's but thine heart's)," promising that if he does, he will find the love and faith he needs to sustain him. He weeps, and his tears run through her golden hair, which she draws over him like a veil.

Before the apparition departs, she instructs the artist to paint her image. He rushes to his easel and takes up his brushes to obey her command. The result is a picture so perfect, so transcendent, that "it was not a thing to be seen of men."

<hr>

While Rossetti was busy writing about and drawing this lovely golden-haired creature, the woman he would soon seize on as the incarnation of his ideal was trudging back and forth from the tenement where she lived with her family to the shop where she worked as a milliner's assistant. Fussing with plump silk roses and ostrich plumes, fending off the impertinent advances of idle young men, Elizabeth Eleanor Siddal would have been hard pressed to see herself as the medieval angel shining in Gabriel Rossetti's imagination.

Cranbourne Alley, where she worked, was a popular hunting ground for men from all over London. A narrow little passage, not even really a street, in the seedy neighborhood of Leicester Square, it drew those who wished to prowl among the pretty girls laboring in its row of bonnet shops. (Hats, just coming into fashion, were still considered quite daring compared to the traditional bonnets, their more demure sisters.) The young women who worked in this trade had a reputation for being attractive and easy, an irresistible combination, particularly to young men of the middle class, who were allowed to see young women of their own station only under the cautious eye of a chaperone. Hopeful fellows hot to flirt wandered in and out of the shops all day long, trumping up inquiries about a hat or a bonnet for mother or sister. If a chap hit it lucky, one of the girls might agree to being escorted home or even taken to dinner, and after that — who knew what might happen?

Elizabeth Siddal worked at Mrs. Tozer's shop six days a week,

from eight in the morning till as late as eight in the evening, and when demand was great, sometimes right through the night. For her labor she received something like twenty-four pounds a year, or a bit more than nine shillings a week. Her life was by no means the hardest of her time. Orphaned boys of ten or eleven made their living as mudlarks, scavenging bits of wood and coal that washed up on the riverbank and selling them; a seamstress who made shirts sixteen hours a day, six days a week, earned as little as four shillings a week, out of which she was expected to pay for her own cotton and candles, so that she was left with two shillings and sixpence.

Lizzie's nine shillings were welcome at home, above the shop where her father eked out a living from his cutlery business. A proud man, he survived on a fantasy of fallen nobility and a lost inheritance, a story he spun for his wife and seven children when they clustered around the hearth to escape the damp chill of a London evening. Going over and over the minutiae of a lawsuit he was forever waging to regain the legacy he stoutly maintained he had been cheated of, he fed them dreams of a return to Hope Hall, the Siddalls' ancestral manor house near his hometown of Sheffield. (The family name originally had two l's; Gabriel later made Lizzie change the spelling, apparently because he thought one l looked more refined.) A talented musician, Mr. Siddall played the violin and sang to entertain his family in their tiny parlor, where the few bits of good furniture were lovingly dusted and polished. He read poetry to them, and so much Dickens that his daughter Lydia could declaim her favorite scenes from memory. Filled with a longing for culture and refinement, he did his best to share what he knew with his progeny, to enrich their lives and to help propel them out of the bottom of the middle class, where he was doomed to founder.

Lizzie seems to have been taught to read and write at home, for there is no evidence that she attended school. She learned good manners at home too, and by the time Gabriel met her, in 1850, she was a quiet, elegant-looking young woman of twenty who attracted a great deal of attention at Mrs. Tozer's bonnet shop by virtue of her ladylike demeanor and self-possession — qualities not looked for in a shopgirl.* She kept to herself, avoiding casual intimacies with the

*No one was sure of Lizzie's age until her birth certificate was located in the 1970s. Most of her contemporaries thought that she was several years younger than she actually was. If she met Gabriel early in 1850, as I think she did, she would have been twenty, as her birthdate was July 25, 1829.

other girls, which made them curious about her and a trifle jealous.

Her beauty may also have isolated her from other women. She was tall for the time — five-seven, the same height as Gabriel — and she had a shapely figure, but it was her face that drew comment. Only two poor photographs of her have survived, but fortunately, descriptions of her abound in letters and memoirs: Everyone seems to have been mesmerized by her. When Ruskin first saw her, he felt that her red-gold hair, ethereal coloring, and large, limpid, brooding eyes gave her the look of a figure who had just stepped out of a medieval Florentine fresco. Admirers and rivals both struggled to describe her, either to pin down the nature of her beauty or to deny that she was attractive at all. The debate had a basis in reality: Physically, she was a chameleon, lovely one moment, plain and stiff the next. Such mutability was part of her attraction for artists.

Lizzie's lovely face was crowned with masses of thick, straight, gleaming hair, which she had inherited from her mother. In a dusky room her hair glinted a rich red, but in the sun it was dazzlingly blonde, with a touch of copper. Her eyes were hazel, which meant that they reflected the color of her clothes; a green dress brought out the green in her irises, a blue one found the blue. She had big, deep-set eyes with huge, delicately veined lids, and her mouth had the undershot bottom lip that one sees so often in the profiles of saints and gentlewomen rendered by the early Italian painters. One thing that all observers did agree on was the beauty of her complexion, colored "as if a rose tint lay beneath the white skin."[1]

One of the young men who hung about in Cranbourne Alley was the Irish poet William Allingham, a friend of the Pre-Raphaelite circle. Allingham knew that the painter Walter Deverell had been searching for a redheaded girl to be a model for Viola in his painting *Twelfth Night,* and when he saw Lizzie it struck him that she would make a superb choice. On Allingham's recommendation Deverell dropped by the shop, and he immediately wanted to paint her. The trick was to persuade the young woman to model. Her proud demeanor made him fear that she might be offended by the idea, misinterpreting his request as a sexual proposition. She might refuse simply in order to protect her reputation; polite society equated artists' models with whores.

To improve his chances, Deverell asked his very proper mother to

visit the shop and speak to this cool young woman on his behalf. Mrs. Deverell's matronly appearance and obvious respectability won Lizzie's confidence, and she agreed to sit for the head and hands of Viola. The prospect of being paid a shilling an hour — the going rate for models — must also have had its appeal. Because business was slow in winter, Mrs. Tozer agreed to let Lizzie have time off, and soon she was on the horse-bus, making the tedious journey down to Kew where Walter had his studio at the bottom of the garden behind his parents' house.

No doubt she was nervous that first day, having put herself in a compromising position just by agreeing to come to the studio. Spending time alone, unchaperoned, with a handsome bachelor was regarded by the mothers of nice young ladies as almost a sin in itself. If Lizzie had known Deverell as well as his male friends did, she would have been even more apprehensive; a friend of his once joked that Walter thought PRB stood for Penis Rather Better! However, there is no evidence that he ever conducted himself as anything but a complete gentleman with Lizzie.[2]

Deverell made no secret of his find that night when he dropped in at Hunt's, where he found Gabriel too. He talked almost distractedly, then bounded out of his chair, unable to contain his excitement, and danced to and fro about the room. Suddenly he stood still and announced, "You fellows can't tell what a stupendously beautiful creature I have found. By Jove! she's like a queen, magnificently tall, with a lovely figure, a stately neck, and a face of the most delicate and finished modelling; the flow of surface from the temples over the cheek is exactly like the carving of a Pheidean goddess. Wait a minute! I haven't done; she has grey eyes, and her hair is like dazzling copper, and shimmers with lustre as she waves it down. . . . today I have been trying to paint her; but I have made a mess of my beginning. Tomorrow she's coming again; you two should come down and see her; she's really a wonder; for while her friends, of course, are quite humble, she behaves like a real lady, by clear commonsense, and without any affectation, knowing perfectly, too, how to keep people at a respectful distance."[3]

Hunt was, as usual, too busy to take Deverell up on the invitation. But Gabriel availed himself of the opportunity and scuttled down to Kew to take a look at this phenomenon, a refined shopgirl, the very next day.

At the time, nothing seemed to be going his way. He had struggled

to paint a difficult and daring Annunciation, only to have the picture savaged by critics. Coming on the heels of so much praise the year before, the rejection shocked him, and he sank into a depression, sleeping away many days when he should have been at his easel. Then he made the mistake of starting a painting that was much too large and complicated for his skills, and his failure to get ahead with it further discouraged him. He was also suffering from the eternal cash problem.

Ripe for a *madonna ex machina* to lift him up into the dream world where he yearned to live, Gabriel took one look at Lizzie and decided that he had finally found the woman with the golden veil; later he told his friend Madox Brown that "when he first saw her he felt his destiny was defined."[4] He began to make approaches to her, dropping in at the shop, offering to walk her home, bringing her little gifts. In these early days he treated her with reverence, winning her trust with his courtly manners and gentle, beguiling voice.

Only too quickly his dream of perfect love bumped into the events of everyday life. Lizzie began to sit for Hunt, too, and they had become friends. On a warm August evening they paid a call on Hunt's friend Jack Tupper, and Hunt proudly introduced Lizzie as his new bride. Tupper congratulated them, but when Gabriel heard about this charade he was livid, ostensibly because of the deception practiced on his good friend. He wrote to his brother William about this "disgraceful hoax," adding, "as soon as I heard of it, however, I made the Mad write a note of apology to Jack."[5] Of course, he was actually furious because Hunt had usurped his place in the dream bed by declaring himself the bridegroom. To Gabriel, Lizzie was a gift from God, and he thought Hunt was using her as a plaything.

Hunt whipped off a note of apology to smooth Gabriel's ruffled feathers, and a month later the two went down to Sevenoaks in Kent to paint backgrounds together in the great deer park at Knole. Hunt was working on his painting *Valentine Rescuing Sylvia from Proteus* and wanted to use Lizzie as the model for the duke's daughter, Sylvia. Gabriel was full of enthusiasm for his own project, writing to Jack Tupper: "My canvas is a whopper again, more than 7 ft. long. Ai! Ai!"[6]

He was planning to paint a *Meeting of Dante and Beatrice in the Garden of Eden*. Dante was always first in Gabriel's pantheon of poets; he had even rearranged the name his parents had given him, Gabriel Charles Dante Rossetti, in order to give his hero precedence.

Why did Dante appeal so strongly to this young Victorian? Gabriel faced the same problem as every vital young man of his age: how to deal with his burgeoning sexuality when his devout mother had raised him to honor women, which dictated an uncomfortable chastity. In Dante's *Vita Nuova* he found a marvelous if impossible paradigm for a perfect love that managed to combine prudence and passion. Over the past several years Gabriel had spent many days working in the Reading Room at the British Museum, toiling over a translation of the cycle of poems and commentary that make up the *Vita Nuova,* and so he was utterly steeped in it. With these poems Dante offered Gabriel a guide to honoring his own Beatrice while indulging in the most exquisitely intense feelings.

In the *Vita Nuova* Dante recounted the story of his love for Beatrice, the daughter of a prominent Florentine citizen. This feeling descended on him at their first meeting, when she was eight and he was nine. Their love remained chaste, not least because Beatrice married someone else. Their relationship unfolds almost exclusively within Dante's heart and mind; in fact, the *Vita Nuova* is really about Dante, and Beatrice serves almost entirely as a catalyst for his emotions, fantasies, and dreams. There were few actual events in this relationship. When Dante was eighteen, he met his beloved out walking with two other ladies, and when she acknowledged him, he had to flee because he was so overwhelmed by her simple, kindly greeting. That night he had an extraordinary dream in which Love appeared to him, carrying Beatrice; Love then forced Beatrice to eat Dante's heart. In the waking world, Dante never touched Beatrice. He worshiped her from afar and in secret, and he was rewarded with visions of her that affirmed her utter purity and caused him to rededicate himself to celebrating her in his poetry. When she died, he was nearly destroyed by grief, but a vision of her waiting in heaven saved him.

Gabriel made the mistake of believing that such a love affair was both desirable and possible, and so he began his search for a Beatrice of his own. Unfortunately, as he soon learned, Lizzie was a woman, not a saint.

For the moment, though, his new love filled him with energy; he bragged in a letter to his mother from Sevenoaks that he had risen at seven, an event hitherto unheard of. Almost immediately his hopes for painting outdoors were dashed by wind and weather, which was not surprising since he had planned a springtime picture when autumn was well advanced. Hunt, who set up his easel close to Gabriel's, said

that he "ran up occasionally to see him, and found him nearly always engaged in a mortal quarrel with some particular leaf which would perversely shake about and get torn off its branch when he was half-way in its representation."[7] But Gabriel's utter downfall was rain. After making a valiant effort "with my umbrella tied over my head to my buttonhole" and water "a full inch above the ankles," he retreated to their lodgings, where he worked on his translations and wrote poetry about Lizzie.[8]

Meanwhile, Hunt pressed on in the forest. When they returned to London three weeks later, the background of Hunt's painting was almost complete, and the artist took up needle and silver thread to embroider hundreds of mock pearls on a dress for Lizzie to wear as Sylvia, since he could not afford to pay someone else to sew it. Gabriel stuck his canvas in a corner.

Back in London, Lizzie had been happily building her career as a model. Besides Hunt and Deverell, she sat for Madox Brown for a figure in *Chaucer at the Court of Edward III* and for *Christ Washing the Feet of St. Peter*. As her confidence in her desirability as a model grew, she cut back her hours in the shop. She relished her freedom from the tiresome business of bonnets, and thrived on the company of these young men. They were civil and grateful to her, for she was punctual, steady, and willing to hold difficult poses for long periods without complaining. She was also an intelligent, sensitive listener, and they were all full of thoughts and dreams, eager for an audience. Their talk was exciting to her. They had read every line of Tennyson, her favorite poet, and pressed her to read more of their favorites: Blake, Keats, Shelley, Browning. They wrote poetry themselves and read her their latest efforts, earnestly searching her face for signs of interest or boredom. To raise their stock with her they made no secret of the fact that they knew many of the most gifted men in London, including Ruskin and Browning and Tennyson; as Lizzie was drawn into their circle, she realized she might well meet people that the average person only read about in newspapers and magazines.

These pleasures carried a certain risk. Lizzie wanted a husband—hardly a surprising desire, since it was virtual social and economic suicide for a woman to consider any other choice in life. There were no real alternatives. She could wear herself out in the shop and die a spinster, pitied by relatives and friends, or she could marry. Beyond these choices she could starve on factory wages or walk the streets;

she didn't have enough education or connections to get a job as a governess or a teacher. Women from the comfortable reaches of the middle class did not work outside the home; it was considered a humiliation. Lizzie had grown up on the fringes of polite society, and she hoped to move a bit closer to the center. She dreamed of more comfort: a servant to lay the fire in the morning, theater tickets, a paisley shawl.

But she was endangering that dream by working as a model. It was not only the legendary Mrs. Grundy who believed that the expression "artist's model" was a euphemism for "whore"; so did just about everyone. Artists were regarded simply as seducers. When Gabriel shared a studio briefly with Walter Deverell, the landlord made them promise that their models would be "kept under some gentlemanly restraint, as some artists sacrifice the dignity of art to the baseness of passion."[9] The landlord was clearly not certain whether it was the artist or the model who was liable to lose all control.

Ladies did once in a great while allow an artist to draw their faces and hands, but this concession was considered daring, something to be undertaken in the presence of a chaperone, preferably a mother or sister.* When Christina Rossetti sat for Holman Hunt, her mother accompanied her to his studio, even though Hunt was an old and trusted friend of the family. Some bourgeois parents would not even allow their daughters to walk on the street unescorted.

Clearly, then, modeling in the nude — or even the suggestion of it — would ruin a girl's reputation. At a time when nakedness was so disturbing that some husbands never saw their wives undressed, the notion that a woman might be willing to stand calmly in front of a man who was a stranger for hours at a time while he scrutinized every inch of her nude body was genuinely shocking. Worse yet, taking money in return for taking off one's clothes seemed only the shortest step from taking money for sex. Ladies could not contemplate such an activity, nor could they know women who did. As a consequence, figure models, who had to take off their clothes, came exclusively from the working class.

*By contrast, ladies were eager to have their portraits painted. They enjoyed the compliment implicit in the artist's desire to render their likeness. What made them hesitate was subject pictures. Here an artist might take their image and use it for his own ends; a lady feared, for instance, that she would find her face on exhibit at the Royal Academy in a subject picture about the rape of the Sabine women. Even if the artist used only her face and placed it atop the body of a working-class model, she would feel ashamed; after all, her friends and family had no way of verifying that the lush body on display was not hers.

There is no evidence that Lizzie modeled in the nude, although it is impossible to know for certain, because these artists destroyed many of their nude studies, and only an occasional drawing of a naked figure has survived. Lizzie was a modest young woman who would probably have refused if she had been asked to undress. However, it didn't really matter whether she did. She was a model from the lower classes; polite society needed no further indictment. Lizzie had courage. Having met these young artists and seen that they were not wanton seducers, she kept going to their studios and enjoying their companionship, even though her father was none too happy about it.

It is clear that most of the Pre-Raphaelite Brothers were smitten with Lizzie's beauty, but it is difficult to know what she felt about them. She was never one to advertise her feelings. So reserved that she did not even speak much in company, she left few traces. However, there is one intriguing clue to her attitude toward Gabriel in a watercolor that he spent a good deal of time on during 1851, the year after they met. In this picture, which he titled *Beatrice Meeting Dante at a Marriage Feast, Denies Him Her Salutation,* Beatrice is protected by a phalanx of other women, and Dante approaches timidly, with little hope in his face. This is the one moment in the *Vita Nuova* when Beatrice scorns Dante. If Lizzie held herself aloof, as the picture suggests, that made her all the more desirable to Gabriel; it made her a successful Beatrice. He was able to enjoy Lizzie's remoteness and revel in his identification with Dante.

Gabriel was not discouraged by Lizzie's resistance, but continued to pursue her, and it seems that by the end of 1851 they had agreed to marry, although no formal announcement of an engagement was ever made. They didn't tell their families about the arrangement, nor did they make any wedding plans.

Romance suddenly became irrelevant in the Siddall household. Lizzie's adored brother Charles came down with scrofula, tuberculosis of the lymph glands, and hovered for weeks at the edge of death. She took her turn nursing him, sitting with him through the long hours of the night, chatting quietly to calm him when he woke from a light sleep, feverish and fretful. But her care was not rewarded. He died in January 1852. The family grieved, but the loss meant the loss of a wage earner as well as of a brother, so Lizzie was writing to Millais within a fortnight to tell him that she was ready to put her grief aside and pose for his painting of the drowned Ophelia.

Millais immediately set up a sitting. The pose was a soggy one; Millais wanted to portray the body floating downstream, buoyed only by full skirts, and therefore made Lizzie stretch out in a bathtub full of water. To keep her as comfortable as possible, he placed lamps under the tub to warm the water. At the last session Lizzie lay still for five hours, until her hands and feet had shriveled like prunes, while Millais concentrated intently. Oblivious, he never noticed that the lamps had run out of oil. As the water grew colder, Lizzie got chilled to the bone, but she never said a word.

The result of the experiment was an extraordinarily beautiful and haunting picture. Ophelia drifts with palms upturned, just breaking the surface of the water, offering herself to death. The face is that of a very young and innocent woman, with delicate ivory-and-rose skin, blue eyes, and blonde brows and lashes. The painter Arthur Hughes called it "wonderfully like" Lizzie.[10] The image is one of utter passivity. One wonders whether Millais chose Lizzie for his model because he saw in her the capacity for such complete surrender.

Millais ended up with a great picture, arguably the best picture he ever painted, but Lizzie ended up with a great cold that was probably pneumonia; it dragged on for months. Her father, cursed with a hunger for litigation, threatened to sue Millais for £150 in damages, figuring that the famous young painter could well afford to pay up. After five months of threats and correspondence, Millais agreed to cover the doctor's bills, which came to just over thirty pounds, and Mr. Siddall backed down.

To speed Lizzie's recovery, the doctor recommended that universal cure-all "a change of air," the pathetic fallback of the Victorian physician, who had few more effective remedies at his disposal. It was decided that she should go down to Hastings, on the Sussex coast, where invalids crowded into cheap lodgings. Over the years Lizzie was to make a series of dreary journeys under doctor's orders to various resorts, including Clevedon, Matlock, Brighton, and Nice, but this first prescription was an adventure for her. At the age of twenty-three, she sat by the train window, straining for her first glimpse of the sea. With her sister Lydia along for company, she rented rooms in a boarding house, and the two of them walked on the beach when Lizzie felt strong enough.

Gabriel came down and spent a few days with them, another irregular event in an increasingly irregular courtship. Although Lizzie had still not met any of the women in the Rossetti family, Christina was by now hearing a good bit about her. On August 4, 1852, Gabriel

wrote to his little sister praising Lizzie to the skies. He tried to leaven his praise with humor, but what comes through is his extravagant, exuberant affection: "My dear Christina, Maria has just shown me a letter of yours by which I find that you have been perpetrating portraits of some kind. If you answer this note, will you enclose a specimen, as I should like to see some of your handiwork? You must take care however not to rival the Sid [one of his nicknames for Lizzie], but keep within respectful limits. Since you went away, I have had sent me . . . a lock of hair shorn from the beloved head of that dear, and radiant as the tresses of Aurora, a sight of which may perhaps dazzle you on your return. That love has lately made herself a grey dress, also a black silk one, the first bringing out her characteristics as a 'meek unconscious dove,' while the second enhances her qualifications as a 'rara avis in terris.' "[11] In his letters Gabriel often used a tiny drawing of a dove instead of Lizzie's name to identify her. This letter also points out that she had begun drawing, a skill that Gabriel had set himself to teach her, to their mutual delight. She loved drawing, and he was proud of her gift. Despite the worry over her health this summer, they were probably never so simply happy together again.

Gabriel began to take steps to protect Lizzie — and to possess her. He asked her to stop modeling for anyone but himself, and she consented. Gabriel may have wanted to erase the blot of modeling from her reputation in preparation for their marriage; more likely, he just didn't want to share her any more. He encouraged her to leave the shop, escaping the exhaustion and embarrassment of being a shopgirl, and he promised to pay her expenses — which were not great, since she still lived at home — out of his own often empty pocket.

By stopping her from modeling and cutting off her salary, Gabriel took away what small economic freedom Lizzie had. Suddenly she was in the position of millions of middle-class women who were constrained by the notion that a job was a humiliation, and yet she had no wage-earning husband to make that position tenable. But Gabriel's intentions were not villainous. He wanted to free her from drudgery so that she could learn to draw and paint and write poetry; he may well have taken as his model the example of his hero William Blake, who taught his wife to read, write, draw, and print his engravings. Lizzie was happy to leave the shop. The fact that she accepted Gabriel as her protector is proof that she trusted him. Whether her choice was foolhardy remained to be seen.

With Gabriel's withdrawal into private life, an essential spark had gone from the PRB, and meetings of the Brothers, once their greatest joy, were now few and far between. Gabriel's personality had been the vital social glue that had held them together. As William Rossetti noted in his diary, "The P.R.B. meeting is no longer a sacred institution — indeed is, as such, well-nigh disused. . . . And the solemn code of rules . . . reads now almost as comic."[12] It had served its function: Rossetti, Millais, and Hunt had taken from each other what they needed. Their egos and ambitions had begun to grate, and so they went their separate ways.

Collinson had been the first to leave, shocking them all with the announcement that he was relinquishing art to enter the Jesuit college at Stonyhurst to prepare for the priesthood. William, an agnostic, had been disheartened by this turn of events: "Goodbye to a man that has had fine capabilities in him, never allowed fair play by himself."[13] Collinson soon realized that he had mistaken his vocation, and returned to the world and to painting, but he never made much more than a bare living by his art.

William and Frederic Stephens, Hunt's pupil, began to face the fact that they would never become painters; instead, both became art critics, making use of their substantial intellectual talents to sustain the efforts of the Brothers who did paint. Thomas Woolner put his energies into a large clay model for a monument to mark Wordsworth's grave, which he submitted to a competition. When an insipid offering was chosen over his, he furiously smashed his model, the work of many months. Convinced that no one of his abilities could make a success as an artist in a country where such sentimental tripe was admired, he booked passage to Australia in July 1852 and went out to join the gold rush.

That autumn Gabriel Rossetti decided that it was high time for him to move out of his parents' house, and he took a set of three ramshackle rooms with good light in Chatham Place, on the river by Blackfriars Bridge. The view was magnificent; from his balcony he could see the Tower, Parliament, and Westminster Abbey. Unable to produce the fifteen pounds needed for the first quarter's rent, he persuaded William to join him as co-tenant (though William never spent more than an occasional night there). The location was convenient, just across the river from Southwark, where the Siddall family had moved the previous year, but it had one repellent drawback: The Fleet Ditch, once the Fleet River but now one of London's principal sewers, ran close by, emptying its germ-ridden contents

into the Thames. When the wind blew his way, the smell was vile, but Gabriel decided he could tolerate it. After three years of awkwardness and frustration, he and Lizzie finally had a place where they could be alone together. Gabriel moved in on November 22, and three days later he was asking William not to invite Hunt for Saturday evening "as I have Lizzie coming, and do not of course wish for anyone else."[14]

Gabriel flourished in this new atmosphere, painting and entertaining his male friends with gusto. In a letter written at the New Year to Woolner in Australia, he crowed: "You cannot imagine what delightful rooms these are for a party, regularly built out into the river, and with windows on all sides — also a large balcony over the water, large enough to sit there with a model and paint — a feat which I actually accomplished the other day for several hours in the teeth of the elements."[15] Sentimentally, Gabriel promised that he was going to arrange for all their friends to meet at noon on April 12, 1853, to draw portraits of each other as gifts for Woolner. In return Woolner was to make a sketch at the same hour, after which their efforts would be exchanged by post between London and Melbourne.

Accordingly, a meeting of the Brotherhood was called for April 12, two days after Handing In Day. The five remaining Brothers gathered at Millais's studio for breakfast and then spent the day drawing pencil sketches of one another. In the evening they repaired to Chatham Place to prolong the pleasure of being together. They would see each other again, but this was their last official meeting.

※──◇※◇◇※◇──※

At Chatham Place, Lizzie and Gabriel retreated into a tiny, dreamlike cocoon of their own making, remote from friends and family. Isolation helped to sustain the illusion of a perfect love. Gabriel drew Lizzie incessantly, sitting in an armchair, curled up with a book, napping: delicate, careful pencil drawings, full of affection and infinitely superior to the large, florid oil pictures that later made his fortune. He drew a funny ink sketch of her drawing him while he posed in a chair with his feet up; its casual humor suggests that they grew cozy and relaxed with each other, tucked up in the little flat. They invented childlike pet names for each other: When Gabriel was trying to cloak their intimacy in casualness, he referred to Lizzie as "the Sid," but when he felt comfortable, as in letters to Brown or his family, he often called her "Guggum," a nickname they used for each other.

He was teaching her everything he knew about drawing and painting, and dreamed that she was a genius who needed only his encouragement to produce beautiful things. He deserves credit for believing in her; few female artists of the nineteenth century had such faithful support. Eventually they were both held back by his disdain for formal training, but at first her work improved by leaps and bounds.

In January Lizzie began her first watercolor, a painting based on Wordsworth's ballad "We Are Seven," probably occasioned by meditation on the death of her brother Charles. In the poem a child confides to the narrator that she often takes her porringer to the graveyard so that she can be with her dead sister while she eats her supper. Despite her grief, she is glad her sister is dead, because she remembers how the little girl lay in bed moaning "till God released her of her pain." Almost every poem Lizzie ever wrote was about death or loss, as her critics and biographers often note with distress or disdain. They miss the fact that for her and many other Victorians, death could be a comforting prospect, the only release from pain and suffering. Because her own health was not strong, Lizzie thought about this a great deal, and was no doubt trying hard to come to terms with the fact of mortality.

In any case, Lizzie was proud of her picture and pleased with her new life. While her spirits were rising, however, Gabriel's drooped. He withdrew from his friends, brooding on his inability to complete a picture of any consequence while Hunt and Millais sped ahead, laying the foundations of their reputations through relentless industry.

Deeper than this worry lay Gabriel's aching conflicts about love and sex. At first he had been happy just to see Lizzie, to be near her, to stroke her hand, then her cheek, to draw out that rare smile. He had discovered how to make her laugh, and that seemed a blessing — a Beatrice who could laugh as well as inspire. Lizzie was neither an obvious nor a forward woman. She kept her own counsel, and he had had to study her to figure out how to make her care for him. Into her silence he had been able to project all his own wishes and dreams. Then, slowly, he had detected small signals that she did love him; eventually he had dared to speak of marriage. Perfect, everlasting union with the lady of the golden veil was the ultimate fulfillment that Chiaro could aspire to. But Gabriel was no Chiaro — nor Dante, for that matter. Sex had broken in on his vision — complicating, confusing, delicious, frightening, hurtful.

He was not sure how to proceed; the code of courtly love set down

by his beloved medieval Italian poets was worthless as a guide to this dangerous and exciting terrain. Dante adored Beatrice, but he never considered making love to her: One does not, indeed cannot, defile blessedness. But Gabriel knew that he could not follow Dante to the end, even if he dreamed that Lizzie could somehow be his Beatrice. He had already turned his back on the promise of one paradise by deserting the religion of his childhood, because he believed its constraints bound the body and the spirit too tightly. He dreamed of living in some new, dimly lit paradise of the imagination, where the ideal was magically reconciled with desire.

A healthy, highly sexed young man of twenty-four, Gabriel was tired of waiting, and he reached out for Lizzie. She had been willing to take all sorts of risks for him, but here she balked. She was not necessarily cold, just scared and proud. She wanted marriage and the recognition that came with it, not the shame of an unwanted pregnancy and a furtive ceremony to dress it up, or worse yet, an illegitimate child to raise by herself. Gabriel pressured her, made promises he couldn't keep, petted her, but she resisted. Always more practical than he, she looked at the facts, at the unreliability of contraception, and said no. She also sensed that sex was her only lever in this situation; give it up and she would no longer have any real power over him. She would remain his Beatrice only as long as her resolve held firm.

Consciously he had no choice but to approve her chastity. He knew that a sexual relationship could hurt her, not him; knew that his mother and sisters would be horrified at what he was urging upon his treasured dove. Underneath it all, however, he was stung by her control in the face of his ardor. Ultimately Gabriel resolved his conflict in a conventional manner, by turning to prostitutes for pleasure and relief.

In response to his confused feelings, he started a painting that would give him no end of trouble, which he called *Found*. It depicts a wretched young woman tarted up in a cheap, showy shawl, sinking to the ground as a young farmer in rustic clothes tries to pull her to her feet. The sonnet Gabriel wrote later to accompany the work tells the story: The young woman grew up in the country, then, like thousands of other girls, came to London and ended up a streetwalker; now the shame of discovery overwhelms her. The farmer was her first love, a boy from the village where she spent her girlhood. In Gabriel's picture, the farmer is bringing a calf to market, bound in a net, to symbolize the girl's plight. The scene suggests that Gabriel sympa-

thized with the women whose favors he bought, that he dreamed of rescuing them.

That summer, feeling at the end of his tether, Gabriel decided to take himself away from temptation for a while. Hopeful that good talk and bathing in the sea would soothe him, he accepted an invitation to visit the painter and poet William Bell Scott at his home in New-castle-upon-Tyne. While he was gone, Lizzie seized the chance to stay in his rooms at Chatham Place, where she could get away from her family and get on with her artwork in the quiet of the studio. On June 20, 1853, Gabriel wrote to advise William of this arrangement: "Do not therefore encourage anyone to go near the place. I have told her to keep the doors locked, and she will probably sleep there sometimes."[16]

Lizzie was ill but productive. She thrived on her solitude at Chatham Place, a sort of freedom that few unmarried women ever experienced, eating and sleeping when she chose, with no domestic chores or parents to obey, callers to receive, or brothers and sisters nattering away. The only sound was the friendly rumble of boats on the river. Fittingly, she undertook a self-portrait, her first work in oils. William felt it was the "most competent piece of execution that she ever produced, an excellent and graceful likeness, and truly good; it is her very self."[17]

"Her very self," as she painted it, was quite different from the lyrical, fluid drawings Gabriel was making of her. She chose a small oval canvas, almost a miniature, only nine inches from top to bottom. Looking out is an odd, particular face, in no way idealized or prettied up — the face of a woman with character and a strong will, stern, sad, watchful. This is not a picture of a young woman hopeful about love. Lizzie worked at it for over a year, coming back to it again and again in an effort to get it just right.

Gabriel's trip to Newcastle was not a success. He found the city dreary, and persuaded Scott to set out on a tour of the countryside in search of subjects to paint. Both formidable talkers, loaded with opinions, they discussed everything under the sun. Scott, who was secretly jealous of his friend's superior artistic gifts, was pleased as punch to discover that Gabriel didn't know whether the earth revolved around the sun. Shifting from science to romance, Gabriel dismissed free love as so much "scoundrelism" on men's part, but Scott sensed that he was growing tired of Lizzie and was "beginning to revise his intention of marriage."[18]

On his return to Chatham Place, Gabriel was amazed by Lizzie's

picture. He knew at once that she had taken a giant leap forward in her art, and for weeks afterward he went around telling everyone about the "perfect wonder of her portrait."[19] She was so buoyed up by his enthusiasm that she began to plan a design from Tennyson's *Lady of Shalott* for submission to the Royal Academy Exhibition of 1854. Neophyte that she was, she already had the nerve to contemplate submission, something Gabriel was too fearful to undertake. (Sadly, all that remains of Lizzie's great hope is a small drawing of the Lady seated before her loom.)

From this time Lizzie was never healthy for more than a few months at a time. Some of her symptoms can be gleaned from Gabriel's letters, which began to read like bulletins from a sickroom. She suffered from a lack of appetite and lost a great deal of weight. At her worst, she vomited everything she tried to eat, sometimes for weeks at a stretch. She spent months in bed, too weak at times even to lift her head. None of her doctors ever arrived at a conclusive or useful diagnosis, and they had little to offer but bed rest and mild air by way of relief.[*]

Lizzie's illness had profound effects on her relationship with Gabriel. He agonized over her condition, and when she was very sick he always came to her aid. Unconsciously she probably understood this miserable reality, and in time learned to use her illness as a means of recapturing his attention. From day to day, though, her weakness left Gabriel with a great deal of time on his hands, and in January 1854, while she lay at home trying to gain strength, he found a more robust companion.

<p style="text-align:center">❧❧❧❧❧</p>

Hunt had just departed on a trip to Egypt and Palestine, leaving behind the young woman he hoped to marry on his return. Annie Miller was a barmaid possessed of a wealth of waving wheat-colored hair and a voluptuous body. Hunt was paying to have her educated while he was away; in his absence he expected his friends to look out for her and respect his claim.

Gabriel promptly invited Annie to spend an evening at Cremorne Gardens, an immensely popular spot in Chelsea that offered drinking

[*]William Rossetti believed that she had consumption, but the best medical guess today is that she did not. Although she suffered from fever, coughing, pallor with flushed cheeks, and general, persistent weakness, all of which hint at tuberculosis, she bounced back too often, recovering for months at a time, to have a progressive organic disease. Twentieth-century doctors have speculated that she was anorectic.

and dancing and a host of innocent, silly entertainments such as a man who "made music" by pounding bricks with a pair of hammers. One French observer was appalled, particularly by the dancing: "People dance here with their hips and their shoulders, seeming to have little control over their legs. They have no ear for time. Frivolous young things improvise all sorts of indecorous antics. This, however, does not seem in any way to interfere with the staid enjoyment of the numerous middle-aged couples who placidly saunter round, occasionally colliding with one or another of the boisterous merrymakers."[20]

The subterranean business of Cremorne Gardens was prostitution. A man had only to stroll along one of the garden paths to connect with the women who waited there for customers. Reformers regularly campaigned to shut the place down, which they eventually succeeded in doing, in 1877. In the meantime, however, Annie was unbothered by the gardens' reputation. She loved dancing, she liked Gabriel, and they had a wonderful time. Hunt would have been horrified, and so would Lizzie, if she had known.

Before long Gabriel and Annie were sleeping together. They were lovers on and off during the next several years. Many Victorian men learned to split pleasure from love, to leave a mistress or a prostitute and walk across town to the embrace of an adored wife, and Gabriel continued his relationship with Lizzie. In fact, Annie probably made it possible for him to sustain the purity of his fantasy, since he no longer had to press Lizzie for sex.

As the possibility of marriage receded, Lizzie's physical symptoms became more pronounced. Although she had been weak and ill for months, she hadn't consulted a doctor. In 1854, however, two new friends became involved in her case. Lizzie met Anna Mary Howitt and her mother at Chatham Place when they came to call on Gabriel, whom they had befriended a few years earlier. The Howitts took to Lizzie too, and decided that she must see a doctor immediately. They pressed her to visit their old family friend Garth Wilkinson, a homeopathic doctor whose wisdom they trusted. Lizzie made an appointment and found Wilkinson to be a kindly, gentle man who listened to her quietly and examined her delicately. According to Wilkinson, Lizzie's problem was not consumption, as she had always feared, but curvature of the spine, and he recommended a great deal

of rest and no painting. Both Gabriel and Lizzie thought this injunction ridiculous, and she paid it no heed.

The Howitts' kindness did not end there. Anna Mary, a gifted and serious painter, introduced Lizzie to her two closest friends, Barbara Leigh-Smith and Bessie Parkes. These three formed a remarkable trio, especially for the nineteenth century. As young women they traveled alone; they attended the first college for women, Bedford College in Regent's Park; they founded a successful feminist newspaper; and they opened an employment agency for women. They started an elementary school, organizing it along radical lines, with no religion, no punishment, and no separation of sexes in the classroom; the children loved it and learned a great deal. Later Barbara helped to found Girton College, the first women's college at Cambridge, selling her collection of paintings to endow it.

When they met Lizzie, the three friends had just undertaken a daring political project, lobbying Parliament to pass the Married Women's Property Act, a bill intended to give wives a measure of control over their own money. Despite their youth and sex, which most men assumed rendered them political idiots, they planned their campaign effectively, and to the chagrin of misogynists everywhere had some real success. They helped to organize a platoon of women who circulated a petition asking Parliament for redress and obtained 24,000 signatures, a number that made its own argument. (The battle was not yet won, however: All the rights to property that they demanded were not granted until 1882.)

They also made time to help Lizzie. Barbara took charge, as she generally did — Anna Mary once painted her as the warrior queen Boadicea — and advised Lizzie to go into a sanatorium run by her cousin, Florence Nightingale. Both Lizzie and Gabriel resisted the idea. In England at this time hospitals and nursing homes were generally filthy breeding grounds for infection; consequently, mortality rates for patients in hospitals were markedly higher than for those nursed at home. The Institution for the Care of Sick Gentlewomen in Distressed Circumstances at 1 Harley Street was the exception — it was the formidable Miss Nightingale's first job, and on her arrival she had scoured the place from top to bottom, having observed during her study of hospitals on the Continent the efficacy of careful hygiene. Under Nightingale's care Lizzie would have received the finest medical attention and the sympathy that she badly needed. But she remained unconvinced, so instead Barbara suggested another long rest at Hastings.

To get this scheme going, Barbara wrote to Bessie, who was herself resting at Scalands, Barbara's father's country home near Hastings.* Even two women as free as Barbara and Bessie understood and had to abide by the social dictum regarding artists' models: "Private now my dear. I have got a strong interest in a young girl formerly model to Millais and Dante Rossetti, now Rossetti's love and pupil, she is a genius and will (if she lives) be a great artist, her gift discovered by a strange accident such as rarely befalls woman. Alas! her life has been hard and full of trials, her home unhappy and her whole fate hard. Rossetti has been an honourable friend to her and I do not doubt if circumstances were favourable would marry her. She is of course under a ban having been a model (tho' only to 2 PRB's) ergo do not mention it to anyone. Dante R told me all about her a secret then, now you are to know because you are to help. She *Miss Siddall* is going down to Hastings on Saturday for her health. Will you give her tea on Saturday and will you dear see if the room Venus had by St. Clement's Church is to let. If not to let, will you ask Mrs. Elphick where there is a room with *sun* and a good woman etc. and for a few shillings a week, say 7 or 8s. or less if possible. It must be big enough to do for eating and drawing and sleeping."[21]

Mrs. Elphick did have a room, and Gabriel brought Lizzie down by train. Bessie arranged for tea to be served on their arrival; the three of them chatted, and Bessie promised Gabriel she would keep an eye on Lizzie and let him know immediately if her condition worsened. This meeting was the start of a relationship between the two women that lasted until Lizzie's death.

While Lizzie was recuperating, some good luck fell into Gabriel's lap. For two years now he had refused to exhibit any pictures, even small ones, and his fear of rejection was leading him down a path to commercial suicide. Gabriel's easy mastery over friends and family did not extend any further; his large ego could be punctured at will by the careless prick of a critic's pen. Although Hunt and Millais suffered mightily from similar stabs, they did press on. But Gabriel's reputation had languished, and was further diminished by his inability to produce consistently.

Now, suddenly, he heard that Ruskin wanted to meet him. An inquiry from Ruskin was as good as a blank check for an artist.

*Barbara's father was a wealthy man who had stunned his friends by giving his daughter outright an income of three hundred pounds on her majority; his friends told him he was mad and would live to regret it.

Ecstatic, Gabriel dashed off an exuberant note to Brown: "Mac-Cracken [one of Gabriel's short list of patrons] of course sent my drawing to Ruskin, who the other day wrote me an incredible letter about it remaining mine respectfully (!!!) and wanting to call."[22]

Within a few days Ruskin had invited Gabriel to lunch at Denmark Hill in Camberwell, where he lived with his parents. The invitation was a sign of special favor, and Gabriel knew it. He dressed carefully and left early to make sure he would arrive on time. In their distant suburban villa, the senior Ruskins lived in stolid splendor, surrounded by expensive, heavy furniture and yards of old lace. Gabriel hardly registered the ugliness; his attention was riveted by the incomparable collection of Turner paintings that filled the house.

The meal proved extremely awkward. In this house, the mighty art critic was reduced to a dutiful little boy tyrannized by his mother. She thought nothing of shouting his name — John Ruskin! — to get his attention at table, even while he was speaking. Midway through the meal a servant appeared with a note on a silver tray, summoning Gabriel home: His father, who had been dangerously ill for months, was dying. The new friendship was for the moment derailed.

Mr. Rossetti died quietly the next afternoon. While Gabriel was helping with funeral preparations, he received a letter from Barbara Leigh-Smith: Lizzie seemed to be very ill but still refused to go to an infirmary. Immediately after his father's funeral Gabriel rushed down to Hastings, where he was relieved to find that Lizzie was not as sick as Barbara feared. He tried to reassure both her and Bessie by writing to say that Lizzie was "if anything a little better. I have known her several years, and always in a state hardly less variable than now; and I can understand that those who have not so long a knowledge of her would naturally be more liable to sudden alarm on her account than I am."[23] Barbara, however, still thought that Lizzie was "going fast" and that Gabriel was "like a child" because he "cannot believe she is in danger."[24]

At a less guarded moment, Gabriel admitted to a close friend that he found it hard to live with the ever-present specter of her death: "Lizzie is a sweet companion, but the fear which the constant sight of her varying states suggests is much less pleasant to live with."[25] (Note that Lizzie was now a "companion," a term that certainly hedges the marriage question.)

Lizzie's strength returned in May, to the point that she and Gabriel could make the twenty-mile journey from Hastings to Scalands, where

they spent a happy afternoon with Barbara and Anna Mary. Gabriel wrote to Brown that Lizzie sat on the grass while he and the others made "sketches of her dear head with iris stuck in her dear hair."[26] Once again Gabriel was in love. Lizzie's illness had revived his feeling for her; her precarious hold on life made her a romantic figure again — Beatrice hovering on the edge of death.

As Lizzie grew stronger, she turned back to her artwork. Gabriel, who was sinking deep into lethargy, could hardly bring himself to draw at all. To Brown he dismissed his failure to produce with the enigmatic rationalization that the "pursuit of art is a bore, except when followed in the dozing style."[27] He sketched Lizzie, but only once in a while did he develop a drawing into a painting. He wrote poems but didn't publish them. When he did rouse himself to work, he painted small, exquisite watercolors that shone like rubies and emeralds and sapphires, which he sold for twenty-five or thirty pounds. Millais and Hunt, by contrast, worked at their easels from early morning until dark six or even seven days a week, producing oil paintings that sold for hundreds of pounds.

At the end of June Lizzie and Gabriel returned to London, and Lizzie continued to visit Gabriel's rooms, even though she was still weak and a cholera epidemic was raging in the neighborhood. Brown described the chaos created by the epidemic vividly in his diary: "Bodies taken from Middlesex Hospital in *vans*. In the pest-stricken street groups of women and children frantic for their relations taken off. Police and others with stretchers running about. Undertakers as common as other people in the streets. . . . Hearses with coffins *outside* as well as in. People following in cabs — one funeral consisted of a cab with coffin atop and people inside."[28] Contagion was just beginning to be understood; the area was not quarantined by public health authorities, but friends and family nonetheless urged Lizzie to stay away. Both she and Gabriel remained heedless of the danger, as if they not only accepted Lizzie's imminent death but had resigned themselves to it, in this case almost courting it.

Fatalism was becoming part of the fabric of their relationship. Gabriel had begun weaving it into their personal myth, just as Dante wove death into almost every strand of the *Vita Nuova*. For Gabriel, the tragedy of losing his beloved would provide the stuff of great art, the raw material he needed, even craved.

During this summer Gabriel admitted that he had failed Lizzie. Years had slipped away since he had asked her to marry him. To a

friend he confessed: "When I look at her sometimes, working or too ill to work, and think how many without one tithe of her genius or greatness of spirit have granted them abundant health and opportunity to labour through the little they can do or will do, while perhaps her soul is never to bloom nor her bright hair to fade, but after hardly escaping from degradation and corruption, all she might have been must sink out again unprofitably in that dark house where she was born. How truly she may say, 'No man cares for my soul.' I do not mean to make myself an exception, for how long I have known her, and not thought of this till so late — perhaps too late. But it is no use writing more about this subject; and I fear, too, my writing at all about it must prevent your easily believing it to be, as it is, by far the nearest thing to my heart."[29]

He knew that his credibility had grown thin. His praise for her in this letter is so extreme that it plants a small, ungenerous seed of suspicion. Apparently Gabriel would soon be free, and the prospect allowed him to wax eloquent about Lizzie's spirit. His love for her was now bound inextricably to the prospect of her death. Once her image was frozen by death, he would be able to re-create her as the ideal love of his life. Her mundane shortcomings would be purged; she could be turned into a sort of virgin martyr for all time. She would then always be his Beatrice, waiting in paradise, the subject of remarkable poems and paintings, while he would be free to embrace fleshier, more vital women.

Ford Madox Brown was a frequent visitor to Chatham Place, and he observed that Gabriel had become preoccupied with making sketches of Lizzie — and little else. On October 7, 1854, Brown noted in his diary: "Gabriel as usual diffuse and inconsequent in his work. Drawing wonderful and lovely 'Guggums' one after another each one a fresh charm each one stamped with immortality, and his picture [*Found*] never advancing."[30] Many of these sketches survive and are now regarded as some of Rossetti's most important work. But at the time critics and buyers saw little value in drawings, however beautiful, and Brown worried that Gabriel was frittering away his time. It disturbed him that his friend seemed unable to make any money — particularly since he had granted Gabriel any number of loans over the years, which he could ill afford to carry. (Later, when Gabriel was a success, he was very generous with Brown, volunteering to lend him money when he knew that a crisis had descended on the Brown family, always framing his offers with humor and tact.)

But Gabriel continued to draw his beloved. The next year Brown was deeply touched by an even larger store of sketches Gabriel brought out for him to see. "I remained talking to Rossetti till 3 A.M. he showed me a drawer full of 'Guggums', God knows how many, but not bad work I should say for the six years he has known her. It is like a monomania with him. Many of them are matchless in beauty however and one day will be worth large sums."*[31] Gabriel drew Lizzie resting, reading, working at her easel, standing by the window, sitting primly in a straight-backed chair with her hands carefully folded. What is moving about these drawings — and revealing in what they suggest about the lovers' relationship — is their quiet, homely realism. The figure is not like the goddesses that later made Rossetti famous, the giant, statuesque women who silence the viewer with their sensuality and sinister knowledge. Gabriel did paint Lizzie as a mythic creature, a cultural and imaginative ideal, but another, healthier part of him loved her and drew her as an ordinary human being. These are tender sketches of a real woman intimately observed, touching because they were drawn by a loving hand.

At the end of 1854 Brown tried to force Gabriel to finish *Found*. In order to supervise him, Brown invited him to stay at the small cottage in Finchley that Brown shared with his wife, Emma, and his daughter, Katy. From a local farmer, Brown rented a calf and cart that Rossetti could use as models. A month after Gabriel had moved in, Brown noted in his diary: "Saw Gabriel's calf, very beautiful but takes a long time. Endless emendations no perceptible progress from day to day and all the time he wearing my great coat which I want and a pair of my breeches, besides food and an unlimited supply of turpentine."[32]

While Gabriel was camping out at the Browns', Lizzie was left to her own devices. On November 19 she was "moderately well" and drawing. In January, when Gabriel returned to the Browns' for a second siege on calf and cart, she was reworking her drawing *We Are Seven*. It was characteristic of her to come back to a drawing or poem a year or two after she first worked on it and try to improve it. William Rossetti, who edited some of her poems for publication at the end of the century, remembered that she "used to take a great deal of pains, and I fancy was seldom or never satisfied with her

*Brown was right, of course; at a recent sale a pencil drawing Gabriel made of Lizzie's head and shoulders sold for £18,700.

productions. One can find a dozen scribblings of the same stanza here and there, modified and corrected."[33] She was a meticulous craftsman, but in the case of her drawings and paintings these corrections proved a liability. Much of her work has a labored quality; colors grew smudged and murky in the attempt to increase their richness. But her poetry did not suffer in this way; it gained simplicity and directness as she refined it.

<div style="text-align:center">❦</div>

Fed up with *Found*, Gabriel put it aside and threw himself into another project: building a friendship with John Ruskin. To show his good will, he undertook to teach a drawing class at the Working Men's College, where Ruskin also taught. The college, an experiment launched by the Christian Socialist Frederick Denison Maurice, offered classes in the evenings to working men, and Maurice managed to snag some of the most talented men of the day as teachers. Gabriel was soon much in demand with the students, who enjoyed his easy manners and lack of condescension. He set them to work at once on live models, using a member of the class when they could not afford to hire from outside. Ruskin was also well liked, but he forced his students to spend hours reproducing a leaf or a bit of rock, just as he counseled Rossetti and Millais to do.

Despite their difference in style, or perhaps because of it, Ruskin was at this stage fascinated by Gabriel. One evening Gabriel ventured into Ruskin's classroom and tossed out all the Prussian blue, the only color Ruskin allowed his pupils, and gave them a riot of colors to use. When Ruskin returned to the room and saw what had happened, he did not take offense but had a good laugh over Gabriel's nerve.

As the friendship moved onto more solid ground, Gabriel set himself to entice Ruskin with stories of Lizzie's genius, her delicacy, her strenuous rise from the slums. Finally he invited the critic to a private exhibition of her work in the studio at Chatham Place. He arranged the drawings to catch the best light, swept up the dust, asked his housekeeper to deliver tea, and donned his best waistcoat to create a sense of occasion. His efforts paid off: Ruskin went into raptures.

Gabriel wrote to a friend that Ruskin had "bought on the spot every scrap of designs hitherto produced by Miss S. He declared that they were far better than mine, or almost anyone's, and seemed quite wild with delight at getting them."[34] He gave good prices for these pictures: When Gabriel asked twenty-five pounds a drawing, Ruskin

voluntarily raised the price to thirty pounds. Brown remarked in his diary entry for March 10, 1855, that Ruskin had said Lizzie's drawings "beat Rossetti's own. This is like R. the incarnation of exaggeration, however he is right to admire them. She is a stunner and no mistake."[35] Brown was, as so often, on the mark. If one set Lizzie's finest drawings next to those that Gabriel was turning out during these years, there can be no question that he was infinitely the greater artist. But Ruskin was an enthusiast; his capacity for terrific excitement, surprising in a man so repressed in most respects, was one of his most attractive qualities. *

Lizzie was not present when Gabriel showed Ruskin her works, probably by her own decision. If she had been there, Ruskin would have had no choice but to compliment her — a gentleman never criticized a lady to her face — and she would have wished to avoid such an awkward and false evaluation. When Ruskin did meet her a few days later, though, he was thrilled by her pale beauty. He made it his task to line up commissions for her, and the immediate effects of his taking her up were happy.

Ruskin pursued his relationship with Lizzie and Gabriel avidly, sending them gifts and inviting them to a luncheon at Denmark Hill so Lizzie could meet his parents. John Ruskin senior was charmed by Lizzie. Relieved to find that she was neither graceless nor plain, as he had assumed a girl of the lower classes would be, he declared grandly that she could pass for a countess. Ruskin junior offered her the run of the house, inviting her to come when she liked, to walk in the garden and peruse his vast library of books and prints. Mrs. Ruskin took her upstairs to her boudoir, where she questioned her at length about her symptoms, and a few days later she sent Lizzie a parcel full of the makings for ivory jelly, an expensive remedy in which she had great faith.

* There was something sinister in his action, however. Money gave him the power to buy up Lizzie's entire output, as if she were a limited company that could be purchased lock, stock, and barrel. By contrast, he made a more open and respectful arrangement with Gabriel, offering to buy everything that he liked up to a certain maximum each year. Furthermore, Ruskin's treatment of more experienced women artists suggests that his extravagant praise of Lizzie may not have been entirely genuine. Two years later he wrote to a painter named Anna Blunden, who was exhibiting regularly at the Royal Academy: "You will probably paint, ultimately, in a way calculated to be of great use and give great pleasure — although you will never be a great painter — but no woman has ever been a great painter yet — and I don't see why you should be vexed because you are not the first exception."[36]

The day after this luncheon, April 12, 1855, a curious thing happened. After knowing Lizzie for five years and being engaged to her for at least three, Gabriel finally introduced her to his mother and sisters. It looked as if he were at last getting ready to marry her. Now that the leading critic of the day had declared her a great artist, Lizzie no longer had to live with the stigma of being a model. However, it is hard to believe that the ban would have mattered in Gabriel's home. His mother and sisters had often sat for him, so they would hardly have scorned Lizzie for posing. Nor were they judgmental women: Of all Gabriel's poems, "Jenny," his meditation on the life of a prostitute, was Mrs. Rossetti's favorite.

Responsibility for Gabriel's failure to introduce Lizzie to his family earlier is usually laid on the doorstep of the Rossetti women, who supposedly did not like Lizzie. Perhaps they were jealous of the woman who was supplanting them in the heart of their beloved son and brother, but all three were deeply religious and scrupulously charitable. They would certainly have given Lizzie a chance, and never would have refused to meet her. Common civility dictated a meeting, and they were practitioners of the civil, whereas Gabriel was not, unless it suited him. (There may even have been some simple confusion in the Rossetti household about the status of Lizzie and Gabriel's relationship. A year after this introduction, the engagement was still not generally recognized. A friend mentioned in a letter of September 1856 that Gabriel was engaged, but she hesitated to mention the name of the lady because she feared the rumor was false.)

It is far more likely that Gabriel chose to keep his kinswomen and his intended apart, especially as his hesitations about marrying Lizzie grew. He may even have feared that his mother and sisters would line up against him on Lizzie's behalf, and he would have been powerless to resist their moral suasion. He undoubtedly preferred to respect his almost pathological fear of responsibility, which had long been the greatest obstacle to his marriage. With a far from perfect record of taking care even of himself, Gabriel couldn't imagine providing for a wife and children. The very idea of having to do so repelled him; he told a close friend, "I loathe and despise family life."[37] Given the ineffectiveness of available methods of contraception, marriage often meant six, eight, even ten children, and Lizzie's fragile health increased the already great risk of death in childbirth. If he married and impregnated her, he might well precipitate her death and have to bear the guilt for the rest of his life.

In any case, Mrs. Rossetti invited Lizzie to tea, and Gabriel, nervous about the encounter, asked Brown, a close friend of the Rossetti family, to attend and smooth the way. Brown happily obliged: He was still hopeful about this romance and eager to bring it along. Only a few weeks earlier he had written in his diary: "Rossetti once told me that when he first saw her he felt his destiny was defined; why does he not marry her?"[38]

The meeting seems to have gone off well enough; no one recorded the particulars, but it is easy to imagine the shyness and anxiety on both sides. Brown spent the night at the Rossettis', staying behind when Gabriel took Lizzie home to have "late talk" with the Rossetti women. No doubt he wished to ensure that their final impression was favorable. He could praise Lizzie to the Rossettis with a greater appearance of disinterest than could Gabriel, caught between the roles of son and lover.

After this visit, Mrs. Rossetti took Lizzie to see her doctor in the hope that he might offer her some relief. Christina tried to get beyond Lizzie's illness to become friends, making overtures by asking Lizzie to illustrate poems she had written, but the project never came to anything. Gabriel's family and his fiancée never became close, but at least Lizzie's position had been clarified to some extent.

Ruskin made Lizzie a grand offer. He proposed to settle £150 a year on her in return for all the artwork she produced. He would keep some of it and act as her agent in selling the rest, paying her anything he realized beyond £150 so that she did not lose by the arrangement. Since Lizzie had never sold any of her work until she met Ruskin, she had nothing to lose. Nonetheless she resisted his proposition, apparently because she was afraid that it would obligate her too deeply. She may well have been suspicious of his enthusiasm, too, sensing the condescension that lay just underneath. Ruskin tried to reassure her with an elaborate and stately compliment, explaining that he was just trying to preserve her "genius" as one would a "beautiful tree from being cut down, or a bit of a Gothic cathedral whose strength was failing."[39]

Gabriel had no hesitations. He wrote joyously to Brown that, although Lizzie was resisting at the moment, "she will be sternly coerced if necessary" and "meanwhile I love him and her and everybody, and feel happier than I have felt for a long while."[40] His faith in Lizzie's genius never flagged; furthermore, he felt it would be silly to turn down an offer of money that Ruskin would never miss. Under Gabriel's pressure, Lizzie consented.

Ruskin meant to set Lizzie's mind at ease and free her to work; however, his offer had a curious impact on her career. She had an income derived from her art, but she remained virtually unknown, since she did not exhibit.[41] During the years she received Ruskin's pension he actually sold only a single work, to his American friend Charles Eliot Norton. It would be hard to argue that Ruskin deprived her of recognition or sales, however; nor did he stop her from exhibiting. Much of her surviving work consists of small, slight sketches, and it is unlikely she could have earned a living from it on her own at this time.

As part of his plan to engineer Lizzie and Gabriel's happiness, Ruskin began to maneuver delicately to get them to marry. To Gabriel he wrote: "I should be very grateful if you thought it right to take me entirely into your confidence, and tell me whether you have any plans or wishes respecting Miss S. which you are prevented from carrying out by want of a certain income, and if so what certain income would enable you to carry them out."[42] He volunteered that he thought Gabriel the "greatest genius" of any painter alive, and added that he hoped marriage would regularize their lives so that both of them could produce more of the paintings he coveted.

Gabriel's reply to this inquiry is lost, but Ruskin's next letter strongly suggests that Gabriel had confided that Lizzie hesitated to tie him down to an invalid wife. Ruskin wrote that he felt "it would be best for you to marry, for the sake of giving Miss Siddal complete protection and care, and putting an end to the peculiar sadness, and want of you hardly know what, that there is in both of you."[43] Touched and confused by their irregular situation, he sensed that something more than illness was plaguing this love affair.

After Ruskin sent Lizzie to a prominent London doctor, who pronounced one of her lungs "seriously affected," he wrote to the respected physician Henry Acland, a good friend since they had been students together at Oxford, asking him if he would take Lizzie as a patient. He told Acland that he worried about what Lizzie's death would do to Gabriel: "I feel this sorrow will soon be sealed — and with what effect upon him, I cannot tell; I see that his attachment to her is very deep. . . . I fear no good can be done, but at least it would put Rossetti's mind at peace if he knew she was in pure air — and at rest."[44]

Acland, who befriended most of the Pre-Raphaelites over the years, was possessed of a keen interest in art and a wide-open heart. He

immediately fired off a letter inviting Lizzie to stay at Oxford so that he could give her case his complete attention. He engaged a room for her in George Street at one pound a week, the sum Ruskin had said she could afford, and when she was strong enough to travel, Gabriel scraped together a few pounds for the journey and took her up by train himself.

Oxford in those days was a monastic enclave populated by eccentric old men who were far more at ease staring at their scholarly tomes than at beautiful young women. Lizzie found them odd, and for the most part unlikable. When she visited the home of the warden of New College, he showed her his Dürer engraving of a black beetle. However, when he offered to have a live bug sent up from the kitchen to compare, she declined. On a happier note, she did make friends with one of the sisters of Edward Pusey, the leader of the Tractarian movement, and no doubt heard Pusey preach. And she enjoyed the company of Charles Lutwidge Dodgson, the sprightly mathematician and creator of *Alice in Wonderland,* who drew a sketch of Gabriel for her.

Gabriel wrote to his mother: "Acland examined her most minutely, and was constantly paying professional visits" for which there was no charge. He also relayed Acland's diagnosis, which is resonant to modern ears: "He thinks her lungs, if at all affected, are only slightly so, and that the leading cause of illness lies in mental power long pent up and lately overtaxed."[45] Acland sensed the link between psyche and soma, a connection that some Victorian physicians were just beginning to explore, and he came to the conclusion that Lizzie's symptoms were a result of the strain under which she had been living. He gently advised Gabriel to break off the relationship, as he foresaw that no good would come of it, but Gabriel ignored his advice and let the situation drift.

Although Acland's insight may have been acute, he lacked the psychotherapeutic tools to bring about any deep change. Medically all that he could recommend was that Lizzie stop painting for a while and spend the winter in a warm place. Neither suggestion was of much practical use. She had already tried warmer air, to little avail, and she refused to stop work. When she was so sick that she couldn't sit up to paint, enforced rest drove her crazy with boredom. She would write home to Gabriel begging him to send her paints, which she would use as soon as she was strong enough to hold a brush. While she was in Oxford, she drew an illustration for the ballad "The

Haunted Tree," and when she left in June, after a month, she gave Acland her drawing *We Are Seven* to show him how much she appreciated his efforts.

At some point during the 1850s, one of Lizzie's doctors — there is no particular reason to think it was Acland — prescribed laudanum for her, probably to calm her persistent stomach pains, and this well-intended gesture changed the course of her life. Laudanum is an opium derivative, less refined and therefore less potent than heroin or morphine, but still a dangerously addictive drug. Because its hazards were little understood, it was one of the great panaceas of the nineteenth century. People could buy it by mail without a doctor's prescription, and even children were dosed with it.

Physicians who had few effective remedies in their pharmacopoeia fell back on this drug because it killed pain and allayed anxiety by submerging it in a drowsy euphoria that left the user indifferent to impending events. Since none of Lizzie's doctors was ever able to diagnose or treat her persistent and alarming complaints with any success, it is not surprising that one of them decided to offer her at least a measure of relief by sending her to the chemist for laudanum. Gabriel believed that she took it to soothe her nerves and to help her sleep; he also came to believe that she could not keep food down without laudanum. The hidden catch was that, because the body quickly develops a tolerance for the drug, Lizzie had to keep increasing the dose to ease her pain and to retrieve the pleasant feeling that became her only reliable refuge from the anxiety caused by Gabriel's continual hedging and drifting.

By her own testimony, Lizzie took "quarts" of laudanum over the years, and eventually she suffered its unpleasant side effects, which she probably thought were new symptoms of her disease. Large doses can cause not only serious constipation but nausea and vomiting, two of Lizzie's most frequently mentioned symptoms. Withdrawal from the drug caused more problems: Lizzie's heart would be slowed by a dose; then, as it wore off, her pulse would begin to race and she would feel dizzy and faint. Chills alternated with fever and violent fits of trembling.

Even more important than the physical impact of the drug was the psychological devastation it wrought over time. Laudanum addicts were prey to violent mood swings as the drug wore off; the delicious high could turn to sudden, severe depression. These mood swings were of course frightening and exhausting. Knowing nothing of

these effects and having real cause for despair in her life, Lizzie no doubt held herself responsible for her erratic feelings. As the years passed, her dependency on the drug increased, and its impact on her physical and mental health grew apace. A doctor who had wished only to quell her pain had handed her the means of her slow destruction.

<hr>

After leaving Oxford, Lizzie traveled in the company of Pusey's sister to Clevedon, a new watering place in Somerset, just a mile from the sea, where she spent two idle, contented weeks resting. Miss Pusey discreetly absented herself before Gabriel appeared to join Lizzie for a few days, and the two of them had a marvelous time, as they usually did when they were alone together, away from London and Annie Miller and other temptations. Left to themselves, they could resurrect their private love for a few days or weeks and be happy again. Gabriel's feelings revived, and Lizzie's hopes were raised.

For the moment they were giddy. They giggled over Lizzie's encounter with a boy from the deep country, who found her London clothes and red-gold hair so exotic that he asked if there were lions where she came from. They dug up some golden water-flag lilies and brought them home to plant on the balcony at Chatham Place. And, with the prospect of a reliable income stretching out before them for the first time in their lives, they amused themselves, going to the theater and to the circus, entertaining friends, and buying Lizzie new clothes. She loved clothes and Gabriel loved to show her off; whenever they came into some unexpected cash they went out and bought her something new to wear.

Ruskin attempted to remonstrate with them: "You are such absurd creatures both of you. I don't say you do wrong, because you don't seem to know what *is* wrong, but just to do whatever you like as far as possible — as puppies and tomtits do."[46] He did not consider that he had taken them on almost as pets, and had indulged his own whim in doing so. When they failed to buckle down and return to their easels, he felt betrayed, but he didn't cut off their funds. Instead he contented himself with writing Gabriel crabby letters full of advice: "If you wanted to oblige *me,* you would keep your room in order and go to bed at night. . . . Take all the pure green out of the flesh in the *Nativity* I send, and try to make it a little less like worsted-work by Wednesday. . . . You are a conceited monkey, thinking

your pictures right when I tell you positively they are wrong. What do you know about the matter, I should like to know."[47] Gabriel put up with this dictatorial art direction, no doubt because he understood that he was as much a trial for Ruskin as Ruskin was for him. And of course Ruskin was footing the bills.

The summer idyll could not last, and when the peace between Lizzie and Gabriel broke, it did so with a major eruption. Lizzie had not pressed Gabriel for marriage for a very long time; indeed, she had waited too long. By the time she raised the subject, she was full of rage. The spark was gossip she had picked up somewhere about Gabriel and Annie, and it set off a loud, screaming fight at the Browns' house, which Brown recorded in his diary on August 13 as "Rossetti and Miss Siddal here behaving (Rossetti) very badly." Distraught, Lizzie remained at the Browns', consoling herself by pouring out her unhappiness to Emma. On the morning of August 16 the crisis escalated: "Emma went into town with Miss Siddal before Rossetti was come in from his rooms at the Queen's Head [a nearby pub], so that when he did come his rage knew no bounds at being done out of the society of Guggum and vented itself in abuse on Emma who 'was always trying to persuade Miss Sid that he was plaguing her etc. etc., whereas that of course Miss Sid liked it as much as he did etc. etc.' Then it was to poor Katy 'O! go and be damned' in tones of most impassioned despair. I did not know whether to laugh most or to be angry so did both, laughed at him and d——d him and at length thought it best to tell him where he could find them. . . . I took a shower bath not having had one since Miss Sid came, she having my room."[48]

Gabriel continued to deflect his anger by claiming that Emma was the real troublemaker. It was Emma who had filled Lizzie's head with the notion that he had mistreated her by not marrying her. It was Emma who had upset Lizzie by gossiping to her about his insignificant little flirtations with other women. In fact Lizzie never had many close friends, and she had to rely on those few she did have. Emma was her confidante, and at times her tactician. Emma did counsel Lizzie to insist on marriage, but her advice was hardly the outrage that Gabriel perceived it to be. Gabriel conveniently glided over the facts that he had long since compromised Lizzie in the eyes of the world and that she, at the age of twenty-six, was not getting any younger. In contrast, Emma Brown, who had also come from a working-class family, had less education and fewer social graces than

Lizzie, but Brown had married her while Gabriel dithered — a reproach to Gabriel and a goad to Lizzie.*

Somehow the quarrel blew over, and fences were more or less mended with the Browns. With Ruskin's blessing and his cash in hand, Lizzie made plans to winter in the south of France. Five days before her departure, Gabriel visited Lizzie's home in Southwark — for the first time in the four years since they had become engaged. Only one of her sisters was at home, and so Gabriel still did not have to meet Lizzie's parents. Nothing else attests quite so clearly to his fear of marriage.

<p style="text-align:center">◈❦◈◈</p>

On the morning of September 23, 1855, Lizzie boarded a boat for Le Havre in the company of a highly respectable chaperone chosen by Gabriel with the help of his mother and sisters. She and Mrs. Kincaid were supposed to stop briefly to rest at Paris and then travel straight on to Nice, but Lizzie fell in love with Paris and couldn't tear herself away. This was her first trip to the Continent and the first time she had traveled any great distance on her own, a novelty for a Victorian woman. Within a month she had spent forty pounds — all the money she had brought with her — on lodgings and entertainment and clothes, so that she had to write home in a panic for funds. Gabriel rose to the crisis. According to Brown, he "began a fresh one Francesca da Rimini . . . worked day and night, finished it in a week, got 35 guineas for it from Ruskin and started off to relieve them. . . . This is how Gabriel can work in a pinch. I must say however that as yet my £15 are in abeyance, but I live in hope."[49] (Gabriel's picture was actually a triptych telling the story of Paolo and Francesca, the lovers doomed by Dante to float through hell forever, clasped in each other's arms.)

Armed with the necessary guineas, Gabriel dashed off to rescue Lizzie. She was ill when he arrived, but they managed to enjoy Paris anyway. The sculptor Alexander Munro, who had made the trip over with Gabriel, reported that his friend was "everyday with his sweetheart of whom he is more foolishly fond than ever I saw lover. Great affection is ever so to the mere looker-on I suppose."[50] Having suc-

*Before anyone enshrines Brown for his sensitivity, it should be pointed out that he did not make Emma his wife until two and a half years after the birth of their first child.

cessfully come to his lady's aid, like one of the knights he painted, Gabriel was exhilarated, and his love for Lizzie was rekindled.

After ten days' visit, Gabriel returned to London and Lizzie finally started for Nice. At some point she and Mrs. Kincaid chafed against each other so severely that they parted company, but Lizzie stayed on at Nice for five months. A letter that she wrote to Gabriel gives us a rare glimpse of Lizzie enjoying herself and shows that she did indeed have a sense of humor: "On your leaving the boat, your passport is taken from you to the Police Station, and there taken charge of till you leave Nice. If a letter is sent to you containing money, the letter is detained at the Post Office, and another written to you by the postmaster ordering you to present yourself and pass-port for his inspection. You have then to go to the Police Station and beg the loan of your passport for half-an-hour, and are again looked upon as a felon of the first order before passport is returned to you. Looking very much like a transport, you make your way to the Post Office, and there present yourself before a grating, which makes the man behind it look like an overdone mutton-chop sticking to a grid-iron. On asking for a letter containing money, Mutton-chop sees at once that you are a murderer, and makes up its mind not to let you off alive; and, treating you as Cain and Alice Gray in one, demands your passport. [Alice Gray was, according to William Rossetti, "a good-looking woman of swindling proclivities," whose exploits had been followed closely by the British press.] After glaring at this and your face (which has by this time become scarlet, and is taken at once as a token of guilt), a book is pushed through the bars of gridiron, and you are expected to sign your death-warrant by writing some-thing which does not answer to the writing on the passport. Mean-while Mutton-chop has been looking as much like doom as overdone mutton can look, and fizzing in French, not one word of which is understood by Alice Gray. But now comes the reward of merit. Mutton sees at once that no two people living and at large could write so badly as the writing on the passport and that in the book; so takes me for Alice, but gives me the money, and wonders whether I shall be let off from hard labour the next time I am taken, on account of my thinness."[51]

From London Gabriel wrote her a long, funny poem for Valentine's Day, mocking his lazy, haphazard ways and complaining that she had been gone too long. The last stanza asks her to come home and cheer him up:

Come back, dear Liz, and, looking wise
In that arm-chair which suits your size,
Through some fresh drawing scrape a hole.
Your Valentine and Orson's* soul
Is sad for those two friendly eyes.[52]

Despite these charming protestations of lonelinesss, Gabriel had been consoling himself with Annie Miller. He must have known he was playing with fire, but he made no attempt to hide his liaison from his friends.

He also made two new and less dangerous friends while Lizzie was in France. The first was an earnest undergraduate from Oxford, Edward Burne Jones, or Ned Jones, as he was familiarly known.** After an agonizing crisis of faith, Ned had given up the idea of taking orders and vowed to become a painter instead. Dissatisfied with most of the painting he saw at the Royal Academy, he had happened upon one of Rossetti's drawings, engraved as an illustration for the poem "The Maids of Elfin-Mere" in William Allingham's volume *The Music Master,* and it had been a revelation to him of what was possible in modern art. At Christmastime he made his way to the monthly faculty meeting at the Working Men's College, hoping just to get a glimpse of the artist. By chance he fell into conversation with a friend of Gabriel's, who invited him to attend a gathering in his chambers a few evenings later, at which the object of Ned's admiration would be present.

When they met, Gabriel was so taken by Ned's innocent and unqualified appreciation that he invited him to come round to the studio in Chatham Place on the following day. Ned was overwhelmed by this astounding turn of events and eager to share his good fortune with his best friend at school, William Morris, who also dreamed of becoming an artist and had already shown promise as a poet. He wrote to tell Morris that Rossetti had read some of his poems and been enormously impressed.

In short order Gabriel took these two aspiring artists under his wing. He talked to them about painting and introduced them to his friends, artists who had heretofore been nothing more than famous

*Valentine and Orson were twin brothers in a French romance Gabriel was fond of.
**Burne-Jones did not legally hyphenate his name till late in life, but he is now always referred to by the double barrel. This convention has been adopted here.

names to Burne-Jones and Morris. He carried them off to the theater, then kept them up talking till three or four in the morning, returning the next day around noon for a late breakfast and more talk. He saw genuine talent in Burne-Jones's drawings and Morris's poems, and he foresaw a second generation of Pre-Raphaelites, sons in art that he could father.

The two young men were floored that Gabriel took so active an interest in them. They did not realize that they were a boon to him; they gave him the fresh start he so desperately needed. Depressed about Lizzie, discouraged about his painting, afraid he would never make a reputation as an artist, he suddenly found two brilliant, talented, sensitive people on his doorstep who not only thought he was the single most important and exciting figure in modern art but wanted nothing more than to listen respectfully while he held forth on any subject that came to mind. To them, his unwillingness to exhibit was a courageous refusal to give in to the tyranny of the Royal Academy. Lizzie was Miss Siddal, his one true love, who had been forced to leave him and journey to the south of France in search of health.

<center>✣❧✣❧✣</center>

When Lizzie returned home early in May 1856, one of the first things she did was to visit the Browns, who had become a second family to her. Like every Briton who ever crossed the Channel, she was bursting with stories of outrages perpetrated by the French, and she was relieved to speak and hear her own language again. But her pleasure in being home died when Emma told her that Gabriel had been seen all over town with Annie. After all her years of patience and loyalty, it was intolerable not just that Gabriel had betrayed her trust but that he had done it so publicly, humiliating her in front of all their friends.

She confronted him with his treachery, asking how he could deceive her and at the same time cuckold Hunt, one of his closest friends. Gabriel didn't deny the charge; he resorted instead to a thin, tired diversionary tactic, accusing Emma of being a busybody, which only made Lizzie angrier. He insisted that he still loved Lizzie and had remained true in his heart, but she was not to be mollified so easily. Gabriel struggled to make amends. First he sent Brown a letter of apology, then he bought Lizzie a paisley shawl and took her to see Charles Kean in *A Winter's Tale,* the hottest theater production of the season.

Soon after her return, Lizzie moved into rooms of her own at 1 Weymouth Street in fashionable Portland Place, close to the Browns and a fair walk from Chatham Place. Victorian ladies did not live alone, but in this regard Lizzie had become an independent woman who was not ruled by what people thought. William Rossetti admired her gumption, or as he called it, "her decided inclination to order her mode of life according to her own liking, whether conformable or not to the views of the British matron."[53]

For Lizzie, living alone was certainly preferable to lingering at home waiting for Gabriel to marry her. She continued to hold out hope, but their relationship deteriorated rapidly. Ignoring all promises, he continued to see Annie Miller, and not only told Lizzie that he had done so but proceeded to describe his feelings for Annie in painful detail. He was also busy finishing an exquisite watercolor he called *Dante's Dream at the Time of the Death of Beatrice*, which he had started while Lizzie was in Nice. It shows a pale girl with thick red-gold hair stretched out on her bed in death. Dante stands off to one side, sturdy and thoughtful, towering over his small, ashen Beatrice. The figure of Love presses a farewell kiss on her forehead as two attendants prepare to cover her with a shroud strewn with flowers. Annie Miller modeled for one of the attendants, and Lizzie must have been chilled when she saw this work on Gabriel's easel.

Lizzie's fury about Annie spent itself in screaming fights. Whether he understood it or not, Gabriel was provoking her to end the relationship by pushing her into a corner where, like a rat, she would be forced to attack. The outbursts used up her small store of strength, and usually left her terribly ill. She also saw that her anger just drove Gabriel away. In desperation she probably increased her doses of laudanum, thereby exacerbating her physical and emotional symptoms. Large doses depressed her nervous system, slowing both her respiration and her blood pressure, so that it might well have appeared that she was dying. Indeed, she could have inadvertently killed herself.

Gabriel panicked. Annie would not make up for the loss of his love. And he had alienated his closest friend; Brown, thoroughly fed up, had written in his diary that Gabriel was "mad past care"[54] and that he was "sick of them coming here and his rudeness."[55] Gabriel scrambled to get back into his loved ones' good graces, finding new buyers for Brown, who was desperate for cash, and promising Lizzie

that he had called off his liaison with Annie. Brown was genuinely grateful for his help, and Lizzie also forgave him; she still had reserves of affection and need on which he could draw.

Spurred by guilt, Gabriel offered to marry Lizzie and take her to live in Algeria, a haven for consumptives, as soon as he had sold the painting he was working on. Saying yes to marriage and no to Algeria, Lizzie began to believe that her years of waiting might have come to an end. Her hopes rose even higher when Gabriel acquired a new patron, Thomas Plint, a stockbroker from Leeds, who was so eager for paintings and so trusting that he asked if he could pay in advance. Gabriel did not hesitate, of course, and the cash problem was solved without his having to put brush to canvas.

But still Gabriel refused to set a wedding date or get a license. Lizzie's pride had suffered enough. She packed her bags and took the train to Bath, intent on washing her hands of him.

No doubt they should have broken it off for good, but neither felt able to do so. The length of their engagement had compromised Lizzie to the point that she would have been hard pressed to find another suitor. Nor could Gabriel go back on his promise now that he had formally presented her to his mother and sisters as his intended bride. And Gabriel still caught glimpses of the beautiful young girl he had adored, though now Lizzie's face was wasted by illness. The drug affected her responses to him, too. When she doped herself she was too easy, too acquiescent; as the laudanum wore off, her moods swung out of control. Deep depressions, intensified by the drug, blackened her hopes. Gabriel wished that he could love her as he once had done, and brooded in the dark hours of the night on whether it was his own failure that he did not. After all, Dante's love for Beatrice had remained perfect and intact, even when he was sorely tempted.

Abashed and lonely, Gabriel soon slunk down to Bath to apologize. Lizzie was too tired and too sick to fight with him, and she once again accepted his apology. By now their relationship had decayed into a pattern of provocation, anger, and guilty reconciliation. But there was no joy in it this time; the two spent a disconsolate Christmas together in a damp boarding house.

On Christmas Eve, Christina Rossetti wrote a sonnet she called "In an Artist's Studio," criticizing Gabriel for his treatment of the "meek unconscious dove" he had been keeping in a gilded cage for some six years. Much as she loved her brother, she saw the pain his self-absorption had caused.

One face looks out from all his canvases,
　　One selfsame figure sits or walks or leans:
　　We found her hidden just behind those screens,
The mirror gave back all her loveliness.
A queen in opal or in ruby dress,
　　A nameless girl in freshest summer-greens,
　　A saint, an angel — every canvas means
The same one meaning, neither more nor less.
He feeds upon her face by day and night,
　　And she with true kind eyes looks back on him,
Fair as the moon and joyful as the light:
　　Not wan with waiting, not with sorrow dim;
Not as she is, but was when hope shone bright;
　　Not as she is, but as she fills his dream.

Christina may not have made friends with Lizzie, but she had comprehended Lizzie's sadness and also her brother's culpability.

Returning to London did not cheer the couple up. Gabriel wrote to a friend: "Today here is neither a bright nor a dark day, but a white smutty day — piebald — wherein accordingly life seems neither worth keeping nor getting rid of. The thick sky has a thin red sun stuck in the middle of it like the specimen wafer outside a box of them. Even if you turned back the lid there would be nothing behind it, be sure, but a jumble of such flat dead suns. I am going to sleep."[56] Which is exactly what he did — sleeping away days on end to avoid facing his problems.

A fresh crisis arose one evening when Lizzie heard about a scheme that Brown was hatching to rent a large house with studios so that a group of artists could live communally. Gabriel claimed later that he had tried to tell Lizzie about the project but that she had not been interested, and that of course he had planned to marry her before he moved into the house. All Lizzie understood was that Gabriel had agreed to move into a house where Hunt would be living with Annie Miller, whom he was finally getting around to marrying. (In fact, the marriage did not come to pass.)

When Gabriel went round to visit Lizzie the next day he found her prostrated by their disagreement. Writing to Brown that night he oozed self-reproach: "She does not better in health, never eating any-

thing to speak of, and I am most wretched about her. . . . Kind and patient she has been with me many and many times, more than I have deserved; and I trust this trouble is over. It is but too natural that her mind should be anxious and disturbed."[57] Gabriel called on Brown at his studio and borrowed ten pounds for a marriage license, but there is no indication that he actually bought one.

A fortnight later Lizzie's health and her nerves broke down so completely that Emma Brown insisted she come to their house, where Emma could nurse her. Brown feared the worst: "Miss Siddal has been here for three days and is I fear dying. She seems now to hate Gabriel in toto." Since it appears that Lizzie developed a pattern of overdosing at times of extreme stress, her sudden, sharp decline may well have been brought on by laudanum. Brown felt sorry for both of them. He understood why Gabriel had "quite lost her affection through his extraordinary proceedings," but by March 15 he was worrying about him, too: "All day with Gabriel who is so unhappy about Miss Sid that I could not leave him."[58]

With his wife's help, Brown tried to mediate between the pair, and his diary became a chronicle of this effort: "Went off to tell Gabriel what Miss Sid said of him. Put him in much affliction and brought him back with the intention of walking over to Hampstead [where Lizzie had new quarters] to try and induce her to give him an interview, but Emma proposed to go and warn her of his coming. . . . This we did but on getting there she would not see him nor me. At length I was admitted but could obtain no favorable speech from her and so Gabriel and I came away again leaving Emma. Gabriel in a sad state. . . . to Hampstead to Miss Siddal's where dined, after which such a scene of recrimination as never — but she seemed relenting."[59]

Lizzie did relent, but then Gabriel drifted once again. He seized an opportunity to travel to Llandaff in Wales to discuss the altarpiece design for the renovation of the cathedral. He had secured this major commission early in the previous year, but so far had done nothing toward starting it. Nor did he put pencil to paper when he got back home.

Lizzie was more productive, and completed one of her most polished and compelling pictures, a watercolor. The subject was drawn from a Tennyson ballad about Lady Clare, who is on the point of marrying Lord Roland when she learns she is the illegitimate child of her maid, Alice. Clare mounts her horse and goes directly to Roland

to tell him the shameful truth. Happily, Roland scorns the problem of her birth, marries her anyway, and they flourish. Rather than illustrate the happy outcome, Lizzie chose to paint Clare brooding on the secret of her birth. The subject suggests that Lizzie may have felt that her failure to marry was in some way her fault, but it also suggests that she harbored a lingering hope that the fineness of her character would shine through and make Gabriel see that they should wed. This year Gabriel painted Lizzie as Saint Catherine, carrying the spiked wheel on which she would be impaled.

A small public triumph came to Lizzie in June. Brown, who detested the Royal Academy, decided to organize a private exhibition of his paintings and those of his friends. He rented a house in Fitzroy Square, then spent weeks putting the show together, lining up exhibitors and hanging their pictures himself, trying to make sure that everyone's work was displayed to best advantage. In return he asked each artist for ten pounds to defray expenses. This was the only time that Lizzie's work was exhibited while she was alive. Gabriel screwed up his courage and sent some of his pictures too.

The exhibition received lukewarm reviews, but Lizzie's work was singled out by Coventry Patmore in the *Saturday Review* as worthy of special attention. "There was one lady contributor Miss E. E. Siddal whose name was new to us. Her drawings display an admiring adoption of all the most startling peculiarities of Mr. Rossetti's style, but they have nevertheless qualities which entitle them to high praise. Her *Study of a Head* [her self-portrait] is a very promising attempt, showing great care, considerable technical power and a high, pure and independent feeling for that much misunderstood object, the human face divine. *We Are Seven* and *Pippa Passes,* by the same lady, deserve more notice than we can stop to give them. Her *Clerk Saunders,* although we heard it highly praised by high authorities, did not please us so much."

Most likely Ruskin and his friend Charles Eliot Norton were the "high authorities," especially since Ruskin and Patmore were good friends. Norton, a wealthy art critic and editor from Cambridge, Massachusetts, was popular with the intelligentsia of Victorian London and was handed round as a specimen of that rare breed, the cultured American. When Ruskin brought him to the exhibition, he promptly bought *Clerk Saunders*.

At this time Lizzie made the startling announcement that she would forgo the allowance Ruskin had been paying her for the last two

years. For a woman in poor health, without husband or employment, to renounce her only means of support was a daring, perhaps foolhardy move, and there is precious little information to explain her motives. It has been suggested that she was forcing Gabriel's hand, making herself utterly dependent on him so that he would have to marry her. But she had been dependent on him in the years before the pension, and he had not married her then. By renouncing it now, she was bound to incur Gabriel's anger for throwing away £150 a year. Probably she didn't give a tinker's damn whether he was angry or not.

She may have heard that Ruskin had recently criticized the work of her friend Anna Mary Howitt so cruelly that Anna Mary had decided to give up painting altogether. Ruskin's rudeness may well have convinced Lizzie that his pension was simply charity masquerading as patronage. Too weak to draw much of the time, she was producing only a very small amount of artwork, and her self-respect may have made it hard for her to accept so much money from Ruskin for so small a return. She had never felt comfortable about taking his money and owing him so great a debt of gratitude, and over the years his interest in her and her work had waned.

Ruskin felt sorry, sensing that in some degree Lizzie's discomfort was his fault. "The only feeling I have about the matter," he wrote to Gabriel, "is of some shame at having allowed the arrangement between us to end as it did, and the chief pleasure I could have about it now would be her simply accepting it as she would have accepted a glass of water when she was thirsty, and never thinking of it anymore."[60]

Lizzie's timing could have been better. Neither she nor Gabriel, nor Millais for that matter, had paid Brown the ten-pound exhibition fee, and in July Brown was reduced to borrowing from Plint to pay for his baby's funeral, a necessity that wounded him to the quick. Lizzie was so caught up in her own troubles that she had grown careless of other people.

<div align="center">⚜</div>

Exhausted and depressed by his battles with Lizzie, Gabriel organized an elaborate lark to distract himself and delight his friends. The architect Benjamin Woodward was just finishing up a true white elephant of a building, a medieval-Victorian hybrid built of bright red brick, to house the Oxford Union. On a whim, Gabriel offered to

cover its white plaster walls with brilliantly colored murals if the university would agree to lodge and feed him and a number of his friends and buy all their paint. Woodward jumped at the offer, and Gabriel started extending invitations. Morris and Burne-Jones were eager to join their mentor in this challenging project, albeit nervous about their lack of training. Four more painters — Valentine Prinsep, John Hungerford Pollen, John Roddam Spencer Stanhope, and Arthur Hughes — made up the rest of the party, and they all happily laid plans to execute their murals over the summer vacation.

The muralists arrived in Oxford armed with grandiose ideas for filling the vast spaces with legends from Malory's *Morte d'Arthur.* Ignorant of fresco technique, they plunged in without preparing the walls, painting directly onto wet plaster covered with just a quick coat of whitewash. The paint sank right into the surface. (Today, despite laborious attempts to retrieve the pictures, the walls tend to a muddy dark red, with ghostly figures and scenes visible here and there.)

Gabriel dominated the scene. For Val Prinsep, at nineteen the youngest of the company, "Rossetti was the planet round which we revolved; we copied his very way of speaking. All beautiful women were 'stunners' with us. Wombats [Gabriel's favorite animal] were the most delightful of God's creatures. Mediaevalism was our *beau ideal* and we sank our own individuality in the strong personality of our adored Gabriel."[61] The casual manner in which Gabriel condescended to the university for its generosity inspired them all to heights of extravagance and irresponsibility. Penny-watching painters who squeezed the last dab out of tubes of paint at home laughed when Gabriel knocked over an entire potful of lapis lazuli, the most expensive of all pigments, making a huge, beautiful, useless pool of dark blue on the floor. The committee in charge of paying their expenses was staggered by the bill they ran up for soda water alone.

They were untroubled. Even the heavens were cooperating. It was the loveliest summer anyone could remember, with scarcely a cloudy or a rainy day. Their fun was innocent, if careless. At six feet two inches and 230 pounds, Val delighted in throwing Burne-Jones under one arm and carrying him up a ladder to the balcony where they worked. Morris, a short, broad fellow, was already beginning to turn to fat, and in the dark corners of the alcoves they painted tiny Morrises with legs sticking straight out in imitation of the famous beefy portraits of Henry VIII. Morris had fallen in love with a weirdly beautiful

young girl named Jane Burden, the daughter of a stable groom, and they all had a wonderful time teasing him about his bashful courtship. Gabriel asked her to sit for his Guinevere, and used the drawings he made of her for the central figure in his mural, instead of those he had prepared using Lizzie as a model.

Gabriel's arrogance was a revelation to these well-brought-up sons of the middle class. As young unmarried artists of some renown, they were social trophies, and the elaborate dinner parties that at first seemed flattering soon became so many evenings in purgatory. With a particularly unpromising meal facing them one late afternoon, Gabriel decreed that being "out of town" was an ironclad excuse. They jumped on a train, dined in London, and slept there, returning in the morning thoroughly charmed by the nerve of their master.

The group worked well beyond the end of the long vacation into the middle of November, when Lizzie wrote from Matlock, a spa outside Sheffield, to tell Gabriel that she was ill and scared. By now she was using her collapses, no doubt unconsciously, to manipulate Gabriel. She may have gotten wind of the threat posed by Jane Burden. Sex was no longer a weapon in her arsenal; the pathos of her illness was all she had left. Gabriel left Oxford immediately, and most of the planets dispersed, deprived of the sun that had shone on them.

Gabriel's stay at Matlock seems to have brought neither Lizzie nor him much comfort. By January 27, 1858, he had returned to London, leaving her behind at the spa. On that day Brown called at Chatham Place to discuss some business, and afterward he and Gabriel walked over to Red Lion Square to visit Burne-Jones and Morris in their studio. There they met a model named Fanny Cornforth, who was sitting for the fledgling artists that day.

"Fanny Cornforth" was actually the *nom de guerre* of Sarah Cox, a blacksmith's daughter who had grown up in a village in Sussex but wound up in London making her living by prostitution. At the moment she was living in a boarding house in Dean Street, the main thoroughfare of Soho, the red-light district. This address alone was virtually enough to identify her profession.

When Gabriel saw her — a large, lovely woman with waving yellow hair that dusted the floor when she unbound it — he was immediately attracted. He asked her to come to his studio the following morning, where, she said, " 'E put my 'ead against the wall and drew it for the 'ead in the calf picture."[62] The calf picture was of course

Found, the canvas that had been gathering dust in a corner of his studio for years. Fanny, a young girl who had come up from the country and now made her living on the city streets, inspired him to take it up once again.

Meeting Fanny led to a rebirth for Gabriel. Gentle but sturdy, she was happy to sleep with him when he wanted and quite able to take care of herself when he wasn't around. In both respects she was Lizzie's opposite. Sex was familiar, even mundane to her. She was thirty-four, five years older than Gabriel. He could relax and let her lead the way, teaching him. He didn't have to persuade her, and he suffered no fear of reproach or reprisal. Pregnancy was an occupational hazard for a prostitute. Information about contraception was more available to her than to other women, and she could be relied on to know how to get an abortion if the need arose and to make no fuss if she had to have one. A prostitute suffered no less than any other woman over an unwanted pregnancy and was as likely to die as the result of a botched operation, but there was far less pressure on her partner, for she was expected to handle these things for herself. So far as anyone knows, Fanny never had a child.

Fanny's easy, good-natured ways were a relief to Gabriel. He spent more and more time with her, seeing Lizzie so little during the rest of 1858 that his brother William thought the relationship had come to an end. Whereas Lizzie had been Gabriel's alone, he seemed to enjoy sharing Fanny. He introduced her to the painter George Boyce, who was also a connoisseur of pretty girls. On December 15, 1858, Boyce recorded in his diary that he had "adjourned to 24 Dean Street, Soho, to see 'Fanny.' Interesting face and jolly hair and engaging disposition."[63] When Fanny moved to a house in Tenison Street, Battersea, a more respectable neighborhood, both Gabriel and Boyce contributed money toward her new establishment. Gabriel did a drawing of Boyce seated at his easel while Fanny stood behind him with her arms clasped lovingly around his neck, and the relaxed sexiness of the sketch suggests that Gabriel basked in the scene's erotic content.

In July 1859 Boyce wrote: "D. G. Rossetti persuaded me into giving him £40 commission for an oil portrait of Fanny, and asked me for £20 down which I could not refuse. . . . He pleaded being very hard up, or I should hardly have let him have so much tin on account."[64] This painting marked a leap forward in Gabriel's work. It was the first in a radically new style of sumptuous dramatic portraits, some-

times of whole figures, but more often just of heads and bosoms, sometimes larger than life, dressed in richly colored velvets and decorated with heavy, stagy jewelry and big blossoms. He called the picture *Bocca Baciata,* "The Mouth Kissed," a reference to a line from Boccaccio that he copied onto a slip of paper and attached to the back of the frame: "Bocca baciate non perde ventura, anzi rinuova come fa la luna" ("The kissed mouth that loses not its fascination, but renews itself as does the moon"). It was the first major painting in oil Gabriel had completed since his Annunciation in 1853. But the picture represented another kind of breakthrough for Gabriel — he discovered that he could draw inspiration from someone other than Lizzie and could in fact paint other women more easily.

For large oils he could charge much higher prices than for drawings and watercolors. He would be able to support himself for the first time, bringing to an end the need to sponge off his brother. Gabriel had painted dozens of small, intense, beautiful watercolors in the 1850s, now regarded by most art historians as his finest work, but had long flagellated himself for his inability to handle oils. Watercolors were regarded as feminine and therefore insignificant; oil, which is harder to handle, was perceived as a man's medium, the vehicle for serious pictures.

Unlike the vulgar extravaganzas that Gabriel produced later, the *Bocca Baciata* is lovely and sensuous. The artist was painting a particular face that he loved; Fanny was not yet lost in the great composite face that he would churn out in the 1860s and 1870s. She gazes out at the viewer, thoughtful and perhaps a little sad, her hands crossed quietly. There is no great stage erected around her, just a few marigolds and a shiny, tempting apple in the foreground. Her jacket is unbuttoned to reveal a hint of white lace lingerie. The invitation to pleasure is clear, but it doesn't shout at the viewer.

Gabriel finished the picture in October 1859. Arthur Hughes wrote to Allingham: "Rossetti has lately finished a most beautiful head. . . . Boyce has bought it and will I expect kiss the dear thing's lips away before you come over to see it."[65] The poet Swinburne, a friend of Gabriel's, was thoroughly aroused by the picture; to him, the lady in the painting was "more stunning than can be decently expressed."[66]

For Gabriel, Lizzie had begun receding like a sad dream. He hadn't forgotten her, but he was turning her into a piece of beautiful history, writing calm, tender poems about the loss of a great love.

Lizzie was not so easily reconciled. She wrote a savagely intelligent poem about their relationship which she titled "Lust of the Eyes." The first two stanzas read:

> I care not for my Lady's soul
> Though I worship before her smile;
> I care not where be my Lady's goal
> When her beauty shall lose its wile.
>
> Low sit I down at my Lady's feet
> Gazing through her wild eyes
> Smiling to think how my love will fleet
> When their starlike beauty dies.

These lines are a stunning indictment of the man she had trusted for so many years. By making the lover the speaker in the poem, she shows him to be not only conscious of but responsible for his betrayal of the lady's trust.

Lizzie had seen through Gabriel. She may have sent him the poem in an attempt to shock him into seeing what he had done to her, but the lines reveal so much anger and despair that it seems more likely she simply gave up on him. They did not even see each other in 1859.

In the spring of 1860 Lizzie became so ill that her doctor dispatched her to Hastings once more. Her condition continued to deteriorate, and she summoned Gabriel. Once more the sight of her in bed, too weak even to lift her head, brought out all his tenderness, and he wished only to care for her. Certain at last that their marriage would be brief and tragic, he suddenly could not marry her fast enough. He no longer had to fear that he would be trapped in a long, squalid tunnel of domesticity. When he begged her to forgive him and marry, she agreed. To his mother he wrote: "Like all the important things I ever meant to do — to fulfill duty or secure happiness — this one has been deferred almost beyond possibility. I have hardly deserved that Lizzie should still consent to it, but she has done so, and I trust I may still have time to prove my thankfulness to her."[67]

To William he wrote more openly, admitting deeper fears: "If I were to lose her now, I do not know what effect it might have on my mind. . . . The ordinary licence we already have, and I still trust

to God we may be enabled to use it. If not, I should have so much . . . to reproach myself with, that I do not know how it might end for me."[68] His desperation was apparent, and the prospect of his grief genuine. But it is revealing that all his fears were for himself. He was worried about the effect her death would have on him; a marriage would mean that he wouldn't have "so much to reproach myself with." And that was important, for Gabriel was deeply threatened by the dilemma he had created; he feared his own suicide.

At the same time he craved freedom. While he kept Lizzie company in her sickroom, where he saw her "ready to die daily and more than once a day,"[69] he painted a picture of an artist kneeling by the woman he loves just after she has dropped dead while modeling for him. There can be no doubt that he was painting his secret wish. One must wonder how he managed to keep that desire so hidden from himself that he could paint the subject without contemplating its implications. Lizzie, watching from her bed, must have seen them fully.

On May 23, as soon as Lizzie was strong enough, they were married at the church of St. Clement in Hastings. No friends and no members of either family were present, and strangers signed the register as witnesses. There was no trousseau, no wedding breakfast, no shower of shoes pelting the carriage for luck. Lizzie was thirty; Gabriel was thirty-two.

They had decided to honeymoon in Paris, and Gabriel wrote to his mother immediately after the wedding to let her know their plans: "We are going to Folkestone today, hoping to get on to Paris if possible but you will be grieved to hear her health is no better as yet. Love to all."[70] They crossed to Boulogne, where they stayed with old friends of the Rossetti family. In Paris they took rooms in the elegant and expensive Hotel Meurice. Gabriel, the soul of conventionality despite his carefree manner, mailed the text of a wedding announcement to the faithful William, who duly posted it to the *Times*.

After a week at the Meurice, funds were running low, and they moved to a boarding house in the rue de Rivoli. Lizzie was still very weak and spent most of her time in bed. Gabriel entertained his bride by reading Boswell and Pepys aloud, and drew her as they talked. With her blessing, he went off to study the pictures in the Louvre, and on his jaunts around Paris he bought her gifts of jewelry and two dogs. Gradually her strength returned, and Gabriel wrote home happily to say that Paris was certainly agreeing with her. They discussed

the possibility of settling there, but dropped the idea, probably because neither could really imagine cutting all ties to home. Gabriel had had a hard time supporting them in London, where he had been building up connections for years; in Paris he knew no one. But it comes as no surprise that the newlyweds shared a fantasy about a fresh start in their favorite city. After all the years of bitterness and recrimination, they found themselves thoroughly enjoying their honeymoon. Where Lizzie might well have feared a relapse and Gabriel the burden of his new responsibilities, they discovered instead that they still loved one another's company — especially when they were far away from the temptations and pressures of London.

Gabriel did quite a bit of work during these weeks, including a strange pen-and-ink drawing of a subject on which he had been working since he first became engaged to Lizzie. In *How They Met Themselves,* a knight and his lady traveling through the forest have come upon their shades, and are shown staring at them with a mixture of horror and uncertainty. Such an encounter is supposed to be a presage of death. The shades are frightened and despairing, which suggests that Gabriel felt that he and Lizzie were entering a dark wood where they would have to face their deepest fears.

Lizzie did one drawing that we know of, an illustration for her husband's poem "The Bride's Prelude." She called her picture *The Woeful Victory*. When their money ran out, the newlyweds headed home.

On their return to London Lizzie once again grew very sick and had to go to bed for some weeks. In a letter to a friend, Gabriel complimented her on her refusal to give in: "She is still so weak that the least excitement knocks her up again, and always so obstinately plucky in illness that there is no keeping her down if she can only be up and doing."[71] Gabriel was anxious to introduce her to Burne-Jones and his new wife, Georgie, so as soon as her strength returned the two couples arranged to meet at the wombat's lair in the zoological gardens. The Rossettis invited Ned and Georgie back to Hampstead, where they had taken rooms to get Lizzie out of the fetid atmosphere of Chatham Place.

Georgie remembered it as a special but sad day. She was fascinated by Lizzie's beauty and her uncanny relation to Gabriel: "I know that I then received an impression which never wore away, of romance

and tragedy between her and her husband. I see her in the little upstairs bedroom with its lattice window, to which she carried me when we arrived, and the mass of her beautiful deep-red hair as she took off her bonnet: she wore her hair very loosely fastened up, so that it fell in soft, heavy wings. Her complexion looked as if a rose tint lay beneath the white skin, producing a most soft and delicate pink for the darkest flesh-tone. Her eyes were of a kind of golden brown — agate-colour is the only word I can think of to describe them — and wonderfully luminous: in all Gabriel's drawings of her and in the type she created in his mind this is to be seen. The eyelids were deep, but without any languor or drowsiness, and had the peculiarity of seeming scarcely to veil the light in her eyes when she was looking down. Whilst we were in her room she shewed me a design she had just made, called *The Woeful Victory* — then the vision passes."[72]

As the two women began to make friends over the next few months, Georgie got a glimpse of what had sustained Lizzie's relationship with Gabriel through so many difficult years. Lizzie "did not talk happily when we were alone, but was excited and melancholy, though with much humour and tenderness as well; and Gabriel's presence seemed needed to set her jarring nerves straight, for her whole manner changed when he came into the room. I see them now as he took his place by her on the sofa and her excitement sank back into peace."[73] Regardless of all the hurt, the reassurance Lizzie received from his mere presence was clearly vital to her.

Despite the famously healthful air in Hampstead, Lizzie took another downturn; the convulsive vomiting started again. That summer set a record for rain, and while it sheeted down day after day, Lizzie lay in bed in one damp room while Fanny posed for Gabriel in the next. It is not known whether Lizzie was aware that Fanny was her husband's lover. There is no record of her protesting Fanny's presence; she may have been too sick to care, or she may have felt, knowing how badly they needed the money the picture would bring, that she could scarcely complain.

Gabriel painted Fanny as Fair Rosamund, and although he painted her many more times after this, he never produced as fine a portrait again. Her lovely young face is so utterly alive that one almost feels she is breathing on the canvas, trembling with feeling. Rosamund, who was the mistress of Henry II, looks out the window of her secret bower, drawing tight the string that will guide her royal lover through

the maze that protects her. Given this subject, it seems unlikely that Gabriel had given up Fanny just because he had married. (So had she; devastated by Gabriel's marriage, she had married a mechanic named Timothy Hughes in 1860. Hughes seems to have brought her little comfort.)

In the autumn Lizzie went to Brighton to take the sea air, with her sister Lydia for company. Gabriel stayed behind in London, painting to make money. An apologetic and pitiful letter from Brighton suggests that he sent her out of town because he was fed up with her. Ostensibly her presence distracted Gabriel from his work, but he had kept his studio at Chatham Place and could easily have stayed there if he needed complete isolation in order to concentrate.

Lizzie wrote that she felt "lost" without him, but would not come home, where she knew she was "in the way." Apparently she had asked in a previous letter if she could return and he had put her off. Now she felt her way carefully: "I am most sorry to have worried you about coming back when you have so many things to upset you. I shall therefore say no more about it. I seem to have gained flesh within the last ten days, and seem also much better in some respects, although I am in constant pain and cannot sleep at nights for fear of another illness like the last. But do not feel anxious about it as I would not fail to let you know in time, and perhaps after all I am better here with Lyddy than quite alone at Hampstead. . . . I should like to have my water-colours sent down if possible, as I am quite destitute of all means of keeping myself alive. I have kept myself alive hitherto by going out to sea in the smallest boat I can find. What do you say to my not being sick in the very roughest weather? . . . I can do without money till next Thursday, after which time £3 a week would be quite enough for all our wants — including rent of course."[74]

Feeling abandoned and all too willing to dramatize her situation, Lizzie went right for Gabriel's soft spot. At the same time that she was attempting to placate Gabriel by getting by on three pounds a week, she was also threatening him with the ever-present specter of her death. Her terrorizing tactics were probably employed subconsciously, for she obviously did not feel that she could ask for what she really wanted or needed. In fact she sounds less like a partner in this marriage than like her husband's debtor. The role made her angry as well as frantic.

But they somehow managed to bounce back from this low point, as they had so often before. In September Lizzie returned to London, where she quickly must have discovered, if she didn't already know, that she was pregnant. They were both thrilled, and for once Lizzie had some good luck. Her health improved markedly, and in that same month Gabriel reported happily that she was "certainly not subject to the same extent to violent fits of illness."[75] This trend continued. Lizzie was one of those fortunate women whose health blooms in the first trimester of pregnancy.

Unable to find a house in Hampstead that they could afford, Lizzie and Gabriel decided to "weather out the winter" at Chatham Place, where the landlord agreed to knock down some walls and put a door through to the flat next door so they could double their space. To make the place more attractive, Gabriel covered the fireplace with blue Dutch tiles, and they bought more of the blue willow china that Lizzie loved. He painted all the doors and the wainscoting a summerhouse green and designed his own wallpaper, which is quite impossible to picture: trees, red and yellow oranges, black leaves, white circles, and yellow stars. As a finishing touch he proudly hung Lizzie's drawings all around the sitting room, and confided his hopes to a friend: "Her last designs would I am sure surprise and delight you. . . . I feel surer every time she works that she has real genius — none of your make-believe — in conception and colour, and if she can only add a little more of the precision in carrying out which it so much needs health and strength to attain, she will I am sure paint such pictures as no woman has painted yet. But it is no use hoping for too much."[76] When their redecorating was complete, they threw themselves a housewarming party, to which they invited William and Christina Rossetti, the Burne-Joneses, and Ruskin. (The Morrises were also invited, but Morris's new wife, Jane, was just days away from her first confinement.)

Their housekeeping was shockingly casual by bourgeois standards. They had no kitchen, although they had the means of getting breakfast or tea for themselves. The painter and poet William Bell Scott, who disapproved thoroughly, noted that Gabriel's "former bachelor habit of working till 9 P.M. then rushing out to dine at a restaurant was continued; Mrs. Siddal Rossetti, little accustomed to the cares and habits of a domestic life, willingly conforming."[77] Ladies, of course, did not frequent chophouses — but Gabriel gave his wife the freedom to work alongside him by not expecting her to do any more housework than he did.

Despite the pressure on Gabriel to work steadily to support them, they entertained quite a bit in the evenings, Gabriel promising "oysters and obloquy" after the sun had set and there was no more light to paint by. He and Lizzie were finally having fun, more fun than they had had in years. Gabriel asked the Browns to dinner at the end of November, but sent a cautionary note: "I write this word to avoid the possibility of your turning up in togs [evening clothes] — an appalling sight — and *never* necessary here."[78]

The Lizzie who had lived in Gabriel's shadow for so long began to emerge as a personality in her own right. She delighted in the company of her new friends, especially Georgie Burne-Jones and Jane Morris. Years later, Georgie remembered, "I never had but one note from Lizzie, and I kept it for love of her even then." The note read: "MY DEAR LITTLE GEORGIE, I hope you intend coming over with Ned tomorrow evening like a sweetmeat, it seems so long since I saw you dear. Janey will be here I hope to meet you. With a willow-pattern dish full of love to you and Ned, LIZZIE."[79]

Lizzie also fell into an easy friendship with Algernon Swinburne, whom Gabriel had known since his days at the Oxford Union. Swinburne treasured her, and thirty-five years later wrote to William Rossetti recalling the happy hours he had spent with her: "Except Lady Trevelyan, I never knew so brilliant and appreciative a woman, so quick to see and so keen to enjoy. . . . I used to come and read to her sometimes, when she was well enough, at Chatham Place; and I shall never forget her delight in Fletcher's magnificent comedy of *The Spanish Curate*. I read it to her — of course with occasional skips, 'tho there really is not much need for a Bowdler . . . I can hear the music of her laughter to this day."[80] The brilliant, neurotic poet whose sadomasochistic themes shocked so many readers was careful to expurgate the bold language of an Elizabethan playwright when he read to a lady. He himself might go to an establishment in St. John's Wood and pay a woman to birch him until his buttocks bled, but he acceded to the belief of the day that certain words would violate even a married woman's sensibilities.

From the beginning Gabriel was apprehensive of talking about Lizzie's pregnancy, almost as if he superstitiously believed that the gods would punish him if he allowed himself to be joyful. However, his caution was characteristic of the time, when childbirth might well mean death; many families kept silent about a pregnancy until it was well advanced, indeed undeniable. Lizzie's history of poor health gave him all the more reason to worry.

In the Rossetti family tradition, he sought the best medical advice; on this count he was utterly responsible, lining up a first-rate obstetrician named Francis Hutchinson and a nurse to attend Lizzie. For added security he took his wife for a consultation with Dr. Babington, the head of the Lying-in Hospital.

By the end of April, when Lizzie was nearly due, Hutchinson suspected that the baby was dead and warned Gabriel. On May 2 Gabriel wrote to Brown: "Lizzie has just had a dead baby."[81] The child was a girl.

Lizzie must have felt the stillness of the baby, and carrying the dead child must have been a nightmare almost beyond imagining. This tragedy may have been caused by laudanum, although Lizzie might not have been taking the drug during her pregnancy, for some doctors understood that its action on a delicate fetal heart might well be fatal. However, laudanum was prescribed by others, who believed that it could sustain an uncertain pregnancy.

Sometime before the stillbirth, Lizzie wrote a poem that she titled "At Last," in which she articulated her worst fears and prepared herself to meet them. The speaker is a woman who is dying after giving birth. Her voice is gentle and calm; she is ready to face death and is looking forward to life in heaven. She bids farewell to her mother, husband, and infant son. Although she makes a special effort to let her husband know that she has died without regret — "my dying heart was gay" — the words with which she reassures him carry a sting: "Tell him I died of my great love," the love that made her give herself to her husband and want his child.

At first Gabriel was simply relieved that Lizzie had survived, writing to a friend: "She herself is so far the most important . . . that I can feel nothing but thankfulness."[82] He watched over her closely in the days that followed, but he couldn't pull her back from the dream world into which she was slipping. Laudanum was her only escape from a reality she could no longer bear. When the Burne-Joneses came to visit, they found Lizzie sitting in a low chair next to an empty cradle. Awaking for a moment from her reverie, she "cried with a kind of soft wildness . . . 'Hush, Ned, you'll waken it!' "[83]

Gabriel never fully got over their loss either. For the rest of his life he used a little child as a symbol for death in his poems. Brooding over what this death meant for their future, he wrote to Georgie, who was pregnant: "By the bye, Lizzie has been talking to me of parting with a certain small wardrobe to you. But don't let her, please. It looks such a bad omen for us."[84]

The Morrises invited Lizzie to come to their new house in the country to rest. Gabriel had to stay at Chatham Place and work, and one Friday in June he received a note from Lizzie, who had just learned that Boyce's sister Joanna Wells, an accomplished painter, had died in childbirth: "It is indeed a dreadful thing about poor Mrs. Wells. All people who are at all happy or useful seem to be taken away. It will be a fearful blow to her husband." (Despite his own recent loss, Gabriel had gone to the Wells home at the request of the family and drawn a portrait of the dead Joanna.) Lizzie asked her husband please to come down and help her with the decorations she was trying to paint for the Morrises: "If you can come down here on Saturday evening I shall be very glad indeed. I want you to do something to the figure I have been trying to paint on the wall. But I fear it must all come out for I am too blind and sick to see what I am about."[85]

In July another calamity hit. Gabriel's patron Thomas Plint died unexpectedly. This was a personal loss, for Plint was a fine, subtle, kindly man who had become Gabriel's friend. It was also a financial disaster, because Gabriel owed him £714 worth of work, and the executors of the estate could not afford to be as forbearing as Plint had been, as they were legally charged with the welfare of a widow and eleven children. With only twenty-five pounds on hand, Gabriel had no choice but to throw himself into work, which proved a strong counter to grief. Another help was John Ruskin, who offered to advance him the hundred pounds necessary to publish his translations of the Italian poets. Late in the year *The Early Italian Poets* was issued, with the *Vita Nuova* as its centerpiece. It was reviewed well, which buoyed Gabriel.

Lizzie, however, had withdrawn into her own grief and could take little joy in the event. She spent hours sitting by the hearth with her feet inside the fender, just gazing into the fire. In October, the month that the Burne-Jones baby was born, she went again to visit Jane and William Morris in the country, while Gabriel traveled up to Yorkshire to paint a lucrative portrait. Lizzie's behavior scared the Morrises. She would appear at dinner and not say a word, then suddenly rise and leave the table without explanation. One day she bolted, without telling them she had gone, and they telegraphed Gabriel. When he heard from Lizzie, who had returned to Chatham Place, he wrote frantically to his mother asking her to rush over with some money, because he knew Lizzie had little, if any, and he returned home as quickly as possible.

Emma Brown, who had lost two babies herself, one to miscarriage

and another at the age of ten months, made Lizzie come to visit her. Lizzie stayed for a few days, but again took off without warning. Gabriel wrote a letter of apology to the Browns: "She tells me she felt unwell after you left yesterday, and finding the noise rather too much for her, left before your return lest she should be feeling worse. Many thanks. . . . I write this word since her departure must have surprised you, as her return did me."[86]

Gabriel's biographers have found these sudden disappearances inexplicable, but they were not strange at all: There were healthy new babies in the Morris and Brown households, and the noise that so oppressed Lizzie at the Browns' was probably the squalling of a newborn. What's more, Jane was already pregnant a second time. Rather than sit quietly and watch these mothers play with their infants, Lizzie fled, overwhelmed by her loss and needing to grieve in private.

Having clung tenaciously to life for so long, Lizzie now saw death as freedom from suffering and misery, even as an affirmation; in a fragment of a poem she wrote longingly of the rest that a laborer deserves when the backbreaking harvest is finished. Her last completed poem, "Lord, May I Come?," was a religious meditation on death and the afterlife, in which she wondered whether God would reunite her with her baby: "Do the dead walk hand in hand?" Reading these lines, one knows that she felt her days on earth were numbered, or at least hoped that they were:

> Life and night are falling from me,
> Death and day are opening on me,
>
> . . .
>
> Hollow hearts are ever near me,
> Soulless eyes have ceased to cheer me:
> Lord, may I come to thee?

Looking at the manuscript years later, William Rossetti noted that it had been "written in a very shaky and straggling way" and surmised that "it must have been done under the influence of laudanum, which she frequently took by medical orders as a palliative against tormenting neuralgia, and probably not long before her death."[87]

On June 8, a month after Lizzie's child was delivered, Christina Rossetti had written a prophetic poem that she called "Wife to Husband." She saw her sister-in-law only rarely, but somehow she had managed to follow the emotional progress of Lizzie's life.

Pardon the faults in me,
 For the love of years ago:
 Good bye.
I must drift across the sea,
 I must sink into the snow,
 I must die.

You can bask in this sun,
 You can drink wine, and eat:
 Good bye.
I must gird myself and run,
 Tho' with unready feet:
 I must die . . .

Christina and Lizzie seem to have been the only ones who knew what was about to happen.

On February 10, 1862, the Rossettis had arranged to dine with Swinburne at the Hotel Sablonière in Leicester Square, a restaurant with a decided radical glamour, frequented by revolutionaries and political refugees from the Continent. As they were climbing into a cab near Chatham Place sometime after six, Gabriel noticed that Lizzie seemed drowsy and suggested that they stay home, but she insisted they go on. During the meal Lizzie struck Swinburne as excited, in unnaturally high spirits. No doubt she had taken a large dose of laudanum before she left the flat.

The Rossettis returned to Chatham Place by eight, and around nine Gabriel went out alone. Returning at eleven-thirty, he felt his way up the stairs in the dark, groping for a light and calling out for Lizzie. He got no reply. When he reached the bedroom, it reeked of laudanum. Rushing to the bed, he shook Lizzie, but he could not rouse her. On the table beside her he found a two-ounce bottle labeled LAUDANUM POISON, now quite empty. (Two ounces of laudanum, if it had not been watered down by her chemist, was the equivalent of six hundred milligrams of morphine; sixty milligrams is a lethal dose.) There was a note pinned to her nightgown asking Gabriel to take care of Harry, her retarded brother.[88]

Lizzie's doctor, Francis Hutchinson, was called for immediately, and he labored over her comatose body in an attempt to flush the laudanum with quarts of water and a stomach pump. At three Lizzie's

sister Clara arrived to wait with Gabriel. At five in the morning Gabriel turned up on Brown's doorstep and told him the story, punctuating it with desperate, breathless sobs. The two men returned to Chatham Place together. At six Gabriel's doctor, John Marshall, arrived to relieve Dr. Hutchinson, but it was too late. An hour and twenty minutes later, Lizzie died.

Brown stepped in and took over. He burned the note in the fireplace, and then set about making all the necessary arrangements, notifying the coroner, the undertaker, family, and friends. For the next week he devoted himself entirely to Gabriel, standing by him as he did in virtually every crisis of Gabriel's life. He sent a messenger to tell the Burne-Joneses. Taking thought for the living, Georgie realized that her husband, who had delicate lungs and nerves, should not make the journey to Chatham Place, and insisted on going by herself. When she got there Gabriel was in seclusion, but she saw Lizzie's "poor body laid in the very bed where I have seen her lie and laugh in the midst of illness."[89]

William Rossetti spent the morning working at his desk in Somerset House, blissfully ignorant of the tragedy just a few blocks away. At lunchtime the Rossettis' housekeeper appeared in his office to tell him. When he looked down on Lizzie's silent form at Chatham Place he thought to himself: "The poor thing looks wonderfully calm now and beautiful."[90] Lines from the *Vita Nuova* kept running through his mind, the same ones that had inspired Gabriel's painting of Dante's dream about Beatrice's death: "Ed avea in se umiltà si verace/ Che parea che dicesse, 'Io sono in pace' " ("And with her was humility so true that I thought she said, 'I am at peace' ").[91] William undertook the painful task of telling his mother and sisters for Gabriel.

When Swinburne arrived as scheduled to sit for his portrait, he was horrified to find the "noble and unfortunate lady" dead, her household in chaos, and her husband felled by grief. Gabriel was undone. He returned to his mother's house, where Lizzie's body was laid out in the drawing room in an open coffin for seven days. When Lizzie's mother and Clara came on the third day, Gabriel couldn't face them. William remembered watching him stand over Lizzie's body with tears pouring down his face, crying, "Lizzie, Lizzie, come back to me."[92] Days after her death, he insisted that Marshall be called in once more, because he was sure that she was still alive. Marshall performed this service for his friend, even though he knew there was no shred of hope.

Because of the circumstances of Lizzie's death, the law required an inquest, which was conducted at Bridewell Hospital at one-thirty in the afternoon on Wednesday, February 12, the day after she died.[93] Clara Siddal, the Rossettis' housekeeper and her daughter, a neighbor named Ellen MacIntire, Algernon Swinburne, Gabriel Rossetti, and Dr. Hutchinson gave testimony.

Clara said that she had seen Lizzie on "Saturday evening last" and that she had "seemed in tolerably good spirits then." She added: "I knew of no harm to her. I don't suspect any." The housekeeper volunteered that "her husband and herself lived very comfortably together," and the housekeeper's daughter said that the bottle of laudanum had been only half full when she had last seen it. Ellen MacIntire testified that Lizzie had told her "she had taken quarts of laudanum in her time." Swinburne spoke at length, striving to establish beyond a doubt the mutual devotion of husband and wife.

Gabriel told the court about her long-time dependence on laudanum and said that he did not believe she had intended to kill herself. "She was in the habit of taking large doses of laudanum. I know that she has taken a hundred drops. I thought that she had the laudanum in brandy. . . . She had not spoken of wishing to die. . . . She was very nervous and had I believe a diseased heart. My impression is that she did not do it to injure herself but to quiet her nerves. She could not have lived without laudanum. She could not sleep at times nor take food." (This was the first and only mention that Lizzie had a problem with her heart. Metaphorically, at least, it rings true.)

The last witness was Lizzie's doctor, who said that "she died from the effects of laudanum which must have been a very large dose." He volunteered the fact that "her child was born dead and had been dead for a fortnight before it was born." He made a direct connection between her baby's death and her own; he knew the horror she must have felt waiting to bear a dead child. During her pregnancy she had been in a "very nervous condition," and he observed that "her husband appeared very much attached to her."

Everyone pulled together to create a rosy picture of a happy, affectionate couple; at this sad moment, faced with the grieving husband, they may have believed in the picture they painted. The jury found that Lizzie "accidentally, casually, and by misfortune came to her death."

Accidental death was a conclusion frequently drawn by sympathetic Victorian juries who agreed to protect the good name of a suicide

and to spare the feelings of the family. But rumors about Lizzie's death surfaced overnight, and some of them survived for years afterward. Those with the most vivid imaginations believed staunchly that Rossetti had murdered his wife. Tales of physical cruelty, of Gabriel dragging Lizzie around the drawing room by her hair, were served up in whispers as corroborating evidence. Oscar Wilde, a man who relished a good story more than the truth, was heard to say that Lizzie had acted silly at dinner and that Gabriel, losing patience, had thrust her into a cab, taken her home, and pressed the bottle of laudanum into her hands, shrieking, "Take the lot."[94] After scolding her, he was alleged to have slammed out of the house.

The story that many of his friends believed was that Gabriel had gone out to see Fanny and that Lizzie had known where he had gone and emptied the bottle in despair. John Marshall's daughter, who was not a malicious gossip by any means, believed that Lizzie had killed herself because of Fanny. Gabriel was tormented with guilt about Lizzie's death for the rest of his life, so it may be that he did see Fanny that night; many years later, not long before his death, he told a friend that Lizzie's note "had left such a scar on his heart as would never be healed."[95] William always maintained that his brother had gone out to the Working Men's College, but apparently Gabriel had resigned his teaching post there four years earlier.

Lizzie had been under intense emotional strain for years. Bad health had drained her. Her endless engagement had worn away her nerves. Gabriel had married her only when he thought her at death's door; she knew this, and the knowledge must have undercut her hopes for the marriage. But the death of her baby had been the great, the final blow; Georgie believed that "if that little baby had lived, she, too, might have done so."[96] Perhaps some small incident sparked her action on that particular night — sharp words, or a flood of painful memories. Even if Gabriel didn't go to Fanny, Lizzie may have imagined that he did. Perhaps just the fact that he left her alone in the house was enough to plunge her into despair; from the height of giddiness she felt at dinner, she may have sunk into gloom as the first dose of laudanum wore off. She may have been intent on dying, or she may have been trying to scare Gabriel by showing him that she was desperate enough to attempt suicide. The reasons and the responsibility for her death reached back in time long before this night. Her will to live had been stretched to a fine thread, and finally it snapped.

On the day of the funeral, Gabriel went alone into the room where

Lizzie lay, taking the gray calf notebook in which he kept fair copies of all his poems. He tucked it in among the masses of red-gold hair, next to the Bible that someone else had nestled there. When he told Brown what he had done, he explained, "I have often been writing at those poems when Lizzie was ill and suffering, and I might have been attending to her, and now they shall go." With this remark he acknowledged what Lizzie had feared: that she had been more important to him as the raw material of his art than as a human being to love and care for. Brown appealed to William to dissuade his brother from the gesture, but William refused to intervene, saying "Well, the feeling does him honour, and let him do as he likes."[97] (One cannot help noting that the action would have done him more honor if he had not mentioned it to anyone. Perhaps he was hoping that Brown would slip into the room and silently remove the notebook.)

When Lizzie was buried that afternoon in the Rossetti family plot at Highgate Cemetery, next to Gabriel's father, the ceremony was attended only by family and a few close friends. Afterward Mrs. Rossetti drove back to Chatham Place to pick up Lizzie's pet bullfinches and take them home with her to Albany Street.

After the funeral, Gabriel moved in with his mother and sisters, setting up his easel in Brown's studio because he could not bear to go back to Chatham Place. When he finally had to clean out the flat, he burned every letter he could find that Lizzie had ever written to him. This common practice among Victorians was intended to protect the confidences and secrets of loved ones, but surely Gabriel was protecting himself as well. He also destroyed every photograph of her in his possession, saying that he felt none of them did her beauty justice. He had himself already immortalized that beauty in dozens of drawings and paintings; by destroying these photos, he wiped out almost every actual image of her. He effectively seized control of how posterity would know Lizzie Siddal.

Gabriel did take pains to preserve Lizzie's artwork. The leading art photographer of the day was commissioned to take photographs of each drawing and painting as insurance, in case anything happened to the originals, and Gabriel hung her work in places of honor in his drawing room. He never published any of her poetry, however, perhaps because, as Christina suggested, the poems were too sad, and because they revealed too much of the pain he had visited upon their author.[98]

Gabriel painted one last picture of Lizzie, returning to a canvas he had laid by many years before. He called it *Beata Beatrix,* and meant for it to commemorate the moment when Beatrice was carried up to heaven. In a letter he explained: "It is not at all intended to represent Death . . . but to render it under the resemblance of a trance, in which Beatrice seated at the balcony overlooking the City is suddenly rapt from Earth to Heaven."[99] On the canvas Lizzie sits with her eyes closed and palms turned upward, offering herself in a moment of mystical ecstasy. In Gabriel's art Lizzie was still Beatrice; he made her immortal, but he also denied her suffering and death.

Years later, when Lizzie's friend Bessie Parkes saw *Beata Beatrix,* she could discern no resemblance to the pure young woman she had known and loved. "When I look at the famous Beatrice in the National Gallery, I feel puzzled by the manner in which the artist took the head and features of a remarkably retiring English girl, with whom I was perfectly familiar, and transfused them with an expression in which I could recognize nothing of the moral nature of Miss Siddal [who] had the look of one who read her Bible and said her prayers every night, which she probably did."[100]

Over a dozen years Gabriel had disappointed this retiring young woman so many times that he had finally extinguished her will to survive. He could not allow her to be a mortal, fallible human being; in fact, he could not forgive her for having failed to remain his Beatrice, a saint on earth. They were both held captive by his fantasy, and it destroyed her first.

Three

PYGMALION
AND GALATEA

AFTER THE EXHIBITION of 1851, William Holman
Hunt seriously contemplated exchanging his studio for
a cattle ranch in Canada. No one had bought his picture,
Valentine Rescuing Sylvia from Proteus, and he was flat
broke. Millais bailed him out for the second year in a row, offering
to lend him all the money he could spare after he met his own family's
expenses. Hunt hesitated, but Millais's parents strongly seconded their
son's offer, and touched by their faith in him, he capitulated.

Flushed with their pleasure in each other and in Ruskin's eloquent
letters to the *Times,* the two young men decided to spend a summer
together in the country, where they could stretch their legs and paint
backgrounds from nature for the next year's exhibition. The majority
of British painters regarded working outdoors as folly and laughed
at them, but since they regarded it as the vital foundation of their
philosophy they pressed on with their plans. After searching for the
perfect site, they eventually settled at Worcester Park Farm, near
Ewell in Surrey.*

Having gained confidence in their technique, they were painting
steadily and surely; these pictures would give them a secure place in
the popular imagination. Hunt was up at cockcrow and off to the site
he had chosen several miles from the farm, where he could isolate himself

*The *plein-airistes* had been working in France for some time, but news of this practice had
not crossed the Channel. Or perhaps it simply struck the British art establishment as further
proof that all Frenchmen were mad.

in order to concentrate. A sybarite by Hunt's standards, Millais slept in most mornings. The delicate child of a protective mother, he enjoyed the chance to join in the life of the farm, where he made the surprising discovery that chopping wood on a cold day warmed him up.

The first painting Millais started was the *Ophelia* that was to cause Lizzie so much misery. The Pre-Raphaelites were fascinated by Hamlet's victim, a woman sacrificed to a man's bitter chastity. Millais planned to paint her drowned, floating downstream. He worked up the background of a stream and its bank dense with wildflowers and weeds, aware of the absurdity of struggling to render tragedy while swatting flies. "My martyrdom is more trying than any I have hitherto experienced," he wrote. "The flies of Surrey are more muscular, and have a still greater propensity for probing human flesh. . . . Am also in danger of being blown by the wind into the water, and becoming intimate with the feelings of Ophelia when that lady sank to muddy death. . . . There are two swans who not a little add to my misery by persisting in watching me from the exact spot I wish to paint, occasionally destroying every water-weed within their reach. My sudden perilous evolutions on the extreme bank, to persuade them to evacuate their position, have the effect of entirely deranging my temper, my picture, brushes, and palette. . . . Certainly the painting of a picture under such circumstances would be a greater punishment to a murderer than hanging."[1]

Millais had more trouble putting a water rat into his picture than he did with the figure of Ophelia herself. Water rats were hard to come by. When his servant finally caught one, it began to decompose before Millais was able to render a likeness. He had to call for a fresh corpse; the search was repeated, and before long he had run through three rats. After all that, visitors who came out from London complained that the rat shouldn't be in the picture at all. Some thought its proximity to Ophelia was indelicate; its presence obtruded on the viewer an awareness that a rodent would soon be feeding on the piteous virgin. Others simply couldn't recognize the animal, guessing it to be a rabbit, a dog, a cat, anything at all but a rat. So the artist painted the rat in and out, in and out, before finally concluding that it had to be banished forever. In the end, the rat triumphed: Today any visitor to the Tate Gallery can see the distinct shadow of a fat, prowling rat in the upper right corner of the canvas.

Hunt was having his own animal difficulties. His picture, *The Hireling Shepherd,* a parable about the shepherd who neglects his flock,

was to feature more than forty sheep. Hunt expected his sheep to be docile creatures. Instead, nets, ropes, and a servant had to be employed to hold them in place. When all else failed, Hunt directed his servant to pick up a flailing sheep and drop it to the ground, thereby rendering it insensible and cooperative.

The Hireling Shepherd is a disquieting picture. Hunt believed that he was depicting an elaborate allegory about the pomposity of men of the church and their failure to meet the real spiritual needs of their flock, but the painting is also an inadvertent disquisition on lust that reveals Hunt's sexual disgust. A muscular shepherd — a thoroughly stupid, mindless fellow, according to Hunt — wraps himself around a ripe shepherdess in order to show her a death's-head moth he has found in the field. In the girl's lap rests a lamb that is about to be ill because it has eaten a green apple while the shepherdess has been distracted from her duties by desire. At first glance this is just a pretty pastoral scene, but the longer one looks, the more repellent the picture becomes, with its lurid reds and greens. The shepherd looks over-heated and crude, and the maiden's brooding gaze hints at a cunning sensuality. The plump sheep in the background prove on close examination to be exploding from engorgement.

<center>⋘⋙</center>

In the evenings Hunt and Millais sat together sketching, chatting, drinking endless cups of black tea, and reading aloud — Tennyson, Patmore, Coleridge, Browning, the Bible, and Shakespeare. As *Ophelia* progressed, Millais began casting about for a second subject, and one night he mentioned that he thought of doing two lovers whispering by a wall. Scenes of courtship appeared more often on the walls of the Victorian Royal Academy Exhibition than any other single subject, including family or battle.[2]

Hunt was put off, but bit his tongue. A couple of evenings later, he overcame his reserve and delivered a lecture to Millais: "When I go to meet my beloved Rebecca or Rachel I shall not invite you to look on, and you will not require my presence when you go to make love to your graceful charmer. . . . Seriously, I don't think that lovers should be pryed [sic] upon by painters. . . . In your hand I know the subject will be treated with a manly vigour that will elevate it, but I should have liked you to be engaged on a picture with the *dramatis personae* actuated by generous thought of a larger world."[3]

Millais was taken aback, but on succeeding days, when the swans

were in abeyance, he mulled it over. After work one night he told Hunt that he agreed it was desirable to avoid "maudlin sentiment," but that, to be practical, the autumn was advancing and he needed to come up with a second subject if he was to have two pictures ready for the spring. Hunt kept pressing him, pointing out that his lovers would be just two more bobbing about in the vast sea of amorous couples that flooded the Academy every blessed year. Most of these well-bred lovers confined their adventures to tidy garden paths, where they were frequently hemmed in by a stone wall or at least a wooden fence, silent testimony to the restriction of their desires. The most extravagant departure found two slim figures in the woods without a chaperone — just the sort of thing that Millais was proposing.

A few evenings later Millais brought up the subject again. He had decided to endow the picture with significance by choosing figures from the "larger world"; he would place his lovers in the time of the Wars of the Roses. If the young woman was the daughter of a Lancastrian and her lover a Yorkist, their affection would be at once star-crossed and validated by history. All Millais had to do to make them intelligible to any Briton and bring a legitimate tear to the eye was to affix a red rose and a white rose to their respective garments.

Hunt threw cold water on this suggestion by remarking that the "theme of the Cavalier and Roundhead has been rather worked to death in our day."[4] His impatience gave Millais a moment's pause; by now he must have begun to sense that Hunt could not control his sense of competition. In fact, Millais's own generosity probably made it necessary for Hunt to demonstrate his independence.

Bouncing back, Millais suggested that he could make the young man an exotic Huguenot rather than a home-grown article; the woman could be a French Roman Catholic struggling to tie a white scarf on her Protestant lover's arm to disguise him as an adherent of Rome and protect him from harm. He would firmly but lovingly resist her intentions, so the viewer would know he intended to sacrifice himself for his faith. The debate was concluded. Millais had his lovers, and Hunt had his significance.

A Huguenot, on St. Bartholomew's Day, Refusing to Shield Himself from Danger by Wearing the Roman Catholic Badge, was the first in a long series of historical love scenes that Millais painted over the years. His struggle with Hunt gave his picture a valuable new element, a sense of drama that engaged the viewer far more than the placid, whispering folk he had first envisioned would have done. This picture

and those that followed in its wake were hugely successful. The tragic situations that trapped Millais's lovers freed viewers to project themselves into the lovers' roles, and since nobility was always about to triumph over Eros, they could for one brief moment allow Eros unusually free play.

Good news came in the post one morning. Hunt had sent *Valentine Rescuing Sylvia* to the annual exhibition at Liverpool, where it had been awarded first prize and a welcome fifty pounds. Three weeks later, a Mr. MacCracken of Belfast wrote to say that he would buy the picture sight unseen, just on the strength of the prize.

Bolstered by these successes, Hunt began to plan an ambitious picture. Jesus, dressed in royal robes and jeweled crown, would stand in the moonlight before a locked door, which would be overgrown with brittle weeds to show how long it had been since any sinner had tried to gain entrance to his heart. To represent the moonlight accurately, Hunt painted by night, building himself a little tent and padding its floor with straw to keep out the worst chill. At dawn he would walk back to the farmhouse through the lightening fields, fall into bed for a few hours, then rush back to take advantage of the remaining daylight hours for his painting of sheep.

Hunt's strength was prodigious, but this day-and-night schedule wore him down. Driven by ambition, he intended to leave a great body of work that would make him an immortal in the history of painting. He also saw himself as the founder of Pre-Raphaelitism, which he fully expected to be recognized as the century's greatest, most daring school of painting. But he also had a tiny side, a humble side; a demon of duty dictated that he must make earnest, full use of every minute of every day in the short time granted to him on earth. Each day he struggled to earn the right to exist by straining every nerve to produce the noble paintings that shone in his imagination.

His manic routine was interrupted briefly on the sixth of December, 1851, when he and Millais packed up their painting kits, their canvases and traps, and started back to London. On the corner where Waterloo Bridge meets the Strand, they said a sad goodbye. Hunt comforted himself with the thought that "we should often again enjoy such happy fellowship."[5] In fact their youth was fast coming to an end; sex was about to distract them both, and they never had another such summer.

At home in his studio just off Cheyne Walk, Hunt was soon working day and night to paint the figure of Christ into *The Light of the World*. He was so obsessed with this picture that during the day he fitted a board over the window in his studio to simulate the moonlit atmosphere he was striving to capture on canvas. In the early evening he bolted around the corner to a grimy pub where he threw down a rough-and-ready meal of chops and washed them down with a mug of beer, and then he raced back to the studio to take advantage of the real moonlight. There he sequestered himself with the canvas and a wooden mannequin that modeled for Christ, which he had dressed up in robes fashioned from his mother's best damask tablecloth. He dabbed steadily at his easel for another eight hours until the moon waned, at around four in the morning. Painting was an enormously stimulating and anxious activity for him, so that by four he was terrifically tense, shoulder muscles frozen, back aching, calves tight, fingers cramped. As soon as he put his brushes to soak, he ran down the stairs into Prospect Place and around the corner, then full tilt up Cheyne Walk until he had tired himself out. Then he would turn and run back to his doorstep, climb the stairs, and fall into bed exhausted.

This frantic ritual did not go unnoticed. One evening he took a break and went across town to spend some time with friends. He took a bus home, and the driver regaled him with tales of eccentric neighborhood characters. The strangest one of all was a "queer cove" who lived by the river and "seemingly is a-drawing of somethink. He does not go to bed like other folks . . . and, as the perlice tells us, when the clock strikes four, out goes the gas, down comes the gemman, opens the street door, runs down Cheyne Walk as hard as he can pelt."[6] Hunt was delighted by the driver's puzzlement but the routine actually wore him down. It took him two years to finish *The Light of the World* to his satisfaction, and he was thrilled when he had painted the last thorn in Christ's crown.

This pious, conventional painting, one of the least interesting of all Hunt's works, was nonetheless the breakthrough he had been waiting for. All the years of struggle — the fights with his father to let him become a painter rather than a clerk, the days when he couldn't mail a letter because he couldn't afford a stamp — began to pay off. Today we generally dismiss Hunt's sweet Jesus, but the figure struck a deep chord in the collective British heart of the time, and eventually *The Light of the World* became the best-known British religious painting in the world. It toured all over the British Isles and out to the

colonies, to Canada and New Zealand and Australia, where people queued patiently, sometimes for hours, in order to pass by and gaze at it for a few minutes, and happily paid for the privilege. It has been estimated that in Australia four million people, or four fifths of the populace, saw it, some two or three times. This painting enjoyed an audience rivaled today only by films like *Star Wars* or *E.T.*, which apparently meet our needs for sentimental release.

This triumph took several decades to unfold. When Hunt had finished the painting, he had to bide his time, waiting for the annual Royal Academy Exhibition in the spring to show it to the world. In the meantime he started another canvas, in hopes of having two ready for the exhibition. He decided to treat himself to the costly extravagance of painting a picture from a living model. This daring new work, a far cry from his unexceptional Jesus, he called *The Awakening Conscience*. In a cluttered, prosperous, bourgeois drawing room, a voluptuous young woman with a strange, disturbed look on her face jumps up from her lover's lap, her dormant conscience startled awake by thoughts of her girlhood home.

Hunt was eager to confront his audience with the price young women paid to satisfy the sexual appetites of unscrupulous middle-class men. Only a few painters had the nerve to make their viewers look at anything so troubling. Those who did take up the theme of the fallen woman often steered away from the sumptuous mistress— an all-too-present figure who threatened the security of middle-class husbands and wives, the very people on whom painters depended to buy their productions. Instead, artists tended to dramatize the despair of streetwalkers, poor, bedraggled women who could be pitied at a safe distance.

Luckily for Hunt, he was able to find a patron broad-minded enough to commission the subject. He also received support and inspiration for this undertaking from friends such as his mentor Augustus Egg, who was at this time painting and exhibiting a three-part narrative called *Past and Present*. In the first panel, a bourgeois wife is shown first prostrated in shame at her husband's feet, having confessed her sexual betrayal. In the final panel she contemplates the moon and suicide in a filthy tunnel by the Thames.

As the model for the mistress in his painting, Hunt approached a gorgeous young woman who worked as a barmaid in the pub around the corner. Over the past three years he had chatted with her as she served him his meals and wiped up spilled beer from the tables around

him. Her high spirits tickled him, and he loved her looks. She could flirt deliciously with her customers when she was in the mood, and at eighteen she was already skilled at fending off their advances. Her ample body and her striking face — high cheekbones and sloe eyes, topped by rippling masses of wheat-colored hair — made her a honeypot for many busy bees.

Her name was Annie Miller, and she had learned the facts of life the hard way. Her mother, name unknown, had been a charwoman, but she had died when Annie was an infant, soon after bearing three children in three years. Annie's father, Henry Miller, had been wounded as a foot soldier in the fight against Napoleon, and he lived off a small military pension. Unable to cope after the death of his wife, he had moved in with his brother so that his sister-in-law could care for his children along with her own. The two families were crowded together in a cellar that they shared with four young men: three chimney sweeps and a clerk. Privacy was unknown; so was plumbing. By the time Annie was ten she was baby-sitting all day for the children of a Mr. Hill while his wife went out to work. Hill liked Annie, but described her as dirty and infested with vermin, speaking the foulest of language. She started working in the pub in her early teens, and quickly learned whatever the young men in the cellar had neglected to teach her about sex.

Hunt was drawn to this beautiful, knowing young woman. She had long been curious about him, too. He was a tall, good-looking, boyish sort, nervy, bound up, hardly aware of what he ate. His wavy dark blond hair made a lovely contrast with his violet eyes. When she took his order and set his plate down in front of him, she teased him to see whether she could put him at ease. He began to look forward to chatting with her in the evenings. Distracted as he was, he was never insensible to her beauty and had long thought of using her in a painting. Now he mentioned casually that his new painting would be exhibited next spring at the Royal Academy, where thousands of people would see it and talk about the lovely woman portrayed in it. Would Annie be willing to come to his studio during the day and model as that woman? She did not need to be pressed.

The sittings went well. Annie was a superb model, with the physical stamina to survive the long hours Hunt put in. The pose, half standing, half sitting, was an awkward one to hold for any length of time, but Hunt had infinite patience in the studio (and almost none anywhere else). The room was chilly, but he did his best to keep Annie warm; he wanted her to keep coming back. Her body was a perpetual

feast for his eyes, and unlike many women who came to sit, she was quite relaxed even after she had taken off her clothes. Hunt's drawing took on a natural quality that grew out of the vital, healthy, almost Edenic atmosphere that sprang up between artist and model.

Many years later, G. S. Layard stopped by to visit Hunt one morning and recorded his impression of the work in progress on the easel, a large *Lady of Shalott* that Hunt had been wanting to paint for years. In the 1850s he drew Annie as the Lady, in the same pose he used for this work. "The figure of the lady was nude," Layard wrote, "and I could not but tell the artist that it seemed to me almost sacrilege to drape so fair and exquisite a conception, which taught the lesson at one flash that modesty has no need of a cloak. This lovely figure bore no evidence of having been servilely copied from a stripped model, who had been distorted by the modiste's art [that is, bound up in a corset]. It did not suggest unclothedness, for the simple reason that it gave no impression that it knew the meaning of clothes at all."[7] If a model is at ease with her body, she takes a deep sensual and narcissistic satisfaction in the knowledge that the artist finds her face and form so interesting that he chooses to spend months struggling to render them. Annie thrived on this attention.

Hunt also flourished in this atmosphere at first, but then he grew afraid of it. Drawing Annie's body day after day became an exquisite mixture of pleasure and pain. He had to see her, but he couldn't let himself touch her. He believed that it would be dishonorable to take advantage of her, especially when he was painting a picture about the callousness of a man who took just that sort of advantage. So instead of crossing the room and taking her in his arms, he talked up a storm, explaining to her that he saw the young man in the picture — who did have his arms around the girl — as the tempter, and the young woman as the "victim of folly." A more hidebound Victorian would have held the girl entirely responsible for her loss of chastity, but confusion lay just beneath the veneer of Hunt's enlightenment. He held both lovers to account. The young man was the "companion of the girl's fall,"[8] he told her, betraying his thoroughly conventional judgment that it was the woman, not the man, who "fell." Underlying all his sympathy for the young woman was his assumption that the only means by which she could redeem herself was to reject her sexuality by jumping out of that embrace once and for all.

All of this elaborate teasing-out of meaning and morals made little sense to Annie. She had grown up in another world, where sex was governed more by economics and lust than by the dictates of con-

science. She also enjoyed sex, and she couldn't understand why Hunt seemed to run from it. She enjoyed his company and the small, polite attentions he paid her, which were a welcome change from some of the rough treatment she got at home and at work, but if he wasn't interested in taking his pleasure with her, other men were. Consequently she didn't need Hunt, while he was growing daily more dependent on her.

He believed he was in love, but didn't dare to act on the feeling, for his was a world in which shame and dishonor ruled as absolutes. What we perceive as an unnatural social prohibition, Victorians regarded as a sacred trust.

The waters were also muddied by his ambition; he hoped to make his reputation as a religious painter, and a sexual misstep that came to the attention of his devout public might blight his career and make him a laughingstock. The son of a fearful man with small dreams, he was terrified of failure, and success was as yet far from assured. But more than public disgrace, Hunt feared sex, both emotionally and physically. The atmosphere of the household in which he grew up had been tight, repressed, prudish, and every effort had been directed at keeping the body and the spirit under restraint at all times. Imbued with his father's fears, the boy had naturally imitated his strategies for coping with them, and had learned to exercise control over every aspect of his existence. Now Hunt was afraid that Annie's power over him might grow if he let her touch him, arousing even stronger feelings than those she already elicited. Ignorant as he was of sexual matters, he knew that the sexual act ends in losing physical control, and he was unwilling to venture into that dizzying pool of sensation.

Despite his fears, Hunt did want to sleep with Annie, and he came up with a classic solution: marriage. But fastidious creature that he was, he could not imagine Annie as a wife. Her hair was forever tangled and matted, and her fingernails were black with grime. She swore like a trooper and couldn't read a word. Deeply ashamed of his own lack of formal education and social graces, Hunt feared that she would drag him down. An incongruous image kept coming to his mind: He pictured himself at an evening party, entering a drawing room full of ladies swathed in tulle and crowned by tiaras, with this street urchin hanging on his arm.

To compensate for his own lack of schooling, he had become a ferocious autodidact, and it struck him that he could undertake An-

nie's education too. He would transform her into the ideal, a lady. Making the transition from one class to another seemed possible to him, even in a society that sniffed at overreaching.

He spent an hour with his landlady, Mrs. Bradshaw, holding forth about his concern for the welfare of this promising young woman who had been so sadly deprived by virtue of her humble birth. The landlady was not so naive as to fall for this line, but she was quite happy to arrange for her daughter, Sarah, to teach Annie to read and write, which would bring in a handy bit of cash. For the trickier tasks of teaching Annie manners and ridding her of a strong Cockney accent, Hunt needed someone more conversant with the requisite graces, so he made arrangements with Mrs. Bramah, the wealthy aunt of a friend, to teach Annie elocution and deportment. (A penchant for rescuing destitute or fallen women had seized any number of middle-class matrons at this period, and Mrs. Bramah was a fervent member of several societies dedicated to this work.) A bit later Hunt signed up a Miss Prout to give Annie lessons in geography, history, and arithmetic.

This plan of education was less implausible than it sounds, because the schooling of most middle-class girls was so pathetically spotty that the gap between their ignorance and Annie's was not as great as we might imagine. Hunt's mistake was to imagine that he could instill a different set of moral values by simply tacking on to his beloved a set of intellectual and cultural accomplishments.

To remove himself from the scene of any possible sexual crime, he planned a trip to distant lands. Since he had been a boy, he had dreamed of painting the actual sites of Biblical events, and now, with the sale of *The Light of the World,* he finally had enough money to travel to "the East" — to Egypt and Syria and Palestine. In his fantasy the job of transforming Annie would be completed while he was away, for he fully intended to spend several years in the East. Then, with several spectacular canvases in hand, he would return home to stun the art world and claim his luxuriant bride.

It occurred to him that he would need a deputy to oversee Annie's progress while he was away. He took his former pupil and Pre-Raphaelite Brother Frederic Stephens into his confidence, explaining that he needed someone he could trust to cherish his intentions and look out for Annie. Stephens was flattered and curious. Hunt asked him to visit Annie regularly, check on her schoolwork, pay her bills, and send reports to Hunt by letter. In return Hunt would permit

Stephens to borrow from the £200 he would be putting into a special account to cover Annie's bills. (Hunt's commitment of £200 to the project shows how serious he was about seeing it through, since he had made only £300 on the sale of *The Light of the World*. A young couple could live for a year, employing a servant, on £150.)

Stephens accepted Hunt's strange offer. His parents' creditors had foreclosed on them the day after the Brothers had gathered to draw portraits for Woolner in Australia; they were in dire straits, and Stephens felt honor-bound to help them. He also had to find a means of supporting himself. In no time he was drawing deeply on the fund, caught like a fly nipped out of the air by a spider.

With all the arrangements in place, Hunt was ready to present his plan to Annie. He had not yet asked her if she wanted to be turned into a lady. One evening he sat her down and told her what he had in mind, skipping one significant item — marriage. If the plan flopped, he wanted to be able to unload Annie as a bad investment.

As he talked, Annie seemed nonplused. Caught short, because he had assumed she would feel honored by the trouble he had taken, he tried to make the proposed course of study sound fun and amusing, adding mentions of new dresses and a dressmaker to pique her interest. She just sat, silent and awkward. Finally she said goodnight and fled.

The next morning she failed to turn up at the studio. Hunt found this lapse annoying, because they had been hard at work on *The Awakening Conscience*. But a few days later Annie appeared out of the blue. Softened by her absence, Hunt listened thoughtfully to her apprehensions and uncertainties. He was afraid of losing her, and so he hinted that he dreamed of being able to marry her one day. She said she had been thinking and saw some merit to his plan.

꧁⌘꧂

At first Mrs. Bramah's house made Annie uncomfortable. The maidservant who answered the door looked her up and down, and the elegant silks and china in the drawing room did nothing to reassure her. She was worried that she might break one of the eggshell-thin cups and cause a scene. Mrs. Bramah spotted her nervousness, and taking it as an indication of the girl's character, set herself the task of putting this guest at ease. The two women liked each other, and before long, lessons were going forward steadily.

As Hunt got deeper and deeper into his vision of a transformation, he plied Mrs. Bramah with directives for refining Annie's appearance

and demeanor. He dashed off notes: her wild mane must be tamed, her laughter must be quieted, she must use a handkerchief instead of her sleeve to blow her nose, she must begin wearing underclothes, she must change them every day. At the same time he was pressing forward with preparations for his trip to the East.

This was a journey into uncharted territory: He was in love with the idea of visiting places where no Englishman had ventured before. His friends trembled at the risks he would be taking; Coventry Patmore offered to lend him a gun. Edward Lear, though, who had been to the East and was about to travel up the Nile in search of scenes to paint, scoffed at such measures. Hunt wrote that Lear "laughs at pistols, thinking poodles about as useful, and oysters much more so."[9] In fact Hunt had already bought a gun, which probably saved his life when he got caught in the crossfire between two feuding tribes in the desert of Palestine.

Millais hated the thought that his closest confidant would be thousands of miles away, in places where mail would take weeks rather than days to arrive, if it reached the desert at all. Once Hunt's friends had resigned themselves to the fact that he was determined to go, however, they gave him gifts to commemorate the occasion. Rossetti gave him a daguerreotype of *The Girlhood of Mary Virgin* inscribed with a poem he had written on the eternal nature of friendship; Hunt kept this memento on his desk for the rest of his life. Millais wrote from Glenfinlas in Scotland, instructing him to go to a posh jeweler in New Bond Street to buy himself a signet ring "which you must always wear" and have his initials engraved on it. Hunt designed a ring that had the initials H and M ingeniously intertwined so that when the ring was turned upside down the letters read PB, for Pre-Raphaelite Brotherhood, and he wore this ring until he died.

Although he was enormously excited about the trip, Hunt was reluctant to leave Annie, so he delayed his departure for months. In the interim he did a curious thing. Ostensibly to protect Annie, who was only eighteen, he furnished Fred Stephens with a list of artists for whom she could sit while he was away: only Millais, Michael Halliday, Egg, Boyce, and Stephens himself. These men were trusted friends. He told Fred that he feared other artists might prey on her, turning her into the slattern that most people believed an artist's model was anyway. He did not have faith in all his friends, however; Gabriel's name is conspicuously absent from the roll. Hunt may have believed that he loved Annie, but clearly he did not trust her to keep

faith with him while he was away. Perhaps even at this early date, he knew he was fooling himself about the relationship, even though he was ready to go to great lengths to protect his illusion.

The gloomy darkness of the English winter conspired to delay him still further, but on January 16, 1854, he wrote: "I was waiting for one bright day to finish *The Awakening Conscience*. . . . and by four o'clock I had accomplished all." This was the pattern of all Hunt's journeys: a tremendously long preparation marked by endless fussing and delays, then a sudden bolt for freedom. "I took a cab and made a round of calls on my friends to say good-bye. . . . John [Millais] came back with me and helped me to pack." Another cab made the dash to Victoria Station. "I had not had time to dine, and Millais rushed to the buffet and seized any likely food he could, tossing it after me into the moving carriage. What a leave-taking it was with him in my heart when the train started! Did other men have such a sacred friendship as that we had formed?"[10]

In Cairo Hunt met his traveling companion, the painter Thomas Seddon, who had gone on ahead. The extraordinary quality of the light, the heat beating down on his head, the strange smells floating up from the bazaar, the jugglers performing in the street, and the buffalo with its calf tethered in front of the hotel — all of Cairo thrilled Hunt. Just standing in his hotel room he felt that "it was impossible to turn one's eyes from the open window, where each minute brought forward a new scene, each scene being one of the perennial dramas of the East, heard of, imagined often, but hitherto cut off from me by the intervening leagues of sea. . . . It was to me the slaking of a long thirst."[11]

He believed himself to be on the verge of the great adventure of his life, but almost immediately his hopes were dashed. No one would model for him. He ran headlong into the Muslim belief that any man who allows another to make an image of him is profaning what God has made. Hunt could not understand how profoundly sacred a belief this was; he dismissed it as so much bosh. Nor would he credit the Muslim fear that if you had your picture painted, your image might arrive first at the gates of heaven and steal your berth. He enlisted the help of the local British, to no avail. He sent his servant to canvass the city, but the man failed to turn up anyone. Finally at his wits' end as to how to please this foreign devil, the servant hit on the idea of taking Hunt to a house of prostitution, where the women could

at least be persuaded to draw back their veils so Hunt could see their faces.

Several women filed shyly into the room, accompanied by a chaperone. Hunt used his twenty words of Arabic with "a great deal of impatience" because "I could not afford much ceremony." (More likely he was simply uncomfortable at finding himself in such a circumstance.) He proceeded to lift several veils, only to find physical imperfections — no front teeth, scars on the cheek — which he regarded as so many personal insults. He prepared to march out the door: "I told my man to express my regret that heaven had not bestowed on me enough talent to do justice to that order of beauty, and I took my departure by shying a gold piece as *backshish* to the old woman, while I took one by the neck with my left and gently hurled her on to the floor for having attempted to intercept my passage to the door, with my right I pushed the other *houris* against the wall; a fight with a man or two in going downstairs, and an encounter with several dogs in the yard, and I found myself in the street with my man behind me in a state of utter bewilderment at the turn affairs had taken."[12] Hunt found himself plunged into a world far stranger and more violent than the one he had known at home, and he relished it. These people were not real to him. He could abuse them at will in a way he would never have permitted himself in England, seizing the opportunity to discharge some of the aggression that he ordinarily repressed.

Hunt passed the time painting watercolors of the landscape, trying to catch the light. Eventually, near the pyramids, he found a young girl who agreed to model. He camped out with Seddon in one of the tombs while he painted her. To make himself look less like a little boy with a turned-up nose, he grew a full beard, which, he reported to Millais, came in "between cadmium and venetian red."

After a few months Hunt and Seddon decided to move on to Jerusalem, where they planned to settle for some years. The travelers had begun to get on each other's nerves, but the first glimpse of Jerusalem healed the breach. As they reached the crest of a ridge, they reined in their horses and looked down upon the city spread out like "some beautiful queen mute and dead, but with eyes open and staring to the heavens, as though not even yet to be at peace." Hunt turned to speak to Seddon and saw him "now leaning forward with clenched hands upon the pommel of his saddle, swaying his shoulders to and fro, while copious tears trickled down his cheeks."[13]

Once he had rented a house, Hunt plunged into a study of ancient

Jewish traditions and ceremonies and pored over descriptions of the Temple as it had looked in the time of Christ. He had set his heart on painting the moment when Joseph and Mary find their lost twelve-year-old preaching to the elders. After the canvas had been stretched and the background of the Temple was well under way, however, he hit the same stumbling block he had encountered in Egypt. The Jews of Jerusalem were as adamant in their refusal to model as the Muslims of Cairo had been. Because they believed that Hunt was spreading Christian propaganda, the rabbis had forbidden their congregations to sit.

In despair, Hunt admitted to himself that his *Finding of the Saviour in the Temple* would never be ready for the Royal Academy Exhibition of 1855, and he put it aside. Instead, he decided to paint a picture with one animal and no people in it: the story of the scapegoat wandering in the desert, taken from Leviticus. His interpretation of the Bible told him that the goat had been cast out by the shore of the Dead Sea near Oosdoom, which he believed was the site of ancient Sodom.

He pinpointed this spot on the map and made plans to go there to paint the background for his picture, in keeping with the Pre-Raphaelite credo of verisimilitude. Cooler heads around Jerusalem, including the British consul, tried to dissuade him from the journey, warning him that the danger from attack by feuding Bedouin tribes was at an all-time high. Nevertheless, he set out with a company of reluctant porters and enough food for several weeks in the desert.

After a series of close calls the party reached the Dead Sea and pitched camp. Their nearest brush with eternity occurred one afternoon while Hunt was seated at his easel by the seashore, porcelain palette in hand. His servant, Soleiman, ran down the hill from camp to tell him that a notorious band of robbers had been sighted in the distance but there was still plenty of time to hide. Characteristically, Hunt refused. He was unwilling to lose a minute from painting, and after much expostulation Soleiman left him to his fate.

Despite his bravado, Hunt was scared, but he kept right on working. A terrifying-looking bunch rode into view: "The horsemen had their faces covered with black *kufeyiahs,* and carried long spears, while the footmen carried guns, swords, and clubs." Hunt decided to bluff. "I continued placidly conveying my paint from palette to canvas, steadying my touch by resting the hand on my double-barreled gun. I knew that my whole chance depended upon the exhibition of

utter unconcern, and I continued as steadily as if in my studio at home."

The leader began to feel humiliated and thundered out a demand for water. Hunt kept painting. The man repeated his demand in a loud, angry voice. Hunt replied quietly, in Arabic, "I am an Englishman; you are an Arab. Englishmen are not the servants of Arabs; I am employing Arabs for servants. You are thirsty — it is hot — the water is there — I will out of kindness let you have some."[14] Quizzical, the leader began to ask Hunt questions about what he was up to, daubing color onto a white square in the hot sun. After a lengthy colloquy, the robbers rode off, apparently unable to make up their minds whether to kill Hunt or to serve him.

Hunt's courage in the face of such threats was great, but the rigors of the trip began to wear down his nerves. He maintained that a man "who has not sojourned in a tent" has not "thoroughly lived," but, growing lonely, he had a vivid dream of home: "I was with the real working Brotherhood, and as I asked for unseen ones they appeared. I had much to tell and not less to hear; many there were whom I took by the hand and grasped familiarly by the shoulder. It was satisfaction almost to pain."[15] As soon as the background of the scapegoat picture was sufficiently advanced, Hunt started for Jerusalem, and he wrote endless letters home to England in tiny script on large, lightweight sheets of paper.

His friends replied promptly, knowing how isolated he felt, and missing him themselves. They sent him newspaper clippings of the reviews of his works on view at the Royal Academy. He read them avidly and was as usual infuriated by the stupidity of the critics, who generally agreed with the *Athenaeum*'s man that *The Awakening Conscience* was "drawn from a very dark and repulsive side of modern domestic life," best left unpainted and unthought of. To Hunt's amazement, most ordinary viewers had no idea of what the picture was about; many came to the conclusion that they were looking at a brother and sister who had just had an argument, and completely missed the implications of the fat, sleek cat who has brought in a freshly killed bird from the garden, the mass of unraveled yarn on the floor, the rings on every finger except the young woman's wedding-ring finger. Such failure of interpretation is surprising, for Victorians were adept at decoding symbols. They loved narrative painting, and the Royal Academy was rife with story pictures every spring. It is a testament to the powers of repression that Hunt's

audience managed to rationalize away this scene; the path down which these clues led was just too disturbing.

Hunt was pleased when Ruskin came to his defense in a letter to the *Times*. Ruskin wrote that he was moved by the girl's face, "rent from its beauty into sudden horror," and that he did not see how the story "could be rendered more distinctly." For him the "fatal newness" of the furniture, so "common, modern, vulgar" and "so carefully painted even to the last vein of the rosewood," reinforced the story line. Such objects have no history, so they could never turn one toward "the old thoughts of home."

Hunt was able to follow the aesthetic and critical fortunes of his paintings through the mails, but he did not find out that by exhibiting his picture of Annie he had torn a hole in his private life. The art gossips, the fashionables who dabbled in the art world, and even some of his friends were buzzing, speculating about the story behind *The Awakening Conscience*. Unlike the naive viewers who stumbled into the Academy, these sophisticated types understood the significance of the absent wedding ring and were titillated by the big red cashmere shawl wrapped around Annie's hips and knotted boldly in the front. They wanted to know more about the relationship of artist and model: Were they lovers or not?

Those who could offer scraps of information about the luscious Miss Miller made capital out of them. Each year there was an informal competition for the "belle of the line," the most beautiful face displayed at the exhibition, and this year Annie won hands down. Hunt had made the mistake of portraying her as both beautiful and fallen — and therefore fair game. And Annie, who had not been raised under the constraints of the middle class, saw no reason not to enjoy herself.

In her world, selling sex was a mundane fact of life for many women and girls. Child prostitution was a booming industry; virgins were particularly prized by gentlemen as "green fruit," and some parents, made heartless by desperation, sold their daughters' maidenheads for as little as five pounds or as much as twenty pounds — more money than some working-class people made in a year. (To salve everyone's conscience, the child was sometimes given chloroform during the defloration.) Officialdom turned a blind eye to this practice: The legal age of consent was raised from twelve to thirteen in 1875.

In June 1848 an article in the *Times* speculated that although a few

girls leaving the workhouse went happily to domestic service, roughly 90 percent took to the streets. It was a question of economic necessity. A woman in a factory might earn as little as two shillings a week; even the lowest rank of prostitutes, the women who haunted the parks and the docks, could earn two shillings in twenty minutes. But a prostitute often paid a horrifying price in disease and death. If syphilis didn't kill her, she might well suffer mutilation and death at the hands of a casual sadist. Such deaths went largely uninvestigated unless they caught the popular imagination, as the victims of Jack the Ripper did. Faced with such prospects, earning money by sitting on the lap of a fastidious young gentleman while wearing a warm, soft gown and singing sentimental songs sounded to Annie like a lovely way to pass a pleasant afternoon.

That summer everyone wanted to spend time with Annie, and she bloomed under this attention. Boating became a favorite excuse for taking her out in the evening. William Rossetti called, and Annie was happy to walk down to the river with him. He rented a boat for a few pence and rowed her about as they watched the sun cast orange and purple gleams on the new Gothic-style Houses of Parliament. Afterward he bought her an ice and then went home, explaining the evening to himself as a bit of innocent and healthy exercise. George Boyce was crazy about her and took her out every chance he could. Stephens too took her rowing, but he capsized the boat, his clumsiness born perhaps of guilt.

Gabriel Rossetti couldn't stay away from her. He asked her to model immediately, and Annie agreed. She found him a refreshing change from Hunt — his easy, open manner, his heavy-lidded, seductive gaze, and his evident delight in flirtation made him a lot more fun to be around. Nor did he keep her locked up in the studio. He was eager to take her dancing, and they went regularly to Cremorne and other pleasure grounds.

When Stephens caught wind of this development he went into high gear. Bringing another of Hunt's close friends, the painter Mike Halliday, along as a chaperon, he took Annie out for a row. Once on the river he questioned her, asking if "any of our people had given her cause for complaint." She answered that she found Hunt's friends a "curious lot" but by no means uncivil, except for one fellow who had been rude to her. Annie was not stupid; when pressed for names, she refused. She did admit that she had been sitting for Gabriel, who she knew was not on the approved list, and Stephens averred stoutly

in his report to Hunt that "I administered a lecture to her." He also reported that she was about to sit for Augustus Egg (on the list) and that he still believed her to be a "good girl."[16]

A few days later Stephens saw Gabriel and "informed him of the position in which [Hunt] regarded [himself] concerning her danger." He assured Hunt that he had put the case "pretty forcibly" and felt that the problem had now been corrected.[17] He was wrong. Annie and Gabriel went on enjoying each other's company. Where Hunt held back, Gabriel pressed his advantage, and soon he and Annie were lovers. If Stephens heard rumors, he stopped his ears.

In fact, Gabriel was far from Hunt's most dangerous rival. Annie met a notorious and thoroughly charming rake, the seventh Viscount Ranelagh, a man who lived and loved more in the style of the Prince Regent than of Victoria. Possessed of plenty of money and no scruples whatsoever, he took her to chic places like Bertolini's, a restaurant where he was seen drinking champagne out of her slipper. This was the sort of man who had dominated Annie's wildest fantasies when she was little — not a prince, but a titled gent who scooped up the poor little girl dressed in rags and carried her off to a dreamland where there was always plenty to eat, beautiful dresses to wear, and enough coal to put on the fire. Annie became Ranelagh's mistress at the first opportunity, and her neighbors were duly impressed when his carriage, complete with footman and coat of arms, arrived to pick her up or drop her off.

Hunt heard not a word of these carryings-on. He was busy painting a goat, and Stephens assured him that Annie was pegging away at her ABCs. In one letter Stephens described this scene to Hunt: "I have a visitor this evening who sits opposite turning over *Pendennis* with a quaint turn of the head . . . I have just said, 'Now, Annie Miller, I am going to say something about you'. . . . She seems rather more lively than usual tonight and I am about to make her put in this letter a few words about herself. She is I believe a good little goose enough, has been sitting to Egg lately and looks very well having very much reformed her hair-dressing. . . . she hopes you are quite well and begs to be most kindly remembered."[18]

Annie was clearly mastering the forms expected of a lady. Stephen's remark that she was "rather more lively than usual" suggests that she curbed her high spirits around him, exerting the kind of ladylike self-control she observed in Mrs. Bramah and knew Stephens wished to observe in her. Her intuitive social skills enabled her to tailor her

behavior to fit different people and situations. Hunt and Stephens may have imagined that they had their prize snuggled in the palm of their hand, but they sorely underestimated her: Annie had potential as an actress.

In spite of her busy social life, Annie labored over her reading and writing with Sarah Bradshaw, and she looked forward to visiting Mrs. Bramah. After a while she confessed shyly to her protectress that although Hunt had not yet proposed, his intentions were matrimonial. She had earned Mrs. Bramah's confidence and affection, and the older woman did her best to prepare Annie for this marriage. She arranged for her hairdresser to come to the house once a month to wash, cut, and singe Annie's hair, but the wild mane resisted every effort to tame it. The hairpins sprang out, causing the three of them to laugh and agree that for formal parties, at which Annie had to look dignified, she would have to lash it down with a hairnet.

In Jerusalem, Hunt was putting in long hours in a desperate attempt to finish the godforsaken goat so that he could go home. By now the rabbis had realized that he had no proselytizing intentions and had relented; they themselves were even coming to his studio to model, so that the Temple picture was finally creeping forward. But Hunt was so homesick he didn't care; he convinced himself that he could finish this picture in London with Semitic models he could recruit there. Twenty-eight years old, he was worn out by the long years of chastity, and he yearned for marriage and hearth and England and children. The minute the canvas of *The Scapegoat* was dry he crated it up, drove it on muleback to the port at Jaffa, and shipped it to Thomas Combe at Oxford for safekeeping. Then, throwing caution to the winds, he took up pen and ink and wrote Annie a proposal of marriage.

But he did not go straight home. He was still afraid of the marriage he longed for, and besides, he wanted to see more of the world before he was tied down by domestic responsibility. He trekked through bitter cold into the mountains to see the cedars of Lebanon. One night as he slept under the stars, he was roused from sleep by a weird animal noise; before he was fully awake, he grabbed the loaded rifle with which he slept and shot a hyena, just as it was about to bite down on his companion's head. He helped to quell a mutiny aboard the steamer carrying him from Beirut to Constantinople, and he found

time to gather oleander seeds for Millais's mother to plant around her cottage at Kingston. He traveled as far east as the Crimea; even though he recognized the political and human folly of Britain's engagement there, he felt that an artist needed to see a war — a man needed to test his courage. A shell exploded right next to him on the battlefield, but he managed to remain calm and in control as his horse reared and danced in the air.

As his train finally pulled into Victoria Station on an icy day early in 1856, Hunt worried that his friends had forgotten about him in the two years he had been away. At three o'clock in the morning, he finally reached Millais's studio, cold, grimy, and worn out with traveling. He knocked, and the door was opened by the painter Lowes Dickinson, who hugged him fiercely. Everyone was relieved and happy that he had made it home safely.

He went around to see Annie straightaway, and was pleased to discover the progress she had made with her studies. She was reading and could write short, clear letters and do simple arithmetic. Her grooming had improved enormously: Her hair was shiny and neatly dressed; her hands and face were clean. His plan seemed successful — she looked like a lady.

Today Hunt's arrogant effort to transform his love seems peculiar — and suspect — but within his circle of friends it was not considered unusual; at least four other men embarked on similar projects. Gabriel's was perhaps the least suspicious — he tried to teach Lizzie what he knew about painting and literature, and he respected her gifts as equal to his own. In contrast, Ford Madox Brown, Gabriel's mentor, fell in love with Emma Hill when she was in her teens and arranged for her to be tutored in secret in a cottage at Highgate before he would live with her. Frederic Shields, another painter on the fringes of the Pre-Raphaelite circle, instructed a lively little girl from a poor family throughout her childhood and married her when she was sixteen and he was forty; but the marriage soon foundered, and he shipped her off to Winnington Hall, a select boarding school for young ladies. Eventually Stephens imitated Hunt by secretly educating Clara Charles, a widow, whom he introduced to his family and friends only after he had married her.

It was a roundabout and painstaking way of securing a wife. Why did it appeal to these men? They were all struggling to move up from the lower reaches of the middle class, and they needed wives who would fit into a more refined society. Even if they did begin to make

money, as Hunt did, they lacked the social confidence to approach the formidable young ladies of the upper middle class. Instead, they were comfortable with working-class women, who would be grateful for their patronage and, because of poverty, far easier to control. And working-class women were more relaxed, and often just more fun, than their bourgeois counterparts. They had not been straitjacketed by a thousand proprieties, fears, and reticences.

By educating a prospective bride, an artist was attempting to create a better companion for himself and to make it possible for the young woman to feel comfortable in a middle-class setting. While such a plan of education appeared to solve a number of problems, it created many others. In hindsight it appears that these marriages were rarely happy over the long term, but Hunt still believed that he could play God and bring Annie to life as his own Galatea. What he failed to take into account was the fact that she was already wildly alive.

Soon after Hunt returned from the East in 1856, he rented a house in Claverton Street, Pimlico, not far from where Annie lived, and set up housekeeping with a couple of friends. Utterly infatuated with Annie, he spent every possible free moment basking in her company.

For her part, Annie was eagerly looking forward to getting married. She had worked hard to do as Hunt wished, struggling with her studies even when they seemed dull. His letter of proposal was tucked away in a safe place. For months she waited for him to speak, but eventually, unable to understand his silence, she brought up the subject herself. When she asked him to set a date, he explained that he had to sell some of the work he had brought back from the East before he could think of taking a wife. She pressed him, saying she didn't need a rich husband and would rather marry right away. Feeling trapped, Hunt turned the tables on her. Claiming that she hadn't made sufficient progress in her studies to make a proper wife, he admonished her to redouble her efforts. Annie, abashed and hurt, didn't know what to say.

Hunt did undertake to straighten out his affairs. The first order of business was selling *The Scapegoat,* the only good-sized oil picture he had to show for all his labors in the East. Many of those who saw it found it weird and incomprehensible. Hunt wasn't too worried; in his mind, he had always reserved the picture for Ernest Gambart, a highly cultured art dealer who had immigrated to England from

France and revolutionized the London art market in thirty years' time. Hunt delighted in matching wits with Gambart: In him he saw an adversary as wily and determined as himself.

Hunt made an appointment with Gambart for the hour most perfectly suited to show off the picture, and he positioned the easel in his studio so that the light fell to greatest advantage. But when the dealer saw the painting, he was at a loss to identify the subject. Hunt explained that it was an episode from the Bible, teasing Gambart by saying, "Ah, I forgot, the book is not known in France, but English people read it more or less, and they would all understand the story of the beast being driven into the wilderness."

Gambart begged to differ, and suggested they invite his English wife and her companion to test the case. When the ladies were ushered in, they did their best to be polite, murmuring, "Oh yes, it is a peculiar goat, you can see by the ears, they droop so."[19] Vanquished, Hunt had to admit that Gambart was right: The goat was unrecognizable. He began to fear that his trip to the East had been a horrible mistake.*

He decided that he had to do something to gain back the respect and attention of his audience, and so he put himself up for election to the Royal Academy. Election would assure a steady supply of patrons, along with a measure of instant fame. Millais had been elected three years earlier, and had not broken under the artistic yoke.

Unfortunately, Hunt was rejected. He was staggered. He tried to rationalize his defeat as proof that the art establishment had been threatened by his brilliance, but the immensely successful Royal Academician William Powell Frith let him know that he had received only one of the forty votes cast. Hunt's pride never recovered. He reacted dramatically: "My position now was like that of a huntsman pursued by wolves, having to throw away his belongings one by one to enable him to keep ahead of destruction."[20]

To pay his bills, he began to crank out safe, easy pictures that could be completed and sold fast. While he stood at his easel, frustrated and angry, he would look over and see the unfinished *Finding of the Saviour in the Temple* turned to the wall, a silent reproach.

Gossip about Annie's evening activities began to drift back to him. At first he brushed it off, but as the reports mounted he became upset. Finally, one Sunday afternoon in July, Hunt decided to go across

*Not everyone was as disparaging of *The Scapegoat* as Gambart, and ultimately the picture received a good share of praise from the critics. At the Royal Academy Exhibition of 1856 it was hung on the line, and later in the year Hunt sold it for his full asking price of 450 guineas.

town to visit Brown. Apparently he was nearly delirious; according to Brown, he ranted on about "Annie Miller's love for him and his liking for her, and perplexities, and how Gabriel like a mad man increased them, taking Annie to all sorts of places of amusement which he had implied if not stated should not be . . . and having allowed her to sit to Gabriel while he was away, Gabriel has let her sit to others not in the list and taken her to dine at Bertolini's and to Cremorne where she danced with Boyce, and William takes her out boating forgetful it seems of Miss R., as Gabriel, sad dog, is of Guggum. They all seem mad about Annie Miller, and poor Hunt has had a fever about it."[21]

Hunt was rewriting history to salve his pride — magically he added Rossetti to the approved list — but he needed to believe that Annie was still innocent; later revelations about her sexual activities positively unhinged him. There is no question that Annie was culpable; she had betrayed Hunt's trust while he was away. But he had been unfair to her too, in his more byzantine fashion, and his expectation that she would wait patiently for him an unspecified number of years was hardly realistic.[*]

Millais also visited Brown's studio to talk. He had been crowing to Hunt about the pleasures of his own new marriage. To Brown he now held forth on "the disgustingness of stale virginities etc in allusion to Hunt." He said he supposed the reason for Hunt's continuing virtuousness was that before doing anything whatever, "he always held a sort of little council with himself in accordance with which he acted."[22] Millais's estimate was perceptive. Hunt's life was a series of such little councils, by means of which he maintained iron control over his appetites.

Time went by, and Hunt's little councils told him that he still could not marry. He heard more stories about a liaison between Gabriel and Annie, and he finally confronted them both. They denied that anything had passed between them but promised to stop seeing each other, and Hunt was apparently mollified.

To hedge his bets, however, he began to spend more weekends visiting Thomas and Martha Combe in Oxford. They had taken him under their wing after Millais had first brought him up to visit, and they had long provided him with the sort of loving, accepting family

[*]It would be enormously helpful if we had evidence of what Annie felt about her own actions. Hunt destroyed all the letters she wrote to him, and because so many men had a vested interest in writing her out of their personal histories, little is known of her from their point of view.

he yearned for. Knowing he regularly worked himself into exhaustion, they asked him up to recuperate, and Mrs. Pat, as Martha was known, enjoyed spoiling him by cooking his favorite dishes and urging him to sleep in. Thomas invested Hunt's earnings for him, and over the years laid the solid foundation of a fortune for him.

Mrs. Pat decided that what the young artist needed was an affectionate, sensible wife who would bring balance to his life. (Naturally he never mentioned Annie to her.) With Hunt's encouragement, she sorted through the local girls, looking for a suitable mate. Hunt then whiled away his weekends checking out the prospects and squiring them around town. He enjoyed their dainty ways and their accomplishments — the piano playing, the singing, the delicate watercolors. But the constraints of dealing with ladies irked him. Physical beauty was so important to him that he could barely observe the civilities with a girl he judged homely, since he feared that any attention would somehow obligate him. In a letter to Stephens, he included a cruel sketch of one plain young woman unlucky enough to have been paired with him and moaned: "Tell me if you ever in all your life (and you have had your trials I know) had to walk out with such an odious creature."[23] But even when he found a "stunner" with whom he fell in love at first sight, his thoughts invariably returned to Annie.

What drew him back every time was her delicious sensuality. That animal vitality in her which frightened him held him in thrall too. He would get furious at her for some delinquency or other, and a week later he would be back on her doorstep, asking if she was free to take a walk by the river. These sudden, sharp swings — the classic dance of approach and avoidance — were characteristic of their relationship.

Early in 1857 Annie again raised the question of marriage. More than a year had passed since she had received Hunt's letter of proposal, and she asked him to set a date for their wedding. He countered with another delaying tactic. In order to put a little more finish on his rough diamond, he said he would pay to send her to a school where she would associate with the right sort of young ladies and attend lectures and museums; *then* he would marry her. Annie stood firm. She was sick of struggling to make herself over to please him. After all, hadn't he proposed to her already? Presumably she had been sufficiently pleasing to him then. He countered that she was still an ill-mannered little girl who had a lot to learn. He gave her an ultimatum: She had one week in which to accept his offer; he was going

to the country to paint, and she could let the hapless Stephens know what she had decided.

Hunt affected bravado, but once in the country he had time to brood. When he didn't hear from Stephens, he wrote: "I am anxious to hear whether the young lady came yesterday, and if so, what her determination is. She must indeed be most uncomplimentarily indifferent about a certain individual's interest, or must be a heroine in self-denial in stopping away from him — more so than the hero if his present wish were weighed — conceived at the side of a melancholy grate in a room in whose dismal solitude there is no thought of life but in a flat whispering from a back room." Then, as if to deny the vulnerability he had just revealed, he added, "To be at all anxious about her decision is very stupid — whether 'yes' or 'no' I am convinced that it will be fruitless to persevere, but I will go on for seven years against all conviction rather than be the first to give up the attempt — which might have such a happy issue if she would determine to give up a wretched false pride and a fatal indolence."[24]

Why Hunt remained in love with a woman whom he perceived to have such disastrous shortcomings is truly a mystery. Over the years he often spoke of her in unflattering terms, and yet she maintained her hold over him. There is little evidence of any real companionship between them. One is forced to the conclusion that he fell in love with her body and her face, just as most men did, and that this physical attraction outweighed the fact that she failed him by his own ethical and spiritual standards. What is truly fascinating is Hunt's blindness to the implications of the attraction. He wanted her body, but clothed his desire in an elaborate structure of moral validation, delaying his gratification while reviling her for seeking her own.

Stephens responded to Hunt's letter with a masterpiece of self-righteousness: "Miss A.M. came to me on Sunday and I represented the case to her: of course only as relative to her own worldly advantage, not being at liberty to enlarge upon your feeling in the matter. I represented you as a most anxious and sincere friend who was desirous of benefiting her so that she might be able to obtain a happier position from her exertions." Annie's reaction shocked Stephens: "All this she treated as a thing which was of no importance, and of little interest to either you or myself."

As he had reached a stalemate, he offered Annie a cup of tea, for lack of anything better to do. This move was reported to Hunt as a bit of strategy: "Knowing the beneficial effect a cup of tea has upon

the female mind, I got her to stop for this, and afterwards renewed the attack." Worn down, Annie finally consented to think over the finishing-school plan once more. Stephens assured Hunt that he had been a model of tact — "If she had been my own sister, I should not have been half so delicate with her" — then concluded by flattering Hunt and lambasting Annie: "Her feelings are so shallow that she will never feel deeply enough to be worthy of the position in which you wish to place her."[25]

"I wonder what particular sin of mine it was that brought me into contact with such a girl," Hunt mourned in reply. A recent exchange with Annie had made him furious. When he had been so kind as to offer her "about five minutes" of assurance of his "unlimited — unended interest in her good," she had reacted by bursting out, "I wish I were dead!" To him this exclamation was proof that "she must either have life without the control of one vanity, or would not have it at all."[26] Probably she had simply reached the end of her patience.

When Hunt called on her the following Sunday to discuss the matter, she was not home, but he spoke with her aunt, who told him that Annie was prepared to follow whatever course Hunt recommended. Why was Annie still trying to please? The likely answer — perhaps a cynical one, but probably inevitable — is that Hunt was a meal ticket. He had made a more comfortable way of life available to her, and he held out a vision of a future that was glamorous and romantic. As the wife of a renowned painter she would accompany her husband into the most elegant circles of society. She would command a large, opulent establishment and have a staff of servants, accounts at the finest stores, a dressmaker to run up evening gowns, and a nanny to care for her children. Hunt offered her the twin benefits of affluence and respectability. As a girl her dreams had revolved around affluence alone; respectability and the security that came with it seemed hopelessly out of her reach. It's hard to imagine that Annie was marrying Hunt for love; she had been deceiving him for years, and he had been making himself unlovable for too long.

At any rate, she agreed to attend a finishing school if she could be admitted as a day pupil. Her refusal to go as a boarder argues that she was unwilling to have her freedom completely curtailed and wanted to keep her nights free. She was probably still seeing Gabriel, and she may have been seeing Lord Ranelagh as well. At some point she and her viscount drifted apart, but they remained on friendly terms.

Hunt's father had died during the previous year, and on his deathbed he had exacted a promise that Hunt would provide a home for his sister Emily and teach her how to paint. Hunt began the search for a house large enough for himself and Emily as well as his housemates. By April 1857 he had moved them all into Tor Villa, a fourteen-room house in Campden Hill, a desirable quarter of Kensington, and he was struggling to turn out enough potboilers to keep up with his increased expenses. This house satisfied his hankering to live among the fashionables. (As soon as he could afford it, Hunt had his suits made in Savile Row.)

Annie was attending the ladies' academy, and Hunt began to contemplate marriage again. In one of the surprising turnabouts that marked their relationship, tensions eased, and this summer was a happy one for them. He decided to set her up in respectable lodgings so that she could be presented to his family as if she had been born a lady. (He also needed to paper over the fact that he had been paying her bills for years.) Stephens went out scouting for a room, and found one in a pleasant boarding house in Bridge Row in Pimlico, run by a Mrs. Stratford. Hunt never explained to Annie why he moved her to Bridge Row — keeping her in suspense about his intentions allowed him to retain the upper hand — and Annie feared that this nice room was some sort of generous farewell gesture.

In January 1858 Hunt suddenly decided he couldn't wait any longer and had to marry immediately — but not until he had made one last foray in his campaign to rehabilitate Annie. On the evening of January 21 he called on George Boyce, who was so stunned by what transpired that he wrote it all down in his diary later that night. Hunt announced his intention to marry Annie, but said that before he did he felt it incumbent upon himself "to destroy as far as was possible all traces of her former occupations,"[27] by which he meant destroying any artworks for which she had modeled. It is hard to understand how the same man who willingly risked his life in the desert to defend a painting could be so dreadfully nervous about what other people might think of a model that he would deliberately destroy the work of other painters. Boyce found it particularly surprising since all of the artists in question were personal friends of Hunt's. Hunt asked Boyce to give him a drawing of Annie that Boyce had done, a study of her head that was readily recognizable. In return, Hunt offered to give him any equivalent work of his own that Boyce fancied. At first Boyce resisted stoutly, but when he realized that his refusal was truly an obstacle to the marriage, he gave way, feeling

that it would be selfish to thwart Annie's prospects and Hunt's happiness.

In spite of this success, Hunt soon grew skittish again, and by the end of the month Ford Madox Brown was writing in his diary: "Hunt who was all hot about Annie M. has somehow quite cooled again in a few days and says now that it is never to be."[28] Astute about sex, Brown knew that this marriage was about lust rather than love. The pattern was repeated again and again: Hunt would edge up to marriage, tantalize himself with the possibility that the long spell of chastity might soon be broken, and then shy away. Millais, whose great delight in the early days of his marriage grew out of his discovery that sex meant pleasure and fun and passion rather than shame and degradation, wrote to Hunt, urging him to marry. But Hunt was not to be persuaded. He imagined that sex would distract him from painting, the most sacred act a man could perform, by his lights.

Not surprisingly, Hunt's ardor returned, suddenly and inexplicably, a couple of months later. He began dropping hints to friends and family that he would soon marry a beautiful but as yet unnamed lady. Then an embarrassing snag developed. Every month Stephens gave Annie a sum of money to pay for her room and board and lessons, but for a good while she had been spending it on other things, mostly clothes, and running up an account with her landlady, Mrs. Stratford. Mrs. Stratford eventually lost patience and marched over to the police station in Rochester Row to register a complaint about her wayward tenant.

This set off a chain reaction. A constable paid a call on Annie, who told him that Stephens paid her bills; the officer went round to confront Stephens, who fired off a note to Hunt, warning him that the police were about to call on him. In the meantime the officious Mrs. Stratford paid a call on Mrs. Bradshaw, Hunt's former landlady, who had recommended Annie to her as a lodger. Mrs. Bradshaw urged Mrs. Stratford to call on Mrs. Bramah, which she did posthaste; Mrs. Bramah was shocked to learn that Annie was not the quiet, sweet girl she had thought her to be. Mrs. Bramah ordered her carriage and drove round to see her nephew, Hunt's friend, who had recommended Annie to *her*. The nephew, who was Mrs. Bramah's heir, rushed off to collar Stephens, and the two of them paid a call on Mrs. Bramah so that Stephens could pour oil on troubled waters.

A lengthy discussion of Mrs. Stratford's dire revelations ensued. Mrs. Bramah admitted that she had steeled herself to ask Mrs. Strat-

ford *the question:* Was Annie sexually active? Mrs. Stratford had "replied satisfactorily" — that is, she had said no. Annie's dreadful behavior apparently consisted of neglecting her lessons in favor of going out in the evenings with men to places a lady should not frequent, and wearing flashy, expensive clothes. This may not sound like much as revelations go, but in fact it amounted to a social earthquake. Nice young ladies were never seen with men in unchaperoned situations. (As late as 1905, Vanessa Bell, Virginia Woolf's sister, endangered her reputation by taking tea with a gentleman alone in his rooms in the middle of the afternoon.) Even more shocking was the information that Mrs. Stratford thought that Annie was posing as an artist's model — without Hunt's knowledge.

A truly protean creature, Annie had been smart enough to spend afternoons with Mrs. Bramah every week for five years without ever mentioning that modeling was an important source of income for her. Like Moll Flanders, she was a sturdy, self-preserving, pleasure-loving woman who looked the world in the eye and could spit at it when necessary. But she also learned to negotiate in situations where Moll would have come a cropper. She must have been irresistible. Everyone — except Hunt and Stephens — liked her and wanted her to succeed. Mrs. Bramah certainly felt this way, and welcomed Annie into her home even after these unsettling revelations.

Hunt, however, decided to take steps to curb Annie's behavior. Miss Prout, her tutor, was ordered to monitor her mail and turn over all suspicious letters to Hunt, which she did. By now he had ample reasons for doubting Annie's fidelity, but instead of confronting her or coming to any resolution about the relationship, he sent Stephens to deal with the unpleasantness and arranged for a third party to begin spying on her, collecting further evidence of her betrayals. Paranoia seemed to operate as a kind of emotional fuel for Hunt.

He wrote Annie a letter chock-a-block with instructions. From this day forward she must keep careful, detailed accounts, she must take up respectable employment, she must quit modeling and stick to her studies. Stephens delivered this letter, and when Annie read it she became enraged. Who were Hunt and Stephens to say she had to give up a high-paying job just because that job would make some prissy, high-toned lady hang her head in shame? She didn't want to walk with mincing steps and speak in a whisper anyway. Besides, what did they have in mind — would Hunt be happy if she went back to wiping up slops in a pub? Had he forgotten that there were no re-

spectable jobs for a lady? When Stephens tried to argue Hunt's position, she showed him the door, adding loudly that she never wanted to see or hear the names Hunt and Stephens again as long as she lived.

Stephens began to crawl. He had not foreseen this development and was afraid Hunt would blame him. Twice he returned and begged her to reconsider, but to no avail. Annie stuck to her guns.

Over the next few months, Hunt learned to go down on his knees to her. The further she removed herself, the more desirable she became. Money, flowers, gifts, and love letters sent via the dogged Stephens were returned. Hunt decided that the only way to win her back was to cast all doubts to the wind and marry her. His sister Emily was outraged: How could he consider marrying a common girl he had picked up out of the gutter? Undaunted, Hunt rushed over to Annie's to tell her his decision. But the news that he would forgive all transgressions and marry her as soon as the Temple picture was finished did not exactly bowl her over. She told him she would consider his offer and give him her answer in a week. Then she asked him to leave.

Hunt had waited too long. Annie was seeing other men, and was enjoying life without him. Months went by and she remained vague. Hunt was dumbfounded. Discouraged by her hesitation, he veered off in another direction. Mrs. Pat wrote to say that she had met a nice young woman named Miss Strong whom she wanted him to meet. He wrote back asking her to widen the search. His principal requirements were still physical: "I really think that you ought to find me all the young ladies whose amiability you can speak of as highly as Miss Strong's to come and see me, but in the event of your knowing one who is tall 5 feet 6 or 7 with rather aquiline nose, long round neck and very beautiful — complexion rather fair or dark if good and not more than 24."[29] (Mortified by his snub nose, he hoped to save his children from this humiliation by breeding with a young lady possessed of a more elegant proboscis.)

Hunt ended up proposing to Miss Strong, although there is no evidence that he was in love with her. His nerves were frayed, and he just wanted to marry a proper, safe young lady and be done with the problem. Fortunately, Miss Strong refused him, tactfully explaining that she did not feel her health would stand up under the strain of keeping house for him in the East, to which he planned to return. If he warned her, as he had Mrs. Pat, that she could look forward to sweeping out a gutted tomb rather than a regular house and to cooking

steaks over a fire made from camel dung, it is not hard to imagine why a lady of delicate health and breeding declined the honor.

Miss Strong subdued Hunt's appetite for ladies all over again, and he paid a call on Annie, who seemed happy to see him. Soon he was painting her in a new picture, a large portrait he called *Il Dolce Far Niente,* roughly "Sweet Idleness." Through all their ups and downs, Hunt had continued to use Annie as a model, painting her even when they were estranged, and his studio was full of works for which she had posed, including a Lady Godiva. Making a beautiful image of her may have been a substitute for making love to her; Hunt's life in the studio was more real to him, certainly more compelling, than his everyday life. In the studio he was confident, the master, and Annie was his to do with as he wished.

One Saturday night a few weeks after he had started his sweet idyll, Hunt noticed a letter with a Belgian stamp on Annie's desk. He asked, then demanded, to know the name of the sender. Annie, either from guilt or from pride, refused to reveal the name, and they had a long, loud fight. Hunt knew that Boyce was in Belgium, and he was jealous of the more relaxed, socially assured painter.* After a great deal of wrangling, Annie volunteered that the sender was a woman friend, but this announcement came too late in the battle to be convincing. From this point the relationship deteriorated rapidly, and both Hunt and Annie began to act in the angry, irrational fashion so characteristic of a bad ending.

Hunt began to fall apart. Paranoia overcame him. In order to do a little digging, he invited several men, including Boyce, to Tor Villa to dine. His friends thought he had broken with Annie, and when her name was mentioned over port and cigars, one of the guests launched into a thoughtless diatribe on her wanton behavior. Dismissing her as a hussy, he congratulated Hunt on getting rid of her, then sank her once and for all with sympathy. He remarked how unfortunate it was that she was about to be thrown out of her lodgings, since she had run out of money and protectors, Lord Ranelagh having dropped her too.

With difficulty Hunt managed to hold himself together until the party broke up, but as soon as the last guest said goodnight, he went

*It seems unlikely that Boyce was Annie's lover. His diary reveals no guilt in relation to Hunt, and he had been genuinely pleased when Hunt told him that Annie felt he had "always behaved most kindly to her."[30]

to his study and dashed off a letter to Stephens: "I learn this creditable fact of the young lady who has caused me so many miseries that immediately before I sent her to school she was seen walking with a Regent Street whore — and also that she was met one day dressed in the extreme of fashion walking down St. James's Street, with a live Lord Somebody — a great rake — a discovery which does not astonish me now."[31] Of course it did astonish him, or he would not have been half so angry.

All his efforts to maintain the fiction of Annie's purity crumbled. His large but fragile ego could not bear the news that others had gotten there first. An onslaught of feelings — persecution, betrayal, hatred, anxiety — overwhelmed his shaky defenses, and during the next few months he nearly went mad. Annie, perhaps foreseeing the inevitable outcome, had disappeared. Torn between disgust and desire, Hunt imagined that she was sending him secret coded messages in the personal columns of the *Times,* which he puzzled out feverishly first thing every morning.

<div align="center">❧❦❧</div>

Work was the anchor that prevented Hunt from drifting entirely into his delusions. He returned to *The Finding of the Saviour in the Temple* and attacked it with fresh energy, fueled by fury. In less than a year the painting he called the "son of my sorrow" was finished. By then he had begun to recover; he was no longer obsessed with Annie, and his thoughts were clear. By the end of 1859 the engagement had been broken off once and for all. Boyce's diary entry for December 22 reads: "Miss Annie Miller called on me in the evening in an excited state to ask me to recommend her someone to sit to. She was determined on sitting again in preference to doing anything else. All was broken off between her and Hunt. I pitied the poor girl very much, by reason of the distraction of her mind and heart."[32]

Hunt turned to the problem of selling his painting. It had been six years since he had had a major work to show, and he faced the challenge of pricing and selling a picture that had taken him as much time as a dozen minor but lucrative ones. From the start he knew that Gambart was the only buyer with enough daring and cash to pay the kind of price he needed to realize, but he hesitated until his friend Wilkie Collins suggested that he consult Charles Dickens, a wily businessman who had driven many hard bargains on behalf of his own art.

Hunt had had a couple of run-ins with Dickens in the past, but Collins, who had collaborated with Dickens for years, insisted that he would enjoy helping out. Hunt arranged to meet the great man at his home in Tavistock Square. Surveying him with his painter's eye, Hunt noted that "all the bones of his face showed, giving it truly statuesque dignity."[33] At forty-eight, Dickens had deep lines running from his nostrils toward his chin whiskers. His hair, still dark and curly, had receded high up onto his forehead, but he brushed it over to the side, making no attempt to hide the retreat. His dress was quiet, with a touch of elegance: A high wing-tipped collar and a full black silk bow tie showed beneath a well-cut waistcoat. His easy mix of urbanity and hearty humor put Hunt at ease, and in a few minutes they got down to business.

Dickens asked exactly how much time and money Hunt had invested in the painting. Pulling out all the stops, Hunt described not only the hundreds of hours he had spent at his easel but also the harassment he had suffered at the hands of would-be models in Jerusalem, the days and nights spent in painstaking research on the Temple, the intricacy of the design, the difficulty of finding Jewish models in England, the hours lost to the English fog, the problem of finding a colorman whose pigments were reliable, the inferior quality of varnishes available in the East, and a great deal more.

When he finished, Dickens asked some acute questions about the art market and about what sort of fellow this Gambart was, to determine how much money the dealer stood to make on the exhibition and sale of the painting. Hunt pointed out that legally an artist held rights to both his painting and the copyright, so a buyer had to purchase the copyright in order to make profits by engraving and printing the painting. Gambart was one of the few dealers skillful enough to make more money from the sale of prints than from the sale of the painting itself; he was already making a lot of money from prints of *The Light of the World*. (In fact, Gambart was careful not to tell Hunt, to whom he had paid only two hundred pounds for the copyright, that he was realizing a thousand pounds a year from those prints.)

Working up all this information, Dickens agreed with Hunt's estimate that he should ask 5500 guineas for the picture — a staggering sum, far more than anyone had ever paid for a single work at that time. Hunt insisted that Gambart would never pay such a price. Keenly alive to Hunt's dilemma, Dickens commiserated: "Yes, we

inspired workers for the public entertainment ought to think of nothing so much as the duty of putting money into publishers' pockets, but we are a low-minded set, and we want a part of this filthy lucre for ourselves, for our landlords and our tradesmen, who most unfeelingly send us in bills as though we did nothing for their pleasure."[34] Hunt left the house chuckling to himself.

Encouraged by this encounter, Hunt girded himself for the match with Gambart. He knew he was not in a strong position. He had exhibited nothing for three years, people had laughed at *The Scapegoat,* the Royal Academy had rejected him, and he was living on money borrowed from Thomas Combe. But he announced to Gambart that the picture was going to cost 6200 guineas, 3000 for the painting and 3200 for the copyright. The dealer told Hunt politely that he was out of his mind even to mention such figures. Hunt held his ground, adding cheerily, "I won't abate a farthing."[35] He gave Gambart a week to make up his mind. In four days, his adversary buckled under and agreed to pay 3000 guineas for the painting, but he would go only as high as 2500 for the copyright.

Gambart believed that he could make his money back. A genius of advertising, he mounted his campaign carefully, with Hunt's aid. Ads were placed in the right newspapers and journals to orchestrate rising expectations regarding this new masterpiece, the fruit of many years' labor by the painter of the legendary *Light of the World.* Stephens helped considerably; he had become the art editor of the prestigious *Athenaeum* and so was able to dilate in its pages on the splendor of Hunt's picture.

Hunt let it be known that he had no intention of exhibiting his painting at the Royal Academy, where its impact would be dissipated by two thousand other works. Sir Charles Eastlake, President of the Academy, assiduously courted him, promising that a rail could be placed around the painting, like the one that had been put up to protect Frith's celebrated *Derby Day*. Hunt was implacable; revenge was sweet. Instead, Gambart rented the German Gallery in New Bond Street, and the picture was displayed by itself. To heighten the mystical flavor of the viewing experience, the room was kept in semidarkness; only the painting was lit, and gaslight was used to cast an aura around it. A canopy was hung over it to cut glare, so that no reflection interfered with direct eye contact. Elegant pasteboard cards were issued for a private viewing, and everyone who was anyone received an invitation.

Before long, as many as a thousand people a day were paying a shilling each to see the painting — the same price they paid to see the two thousand paintings at the Royal Academy. When Hunt ran into Dickens at a party, his conspirator teased him: "You have caused my hatter to be madder than ever. He declares that you have choked up Bond Street with the carriages for your exhibition, so that none of his established customers can get to his shop."[36] Many who saw the work felt it to be akin to a genuine religious experience. The noted diarist Arthur Munby wrote: "I cannot trust myself to speak of it. It is unique, and simply wonderful . . . one should sit before it in quiet, and for hours."[37]

For Gambart, the viewing was a sublime commercial success. He recouped the purchase price of the painting in four months. The enterprise was not without its moments of panic, however. Prince Albert stopped by the gallery to see what the hullabaloo was about and took his place in the queue, but an attendant spotted him and offered to arrange for a private viewing. Soon after, the picture was taken to the palace by royal command so that the Queen and her consort could view it at their leisure. On another occasion the gaslights flared up, and flames danced around the picture's frame. Quick thinking saved the day — while everyone else stood immobile with horror, a woman stepped out of line and threw her cashmere shawl on the flames to smother them, then slipped away in the confusion. The sky in the painting had been melted slightly by the heat, but Hunt was able to repair the damage.

Hunt loved the drama and the crowds. He basked in all the attention that was finally coming his way. The Queen wrote him a complimentary note. Overnight he became the most desirable nonroyal bachelor in London. Mothers dreamed of snaring him for their daughters, and daughters eagerly sought his company.* One young woman who met him troubled to write down her impressions. She found Hunt to be a "very genial, young-looking creature, with a large square yellow beard, clear blue laughing eyes, a nose with a little messy upward turn on it, and dimples in the cheek, and the whole expression sunny and full of simple boyish happiness. His voice is most musical

*Many jokes were made about the Victorian marriage market, at the expense of supposedly greedy mothers and their alarmingly voracious daughters. In fact, competition grew up because females outnumbered males in the British Isles. Thirty percent of all women between the ages of twenty and forty were single, and the percentage was even higher among upper-middle-class women in urban areas.

and there is nothing in his look or bearing, spite of the strongly marked forehead, to suggest the High Priest of Pre-Raphaelitism."[38] Not all assessments were as lofty. One gossip columnist dubbed the new celebrity the "plebeian lion of the season"![39]

<center>◈◈◈◈◈</center>

Annie had returned to Mrs. Stratford's, but she had been moved from the best room in the front to the smallest, cheapest room at the back. She no longer had Hunt's subsidy and could not get enough modeling to catch up on her bills. At moments she regretted that she had not accepted Hunt's last proposal.

But Mrs. Stratford proved to be her wild card. Formerly a self-righteous critic of Annie's behavior, she now decided, for whatever reason, to help the girl out. Perhaps Annie had at last succeeded in winning her over, as she had so many others along the way. At any rate, Mrs. Stratford suggested that Annie might be able to hold Hunt to account for the six good years she had wasted in waiting for him to marry her. Since Annie had saved many of his letters, including the crucial one from Jerusalem in which he had proposed, she could threaten to sue for breach of promise.

Annie's friends hotly debated the wisdom and practicability of a lawsuit. On the one hand, there was a strong chance that Hunt could embarrass her by bringing witnesses to testify that she had kept company with other men. On the other, he had much more to lose than she did. Riding the crest of his popularity, he might well be ruined if the newspapers got wind of his relations with Miss Annie Miller.

Mrs. Stratford was the one who made a move. She called on Stephens, politely informed him of Annie's debt to her, and made it clear that she believed Hunt was still the girl's protector, responsible for her expenses. Now Annie had her own lieutenant, who was more than a match for Stephens. Dropping everything, he dashed up to Tor Villa. Hunt was cool: Stephens was to tell Mrs. Stratford that Mr. Hunt was prepared to pay one last bill. Beyond that, he was willing to pay for Annie's training at a job of which he approved or for her passage to Australia.

Thousands of Englishwomen shipped out to Australia during the 1850s and 1860s, in search of husbands and work. Among them were a significant number of ex-mistresses, sent to the other side of the world so that they could not embarrass or blackmail their former lovers. Australia was also regarded as the ideal destination for thou-

sands of convicted criminals, ranging from petty thieves to murderers, who were also being relocated to the distant colony so they could no longer trouble the good citizens of the mother country. The difference between the mistresses and the criminals was that the latter were often permitted to return to England after a certain number of years.

Hunt handed Stephens an envelope of banknotes with which to pay Annie off. Later he wrote him a letter of instruction, specifying what Stephens should say when presenting the envelope. Rising to new heights of sententiousness, he intoned: "If she cannot be preached to from the texts of her own bitter experience, then she cannot be awakened at all."[40]

Confronted with Hunt's offer, Annie asked that he pay for her to apprentice herself as a hatmaker. Hunt dismissed this notion as absurd on the grounds that there were already too many milliners in England, but in truth he was more interested in getting Annie out of the country than in getting her into a promising line of work. At his command, Stephens continued to push for emigration, and Annie eventually agreed to consider it, if she could first be trained as a milliner, since she would need a means of supporting herself in Australia just as much as she did in England.

The question of Annie's future was left up in the air. Hunt fired off another letter of instruction and recrimination to Stephens. Dismissing Annie's complaint that his plan for her emigration grew out of a selfish desire to get her out of the way, he insisted that he was urging it for her own good. He remained oblivious of the wrench he had thrown into her life. Given just enough schooling to render her neither fish nor fowl, Annie had moved out of the working class but was not yet part of the bourgeoisie. Nobody in polite society would receive her on her own; she had to have a gentleman for a husband as her entrée to that world. Annie understood what had happened, but Hunt regarded "the notion she expressed that *I* had taken her out of her original position and the inference that her present one was that of a person of the higher classes, in spite of the too obvious fact that she can't write two lines of English as well as the youngest tutor in a charity school,"[41] as ridiculous. He felt he had been taken advantage of.

When Hunt heard some days later that Annie still refused to emigrate, he decided to have done with her: "I shall now only fork out £5 to Mrs. Stratford."[42] Annie retreated to discuss her next move with her advisers. They pressed her to enter a suit for breach of

promise, but Annie worried that courtroom revelations would alienate her other long-time protector, Lord Ranelagh. She called on him at Mulgrave House in Fulham to broach the matter. (Hunt's gossiping friend may have been correct in reporting that Annie was no longer Ranelagh's mistress, but the viscount was a generous and easy-going fellow who would have been happy to help Annie if she were in trouble.)

Rising from the sofa in his elegant Regency sitting room, he greeted her warmly. Annie had never threatened him as she did Hunt. He loved her vitality, and losing himself in the tangled wilderness of her hair was a pleasure he dreamed about, not a danger he ran from. But on this occasion Annie's mind was elsewhere; she was twisting her handkerchief and picking at her sleeve, uncertain how to begin. He drew her out, and slowly she revealed her dilemma: She wanted to call Hunt to account, but feared that smart lawyers would find witnesses to connect her with Ranelagh.

The viscount was amused rather than perturbed. As they talked, it occurred to him that there might be a more discreet and less risky means of extracting money from Hunt. Why shouldn't Annie just hint that the tabloids would be eager to print his love letters, which would in a moment destroy the reputation for Christian purity so important to the sale of his paintings? Surely he would offer to buy the letters from her at a nice price.

Mrs. Stratford was intrigued by Annie's report of her meeting with Ranelagh. The landlady wanted her money, but now she was also keenly interested in humbling the mighty Hunt. She went round to Stephens's flat in Lupus Street and scared the daylights out of him. First she recalled how faithfully she and her husband had stood by the lodger for whom they had developed such an affection over the years, despite her inability to keep up with her bill. Warming to her subject, she allowed as how she was shocked by the way in which a supposedly fine Christian gentleman like Mr. Hunt had been shirking his duty to Miss Miller. Then she mentioned that Annie was in possession of a great many letters Hunt had written to her, as well as a number of handsome drawings he had done of her; no doubt she implied that these were drawings from the nude. With a touch of melodrama designed to mobilize her fatuous adversaries, Mrs. Stratford announced that only that morning Annie had paid her the last bit of her savings, and might now have no choice but to turn to that good-for-nothing rascal Lord Ranelagh for help. Leaving this host of

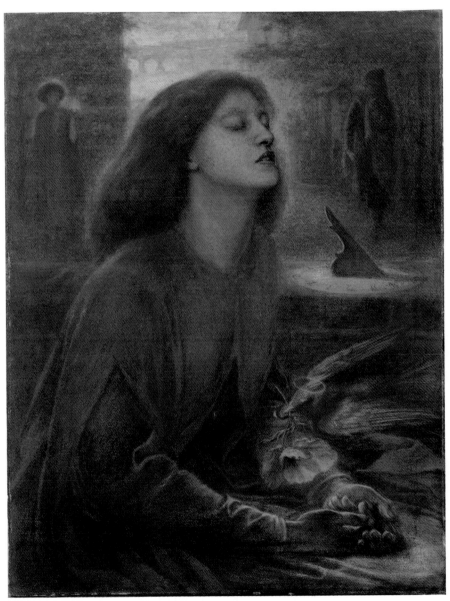

Dante Gabriel Rossetti • *Beata Beatrix*
(Model: Elizabeth Siddal)

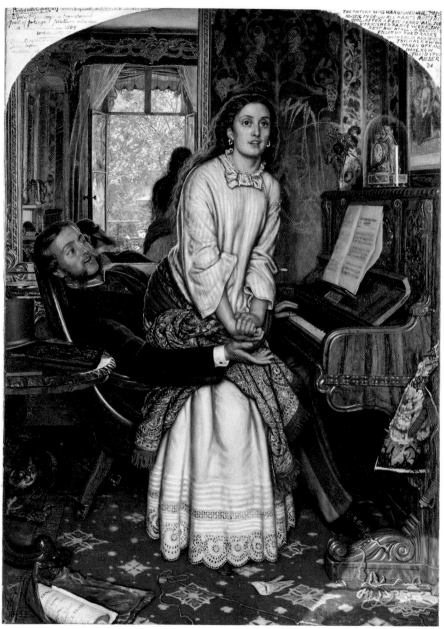

William Holman Hunt • *The Awakening Conscience*
(Model: Annie Miller)

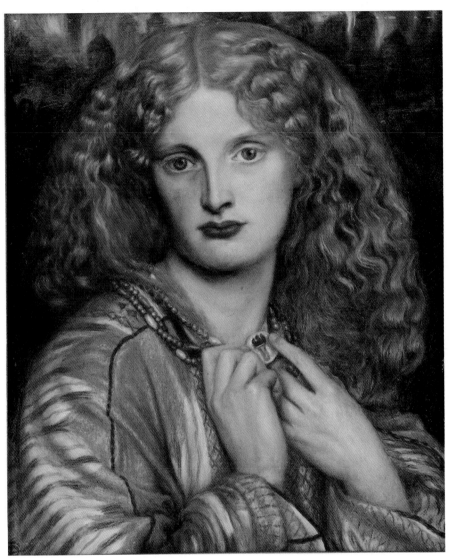

Dante Gabriel Rossetti • *Helen of Troy*
(Model: Annie Miller)

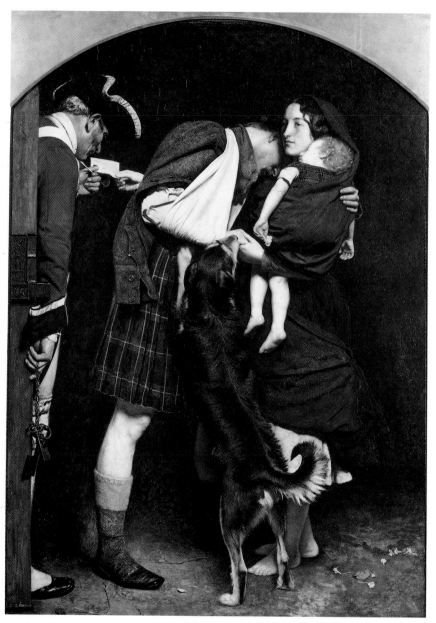

John Everett Millais • *The Order of Release*
(Model: Effie Ruskin, later Millais)

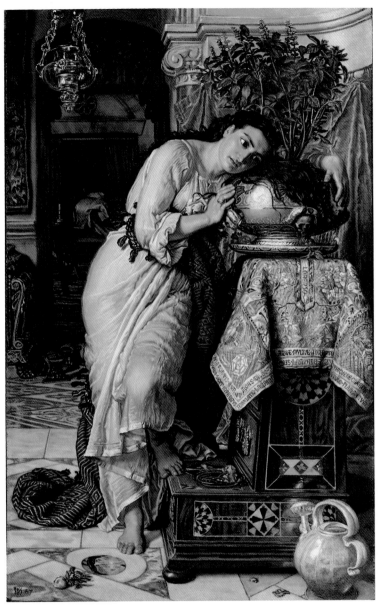

William Holman Hunt • *Isabella and the Pot of Basil*
(Model: Fanny Hunt)

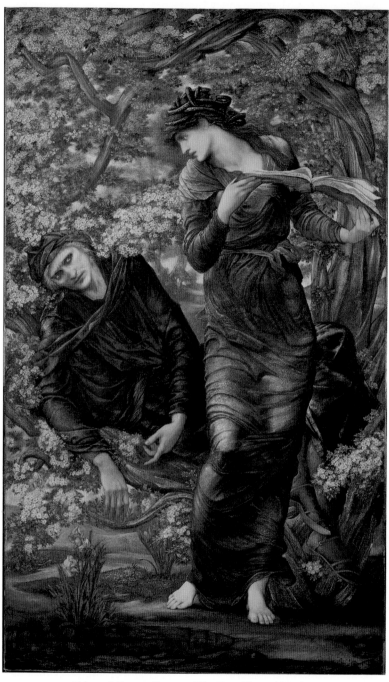

Edward Burne-Jones • *The Beguiling of Merlin*
(Model: Maria Zambaco)

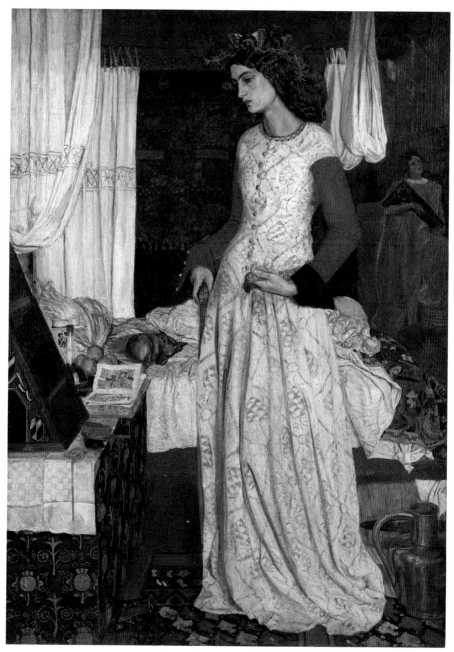

William Morris • *La Belle Iseult*
(Model: Jane Morris)

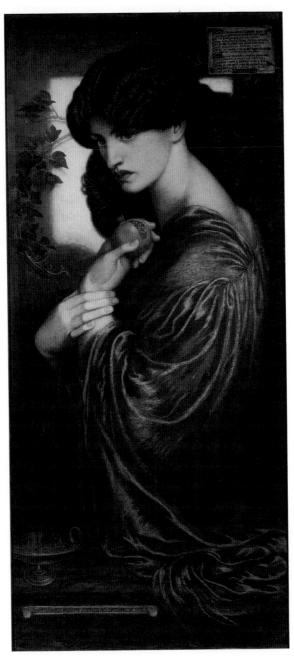

Dante Gabriel Rossetti • *Proserpine*
(Model: Jane Morris)

alarming possibilities hanging in the air, she bid Stephens good day.

Stephens went running to Hunt. This time Hunt was alarmed. He decided to call on Lord Ranelagh himself, and was aghast to hear the viscount calmly admit that Annie had been his mistress for years. He added nonchalantly that she was only one of many. Hunt, who fancied himself a man of the world, could hardly take it all in.

He went immediately to confront Annie, who told him a bald-faced lie, claiming that she knew no one by the name of Ranelagh. When Hunt repeated enough of what he had heard to make her see that she would not be able to sustain this fiction, she took another tack, pretending she didn't know Ranelagh's name and had not seen him "but within the fortnight — as an unknown fellow who followed her home against her will."[43] Hunt made his way to the door, where Mrs. Stratford shoved another bill into his hands.

Out of his depth, Hunt wrote to Stephens for assistance: "You must see how she takes the announcement of Lord R's name — if she is proud of his noble friendship — of course it would be unwise to threaten her with exposure of his connection with her in court. If you find he is instigating her to make use of the letters to annoy me — do not hesitate — because, black as he is, he would rather dread having her account of his behaviour come out — as I should, he would know — rather damage him even in the eyes of those who hold whore's honour."[44] Hunt obviously did not understand that the values of an aristocratic rake were very different from those of a serious middle-class virgin.

In another letter written on the same day, Hunt outlined his game plan. Stephens should let Annie know that he was ready to take her on in court and that he was confident he had sufficient evidence to blow her case apart. He believed that the introduction of Ranelagh's name alone would be enough to undo her. Now prepared for full-scale public battle, Hunt was ready to destroy his own career by creating a scandal in which he would humiliate Annie and revoke her claim on him. Clearly, he was losing control. The arguments he made to convince Annie that she should voluntarily return his letters were pathetic: Stephens was to tell her that "my only desire to get them comes from a knowledge that after her lifetime and mine they might get into someone's hands who would print them when there was less chance of the secrets in them being explained."[45]

Naturally, the penniless Annie failed to be persuaded. Soon Hunt was buying her neighbors drinks at the pub to encourage them to

divulge her secrets. When he was confident that he had enough gossip to buy back the letters and drawings, he penned a two-thousand-word epistle to Stephens detailing the interview he must have with this unrepentant whore. He titled his plan THE PLOT and blocked out the scene as if he were writing a play.

Somehow he had arrived at seven pounds as the figure that he should have to pay in return for all his things — a sum that probably just covered Annie's outstanding account with her landlady. (Of course, both Annie and Mrs. Stratford had read in the newspapers what Hunt had been paid for the Temple painting.) If she balked at the seven pounds, Stephens was to brandish a variety of threats, including exposure of the fact that Annie's childhood had been passed in dire poverty. Apparently unaware that revealing this information would be more degrading to him than to her, Hunt even dreamed that in the wake of this threat he would be able to extract a moral vindication from her. Stephens was supposed to force Annie to sign a document reading "Received of W. Holman Hunt seven pounds in consideration for which I return to him the books and all the letters sent from him to me at different times excepting no one . . . and I hereby declare that I retain no right or claim of any kind against him." Hunt added: "When you are writing it and have got to here say 'Shall I add an acknowledgment of his past friendly attention to you' — , if she says 'just as you like' write 'and I express my sense of the unselfish kindness and liberality with which he has always treated me.' "[46]

Of course Annie refused to sign. Luckily for Hunt, she had fallen in love with Thomas Ranelagh Thomson, a cousin of Lord Ranelagh's who had been present during her interview with him and who had been dancing attendance on her ever since. Thomson was a gentle, pleasure-loving, good-natured young man with a comfortable income and a house in Mayfair. Before long he asked Annie to come live with him, and she jumped at the chance to leave forever the dank room in Bridge Row, the cranky, manipulative Stratfords, the tiresome, wheedling Stephens, and the tendentious, high-handed W. Holman Hunt.*

*Annie may have managed to haunt her self-styled protector. An undated note mixed in with the Hunt–Stephens correspondence in the Bodleian Library refers to the "loss and signing away of £1000." Perhaps Annie bided her time, waiting until she knew that Hunt was engaged to a wealthy young lady whose parents would be shocked beyond recall by the tale she had to tell. But by the time Hunt was engaged, Annie was happily married and her money problems had been solved, so this note could refer to some other debt.

Annie married Thomson on July 25, 1863, in St. Pancras Church. Hunt's plan of education had worked. She had become a respectable upper-middle-class wife, just as he had hoped she would. Just as he had feared at the start, though, he had brought her up to be somebody else's darling.

<p style="text-align:center">❦</p>

Hunt almost succeeded in wiping out Annie's past as a model, by blotting her face from the only famous painting in which she ever appeared. When his patron complained that the look of horror on the young woman's face in *The Awakening Conscience* was too disturbing to live with every day, Hunt graciously consented to repaint the face. Later he realized that he had ruined the picture and regretted what he had done. The girl who looks out from *The Awakening Conscience* today appears startled but not particularly uncomfortable — more hopeful than upset.

As years passed Hunt's bitterness dwindled, and when he was an old man he served up his own strange version of the story to a group of friends as a weekend's entertainment. His friend Edward Clodd described this remarkable tale in a memoir: "One Whitsuntide [Hunt] told the story of a pretty girl of humble class whom he had engaged as his model. There was the making of an intelligent woman in her, and . . . he had arranged to have her educated, possibly, so he hinted, with a view to marrying her. But Rossetti, whose principles were exceedingly lax, beguiled the girl away from him. Years afterward HH met her by chance, a buxom matron with a carriage full of children, on Richmond Hill, and learned that she had married happily. A very simple story, but recited in so vivid a minuteness as to hold the hearers spellbound; the reciter's wonderful memory supplying the actual conversations between the artist and his model, and between him and Rossetti. It began in the afternoon, it went on through dinner to bedtime, it was finished the next morning, by which time it had reached the length of *Sir Charles Grandison*."[47]

If Samuel Richardson had been alive, he would indeed have loved to write the story of Annie Miller — but Gabriel would have been just one player in an intricate game of seduction and betrayal.

Four

AN ORDER
OF RELEASE

WHEN WILLIAM HOLMAN HUNT and John Everett
Millais sent John Ruskin a letter thanking him for his
support in the *Times,* Ruskin was so pleased that he and
his wife, Euphemia, took their carriage to Millais's studio
in Gower Street that same afternoon. The tall, bony, stoop-shoul-
dered critic understood that most painters were intimidated by his
enormous power, so he carried the burden of this first conversation,
asking questions and making suggestions, exclaiming over works that
he particularly liked, throwing out allusions to masterpieces. His wife,
an intelligent observer who had learned a great deal about painting
from her husband over the years, did her best to help out, so that
before long Millais and the Ruskins were laughing and talking as if
they had known each other for ages. Skipping the formalities, the
Ruskins popped Millais into their carriage and took him home to
share their supper at their small townhouse in Park Street, Mayfair.

Basking in the warmth of their attention, Millais settled back in
his chair and indulged in a bit of speculation about this spirited young
couple. He doubted whether Mrs. Ruskin, or Effie, as she was called,
remembered that she had met him six years earlier at a dance in the
country. Then she had been the center of attention: seventeen, radiant
with youth, self-possessed, light on her feet, surrounded by a gaggle
of young men fighting for a place on her dance card. On that night
Millais had been sixteen, a tall, gawky lad beneath her notice. Now
it looked as if she had made the sort of brilliant marriage he would
have predicted for the girl at the dance. Her husband was acknowl-

edged as the leading art critic of the day and as a scholar to be reckoned with; what's more, he was wonderfully rich, the son of a man who had made a fortune by importing sherry from Spain. Yet despite Ruskin's extraordinary gifts and the recognition he received, he remained ill at ease. A dog bite in childhood had left him with a small scar on his lip, and he still brooded on the disfigurement. He thought himself so plain he avoided photographs. Millais noted this shyness; he also saw that Ruskin was a bit formal with his wife of some years. He found himself wondering who had done the wooing.

While Effie offered second helpings and signaled to the servants, she was also busy sizing up this curious, handsome young man. She had seen his *Mariana* on the walls of the Royal Academy and knew that he was more than a technical virtuoso. He had taken Tennyson's thin if popular ballad and turned it into something sensual and provocative. His Mariana, stretching in her blue velvet gown, riveted Effie as well as thousands of other viewers who attended the exhibition. This eager, headstrong boy understood something about women, and Effie wondered where he had learned it.

Ruskin was also attracted to Millais. Some talented painters proved depressingly inarticulate, but Millais was a find, crammed with ideas about his own paintings, about everybody else's paintings, about the history of painting, and about his plans for the future. He was willing to listen to another man's ideas but perfectly able to stand up for his own.

Everyone felt that the meeting had been a great success, and they said their goodnights with genuine warmth and regret, promising to see each other again soon and often. It would be a good while before this friendship got under way, however. John and Effie soon went to live in Venice, while Millais spent the summer painting backgrounds at Ewell with Hunt.

<hr />

Millais was right to wonder about this odd couple — there was something radically wrong in the Ruskin household. After four years of marriage, Ruskin treated his wife with the sort of gentle, distant good humor an undergraduate might extend to a pert little sister. When Effie reread the passionate letters he had sent her during their engagement, she could hardly believe they had been written by the same man.

John Ruskin and Effie Gray had known each other since she was

twelve and he twenty-one; their families had been friends for many years. Effie's father, George Gray, was a writer to the signet — a high-powered solicitor — in Perth. So that his beloved first daughter could have every social and educational advantage, he and his wife, Sophia, had sent Effie to Avonbank, a decorous boarding school for young ladies at Stratford-on-Avon. On her way to and from Scotland, Effie stayed with the Ruskin family at Denmark Hill, their home in the London suburb of Camberwell. Over the course of these visits John's parents grew quite attached to the girl; they had had only the one child, quite late in life, and Effie became like a daughter to them. A talented pianist, she played them to sleep in the evenings as they sat in their armchairs.

In the summer of 1841, when Effie had just completed her second term at Avonbank, all three of her little sisters were stricken with scarlet fever, and the Ruskins agreed to keep Effie until the threat of contagion had passed. When the third sister died, thirteen-year-old Effie wrote to her parents with maturity worthy of an adult: "Do not be at all uneasy on my account for they are very kind to me here," she told them, and "do not write to me till you feel yourself quite able."[1] At the end of the summer Effie went home instead of returning to school, because her father could not bear the silence of his house. Two years later she tried another term at Avonbank, but this time her small brother Andrew died suddenly and she was summoned home again.*

By the time the Ruskins invited Effie to Denmark Hill for a visit in the spring of 1847, when she was almost nineteen, their twenty-eight-year-old son was well on his way toward becoming a celebrity. He had just published the second volume of *Modern Painters,* to rave reviews. Recognition of his genius did not make everyday life any more comfortable for him, however. Until recently, when his books had brought him into the public eye, he had led a remarkably sheltered life. As a little boy he had had no playmates, because his parents were concerned that other children might lead him astray. He was schooled at home until he went up to Oxford, accompanied by his mother; he lived in college, and she took rooms in the high street, where he came for tea every evening.

In 1847 John's parents imagined he had proposed to the heiress

*Between 1828 and 1855 Effie's mother bore fifteen children, but seven of them died before the age of eight.

Charlotte Lockhart, great-granddaughter of Sir Walter Scott — a prestigious marriage that would have pleased Mr. Ruskin especially, for he had great social ambitions for his son. Now, to their consternation, John began paying attention to Effie. The Ruskins felt that John was dishonoring Charlotte while trifling with Effie's affections, and Mr. Ruskin dashed off a warning letter to George Gray. Mrs. Gray wrote posthaste to Effie, who immediately reassured her mother: "Mrs. Ruskin told me of John's *affaire* the first night I came but I did not tell you as I thought she perhaps did not wish it to be known but she did not tell me who the lady is and John never hints of her, he is the strangest being I ever saw, for a lover, he never goes out without grumbling."[2] (In fact John was quite terrified of Charlotte, whom he had seen only at public gatherings, where they had exchanged the most commonplace pleasantries.) While Effie appreciated the humor in this situation, she was also perspicacious enough to see the danger lurking in it for John: "I think Mr. and Mrs. R. are doing wrong — at least they are wishing for their son's happiness and going the wrong way to work. He adores them and will sacrifice himself for them, as I see too easily." She closed with the exclamation: "Private!"[3]

But John had lost interest, if he had ever had any, in Charlotte. He and Effie had fallen in love. Theirs was a romance at once tremulous and intense. John approached Effie as hesitantly as if she were a Dresden figurine. He relished their intimate companionship, but his pleasure was oddly tinged with fear. In a letter written a few months later, he recalled their first private moments: "When I was frightened at finding you practicing in a cold drawing room, and stopped — and your giving me leave an evening or two afterwards — what a luxury it was to call you Effie — and is."[4]

He was afraid to declare his love because he knew that doing so would cause his parents pain. When John wanted to take Effie to the opera, Mrs. Ruskin refused to go, which meant that Effie could not go because she had no chaperone. To make John happy, a compromise was finally effected whereby Mr. Ruskin accompanied the young people. While Effie was listening blissfully to the divine Jenny Lind and John was admiring Effie, Mr. Ruskin was suffering agonies of embarrassment because the audience, which included Charlotte Lockhart's father, could look up at their box and see that John was "over head and ears" in love with Effie.

Ostensibly John's parents' hearts were set on the Lockhart union,

but the fact was that they could not bear to share him with anyone. After Effie had boarded the Dundee steamer for her return to Scotland, John gathered his courage and broached the idea that he would propose to her. Immediately Mr. and Mrs. Ruskin weighed in with a raft of objections. Now that she was a potential daughter-in-law, they forgot their affection for her and could find only fault. However, once they saw that their son's happiness, and perhaps his mental health, hinged on this marriage, they capitulated. (Years before, John had been wild to marry Adèle Domecq, the daughter of one of Mr. Ruskin's partners. When his parents had forced him to give her up, he had hemorrhaged from the throat. The doctors had diagnosed consumption, and it had taken a year of careful nursing to restore their precious child to health.)

In a letter to John, Mr. Ruskin struggled awkwardly to argue in favor of a marriage with Effie: "Be sure of this that all hesitation *or pause* on my part is for fear of you — vanity does mingle a little — but mortification I should have had double in the L[ockhart] union I always knew this — but we had kept you to ourselves till marriage and I expected you might marry rather high from opportunities given and that then we must give you up — now with E. G. I gain much — I escape also from painful communications even for a short time with people out of my sphere."* He went on to set out his fears about the deficiencies of Effie's character, which John apparently shared: "I dread any future discovery of what you seem to fear — motives of ambition more than love — or of tutored affection or semblance of it, though I only do so from the knowledge of the desirability of the union to the father not as you do from supposing you not to be lovable."[5]

Despite his misgivings, John's resolve held. He wrote to Effie proposing marriage, and was accepted. During their engagement he wrote her long, impassioned letters several times a week. The first that survives opens with the exuberant salutation "My own Effie — my kind Effie — my mistress — my friend — my queen — my darling — my only love."[6] Effie replied with sweet letters in which she promised to love him and serve him in every way, down to learning how to repair his pens.

*Mr. Ruskin's sphere was trade, and in his defense it should be remembered that the humiliation of this pursuit was real; it oppressed not only him but millions of other middle-class Victorians. The fact that he had made a fortune in his sherry business did little to mitigate the shame he felt. But it is difficult not to notice how thoroughly his view of his son's marriage was colored by the possible effects of the event on himself.

John wanted to marry immediately, but Effie and her mother wanted a little time to prepare for the wedding. The Gray family found it hard to rush into celebration because Mr. Gray had speculated heavily in one of the new railway companies, and a recent margin call had left him teetering on the edge of bankruptcy. John's mother became terribly upset that the ceremony might be performed during Lent, which further delayed the wedding. Frenzied with impatience, John nonetheless forced himself to wait, bowing to the wishes of his mother and his bride.

The wedding was finally celebrated on April 10, 1848, at the Grays' home, Bowerswell, in Perth, but John's parents did not attend. The couple had planned a honeymoon in Europe, with the elder Ruskins for company, but revolution in France forestalled the trip, so John and Effie made a tour of the Scottish Highlands instead. The wedding night, at an inn in Blair Atholl, was a disaster. Indeed, John spent the next week mounting arguments against sexual relations. The fact that he could instantly produce such a barrage of excuses suggests that he had martialed them in advance, sensing perhaps that he might not be able to nerve himself to the deed. Pride and the difficulty of discussing sex made it impossible for him to admit his fear or to seek any help in conquering it. Effie was definitely ignorant of the mechanics of sex; very likely, John was almost as ignorant as she was.

Sexual abstinence did not dampen Effie's enthusiasm for her new husband. Soon after they had returned to Denmark Hill, where they were to live with Ruskin's parents, she wrote home to Bowerswell ecstatically: "I never saw anything like John, he is just perfect!!!"[7] Within a couple of months, however, life with the senior Ruskins had begun to grate on her nerves. The two couples made a tour of abbeys and cathedrals in southern England to further John's research on Gothic architecture. When John caught cold, his parents' fussing irritated Effie so intensely that she complained to her parents in a letter from Salisbury: "John's cold is not away yet but . . . I think it would go away with care if Mr. and Mrs. Ruskin would only let him alone . . . in the morning Mrs. Ruskin begins with 'don't sit near these towels John they're damp' and in the forenoon 'John you must not read these papers till they are dried.' . . . it would amuse me all this if I did not see that it makes John notwithstanding quite nervous."[8]

By August the political situation in France had eased, and John and Effie went to Normandy on their own. Effie helped John with his research, and his daily letters home praised her diligence and patience:

"She will *wait* for me three hours together — (and I certainly could not always say as much for you)."[9] Yet despite his appreciation, he was unable to offer her any deeper emotional support. When Effie received a letter warning her of her father's imminent bankruptcy, John was at a loss. To his parents he admitted how difficult intimacy was proving to be: "It was — and perhaps still is — growing upon me — that it may be just as well that I am forced to think and feel a little for others — at least I may think — but I don't feel — even when poor Effie was crying last night I felt it by no means as a husband should — but rather a bore — however I comforted her in a very dutiful way."[10]

Ruskin's parents realized that the experiment of living with the young couple was a failure, and so by the time John and Effie returned from Normandy in November, Mr. Ruskin had leased and furnished a townhouse for them in Park Street. Effie was delighted, but John was uneasy. To his father he wrote plaintively: "How will you and my mother manage — at all — when I am so near and yet not with you in the evenings!"[11]

Christmas was celebrated at Denmark Hill, where Effie came down with a bad cold. When Mrs. Ruskin insisted on dosing her with a combination of ipecacuanha (which induces vomiting and is now used as an antidote for certain poisons), laudanum, and spa water, Effie rebeled. There was an argument, and even though John saw that Effie deserved indulgence, he resolved the conflict in favor of his mother, writing to Effie's parents that she had richly deserved his mother's scolding.

Mr. Gray's railway holdings had made substantial gains and bankruptcy had been averted, so Effie felt able to ask her mother to come to London to nurse her. In the end they both returned to Perth. Husband and wife, who had been married only eleven months, were now separated for another nine, as John and his parents set out on the journey to France and the Alps that had originally been planned as a honeymoon. Distance, however, gave the newlyweds a chance to sort out their problems by letter and to rekindle the embers of their romance. From Paris John wrote: "Do you know, pet, it seems almost a dream to me that we have been married: I look forward to meeting you: and to your *next* bridal night: and to the time when I shall again draw your dress from your snowy shoulders: and lean my cheek upon them, as if you were still my betrothed only: and I had never held you in my arms."[12] His next letter, dated April 27, 1849,

began: "My darling Effie, I have your precious letter* here with the
account so long and kind — of all your trial at Blair Atholl — indeed
it must have been cruel my dearest: I think it will be much nicer next
time, we shall neither of us be frightened."[13] In July he was writing
that he too hoped they would be able to make "a little Effie" to-
gether.[14]

It is shocking to discover that two days after the "little Effie" letter
John was writing to Mr. Gray to explain that he felt Effie was suffering
from a "nervous disease affecting the brain," which manifested itself
in tears, depression, and "causeless petulance towards my mother."
He did not hesitate to tell Effie's father that while he could tolerate
"restiveness" in horses and asses, he looked for meekness and gentle-
ness in a woman.[15] From this time John undertook to build a case
that he could not consummate the marriage for fear of producing
mentally defective children with a woman whose illness bordered on
insanity, but all he ever had to offer in the way of proof was Effie's
sadness, anger, and resentment — hardly the symptoms of mental
illness.

When John and Effie were reunited in Park Street, she surprised him
with an appealing proposal. She knew he wanted to do research in
Venice before the rage for restoration blotted out all traces of the
history of its monuments, and she asked him whether they could live
in Venice for a year or two. Perhaps she dreamed that once they were
out from under the thumb of the older Ruskins, their marriage would
bloom in that notoriously romantic city. In any case, John was en-
thusiastic about the idea, and within a few days the two had packed
their bags and set out for Venice.

The adventure turned out to be more or less a holding action in
their relationship. Starting work on *The Stones of Venice* fascinated
and preoccupied John, while Effie was equally consumed by the cos-
mopolitan social whirl, which was so much more urbane and easy-
going than the social climate in London. She was invited to countless
parties, and she attended them all, enjoying herself immensely. Of-
ficers of the Austrian army, which had mounted an invasion in 1848
and was now occupying Venice, found her charming and took ad-
vantage of every occasion to flirt. When her brother George got wind

*Unfortunately, this letter has not survived.

of this development, he rushed out a letter of reproach. Indignantly Effie defended herself to her mother: "Men are really great fools! and if you suppose that I ever forget my duty for an instant to my husband, you are . . . wrong . . . I hope I have inherited a little of my father's sense and your discretion to some purpose. In fact John would require a wife who could take care of her own character, for you know he is intensely occupied and never with us but at meal times, so that we can do anything we like and he does not care how much people are with us or what attention they pay us.* I understand him perfectly and he is so kind and good when he is in the house that his gentle manners are quite refreshing after the indolent Italian and the calculating German, but we ladies like to see and know everything and I find I am much happier following my own plans and pursuits and never troubling John, or he me."[16]

The freedom of life in Venice was a revelation to Effie. When Mr. Ruskin heard that she had enjoyed strolling about under the stars in the Piazza San Marco one evening without a bonnet, he was appalled. Luckily, he never found out that she also rowed the Ruskin gondola herself, or that a Captain Paulizza had fallen in love with her. Still untouched herself, Effie delighted in Paulizza's delicate attentions and blinded herself to the pain his hopeless love caused him. John was not only undisturbed by the other man's interest, he told his wife that he respected her more because a man as cultured as Paulizza liked her.

When it came time to return to London, Effie was downcast at the prospect of life there, which now seemed dreary and stifling to her. During the year they spent at home, she lobbied constantly for a return to Italy, and eventually John consented, because he needed to finish his research. When the boat train finally lurched and pulled out of Victoria Station on the fourth of August, 1851, Effie breathed a sigh of relief — at last she would be free again.

On the surface, their second stay in Venice was even more delicious than the first. Their rooms fronting on the Grand Canal cost seventeen pounds a month, for which they got what amounted to a good-sized house, complete with servants' quarters; they kept their own gondola, and lived and ate exceptionally well. To her brother in Perth, Effie wrote: "The cook I pay 16 zwanzigers a day to, or 11/-, for this he feeds Mary and George [her maid and John's valet], a dish at breakfast

*Effie had brought along Charlotte Ker, a childhood friend, as a companion.

for us, two at luncheon, and then our dinner at five, which is everyday varied in the most wonderful manner. Yesterday we had first macaroni soup, second fish of tunny, third small leg of mutton, fourth cold veal in jelly beautifully made, fifth sweetbreads fried, sixth roasted larks and blackbirds, seventh sort of Spanish fritters — and everyday this sort of thing."[17] Their routine was so luxurious and so civilized that she felt she should be happy; she told herself she *was* happy. Her only immediate worry was keeping expenses down, for she and John always had trouble living within their income — which infuriated Mr. Ruskin, who had recently written: "Unless Effie takes to a little housewifery and housekeeping you will find living abroad a sad bore and taking house worse than hotels. Foreigners are too sharp not to see who are managers and will pluck you dreadfully."[18]

Without children, with little housework to do, and with no real work of her own, Effie had a great deal of time on her hands. There was little for her to do but read, improve her Italian, tend her houseplants, and write voluminous letters home. Fortunately she had another valuable outlet: She loved the company of other people and was superb company herself.

The only obstacle to her complete social success was John. At the end of a hard day of work, he wanted nothing more than to read a good book and doze off; as he told his parents, "Operas, drawing rooms and living creatures have become alike nuisances to me. I go out to them as if I was to pass the time in the stocks."[19] This attitude angered Effie and put a severe crimp in her style, for convention dictated that a lady should not appear in society without her husband. This dictum was easier to ignore in Venice than at home, but Effie knew that people whispered, wondering why John Ruskin did not seem to enjoy the company of his lovely young wife. Effie herself wondered, and her ceaseless complaints about her husband's refusal to go into society were a substitute for the subject she could not raise — his unwillingness to satisfy her on more intimate levels.

For a time, however, Effie's personal success in Venetian society buoyed her spirits and kept her afloat emotionally. She tried to work around the constraints by arranging for a chaperone to replace John, and she made good use of an introduction to Lady Sorell, a power in the English expatriate community. The older woman was charmed by Effie, as almost everyone was, and was happy to take her along everywhere she went. Soon Effie was constantly, almost frenetically busy, coming and going to lunches, teas, dinners, evening parties,

and balls. She continued to be particularly popular with the dashing young Austrian officers; one of the secrets of her success was that she loved to dance and refused no one, so that no partner felt slighted or rejected. (Sometimes this led her into trouble, as one evening when "I danced so much, indeed I could not help myself, that my big toes have been sore ever since.")[20]

John had observed her carefully and believed he could trust her anywhere, which in fact he could; Effie's innocence protected her. Other people were surprised by the unflagging decorousness of her conduct, but she understood that one misstep could spell her downfall. In her letters home she used one adjective again and again to describe herself: "well-behaved."

But the pressure on her mounted as time passed and the young officers crowded in, demanding her attention and seeking greater intimacy. They began to presume on her good nature. A Count Wrbna, who was mad about her, came to see her virtually every day for months. During Carnival she realized she was exhausted; worrying that her always delicate health would break down, she decided to go out only once in a while at night and to stay home quietly by herself during the day, so she instructed her servant to turn away all visitors who called. The count was "dreadfully offended" and applied for special dispensation to call. Surprised and annoyed, Effie pointed out to him how rude it would be if she made an exception. Trying to insinuate himself, he argued that she should permit him because "I like you as much as all the rest put together." First she lost her temper; then he lost his, stalking off and fuming that he would revenge himself. She threatened him flirtatiously: "What, will you send for your 1,500 men to keep me in order?" But she ended the confrontation primly, bringing him up short: "I told him not to talk such *bavardages* because his *amour propre* was hurt."[21]

The climax of Effie's social career in Italy was a ball held to mark the end of Carnival in 1852. On her first visit to Venice she had written home that she was determined to get a glimpse of Field Marshal Radetzky, the commander of the Austrian forces of occupation in Italy and a "decided lion." At last she was formally presented to him, at a ball that he gave in his palace at Verona. The marshal, who at eighty-six was still bursting with energy, had heard a great deal about this appealing young woman from his junior officers, and he was delighted to see that she lived up to his expectations. Effie was flattered when he took her by the hand and presented her to

Archduke Charles Ferdinand. To complete his courtesies, he led her to the other end of the room, where he introduced her to his wife, Countess Radetzky: "I talked with her till Count Festitics came with some half dozen of his children as he calls his officers and I was soon dancing away with people of all nations and tongues."[22] When the marshal and the archduke pronounced Effie *"la reine du bal,"* she could not have been more pleased.

<div align="center">⟨⟩⟨⟩⟨⟩</div>

From this height, Effie's winged chariot crashed to the ground. She had been living under the illusion that John's parents were her only critics. She did not know that John had subtly stoked the fires of his parents' disgust by writing letters that trivialized and condescended to her, even when he appeared to be defending her. He not only failed to hide his callousness; he almost reveled in it: "I am always either kind or indifferent to Effie — I never scold — simply take my own way and let her have hers — love her, as it is easy to do — and never vex myself — if she did anything definitely wrong — gambled — or spent money — or lost her character — it would be another affair — but as she is very good and prudent in her general conduct — the only way is to let her do as she likes — as long as she does not interfere with me: and that she has long ago learned — won't do."[23] It was damnation with faint praise. John's benevolence reminds one of a somewhat remote, if friendly, colonial power discussing the colonized. For him, the marriage had become largely a formality.

By post John and his parents had been quietly hatching plans for the young couple's return to England. The lease at Park Street had been given up, and in February 1852 John announced to Effie that his father had rented another house for them and was paying to furnish it. The new house, at Herne Hill, was a short carriage drive from Denmark Hill and a very long carriage drive from the West End, where most of Effie's friends lived. It had also been decided that Effie would no longer have a carriage of her own. The prospect of such isolation, after all the activity in Venice, depressed her, and she resented the fact that she had not been consulted. Most disturbing, though, was John's response to her objections. She wrote to her mother that "John said he *never intended as long as they lived to consult me* on any subject of importance as he owed it to them to follow their commands implicitly. . . . John, as long as I never interfere, is kindness itself to me were that all that one wanted."[24]

Effie tried to enjoy her last weeks in Italy. Her health had improved there, and she had known a simple freedom that she knew she would lose in London. Wistfulness is mixed with pleasure in her account of an evening she spent on the water just before she left: "It is so delightfully warm now that I feel much stronger and better. It is to me real comfort to plunge into the sea which is quite warm and roll about for twenty minutes and dress myself in the evening in a muslin frock with one petticoat, no stays and chemise only, and go out in the open boat on the water where is always a little breeze, and the beauty of the place was never seen to such advantage."[25]

Even John was aghast when he saw the house his father had rented for them. Mr. Ruskin had given a decorator the enormous sum of two thousand pounds and free rein to furnish the place, and the rooms had been filled with hideous, cheap new goods. Effie suspected the decorator had pocketed at least half the money. John, horrified that a person of his refined sensibilities would have to live with such trash, declared the house fit only for a clerk and announced that he would be too embarrassed to invite his cultured friends to visit. Effie remained calm and tried to reconcile John, but he would not be mollified; instead, he simply began spending most of his time at Denmark Hill. Since the couple were economizing and thus had no cook, they dined with John's parents each evening anyway, and John claimed that he had to work in his old study during the day because the light was ideally suited to the examination of prints and drawings. He returned to Herne Hill only to sleep, and so Effie became less a wife than a figurehead, sitting alone in the silence of her tacky suburban villa.

She grew increasingly resentful of the way John's parents monopolized him. They were constantly meddling as well, particularly in the conduct of her social life. To her mother she wrote: "The Ruskins are bothering me now because I won't visit at all without John or go to balls alone. How is one to please them?" If she went by herself, she was criticized for spending money on hired carriages. If she didn't go out, they said it was her fault if she lacked for society. "I may go wherever I like or do what I choose provided I don't *degrade* John by taking him into society. In fact, they don't care any of them what becomes of me or what I do so that they are left to enjoy themselves selfishly alone." At her wits' end, she said: "I think of sending all my invitations to DH [Denmark Hill] to be decided upon. . . . They will be kind to me but then I must be their slave in return. I must

praise them as three perfect people and be treated as a fool or a child, whichever suits me best, but then I must never complain or else get a torrent of insults in return."[26]

Effie was not quite so innocent as she represented herself. She had in fact aired her resentments to a number of friends, complaining about John's inattentiveness and lack of consideration for her. She too was beginning to build a case against her spouse and to gather her allies in case of a struggle.

This dreary round of petty oppressions and annoyances was broken by a pleasant distraction when Millais asked Effie if she would sit for him for the central figure in a painting he was doing for the Royal Academy Exhibition of 1853. Both John and Effie were flattered by the painter's choice of model, and Ruskin was delighted to find that he could help his young friend, who would in turn keep Effie out of his hair while he finished *The Stones of Venice*.

Effie looked forward eagerly to the hours she spent in the studio; it was a treat for her to be part of something, to feel useful. Millais chatted as he painted, which made it easier to endure the long hours of sitting immobile, and he discovered the charm of her company. Soon he too was looking forward to their sessions. For a change, Effie wrote home with a bit of good news: "These last days I have been sitting to Millais from immediately after breakfast to dinner, through all the afternoon till dark which gave me not a moment, and now I am rather tired and a stiff neck but I was anxious to be as much help to him as possible as the whole importance of this picture is in the success of the head. . . . He found my head like everyone who has tried it immensely difficult and he was greatly delighted last night when he said he had quite got it. The features are at once so curious and the expression so difficult to catch that he wanted — half a smile. He says he is to do me for another picture next year for another kind of expression. He paints so slowly and so finely that no man working as he does can paint faster. . . . He says nobody has painted me at all yet, that the others have cheated themselves into making me look pensive in order to escape the difficulties of colour and expression." (She did have an odd face, by no means conventionally beautiful. Heart-shaped, with a pointed chin and extremely wide at the cheekbones, it had almost an Oriental cast, which Millais captured.) Effie was pleased with the portrait when Millais let her see it, and tried to mask her pleasure by joking that it was "absurdly like."[27]

The Order of Release shows a tall, sturdy woman wrapped in a huge shawl and carrying a sleeping child. She stands at a prison gate, handing the jailer an order to free her husband, a Highlander who was taken captive in the civil wars. This figure stands before her, bending to rest his weary head on her shoulder as he clasps one of her hands.

When the canvas was exhibited in the spring of 1853, it was a tremendous success with the public. John's servant reported to Effie that it was "hardly possible to approach it for the rows of bonnets."[28] For the first time in its history, the Royal Academy had to hire a guard to protect a painting and to direct the crowds who pressed in to see it. *The Order of Release* was just the sort of highly realistic, straightforward story picture the Victorian audience delighted in, and its theme played to the Victorian preference for powerful madonna figures who could protect and defend the wounded male ego. Knowing a bit about Effie and her husband, one has to ask whether Millais painted an allegory of their relationship, consciously or not. He may have sensed Ruskin's frailty, perceived Effie's fundamental strength, and jumped to the conclusion that she was the pillar on which Ruskin rested.

In any case, the picture pulled all the right heartstrings, and the crowds loved it. Even the art press praised it. Some critics expressed the hope that it marked the end of Millais's dangerous dabbling with those fantastic Pre-Raphaelites. Only *Blackwood's* tore into it: "Her face, instead of being lovely, is plain to a degree; and if it be true that he had a certain model, this is really inexcusable, and is a proof that Mr. Millais has no perception of beauty whatever." This reviewer felt that the heroine of such a picture should be beautiful, soft, weepy, and gentle; it did not occur to him that the woman might have needed some grit to obtain her husband's release. "Instead of the eye dimmed even with a tear, it looks defiance. . . . Instead of tenderness, she is the hardest-looking creature you can imagine. Her under lip — and both are as red as peonies — is thrust out to a very disagreeable expression." In summary, he dismissed her by quoting "a friend of ours" who remarked aloud what no one else had ventured to say: " 'I would rather remain in prison all my life, or even be hanged, than go out of prison to live with that woman.' "

Around the time of the exhibition, John proposed that Millais, Millais's brother William, and Holman Hunt should accompany him and

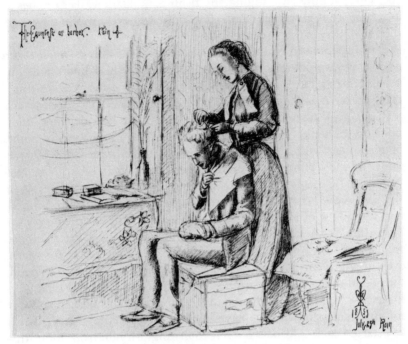

John Everett Millais • *Countess as Barber*

Effie on a holiday in the Scottish Highlands. The prospect of getting away from London was a relief to Effie, who packed with great enthusiasm an enormous hamper of sherry, tea, sugar, and other provisions, since, as she told her mother, it sounded as if there might be nothing but trout to eat at the other end.

Hunt declined the invitation because he was preoccupied with Annie Miller, but by the ninth of July the rest of the party had encamped in rented rooms in a schoolmaster's thatched cottage at Glenfinlas, a remote Highland spot to the west of Perth. The schoolmaster and his wife were amiable folk who charged them only one pound a week per person for room and board. Space was short, as Effie wrote to her mother: "John Millais and I have each two little dens where we have room to sleep and turn in . . . and John [Ruskin] sleeps on the sofa in the parlor."[29] At first the congestion didn't bother them, because they were spending every possible moment outside. Ruskin wrote to his father: "We have been out all day again sitting on the

rocks — painting and singing and fishing. William Millais catches us a dish of trout always for breakfast, and we have a picnic dinner on the rocks beside the stream."[30]

Writing home to Hunt, Millais praised the Ruskins as "*most perfect people,* always anxious and ready to sacrifice their interest in our behalf. She is the most delightful unselfish kind-hearted creature I ever knew, it is impossible to help liking her — he is gentle and forbearing."[31] At night he and Ruskin stayed up late, debating questions of aesthetics and painting technique. They found many points of agreement, and soon Ruskin had enlisted Millais to draw illustrations for the lectures he would be delivering in Edinburgh in November.

There were just two flies in the ointment: the inevitable Scottish rain and a lack of fresh fruits and vegetables. Effie chortled over the "groaning" of her "gentlemen" and evidently enjoyed the chance to spoil them. She was willing to perform any little office for them, even down to cutting Millais's hair. But when she wrote to a friend, she poked fun at their absurdities: "At breakfast, Everett Millais says to his brother, 'Well, William, there's nothing but rain here and the summer is passing and we have not had a single strawberry.' [Effie had started calling Millais Everett to distinguish him from John Ruskin.] 'Yes,' replied William, 'but only think of the lamb without mint sauce or vegetables. I suppose the peas are ready here about Christmas,' therefore I was ordered to open communication with a greengrocer at Stirling for the supply of the artistic table. These are the gentlemen who actually live on hotchpotch, fruit tarts, broiled trout for tea and the richest cream, milk, eggs, everything of the very best — but who [talk?] in an ideal manner of the necessity of living on beef sandwiches which they make a resolution every second morning to dine upon with nothing for their drink but the torrent water."[32]

Although Millais had planned to do nothing but rest on this holiday, he decided to amuse himself by painting a portrait of Ruskin. Behind the cottage was a waterfall that poured over some interesting rocks — just the sort of intricate geological formation that Ruskin loved to sketch — which would make a wonderful background. While he waited for the canvas he had ordered to arrive, Millais did a tiny picture of Effie sitting on the rocks, and the two of them began spending much of the day alone together, sliding easily into the gentle intimacy that had grown up between them when she sat for *The Order of Release.*

Effie began to tell Millais about herself and her family, about her

childhood in Perth, about her adoring parents. She told him about the seven brothers and sisters who had died, and as her trust grew, she told him a bit about her marriage and why it perplexed and worried her. She had long hesitated to say much to anyone, even her family; knowing that something was amiss, she had not even been sure what questions to ask. Now she sensed in Millais a sympathy and a delicacy that encouraged her to be bold. She blamed her problems with John almost entirely on his possessive parents. Warming to her subject, she told Millais how John had planned to take his parents along on the honeymoon, and how he had left her at Bowerswell with her parents for nine months, ostensibly because she was too ill to travel. Finally she confessed that her husband believed she was not of sound mind.

To Millais, listening to this distraught young woman, her face clouded over with misery and anger and embarrassment, it began to sound as if Ruskin was the one whose sanity might be in question. Having already observed little signs that made him uneasy, he began to watch Ruskin more closely. He found Effie a most charming and intelligent companion and wondered how Ruskin could take for granted so attractive a wife. Something didn't add up. He began to ask a few discreet questions, and before long Effie's deeper fears and grief were tumbling out in a confused rush.

There were no children, and she didn't think there ever would be. She wanted babies, but John hated them; he thought they looked like so many lumps of putty. John had a hundred reasons they must not have children — they must live as purely as angels, he must not mar her beauty, if she were pregnant they could not travel. Millais began to understand, but he could see that Effie did not.

Effie was enormously pleased with her confidant, who did his best to reassure her about herself, to let her know that she was a healthy, normal human being with natural needs and desires. Sharing her troubles made them seem less overwhelming, and the novel, radiant awareness that was growing between them from hour to hour cheered her in a way that nothing had for years. She felt Millais's protection spread around her like a warm cloak, insulating her from her pain.

To please Effie and to give himself another reason to spend time with her, Millais began to give her drawing lessons. Soon he was lavishing praise on her in letters to Hunt: "Mrs. Ruskin . . . gets on in a manner reflecting great disgrace on me for having been so long before painting as I do now. She has drawn and painted some flowers

in oil (the first time she has ever touched a brush) almost as well as I could do them myself. If it was not for her being such a captivating person I should feel disgusted with such aptitude."[33] Ruskin was not oblivious of what was happening, but he had seen many young men fall in love with Effie, and he assumed that she would let Millais down lightly, causing him as little pain as possible. Happy to see her talent burgeoning, he wrote home: "Millais has taught her to draw portraits — and she has done wonderful things already of us all — and works hard all day nearly — she is so pleased at finding that she has this power."[34]

In the evenings when the weather was fine, the quartet ate their trout out on the rocks, and afterward Millais and Effie walked in the woods while John and William Millais worked on the dam they were building across the stream. Later people speculated that Ruskin had schemed to throw his protégé and his wife together so that they would fall in love and disgrace themselves. It is certainly possible that he did — Ruskin was capable of intricately devious behavior — but it seems unlikely, since he stood to lose not only his wife but also his treasured new friend. Chances are he just enjoyed the simple activity of building a little stonework; physical labor was as novel to him as friendship. Over the years he had had plenty of Effie's company, and now he was relieved to let Millais entertain her.

But as Millais saw more and more plainly how Ruskin ignored his wife, and as he fell more deeply in love with her, he grew angry at this neglect and even angrier at his own impotence to do anything about it. Paying too much attention to Effie could lead only to trouble. Living at such close quarters, sleeping just a few feet away from his beloved and her husband, became a sort of purgatory for him. Effie was also uncomfortable, but she had spent years getting accustomed to the strains and unhappiness of her marriage. The feelings stirring in her were delicious and new, but she knew they could be no more than a passing pleasure. Divorce was not a possibility; it was virtually unheard of, and extremely difficult to secure even when a couple desired it.* If a woman left her husband, social ostracism was inev-

*Women were at a tremendous legal disadvantage, since they were classed with children, criminals, and minors, and had no rights to speak of. Until 1857 marriages could be ended only in ecclesiastical courts, and grounds for severing a union were precious few. After 1857, when the Matrimonial Causes Act eased the situation and moved divorce into the secular courts, divorce remained a luxury only the rich could afford. Until 1900 fewer than a thousand divorces a year were granted in Britain.

itable — a painful consequence for so social a being as Effie, and one that Millais as a gentleman could not consider asking her to contemplate.

When Millais could no longer hide his unhappiness, he seized on Hunt's imminent departure for the East as a pretext. The prospect of not seeing his closest friend for several years was genuinely distressing to him, but it also served as a useful channel for all his desperation. Grief about losing a friend was an eminently honorable emotion for a gentleman to experience, whereas grief caused by coveting another man's wife was not a feeling he could permit himself. Before long Millais's feelings about his friend's journey became wildly distorted. He wrote to Hunt: "I quite hate the thought of your leaving me positively friendless. . . . I do believe you will never see me again if you stay away long. I have at night dreadful wakefulness and the most miserable forebodings. . . . You will find all this very weak but I don't profess otherwise. . . . I don't believe there is a more wretched being alive than the much envied J. E. Millais. . . . Goodnight you runaway."[35]

In his letters he also told Hunt a good deal about what was passing between himself and Effie, seeking advice and consolation. Years later Hunt's second wife spent many hours censoring these letters, but one passage that betrays Millais's disgust at Ruskin's sexual fecklessness slipped through, perhaps because Mrs. Hunt was unconscious of its implications: "His [Ruskin's] great hobby now is illuminated Twelfth Century drawings, dragons passionately biting their own persons and bodiless fiddleplayers and hooded jesters terminating into supple macaroni — you know the kind of thing, the colour delicately pretty."[36]

Ruskin grew alarmed at Millais's state: "He paints till his limbs are numb, and his back has as many aches as joints in it. He won't take exercise in the regular way, but sometimes won't or can't eat any breakfast or dinner, sometimes eats enormously without seeming to enjoy anything. Sometimes he is all excitement, sometimes depressed, sick and faint as a woman, always restless and unhappy. I think I never saw such a miserable person on the whole. . . . The faintness seems so excessive, sometimes appearing almost hysterical."[37] Accepting Millais's official reason for his condition, he wrote to Hunt on October 20 to try to dissuade him from going to the East. By now he saw that Millais had lost patience with him, although he was not sure why: "Here is Everett lying crying upon his bed like a child — or rather with that bitterness which is only in a man's

grief. . . . I can be of no use to him — he has no sympathy with me or my ways . . . he has nobody to take your place."[38]

Millais confessed to Hunt that he had begun to dream about turning celibate as a way of finding comfort in a life that sickened him. Ruskin was thinking along the same lines; Effie testified later that John asked her at about this time whether she would consent to an agreement whereby she would retain the name Mrs. Ruskin and receive eight hundred pounds a year and he would go to live in a monastery. She refused the offer: It would have left her in limbo, condemned to be Mrs. Ruskin forever, without even the semblance of a husband.

The dam of Effie's anger, built so carefully over many years, gave way now under the pressure of her feeling for Millais. Faced with the fact that she could never have any sort of life with the man she loved, she turned her frustration on the man who stood in the way and finally confronted John about the failure of their marriage. Later he wrote: "Her feelings of affection towards me appeared gradually to become extinguished and were at last replaced by a hatred so great that she told me, about the end of September or beginning of October 1853, we being then in Scotland, that if she ever were to suffer the pains of eternal torment they could not be worse than going home to live at Herne Hill with me."[39]

Something happened to rip the surface of the threesome's mutual civility and forced Ruskin to see that things were not as innocent as they seemed. There is no record of the actual incident — it may have been an embrace, a kiss, a letter left out on a table, or just a few ill-considered words — but afterward Effie mentioned to her mother that she wanted to avoid a "fresh scrape."[40] Whatever it was, all three decided to sweep it under the carpet, although by now they must have longed for some sort of escape from their unhappy triangle.

Instead they went about their business. On October 26 John and Effie traveled to Edinburgh so John could prepare to deliver his lectures, and Millais stayed behind to continue work on his picture. He planned to paint in the figure of Ruskin after they returned to London, but both he and Ruskin felt that he should adhere to Pre-Raphaelite theory and finish the background of rocks and waterfall in Glenfinlas. By now putting theory into practice was becoming nightmarish to Millais. He was so overwrought that he wrote to tell Hunt that he feared the bad weather might kill him.

Given his state of mind, it is not surprising that Millais left Glenfinlas on October 28, just two days after the Ruskins' departure. Despite the rift, Ruskin still cared deeply for Millais, and sensing his

friend's misery, he sent his manservant to bring him to Edinburgh. Millais stayed there a few days, then went briefly to Perth, where Effie had gone on a visit to her family. He returned to London still hopelessly in love, and resolved to go out to join Hunt in Cairo in order to put a great, safe distance between himself and his beloved.

Millais had another, urgent reason for getting back to London. On November 7 the Royal Academy held its elections, and he was standing for Associate. The powerful dealer Ernest Gambart had offered to pay him twice his price for every picture he painted if he would boycott the Royal Academy and give Gambart first rights of exhibition, but Millais was not tempted. He recognized the dangers of dissent, and saw no point in making a martyr of himself. In fact, he was so anxious on election day that he asked his brother William and his friends Wilkie and Charles Collins to keep him company on a long walk in the country, to try to help him calm down. He needn't have worried. The Academy finally acknowledged Millais's gift, despite his heretical technique, and Gabriel Rossetti wrote to his sister on the following day "so now the whole Round Table is dissolved."[41]

Meanwhile, Ruskin's lectures in Edinburgh were a huge success. Each one was attended by at least a thousand listeners; many spilled out into the hallway, and the room was so jammed that people fainted and had to be carried out. Effie's energies were consumed by entertaining friends and family who attended, arranging for seats so that no one was slighted. John's parents decided not to come, largely because they did not approve of his lecturing. Having failed to attend his wedding, they now missed his first important public appearance. Mr. Ruskin rationalized their choice in a letter to Mrs. Gray: "Our feelings would have been agitated," and consequently, "John knowing our anxiety might have been disturbed himself."[42]

Afterward John stayed on at Edinburgh while Effie went to her family at Bowerswell. He asked his parents' permission to pursue a course of throat massages recommended by a Dr. Beveridge to relieve his persistent headaches. Every day for a month Beveridge rubbed the skin on his neck raw, but John was happy as a clam. Without Effie or his parents to hound him, he was productive and peaceful. During this month he seems to have faced the failure of his marriage; he became almost dispassionate about it, writing to his father: "When we married, I expected to change *her* — she expected to change me. Neither have succeeded, and both are displeased."[43]

By the middle of December, John and Effie were traveling down to London, bringing Effie's ten-year-old sister, Sophie, with them. At about the same time, Millais wrote an extraordinary letter to Mrs. Gray, whom he had met for the first time only a few weeks earlier. Obviously Effie had told her mother she was in love; Millais did not duck the issue. "My dear Mrs. Gray . . . Believe me *I will do everything you can desire of me,* so keep your mind perfectly at rest. . . . I will never write again to his wife, as it will *be better,* and will exclude the possibility of his further complaining, although sufficient has past [sic] to enable him to do so, at any time he may think fit. One is never safe against such a brooding selfish lot as those Ruskins. His absence in the Highlands seemed purposely to give me an opportunity of being in his wife's society — His wickedness must be without parallel if he kept himself away to the end that has come about, as I am sometimes inclined to think. Altogether his conduct is incomprehensible — he is either crazed or anything but a desirable acquaintance. The *worst of all is the wretchedness* of her position. . . . I consider Ruskin's treatment of her so sickening that for quietness' sake she should as much as possible prevent his traveling, or staying a summer in company with a friend, *who cannot but observe* his hopeless apathy in *everything regarding her happiness.* I cannot conceal the truth from you, that she has more to put up with than any living woman."[44]

Millais was by now somewhat hysterical, but Effie was truly suffering. She had developed a painful facial tic that made it impossible for her to appear in company much of the time, and even Ruskin commented upon her distress. "She passes her days in sullen melancholy," he wrote to her mother, "and nothing can help her but an entire change of heart."[45]

Effie made one last stab at effecting a truce at the New Year, but her letter home revealed that things had already gone too far: "I told John I wished to have a conversation with him as I did not wish to begin another year in this uncomfortable state and that I merely wished him to know that one of his objections to my conduct was not helping him in his work and that he must understand that I was quite ready to do anything he might desire and help him in his work — I took all the hard things he said to me and which it is useless repeating. You may be quite sure I will try my best with them and everything I do will be well weighed one day, but it is a hard trial to know that I am all day long considered by them all as a maniac in the house." She made a pathetic appeal for her parents' sympathy: "I do not think you will hear anymore about my affairs from me. I have now nothing

more to tell and you cannot expect that I will ever be happy."[46] She was begging for help, but her parents did not know what to do.

Effie's sister's tender age did not protect her from being drawn into the fray. Everybody used Sophie. When she visited Denmark Hill, John and his mother plied her with criticisms of Effie. Millais, who was painting the girl's portrait, seized the sittings as a chance to garner news of the older sister he had vowed not to see. When Sophie returned home from either place, Effie pumped her, either for the latest outrages issuing from Denmark Hill or for news of her lover.

In the last week of February, Effie wrote her mother a lengthy letter in which she detailed the shocking things that John and his mother had been telling Sophie. After a disturbing scene in which the child had walked into John's study to find "his mother fondling him and going on in her usual way," Sophie had broken down and told Effie that all three Ruskins had been using her as a confidante. "The baseness of their line of action is something perfectly astonishing, Mr. and Mrs. R openly telling her everything that could lower her opinion of her parents and flatter herself, Mrs. R kissing her and saying she wished she could have the charge of her — for her mother was a weak, ignorant woman and I, a poor, silly creature, simply raised into respectability by my husband's talents — that I thought myself very clever and that people made much of me but . . . I was merely a Scotch girl with bad manners. . . . John's revelations are much more serious, and I think it is perfectly disgusting his trying to corrupt Sophie's mind by such disclosures, and I am sure my father and you will be filled with indignation at such unmanly conduct."[47]

John certainly had given Sophie an earful. He told her that as soon as Effie returned from a proposed trip to Germany, he was going to institute a course of treatment intended to break her spirit. He confided that his friends had warned him not to marry Effie, but that she had ensnared him with her advances, just as she had Millais. He added that he was going to write a book about Effie's shocking conduct and obtain a divorce from her. This was about as much as Effie could stand. After writing to her parents for advice about what to do with her overburdened little sister, she sought out her friend Elizabeth Eastlake for sympathy and advice.

Elizabeth Eastlake, the wife of Sir Charles Eastlake, President of the Royal Academy, was an art critic. She was also the daughter of an obstetrician. Over the past couple of years she had drawn Effie out enough to confirm that she was still a virgin, a fact of which Effie herself was only hazily aware. She was fond of Effie and had

brooded over the fact that her young friend was trapped in a loveless marriage. Eventually she delicately explained to Effie what she was missing and why she was not bearing children. She also counseled her to tell her parents.

But pride and modesty kept Effie silent on this score. A sense that she had been cheated by a husband who blamed her for the failure of their marriage grew in her; a sense that she could not do anything to remedy the situation left her feeling helpless and furious. The most she was able to do was to drop a broad hint to her parents, attacking all the Ruskins: "I do not know what on earth they are such fools for, especially John, as were it not for the pain of exposure I have him most completely in my power."[48] Millais, too, wrote to the Grays, imploring them to act: "*Something must be done by you* if she continues to be martyred, as it is *grossly sinful* to permit matters to stand as they do."[49] Remarkably, it seems the Grays never did draw the obvious conclusion, in spite of such hints.

For the first time Effie allowed herself to mention the possibility that the marriage might break up: "I suppose by the autumn something will be done by the Rs — do not think any manifestation will come from me."[50] She still saw herself as a passive figure in this drama; a lady had no right to end her marriage. Four days later she was writing: "These trials have been for seven years nearly. . . . it is better that they should have an end before either these people kill me or lead me into a scrape."[51] Death and "a scrape" were equally hideous prospects, and in fact the exclusion from society that would follow her misconduct must have seemed a sort of suicide.

On March 7 Effie's nerves finally snapped, and she sent a letter to her father telling him the truth and imploring him to rescue her: "You are aware that since 1848 [the year she was married] to this last year I have never made any formal complaint to you. There were many reasons for my silence, the principal being of course my great love for you and my dear mother. . . . to come to the present moment, when even now I was unwilling to tell you all, fearing your anger against John Ruskin who has so illtreated and abused me, and his parents who have seconded him, although so far they are innocent, not knowing the gravity of the offense with which I charge him. . . . I have therefore simply to tell you that I do not think I am John Ruskin's wife at all — and I entreat you to assist me to get released from the unnatural position in which I stand to him. To go back to the day of my marriage, the 10th of April 1848. I went as you know away to the Highlands. I had never been told the duties of married persons

to each other and knew little or nothing about their relations in the closest union on earth. For days John talked about this relation to me but avowed no intention of making me his wife. He alleged various reasons: hatred to children, religious motives, a desire to preserve my beauty, and finally this last year told me his true reason (and this to me is as villainous as all the rest), that he had imagined women were quite different to what he saw I was, and that the reason he did not make me his wife was because he was disgusted with my person the first evening 10th April. After I began to see things better I argued with him and took the Bible, but he soon silenced me and I was not sufficiently awake to what position I was in. Then he said after six years he would marry me, when I was twenty-five. This last year we spoke about it. I did say what I thought about it in May [on her twenty-fifth birthday]. He then said, as I professed quite a dislike to him, that it would be *sinful* to enter into such a connection, as if I was not very *wicked* I was at least insane and the responsibility that I might have children was too great, as I was quite unfit to bring them up. These are some of the facts. You may imagine what I have gone through — and besides all this the temptations his neglect threw me in the way of. If he had only been kind, I might have lived and died in my maiden state, but in addition to this brutality, his leaving me on every occasion — his threats for the future of a wish to break my spirit. . . . I don't think, poor creature, he knows anything about human creatures — but he is so gifted otherwise and so cold at the same time that he never thinks of people's feelings and yet with his eloquence will always command admiration. . . . All this you must consider over and find out what you can do."[52]

There was no ignoring such a call to action. Mr. Gray decided to travel to London to talk to Mr. Ruskin in person; meanwhile, Mrs. Gray turned to Millais, on whom she depended to ensure her daughter's happiness. He replied: "I confess in spite of the distress it must occasion that I am glad that you know all. You will better understand now how all the Highland affair came about, and how little right Ruskin has to complain of her conduct. I think the most generous way of looking upon his behaviour is to believe him partially out of his mind."[53]

Life at Herne Hill was becoming intolerable. Effie's struggle to maintain a semblance of calm only increased John's hostility. He had been threatening to forbid her the trip to Germany when, to steal his thunder, she announced she wasn't going. Effie reported to her mother that he had said her "insolence was unpardonable and that the only

thing for me was a good beating with a common stick."[54] There is no evidence that he ever made good on this threat, but one disturbing fragment of a letter survives. On March 30 Effie wrote to her mother: "These two or three mornings I have come down quite exhausted for John has found out a new method . . . "[55] The rest of the page has been carefully torn away.

Although both John and Effie were trying to keep up appearances, Effie was scared: "His extremely bland manners, and his actions so opposite, render him most dangerous."[56] Mr. Gray was determined to speak to Mr. Ruskin as soon as possible, but Effie, realizing that a resolution could not be rushed, begged him to proceed with caution: "It appears to me still that it would be *very* premature to go to Mr. R the very afternoon of his arrival. My affairs unhappily cannot be disposed of so quickly and will require mature deliberation. . . . This is the most important event of my life upon which all my future depends. Everything now is but a choice of evils."[57]

Four days later, on her sixth wedding anniversary, Effie felt she could wait no longer. "You really must come here," she wrote to her parents. "I think when . . . things begin to be arranged it would be most improper for me to be here alone as I am quite afraid of John and you do not know what he might not do." (One possibility was that he would force her to consummate the marriage before she could escape, and so deprive her of the legal grounds for breaking the marriage contract.) She closed this letter by recalling: "This day April 10th six years ago I was preparing for my marriage — and my mother was dressing me for the ceremony! I thought to be very happy — I do not know if I shall get over all this."[58]

~~~~~~

Mr. and Mrs. Gray arrived on the evening of April 14, 1854, and took lodgings in Bury Street, St. James. Mr. Gray had decided to seek legal advice before making a move, and the solicitor he retained counseled against seeing the Ruskins at all. Instead, he advised, Effie should return to Perth as quietly as possible, as if she were going home for a routine visit. The solicitor explained that she had grounds to sue for an annulment but that first she would have to submit to a doctor's examination to certify her virginity.

Millais managed to pay a quiet visit to the Grays. He also sent a letter of support, shoring up their faith in the drastic action they were taking: "She can have *nothing to blame herself for, and with that knowledge should go bravely through it.* It is only the wretchedness of society that

makes us attach so much importance to disclosures of the kind, making thousands endure a slow, inward martyrdom for years rather than suffer a temporary exposure of facts."[59]

Effie's escape was as carefully planned and executed as any covert operation in a spy novel. On the morning of April 25, Ruskin escorted her and Sophie to King's Cross so that they could catch the 9:30 train to Perth. Mr. and Mrs. Gray were waiting at Hitchin, an obscure station just outside London where the train was scheduled to make a two-minute stop at 10:10. Sophie had been kept out of the plot so she couldn't spill the beans, and as the train pulled out of the station Effie quickly explained to her what was happening. In a letter to a friend, Effie described the sequence of events: "Twenty miles out of London my father and mother were waiting. Sophie jumped out to her father, and Mama came in beside me. I gave Papa a parcel directed to Mrs. Ruskin containing my accounts and all my keys — they were to be delivered by the lawyer and another gentleman at six at Denmark Hill when John and his father were each to be called out and a paper delivered to each of them."[60] Mr. Gray remained behind to convey this parcel to the solicitor after Effie was safely out of reach; he and Sophie left the following day.

It is hard to know how the news was received at Denmark Hill. Mr. Ruskin's diary entry for April 25 is singularly unrevealing: "Effie went to Scotland — John at six got citation."[61] The package of accounts and keys had been delivered; it contained Effie's wedding ring and a letter from her to Mrs. Ruskin. Quietly but definitely she made her point: "Your son has never made me his wife, or wished to do so, as he at first overcame my judgment, which was ignorant on such points, by a variety of arguments which even showing him the words in Scripture did not refute or cause him to change his opinions in the least about."[62] She was clever to use the Bible as her first appeal to her mother-in-law's understanding. Religious faith ran strong in Margaret Ruskin; it was also one of the few issues on which she and her beloved son had ever seriously disagreed.

Within days the scandal began to erupt. Nobody in society could talk of anything else. Millais tried to reassure Mrs. Gray, predicting that it would be "but a nine days' wonder and it will all be over." He felt that news from the Crimea, where war had recently broken out, would soon take precedence: "One great battle with the Russians will swamp the little talk."[63] He was wrong. A choice local embarrassment proved far more interesting than hundreds of unknown soldiers dying at a great distance, and the story of John and Effie

Ruskin's marriage was warmed and served up daily at dinner parties for months. When the ladies withdrew after a meal, their conversation was a series of heated whispered debates as they discussed marital duties and speculated about how far Effie's flirtations had gone. Gentlemen lingered long over the port to apprise each other of the latest rumors and to talk over Ruskin's "stoneless" state, as Ford Madox Brown bluntly termed it in his diary.[64]

Lady Eastlake undertook to orchestrate Effie's defense and rehabilitate her reputation. She was in a good position to do so — she had a web of powerful friends, which made her a formidable ally, and she also had warmth and shrewdness. With Effie's consent she paid endless calls to a carefully selected group of influential friends, giving them such details of Effie's experience as she felt were necessary to make it clear that Ruskin was the villain in the case. Her object was to convince society to make an extraordinary exception and to overlook the disgrace that attended separation, divorce, or even annulment. She soon had most of her ducks in a row and wrote to reassure Effie, who was tucked up at Bowerswell and waiting nervously for news: "I hear you honoured on all sides, so that I am indeed comforted and relieved of all my burden."[65] She forwarded to Perth letters from sympathetic friends, especially those who promised to call on Effie or to receive her if she came to call on them. She was delighted to report that a Mrs. Murray broke down and sobbed when she heard Effie's story, and Lady Davy, a definite grande dame, hoped to make a dramatic courtroom appearance as a character witness.

This campaign was kind, but Elizabeth Eastlake's concomitant efforts to abuse Ruskin were truly ugly; she worked hard to arouse disgust at his behavior. She did not have great success. There is little record of Ruskin's being turned away at anyone's door, although many of his friends avoided him for some time, not knowing what to say or how to act.

She also failed in one other important objective. As she wrote to Effie: "Sir Charles thinks that the court is ignorant of the matter and that it is as well that our good Queen should know the truth."[66] She asked Effie's old friend the countess of Charlemont, a lady-in-waiting to Victoria, to tell Her Majesty the truth before a garbled version reached her ears — but Lady Charlemont was so afraid of the Queen's reaction that she could not bring herself to speak on the subject.

Effie's friends were more forthcoming; several were sufficiently daring to write directly to her and offer their support. Eleanor Vere Boyle wrote kindly: "I cannot any longer put off writing to you, and

telling my own self, how my heart has been with you through the trials of these past months — ever since I first heard of your painful life (from Lady Eastlake) how I have grieved for all you have suffered, and yet rejoiced that at last you were free and safe from cold and cruel hearts under your father's roof. . . . I always felt as if there were some unhappy mystery about you."[67]

In London, Millais was suffering from the wildest rumors and the ceaseless speculation about his own role in the affair. He heard that Thomas Carlyle was "very boisterous in the question of the *asunder-ing, his judgment is that no woman has any right to complain of any treatment whatsoever, and should patiently undergo all misery*"[68] — but he could not know that Carlyle's long-suffering wife, Jane, was also a virgin. Effie was by no means the only married woman in Victorian London who languished in the maiden state.

Millais reported Carlyle's opinion to Mrs. Gray, adding that he felt it was best for Effie to hear the worst sooner rather than later. He also announced that the scandal was "reaching the extreme limit of invention," so he felt that it would be sensible if he did not see any of the Gray family until it began to wear itself out, to minimize damage to himself and to Effie. Extravagant tales were making the rounds, including a report that Effie would have to plead her case personally before the House of Lords. But Millais was most disturbed by the "barbarous" theory in circulation "regarding my absence from the R. A. walls."[69] He had been unable to finish his portrait of Ruskin and emotional turmoil had made it impossible for him to finish anything else, but the gossips had it that he had been banned from the exhibition for flouting moral conventions and offending the Academicians. If wealthy patrons decided they could not countenance his apparent home-wrecking conduct, his future earnings would be jeopardized. The tide seemed to be turning against Ruskin, but he was afraid to trust the final judgment of a fickle public.

Ruskin, of course, was suffering his own share of humiliation and awkwardness. He put off a trip to Switzerland so that he could go about in public as much as possible, attending exhibitions, writing to the *Times* to defend Hunt's Jesus picture and *The Awakening Conscience,* trying to make a quiet statement that he would weather the storm and continue his work. His father's behavior can hardly have eased the situation for him. Rawdon Brown, a friend from Venice who was in England for a visit, took a perverse pleasure in recounting to Effie a scene that took place when John and his father attended the Old Water-Colour Society Exhibition on April 29, only four days

after she had fled. The two men "were accosted by Mr. Roberts who told them it would be affectation to feign ignorance of what was in the mouth of everybody, etc., whereupon J. R. seems to have admitted the truth of the fact without much explanatory comment, but the father, when Mr. Roberts said what all your friends think of you [Effie], rejoined by vituperating your *temper!* and *extravagance,* saying his son had been entrapped into the marriage and might have married a French countess! (the old gentleman would I think have had plenty of grandchildren *then*) and wound up his discourse with words of the following import: 'Never mind, John, we shall have to pay for it, but we shall at least have you all to ourselves.' "[70]

Effie had further trials to endure before she could obtain the order of release for which she longed. Her first happiness on being safe at Bowerswell did not last. At the end of May she was scheduled to make a trip to London to give a deposition and to certify her virginity for the ecclesiastical court that would hear her case. The prospect of this ordeal brought on a hysterical paralysis: For ten days she was unable to move or speak. Luckily, her physician immediately understood the origins of her problem and was able to reassure her that it had no physiological basis.

On May 24 Effie and her father boarded a Dundee steamer bound for London. Eager to keep her visit a secret, they took the same rooms in Bury Street where the Grays had stayed when they had come to rescue her. Effie was extremely relieved to learn that she did not actually have to appear in court, but in one long day she was subjected to the double embarrassment of giving a deposition and submitting to a gynecological examination.* She told the court's proctor that John had promised to "marry" her when she was twenty-five but that he had failed to do so. The physicians who examined her filed their own deposition: "We found that the usual signs of virginity are perfect and that she is naturally and properly formed and there are no impediments on her part to a proper consummation of the marriage."[71]

The physical examination was enormously stressful for Effie. Not only was she modest; she also feared that the doctor would find that

---

*Vaginal exams were uncommon. Medical students were advised to avoid them; if it became absolutely necessary to perform one, they were counseled to look up at the ceiling.

John had been right all along — that her body was deformed. Ruskin's biographers have speculated that he felt disgust with Effie's person on their wedding night because his only knowledge of the nude female body came from his observation of statues and paintings, which never showed pubic hair. As a consequence, he may have been shocked by Effie's appearance and imagined that her pubic hair was a unique deformity that had been kept secret from him until it was too late. (Apparently he was devoid of the empathic capacity to imagine that his own body might look equally strange to Effie.)

Whatever the reason for Ruskin's behavior, Effie returned to Perth with a sense of relief that the worst was over. While she waited at home for her case to be heard, Millais journeyed back to Glenfinlas to complete the background of his portrait of Ruskin. He had not relished the thought of returning to the scene, but Ruskin — now more Pre-Raphaelite than the Pre-Raphaelites — had insisted: "For a time I intended to finish the waterfall from Wales, but Ruskin did not seem satisfied with this, his notion was the rocks are of quite a different strata there, so I have made up my mind to go back to the old place and have done with it."[72] Nor did he look forward to finishing the figure of Ruskin: "One thing I dread the thought of is Ruskin sitting to me again for the hands. I have been thinking a great deal of him lately, and I am sure many allowances should be made for him, for he is certainly *mad* or has a slate loose."[73] One has to wonder why Millais didn't just drop the picture, but apparently he felt that he had to endure any distress rather than sacrifice his work, and that he owed a debt of honor to Ruskin in regard to the portrait.

In June the Grays took a house at St. Andrews, where they vacationed every summer. Effie enjoyed long walks on the beach and found that she was sleeping better. Her brother George was pleased that her thin face was "getting as round as the moon."[74] (Victorian men always worried when their wives or sisters lost weight, and pleaded with them to try to gain for the sake of their health and beauty. "Fat" was not necessarily an insult, but more often a compliment.)

She still had to be careful: Her nerves were not yet strong, and her facial tic returned under stress. She feared she would be permanently damaged by her marriage but felt lucky to have escaped from it: "I am as much to be envied in getting away instead of dying of misery as many a poor woman has to do who has a worthless wretch to drag on all her days without the possibility of release. I feel so distinctly

also how very much I required all the trials I have had and how peculiarly they were fitted for me. . . . I look at them all as having come entirely from God, this takes away all irritation as to human instrumentality and is the true way of accepting the chastisement of our everlasting protector."[75]

On July 20 a letter arrived, announcing that her case had been heard by the court four months early. An annulment had been granted, and a decree issued stating that Euphemia Chalmers Gray had been "falsely called Ruskin" because the "said John Ruskin was incapable of consummating the same [marriage] by reason of incurable impotency."[76] Effie was overjoyed with the news.

From Switzerland Ruskin wrote to his friend Henry Acland to assure him that he was not upset by this turn of events: "As to the extent of the misfortune itself, I believe I know it to the utmost of its possibilities — and did so at the first hour of its happening, as far as it regards myself only." He also said that he had been trying to understand himself, and had not found it an easy task. "I find it a marvelous hard thing to unbake myself — which I have been trying to do more than usual lately, in consequence of the self-examination I have been led into by this matter."[77]

Millais was in Derbyshire, where he had gone to paint, when he heard the verdict, and he dashed off a letter to Effie: "I have been painting out of doors all day, or rather pretending to paint — so that I might be away from my friends and have some quiet to think upon this wonderful change. . . . This time last year there seemed no more chance of what has happened than that the moon should fall, and now you are Miss Gray again. If you could see me, I am sure you would pity me, for I am scarcely able to write common sense I am so bewildered. I cannot separate you in my mind from what appeared to be your inevitable doom." He wanted to visit her immediately: "How glad I shall be to see you again. . . . I can never be sufficiently thankful for God's goodness to me — I really believe that I should have grown a selfish callous fellow if this alteration had not come about." He asked that she reply by return of post, then hesitated: "If I have done wrong in writing to you, take no notice of my letter beyond asking your mother to write me a word in answer." However, he regained his composure sufficiently to stick a joke into his postscript: "You must now grow so fat that cabmen will refuse to take you as a single fare."[78]

She did write, but refused him permission to come to her, asking instead for time to heal. When half a year had passed and even friends had begun to pressure her to get on with it, she resisted them, writing to Rawdon Brown: "Really I see you will not be pleased till you get me married as you told me — but why all this hurry? . . . Why grudge me my happy security and quiet life now — patience, my dear friend, for I have lots to do first and am very shy."[79] Effie was right; emotionally, she had "lots to do." By making Millais wait — she did not permit him so much as a visit until seven months after the annulment was granted — she was testing him. She had already made one huge mistake by marrying the cold-hearted Ruskin, and she wanted to be certain that Millais had sufficient feeling to wait for her. She was also testing the strength of her own love. No doubt she was secretly afraid of whatever revelations a second marriage might bring forth — and even if her body proved perfect, sexual relations of any kind must by now have assumed daunting proportions in her mind.

Elizabeth Eastlake was one friend who did not pressure her; she saw the wisdom of delay and counseled Effie to resist Millais for as long as she needed to. "Be sure that you do more than enough for him in letting him look forward to the privilege of making you really happy — and let neither his happiness nor misery disturb that rest of body and peace of thought which you so much need. Think only of *yourself* — it won't be *selfishness*. I should better like to have shipwrecked him — with canvas, colours and brushes — on a desert island for two years — but I do not want him yet awhile. I wanted my Effie to be untroubled till she was fit for this life's work again, knowing all the time that the two dear people were safe enough to come together at last. But all is overruled — think of his waving locks as little as you can, and give him just the scantiest parish allowance to keep him from starving."[80]

Early in October Ruskin and his parents returned from Switzerland. Within a week John was writing to Millais that he hoped their friendship would not be ruined by what had transpired — a fond hope that only the most naive gentleman could have entertained. They did meet for sittings to complete the dreaded work on the portrait, however, and by early December 1854 the picture had been finished and delivered to Denmark Hill. Legend has it that Millais posed Ruskin at the top of a flight of stairs and stood below at his easel so that he would not have to speak a word to his model, but the tone of Ruskin's subsequent communications suggests that Millais was civil. He wrote happily to announce that the picture had been hung "in I think the

very light it wants," although he added, in case the artist should fear an implied criticism, "it cannot be said to *want* any light."[81] In fact the portrait is a wonderful record of Ruskin, made by the man who had most reason to study him.

When five days had passed and Millais still had not replied to his thank-you note, Ruskin wrote again. This time Millais rebuffed him bluntly: "I can scarcely see how you conceive it possible that I can desire to continue on terms of intimacy with you. Indeed I concluded that after finishing your portrait, you yourself would have seen the necessity of abstaining from further intercourse."[82] What Ruskin had feared all along had come to pass: He had lost not only his wife but his friend. Shocked and hurt, he replied: "I have to thank you for a last lesson, though I have had to learn many and bitter ones, of the possible extent of human folly and ingratitude. I trust that you may be spared the natural consequences of the one, or the dire punishment of the other."[83]

Freed from the incubus of Ruskin's portrait, Millais was finally able to start a fresh picture for the Royal Academy Exhibition of 1855. Late one night as he and his brother were driving home from a dinner party in a cab, they came upon a fire and watched as two firemen fell from a rafter to their death. Moved by their heroism and inspired by the inherent drama of the situation, Millais began *The Rescue,* in which a fireman weighed down by three children dressed in nightshirts emerges from the flames to hand them into the arms of the desperate mother kneeling below him. Perhaps he was starting to think about wife and children and the need to protect them. Whatever the emotional significance of the painting, Millais had set himself a complicated technical problem — how to paint a wall of flames — and he threw himself into solving it as a welcome distraction from the strain of waiting, endlessly waiting, to see Effie.

Finally, in February 1855, Effie decided to allow her suitor a short, secret visit to Bowerswell. This first encounter, after more than a year of anticipation, was less than a romantic idyll. In January all of the Grays except Effie had been stricken with violent influenza, and she had worn herself out running from one sickbed to the next. Even more worrying, her mother, who was expecting to deliver a fifteenth child in March, had come down with erysipelas, a streptococcal infection that marked her face and head with flaming red patches. (Now treated with antibiotics, it could easily have killed her; in fact, it is a testimony to her hardiness that she survived and delivered her baby

safely.) Consequently, Millais's visit lasted only two days. The weather was very cold, and both he and Effie became ill. They decided it would be best for him to return in the spring when his picture was finished, and then they would be married quietly.

Back in London Millais worked frantically to finish *The Rescue* in time for Handing In Day. He confided to Ford Madox Brown that he had "terribly scamped his picture of the fireman but thought he must send in this year,"[84] because he had failed to do so the year before. Even so, when he discovered on Varnishing Day that his picture had not been hung on the line, he blew up: "I almost dropped down in a fit of rage in a row I had with the three hangers, in which I forgot all restraint and shook my fist in their faces, calling them every conceivable name of abuse."[85] All the anger he had felt during the years when the Academy had condescended to the Pre-Raphaelites came to a head, exacerbated perhaps by his frustration over the long wait for Effie. As an elected Associate, he felt that he could finally assert his authority. The Hanging Committee caved in when he threatened to resign instantly, and moved the picture down several inches to eye level. In a matter of hours the story of how Millais had brought the Academy to its knees was circulating to studios all over town, not least because he was busy repeating it to all his friends. Millais's year of trembling about whether his social transgression would harm his reputation was over.

His faith in his painting was validated when Ruskin praised it without stint. Eager to show publicly that his objectivity had not been damaged by personal loss, Ruskin rhapsodized: "Titian could hardly head him now. The picture is as brilliant in invention, as consummate in execution."[86] But his was not the only enthusiastic voice. Rossetti, who ordinarily eschewed the sentimental, felt that *The Rescue* was Millais's most powerful painting yet.

Millais wrote to tell Hunt about the exhibition of 1855 and his wedding plans for early summer: "Fancy me married, my old boy, I feel *desperately melancholy* about it, which is rather different to most bridegrooms." He and Effie intended to live in Scotland, next door to Effie's parents, because she could not bear to return to London. "I much fear it will never cease to live in her memory, and will always affect her spirits, but time will show. I have so little belief in my own ability to blot out this ruin in her first life that I am often very desponding in the matter."[87]

Ruskin speculated a good deal about this marriage and took a per-

verse pleasure in imagining that Effie would prove her own worst punishment. To a friend he wrote about Millais: "Feeling he had been the temptation to the woman, and the cause of her giving up all her worldly prospects, he may from the moment of our separation have felt like something of a principle of honour enforcing his inclination to become her protector. What the result may be to him I cannot conjecture; — I only know that if there is anything like visible retribution in the affairs of this life there are assuredly dark hours in the distance for her to whom he has chosen to bind his life."[88]

On June ninth, after a stag party thrown by Wilkie Collins, Millais traveled north to spend a month helping with wedding preparations and getting reacquainted with his bride. Soon he was writing to Wilkie's brother Charley to describe his cozy life at Bowerswell, where he was being petted and spoiled. He had settled into the family routines easily, and the Grays were enjoying their first taste of having a companionable son-in-law: "Last night I won *seventeen* shillings at whist with Mr. Gray, who in consequence is very happy."[89]

<center>⚜</center>

On the morning of the wedding Millais was decidedly less confident. He wrote to Charley in a tumble of mixed feelings: "Here is the day at last. I find myself positively *not* in the least nervous, and very happy. I don't see the Countess [his nickname for Effie] until two when we are to be married. . . . Last night I slept well and awoke refreshed this morning, not so with the Countess who had no sleep, and I believe is rather headachy this morning. . . . The room we are to be married in is full of beautiful flowers. . . . A brougham is to be here at three and away we go by train to Glasgow, and down the Clyde. Fancy I have just been writing Mrs. Millais on some directions. I confess I wish all this part was over. I am throwing myself blindly to the waves. . . . I feel feverish, and slightly out of sorts, an exaggerated sensation of going to an evening party at fifteen years of age. . . . This is a trial without doubt as it either proves a blessing or a curse to two poor bodies only anxious to do their best. . . . There are some startling accompaniments, my boy, like the glimpse of the dentist's instruments — My poor brain and soul is [sic] fatigued with dwelling on unpleasant probabilities so I am aroused for the fight."[90]

Effie spent the morning by herself in her room, thinking over her past life and her future with her new husband. When her father came

to take her downstairs to be married, he said, "Come away, my dear lassie, this time I feel happy in putting you into good hands." As she wrote her name on the marriage contract, she thought of that day a year before when she had signed the deposition that freed her from John Ruskin: "I now signed and bound myself by the same signature for life to another with every feeling of confidence and happiness." Nonetheless, she saw that her groom was agitated: "He said afterwards he felt very much inclined to throw down the pen and ask what play he was performing in and refuse to sign." But she "looked on this as the third act happily concluding and leaving the spectators and the actors equally pleased by a conclusion which finished off in the most approved style of the romance or drama."[91]

Once they were alone on the train for Glasgow, Millais's nerves gave way completely, but Effie was equal to the task of cheering him: "Instead of the usual comfort I suppose that the brides require on those occasions of leaving, I had to give him all my sympathy. He cried dreadfully, said he did not know how he had got through it, felt wretched; it had added ten years to his life. . . . I bathed his face with *eau de cologne,* held his head and opened one of the windows, and he soon began to get better." As the train pulled into the station, they pursued the usual strategies for hiding their status: "We were very anxious not to be thought like new married people. I put off my white shawl, put on dark gloves and black veil, and so habited we reached the Queen's Hotel."[92] (Most bourgeois Victorian couples resorted to such ruses — drab old clothes, worn shoes set out in the hall for the porter at night, a show of mundane domestic objects on the bedside table — to hide their newlywed state, no doubt because they felt that all eyes were watching them as they encountered the embarrassing mysteries of sex for the first time.)

From Glasgow the couple set out on an ambitious five-week wedding tour of the west coast of Scotland. The honeymoon started badly in Rothesay, a singularly smelly and squalid town. They fled to Brodick the next day, where they proceeded to have a marvelous time. In a few days Millais was writing to his new father-in-law to boast: "We get on capitally together at this place, and never find a moment heavy on our hands. . . . Although we have been here nearly a week we have scarcely walked out of sight of this inn."[93] Mr. Gray must have breathed a sigh of relief when he read between the enthusiastic lines of this letter.

Sex was a revelation to both of them, and they bloomed. Three

weeks after the wedding, Millais confided to Charley Collins: "I think you will be astonished with my Countess for she is certainly the sharpest woman alive, without being objectionably knowing. She looks really beautiful, and is improved by her marriage beyond all [word unintelligible] so clear and bright in her complexion and looks that I feel quite proud and assured that all boyish timidity will leave me now. At first, I suffered a little from my altered position, but now I feel as if I possessed all the world, and a great deal more. It is a *very great* change becoming really a married man such as one cannot imagine, and very different altogether by [?] my preconceived ideas, but I long to speak to you and not write this — I am surprised at my strength, and wonder at all my absurd misgivings, although they were natural." Looking back, he wondered how he had ever sustained himself without sex: "Nothing will ever convince me that a single man in continual restlessness does better things than a married man who has half the anxiety, *almost* all, taken from him, and enabled to give undisturbed attention to his calling."[94]

He speculated that much of his earlier distrust of women had stemmed from his dealings with professional models, who were more directly sexual; he found Effie's delicacy reassuring. "*I was,* and *you are quite mistaken* in your estimate of women. The life and creatures artists are closely associated with by their profession go far to destroy the just conception of a *ladies'* [sic] *character*. This is very badly expressed, but you will partly gather my meaning, and horrors are conjured up in the mind to sickliness which should not be permitted. . . . and here is all over happily and a wife made as happy as any woman living, *more so* I think. . . . it is such a delight to feel a woman always about one part of oneself, but I cannot describe this."[95]

While Effie did not go into so many particulars, it is apparent from her letters to her mother that she was experiencing something of the same pleasure and relief: "I am so happy with him. You can imagine how much I appreciate his natural character." She confessed: "I really think, if it was not rather wicked to say so, that I would almost go through much misery again. . . . he is so kind and nice and easy to be with."[96] To her brother George she wrote: "He diverts me beyond everything. I don't think I have laughed so much since I was Alice's age" (her sister Alice was ten).[97]

As they relaxed with each other, affectionate teasing became the order of the day. Millais wrote to her father: "The Countess is as good as a daily paper to me for the news I gain through her ever

wagging tongue,"[98] and to her brother: "The Countess is making tea, and eating salad in the most extraordinary style, whole leaves disappearing at a gulp, now she has remembered her duty to me and is making the same for me so that I must finish this letter." He decided to keep on with the letter anyway, but soon: "Effie is blowing me up for writing and eating at the same time, so I must desist. Oh liberty where art thou? I knew thee once a goodly companion, but now I find no freedom of thought or action with this garrulous sister of yours."[99]

After the newlyweds had settled into Annat Lodge, Effie organized the household around her husband's need to concentrate on his work. Her practicality and common sense were a boon to him. During the early years she served proudly as his model, although she found it irksome and uncomfortable at times; she was more successful as a recruiter, rounding up models from the neighborhood. Millais fairly crowed to Hunt: "Effie . . . is the best jackal for her lion husband (I hope this doesn't appear conceited) in the procuring of models you can conceive, going into strange habitations and seizing adults and children without explanation and dragging them here, and sending them back to their homes with a *sixpence* when I should have been doubtful between a sovereign and thirty shillings."[100] When he needed historical costumes for a picture, she did the research and sewed them herself, just as his mother had done when he was younger.

High-strung, Millais pushed himself too hard, so that he suffered continually from nervous exhaustion and crippling headaches. To protect him from himself, Effie arranged occasions for him to relax and nursed him whenever he needed soothing and caressing. It took her nearly three years to convince him that he should rest one day a week, and when he finally did consent to take Sundays off, she observed with pride that his productivity increased.

Effie was willing to try anything to make life tolerable for her temperamental husband, even if it meant suffering his wrath. One evening an extraordinary purple-and-gold sunset made him pick up a stretched canvas and rush to a field by the house to try to capture the colors before the light faded. The picture that resulted, *The Vale of Rest,* shows two nuns in a graveyard, one digging while the other stares directly at the viewer. This latter figure caused Millais considerable torment: "Everything was perfect in the picture except this

wretched female, and nothing would induce her to go right." To put an end to the desperation reigning in the studio, Effie and her mother decided to kidnap the canvas and lock it in the wine cellar. Thinking he had lost the picture forever, Millais panicked; then it dawned on him that a trick had been played. He asked nicely for the return of the painting, he pleaded, he cajoled, he threatened, finally he was reduced to shouting, but the women stood pat. After a few days he turned his attention to other work, all the while remonstrating with them until the "situation at last became comic — Millais furious, the conspirators placid, smiling, but firm."[101] Eventually they quietly returned the picture to his easel, and looking at it with a fresh eye, he saw where he had gone wrong and fixed it in a trice.

<center>❧✤❧</center>

Each year in the spring Millais journeyed down to London to carry his pictures to the Royal Academy in time for Handing In Day. For two or three months he tended to business, meeting with dealers, freshening old contacts and making new ones, exerting himself to sell his work for the maximum price. He still felt insecure about his place in the art world, even though he had been making a good living for years. When critics condescended to his work, he feared that buyers would become wary.

In 1856 he had three substantial pictures to show: *The Blind Girl,* for which Effie had posed; *Autumn Leaves,* a study of four young girls raking and burning leaves, for which Effie's sisters and some girls from the village had modeled; and *Peace Concluded,* depicting an officer's return to his family after the Crimean War. Although the critic for the *Athenaeum* described *The Blind Girl* as "another study of red hair" that "really rather excited our gall," most of the critics were receptive and even enthusiastic, and so were the patrons. As early as April 11, almost a month before the opening of the exhibition, Millais wrote ecstatically to Effie that he had already sold all three paintings for a total of two thousand guineas and "people are as greedy for my things as a pike for minnows."[102]

The following year Millais exhibited two pictures, including *Sir Isumbras at the Ford,* a sentimental painting of an aged knight carrying two ragged barefoot children across a stream on his horse. The horse caused Millais no end of trouble; he spent untold hours painting in the snow while a bitter east wind whistled through his coat, and the damnable horse that served as a model never stood still for a moment.

On the advice of the dealer Gambart he repainted the horse to make it larger; now, to his dismay, the critics howled at the size of the huge black beast. Furthermore, the same reviewers who had praised the tear-jerking *Rescue* denounced this picture as maudlin. Even Ruskin, who had been scrupulously generous to Millais's work since Effie had left him, declared this picture a catastrophe. A young painter named Frederick Sandys seized the opportunity and made a great splash with a comical engraving of a sour Millais wearing a suit of armor and sitting astride a huge, braying ass with J R OXON branded on its rump. Sitting in Millais's lap is Rossetti, wearing a beard and a little girl's dress, and a tiny, bare-legged Hunt sits behind Millais, clinging to his waist for dear life. Prints sold like hotcakes.

Taking Hunt's advice, Millais carted *Sir Isumbras* back to Scotland and repainted the horse, smaller this time. During the next year he worked on four more large pictures, but somehow none of them were ready when it came time to go to London. No doubt he was too discouraged to brave the critics' scorn. Despite their deprecations, however, he was commanding higher prices than all but a handful of living artists.

To ensure a steady income, Millais took on a huge commission for a series of engravings called *The Parables of Our Lord*. The project, which took him six years to finish, represents some of his finest work. He had studied the process of engraving until he understood it top to bottom; his letters to the Dalziel brothers, who commissioned the work, include hundreds of minutely detailed corrections that attest to his pride and skill as a craftsman.

In 1859 Millais brought three pictures to the exhibition: *The Vale of Rest, The Love of James I of Scotland,* and *Apple Blossoms,* in which eight young girls lounge on the grass at the end of a tea party. This year he was determined to accept nothing less than a thousand guineas per picture. Painting the background for *Apple Blossoms* had been a fresh ordeal each spring, since wind and rain dashed down the blooms faster than he could record them; all told, it had taken him four years and much grief to finish the picture. Once again the critics thrashed him, and he wrote home sadly. "The fact of the matter is, I am out of fashion."[103] He warned Effie that they would have to economize, and at his lowest ebb predicted that he might have to take his pictures to New York. For a British gentleman, America was the last resort; debtors' prison was a more appealing prospect to some.

To protect himself the following year, Millais decided to paint an

irreproachable subject. He was moving his family down to London, which would mean a dramatic increase in expenses, so he reverted to a theme that had stood him in good stead so many times before: lovers parted by tragic adversity. In *The Black Brunswicker* a mild young Englishwoman in a dazzling white satin gown presses herself to the chest of an officer from the Brunswick cavalry. (The German Black Brunswickers were nearly decimated at Waterloo, and so, with the benefit of hindsight, the audience would sympathize with this demure virgin, who almost certainly lost her hero on the battlefield.) The painter asked Charles Dickens's daughter Kate to pose for the young woman, which could only improve the picture's reception, and for insurance he added a highly burnished puppy at the lower left, resting on his hindquarters and offering his cute little paws.*

The critics treated this picture coolly at the exhibition of 1860, but the public was wildly enthusiastic. Gambart scooped it up, and gladly paid the thousand guineas Millais demanded. The tide had finally turned; after this year, a thousand guineas per picture became a commonplace for Millais. As soon as he decided to give the public what it craved, his bank balance and his reputation soared, so that by 1863 he was elevated to Royal Academician and became one of the ruling members of the august and rigid body he had disdained as a youth.

Success, however, had its price. Millais felt that he had no choice but to give in to public taste, and complained that he was forced to paint only the broadest, most popular subjects when he painted subject pictures at all. Over the next thirty-five years he cranked out endless portraits, because they were commissions and there was no question that he would be paid.

<center>⁂</center>

While Millais was struggling to establish himself once and for all, Effie was busy having babies in quick succession. Two months after she married, she was expecting. In the fifth month of her pregnancy, she wrote to Rawdon Brown in Venice, mentioning that Millais would be going to London in April to exhibit his paintings and explaining that he "will return here immediately as I will not be able

---

*Years later, when John Guille Millais wrote the official biography of his father, he assured readers that Miss Dickens and the male model had never sat together: "The Black Brunswicker clasped a lay-figure to his breast, while the fair lady leant on the bosom of a man of wood."[104]

to accompany him for a reason which you will be glad to guess easily. I think we shall on that account pass most of the summer here if I am spared we shall move south in the autumn."[105] That tiny phrase "if I am spared," tucked so awkwardly into the rest of her sentence, betrays her fear.

Every Victorian woman who became pregnant had to face the fact that childbirth was little more than a game of Russian roulette. Before antisepsis was understood, preparing for childbirth was much like preparing for death.* Most women wrote their wills at this time. They also had to cope with the fear that the baby might die; the infant mortality rate ran at about 150 per thousand right through to the end of Victoria's reign, in 1901. In most of Britain infant deaths accounted for half of all deaths. Effie, of course, had lost seven brothers and sisters, and two of her aunts had died as a result of childbirth, though her mother had survived fifteen pregnancies and deliveries.

Despite her fears, Effie's first delivery was relatively untroubled, and husband and wife were both thrilled with the birth of their first son, Everett, on May 30, 1856. Millais grew more and more fond of his namesake as the baby took on character. In November he was reporting with all the pride of a happy new parent: "I must tell you what a beautiful boy my son is growing and how tremendously interesting his growth is to watch. The extraordinary intelligence so small a creature shows in a few months — he roars with laughter, throwing a little head back and shrieking out a little guttural noise that fills the house all day."[106]

Early in the winter of 1857, just seven months after the birth of little Evie, Effie was pregnant again. In September she delivered without mishap a second son, named George after her father. By March 1858 she was pregnant again; her body had had only five months' rest between the birth of her second child and this third conception.

---

*More women died of childbed or puerperal fever than of all other complications of delivery. In 1847 a Hungarian doctor named Ignaz Semmelweis had published his discovery that doctors could effect a stunning decline in the number of cases of childbed fever by taking the simple precaution of washing their hands with chloride of lime to disinfect them before touching a woman in labor. Semmelweis had figured out that puerperal fever was a sort of blood poisoning, or septicemia; by instituting simple hygiene in his obstetric wards, he had brought the mortality rate down from 9.92 percent to 1.27 percent in less than two years. Despite these impressive results, the medical establishment was so insulted and shocked by the implication that doctors were responsible for women's deaths that it was many years before his recommendation was generally adopted, and doctors in Great Britain dragged their heels longer than those on the Continent.

Despite help from servants and her mother next door, child care was a burden, and the frequency of her pregnancies was taking its toll: "I hope this time to have a little girl and then I hope *Basta*."[107]

In late November Effie delivered the daughter she had hoped for, whom they named Euphemia, but this time her recovery was not so swift. Her deliveries seem to have become increasingly dangerous, and more than once it was feared that she would die in childbirth. Insomnia began to plague her, and she developed an eye infection that affected the optic nerve and gradually weakened her vision, so that the threat of blindness hung over her.

In order to stop at three children as she intended, Effie must have planned to use birth control of some sort. Information about contraception was available to middle-class couples who wanted it, but most did not: The average middle-class family in the 1850s had six children. While many couples found the idea of preventing procreation disturbing and ungodly, Effie's fears were sufficient to overcome any scruples she may have had. She regularly consulted the eminent obstetrician and gynecologist James Young Simpson, who had pioneered the use of chloroform to relieve labor pains. Conversant with the most advanced medical information of the day and passionately dedicated to relieving the suffering of his patients, he would certainly have advised her on birth control measures. *

Whatever Effie chose to do, the biggest stumbling block to fewer pregnancies was her husband's insatiable interest in sex. If they were separated, he believed himself to be suffering mightily. He was occasionally apologetic about his needs, but always insistent. When Effie was at Bowerswell nursing her mother, who had been very ill, he wrote from London, complaining that he was in agony and unable to work: "I don't think I can properly wait until my picture is done. My hands tremble so I can scarcely write, and my head is swimming — It would be much better if I didn't tell you all this but I am past all control — Tell me when I might come, and I would come with the

---

* A book that explained how to douche, written by an American, Charles Knowlton, and cunningly titled the *The Fruits of Philosophy*, sold 42,000 copies in Britain between 1834 and 1876. In 1854 Dr. George Drysdale published *The Elements of Social Science; or Physical, Sexual and Natural Religion. An Exposition of the true Cause and only Cure of the Three Primary Evils: Poverty, Prostitution and Celibacy*, which included a couple of vital pages detailing various methods of birth control. Along with many in the medical profession, Drysdale misunderstood the "safe period," believing that a woman could have intercourse without conceiving at midcycle, the worst possible time. He warned against the practice of withdrawal, which he felt was apt to produce nervous disorder and sexual enfeeblement. The sheath he disdained as dulling the enjoyment; instead, he advocated use of a sponge or douching.

small picture and paint there. It would not be fair to keep us [apart] till July past [sic]. *You mustn't be upset.* I only tell you what should be a sense of congratulation to yourself that you are so much in my thoughts. I can draw occasionally, but I know I couldn't paint a bit."[108]

In 1859, the year when he felt "everything was done to drown him," Millais grew especially desperate to see Effie while he was in London. He needed the comfort of her body; he craved the freedom of sexual triumph. As soon as he foresaw the likelihood of a sale, he sat down to write her the good news and to persuade her to come to see him on the strength of it. As the letter progressed, his fantasies of making love to her seized him, and he became even more frantic — indeed, he kept compressing his plan so that they could meet sooner. "I should like you without the smallest delay to meet me. . . . You cannot be wearying as much as I am to be together, only the long unhealthy separation blunts me. . . . I should meet you at York say. Let me know how you would propose this *by return of post.* . . . Let me know immediately if you could meet me at a *day's* notice anywhere along the line for I am sick to be with you (if I telegraph) *please come away at once,* we can afford a little trip. . . . I think York the place to meet, what think you? On the other hand, if I don't sell the small or orchard picture *this week I will return on Saturday.*" (The page has been cut here, no doubt for propriety's sake.) "As the chance approaches of seeing and living with you I grow more impatient. I am really a good husband, though I says what shouldn't, for I am very unfitted for such a lengthened separation as I have had to bear. We shall be the happier I am sure when we do meet. Now you understand clearly." Certainly he assumed that she was eager to meet him too; nonetheless, to rule out any possibility that she might resist or mistake his demand, he finally resorted to direct instruction: "Come to the York Station Hotel upon hearing of the sale of one or other of the pictures unsold. Do *not wait* for a letter, but send by telegraph *when* to meet you. We might arrange trains. Come the *next day* upon hearing such news. . . . *Mind* come upon receiving a message. . . . If I should arrive at York first I will get a room and food ready, should you beforehand you will do the same for me."[109] Effie did meet him, not at York but at Birmingham.

Millais's intense need for sex never flagged. On August 9, 1865, he wrote to London from Perth: "It is quite impossible for me to do this all alone as Nature won't stand it. If you could join me in a few days here I would work twice as fast and have no irritation."[110]

In the fall of 1867 Effie's sister Alice was being courted by a wealthy

young man named Harry Mendel. Alice was nervous about marrying, and Harry's father did not approve of the union. Harry was being driven mad by delay, and apparently there was a shocking quarrel in which Harry pressed Alice to go ahead with the marriage. From London Millais wrote to Effie in Scotland: "I have just received your letters and the long one was really alarming, but I quite understand Harry's state, which of course is a riddle to a young girl who is usually as cold as marble, and incapable of understanding the cause of a man's irrationality — I am in the same state myself at this moment and sometimes feel nearly out of my mind and would give £50 to have you here *indeed will if you will come.*"[111]

When Millais and Effie were in their sixties and had been married for more than thirty-five years, he was still as eager and as enslaved as a boy. By now his remarks were brief; a sentence, even a phrase, sufficed to let Effie know what the problem was. On August 6, 1890, he wrote: "You might send a telegram where you are as you know I am anxious to see you after so long a separation."[112] The next year it was just "I don't appreciate a long separation as you know."[113]

Despite Effie's resolve not to have more children, over the nine years between 1859 and 1868 she had five more babies and one miscarriage. The miscarriage occurred in the spring of 1861, when the couple traveled to London to look for a new house. During their stay, Effie's eye ailment flared up so severely that she was blind for a time, and she wrote to her mother that "so much medicine and pain have produced internal relaxation and I must move very little for a month. The doctor says he thinks it will wear off, but there are certain appearances which indicate this, and I do not think that even could I go out it would be safe for me to walk. It is a great pity but one must have patience."[114]

Three days later Millais was writing: "Dear Mrs. Gray, Effie is *much* better now, as the whole business has resulted in an easy miscarriage without the *least* pain." He tried in every way possible to reassure his mother-in-law: Effie was eating her breakfast as he was writing and was "quite jolly. The doctor says it is a good thing it ended so, as she would never have been well through it." He added that Effie was "rather glad herself."[115]

Effie's health, which had never been strong, now grew increasingly fragile. Even Dr. Simpson, one of the most gifted researchers and innovators of his day, admitted frankly that he could do little to help

her. To her father she wrote that Simpson "gave me a bundle of prescriptions and told me to try all one after the other and go on with any that suited best, that he could only alleviate my present distress not cure it."[116] The insomnia was unrelenting, and by September 1863, the month Geoffroy, their sixth child, was born, she was taking chloroform as a sleeping draft.

Effie blamed Ruskin for the breakdown of her health, for she believed that her nerves had never recovered from the traumatic experience of being married to him.* Ruskin may have been an effective scapegoat, but it is clear that the burden of childbearing and other strains within Effie's second marriage contributed to the tension that made it impossible for her to relax and sleep. Her nervousness was at least in part an expression of her fear that she would not survive the next birth. Effie loved her husband and wanted him to be happy, sexually and in every other way, and in the early years of her marriage she too delighted in their sexual relations. But the knowledge that death might well be the outcome of their passion ruined the pleasure for her and put her at odds with her beloved mate. As the children kept on coming, the tension between them can only have mounted.

That tension seems to have expressed itself in petty disagreements. Despite the fact that Effie loved Millais, her letters home were rife with complaints about him. She longed to travel; he was a xenophobe, and it infuriated her that he fussed endlessly when they were abroad. It annoyed her too that he could not keep up with his voluminous business correspondence.**

---

*She forbade her family ever to mention Ruskin or the marriage, and her wishes were respected. Even after her death, her children trod carefully over this ground. In his biography of his father, John Guille Millais devoted only a delicate footnote to Effie's marriage to Ruskin: "Miss Gray had been previously married, but that marriage had been annulled in 1854, on grounds sanctioned equally by Church and State. Both good taste and feeling seem to require that no detailed reference should be made to the circumstances attending that annulment. But, on behalf of those who loved their mother well, it may surely be said that during the course of the judicial proceedings instituted by her, and throughout the period of the void marriage and the whole of her after years, not one word could be, or ever was, uttered impugning the correctness and purity of her life."[117]

**Millais's letters show an artist who was remarkably reliable in his business conduct. Whereas Rossetti's patrons were maddened by years of delay and dissembling, Millais's buyers uttered nary a peep. He became a painting machine, turning out extraordinary numbers of paintings — 101 between 1871 and 1880 — and delivering them one after the other. At the height of his powers, he could execute a full-length portrait in several days, sometimes not even drawing on the canvas before he took up his brush. These portraits became so popular that by June 1867 he was turning down commissions every day, simply because he did not have the time to carry them out. At that rate it is hardly surprising that he fell behind in his correspondence.

Entertaining was another source of friction. As the years passed, there was less and less room for artistic temperament in Effie's vision of life; she expected her husband to toe the line and meet their increasing social obligations, and she complained when he didn't. On the occasion of a large party, she wrote to her mother: "I suppose he told you that he locked himself into the studio and would not see anybody yesterday, but he tells me he wrote Harry and Alice two very funny letters whilst he left me to entertain about one hundred people. I had been very unwell the night before and did not rise till the forenoon so it was rather a hurry to get ready but I had three men in and Collard's people got in the piano safely and I got better and my headache left as afternoon came on."[118] Such petty complaints were probably stand-ins for the deeper frustrations and disappointments of her life, about which she could not speak.

Pregnancy was one misery that she felt she could speak about — and her words may have contributed to the fear of marriage that her sisters Sophie and Alice developed. Resentment clouded Effie's judgment in a letter she wrote to Sophie on February 10, 1865: "Alice and you should be happy and thankful at home to be able to read and work and do what you like. You don't know anything yet of prolonged bodily suffering and the frightful strain it is to mind and body continual pain and irritation and want of sleep, but I don't wish to complain."[119] She may not have wished to complain, but she certainly did.

On June 15, 1868, Effie had her eighth and last child, a girl, Sophia Margaret. She had just passed her fortieth birthday. Unfortunately, the insomnia did not leave her, and her health continued to be delicate. She never truly recovered from the collective assaults she had suffered on mind and body.

<p style="text-align:center">❧❦❧</p>

Millais adored his children, and they adored him. Though he was all business in the studio, once he had put his brushes to soak at the end of the day he was all theirs, and he was delighted to join in their fun. He loved to act the pater, holding forth on the virtues of rising and retiring early, regaling them with bogus tales of his own herculean early labors. They saw through his pretense of sternness in a minute, and feared him little if at all. Instead they teased him, even about his pictures. He took endless ribbing about one painting in particular, which shows two newly declared lovers saying a fond goodbye, he

with portmanteau in hand. Millais called it *Yes!*, but the family retitled it *Have you put in my sponge-bag and toothbrush?* They could well afford to laugh; the dealer Agnew paid two thousand pounds for this frothy piece of baggage.

The only time Millais's children struggled to evade his grasp was when he wanted them to model. He had always disliked using professional models, much preferring to work with family and friends. After the resounding success of *My First Sermon,* a picture he exhibited in 1863 of five-year-old Effie dressed in her Sunday best, earnestly seeking to understand the parson's speech, none of the children were safe. He capitalized on that picture's popularity with a *Second Sermon,* in which Effie was stationed in the pew again, asleep this time, and pictures of adorable children became a specialty for him, as well as an unfailing source of revenue.

Posing was a little sojourn in purgatory for the Millais children, just as it would be for any healthy, active youngster, and over the years the models devised ways of getting their own back. When Carrie was forced to pose for *Sleeping,* a depiction of a slumbering cherub, she registered her annoyance by biding her time until the background was well advanced, then kicked off the blankets and destroyed every fold of cloth that her father was struggling to record. To show her own flair for the demonic, Mary, who modeled for *Waking,* quietly crept over to the easel while her father was out of the room and planted a few fat strokes of brown paint on the canvas with one of his brushes, ostensibly to help him with his work. But Millais's anger over these episodes was always a fleeting storm, and the struggle inside the studio never dampened his real sympathy for his children, especially his daughters.

Effie's relationship with the children was apparently cooler and more remote than her husband's. Her children loved her and respected her, but they don't seem to have played with her. Perhaps she took up the role of disciplinarian and left her husband free to be the playmate at the end of the day, or perhaps her continual pregnancies and the fear that she might not survive the next delivery drained her enthusiasm. For whatever reason, her letters are generally devoid of all but the most mundane references to the children's comings and goings; by contrast, Millais's letters are full of the amusing little anecdotes that delight a fond parent and sometimes bore the rest of us. Effie held her daughters at arm's length, perhaps because she felt jealous of Millais's unalloyed excitement about them. She did indulge

the boys, however, and on occasion Millais had to press her to rein them in. In emergencies — when her children were ill or endangered — her deep underlying strength always came to the fore; she would do anything to help them.

Much of the daily, hands-on care of the children was left to servants in the usual Victorian way. Nannies brought the children in to see Effie after they had been washed and combed. The boys were sent to boarding school when they were still small, and governesses, usually French, lived in and supervised the girls. After the family moved to London in 1861, the children were frequently shipped to Bowerswell for extended visits; in this way Effie got them out of the hurly-burly of the capital and bought herself a measure of peace and quiet.

Despite all the help, the responsibility for managing eight children simply overwhelmed Effie at times. Child-rearing on such a scale may well have seemed more like leading a platoon of untrained, wild-eyed recruits into battle than romping in the company of the precious darlings pictured in *Sleeping, Waking,* and *Getting Better.* In an age when motherhood was enshrined as sacred, Effie could hardly have admitted that she wasn't all that thrilled about it, especially with her own mother as a model. Furthermore, she had already shocked polite society by ending a marriage, and she needed to live up to expectations in other respects if she wanted to be accepted back into its precincts. So she had very little room to turn around in, which made her feel more than a little trapped and discomforted.

In order to give herself a respite from all these pressures, Effie maintained a tradition of taking a holiday each year, separately from her husband. Every August she and the children joined her parents at St. Andrews on the coast, while Millais went hunting and fishing in the interior of Scotland with a group of male friends. He found these breaks at least as refreshing as she did, for he was a passionate sportsman. He was probably never as simply happy as when he could tramp through the woods all day stalking deer. In the evening he loved to sit by the fire joking and carrying on with his companions, looking forward to the deep, natural sleep that comes after physical exertion. The letters he wrote Effie on such trips brim with vigor and excitement, and they are singularly free of complaints about sexual deprivation. Instead, he was likely to announce cheerfully that the shooting this year was the "best ever" — a bag of three thousand head, including six hundred brace of partridges and a thousand pheasant.

Effie encouraged these breaks partly because she knew how badly he needed the rest but also because they provided her with a limited but effective means of contraception. With babies coming almost every year, she needed time to build her strength. She also paid frequent, extended visits to her parents at Bowerswell, leaving Millais at home in London to work.

Not long before Sophie was born, Effie's past reared its ugly head. Some years earlier Ruskin had fallen in love with a beautiful, willful, profoundly religious Irish girl named Rose La Touche. They had met early in 1858, when Rose was ten years old and her mother asked Ruskin to give drawing lessons to her two young daughters. An intense friendship had grown up; both the mother and Rose were strongly attracted to Ruskin, and he developed a passionate crush on Rose. Letters, visits, and gifts were eagerly exchanged. They made up nicknames for each other: He called the child Rosie-posie, and she named him St. Crumpet. (Rose called her beloved governess, Miss Bunnett, "Bun"; hence St. Crumpet.) On February 25, 1861, Ruskin wrote to Charles Eliot Norton that he didn't know what would have happened to him "if a little child . . . hadn't put her fingers on the helm at the right time; and chosen to make a pet of herself to me; and her mother to make a friend of herself."[120] Ruskin had lost his religious faith, and both mother and daughter were wrestling to save his soul.

Soon after Ruskin's first visit to Harristown, the La Touche estate in County Kildare, Rose suffered her first mental breakdown. A second followed in 1863. This one was marked by a period of clairvoyance during which Rose could predict what was going to happen to her all through the day, after which she had a thorough regression to the age of two. Her head hurt so badly that it was torture for her to think at all.

Rose's parents were for a long while more or less oblivious of the probable cause of these torments. Mrs. La Touche had long supposed that Ruskin was attracted to her, which was not surprising, since she had been a lonely woman of thirty-eight, unsatisfied in her marriage, when they met, and Ruskin was just a year older than she. When it dawned on her that it was Rose whom he fancied, she was horrified, as was her husband, but their efforts to halt the odd relationship were fruitless. They failed to perceive that Rose was as deeply infatuated

with Ruskin as he was with her. Once when she received a letter from him, she slipped it into her pocket before her mother saw it and left the house to go riding. To Ruskin she wrote innocently that her pony was so excited to be carrying his letter that "she took to kicking and jumping in such a way, till I felt like a stormy petrel riding a great wave."[121]

Having waited until Rose had more or less recovered from her collapses, Ruskin asked her to marry him on February 2, 1866, shortly after her eighteenth birthday. Something daunted her — possibly her instincts told her something was wrong in their relation to each other — and she asked him to wait three years, until she reached her majority. Rose had been so sheltered that she knew little about sex, and she had no idea why his first marriage had ended. Ruskin agreed to her proposal, and began numbering the days in his diary until he could propose again.

The next year Rose had her most serious breakdown and was placed in a sanatorium, where she grew so violent that she had to be strapped to her bed. She recovered sufficiently to come home in the spring of 1868, and soon Mr. and Mrs. La Touche discovered that she was writing to Ruskin again. The thirty-year age difference, Ruskin's rejection of religion, and, worst of all, the scandal surrounding his first marriage made them frantic at the prospect that he might convince their headstrong but terribly fragile daughter to elope with him. In their desperation they resorted to the awkward expedient of writing to Effie, begging her to help them prevent this disastrous union.

A most curious and painful correspondence ensued. Some of the letters have disappeared, but enough survive to tell the story. Apparently Effie firmly but politely made it known that Ruskin would not make a healthy husband, and Rose was made to understand this. On May 21, 1868, Mrs. La Touche thanked Effie: "I trouble you with one more line, in acknowledgment of your kind, and *most true* letter this day received — and also to tell you that my daughter earnestly begs me to express to you her deep gratitude . . . for your generosity in granting the information that has saved her, and us all, from so much misery."[122] Effie had mentioned that she did not believe Ruskin was legally free to marry, and the La Touches consulted a solicitor, who confirmed this opinion. He told Rose's worried parents that if Ruskin should have children with Rose, the annulment could be voided, and Rose's children would be regarded as illegitimate. (In consequence, Effie's children would also have become illegitimate.)

The possibility of more trouble — and such confusing trouble — from Ruskin infuriated and frightened Effie. It seemed that she would never get free of him. And she was not wrong to worry: Ruskin was obsessed with the idea of marrying Rose and would have effected it if it were humanly possible. (At one point he dispatched his friend Charles Howell to Ireland to call on the La Touches dressed as a tramp in order to catch them unawares and plead Ruskin's cause.) The legal and social flurry that would have followed such a marriage would have caused great unpleasantness for Effie and her children. But Rose promised her parents that she would not see or write to Ruskin. For the moment the danger passed.

By 1870 Rose's resolve failed her. After what was ostensibly a chance meeting in London, she and Ruskin were reunited, unbeknown to her parents. Ruskin convinced Rose that she was the only woman who could ever make him happy. This intense and troubled young woman saw his profound despair and felt it was God's will that she try to rescue him and restore his faith. When the reunion was discovered, the La Touches panicked and again wrote to Effie for help.

On October 5, 1870, Millais replied, because he didn't want Effie to be drawn in and upset a second time. His letter was extremely blunt and left no doubt about the cause of the annulment. He explained that as part of the legal proceedings Effie had been certified a virgin and that the decree had been granted on the grounds of impotency, a charge Ruskin had declined to refute.

Mrs. La Touche could not rest easy. Three days later she wrote to Effie once more, supposedly because she felt "we owe it to you, to inform you of what is going on, that you may be at liberty to take whatever measures you think proper."[123] She went on to enumerate the outrageous lies Ruskin was telling Rose — that he had never loved Effie, that the marriage had been arranged by his parents and the Grays against his will, that he had respected Effie too much to have sexual relations with her but had merely acted instead as her protector and companion, living with her as if she were his sister.

Effie decided to put Ruskin's lies to rest once and for all. From Bowerswell she replied: "He [Ruskin] pursued exactly the same course with me as with her, he always took the tone of his love and adoration being higher and above that of ordinary mortals, and immediately after the ceremony proceeded to inform me that I was not his wife and that he did not intend to marry me. He afterwards excused himself

from doing so by saying that I had an internal disease. . . . Our marriage was *never arranged* by anybody. . . . Now that I am a married woman and happy with a family I think his conduct can only be excused on the score of madness as his wickedness in trying his dreadful influence over your daughter is terrible to think of. I can easily understand the hold he has acquired as it was exactly the same over myself. His conduct to me was impure in the highest degree, discreditable and so dishonourable that I submitted to it for years not knowing what else to do, although I would have often been thankful to have run away and envied the people sweeping the crossings." In closing she said: "It is very painful for me to write all this and be again obliged to recall all these years of distress and suffering which I nearly died of and has hurt me even now dreadfully and my nervous system was so shaken that I never will recover that again. But I hope that your daughter may be saved and come to see things in a different light."[124]

Four days later Mrs. La Touche wrote gratefully — "I do believe that my child is now *quite* saved" — to justify her repeated intrusions: "She never would believe any evidence *but yours*."[125] Rose did break it off with Ruskin, but her freedom brought her no happiness. Her mental and physical health continued to go downhill, and she died of unknown causes on May 25, 1875, at the age of twenty-seven. After her death Ruskin carried her letters with him, protected between gold plates inside a silk wallet. When he found out that Effie had been instrumental to his parting from Rose, he was enraged. To him, Rose was the "victim of her mother and that *accursed woman of Perth*."[126]

༄༅༄༅

When Effie had left John Ruskin, she had feared that society would turn her out, and in the first years of her second marriage Millais had been acutely sensitive to the fact that she hesitated to learn which London doors would be shut in her face. From the city he wrote her letters of reassurance: "I sat next Mrs. Dickens, who desired her best remembrances to you, and hopes you will call and bring the children to see her."[127] When she did take the plunge, in the winter of 1857, she found that almost all her old friends were happy to receive her.

The only people who truly closed their doors to her were a handful of the most rigid, sniffy members of the aristocracy, who would see only those who were welcome in the presence of the Queen, who was not willing to receive Mrs. Millais. Effie therefore presented a

problem to hostesses who wanted to invite her or her husband to a party that the Queen might attend. When Millais was invited without her, the snub understandably rankled.

Seventeen years earlier she had been presented to the Queen, and Mr. Ruskin had laid out the handsome sum of twenty pounds to buy her a gorgeous emerald green satin dress for the occasion. Then she had been absolutely in her element, regaling her mother with an account of the tension and the ritual and giggling about the splash she had made with her dress *"en Louis XV."* On that day she had found the Queen to be a lovely little lady, nowhere near as plain as other people had claimed. And every quarter of fashionable London had been open to her after she had made her presentation curtsy.

Now, in the last week of May 1868, on the occasion of a garden party given by the duke of Portland, Effie could walk partway across London to keep her husband company, but she had to turn back as they drew near the duke's house to avoid being seen. How tense she must have felt as she calculated the point at which she must turn back; how angry it must have made her to be cheated out of so many pleasant afternoons and evenings because one spoiled, narrow, selfish woman couldn't imagine the pain of a bad marriage and had the power to punish a woman who left such a union.

Of course, not everyone cared what the Queen thought — not even her children, in fact. Victoria's daughter Princess Louise became a close friend of Millais's and was always welcome in the studio, and the Prince and Princess of Wales visited his open studio year after year. Many members of the royal family ignored the Queen's interdiction, turning up at the studio and chatting cheerfully with Effie. The queen of Holland, a gifted amateur painter, was grateful for the chance to know Millais and spent the afternoon with him and Effie in their home several times.

Over the years, in fact, Effie and her husband developed a rich and complicated social life as he became the most popular and well-loved painter in the British empire. They were invited to far more parties than they ever could have attended. Effie's letters to her mother mention dinners and dancing in Mayfair and Belgravia, visits to country houses where she was pampered and catered to, a box at the Derby, a reception for the czar, a ball thrown to honor the shah of Persia, a party for Garibaldi. Invitations to her home were coveted. In her diary for July 12, 1884, the young Beatrix Potter noted: "Papa and Mama went to a ball at the Millais' a week or two since. There

was an extraordinary mixture of actors, rich Jews, nobility, literary, etc. Du Maurier had been to the ball the week before, and Carrie Millais said they thought they had seen him taking sketches on the sly. Oscar Wilde was there. I thought he was a long lanky melancholy man, but he is fat and merry. He was not wearing a lily in his buttonhole, but, to make up for it, his wife had her front covered with great water-lilies."[128] One wonders whether Effie felt any kinship with Wilde later on, when he was cast out of polite society. One also wonders, given the scale on which she was entertaining, how she even had time to worry about those who did not invite her. But hindsight is always easy, and ostracism of this sort is now only a pathetic anachronism — we cannot truly imagine its lash because we will never feel its sting.

The great irony of their situation is that Millais came closer than any of the other Pre-Raphaelites to bridging the gap between artist and society. He became a cultural hero. Society was eager to come to him and worship; he was the prince whose sufferance they had to beg in order to be admitted to his studio, his home, his company. This success was a function of his charm, his ambition, his values — and of the profoundly conventional paintings for which he charged such extraordinary prices. He extracted a maximum from both his roles: As an artist, he exercised his creative power to mystify and amaze those who do not create; as a thoroughly bourgeois gentleman, he commanded the respect that is accorded a man with money and the social position it confers.

Unfortunately, even Millais's great social power could not protect Effie entirely. She had to live with the fact that those who were polite to her face often talked behind her back, tittering about Ruskin, speculating that her rampant sexuality had made it necessary for her to leave him. In the beginning Millais had predicted that the scandal would be a nine days' wonder, but he couldn't have been more wrong.

When Effie's oldest daughter was fifteen and it was time to start thinking about her coming-out, her parents decided to confront the long-standing awkwardness about the Queen head on by asking Her Majesty to allow Mrs. Millais to be presented; otherwise Effie would not be able to chaperone her daughter to a good many of the events to which she would be invited. During the season there was a ball or a dance of some kind almost every night, and the ballroom was ringed with chairs where mothers sat chatting with each other and keeping a careful eye on the action, appraising possible suitors as they

made their approach on the dance floor. The Millaises had a keen interest in helping their daughter find a young man with both character and comfortable means, and Effie wished to be on the scene to guide and counsel the girl. Nor did she want to miss any of the fun. She had worked hard to build her husband's career so that they would be welcomed into the highest reaches of society, and she had no intention of being shut out now if she could help it.

Millais and Effie were good friends of the duchess of Sutherland, who had the ear of the Queen and appreciated Effie's dilemma. The duchess assured Millais that she could clear the way for presentation, but she was mortified to learn that when she sent a card in to the lord chamberlain, asking that Effie be put on the list for the next reception, the lord chamberlain took exception. To clear up the matter she wrote directly to the Queen, asking her to suspend the rule against receiving anyone who had been divorced. She was confident that she could count on the Queen's good sense and compassion, but regrettably, Victoria refused, pleading propriety and custom. In fact the Queen loved gossip, despite her stiff-necked reputation, and she believed that Millais had seduced Effie when she was still married to Ruskin.

When the duchess wrote to explain and apologize, Effie replied: "I was distressed and shocked beyond measure on reading your kind letter last night. I am satisfied that Her Majesty would not do an act of injustice to any of her subjects, and would not if correctly informed of my case have denied me the privilege of presentation. I have never been divorced nor did I divorce Mr. Ruskin. By the ecclesiastical law of England, the church of which Her Majesty is the head, and the civil law of the country I was given my freedom, the ceremony of marriage through which I had passed being declared null and void by the Bishop of Winchester. . . . His sentence can be seen any day in Doctors Commons which declared me stainless and blameless and free to contract marriage as a spinster, and I was married to Mr. Millais more than a year later." She also apologized: "I cannot tell you how it distresses me having put you in so unpleasant a position."[129]

The duchess tried the Queen a second time, and was refused once again. Outraged, Millais wrote to the duchess himself: "Please take no more trouble in the matter. Had Her Majesty permitted my wife to pass before she could not have done it, the indignity has completely upset her. One thing shall certainly be known and proved and that

is she was pure, and entirely free from a shadow of misconduct in all that concerns her freedom. . . . *Injustice to my wife is not defensible on the score of her misfortune proving an awkward precedent.* Think what the Queen's prohibition carries with it — Every one, even to her own children, will conclude there must be something against her character, because she may not be presented there again. If she is not considered worthy of passing before Her Majesty, how is she to mix in the society in which we move — to go to Chiswick's [home of the duke of Devonshire] or Stafford [the Sutherlands' home] where the Queen may be? The present state of things is impossible. . . . The Prince of Wales already knows and will be further informed of the whole case."[130]

Unfortunately, even the prince was powerless to move his mother. He read the materials Millais submitted to him through the duke of Westminster, but replied that even though he himself felt these hard-and-fast rules were absurd, there was absolutely nothing he could do.

Millais made one last attempt to remedy the situation by asking the eminent solicitor Sir Arthur Helps to put the case before the Queen. Eventually Sir Thomas Biddulph also got into the act, and on June 17, 1874, he wrote a letter to Millais explaining that he had laid the case before the Queen at Balmoral but that she had refused to bend. He temporized: "It seems a hard case no doubt, but I believe all precedent is against receiving a lady who has been the wife of another man still living, and the public might not understand the peculiar circumstances."[131]

Having abased themselves to this extent, Effie and Millais called a halt. An intransigent old woman had crushed their dignity, and there was nothing more they could do about it. Millais squired his daughter to the parties; Effie stayed at home and fumed. This prohibition drove a further wedge between Effie and her beautiful daughters, who had the company of the father they adored and free access to society while she did not. And she could not have escaped noticing the fact that her husband was an outrageous flirt. Everyone had a story about Millais chucking some lovely young thing under the chin and commenting on what a marvelous picture she would make. Ostensibly this was all in fun — he posed as an old fellow who had earned the right to compliment a girl young enough to be his daughter — but it must have been painful for Effie, who had to sit at home now while he danced the night away.

In some ways Effie never surpassed that evening in Verona when Field Marshal Radetzky pronounced her *la reine de son bal*. She had imagined that that night of triumph would be just the beginning, but in middle age she had to face the fact that she would never have the great career in society she had dreamed of since she was a young girl.

After she had freed herself from Ruskin, she had hoped to make a fresh start. With a new, loving husband who was also a significant figure in the cultural scene, she had planned to make her way afresh, a fantasy that Elizabeth Eastlake had encouraged and nourished. Effie had helped Millais in every way she knew, and with her assistance he had solidified his position. But his success had not brought her the satisfaction or the acceptance she wanted for herself, and this infuriated her. No matter how many invitations they received or how many guests attended their balls, she never felt at ease.

While Millais was free to enjoy his celebrity, Effie was doomed to remain the wife with the embarrassing failed marriage in her past. Her sense of exclusion was compounded because for much of the first fourteen years of their marriage she was compelled to stay at home, too pregnant or too sick to accompany him. When she had married for the second time, she had gloried in the idea of being the lovely Mrs. John Everett Millais; instead, her second chance was slowly, inexorably leached away by one infant after another. First the little darlings usurped her place on the model's throne; then one day she woke up and realized that her daughters were the lovely Misses Millais and she was just a tired, ill, middle-aged matron. Life had offered her a number of bitter pills, which she could not swallow but simply chewed and chewed, unable to get their acrid taste out of her mouth.

The young Effie was a genuine charmer — lively, sensitive, curious, vulnerable, and so innocently pleased with herself that almost the only one who could resist her was her tragically limited first husband. But this older Effie, who had secured the husband of her dreams against almost insurmountable odds, had lost her innocence and much of her appeal. We like to think that misery ennobles, but perhaps more often it simply wears away first hope and then generosity. As time passed, Effie grew sharp and self-important. Even the quality of her observations diminished; the letters she wrote to her mother, once so full of warmth and perception, now skimmed over the surface of things, as if she no longer had the patience to look below.

Perhaps the social life Effie tried to build might ultimately have

proved unsatisfying to her, even if there had been no complicating factors — no Ruskin, fewer pregnancies. The desire to shine in society is essentially a desire to make a name for oneself, to be known and praised for one's charm, intelligence, and grace. But such recognition is inherently ephemeral. Living in the shadow of a famous husband was the most Effie could achieve, in her own terms, and it seems unlikely that this life could ever have brought her the recognition she craved.

꧁ꕥꕥꕥ꧂

To cheer his wife, to please himself, and to buttress their position in society, Millais decided in the mid-1870s that the time had come to build the house of their dreams. They lived in a world where social status counted more than money, but money could still offer comfort. Millais bought a lot at 2 Palace Gate, close by Kensington Palace, and commissioned an elegant white neo-Renaissance mansion, which was completed in 1878. The entrance hall was imperial; its floor was a checkerboard of black and white marble, marble pillars supported the ceiling, and a veined white marble dado encircled the hall, continuing up a grand staircase whose risers were laid with a lush Persian carpet. On the landing was a fountain with a black marble sea lion by the noted sculptor Boehm. At the top of the stairs one entered an enormous studio, its red walls lined with Beauvais tapestry. (The tapestry was a sound investment; it did yeoman service as the background for many a portrait.) The entire house was filled with antiques and treasures; the drawing room was crowned by Michelangelo's carving of Leda and the swan. (Millais had acquired this masterpiece on a visit to Italy in 1867. When he heard that it was for sale and would probably be the last of the artist's works to leave the country, he made an immediate bid and beat out by a single day the Russian government's representative, who had been instructed to pay any price.)

When Thomas Carlyle paid his first visit to the Millais home at Palace Gate, he is reported to have said: "Has paint done all this, Mr. Millais? It only shows how many fools there are in the world."[132] Unlike the crusty Carlyle, a man of titanic tactlessness, most visitors were thrilled and delighted by the new house; no doubt a few were also intimidated by its grandeur. Some of the suitors who rang the bell must have shaken in their boots as they stood waiting in the hall for the Millais daughters.

When her daughters married, Effie spared no expense. Beatrix Potter attended one of these celebrations in January 1886, and noted: "The Millais had a very grand wedding at the St. Mary Abbotts. All London on such occasions. Lady Millais is one of the aristocracy."[133] Miss Potter could see clearly what Effie was never sure of herself — the fact that her place in society was quite grand.

In the process of realizing his social ambitions, Millais made some sad sacrifices in his art. Over the years his style and technique changed so radically that it is sometimes hard to believe that his late works were executed by the same man who painted his Pre-Raphaelite pictures. The painstaking method of working on a wet white ground had quickly grown irksome to him, and because it was terrifically time-consuming, it was not sufficiently lucrative. He began to experiment with faster, looser techniques, and by the early 1860s had become incredibly quick. His son John Guille, who also painted, loved to watch his father work, and noted proudly that Millais had such a sure touch that he could paint a leaf with three quick strokes of the brush.

Speed in and of itself is in no way deplorable; Millais had increased his pace by means of intense concentration and infinite practice, and he remained a fine craftsman whose technique was envied by other painters. But as he aged that technique became a trap, a facility that he could rely on instead of inspiration as he raced to do too many commissions too quickly, because he and Effie spent whatever he earned. Long after his success was solidly established, he consented to endless drudgery in order to maximize his receipts. In 1867 he wrote to Effie that he was working from ten A.M. till seven P.M. grinding out watercolor copies of two of his most popular oils because they were the "best paying things I do — as I consider I am making a hundred a day whilst working."[134]

He became a superb businessman, averaging in his prime between £20,000 and £25,000 a year, and reaching an all-time high of £40,000. By contrast, Rossetti lived like a king on no more than £3000 a year. Still, as late as 1877 Millais was warning Effie that because of an economic slump throughout Britain, his income would probably drop sharply; he listed the business failures of various friends and begged her to be economical, even though he had just received a second payment of a thousand pounds from Agnew for *Yes!*. Most middle-

class families could have lived comfortably for a year on that payment alone.

It has become commonplace among Millais's biographers to blame Effie — to say that she insisted on living beyond their means and destroyed his talent in the process. Her critics argue that she pressured him to raise his prices beyond what was reasonable, and so made it hard for him to sell his paintings; as a result he turned to ever more popular and sentimental subjects to make sure that he would always be able to unload his work on some Philistine or other. There is some evidence to support this. His letters contain more than a few admonitions to Effie to reduce her rate of spending, but the reality was that they both wanted to live on a grand scale. Effie's expenditures, particularly on lavish entertainments, were a means of displaying her wealth and power, and insecurity may have made it hard for her to control them. But it is too simple to blame Millais's failings on Effie. She could never have forced him to go into the studio and alter his technique as profoundly as he did; that was a choice only he could have made. And it was a choice he made quite happily. He reveled in his newfound speed and looked back on the Pre-Raphaelite methods as dull.

Nor could Effie have forced him to paint subjects he hated. From the 1860s onward, Millais painted three sorts of pictures: crowd pleasers, portraits, and landscapes. The landscapes were his private refuge, pictures he painted for himself while on holiday in Scotland, and they show a subtlety, care, and beauty missing from much of the work he did for that broad public which craved his sentimental pictures of children: *My First Sermon* and *My Second Sermon* were followed by *Puss in Boots, Little Red Riding Hood, The Boyhood of Raleigh, Cherry Ripe, Bubbles, Cinderella,* and a host of others. His Biblical subjects were popular, and patriotism always stood him in good stead, as did a romantic brand of historicism: The heart-melting *Princes in the Tower* sold so quickly that he capitalized on its success the next year with *Princess Elizabeth in Prison at St. James',* using twelve-year-old Sophie as his model. Nor did he ever desert his old standby, the courting couple, although he did develop a variation on this theme: the young girl alone, contemplating the wonder of her romance. The huge (112-inch by 91-inch) and dramatic *Yes or No?,* for example, shows a beautiful, full-figured young woman dressed in the fashion of the day, wearing a troubled look and holding a picture of the gentleman in question behind her back. This painting was so successful that

Millais followed it up four years later in 1875 with *No!*, which shows a depressed young woman sitting in a chair, staring gloomily down at the letter of rejection she has just finished writing. The year 1877 saw the completion of this series with *Yes!*, the picture of parting lovers that his family teased him about.

Some of these paintings are still appealing today; the young lady in *Yes or No?* gives us a glimpse of thoughtful, sensitive, bourgeois Victorian womanhood at its most charming. Many of them, however, especially the adorable children, border on the embarrassing. Nonetheless, Millais consummately expressed the taste, the desires, and the values of his enormous audience. For instance, *Cherry Ripe*, a picture of a diminutive milkmaid with a handkerchief full of cherries in her lap, was painted in a week; Millais was not entirely happy with it so he sold it to the editors of the *Graphic* at a bargain rate of a thousand guineas. They issued it as a Christmas supplement, and the print run of 600,000 sold out overnight.

This subject and others like it spread the painter's fame around the world. In 1878 Millais was awarded the *Légion d'honneur;* in 1882 France elected him a foreign associate of the Académie des Beaux-Arts; and Germany conferred on him its highest civil order. In his own country Oxford University granted him an honorary doctorate. A print of *Cherry Ripe* was seen in a Tartar's tent; a Samoan chieftain owned a reproduction of *Cinderella,* which he displayed proudly in an elaborate frame. When John Guille Millais was hunting springbok on the great karoo in South Africa, he was forced to take refuge during a thunderstorm in the hut of a Hottentot shepherd, where he noticed an oleograph of *The Northwest Passage* tacked up on the mud wall.

Only a handful of Millais's contemporaries criticized him for what they perceived as the debasing of his talent. His harshest critic may have been Gleeson White, who wrote in his 1891 *Letters to Living Artists:* "You seem to have the soul of a great master in the body of a Philistine Briton." Ruskin had noted a falling-off earlier, when he reviewed *The Crown of Love,* a pair of lovers Millais painted for the Royal Academy Exhibition of 1875. In his *Academy Notes* Ruskin argued that the picture balanced "its excess of sentiment by defect of industry" and made a sad contrast with the splendors of those first lovers Millais had painted in *A Huguenot.* Millais heard these attacks and they pained him, but most critics, particularly those who had been uncomfortable with Pre-Raphaelitism, saw his late style as a

great advance over his early work, and Ruskin was no longer king of the art hill.

The artist became a member of the select Hanging Committee for the Royal Academy. He had made his peace with the institution he had once scorned. He did not, however, entirely forget the past; instead, he worked from within the Academy to accomplish some of the goals that he and Hunt and Rossetti had set for themselves in their youth. Because he had not forgotten the drudgery of his student years, he lobbied for reform of the educational system at the Royal Academy Schools. Many a young painter had him to thank for the more vital, challenging, and helpful methods of teaching that were instituted there in the latter part of the century. Millais himself was one of the most popular teachers, because he never preached; the students loved him because he would stand quietly regarding one of their works in progress, then pick up a brush and make a simple adjustment that set the thing right. He always said that he just wanted students to see that careful drawing made all the difference. He also used his celebrity to help others: With his friend Philip Hardwick, he set up the Artists' Orphan Fund, and he was thrilled when sixteen thousand pounds was pledged at the inaugural dinner in 1871.

Not only the Philistines thought highly of Millais's later work. Edward Burne-Jones, whose work could not have been more different in style, intent, content, or coloration than that of Millais, was sincerely enthusiastic about his friend's achievement and counted it a privilege to know him. Burne-Jones wrote him a letter of appreciation on February 8, 1886, just after he attended a retrospective exhibition of Millais's work: "I do want to tell you what I might be shy of saying to your face, that the splendid show of your work at the Grosvenor Gallery has impressed me excited me and revived me beyond words — I don't know why I should be so diffident of saying this to you — after all no praise is so helpful as that of another artist and it is no news to you that I admire you this many a year. . . . I went the other day sick of myself and dark skies and the day's failures and came away so full of enthusiasm and new life that I was ready to begin all my days over again the walls shouted life and hope."[135]

Millais's own reaction to the retrospective seems to have been quite different. Early in the morning just after the pictures had been hung, Lady Constance Leslie, a friend and admirer, met him coming down the stairs of the Grosvenor Gallery. As they came together she saw that there were tears in his eyes, and he said to her: "Ah, dear Lady

Constance, you see me unmanned. Well, I'm not ashamed of avowing that in looking at my earliest pictures I have been overcome with chagrin that I so far failed in my maturity to fulfill the full forecast of my youth."[136] Millais's willingness to speak plainly about this sense of failure is worthy of our respect. What is also interesting about this encounter is that we would probably never have heard about it if Hunt had not decided to describe it in his autobiography. Subtly he was taking revenge on the hero of his youth.

Hunt also recounted a conversation he himself had had with Millais. Hunt had accused Millais of descending into the popular mire where the money flowed so quickly, but Millais defended himself quite eloquently: "You argue that if I paint for the passing fashion of the day my reputation some centuries hence will not be what my powers would secure for me if I did more ambitious work. I don't agree. A painter must work for the taste of his own day. How does he know what people will like two or three hundred years hence? I maintain that a man should hold up the mirror to his own times. I want proof that the people of my day enjoy my work, and how can I get this better than by finding people willing to give me money for my productions, and that I win honours from contemporaries. What good would recognition of my labours hundreds of years hence do me? I should be dead, buried, and crumbled into dust."[137] There is more sense to this argument than most artists would be willing to admit.

For all his disclaimers, however, Millais was clearly driven by a fear that he would fail — that if he did not give the public exactly what it wanted, he would lose the hallowed place he had occupied since he first sprang on the scene as an eleven-year-old prodigy, the youngest student in the history of the Royal Academy Schools. He knew that even a prodigy could be rejected, and he long believed, despite all evidence to the contrary, that the public had grown tired of his subject paintings. In consequence, he argued, he had to keep cranking out portraits in order to survive.

Perhaps this was all for the best. Millais's portraits have an unmistakable dignity and power. He left us a remarkable record of some of the greatest men of his age: Tennyson, Gladstone, Disraeli, Newman, and Carlyle. He also did dozens of portraits of women: grande dames, pretty matrons, and young girls, the mothers, wives, and daughters of the ruling classes. In doing so he left us a rich accounting of conventional feminine beauty, fashion, and ornament. These portraits earn him a place on the continuum between his old nemesis Sir

Joshua Reynolds and that gifted young American who was just coming on the scene, John Singer Sargent.

The artist painted only one portrait of his wife in the last thirty years of their marriage. It is a strong, sad likeness. Effie sits in an armchair holding a magazine. She is gowned in sumptuous red velvet and wears a necklace very much in the fashion of the time: From a strand of agates set in gold hang four lockets with glass covers that display locks of hair, one from each of her four sons. The portrait shows us that Millais had a deep understanding of what his wife had endured and how profoundly her trials had changed her. The delicate face in his early watercolors, the fiercely triumphant visage of *The Order of Release,* have vanished; in their place is a face that is thoughtful, passionate, and thoroughly somber. Expectations have not been met; the sitter has survived, but without joy.

<center>❦</center>

In recognition of Millais's contribution to British culture, Gladstone conferred a baronetcy on him in 1885, the first ever granted to an artist. From now on his fame was at flood tide. He luxuriated in the accouterments of fame but bemoaned the irritations. Interruptions were endless, and he found it hard to get a moment's peace in which to paint. It was not unusual for five hundred visitors to teem through the house each day during his annual open studio. He often hid, and Effie complained to her mother about the gatecrashers who pushed right past the servants and turned the house into Piccadilly for the day. One of the most annoying developments was that the press now hounded Millais continually for interviews. He hated to waste precious daylight gabbling with journalists, who, he said, "want to know everything; they want to know what you had for dinner, and if you say 'chops,' they want to know what you did with the bones!"[138]

To his credit, Millais never rested on his laurels, but kept a full work schedule, getting up at 6:30 A.M. and painting till 6:00 P.M. six days a week. By 1892, however, he could no longer ignore a swelling in his throat, which had begun to affect his power of speech. He was right to worry: This was the beginning of a cancer that his doctors could not yet diagnose. Influenza had also weakened him the previous spring, and the weather, a series of evil fogs, was conspiring to make it impossible for him to work.

The following year Effie's eye ailment began to bother her again,

and an operation was tried, with no success. From now on her vision was minimal, and she struggled with depression about her own poor health as well as that of her husband. Millais may have had a series of small strokes around the turn of the year — he was nearly sixty-five — or perhaps just a revisitation of the migraines that had plagued him since he was a boy. In April 1894 he went alone to Bournemouth, where he tried to recoup his strength. A letter home starts out resolutely cheerful and hopeful, then suddenly he breaks down: "Have had a return of my head disturbance, so bad this morning that I thought of telegraphing for you crying and having to leave the breakfast table, in short the old story over again."[139] In the summer he recovered enough to go shooting at Corriemuckloch, near Dunkeld. The company bagged more than four hundred brace of grouse, which were dispatched as gifts to some two hundred friends, and he suddenly felt glorious. Probably his cancer had gone into remission, but the respite was only too brief.

Frederic Leighton, the President of the Royal Academy, was also very ill — so ill that he asked Millais to take over the duties of the office for him. Millais hesitated because he too was now perilously weak, but he accepted the honor. Burne-Jones was protectively furious: "If they waste his time and force him to make speeches I'll kill them."[140] There was just one speech, at the annual Royal Academy dinner in 1895, and Millais worried endlessly over whether his voice would last and whether he would be heard at all. Somehow he summoned a last remnant of strength and made a fine speech. Everyone in the audience knew what it was costing him, and there were few dry eyes.

When Leighton died in January 1896, Millais insisted on attending the funeral, although he was really too ill to leave the house. He carried the Academy's wreath and placed it on the coffin just as it was being lowered into the ground. The following month he was voted in as the new President. Hunt sent an enthusiastic letter, congratulating him heartily and teasing him with Edward Lear's old pun about the Millais-nium of art. At his last Varnishing Day, in the spring of 1896, Millais volunteered to give one of his spots on the line to a young artist who had been given a poor place, a generous offer he had also made in previous years.

Late in May his doctors performed a tracheotomy that afforded him some relief from the growing pain of the cancer. The family posted a bulletin on the front door, saying that the artist had survived

and was recovering nicely. His daughter Mary wrote to Hunt: "The doctors think he may go on like this for some time, some months perhaps, but it is terribly sad for him as the disease which is cancer at the back of the throat is going on, and he can't be operated on for that now — on Thursday last week we did not expect him to live, and I must tell you he was thinking of you as he wrote amongst many messages on the slate to me — 'I wish Hunt to be a pall-bearer.' "[141]

By now he was virtually bedridden and could whisper only a few words at a time. The Queen sent one of her gentlemen to offer sympathy and to ask if there was anything she could do. Millais played his trump card; on his slate he wrote in clear, unmistakable handwriting: "I wish Her Majesty the Queen would see my wife."[142] At this desperate juncture Victoria had no choice but to agree, and her meeting with Effie was duly posted in the court calendar of the *Times* on July 3.

Mary took the train to Windsor with her frail mother, but she stayed behind in the corridor while Effie went in to see the Queen. Princess Louise, Millais's old friend, accompanied her to make the actual presentation. Unfortunately, Effie left no account of their conversation. The *Times* noted: "Their Royal Highnesses Princess Christian of Schleswig-Holstein and Princess Louise (Marchioness of Lorne) visited Her Majesty today and remained to luncheon. . . . Lady Millais arrived at the Castle and had the honour of being presented to the Queen." The royals at least might have offered Effie lunch. With her husband waiting for death at home, if she felt any sense of triumph at all, it must have been bitter and fleeting.

Millais had no illusions; he knew the end was coming. When John Guille showed him some drawings of deer stalking, he wrote on his slate: "Don't show me anymore. It makes me think of Scotland, which I shall never see again."[143]

Millais died on August 13, 1896, at the age of sixty-seven. When he was buried in Painters' Corner at St. Paul's a week later, Hunt helped to carry the coffin, which was laid to rest next to Turner's.

Effie died a little more than a year later, at Bowerswell, on December 23, 1897. The last letter she dictated to Mary was to the princesse de Bethune, sister of Adèle Domecq — the young woman who had broken Ruskin's heart before he turned to the young Effie Gray for consolation. The letter has been lost.

Five

# TRIUMPH OF
# THE INNOCENTS

AT FIFTEEN AND SIXTEEN, Edith and Alice Waugh were still in the nursery. They had not yet put up their hair, nor were they allowed to come downstairs for dinner. When a friend of the family, the sculptor and Pre-Raphaelite Brother Thomas Woolner, brought his famous friend William Holman Hunt for dinner, the girls had to content themselves with a bird's-eye view from the landing on the stairs. Through the railing Alice studied every smile and grimace of her beloved Mr. Woolner, who had been fervently courting her oldest sister, Fanny. She looked down with dismay on Fanny's womanly body, her tall, stately carriage, those large, deep-set, heavily lidded dark eyes, that ivory skin, those masses of shiny dark brown hair. Everyone regarded Fanny as a great beauty. Next to her, Alice looked like a skinny, pale little girl, and she knew it.

By this spring evening in 1861, Woolner had been calling on Fanny at the Waughs' house in fashionable Queensborough Terrace, just up the road from Kensington Palace, for two years, and was eager to marry her. Her seven sisters were eager to see her married so that they might make matches of their own. Her mother favored the idea. But Alice lived in hope. She saw that Fanny was cool. Even more promising, her father opposed the marriage. Fanny was his favorite, and he dreaded the prospect of losing her. And Fanny was devoted to her father. (This would not necessarily have discouraged Woolner, as it might today, because devotion to a father was regarded as a good index of devotion to a husband.) She had shocked her sisters

recently by remarking that while she liked Mr. Woolner well enough, she would be perfectly happy to live out her life as a spinster. Her sisters found this sentiment incomprehensible and disheartening — especially Alice, who feared that Fanny might lead Mr. Woolner on for years, breaking his heart and ruining her life.

Edith respected Alice's feeling for Woolner, and so from her perch on the landing she looked right past him, anxious to get a glimpse of Hunt, the esteemed religious painter whose bachelor status had been trumpeted in the gossip columns. Edith was enchanted. Standing below in the front hall, sporting the most elegantly tailored evening clothes, his dark blond beard making a handsome contrast with his violet eyes, he was shaking hands with her father, bowing to the ladies. Half a century later, Edith told her granddaughter that she had fallen in love at first sight — an extravagant claim, but Edith was an impressionable and romantic young girl, and Hunt was handsome, amusing, and one of the leading celebrities of the day.

Woolner may have made a fatal mistake in bringing Hunt to meet his beloved. When he asked Fanny to marry him, shortly after this dinner party, she gently but immediately said no. Almost in the same breath she encouraged him to keep on calling, since, she assured him, everyone in the family regarded him as a friend and would miss him if he didn't. Woolner took this as a sop to his ego, a ladylike bit of condescension, but he was wrong. Fanny genuinely wished him well. She also knew that her younger sister was in love with him. When she went to her mother's bedroom that night to explain that she had rejected Woolner's suit, she asked Mrs. Waugh to smooth the way for Alice. Mrs. Waugh, a practical woman, ordered the dressmaker to stitch up long skirts for Alice and Edith, who were told that they would be allowed to leave the nursery a trifle early.

The way had been cleared for Hunt, who began calling on Fanny regularly. The success of the Temple picture had given him confidence. Where once he would have hesitated, now he felt able to knock at the door of this wealthy family, even though he was still a bit afraid of the "nob's daughters." Fanny's gentle voice, the embroidery laid to one side as he came in, the little sisters practicing at the piano — it all made a soothing contrast to the rough-and-ready world he had come to know through Annie Miller.

Hunt became a favorite with the Waughs and was soon receiving invitations to visit them at their country home at Leatherhead, in Surrey. Woolner was spending his weekends at Leatherhead, too; he

had swallowed his pride and turned his attention to Alice, whom he found infinitely more receptive to his charms than Fanny had ever been. Both Woolner and Alice felt a bit awkward around Fanny now, but Mrs. Waugh did what she could to ease the tension, since they saw each other constantly, at meals, in the garden, in the game room. She thought that both young men would make good husbands, and she went out of her way to encourage them.

Soon Hunt appeared to be in love, but, being Hunt, he was terribly, terribly careful. His recent rejection by Annie still stung, and the scars were not yet healed. In fact, he was drawn to Fanny precisely because she was the diametric opposite of Annie. Where Annie was fair, Fanny was dark. Where Annie had been an endless drain on his bank account, Fanny would bring with her a generous marriage settlement; her father, George Waugh, had started life as a chemist, but he had invested wisely, purchasing a great deal of property in and around Regent Street. Fanny was a lady down to her fingertips. She had been carefully educated in all the womanly arts, and she was gentle to the point of meekness, always thinking of others before herself. In this regard, she was balm to Hunt's nerves. Perhaps most important, sex seemed to be of little interest to her. The only thing that Fanny had in common with Annie was beauty.

Despite Fanny's obvious merits, Hunt hung back. On July 20, 1864, three years after Woolner had introduced them, he wrote Stephens a letter reviewing their relationship. It was a masterpiece of illogic: "I have in fact no intention of matrimony at all now. Two mistakes in a life do not leave a man of my slow nature in that state of faith which is essential to serious love making — with conditions of cold-blooded strategy fixed as they are by fathers and mothers in this day." Apparently he was feeling pressure from Mrs. Waugh, who had been watching this romance unfold for three years — Fanny was now thirty-one, already on the shelf by most standards — and quite reasonably wanted some sign of Hunt's intentions. Hunt admitted to Stephens that "if you brought the lady to my study and left her with me alone for a day, the chances are that I should end by declaring myself in love and be either rejected or accepted," but he remained, as ever, in control. "As it is I have to make my calculations coolly, and these do not encourage me to take any such step." He argued that money remained a stumbling block: "I have not made a reasonable sort of income for the last four years. I have been drawing for the whole of that time upon my capital, not of course for a large proportion of

my expenditure but for enough to make it clear that I ought rather to diminish than increase my outlay." This was nonsense. Combe was making sound investments with the enormous sum of money Gambart had paid for the Temple painting, and Hunt was on his way to becoming a rich man.* Still, self-pity washed over him: "My spirits are not up to the old mark — and so I look forward to the quiet sleep with a feeling of something nearer to contentment than I have for any other prospect in the world." Despite the fact that he had everything to live for — health, friends, talent, fame, wealth — he nursed his despair, claiming that he was happy just waiting for death, if it were not for one scary but compelling hook to life: sex. "The only thing that disturbs me in this outlook is the evidence that sometimes . . . my passions still burn within me and the fear that these — having no lawful hope — should burst out by contact with unlawful tinder into an unholy flame."[1] Relying on the pious diction of shame, he at the same time admitted that Eros bound him to life, even though its power humiliated and disturbed him.

By the end of his letter, Hunt had come full circle and was almost arguing in favor of marriage; apparently, like St. Paul, he had decided it was better to marry than burn: "When I have to reflect on some danger of this only just escaped I would do much to encourage a legitimate passion but not anything like the sort of thing that Woolner is going thro' now."[2] (Woolner had proposed, Alice had of course accepted, and plans for an elaborate wedding were proceeding.) Finally, Hunt backed off once again: Marriage was too much fuss and bother, too great a distraction from the sacred act of painting.

The wandering skittishness of this letter only confirms what Hunt's endless postponements of marriage to Annie implied: He was truly afraid of marriage, of responsibility, of emotional intimacy and dependency, and of the sexual knowledge that lay in store. He was also afraid that Fanny would say no. That calm, that chastity, that ladylike demeanor, all that money — the very things that made her so desirable were also what made her daunting. From the height of her class and her advantages, she could coolly consider whether she would accept him, and he couldn't bear it. In the case of Annie, the choice had been his; now the balance of power was more even. He couldn't tolerate being so vulnerable, losing so much control, and so he threw up a smokescreen of reasons not to marry.

*At his death, he left an estate of £163,000.

Still, Fanny drew him. He might temporize endlessly to Stephens, but he did not stop calling in Queensborough Terrace. As far as the family was concerned, he was the unofficial intended. When Alice and Tom Woolner were married on September 6, 1864, Fanny was her sister's maid of honor, and Hunt was the best man. Warming to the occasion, he made an interminable speech celebrating marriage, congratulating the groom, and wishing the bride every good fortune. Edith, who was still nurturing a violent crush on Hunt, was sick with apprehension that he might wind up his toast by announcing the happy fact of his engagement to Fanny. To her immense relief, nothing was said. But she did brood on the fact that her bouquet wilted while Fanny's did not.

Suddenly Hunt announced that he would be returning to the East for two or three years. Once again the East looked like his escape hatch, his means of taking himself out of harm's way. But when it came down to it, he couldn't make the break. Unexpectedly, the romance heated up. The genteel Fanny began coming to his studio, without mentioning the visits to her parents, in order to model for him.

This action was remarkable, and quite unlike Fanny. It is impossible to know her feelings firsthand because none of her letters have survived, but this defiance of her parents, whom she loved dearly, suggests that she must have been very much in love with Hunt and with the idea that he was an artist, and that she was eager to please him. By all reports, she was a woman singularly without vanity, so the immediate narcissistic satisfaction of modeling would have been little or no draw for her.

Taking up *Il Dolce Far Niente,* a canvas he had started when Annie was modeling for him, Hunt scraped out the face and painted in Fanny's. His motive for creating such a peculiar hybrid is unclear. One can well imagine his desire to erase Annie's image, to dishonor her memory, but why not abandon the canvas altogether, or just finish it using a professional model? Perhaps he hoped to redeem the picture by making it over in the image of the woman he loved. In any case, the result, as one might guess, was an aesthetic disaster.

After the painting was finished, there remained one insurmountable problem. Since Fanny's face would be recognized, it could not be exhibited without Mr. and Mrs. Waugh's finding out that Fanny had been going to the studio. Hunt must have promised her he would not show the finished work, for he would never have willfully em-

barrassed her before her parents. The necessity of withholding the picture from exhibition or sale makes it all the more certain that he was settling a private score by painting this weird creature.

Finally Hunt stopped protecting himself and started arguing the virtues of marriage, love, and sex. In June 1865 he wrote to Stephens: "She thought of taking her beautiful self unembraced to Heaven, and she cannot really reconcile herself to the great change of life I propose, and I believe she would adhere to her first resolve and never see me again if her tender heart did not dread causing me real pain."[3]

Unfortunately, just as Hunt was getting close to a proposal, Woolner was busy acquainting Alice (who could be told the sordid truth now that she was a married woman) with the story of Hunt and Annie Miller. Woolner's career had never really gotten off the ground, and he resented Hunt for his success as an artist, for his success with Fanny, even for the three-hundred-pound loan that Hunt had passed on to him from Thomas Combe, which he regarded as a species of charity. And he still held a grudge against Fanny for rejecting him. Now he took his revenge.

Alice, who had never quite forgiven Fanny for scorning Woolner, couldn't wait to fill her mother's ears. Seizing her chance to even the score, she proceeded to unfold the whole bizarre history under the guise of protecting Fanny from the depredations of this wicked Svengali, William Holman Hunt. Mrs. Waugh didn't know what to think, but she decided that she could not shirk the unpleasant task of confronting Hunt. Summoning him to a private interview in her sitting room, she demanded to know whether the disgraceful and outlandish story she had heard was true. Hunt did not lie, but somehow he managed to talk his way out of trouble by offering up an artfully sanitized version of what had happened. Once again he became the disinterested benefactor, and Annie the graceless, heartless recipient of all his time, love, and money. To Stephens he wrote: "I had no choice — by a curious chance, but to tell Mrs. W all the history of the A.M. affair — she was shocked beyond measure at it and at my part in it, really regarding it as incredibly perverse and shameful."[4]

For whatever reason, Mrs. Waugh decided to trust Hunt. She kept the story to herself, fearing it would give her husband the opportunity to dismiss him as a cad. Two months later Mr. Waugh broke down and gave consent to the marriage he dreaded.

Once Hunt had made up his mind to marry Fanny, he could brook no delay. To his dismay, he found that his quiet, gentle fiancée had a will of her own, a discovery that infuriated him, as he told Stephens: "At the present rate of action . . . no chance of getting the young lady to settle the day in this century."[5] Eventually this hurdle was cleared; the engagement was formally announced, and Hunt was ecstatic. In a rare moment of exuberance he suddenly burst out: "My dear Stivvy, You will be glad I know to hear that all is concluded now in my favor and my engagement to Fanny Waugh may be spoken of publicly. It makes me more truly happy than I have been for many years. Everyday I see the darling I discover some new merit in her."[6] Only one small, dark cloud loomed over his vale of delight: The family wanted to wait until the end of the year in order to have time to prepare. Hunt's fears were coming true. Like Woolner before him, he was being drawn into the preparations for an upper-middle-class wedding, and he was annoyed. For Hunt, the idea that so much effort should be exerted over anything but the creation of a painting was ridiculous. Where he might have commandeered a cab and driven a poor girl like Annie directly to the registry office, losing only a morning at his easel, here the bride would play the tune and he had no choice but to dance.

Just five weeks after he had written his crowing letter to "dear Stivvy," Hunt was writing again to lament: "My own affair does not, I am sorry to say, give me anything [like] unmixed satisfaction — the conventionalities of the world have much too great a power in my case to make my position a delight — there are reasons for delay — accouchements of sisters, illnesses of father and uncle, etc. etc., each in themselves of importance and of a kind that individually one could not but be patient towards but which collectively are most intolerable and most ruinous to my worldly position — say that they will occasion me a year of the most infurious slavery when I am in the East." Happily, there is no indication that he voiced these complaints to his bride-to-be. The fact that he had to put on a polite face with the Waughs, however, just made the situation more intolerable. He brought his jeremiad to a climax with the contention that "if I had only foreseen these difficulties, I should have regarded it as nothing less than madness to take the step which has led [sic] me captive."[7] *Captive* is the key word: Marriage might prove to be the ultimate slavery, and so Hunt flailed against all the tiny silken bonds of prenuptial preparations.

Most Victorian weddings were quiet affairs, but wealthier families such as the Waughs threw big parties. Upper-middle-class weddings of the time were patterned on those of royalty, and from that pattern we have taken our own "white wedding," which is a distant replica of Queen Victoria's nuptials.

Fanny and her mother called in dressmakers and scheduled long sessions with the cook, the housekeeper, and the butler to plan the wedding breakfast and the decoration of the house. The wedding was set for the morning of December 28, 1865. Afterward, everyone would come back to the house for breakfast.

The bridal gown was just becoming the focus of attention that it is today. Elaborate white dresses and veils had first come into style earlier in the century. The dressmaker started by constructing an underdress from upwards of twenty yards of silk, satin, or muslin; then she covered it with lace — Honiton lace, the Queen's choice, if the bride could afford it. The veil was secured by a wreath of orange blossoms, although for an older bride like Fanny a simple bonnet was considered more appropriate. All the manuals agreed that although two to twelve bridesmaids were permissible, six to eight were ideal. The older bride was warned against young attendants who might make her look "plain and foolish," in which case "a discreet woman of thirty-five might be more suitable."[8] Because Fanny was not the type to worry about her wrinkles, all of her sisters were included in the celebration, and seven white dresses trimmed with colored ribbons were ordered for them.

The groom was counseled to wear morning dress, and despite Hunt's irritation, he undoubtedly followed directions and enjoyed doing it; he loved beautiful clothes. This rig included a frock coat with a velvet collar in blue, claret, or mulberry (black and green were considered gauche), a waistcoat of white quilting, and trousers, preferably of drab or lavender doeskin (Hunt no doubt picked lavender, to match his eyes). A boutonnière was *de rigueur,* and a smart florist had already figured out how to conceal a tiny bottle of water under the lapel to keep the blossom fresh.

Loading Fanny and her skirts and veil very tenderly into his carriage, Mr. Waugh drove her to Christ Church, Paddington, where Hunt and his best man anxiously awaited their arrival in the vestry. Stifling his reluctance, Mr. Waugh guided Fanny down the aisle and handed her over to the groom. The etiquette books asked the bride to think of her parents at this moment: "If tears can be restrained,

and a quiet modesty in the lady displayed, and her emotions subdued, it adds much to the gratification of others and saves a few pangs to the parents from whom she is to part."⁹ In fact, the books enjoined all participants to exert self-control, and came down quite hard on those who failed: "Perfect control should be exhibited by all parties during the ceremony. Nothing is more undignified than the exhibition of feeling in public. People who have no self-control had better remain at home."¹⁰

Fanny stood on Hunt's left; the best man was on his right, to hold his top hat and the plain gold ring he had chosen for his bride. The minister read the Church of England liturgy, little changed to this day. A kiss at the close of the ceremony was just coming into fashion, but the manuals found it appallingly vulgar; they also warned against kissing in the vestry after the ceremony, when witnesses signed the registry. Presumably a kiss in the carriage after the bride and groom had left the church was permissible, but only if the blinds were drawn.

Back at the house all was in readiness to receive the guests. Orange blossoms, camellias, azaleas, and gardenias, all white, filled every room with the most wonderful smells. Hunt had bought bouquets for the bride and for the bridesmaids, which were presented when the wedding party returned. Some brides carried bouquets in church, but it was still considered not quite the thing.

The breakfast was a feast. In her *Book of Household Management,* Mrs. Beeton, never one to go overboard, provided a list of one hundred dishes that should be set out to feed a crowd of seventy to eighty guests at a wedding breakfast, including three roast fowl, three garnished tongues, two hams, two lamb shoulders, eight bowls of lobster salad, three pigeon pies, two collared eels, a boar's head, eight blancmanges, and six cheesecakes. Nothing was stinted on this occasion, and the spread the Waughs provided was probably even more elaborate.

When the guests had eaten their fill, Fanny may have cut the cake, topped with a small bouquet of orange blossoms, or it may have been cut just as properly by the "nearest gentleman." Much effort was expended to take pressure off the bride, who was considered to be in a delicate state of nerves on this day. A round of toasts followed the cutting of the cake, after which Fanny excused herself to go upstairs and change into her going-away costume. Many a bride skipped the breakfast entirely, going straight from the carriage to her room to rest while everyone else celebrated. The manuals deemed it

quite understandable if the bride felt too shy to appear; one writer — a bachelor — argued that it was in bad taste to expect her to show herself at this time: "The peculiar situation of the bride, tricked out with finery like the *boeuf gras* on Shrove Tuesday, everyone staring at her to see how she looks; her sensitive nature all excited by the past solemnity, her inmost feelings crushed or raked up, as may be, by congratulations. To subject a lady to such torture seems an act of cruelty in cold blood. Suppose her joy is too great for utterance, that there has been opposition and delay, why stick her up on a pedestal, so that all may read the emotions of that throbbing heart beneath its encasement of Brussels lace?"[11] The subtext of this concern is the sexual experience looming just at the corner of everyone's consciousness; the bachelor wanted to protect the bride from the fantasies of her guests.

Fanny did not hide. She was enormously happy about her marriage, even if she couldn't help but regret leaving her parents, especially her father. Edith, on the other hand, was miserable. When it came time for the bride and groom to say their goodbyes, Hunt put his hands on Edith's shoulders and pulled her close. She felt as though she might faint. Minutes later the newlyweds were climbing into their carriage to leave, and Edith was left with nothing but the memory of a single embrace to replay endlessly to herself. The guests gathered in front of the house to throw shoes at the carriage as they drove away. The shoes were a must; even the Queen had been pelted by a hail of satin slippers.

Fanny got pregnant on the honeymoon. When they returned home, Hunt announced his intention of taking her to the East as soon as possible. Fanny was quite content to follow him to Jerusalem and refused to let tales of the rigors of life in the East worry her. In preparation Hunt taught her to shoot a rifle, and to his delight she soon became as good a shot as he was. Her parents, however, were frantic at the idea of their daughter, in her delicate condition, going to live among barbarians. Blithely Hunt assured them that Fanny and the child would thrive, despite the fevers and the unclean water of Egypt and Palestine. The notion of a foreign doctor or, even worse, an Arab midwife terrified the Waughs, but Hunt insisted that a good English doctor would be found when the time came, which was by no means impossible, since there was an English colony in Jerusalem.

(However, when Hunt was in the East he always complained that the nearest competent dentist was in Switzerland, and sometimes he endured months of toothache rather than brave the local men.)

But instead of packing up right away and traveling out while Fanny was in the early, more mobile stage of her pregnancy, Hunt delayed their departure from month to month, finishing up every last sketch and canvas in his studio, right down to a study of pigeons that his sister Emily had abandoned. He always had trouble making a break, but exactly what held him up on this occasion is not clear. He wasn't waiting for the baby. He may have been trying to fatten his bank account as a hedge against the disaster that always loomed in his imagination, no matter how rich he became. Although Fanny had brought with her a handsome marriage settlement, he had recently suffered a setback from some poor investments.

He may have been waiting to resolve a sticky situation. If Annie, who still had the love letters he had written her, had reappeared and demanded a considerable sum of money in return for her silence, Hunt would have been frantic. Cryptic notes between Stephens and Hunt suggest alarm that the letters were about to fall into the wrong hands, but as their correspondence was even more circumspect than usual it is impossible to determine exactly what was happening or who was threatening what. The love letters have never come to light, so Hunt may have recovered and destroyed them — or Annie may have burned them.

While Hunt labored on in his London studio, the Waughs read reports about cholera in Jerusalem, which caused their headstrong new son-in-law to inveigh against the *Times* for daring to print such inconvenient news. Mr. Waugh took to his bed in despair. Finally Hunt was ready — in August, the hottest month of the year — and they set out, just two months before Fanny's baby was due. As the family said goodbye in the front hall at Queenborough Terrace, tears rained down. Mr. and Mrs. Waugh cried because they were losing Fanny; Fanny cried because she was leaving her parents; Edith cried because she was losing Hunt; Hunt squirmed.

The Hunts took the boat train to France and continued down to Marseilles, where they planned to board the P&O steamer for Alexandria, just as Hunt had done twelve years earlier. But Marseilles had been struck by a cholera epidemic, and no boats could leave the port because of quarantine. When Hunt heard that it was possible to embark from Leghorn and reach Alexandria via Malta, he decided

that they would go across the Alps, despite Fanny's condition. But when the couple reached Florence, they learned that Egypt had been quarantined too.

Florence had a well-established English colony, so it seemed like a safe place to wait for the baby. The Hunts rented a studio with sleeping quarters. The heat was so intense that they were forced to stay indoors by day, and even Hunt had to admit that the city was "stinking and pestilent." But the evenings brought some relief, and they ventured out for exercise, strolling in the little streets and searching the shops for glass and lace and pictures with which to decorate the studio.

Never one to waste time, Hunt set to work, using Fanny as his model. He could well have afforded a professional model, but he wanted to paint his beautiful new wife. He asked her to pose standing, with her head resting against a chimney. Fanny stood for him hour after hour, sweat soaking her clothes and hair, her feet swelling, the baby growing heavier each day. When she got too weak to stand, he turned to another picture, which posed her lying in bed. It wasn't that Hunt didn't adore Fanny; he was simply unable to see that pregnancy took its toll, and she apparently never asked to be excused.

The subject for the large canvas, Isabella mourning over her basil pot, was macabre in light of their recent marriage. In the poem by Keats on which the painting was based, Isabella's brothers murder her lover out of jealousy and bury him in the forest. Eventually Isabella finds the shallow grave, digs up the body, and cuts off the head, which she hides in a pot; she then grows a luxuriant crop of basil that feeds off the decaying brain. Keats was Hunt's favorite poet, and he had probably had the subject in mind for a long time, but the picture may also have expressed his feeling that the men in Fanny's family — Woolner and Mr. Waugh — had tormented him with their subversion of his suit and that he was martyred in his relationship to them. Certainly it would have been more appropriate to paint Fanny dreaming about a living lover. In the picture she is bending to embrace the fat pot, the handles of which are contrived of skulls; her long, waving dark hair spreads luxuriantly over the basil plant while, bursting with sensuous life, she clings to her lover in death.

On October 26, 1866, Fanny gave birth to a son, with an Italian doctor in attendance and Hunt at her bedside. Afterward he wrote to Stephens: "Poor Fanny suffered most cruelly at the confinement. Her preliminary pains were so extreme and the danger was so great

that it was resolved upon as the only means of saving her life that instruments should be used to extract the child by force — by some chance little short of a miracle — as it seemed with a knowledge of the violence employed — the poor little child was born alive although so badly injured about the head as to leave great doubts whether he would live a day. . . . the poor mother however was injured much more seriously — (for nine days the baby is not getting proper food) poor Fanny has had to lie at the very gates of death many and many an hour. Now I bless God it is thought she is out of imminent danger, although she is sadly wasted and very feeble."[12]

They named the baby Cyril and gave him Benone, which means "child of sorrow" in Hebrew, as a middle name. He continued weak and puny. Fanny had suffered internal injuries from the clumsy use of forceps, and she contracted a fever, most probably as a result of infection introduced by dirty hands or instruments. She hung on for six weeks; Hunt spent most of the time at her bedside, talking to her and soothing her, holding the baby so that she could see him, sitting and watching her or drawing her when she slept. Fanny did her best to reassure him and to prepare him for the death that she knew was coming. To Stephens he wrote that she "frequently reminded me we had never had any word between us but those of unbroken love and happiness. The difficulties of our life had been certainly very vexing, but they had only made us cling to one another the more. We had been in spite of everything supremely happy."[13] On December 20 at ten o'clock in the morning, eight days short of her first wedding anniversary, Fanny's strength gave way and she died.

Hunt revered the memory of Fanny. Together he and her family turned her into a saint. Since none of her letters survive, we see her only through their eyes, and because they never recovered from her death they spoke only good of her ever after — always kind, always gentle, never crabby or selfish even for a moment. We will never be able to know her frailties or the fullness of her character. Fragments of information suggest that she was a remarkable woman for her place and time: She wasn't desperate to marry, didn't see a husband as her only salvation, but did marry when she found a man whom she loved. She let Hunt paint her picture, she learned to shoot his rifle, and she agreed to go to the East with him even though she was pregnant. If she had insisted on staying home until her baby was

born, she might have survived. Perhaps her willingness to travel was not so much daring as a foolhardy disregard for herself; by submitting to Hunt's will and suppressing her own needs, she may unwittingly have engineered her own death. Standing in a twisted posture so that her husband could paint her may have exhausted her to the point that she had no reserves with which to fight the infection that ravaged her body. Of course, hundreds of thousands of Victorian women died of childbed fever; she could easily have died at home in the hands of the best English obstetrician.

Everyone's immediate concern was the baby, Cyril. One of Fanny's sisters — not Edith — came straight out to take him home to England. Tom Woolner accompanied her in order to help Hunt with practical matters; in this crisis he threw aside petty jealousies and rushed to his old friend's side. Hunt's sister Emily wrote to insist that she should take the baby and raise him. But Hunt refused to give him up; he could not bear to be parted from this last dear, living fragment of Fanny. A struggle of wills was played out through the mail, and eventually the Waughs agreed to let him keep the child, on condition that a familiar English family, the Spencer Stanhopes, take Cyril into their home in Florence and care for him. Emily never forgave her brother for refusing her wish.

Millais wrote from home, trying to console Hunt by sharing his grief and paying tribute to Fanny. "My wife has nearly died more than once in childbirth, and I know the terrible nature of the trial . . . [I have also] seen that one evening that you dined with us quite enough to show that you had chosen wisely and that she [Fanny] possessed all the grace and nobility of character which you speak of and which shone unmistakably in her beautiful face."[14]

But Hunt could not be consoled; he felt shattered and guilty, for he knew that he bore a share of responsibility for Fanny's death. To Stephens he wrote: "It is the one comfort to me now that she loved me beyond all measure. That she valued this affection for me so highly that I was her first thought in the hope that her life might yet be spared to her. With so short a term of married life it would have been melancholy if there had been any but a continually growing admiration of her — an increasing desire to exhibit affection for her on my part. . . . How long now must I be in doubt whether she still loves me? The still silence makes me dread that she knows all my unworthiness and despises me. I will however gather all my strength to be worthy of her — she shall not see me worse than she knew me if the God in whom I trust will not humiliate me."[15]

Following the time-honored prescription for grief, Hunt threw himself into his work, designing a monument to mark Fanny's grave and returning to *Isabella*. (The subject of the picture seems even more macabre in light of her death. At the end of Keats's poem, the heroine dies of a broken heart, and so the lovers are united in death, just as Hunt hoped that he and Fanny would be.)

When the Stanhopes' child came down with scarlet fever, Hunt had to take Cyril back to his own quarters. He found that all his time was eaten up with the care of the baby, especially when he discovered that the hired wet-nurse had no milk. After she was fired, Hunt noticed that Fanny's portmanteau, a silk shawl, and some baby clothes were missing. He called in the police, who found that the woman had been quietly stealing Fanny's clothes and jewelry. The nurse's family bribed friends to say that Fanny had given her these things; then, when it appeared that this lie wasn't going to stick, they raised the ante considerably: Hunt answered a knock at his studio door to find a messenger threatening him with assassination. He decided to drop the inquiry and live to tell the tale.

A second wet-nurse was engaged, and the three of them set out for England, stopping in Paris so that Hunt could see an exhibition staged by the Impressionists. After a few days of gallery hopping and visiting, he realized that Cyril was growing dangerously weak, and so he made a dash for home, arriving in Queensborough Terrace just as dinner was being served. One look at the baby told Mrs. Waugh that he was nearly dead. Dinner was abandoned and the doctor sent for. Fortunately, he saw immediately that the second wet-nurse had also lied: She had no milk either. Baby foods were offered to Cyril, but he vomited them right back up, and the doctor deduced that although he was a year old, his digestive system was still undeveloped. Edith hovered in the background, torn between her natural sympathy for the baby and her anger that his illness had ruined the reunion to which she had been looking forward for months. Hunt was desperate about Cyril; he didn't even notice her.

The case looked hopeless, but by midnight someone had found a young girl whose own baby had died earlier in the day, and she agreed to put Cyril to feed. The child squeaked through, and from this moment on Mrs. Waugh kept a close watch over him. Edith was sent downstairs to tell the terrified wet-nurse that her passage back to Italy would be taken care of.

The Waughs held Hunt responsible for Fanny's death, but they also blamed themselves. Mrs. Waugh felt that she never should have

encouraged the match; she should have listened to her husband instead. Mr. Waugh was sick at heart. If he had not let Fanny marry such a willful, selfish man, if he had put his foot down and forbidden her to leave the country, an English doctor might have known how to save her. Despite these feelings, the Waughs tried to forgive Hunt, not least because he was Cyril's father, and to help him. As a step in that direction, Mr. Waugh commissioned some family portraits.

To commemorate Edith's twenty-first birthday, Hunt started a picture of her. This collaboration was a strange experience for both of them, fraught with possibility for Edith and heartache for Hunt. Because Edith resembled Fanny closely, a confusing mixture of grief and pleasure welled up in Hunt as he drew every contour of Edith's face, the line of her shoulder, the curve of her hand. She was just about as near to being a living Fanny as anyone could be — except that her frame was smaller and her features were more refined. She capitalized on the resemblance by dressing her hair in the same way her sister had and by pinning to her bosom Fanny's cameo brooch, which Hunt had given her as a memento. Hunt colluded in this effort, whether he realized it or not, by planning Edith's portrait as a companion to his formal portrait of Fanny. The canvases are the same size, the backgrounds and props are similar in coloration, the frames are identical.

Edith felt that this was her chance. Finally she had Hunt's full attention. Guilt teased at the edge of her awareness, but she brushed it aside. For six years she had watched him quietly from the sidelines, drawn by his physical beauty and by intense sexual attraction. She loved his fierceness because it matched her own; she admired his carefully worked-out political and religious convictions; she was dazzled by his worldly achievements. She didn't care that he was twenty years older.

As the portrait progressed, Hunt began to respond to her apparent interest. The atmosphere in the studio grew more and more charged; he did not know what to do. To speak out loud what was so patently obvious to both of them was to insult the memory of his beloved wife. Eventually the tension broke. One day as they sat talking quietly in the conservatory, they declared their love for each other. Then, amid the aspidistras and hanging ferns, Hunt took up his brush and painted a tiny fly on Edith's fan. They were delighted with themselves, but he was also shocked and overwhelmed. He decided that the only honorable thing to do in the circumstances was to part forever

so that their love could remain perfect. Once again he announced that he was leaving immediately on a long trip to the East.

Never had Hunt needed his escape hatch so badly. Whereas his usual wind-up for a trip lasted months, if not years, this time he made his getaway in a few days. He did ask if he could take Cyril with him, but Mrs. Waugh put her foot down, and with the child's terrifying brush with death fresh in his memory, Hunt bowed to her will. Edith stayed behind and threw herself into taking care of Cyril. She hoped that by making herself the perfect mother, she would earn a legitimate and central place in her beloved's heart.

Stopping in Florence, Hunt found that the marble carver he had hired to execute a funeral monument for Fanny had made little progress, so he took up the tools himself and worked out his guilt with his hands. He stayed on in Florence and picked up the threads of friendship. He was introduced to a ripe young American, a Miss Lydiard, and he asked if she would be so kind as to model for him. The result was a large, florid three-quarters pose called *Bianca,* which he shipped home to Queensborough Terrace to be held for the Royal Academy Exhibition.

The rumor mill started cranking, and in no time well-intentioned persons had informed the Waughs that Hunt was going to marry the Yankee who had sat for *Bianca.* The loathsome Miss Lydiard beamed hideously at Edith each time she entered the drawing room, where the picture was on display. The possibility of this marriage gave her many a sleepless night, but she had no way of asking Hunt about it. Later he claimed that Miss Lydiard had been "of no more personal interest than a flower would be," but at the time he was not quite so cool.[16] Edith had to take what comfort she could in the fact that he faithfully wrote to Cyril each Sunday, recounting his adventures abroad. Cyril was just two and a half and hardly able to comprehend the contents of these long, charming letters, which provided a decorous means by which Hunt and Edith could keep in touch.

Hunt left Florence and arrived at his beloved Jerusalem on August 31, 1869. This time he planned to settle, so he bought a broken-down house in the Muslim quarter of the city, which he shared with a horde of rats, snakes, and scorpions. Accepting this company with his usual sang-froid, he leaned his gun next to the bed at night so he could shoot snakes without getting up. In this bizarre setting he began to

paint *The Shadow of Death,* a canvas that shows Christ stretching his sore limbs at the end of a hard day in his father's carpentry shop, arms raised to prefigure the crucifixion. This picture is extraordinary in its representation of the body, rippled with muscles, knotted with veins, and covered with glowing skin bronzed by the sun. The flesh is so luminous and so sensuously realized that one is tempted to reach out and touch it. The Christ of *The Light of the World* was a sentimental god dripping with drapes and jewelry, but this Christ was a radiant young man with a remarkably beautiful, almost naked body.

Hunt labored at this picture with his customary intensity, waking at dawn and staying at the easel until the sun betrayed him by setting each day. In his letters home he wrote that he was weeping all the time, and reading the Bible "as if Christ had really been one of my friends."[17] His anxiety about the work ruined his sleep; he drove himself mercilessly for two years and made himself ill. All his frustrated sensuality was poured into the picture; he had nowhere else to lavish the feelings that Fanny had awakened in him.

He longed for Cyril. Hunt's uncomplicated love for his son was one of the finest things about him. He cared for the child without the evasion or bombast or drama that so often marred his love for women. At one point he wrote to William Rossetti: "Go and have a look at my little boy and tell me how he seems. I am wondering whether I shall ever get hold of him. I want him so much *here.* I must have someone to love near me."[18] Edith volunteered to take the child out to the East to join his father, which would have put her alone with Hunt in an exotically romantic situation, but Mrs. Waugh refused to let the child go.

Hunt knew he was driving himself toward a collapse, as he did with virtually every major picture. He dreamed of how Fanny might have saved him, writing to a friend: "If my good wife had lived, my stay here while times were quiet would not be at all unpleasant — house things might be kept in order without my being disturbed. Letters might be attended to, callers staved off, and in the evening and at meals there would be the babies and a chat about home friends to divert one instead of being a 'brother to owls and a companion to dragons' as I am now."[19] The perfect wife would have devoted herself entirely to him, to his children, and to his painting.

He was starting to think about a new wife, but there was, understandably, no mention of Edith. In law such a marriage was not possible: It was illegal in Britain for a man to marry his deceased

wife's sister. Hunt wondered aloud in letters to a male friend in Florence whether Miss Lydiard had developed a mind in the interval, and what had happened to that "sensible" Miss Roberts? He fantasized a trip to snap one of them up and bring her back to Jerusalem to tend his hearth and warm his bed. Instead, he came down with malaria and jaundice. In his delirious fever, he "dreamed of nothing but newly-discovered faults — of paint drying before it could be blended, of wind blowing down my picture and breaking it, etc. — until my eyes sank so deep into my head, and my body seemed such a heavy, stiff and unelastic corpse that I thought the next stage must be coffinward. And now that it is past, people tell me they thought me a doomed man."[20]

He left Jerusalem for England in June 1872. The reunion with Cyril was a great day. Hunt found him to be "a merry little cricket — full of life and fun without an atom of shyness and quite determined to come back with me" to Jerusalem.[21] Hunt's nerves, however, had reached the breaking point, and William Rossetti was shocked by how thin and worn out he looked. His doctor prescribed a tonic that had to be taken seven times a day and admonished him to eat his meat separately from his vegetables.

Hunt rented a house in Campden Hill, and as soon as he could persuade the Waughs to give Cyril into his care, he hired a nursemaid and brought the boy to live with him. To a friend he wrote: "The old people were coddling and crushing him dreadfully and he was already too advanced for them. They would have either broken his spirits or made him rebel. The old gentleman had ruled his family with a rod of iron. I am indebted to them for the care of him in his infancy."[22] In the morning he took the boy swimming or riding; in the afternoon, while Cyril rested, he worked in his studio. They were merry together, and Edith was cut out.

Edith had been dreaming of her own happy reunion; instead, she lost the child to whom she had been like a mother. To her dismay she found that she was no closer to Hunt than she had been when he was a thousand miles away. He was polite, but distant and preoccupied. It pained her to see him lavishing all his love on the little boy. She needed to believe that Hunt was the perfect, unflawed man she dreamed he was, so she fastened on Cyril as the spoiler. Cyril was the living embodiment of Fanny, her double, her shadow, the woman who had taken Hunt away from her just by being older, luckier, in the right place at the right time. Where Edith craved Hunt,

Fanny had debated whether to accept him. Where Edith yearned for him fruitlessly, Fanny had had all the pleasure and joy of being his wife. Now, in death, she possessed that title absolutely and forever, living on in the memory of Hunt and of her family as the wife-martyr.

Waiting for years, often without hope, had worn away Edith's nerves and her good sense, making her subject to rancors and pettiness. She took great pleasure in the fact that she was spoken of as more beautiful than her dead sister. But time was slipping away, beauty would fade, and she was growing desperate. She broke down, threw maidenly modesty to one side, and wrote Hunt a letter confessing all her love and grief. He was touched but uncertain how to respond. After much thought he sent her a letter in which he gently made it clear that he had long regarded marriage as impossible for them and that he saw her now as a sister. That sexless denomination crushed her, but she did not give up.

As the months went by, a correspondence grew up between them. Even though they lived in the same city, it was awkward for them to see each other, because Hunt did not feel welcome in her home (as indeed he was not) and because Edith could not visit his studio without a chaperone. The only place in which they could be private and at ease together was on paper. Hunt saw that Edith remained steadfast in her commitment to him, and so he began to reconsider her as a wife and as a mother for Cyril. He was no longer in love with her, but the brief, keen sweetness of his life with Fanny had left him with a hunger for marriage. Feeling that he might well be too old to indulge in romance, he thought that he would be lucky to find a generous, hard-working woman to care for him and his boy.

The two spent a year getting to know each other by mail, feeling their way over the delicate ground between them. By the end of the year, they had decided to marry, perhaps in America, where, Hunt imagined, they would be able to circumvent British law. Bearing a burden of guilt and apprehension for the future, he wrote to Stephens on October 14, 1872: "It saddens me to think how much pain I have cost her, her mother and her sister, and still more to consider how much more she will have to bear whichever way the thing will end. Could it be undone by going back I would willingly do so, although I see more than ever what a good and affectionate creature she is." This was Hunt in one of his simplest and most honest moments. For once he forgot himself and acknowledged the hardship that others

faced as a result of his actions and what he meant to them. However, succumbing to the lure of himself again, he went on to write: "I am unfortunate in having to go to many dinner parties now. I can scarcely bear them, but the numbers of guests force one to put on a show of bravery. Altho' as I emerge into the street I weep."[23]

With great trepidation Edith and her fiancé entered the drawing room at Queensborough Terrace to announce their intentions. Mr. and Mrs. Waugh were first caught by surprise, then, in short order, horrified. They struggled to be polite but failed. Drawing room decorum went out the window, and they spoke their objections plainly. Hunt had come like a wolf and carried off their firstborn; now he was returning to snag another of their beloved flock of maiden daughters. The first time they had been so naive as to welcome the wolf and make a place for him at their table. This time they were going to fight to protect their own. Insult was added to injury when they realized that Edith was earnestly beseeching them to let her offer herself for sacrifice. The betrayal of Fanny's memory was too much for them to bear. It was bad enough that Hunt would consider the match, but far worse that Edith should plead for it, trumpeting her desire for a relationship that amounted to incest in their eyes and in the eyes of the law.

There was no resolution of the conflict that night, nor in the months to follow. Edith had to remain in her parents' house, and they set themselves to convince her of her stupidity and heartlessness. The law validated their dislike of Hunt; it offered them a cudgel with which to protect and punish their daughter. They pointed out to her that she could not be married in her own country but would have to sneak off like some pitiful bankrupt or fraud to the Continent. If she had the temerity to return to England, she would be a social outcast, shut out from the good society in which she had been raised. Nor did they fail to elaborate on the shame and embarrassment she would bring down on the family that had treasured her, faithless creature, all her life.

When the Waughs realized that Edith wanted the marriage far more keenly than Hunt did, they could not forgive her. There were endless scenes, shouting and tears. Alice and Tom Woolner were acutely disturbed by the idea of this marriage too, and whenever the flames of parental anger died down, they threw coal on the fire. Leaning heavily on the incest angle, they retailed the story to all their acquaintance, spreading the scandal far and wide.

The pressure on Edith never let up. When her now invalid father took a turn for the worse, her mother told her that it was her obstinacy that had made him ill. When he died over the Christmas holidays, Mrs. Waugh let her grief run away with her and charged Edith with killing him. She granted that Fanny's death had weakened him, but Edith's desertion had dealt the final blow. Edith withstood this onslaught through the winter, but finally she broke. On April 30, 1873, she wrote Hunt a letter calling off the engagement. Her mother had won.

Hunt was angry at Edith, and on May 2 he vented his hurt and impatience in a letter to Stephens: "I have just got an answer from Edith and it is to say, what do you think? that she cannot be my wife since the law would not recognize the marriage, as tho she had not been writing to me all this while, and had not called me back from wooing elsewhere with the repeated declaration that she did not care for the law when opposed to God's written will. I have replied of course kindly and considerately saying that I felt that the decision was the wisest for her, but pointing out that there must be no more letters pass between us." He decided his next step was to search for a replacement for Edith: "I must now try and get interested in some other woman for the disquiet and untrusted longings of this last mistake of mine must go on no longer."[24] In a letter written two days later, he mentioned his interest in "some other aquiline-nosed ladies";[25] at forty-six, he was still fretting that his progeny might be afflicted with his snub nose.

Less than a fortnight later he wrote to a friend in Florence with a scheme for finding a new wife. The friend should collect and bring with him to England all the *cartes de visite* of young ladies he thought Hunt might find suitable. If one seemed especially likely, Hunt said, "I might *put aside my work for a fortnight* and go over to Florence without waiting for my Eastern journey and do my best to capture her and bring her back to delight my eyes while I am making arrangements for my start — A portrait together with a verbal description ought to enable me to know pretty accurately what the young lady were before I saw her." He described a "swell party" he had attended that afternoon, where he had surveyed the room, presumably with an eye to good noses, only to discover inside a quarter of an hour that the "maidens were too tender, too idle and too blooming for me, the widows and old maids too serious an undertaking."[26]

While Hunt was entertaining himself with such nonsense, Edith was on the rack at home, facing the prospect that, at twenty-six, she would soon become one of those old maids. The idea of living out her life nursing the mother who had grown to dislike and distrust her was grim. By the middle of June she had nerved herself to make the break with her family once and for all.

Hunt wrote to Stephens's wife, Clara, asking her to help Edith: "Fred has doubtless told you that Edith Waugh is to be my wife spite of the Lords and the High Church parsons. I have seen her twice and feel certain that she will adhere to her resolution now. There will, however, be a frightful explosion when she communicates her intention to her mother. I must not, however, leave her at home with the family if they cannot recognize her right to do what she in her own conscience sees to be right, and so I have told her that she must at once come to you if they make it uncomfortable at home. I know I can rely upon your goodness to befriend her. I only explain the need there may be for your hospitality because I can imagine that after she had exercised her courage enough to stop, on knocking at the door for it to be opened she might not be able to unfold to you the need she was under to stay."[27] Other friends rallied around too. William Rossetti thought the Woolners obnoxious: "My feeling," he wrote, "was . . . that H. and Miss E. W. had a perfect right to attend to their own affairs themselves."[28]

While all this was going on, Hunt was busy negotiating the sale of *The Shadow of Death* to the dealer Agnew. Eventually Agnew paid the phenomenal sum of £10,500, almost twice the price Gambart had paid for the Temple picture and once again the highest price that had ever been paid for a British painting. Hunt's long years of struggle had truly paid off, at least in pounds sterling.

When Edith told her mother of her decision, Mrs. Waugh dug in her heels and announced that Edith would never see a shilling of the generous marriage settlement her father had left her in his will, since this marriage would not be legal. She made it clear that Edith would also lose her family. Heartbroken, Edith did turn up on the Stephenses' doorstep, and they took her in and sheltered her for many weeks. Hunt's family also spurned him. His mother cut him out of her will, and both of his sisters stopped speaking to him.

⁂

Edith and Hunt had cast their lot together and from now on were forced to depend on each other completely. Their relationship might

well have foundered under this pressure, but instead it survived and even began to grow. Edith had dared everything, and Hunt admired that, seeing in her a kindred spirit, possessed of equal purpose and determination. But he also saw the toll that the months of acrimony had taken, and protective feelings welled up in him. He began to fall in love with her again.

Hunt threw himself into lobbying for legislation to repeal the law forbidding their marriage, a campaign that he waged for the next thirty years. He wrote scores of letters and organized countless meetings and committees until the Deceased Wife's Sister's Marriage Act was finally given royal assent in 1907. Once he became Edith's partisan, he was faithful to the end. In a fight he was a terrific man to have on your side.

When he inquired at the American embassy, officials there discouraged him, saying they could not sanction an action that was intended to evade the law of his own country. Hunt decided to take Edith to the Continent and marry her there before going back to the East. In Jerusalem they would be able to set up housekeeping away from the emotional artillery at home, and he could paint a few of the thousand subjects crowding his imagination. But he could not bring himself to take the last, irrevocable step, and instead he hid behind the usual excuses — lack of money, unfinished paintings. In the recesses of his mind lurked the fear that he might lose another wife in childbirth; better, perhaps, to have no wife at all than to endure that grief and guilt a second time.

The delay drove Edith to the brink; she knew that he was still capable of backing out altogether. There are some indications that Edith was living with Hunt by this time, in which case she had even greater reason to press for the legitimation of marriage. She was mortally afraid that the delay meant he still loved Fanny. Now she wondered whether he had agreed to marry her only because she reminded him of her sister.

Crippled by his anxieties, Hunt hung on for two years and four months. Finally, under pressure from Edith, he lined up a chaperone, the wife of his friend Dr. Durham, to travel with Edith to Switzerland, where he promised to meet and marry her. Soon Dr. Durham had collected a stack of letters from Hunt, who wrote every week explaining why he had to postpone their departure. His portrait of Cyril was still not done; he had to repaint the right hand this week, repaint the hair the next. It was always "tinker tinker tinker."[29]

Finally his plans came together, but Mrs. Durham was no longer available. A substitute was found, the popular novelist Dinah Craik, who traveled with Edith to Neuchâtel, where they waited for Hunt. He had promised to be there at the end of September, but didn't arrive until the beginning of November. As it was, he left London in his usual mad flurry, packing three crates of painting supplies, then leaving them for Stephens to attend to when the shipper failed to show up on the morning that he wanted to leave. When he reached Neuchâtel, he and Edith were married immediately, on November 14, 1875. She was triumphant. The survival of her love for Hunt over all these years was a testimony to her spirit — and to her folly.

For their honeymoon the newlyweds went walking in the Alps, and Hunt was relieved to see how quickly Edith regained her health and her looks now that she was away from London and her family. She was relieved finally to be married to the man she had dreamed of and waited for nearly half her life. Fourteen years had passed since that night when she had crouched on the landing in her parents' house. Edith held no grudge against Hunt for those years; she blamed Fanny, she blamed her mother and Alice and Woolner — anyone but her adored husband.

Cyril had been dispatched with his nurse for a leisurely trip down the Rhine so that Edith and Hunt could honeymoon alone. The quartet reunited in Italy and boarded a steamer at Venice for Alexandria. By December they reached Jaffa, where Hunt found to his dismay that his crates of painting supplies had not arrived. At Jerusalem they were horrified to learn that Hunt's house, in which he had stored his sketches, pictures, books, and materials, had a leaky roof, and nearly everything had been ruined or stolen. They had no choice but to move to a hotel until the house could be repaired. Hunt managed to salvage a few bits of pigment and copal varnish and the like from his stores so that he could start work, but between the packing cases that had gone astray and the expense and discomfort of the hotel he grew desperate; within a month, he wrote to Stephens that he had contracted lumbago and sciatica and could barely stand up to work.

Stephens had of course been ordered to look into the delay of the painting supplies from his end; in fact, he was receiving letters every few days from Hunt. The first ones were more or less reasonable, but soon Hunt gave up the attempt to hide his frenzy about the

packing cases. Their failure to arrive became to him a cataclysm that endangered his career and his livelihood. In this crisis, his newfound happiness with Edith availed him not at all.

Edith saw what was happening and did not hesitate to set things right. She had been readying herself for the role of wife of the great religious painter for years, and she took up that role with enormous gusto. Jerusalem was to Edith Hunt what Annat Lodge was to Effie Millais, a haven from the slings and arrows of polite society, and she blossomed there. After Hunt had wasted weeks trying to force carpenters to patch up the old house, which she saw was hopelessly ramshackle, she strode forth to rent a new house. Having scrambled to learn a few words of Arabic, she lined up repairmen to put the new house in good order and let Hunt commission builders to add on the dream studio he had always hungered after. With a servant in tow, she descended on the bazaar and bought chairs, tables, beds, fabric for curtains. Hiring a carriage, she left cards all over town for the ladies of the English colony, then for the Germans and the French, building a network of information and contacts; before long she had rounded up a first-rate cook and a staff of servants. She made it her business to find the best doctor in the city, because by February, three months after her wedding, she was pregnant, and she had no intention of dying. If she suffered from morning sickness, she never let it slow her down for a minute.

Hunt was thrilled by the efforts she made on his behalf, and she thrived on his approval. Writing home to a friend on March 3, 1876, he said that even though they were still suffering the aggravations of hotel life, "it cheers one to have a wife about one and Cyril drives away the blue devils even when one at first feels too worn out with the day's worries to be able to bear his chatter. Edith is full of business in arranging things for the house and is always full of energy and determination which to the natives here seems most unnatural."[30]

Edith was the perfect wife for Hunt. She was beautiful. She was intelligent, and he could discuss his artistic problems with her. But most important of all, she worshiped him. She sensed his frailties, his fears, his uncertainties, and she set herself to supplement them with her own great physical and mental strength. She was also very much like him in that she had only one great ambition: to make sure that he realized his dream of being the greatest painter of his time. Like him, she would run herself into the ground, exhausting herself in the process of achieving her goal. (He admired this fierceness in

her and learned to look out for her too, by trying to make her rest and conserve her energy.) She became as imperious as he in her pursuit of their needs. Soon after she arrived in Jerusalem she wrote to Clara Stephens, directing her to go to the shoemaker at Whiteley's and order her some new boots, and to take care that they were made up from her own last, not from a last belonging to one of the other Miss Waughs. In a letter to Stephens in April, she included a long list of European foods that he must buy, pack, and send to her because they were too expensive in Jerusalem, along with schoolbooks for Cyril, two yards of cheap white merino, four glass or china candlestick holders, and those "glass things" she needed to keep the candles from dripping.

Edith was also, like Hunt, physically fearless. Early in her pregnancy he took her on a camping trip, despite murmurs that the desert tribes were in a mood to massacre Christians. (England seemed to be on the point of realigning itself with the Russians and against its old allies the Turks. The more bloodthirsty tribesmen had never been fond of these high-handed, intrusive foreigners with the wrong god, and thought this might prove an excellent excuse to wipe them out.) Hunt told Stephens proudly: "Edith went with me down to the Jordan — a tent life in a blazing sun of two days and a half. All hard riding and no mistake and she behaved like a heroine."[31] But before long the danger posed by marauding tribesmen became too great, and the Hunts were confined to the city.

There was, however, one thing that Edith could not do for her husband: She could not make the packing cases full of paint supplies appear at Jaffa. Hunt had known before he left England that packages frequently were lost en route, and so one wonders why he didn't bring a basic kit with him. In the privacy of his own mind he must also have asked that question, but he mostly heaped reproaches on Stephens, insisting that his friend must have made some dreadful mistake in the shipping. He considered going to Alexandria or Naples to buy paints, but felt he could not leave Edith and Cyril behind, because of the threat of massacre. Bad investments had eaten into his capital, and Edith's pregnancy meant another mouth to feed soon, which added to his anxiety.

Finally, against his better judgment, he scoured the bazaar for the best-quality fabric he could find and stretched it tightly over a frame. He then painted a small picture as a trial. Satisfied with the result, he went ahead and covered a huge frame, sixty-two by ninety-eight

inches, with a piece of the same material and started a picture he had long meditated called *The Triumph of the Innocents*. For this painting he chose the traditional subject of the flight into Egypt, with Mary astride a donkey, the baby Jesus in her arms, but he imagined the Virgin having a vision of the babies that Herod murdered in the attempt to kill her precious child.

After he had started to work on this makeshift canvas, Hunt received word from the agent at Jaffa that a shipment addressed to him had come into port. Dropping everything, he jumped on his horse and galloped over the mountains to Jaffa, where he was amazed to discover not his three packing cases but a single large crate. He stood there spluttering on the dock as porters struggled to open it. Eventually they hauled out the three smaller cases, then a further twenty-eight parcels — the many additional items of houseware and apparel he had asked Stephens to ship in letters dispatched from Switzerland while he and Edith were honeymooning. Hunt was angry because Stephens had been so stupid as to send such an enormous crate; he should have known that shippers along the way would leave it till last because of its weight. It would have been clear to anyone else that Stephens had gone to extraordinary trouble to send every single item that Hunt had requested and to make absolutely sure that the case was strong enough to survive the depredations of any thief or fool. From Hunt's distress over the delay, one would think the crates had been years in transit; in fact this unthinkable delay had lasted five months.

The friendship between Hunt and Stephens never really recovered from this mishap. A trivial disagreement a few years later occasioned a complete break between the two, who had shared all their sorrows and joys for so many years. The yoke that Stephens had labored under had galled him deeply, and he finally rebelled. Hunt lost his lieutenant, his confidant, and his most uncritical critic. The dozens of reviews and items about Hunt's work that Stephens had supplied over the years to the *Athenaeum,* tantalizing the public with hints about works still on the easel and praising finished pictures as masterpieces, had done much to make Hunt a major figure on the art scene, and after the break they dwindled away. In his autobiography Hunt dismissed Stephens bitterly as "my quondam friend."[32]

Once the enormous crate full of supplies had arrived, Hunt was able to settle down and work steadily at *The Triumph of the Innocents*. A

tribute to Edith and to the child that she was carrying, this picture took Hunt many years to complete, but Edith was tireless as a model. Her olive skin and thick brown hair made her an ideal figure for the Virgin, and she had the patience to hold a pose indefinitely, so she was perfectly suited to his painstaking technique. Beyond the figure of the Virgin, however, Hunt had set himself a task that seemed tailor-made to drive him crazy. Around Mary and the baby Jesus he wanted to depict fifteen cherubs, which required an endless supply of infant models.

Painting babies, who inevitably wiggle, cry, throw up, or fall asleep, is a trial to be dreaded by the most relaxed, easy-going painter in the world; for Hunt, one could predict that it would become an epic drama. Fortunately, it turned out that he liked the little wigglers and could often accept their demands with an equanimity he never extended to grownups. In a letter to Edith he joked that he had had a squinting baby in the studio that morning and "I set to work to amuse the little monster by imitating a cat."[33]

This brief calm was disturbed by increasingly vocal Muslim threats against the Christians. By late spring 1876 both Edith and Hunt were concerned enough to consider evacuating. He painted furiously by day and fortified the house in the evening. He wanted to get the picture advanced enough to take it with him; as the threats grew louder, he was torn between his feeling that he should escort Edith and Cyril to safety in Malta or Naples and a feeling that he could not leave his painting behind unguarded. The canvas was wet, and even if he stopped work, it would be weeks before it was dry enough to move. The tension was heightened because Edith refused to leave Jerusalem alone; she preferred to stay and face the danger with him. He loved her for her courage, but both of them feared for Cyril and for the baby on the way.

Into the midst of this worry their daughter, Gladys, was born, on September 20, 1876. Edith recovered her strength quickly, and they were both thrilled with the infant. Hunt especially was relieved that she was plump and jolly; memories of Cyril's mewling hunger and emaciation haunted him. One day in December he stopped in at the consulate to register her birth. Mortified, the consul explained delicately that he was unable to register Gladys because she was a bastard under British law. This news fazed Hunt not at all; he saw the consul blush and tried to ease his discomfort. Gladys's happiness and health were all that mattered to him. And she provided him with another special pleasure: Now he had his very own baby model. Both parents

were pleased that they could show off their adored child in Hunt's sacred painting.

By the first of February 1877, the need for flight seemed imminent, but the Hunts were waiting for the recommendation of the consul, who held off evacuation from week to week. The wear and tear on their nerves mounted. Hunt was painting from dawn to dusk. Finally he decided that the danger was too great and insisted that Edith leave Jerusalem. A party of English officers was making the trip to Jaffa, and Hunt felt they could provide adequate protection for Edith and the children. But he had a hard time persuading her, as he told Stephens: "I induced Edith to go by showing her how dangerous to me it would be if an outbreak occurred while she were here — that it would be almost certainly fatal to all of us if I had to guard them all the way to Jaffa."[34]

At Jaffa Edith took refuge in the convent at Ramleh, a fortress built into the rocks along the coast. A gunboat from Her Majesty's fleet lay waiting to move British subjects to safety should it become necessary. While they were apart, husband and wife wrote to each other every day and often twice a day. When a letter did not arrive, Hunt worried. On May 11 he wrote: "Darling Contentment, I have my previous fast made up by a feast today for the post in the afternoon brought me a second letter of yours of yesterday which relieved very much in the news it gave of your success in the attempt to quell the wretched vermin and in your consequent sweet sleep for your want of which I felt anxious. I now feel that you have your usual vigour for dealing with difficulties so I am not afraid you will be beaten."[35] Edith was having a few trials; later she scribbled on the envelope of one of his letters: "Snakes came from roof to drink milk hung out of window for our use" and "bugs dropped from the gilded ceiling onto Gladys' cradle beside which I sat to take them off!"[36]

The threat in Jerusalem continued to escalate. On May 12 Hunt wrote: "I rejoice that you and the children are not here as I should really be anxious." Even he was afraid now, but he was also working furiously and wearing himself out: "It is absurd that I should feel sleepy while a body of unknown armed men are wailing mysteriously under my window but so I do to the extent that I can scarcely write."[37] This information must have scared Edith out of her wits. In a second letter written the same day, he warned her that if the situation deteriorated further, she would have to leave for Europe within the week. On May 13 he wrote to say that he still hoped she would not

have to go to Naples without him, "for one thing because the journey to that place with you and the showing you the delights of Naples I look to as a special pleasure in our honeymoon which I don't consider half finished which in fact I intend should never finish."[38]

Five days later he was still "shuttling baby models in and out of the studio" and finding that some of the "little imps" were just too ugly, others too cranky to deal with. In the same letter he promised to ask their doctor about weaning Gladys: "I will make it my business to ask the doctor the first time I see him about the additional food for baby. . . . My notion is that it would be a security for Gladys if she were to get accustomed in part to extra food for suppose any overtaxing of your strength or any over anxiety were to reduce your supply of milk — as is more likely while things are so unsettled. . . . Moreover I see this argument in favor of beginning now that if we wait until we get settled baby will be a fine suckling of three or four years old and when she is at her first party she will ask her partners to excuse her that she may go and have a little titty."\*[39]

On May 29 Edith was still at Ramleh. Massacre seemed imminent, and Hunt had not heard from her for two days. He panicked and telegraphed to her at eight P.M., receiving a reply at one A.M. that gave him enormous relief. On May 30, however, he still had not received any letters, and he wrote to say that if he didn't hear from her by the next day, he would leave for Jaffa. It turned out that her letters had gone astray because the postman couldn't read the address, written in Edith's uncertain Arabic, and on the following day a bunch arrived together.

The crisis in Jerusalem finally petered out when Russia and England became annoyed with each other, by which time Hunt was fed up with their posturing. He had written home that he hoped both nations would be "crippled and humbled and so learn to be wiser and better, which the Devil will prefer it is difficult to see."[40] Edith and the two children returned to Jerusalem, to Hunt's delight. Freed to concentrate on his picture, he was ready to begin the figures of Mary and Jesus, but he was horrified to discover that the center of his canvas — or rather, of the linen that he had bought to substitute — had grown

---

\*Much later Edith tried to cover that last word with a stroke of thick black ink, but when the letter is held up to the light, the word is clearly visible. This tiny slip gives us a glimpse of the secret life of this Victorian husband and wife, and of the ease and humor that underlay the thick coating of reserve they tried to paint over so much of their lives. If we could see more of this private Hunt, we might find a more appealing man.

soft and wrinkled, so that it gave way when he pressed it with his brush. For weeks he considered the problem. Finally, he decided that there was nothing to do but go home for help.

Edith packed up the house, and they started for England. The time alone together in the East had given them the freedom Hunt wanted, the chance to learn about each other and grow easy, far from censorious relatives and busybodies. Their marriage was well established, and they would have felt ready to meet any battle at home, if only the worry about the wrinkled picture had not infected everything. Hunt tried to hide his anxieties from Edith, but she, who had spent so many years studying his every twitch and grimace, knew exactly what was wrong.

Later Hunt summed up this period in his autobiography: "Even thus far I had wasted much of my best life. After two and a half years I returned to England with nothing but this partly finished picture. When I arrived in London, unpacking my painting was like the re-apparition of an appalling ghost that had been laid for a time. My restorer undertook to back with a strong canvas my feeble cloth, but although the prospect at first seemed hopeful, it was only delusive, for after all, the original linen sheet retained its corrugations. Weeks grew into months, and months into years — always promising to each new effort a success which never came. It was indeed an evil time; friends naturally wondered at my postponement of invitation to come to my studio, and asked as a joke whether I had not altogether given up painting. When I tried to form a clear judgment I often persuaded myself that another fortnight might get me over the difficulty, for continually some new expedient recommended itself to me as promising."[41] This time Hunt was not dramatizing. He spent most of the next ten years struggling with this painting. A thousand times he decided to give it up, but something always held him back; he could not bring himself to abandon the years of brushwork, the days and nights spent sketching in the desert, the hundreds of hours given up to quieting fractious infants.

Worn to a frazzle, Hunt contracted typhoid in the winter of 1879. Edith was pregnant with her second child, but she stayed up many nights to keep watch by the bed where he lay delirious with fever, tenderly blotting the sweat on his forehead and cheeks with a soft piece of linen, praying silently to herself that he would be spared. When at long last the fever broke, she was his first thought: "My

great anxiety at the present moment is to prevent Edith from doing all that her activity of mind impels her to do over and above what is absolutely necessary which at the very least is a great deal more than at this period she should do."[42]

In spite of her exhaustion, Edith delivered a healthy son at five in the morning of May 6, 1879. They named him Hilary and doted on him just as they did on Gladys. After this birth, Edith and Hunt must have used some form of contraception, because the flow of children which had begun so easily abruptly stopped.* They may have practiced abstinence — so familiar to Hunt from his bachelor years — but they took such great delight in each other that they would have been reluctant to give up their sexual relations.

Meanwhile, Hunt continued to be tormented by *The Triumph of the Innocents*. He was ashamed and afraid to show it to anyone, even to his closest friends, in part because he feared that when its defect became known, gossip would spoil his chance of getting a fair price for it. At his wits' end, he invited Millais to the studio and revealed the dreadful truth. Millais comforted his friend and told him that there was no reason for despair, because he knew a picture liner who could fix the problem. This fellow seemed to do just that, and soon Hunt was able to pick up his brushes with renewed hope. Eight months later he grew heartsick when he saw that the fabric had begun to give way again.

Hunt often told Edith that he thought the devil was torturing him with this picture. On Christmas Day 1879 he was working in his rented studio when he became convinced that he had finally achieved a breakthrough. He whispered to himself over and over: "I think I've beaten the devil."[43] Suddenly an enormous explosion much like an earthquake rocked the whole block of studios. Hunt imagined that God had vanquished the devil and freed him to finish his picture.

---

*By the 1870s vulcanization of rubber had made condoms widely available; they could be purchased in any barbershop. The public was increasingly eager for information about contraception, although the medical profession continued to lag behind. At a meeting of the Obstetrical Section of the British Medical Association at Bath in 1878, a physician presented a paper arguing that contraception was desperately dangerous for women, leading to leukorrhea, hyperesthesia of the genital organs, galloping cancer, sterility, or nymphomania. For a man consequences were as varied as nervous prostration, mental decay, intense cardiac palpitations, and mania leading to suicide. People turned a deaf ear to these predictions, and the birthrate continued to drop steadily through the second half of the nineteenth century. Whereas the middle-class family had had an average of six children in the 1850s, by the 1860s the number had dropped to five, and by the 1870s, when Edith had her children, the number was four.

This freedom proved illusory, and before long Hunt was plunged into despair as the material stretched yet again.

Deciding it was high time to cut his losses and make a fresh start, he purchased a piece of the finest canvas and had a new frame stretched, this one even larger than the first. Desperate to redeem the years he had lost, he worked so frantically that he brought on what was probably a mild heart attack. The ministrations of the doctor who had pulled him through typhoid saved him again, but this time he was ordered to Switzerland for a lengthy convalescence.

After he returned to London, still fragile, he resolved to take an irrevocable step: He would ask his liner to cut a hole around the wrinkles in the original canvas and sew in a new piece of stronger stuff. Hunt was taking quite a risk: Generally such a repair proved painfully obvious. (The hole that had to be cut was large; the patch measures twenty-three by eighteen inches.) For once luck was with him and the mending was unobtrusive, satisfactory even by his standards. He threw himself back into work on both versions, while Edith remonstrated with him for wearing himself out again. There was one spot of pleasure in this vale of tears: Hilary was able to sit for the infant Jesus, and Edith had the satisfaction of seeing herself portrayed as Jesus' mother. One day Hunt suddenly realized, as he was standing at his easel, that the long ordeal was over: "It was an occasion of the greatest joy to me when both of them were completely finished, and I had no longer to fear the possibility of further painful surprises."[44] Edith was simply relieved that he had survived.

There is one sad footnote to this story: Overall, *The Triumph of the Innocents* is a remarkably ugly picture. Edith made a beautiful Levantine Madonna, but the Virgin is surrounded by a crowd of the most tiresomely sentimental cherubs ever painted. Hunt's penchant for fat, cute babies was the trouble; their sugary flesh and the flowers twining them together make a bathetic contrast with the neat little knife wounds, which show only a drop or two of ornamental blood. Worst of all, both versions are overlaid with a dark, murky, bluish green that obscures both sky and ground. This color was Hunt's attempt to render a supernatural light; instead, it makes one wonder whether the Virgin isn't five fathoms deep. Fortunately for Hunt, not everyone was repelled. Ruskin hailed it as the greatest picture Hunt had ever painted, and eventually both versions sold, the original, troubled work going to the Liverpool Art Gallery for 3500 guineas.

As this crisis passed the Hunts settled into a more comfortable existence. They bought Draycott Lodge, a big house in Fulham; later they moved to an even grander house in Melbury Road, Holland Park. Their home was soon filled with treasures collected in Florence and in the East: Islamic metalwork, pottery, two Tintorettos, a Titian, a Bellini, a Velázquez, and a bas-relief thought to be a Donatello. Cyril was sent away to boarding school and then to Cambridge. In the summers the family rented a house on the south coast, where Edith and the children spent the season, Hunt taking the train at weekends to join them.

But there was never any danger that the Hunts would become a boring bourgeois family. Gladys and Hilary were no doubt the only children in Fulham whose father ever boiled down a horse in the front yard because he needed the skeleton to draw. (Actually he wanted a donkey skeleton, because he was having trouble sketching an ass to carry Mary and Jesus on their flight into Egypt, but the knacker didn't have one so he had to make do with a dead horse.) When the carcass was delivered to the back door at Draycott Lodge, it already stank to high heaven. Hunt assumed that he would just plop the thing in a pot and turn on the fire. As Edith told her granddaughter many years later: "Holman had imagined the flesh would soon fall from the bone and he would assemble the skeleton with ease in his studio."

When it dawned on him that there was no pot big enough in his or any other kitchen, he came to Edith for help. "After much confabulation" the pair scoured the neighborhood. They found a stupendous copper kettle abandoned in a builder's yard, so they loaded it into a barrow and wheeled it home, "causing some consternation in the streets — dear Holman was quite unselfconscious." They had to build a platform of bricks in the front yard on which to rest the kettle, then carry untold jugs of water from the pump. Long after the fire had been lit, the water refused to boil, which sent Hunt into a frenzy of impatience. He was always shocked when nature refused to operate according to the laws he laid down for it.

Eventually the water began to steam, at which point the problem of getting the horse into the pot had to be faced. Hunt hacked the beast up into "huge red joints," and Edith helped him to carry them through the drawing room, watching in silent agony as bloody pieces fell onto the Persian carpets that she revered as "silk pictures on the floor." The cooking went on for days and days; rain poured down (after all, this was England); the fire went out and had to be relit. Finally the neighbors complained. A policeman appeared at the gate,

and even Edith, who always backed Holman against the world, had to sympathize because "the stench was indescribable."[45] But the constabulary was no match for Hunt. He finished his ungodly stew, dried off the bones, and lovingly rearticulated them in his studio, just as he had planned.

Their life was not all comedy, of course. In coming home to England, the Hunts had to face the personal and social consequences of their irregular marriage. Mrs. Waugh would not see either Hunt or her daughter; she was immune even to the lure of her grandchildren. (Hunt's mother, however, caved in.) Hunt held no grudge against his mother-in-law; he just felt sorry for her. When Gladys was recovering from an illness, he wrote to a friend: "She is I rejoice much to say quite glorious again making lovers everywhere excepting in her mother's family of course. The old lady has been asked to come when I am away but she has refused, at which I feel only commiseration for the silly creature with her very little more time to become ripe for the great harvest."[46]

Alice and Tom Woolner took the battle outside the family into the homes of their friends. At a dinner party, a young American girl struggling to start a conversation with Alice had the misfortune to volunteer that she had just had the pleasure of meeting Mrs. Holman Hunt. Alice cut her to the ground: "That is quite impossible — my sister Mrs. Holman Hunt died many years ago!"[47] The poor girl was left in utter bewilderment, knowing only that she had offended. The tentacles of the Woolners' disdain reached out beyond their immediate circle. Mrs. Durham, the friend who had originally agreed to chaperone Edith to Switzerland, found that she had to be careful when planning a party that included the Hunts. To forestall any embarrassment for Edith, she made discreet inquiries beforehand, advising her guests that Edith would be present. One friend replied to her invitation: "My dear Mrs. Durham, Of course I should be civil to anyone I met in your house. But she is really a concubine."[48]

Fortunately, many people branded Alice and Tom priggish and uncharitable. In fact, the Hunts may have been spared some deadly evenings listening to the insufferable types who enjoyed clinging to such a prohibition. To whatever extent Edith did suffer from those who cut her — and she must have — she appears to have suffered in silence. If she ever wrote a note or a letter in which she alludes to the problem, none survives. When she was helping Hunt to collect the materials for his autobiography, she carefully arranged and pre-

served all his letters, censoring passages that she did not want posterity to read with fat circles of black ink. At the same time she systematically burned her own letters and papers, including all her diaries. One might be tempted to interpret this destruction as an act of self-effacement, but Edith had a very strong ego. It is more likely that she had no desire for strangers to poke their noses into her affairs. Nonetheless, those of her letters that were saved by friends to whom they had been written show not a trace of self-pity.

Instead of staying at home and feeling sorry for herself, Edith took the offensive. She gave tea parties, dinners, musicales, and at-homes, which both she and Hunt enjoyed enormously. Although Hunt saw himself as a solitary artist and did spend his days alone in the studio, he loved elegance and fun and chatting, and particularly dancing.

For Hilary's third birthday, they invited a large group of friends and their children. Violet Hunt, a sixteen-year-old guest who was no relation, wrote in her diary that night: "Went to a child's party at the Holman Hunts played games . . . Mr. Hunt behaved charmingly, running about, kiss in the ring, etc. He is very kind and gentle and simple. But to see the painter of *The Light of the World* tearing madly about a lawn is a curious sight. Mrs. Hunt was attired oddly, as usual, white muslin sort of pinafore, and she put on a sort of Hindu bed-gown to play in the garden."⁴⁹ They entertained almost to the end of their lives. On May 26, 1900, when Hunt was seventy-three, Violet went to their home in the evening to see Isadora Duncan dance.

Edith loved her parties — she gloried in knowing famous and talented people — but secretly she worried that Hunt did not approve of such frivolity. After he died, she confided to her granddaughter: "Parties! The parties which I've been privileged to attend! I kept every invitation; and unbeknownst to Holman, who would, I know, have disapproved, I kept a scrapbook of cuttings, referring to my own modest entertainments."⁵⁰ Even to his beloved wife, Hunt remained a somewhat austere figure, prone to judgment.

Hunt kept painting steadily even beyond the turn of the century, but after *The Triumph of the Innocents* he completed only one more large painting. Perhaps he had been too scarred by the experience of the wrinkled canvas. At this point he didn't need to produce major works; his reputation was secure. He was a national institution, the greatest religious painter of his time. The world knew him by the epithet "painter of *The Light of the World.*"

His last major painting was *The Lady of Shalott,* based on a drawing

of Annie that he had made almost thirty years earlier to illustrate the Tennyson poem.* The ancient wound that Annie had inflicted had healed; he was able to paint her once again as a great and powerful beauty. Tennyson's lady is a mysterious woman who surrenders herself to death after a curse falls upon her and the tapestry she is weaving flies apart. But Hunt's lady is a masterful figure who is intently spinning a wild web all around herself and through the air, using the wool meant for her tapestry. Hunt's interpretation — or misinterpretation — of the poem shows Annie actively creating a chaos, which is what he felt she had done to his life. Through his art he was having the last word, but he did not falsify the past. Annie's force was displayed intact; he no longer needed to control her.

It is also interesting that he chose to paint Annie instead of Edith. He never painted Edith as a large-scale mythical figure endowed with romance or sexuality. He did have romantic and sexual feelings for her — he continued to believe that their honeymoon had never ended — but those feelings never disturbed him in the way that his feelings for Annie did. His love for Edith grew from a real knowledge of the particular woman that she was, not from fantasy, and so it survived and flourished. Which is not to say that Edith had no place in his imagination: She was beautiful enough to paint as the Madonna, but this was not just a physical charm; he saw in her a purity of spirit that embodied his own religious faith.

In 1892 Hunt and Edith made one last trip to the East, where they found their house, vacant for fourteen years, in ruins. The visit left them feeling a complicated mixture of satisfaction and regret. Hunt was unhappy to have to sell the dream studio that he had occupied so briefly, unhappier still that he had to sell it to a wretched American woman. Looking back over his career, he grew despondent, and wrote to Frederic Shields: "What I have hitherto done amounts to nothing." But, equally in character, he resolved to do better: "I have the conviction that I should know better what to do and be able to do it better, and much quicker . . . I have more confidence in working from instinct — which is tutored now enough to be trusted."[51] Back in England he thought about why he had loved the East and rejoiced in his memories: "I am overflowingly grateful for the earth is so lovely, and each fresh scene is burnt into my soul as further

---

*Hunt employed professional models extensively while he was working on this painting, but I believe Annie Miller was the inspiration for it.

treasure not fully but abundantly valued by my overjoyed senses. Probably I shall never see them again with eyes of flesh and blood."[52]

For his next painting, Hunt took up a subject inspired by his love for the East. "It would be a pity if I, who had seen the wild ceremony of the miracle of the Holy Fire so often . . . should not take the opportunity of perpetuating for future generations the astounding scene."[53] He worked on *The Miracle of the Holy Fire* for the next seven years, until he had to accept the fact that his eyes had given out on him. The extraordinarily intricate picture gives us some feeling for the drama of the ritual, but glaucoma obviously hindered the artist's efforts. He worked by immensely bright light in an attempt to make up for the deficiencies of his sight, but no amount of light was enough. The brushwork is feeble; still, this painting stands as one last touching proof of Hunt's dedication to the cradle of his imagination.

At home there were still plenty of battles to fight. Despite failing strength and eyesight, he had no intention of fading from the scene; nor did Edith, who was right beside him every step of the way. He still hated the Royal Academy with the passion he had been nursing since the Academicians made the mistake of voting him down in 1856, and he made himself available to testify to its venality whenever the opportunity presented itself. Edith embraced his hatred, and when Burne-Jones reluctantly accepted election in 1885, she took against him. After that, Mrs. Durham heard her cry out in a booming voice when his name was mentioned: "Burne-Jones DON'T mention him in THIS house. He has gone into trade! He has gone into trade!"[54]

Toward the end of the nineties, the couple embarked on the project of writing Hunt's autobiography, Edith taking dictation to spare her husband's eyes. The two volumes are a goldmine of information and reminiscence about the Pre-Raphaelites, but the primary thrust of the work is to establish once and for all that William Holman Hunt was the founder and leader of the Brotherhood, the artist responsible for its technical innovation and imaginative genius, the teacher who enabled everyone else to produce every work deserving the Pre-Raphaelite label. Hunt was enraged by the popular notion that Rossetti had founded the Brotherhood, and in his autobiography seized every chance to stomp out this heinous misconception.

Hunt had come to believe that he was the only true Pre-Raphaelite; even his adored Millais had turned his back on their revolution, prostituting himself instead to the fashion for "little girls in mob caps."[55] Hunt looked around and saw himself deserted: "I alone still declared

that I worked on the simple principle of Pre-Raphaelitism, which, being the unending study of Nature, is an eternal law, and the consequence of my persistence was that I was greeted by critics with pity and derision as incorrigible and incapable of profiting by admonition."[56]

His works were still esteemed and brought high prices when resold at auction, as they continued to do up until the start of the First World War. (As late as 1923 the Lady Lever Art Gallery paid £4830 for *The Scapegoat*, which would have delighted Hunt.) In 1905 he was awarded the Order of Merit for his contribution to the empire. The decoration pleased him, but Edith was upset that he had not been made a baronet, as Millais and Burne-Jones had been. Trying to conceal her hurt, she sniped to Millais's daughter: "Without meaning to sound offensive, Mary, how typical it was that your father rejoiced in an ostentatious title; whereas my ever-modest Holman preferred the more subtle and distinguished honour of the Order of Merit."[57]

In 1907 further vindication came when at last the Deceased Wife's Sister's Marriage Act was passed, which made Hunt's and Edith's marriage legal in Britain. Gladys and Edith were presented to Queen Alexandra, which was a relief to Gladys and a pleasure for Edith, but the honor came too late to make much difference in Edith's life. In her sixties, she had long since accepted the inconveniences and embarrassment that the law had caused her. Her only care was for her frail and dear husband, who had just turned eighty and knew that death was approaching. (Frederic Stephens died in this year, but he went to his grave unreconciled with the man who had been his closest friend for half a lifetime.)

Strangely, the prospect of death seems to have been the thing that brought Hunt peace. His religious faith sustained him; he wrote to Shields, also a religious mystic, about his curiosity: "Death is a very little change from the other side, and yet it must be a great clearer away of mists."[58] From his study he sent a note across town to his old friend William Rossetti: "Now all is different. The master death has stept in and taken all but our two selves away. . . . If it were not for my asthma and blindness I should come and tap at your window with my umbrella and come in to smoke a pipe with you and learn your views on all matters."[59]

Death came to clear away the mists for him just after midnight on the seventh of September, 1910. He was buried near Millais in Painters' Corner at St. Paul's, and William Rossetti was one of his pallbearers.

Edith lived on as the keeper of the flame. On Sundays she often

visited his tomb, and she also stopped by the large replica of *The Light of the World* that still hangs in St. Paul's, standing before the painting and expatiating on its beauties in a loud voice to passersby, explaining the symbolism of the weeds and the lantern and the locked door, adding: "I have the honour to be the artist's widow."[60]

<hr/>

The Hunts' marriage was truly a success, in that each partner had an admiration and love for the other that only deepened as the years went by. They were in perfect agreement about their goals, their way of life, their values. The basis for their accord was the fact that Edith molded herself to Hunt, adopting his hopes, habits, and prejudices. She gloried in being his wife. Her only ambition was to help him become the greatest painter of the age; her only desire was to have the pleasure of his company.

There was just one flaw in her happiness: Fanny. Her sister dogged her like a bad dream. No matter how many times Hunt told her that he loved her, she never entirely believed him. Somewhere she always feared that Fanny still held first place in his heart. When Edith lay dying in the hospital, she confided her worst fear to her granddaughter: "The idea is so disturbing — that all these years he and Fanny have been united in heaven, perhaps as they never were before."[61] Once again Fanny had gotten there first, repossessing Hunt before Edith could stake her claim.

Edith never understood that in the competition with her sister, she had been the victor. Fanny had become a dear but faded memory to her husband, and she the living, breathing, beloved reality. Instead, she imagined that through her death, Fanny had earned Hunt's absolute allegiance. This fear was an expression of Edith's guilt. All the denials, all the parties in the world, could not erase a feeling that she had usurped her sister's place. Although Edith would never have admitted it, she believed that her mother and Alice had been right — that she had taken what did not belong to her. They had had their revenge.

Her insecurity was also partly Hunt's fault. The years that she had had to wait while he readied himself to marry her had left her with a lifelong scar, a nagging fear that he did not truly want to be her husband. But there is every evidence that after they did marry, he loved her without reserve and expressed his love openly and passionately.

The deepest scars Edith bore were the result of wounds inflicted within the family. Fanny was thirteen when Edith was born; by the time Edith was aware of her, she was already a beautiful and accomplished young woman. Edith was doomed to be the littlest sister, always with a streaming nose, clumsy, running to catch up. After Hunt had gone blind, when she was in her late fifties, she ordered his assistant to repaint the portrait that Hunt had done for her twenty-first birthday so that her waist would be slimmer and she would be just one bit more delicate and lovely than Fanny in the companion portrait. Fanny must always have seemed more worldly, more charming, easier than Edith thought she could ever be. And in fact that was true. Fanny was graceful and calm, but Edith was passionate, fierce; she took everything hard. Hunt loved her for that very intensity, but when Edith was a tempestuous little girl, her mother had held up Fanny's cool self-possession as an ideal.

Far worse, Fanny had been her father's princess, and Edith had learned that she could never challenge her on that front. Edith might have survived this loss, like many little sisters, had it not been for what came afterward. Once Fanny died, she reigned supreme as the family martyr, a victim of Hunt's ego. Then Edith chose Hunt and, according to her mother, broke her father's heart and killed him. She took her place in the family mythology as the murderer, as Hunt's accomplice, as the usurper in the marriage bed that should have remained vacant for the rest of Hunt's life as a memorial to the wife he had slain. Edith could never unburden herself of such weighty baggage, no matter how much she loved Hunt or he loved her.

She tried to buy some insurance to protect herself against Fanny. In an effort to guarantee that when she arrived in heaven she would be received as the true wife, the real Mrs. Holman Hunt, she left instructions that the dedication of Hunt's autobiography must be copied onto a piece of paper and burned with her body: "This is an insufficient tribute to Edith my wife, whose constant virtues ever exalt my understanding of the nature and influence of womanhood."[62]

Edith lived twenty-one years after her husband's death. In an attempt to maintain a connection with her beloved, she kept a diary, which was really a series of extended conversations with him, but she made certain that the volumes were burned so that their talk would remain private. She died after she was run over by an omnibus on her way to the bakery to buy a Dundee cake for a little tea party.

Six

# KING COPHETUA AND THE BEGGAR MAID

E VERY SEPTEMBER THIRD and several Sundays throughout the year, Richard Jones visited the grave of his pretty young wife, Betsy, who was buried next to their baby daughter. As soon as his son, Ned, was old enough, he would take the boy by the hand and set off through the foul streets of downtown Birmingham, walking the few blocks from their home to the cemetery in Icknield Street. Mr. Jones must have found some kind of comfort there, but what his son remembered about these visits was his father sitting by the grave in tears, holding his small hand so tightly that it hurt. The boy would sit by the headstone and listen intently to his father's stories about his mother, who had died on September 3, 1833, just six days after his birth.

Back at home, the Joneses' housekeeper, Miss Sampson, waited to pour out tea for the chilly grave visitors. Miss Sampson had come to them when Ned was the frailest of infants, and her vigilance had saved him from almost certain death. During the years when Mr. Jones was utterly shut away in his grief — for four years he could not even bear to hold Ned in his arms, so strongly did the child remind him of his wife — she had kept the household together and given Ned the love his father withheld.

As Mr. Jones began to emerge from his mourning, however, the little boy became the planet around which the two adults revolved. He was an imp, full of fun, and tender from the first. The three of them lived in a desolate flat above the shop where Mr. Jones plied his trade as a frame maker, doing clumsy work that brought in little

money. In this gloomy household, Ned was the sole source of joy and satisfaction, and in response to the affection showered on him he grew into a loving, dutiful child.

Over time, though, the adults' intense devotion became an oppression as well as a glory, and Ned retreated into a private world of his own making. A brilliant child, increasingly isolated from the two kindly but rather unimaginative people he lived with, he discovered drawing, which became his great refuge. Years later, when an artist friend said that as a child he had never felt unhappy when left by himself, Ned remarked, "Ah, that was because you could draw. It was the same with me. I was always drawing. Unmothered, with a sad papa, without sister or brother, always alone, I was never unhappy, because I was always drawing."[1]

Ned found in drawing more than pleasure; it became a means of working out his problems. Pressed by the humorless Miss Sampson to be a perfect little gentleman, he generally complied; but at the same time he filled his sketches with tiny hell-raising devils. Drawing was also a weapon against the nightmares that plagued him. Thoughtless adults were partly to blame. Decades later Ned recalled how a friend of his father's had burst into the flat to announce the massacre of British troops at the Khyber Pass: "I was a very little chap and was terrified at the idea of all the men shut in by the rocks and being shot down and killed from above without being able to do anything."[2] Night after night he lay in bed imagining the horrifying death of those soldiers, afraid to fall asleep because his nightmares were worse than his fantasies. In desperation he set himself to tame the dreams by getting them down on paper; he recalled that he had drawn the Khyber Pass at least forty times.

It might seem that young Edward Coley Burne Jones, with his active imagination and his love of drawing, was well started on the path that would lead him to greatness as a painter, but in fact such was not the case. Birmingham was a brutal, dirty, dangerous industrial city in the 1830s and 1840s, a place where the fine arts were little heard of. There was no museum; Ned did not lay eyes on a major painting until he went to London as a teenager. His only contact with pictures came by accident, and that not entirely a fortuitous one. Friends of his father's, a childless couple named Caswell, sometimes invited Ned to stay for a few days and surrounded him with a relaxed cheerfulness that eased the strain under which he lived at home. As a hobby, Mr. Caswell bought inexpensive paintings at auction and

brought them home to "touch up." The little boy loved watching him mess about with the paints, squeezing them out of their little tubes and mixing them up on his palette, but the pictures themselves appalled him — they were just the sort of murky, pedestrian canvases that also repelled Rossetti, Hunt, and Millais when they were boys. Ned told his wife many years later, "I quite hated painting when I was little. Until I saw Rossetti's work and Fra Angelico's, I never supposed that I liked painting."[3]

When Ned was eleven, his father enrolled him at King Edward's School, a prestigious institution with a rich endowment that offered free tuition and was just a few blocks' walk from their home. Mr. Jones had to pay only for textbooks, which he did gladly. He entered Ned in the commercial course in the hope that his bright little boy would grow up to become an industrial magnate. Luckily a teacher — who was, according to Ned, "the only master I ever had who had any brains" — detected his extraordinary artistic and intellectual gifts, and eventually this man persuaded Mr. Jones that his son should be switched into the classical course and prepared for university.

Intellectual effort was a deep pleasure to Ned. Even as a boy he worked as late as two in the morning in his study at the top of the house, a habit that required many extra candles — an expense the household could ill afford but that was never begrudged him. At school he made one great friend, Crom Price, and the two spent almost every afternoon in Ned's study, crafting a private world out of their ideas and dreams. They plunged into homework, translating Homer and Virgil, bearing down on Thucydides, memorizing great chunks of Milton. In their spare time they created a museum filled with fossils and minerals and mementos of battles, including a stone taken from the very spot on Bosworth Field where Richard III had been slain. They read Keats and Tennyson aloud and reveled in tales of Sir Gawain and Sir Galahad and the other knights of the Round Table. They even embarked on writing a history of the ancient world for students, because they felt the lack of a good one.

In his schoolwork Ned became a terrific competitor, and during his last eighteen months at King Edward's he was head boy. Working till he dropped was his style, as it always would be. A friend later recalled: "At school he was high-spirited, boisterous or humorous: but with melancholy beneath. His temper was hot and rather fierce. He would give place to none. . . . I remember a story that he once, in the Commercial School, carried off an armful of prizes home, rolled

them in the door-mat, and then fainted upon them," having worked beyond exhaustion.[4] Despite his fierceness, though, he was a friendly boy who drew other students to him; his customary greeting was "Are you happy?"[5]

One day a classmate named Harry Macdonald invited Ned home to meet his family. Harry was the much-loved oldest brother in a family of eight, six of them sisters: Alice, Caroline, Georgiana, Agnes, Louisa, and Edith, better known as Alice, Carrie, Georgie, Aggie, Louie, and Edie. Suddenly Ned was thrown into the company of young girls — there were girls everywhere, swirling up and down the stairs, in and out of the sitting room, with their full skirts and their touches of lace and ribbon, their laughter, their feminine mysteries, their passions and their jokes. He began to fall in love with the whole family. The Macdonalds' affection and humor were a powerful draw, a hint of the camaraderie and nurturing that Ned had missed, and he found himself longing for more invitations. But when they came, shyness often kept him away; girls intimidated him because "they do quiz so, and I make such a capital subject."[6]

The Macdonald girls were not, however, hardhearted flirts, and gradually he overcame his embarrassment. Daughters of a Methodist minister, they had been raised to the highest standards of conscience and duty. They adored their father, who could be great fun when he relaxed but who rarely allowed himself the luxury. Face to face, he found it hard to speak about his deepest feelings, but in the pulpit he had a gift for oratory that gave him tremendous moral suasion over his children, lined up in the front row of his chapel every Sunday. Unfortunately, he was away much of the time, preaching the gospel in small industrial towns and isolated villages, and when he was home he was often shut up in his study writing his remarkable sermons. So the children turned to their mother, in whom they found both riches and sadness.[7]

Hannah Macdonald ruled her brood with a gentle but very firm hand. None of her children could remember her ever losing her temper, and they loved her for it. However, she forbade them to quarrel, and forced them to develop the sort of iron self-control that she exercised over her own feelings. The Reverend Macdonald's frequent absences from home were hard on her, and although she hid her depression from her children, she did express her feelings in her diary

and in letters to her sister. There she felt free to discuss the troubles attendant upon having little money and many children: "The children have colds: Georgy is the worst . . . I am so wearied, of sickness and nursing in addition to my many domestic cares, that I sometimes feel almost stupefied, and fearful of sinning against God, by a sort of reckless indifference as to what may befall me. This however is not the general state of my feelings. . . ." Humor was one of her great resources: "You may well ask how I manage with one serv-ant. . . . My servant is one in a hundred or she would have run away and left us, under the influence of fear, of fever and fatigue. I have got a second servant on trial, fresh from the country, whether the trial will be the greatest to me or herself I cannot exactly say."[8]

Despite a delicate constitution, Hannah Macdonald bore eleven children, not all of whom survived. Her first child, a daughter who was born blind, died at the age of three, and two boys died in infancy. These losses took a heavy toll. After four-month-old Herbert's death, she wrote to her sister: "My thoughts are incessantly reverting to my last darling. . . . O how I wish you could have seen him, his beauty was most touching to behold, stamped with the marble hue of death. . . . Soon after his death which took place in his little cot I took him upon my lap, washed and dressed him, then gently laid him down again to his peaceful repose, my sorrow was not then so great as now. I had not realized my loss. I was able to sleep that night, profoundly comforted by his freedom from suffering. I have not been able to rest since. I miss him from my arm and sadly I miss him from the bosom that sustained him, in which the wellspring of life is not dried up. I believe I did not rebel, but I fear lest my grief should be excessive. . . . You will perhaps be ready to wonder that I should be so greatly afflicted. I almost wonder myself. My life is so entirely domestic, so completely merged in those of my husband and children that the loss of one out of my circle, though it be the least and latest, makes a fearful blank in my heart."[9]

Resolutely Hannah gave up any hope of breaking out of the do-mestic circle, but she wanted more for her girls: "I wish the lives of my daughters to be fuller, more complete than mine has been (for it has been rather one-sided)."[10] She could not, however, give them the one thing that made an absolute difference in the lives of men and women: a formal education. There was little money for schooling, and it went without saying that most of it would be spent on the two boys. Governesses came in to teach the girls, and later on they at-

tended day schools for young ladies, but the gap between these re-
sources and King Edward's School was very great.

Of all the girls, Georgie would probably have benefited most from
formal education. She was a great dreamer and a great reader in her
father's library, though almost every book there was dry-as-dust
theology. Even as an old woman she could list the exceptions. Shake-
speare was there, but forbidden. She enjoyed Quarles's *Emblems, The
Pilgrim's Progress,* and the Bible, which was read aloud every morning
during family prayers. She found a volume of the adventures of Robin
Hood lying neglected on a bottom shelf, and a friend took pity on
the Macdonald children and sent them a copy of *Grimm's Household
Stories.* Georgie read every one of these books again and again, until
she had absorbed the very fiber of their rhetoric, their locutions, and
their logic. The result was that she became eloquent as both a writer
and a speaker. The only book she wrote, a biography of her husband,
is moving and subtle, and her letters are a joy to read. Whereas most
of us stumble and drift in conversation, Georgie gave her listeners
the distinct impression that she never started a sentence without knowing
exactly how she was going to end it.

Georgie was blessed with artistic as well as intellectual gifts, and
her parents made sure that she had the best piano teachers they could
afford. By the time she was ten she was giving her younger sister
Aggie lessons. Because she also had a talent for drawing, she was
allowed to attend classes at the Government School of Design in
Birmingham — the same institution where Ned received his first for-
mal art instruction. Still, her privileges were not those of a boy. She
had to scrounge up coins in order to rent a picture so she could copy
it, whereas a male art student would have been drawing and copying
from classical busts all day long, six days a week.

In an attempt to overcome their limitations, of which they were
well aware, the Macdonald girls turned to their brothers and their
brothers' friends for clues to what went on in the mysterious world
of school. Wilfrid Heeley was a particular favorite; he compensated
for his shyness by writing notes at school and using Harry as a post-
man to deliver them to his sisters. "What he said and wrote lit up a
new world for us," Georgie wrote. "[His] talk was different from
anything we had known before, and our intelligence was stimulated
by his taking it for granted that we should understand him."[11] Harry's
pal Fulford was the first person to read poetry aloud to the girls, and
he sat down at the piano and taught Georgie his favorite pieces by

Beethoven and Mendelssohn. Not all their interchange was high-brow, however. Alice challenged Heeley to eat a mouse pie, and she and her sisters trapped a hapless rodent, skinned it, and baked it in a crust. But Heeley funked the dare, failing to show up at teatime. To make their triumph complete, Georgie ate a slice herself.

Among Harry's friends, Ned was the one that Georgie most admired. From his first visit she sensed that there was something special about him, and she began to watch him closely, recording each of his comings and goings. He was nineteen and the head boy at King Edward's — in her eyes, a young man of supreme intellectual accomplishments who would have no reason to take notice of a twelve-year-old, no matter how much time she spent in her father's library. But she kept her eyes on him, and the description she wrote many years later shows how carefully she observed this young man, really as an artist might have done: "His aspect made the deepest impression upon me. Rather tall and very thin, though not especially slender, straightly built and with wide shoulders. Extremely pale he was, with the paleness that belongs to fair-haired people, and looked delicate, but not ill. His hair was perfectly straight, and of a colourless kind. His eyes were light grey . . . and the space that their setting took up under his brow was extraordinary: the nose quite right in proportion, but very individual in outline, and a mouth large and well moulded, the lips meeting with absolute sweetness and repose." She also studied the spirit inside the body: "From the eyes themselves power simply radiated, and as he talked and listened, if anything moved him, not only his eyes but his whole face seemed lit up from within. I learned afterwards that he had an immoveable conviction that he was hopelessly plain. His ordinary manner was shy, but not self-conscious, for it gave the impression that he noticed everything. . . . At once his power of words struck me and his vehemence. He was easily stirred, and then his speech was as swift and clear as possible, yet well ordered and going straight to the mark. He had a beautiful voice."[12]

Who could resist such a young man? He seemed to possess the spiritual grace Georgie admired in both her parents and the intellectual achievements she dreamed of for herself. When she learned that he was also an artist, she was firmly hooked.

Unfortunately, the possibility of further conversations was cut short when the Reverend Macdonald was transferred to a new chapel in London. Georgie, just thirteen, was distraught: "As the train passed

slowly through the tunnel of the Great Western Railway at the beginning of our journey to London, I grieved in the darkness because I was leaving the place where he lived."[13] Wanting to hide her pain from the family, she waited for the privacy of the tunnel in which to weep. Ned had gone up to Oxford earlier in the year, and she would have to continue to feed on the thin fodder offered by some day school. She worried that the intellectual gap between them would grow to a hopeless chasm.

<p align="center">❧❀❧</p>

Ned was utterly absorbed by Oxford. During his last years at King Edward's, he had been drawn to the Oxford Movement, a religious revival led by a group of university theologians who earnestly sought to purge the Church of England of the errors and sloth that they felt had been accumulating ever since the Reformation. They hoped to bring an awareness of the spirit back into the everyday life of the faithful and to reinstate the sacramental mysteries of the Mass, which would move the English church closer to Rome — a shocking suggestion. The most charismatic and brilliant of the movement's leaders, Henry Newman, had converted to Roman Catholicism in 1845. This decision had scandalized most Anglican communicants but fascinated Ned, who loved the music and the ritual of the Mass.

In 1849 Newman had gone to work in Birmingham, and Ned had been profoundly affected by the sincerity of his message: "When I was fifteen or sixteen he taught me so much I do mind — things that will never be out of me. In an age of sofas and cushions he taught me to be indifferent to comfort, and in an age of materialism he taught me to venture all on the unseen, and this so early that it was well in me when life began, and I was equipped before I went to Oxford with a real good panoply and it has never failed me. So if this world cannot tempt me with money or luxury — and it can't — or anything it has in its trumpery treasure-house, it is most of all because he said it in a way that touched me, not scolding nor forbidding, nor much leading — walking with me a step in front. So he stands to me as a great image or symbol of a man who never stooped, and who put all this world's life in one splendid venture, which he knew as well as you or I might fail, but with a glorious scorn of every thing that was not his dream."[14]

Ned went to Oxford expecting to join a community of men eagerly embarking on a passionate renewal of the spiritual life. To his great

discouragement, he found that the fire of the movement was flickering out. Within days, though, he had found consolation more appropriate to his nature: the companionship of another undergraduate, named William Morris.

Morris had a short, stocky body topped by a mop of hopelessly unruly brown hair, which inspired Ned to nickname him Topsy, after the little slave girl in *Uncle Tom's Cabin* whose "woolly hair was braided in sundry little tails, which stuck out in every direction." Possessed of enormous physical energy, he was a fierce competitor who could demolish his partner in singlestick. Ned admired his earthy intensity but was daunted by his blustery temper, which Ned perceived as Morris's single flaw. The son of a London stockbroker who had made a fortune, Morris had plenty of pocket money, and soon he offered to share it with Ned, whose father had had to move to a smaller house in order to pay Ned's bills at university. Ned was too proud to accept, but Morris found many unobtrusive means of helping him out.

Soon the two were inseparable. Ned was always happier dealing with an individual than with a movement, and soon Morris became his double, his brother, and also his mentor. Together they explored every corner of Oxford, the physical relic and symbolic representation of that lost medieval world, so aesthetically and spiritually beautiful, for which they both longed. They wandered in the meadows surrounding the city; they drank claret and champagne together in their rooms; they worshiped together and chanted plainsong every morning in St. Thomas Church.

The two young men shared an attraction to medieval Christianity, which led them quickly to scent the more wide-ranging medieval cultural revival that was in the air. They read Ruskin and took to heart his praise of the Gothic cathedral as the sublime pinnacle of architectural achievement. When Ruskin argued that the stone carver who had hewn ornaments for that cathedral had been the last free worker and an artisan of great distinction because he had labored to express his faith, they nodded in agreement. When Ruskin contrasted that stone carver with the wage slaves born of the industrial revolution, who ground out hideous, false products by the thousand, they looked around and saw proofs of his argument everywhere. Talking together, they began to forge the values by which they would live and make their art.

Ned had arrived in Oxford expecting to take orders in the Church

of England, but soon he was thinking, along with Morris, of going over to Rome. He had visited the Cistercian monastery at Charnwood in Leicestershire, and the peace and order and beauty of the monks' life there made a lasting impression on him. He coveted their prayerful silence and composure. Celibacy seemed an attractive alternative to the frightening prospect of sex, which was especially threatening to a boy whose mother had died in childbirth. But he hesitated to take the final step and convert, in part because he knew it would grieve his father and Miss Sampson.

Instead, he began to craft plans for a new, secular brotherhood, which he would found with Morris and a group of friends who had come up to Oxford with him from King Edward's. He wrote to Crom, who hadn't yet come up to Oxford but naturally would be included: "I have set my heart on our founding a Brotherhood. Learn Sir Galahad by heart. He is to be the patron of our Order. I have enlisted *one* in the project up here, heart and soul."[15] Together they would live in the East End of London, in poverty and chastity, ministering to the needs of those less fortunate than themselves. Ned had not walked the streets of Birmingham all those years with his eyes blinkered. He had seen the starving children covered with sores, the wholesale drunkenness of their parents on Saturday night, the girls and women who sold their bodies for a pittance. He had looked into courtyards that were open sewers around which hundreds lived, crowded into stinking, fetid rooms, bedded down on straw, drinking water infested with cholera. Now he eschewed the retreat to Charnwood and planned a life of action and service.

He was still drawing, going off by himself to sketch in the same meadows where the young Millais had set up his easel a couple of years before. Sometimes he laid his drawing pad to one side and gave way to daydreams, incubating pictures for the future. He lived in his dreams; even after he was established as a painter, he loved to talk about "dreamland, which is my true home," and resented the mundane parts of life that dragged him away from it.

In one of the letters he wrote home each week, he described a little journey that affords an extraordinary glimpse into the world of his imagination: "I have just come in from my terminal pilgrimage to Godstowe ruins and the burial place of Fair Rosamond. The day has gone down magnificently; all by the river's side I came back in a delirium of joy, the land was so enchanted with bright colours, blue and purple in the sky, shot over with a dust of golden shower, and in the water, a mirror'd counterpart, ruffled by a light west wind —

and in my mind pictures of the old days, the abbey, and long proces-
sions of the faithful, banners of the cross, copes and crosiers, gay
knights and ladies by the river bank, hawking-parties and all the
pageantry of the golden age — it made me feel so wild and mad I
had to throw stones into the water to break the dream. I never re-
member having such an unutterable ecstasy, it was quite painful with
intensity, as if my forehead would burst. I get frightened of indulging
now in dreams, so vivid that they seem recollections rather than
imaginations, but they seldom last more than half-an-hour; and the
sound of earthly bells in the distance, and presently the wreathing of
steam upon the trees where the railway runs, called me back to the
years I cannot convince myself of living in."[16]

These were the knights and ladies he would paint; these were his
colors, blue and purple shot with gold. When they came to him in
daydreams, he experienced a rapture so extreme that he feared for
his sanity. No wonder he was daunted by thoughts of women and
sex. Even when he allowed himself to explore them within the com-
paratively safe realm of fantasy, he scared himself. To protect himself
he had to destroy his vision, piercing the picture in water with a
stone. The heroine of this fantasy, Fair Rosamond, or Rosamund,
the mistress of Henry II, according to legend was put to death for
her treachery by Queen Eleanor. She was the first in a long line of
beautiful sexual offenders whom Ned would dream about and strive
to capture with paint.

As the twilight came on he returned to Oxford, where the monastic
tradition of the university, some seven hundred years old, insulated
him pretty thoroughly from all that he feared, including beautiful
mistresses.[17] Some undergraduates knew where to find prostitutes in
Oxford, but Ned had no such inclination. Georgie wrote later about
Ned and his friends: "They had no conquering airs with women, but
were either frank and pleased in their society or shy and humble. I
am confident that the mystery which shrouds men and women from
each other in youth was sacred to each one of them."[18]

Back in London the Macdonald family was coping with Caroline's
consumption. Their Carrie had been a spirited child; as a tiny girl
Georgie had once fallen asleep at the kitchen table only to be awakened
by Carrie busily buttering her, ostensibly to prevent sunburn. By
contrast, Carrie's growing weakness was all the more shocking and
heartbreaking. When she was twelve, her doctor told Mrs. Macdonald

that the child had tuberculosis and would not recover. When Hannah told Carrie, the child startled her mother by telling her not to worry, she already knew; when the first pain in her chest had come on at school, she had looked around and silently said goodbye to all her mates. She maintained this extraordinary self-possession until her death four years later, on May 15, 1854.

The loss of three babies had been a burden for all the children, but the death of a teenaged sister with whom they had shared a bed, secrets, and jokes was devastating. From then on Georgie must have been haunted by the fear that death would come and snatch her too. None of the sisters enjoyed sturdy health, and all of them lived with the knowledge that the fatigue that dogged them might presage consumption. But like her mother, Georgie was not one to wallow in her distress, and when her parents took a rare trip to Oxford to recuperate after Carrie's death, she put aside concern for herself and took responsibility for the younger children.

Georgie saw little of Ned during his years at the university, but much of her time was spent fantasizing about the glamorous life he led there. Letters from Harry provided scraps of news, not much to go on. On one of the few occasions that Ned did come to call, which Georgie remembered as July 18, 1855, she was just returning home as he left the house: "I missed him so narrowly that I distinctly saw him walking away down the street as I reached my own door."[19] She could not run and catch him to say hello; such conduct would have been too forward. When, as an old woman, Georgie sat down to try to write about Ned's life in Oxford, she revealed how painful the exclusion had been to her: "How can a woman hope to describe the life of men at college, since she can never have seen it as it really is? The thing is impossible."[20]

Georgie seems not to have known about the religious crisis that was consuming Ned. He was losing the faith of his childhood, which sunk him for a time into a frightening despair. According to Ned, the philosophy that he and Morris had been reading "presently shot up like lightning and sent all our hopes, for it shrivelled the belief of one and palsied mine, I fear for years, and so our poor little brotherhood fell through and did not even live to be born."[21] He talked wildly of sacrificing himself in the Crimea — "I want to go and get killed" — and even went so far as to volunteer, but fortunately was rejected on grounds of poor health.[22] Gradually, with the support of Morris, he recovered his equilibrium, and the two of them set out

on a different path: "We were both settling in our minds that the clerical life was not for us, and art was growing more and more dominant daily."[23]

They had already discovered Ruskin. When the Edinburgh lectures were printed in 1854, Morris waited at the bookshop for the first copies to be delivered. A few minutes later he rushed into Ned's room and insisted that he drop everything and listen while Morris read the lectures aloud from start to finish. For both young men they were a revelation: "There we first saw about the Pre-Raphaelites, and there I first saw the name of Rossetti. So for many a day after that we talked of little else but paintings which we had never seen."[24]

Fortuitously, a print seller on the High Street mounted a small exhibition of Pre-Raphaelite work, which gave the two young enthusiasts a chance to look their fill at Millais's gentle *Return of the Dove to the Ark,* a picture that reduces the melodrama of the Flood to two innocent young girls standing in straw and stroking a dove. They wangled an invitation to the Combes's house, where they were welcome to look round the drawing room, which was replete with Pre-Raphaelite pictures. They scouted out a copy of *The Germ* and pored over every line of the engravings and the poems. Down in London they managed to get an invitation to see the collection of Mr. Windus at Tottenham, which included Ford Madox Brown's poignant *The Last of England.* They rushed over to the Royal Academy Exhibition to see *The Light of the World* and *The Awakening Conscience.*

Hunt became a hero to Ned: "I used to worship Holman Hunt more than anyone in all the world, and never having seen him used to draw imaginary portraits of him, making him straight nosed and as perfect as I could, and talked incessantly of him."[25] (Hunt would have appreciated the straight nose.) Ned also admired Rossetti's work, especially an illustration for Allingham's poem "The Maids of Elfin-Mere," which was a turning point for him. This lovely engraving and Ned's early drawings share a romantic, fairy-tale spirit, but the bold certainty of Gabriel's line in this illustration makes an impressive contrast to the tentative, intricate scenes Ned was producing. By now Ned believed that "the Pre-Raphaelites had indeed come at a time when there was need for them," and he resolved to follow in their footsteps.[26]

In 1855 he and Morris were early visitors at the Academy exhibition. Hunt, who was struggling in the East with his *Scapegoat,* had no pictures on view, but Millais's dramatic *Rescue* hung on the line.

Heeley escorted Georgie to the exhibition, where they ran into Morris, lost in study of the painter's heroic fireman. Waiting quietly until Morris had turned to go on to another picture, Heeley stopped him and introduced Georgie. Knowing that William Morris was Ned's best friend, Georgie scrutinized him carefully. "He was very handsome," she later recalled, "of an unusual type — the statues of mediaeval kings often remind me of him." But there was something in him that froze her a bit: "His eyes always seemed to me to take in rather than to give out."[27]

That summer Morris and Ned made a decisive pilgrimage to France. Ned was listening to a solemn Mass in the medieval cathedral at Beauvais when he realized that he must begin his life as an artist. For him the impulse to worship and the impulse to make art were intimately related, at times the same thing. Much later he told a friend about that morning: "It is thirty-seven years since I saw it and I remember it all — and the processions — and the trombones — and the ancient singing — more beautiful than anything I had ever heard and I think I have never heard the like since. And the great organ that made the air tremble — and the greater organ that pealed out suddenly, and I thought the Day of Judgment had come — and the roof, and the long lights that are the most graceful things man has ever made. What a day it was, and how alive I was, and young — and a blue dragon-fly stood still in the air so long that I could have painted him. Oh me, what fun it was to be young. Yes, if I took account of my life and the days in it that most went to make me, the Sunday at Beauvais would be the first day of creation."[28]

From Beauvais they journeyed to Paris and Chartres and Rouen, stopping at every church they could find. Near the end of their journey, Morris and Ned went for a walk late one night on the quay at Le Havre. Looking out at the moon reflected yellow in the ocean, listening to the sound of the waves pounding the shore, the two friends "resolved definitely that we would begin a life of art, and put off our decision no longer — he should be an architect and I a painter."[29]

Back at Oxford, they started the *Oxford and Cambridge Magazine* as an outlet for their poems, stories, and drawings. Over the Christmas holiday Ned went down to London, where he stayed with an aunt in Camberwell, the dreary suburb in which Ruskin lived with his parents. He sent a copy of the new magazine with a covering note

to the famous critic, and when he got an immediate acknowledgment, he exulted to Crom: "I'm not E. C. B. Jones now — I've dropped my personality — I'm a correspondent with RUSKIN, and my future title is 'the man who wrote to Ruskin and got an answer by return.' "[30]

It was during the winter holiday in 1855 that Ned caught his first glimpse of Rossetti, at an open faculty meeting of the Working Men's College: "Good fellowship was the rule there, that was clear, and a man sitting opposite to me spoke at once to me, introducing himself by the name of Furnivall, and I gave my name and college and my reason for coming. He reached across the table to a kindly-looking man whom he introduced to me as Vernon Lushington, to whom I repeated my reason for coming, and begged him to tell me when Rossetti entered the room. It seemed that it was doubtful if he would appear at all, that he was constant in his work of teaching drawing at the College, but had no great taste for the nights of addresses and speeches, and as I must have looked downcast at this, Lushington, with a kindness never to be forgotten by me, invited me to go to his rooms in Doctors Commons a few nights afterwards, where Rossetti had promised to come. So I waited a good hour, or more, listening to speeches about the progress of the College . . . and then Lushington whispered to me that Rossetti had come in, and so I saw him for the first time, his face satisfying all my worship, and I listened to addresses no more, but had my fill of looking, only I would not be introduced to him. You may be sure I sent a long letter about all this to Morris at Walthamstow."[31]

You may also be sure that he appeared promptly at Lushington's chambers in Doctors Commons on the appointed evening, where he met Gabriel. When someone in the assembled crowd dared to criticize Browning's *Men and Women,* which had been published just a few days before, Gabriel attacked the poor fellow's criticisms so savagely that he was silent for the rest of the evening. For Ned this rude outburst was the last touch required to ensure his worship: "I saw my hero could be a tyrant," he said, "and I thought it sat finely upon him."[32]

Ned was just the sort of acolyte who appealed to Gabriel, who invited him to visit his studio the following day. At Chatham Place the young artist found Gabriel at work on a watercolor of a monk who was busily painting a mouse into the manuscript that he was illuminating. Few subjects could have touched Ned more, given his

passion for the Middle Ages and his longing for the repose and protection of the monastic life. Gabriel chatted at his easel, asking many questions about William Morris, whose poetry in the *Oxford and Cambridge Magazine* he had admired mightily. He had also read Ned's essay on Thackeray's novel *The Newcomes,* which contained a lucky digression praising Rossetti's drawing *The Maids of Elfin-Mere.* Gabriel was genuinely pleased; in a letter to a friend, he wrote: "That notice . . . was the most gratifying thing by far that ever happened to me — being unmistakably genuine. . . . it turns out to be by a certain youthful Jones, who was in London the other day, and whom . . . I have now met. One of the nicest young fellows in — Dreamland. For there most of the writers in that miraculous piece of literature seem to be. Surely this cometh in some wise of *The Germ,* with which it might bind up."[33]

Having now corresponded with Ruskin and watched Rossetti work, Ned felt that returning to Oxford was a dull business. By the spring his impatience had mastered him, and he bolted for London, without a degree and with next to nothing in his pocket. Tramping the streets of Chelsea, he and Fulford, who had agreed to share rooms with him, called on a remarkable number of landladies — no less than 2845 by Ned's exhausted calculation — in search of tolerable rooms to rent within their limited means. Ned regaled his father with their exploits, mocking himself for his squeamishness before these ladies: "Such viragos some of them were, I didn't think womankind really was so appalling."[34] Finally they took rooms at 13 Sloane Terrace, an address that is smart today but was then just one of a row of down-at-heel boarding houses. Their chief attraction was proximity to the Reverend Macdonald's chapel.

Although, as Georgie lamented, she and Ned had had few chances of seeing each other during his time at Oxford, Ned had been thinking and dreaming about her. He had come to love her for her absolute integrity, her sense of fun, her intellectual curiosity, and her gentle, tender ways. He must also have realized and been swayed by the fact that he was an intensely romantic figure to her. Shyness had no doubt kept him from speaking at first, but now he was impatient to see her and speak about his feelings.

Once he arrived in London, their love affair got under way in earnest. Her only reference to this stage in their romance is a delicately allusive remark: "The house in Sloane Terrace where

Edward lodged was almost exactly opposite the chapel of which my father was a minister, and sometimes after service, as the congregation filed out, the eyes of a girl amongst the slowly moving crowd were lifted and saw for a moment his face watching at a window."[35] Ned began calling at the Macdonalds' house in Walpole Street almost every day. On May 19, not long after his arrival in the city, he took Georgie to the Royal Academy Exhibition, where, standing before Arthur Hughes's *April Love,* he asked her to marry him. The young man who feared girls, detested flirts, and dreamed of being a monk was moving awfully fast. Clearly he had had this in mind before he arrived in London.

Ned was twenty-three and Georgie was not quite sixteen, so her parents took time to consider their decision. Georgie waited in suspense, until "one day early in June my mother called me into her room and told me that Edward had been to see my father and herself; and then she went on with what seemed to me to have been written from the beginning of the world, and ended by saying that they left the answer they should give him entirely to my decision. There was no difficulty in her seeing what that was, and we knelt down together to ask for the blessing of God upon it. . . . Looking back I feel the deepest respect for my parents because they never discussed with me the 'prospects' of my marriage; my father asked Edward no questions about his 'position,' but, so far as my judgment goes, acted as a minister of the Christian religion should do, seeking nothing but character and leaving the question of fortune altogether on one side."[36]

Before breakfast the next day Ned had sent round to Georgie every book by Ruskin that he owned. Later he paid a morning call, and as they sat in the parlor together, speaking for the first time as affianced lovers, they realized to their delight that the date of their official engagement was "Dante's own day," the anniversary of Beatrice's death. This may seem a macabre cause for delight, but it was of course also the day that Beatrice ascended to heaven, an event that made the achievement of Dante's great poem possible. The date was a fitting symbol of the innocence and purity of Georgie and Ned's romance. Resolving that it would be their anniversary too, they vowed to marry on June 9, but the wedding was still in the distance because Ned could not yet support a wife.

Their courtship was easier and more intimate than that of many middle-class couples, mainly because Hannah and George Macdonald allowed their daughters a real measure of freedom. They knew they

could trust their girls and did not insist that all events be chaperoned. God's good opinion mattered to them, but their neighbors' did not. Georgie was taking drawing lessons at the Government School of Design in Gore House, Kensington, and Ned often met her afterward, bringing flowers, to escort her home. They walked and talked together in complete privacy. It may have been during one of these walks that they confessed to each other that they had both lost faith in doctrinal Christianity, a loss that Georgie could not discuss at home; sharing it brought them some relief. At the same time, neither of them ever rejected the spirit of Christianity, and out of respect for Georgie's father they continued to attend services in his chapel every Sunday.

Ned was always sure of a warm welcome and a meal at the Macdonalds', which in itself was a terrific attraction in these lean times. The children called him "Mr. Edward," but they found in him a boon companion. He would perform tricks for them with his pencil, covering "reams of paper with drawings that came as easily to him as his breath. . . . They filled up moments of waiting, moments of silence, or uncomfortable moments, bringing everyone together again in wonder at the swiftness of their creation, and laughter at their endless fun."[37] Georgie must have felt that she had won a man as charming and amusing as her father, but one who would be available, who would share his joy spontaneously rather than withhold himself in the service of a tiresome and demanding God.

Ned, however, was worried about how his father would take the announcement of his coming marriage, so he made a special trip home to Birmingham, though he could ill afford it, to tell him in person. The two made their familiar journey down to the cemetery in Icknield Street, where, sitting by his mother's grave, Ned broke the news as gently as he could. Mr. Jones seems to have accepted his son's wish with equanimity; it was Miss Sampson who balked. Looking back fifty years later, Georgie understood the currents of tension and distress that had greeted her when she visited Birmingham shortly after Ned made his announcement: "He took us to his own home, where I made the acquaintance of Miss Sampson, and dimly perceived what became clearer to me afterwards, that an angel from heaven would have been unworthy in her eyes to occupy the position I then did. Her devotion to Edward, however, and the spirit of hospitality that reigned in the little house, controlled the flames of jealousy."[38]

At twenty-three, Ned knew he should have been finishing his training as an artist, not starting it, so he threw himself into his work to make up for lost time. Apprenticing himself to Rossetti, he went to Chatham Place whenever he was asked, which was often. "My first summer with Rossetti," he wrote, "I worked with him entirely, and he would paint away without stopping to eat anything at all but such a thing as a huge dish of strawberries that he would share with me — and when it was dark he'd go out and wander about for a long time and sometimes wouldn't come home till very late, early morning even. Then begin again in good time for the next day."[39] Gabriel didn't realize that Ned was so short of money that the half dish of strawberries might be all he had to eat that day, and the next as well. (Mrs. Macdonald would certainly have fed him more often had she known, but pride kept him silent.) Not enough food and not enough sleep left Ned lightheaded at times, and he began to be visited by a hallucination that returned to him periodically for the rest of his life: A man carrying a black bag would walk up to him in the street, whistle a little tune in his ear, then say "God bless you" and move off. A benign enough figure, but certainly his appearance suggested that things had gone too far. Ned, who was never very sturdy, had sense enough to see that he could not sustain this pace.

His realization that he had to slow down and take better care of himself coincided with Morris's arrival in London. Indeed, Morris's decision to leave Oxford may well have been influenced by his sense that Ned needed help. He took a house in Gordon Square and asked his friend to come live with him. He engaged a cook, and suddenly there was dinner on the table every night when Ned came home, and his dearest friend to share it with. Ned still saw Gabriel regularly, but he also enrolled in a conventional art school. Again he went overboard; he eventually attended three schools at once: Gandish's and Cary's by day and a life class in the evening.

By November, Morris and Ned had decamped from respectable Gordon Square and taken more suitably bohemian quarters in Red Lion Square, on the advice of Gabriel, who had once shared the rooms with Walter Deverell. Also at Gabriel's urging, Morris left the office of the architect G. E. Street, where he was training. Painting was the supreme art, Gabriel argued, and architecture a poor second. Convinced for a time, Morris apprenticed himself to Gabriel.

All Ned's dreams seemed to be coming true at once; for him, 1856 was the "year in which I think it never rained nor clouded, but was blue summer from Christmas to Christmas, and London streets glit-

tered, and it was always morning, and the air sweet and full of bells."[40] Georgie had agreed to marry him. He and Morris were painting together in the same studio, and they had a standing appointment with Ruskin every Thursday evening. Ned had also begun to replace Gabriel as Ruskin's protégé; the position had grown irksome to Gabriel, who was happy to pass it on. Ruskin bought Ned's paintings and brought other patrons to meet him.

Meanwhile, Gabriel introduced Ned and Morris to all his friends, and suddenly they found themselves swanning around with the very men whose paintings they had only read about at Oxford. Before long Ford Madox Brown, Millais, George Boyce, Arthur Hughes, and William Bell Scott were dropping by Red Lion Square to see them and inviting them to visit their own studios. For Ned, the great prize was Holman Hunt. He wrote to his father (who had once sat at the breakfast table with him while Ned tried to draw a portrait of Hunt, without ever having seen him): "A glorious day it has been — a glorious day, one to be remembered by the side of the most notable ones in my life: for whilst I was painting and Topsy was making drawings in Rossetti's studio, there entered the greatest genius that is on earth alive, William Holman Hunt — such a grand-looking fellow, such a splendour of a man, with a great wiry golden beard, and faithful violet eyes — oh, such a man. And Rossetti sat by him and played with his golden beard passing his paint brush through the hair of it. And all evening through Rossetti talked most gloriously, such talk as I do not believe any man could talk beside him."[41] What Ned didn't know was that Annie Miller was a lively, painful ghost in the room that day, and Gabriel was trying to make up to Hunt by swathing him in charming talk.

At this time Gabriel was struggling with his painting, had his own money problems, and was worrying about Lizzie, who was ill in the south of France, yet he didn't hesitate to help Ned. He was at his best in this sort of relationship, when he could take care of another man who needed his help. He undertook to get Ned the money he so badly needed. He introduced the young artist to Thomas Plint, who was at the head of his own short list of patrons, and Plint obliged by immediately commissioning a painting on a subject of Ned's choice, with payment in advance. Next Gabriel arranged for Ned to do some designs for stained glass, which provided him with a steady income not just for the next several years but for the rest of his life. In sum, Gabriel did almost everything humanly possible to see that Ned was

launched as an artist and given every opportunity to develop his talent.

On his side, Ned never failed to be grateful, saying of Gabriel: "Towards other men's ideas he was decidedly the most generous man I ever knew. No one so threw himself into what other men did — it was part of his enormous imagination."[42] Ned never finished a piece of work without wondering what Gabriel would think of it. Later he recognized that the access of moral courage he took from this relationship was far more important than the few practical details he had learned from Gabriel: "He taught me to have no fear or shame of my own ideas, to design perpetually, to seek no popularity, to be altogether myself."[43]

Taking his cue from his mentor, Ned busily explored London, spending days in the British Museum, the National Gallery, and the newly opened South Kensington Museum (now the Victoria and Albert). Gabriel encouraged him to believe that his imaginative life was not an indulgence but the absolutely necessary wellspring of his art, so he spent much of his time reading and drawing, learning to live more fully in dreamland.

His favorite book was Malory's *Morte d'Arthur,* which was to provide the subjects for many of his greatest paintings. In the legend of the Holy Grail, Ned saw spirit joined to romance in a perfect, mystical union, a union that he wished to achieve in his own life. He had long ago embarked on the quest, in the days when he and Crom had spoken about the legend in his room at the top of the house; in Malory's book he found only a new and more beautiful rendition of this idea. Georgie was to be the damsel in his romance: acutely intelligent and yet innocent, talented but modest, gentle and kind and true. Ned knew how lucky he was to have secured her hand. He made genuine efforts to share his aesthetic and spiritual adventure with her, to bring her into his new world of art, but it was nearly impossible for a sixteen-year-old girl who was neither a model nor a prostitute to take a place in that almost exclusively male world.

However, Georgie remembered and recorded each of the moments when she was allowed in for a peek: "To the shrine of Rossetti at Blackfriars I was led for a short awestruck visit, of which I remember little except that he went on painting while we were there, and that I noticed the sensitive look of his hand as well as the beautiful olive colour of his skin, so different from that of a dark Englishman."[44] She was also taken to meet Ruskin in the basement of the National

Gallery, where he was engaged in the endless task of cataloguing and conserving the thousands of drawings in the Turner bequest. That day Ruskin was kindness itself. He showed them a selection of the drawings and took Georgie around the dusty storage area so she could see some old pictures Sir Charles Eastlake had just brought back from Italy. He praised Ned's work to her extravagantly, and so it was for her a "golden hour."[45]

Georgie went only rarely to Red Lion Square, for a young lady could not visit her intended in his bachelor quarters, at least not without a chaperone. But she and Alice did attend at least one party there, at which Georgie provided the entertainment by singing some old French songs while accompanying herself on a piano rented for the evening. Eventually she was famed among their friends for her musical gifts, and her endurance — once seated at the piano, she could sing for hours if her listeners demanded. It was quite startling to hear such a volume of music issue from so tiny a being: Georgie stood barely five feet tall. William Bell Scott's wife listened in amazement as this petite young woman, with her pale, delicate features and shiny dark hair pulled back to a simple knot, thrilled her audience with "loud wild tones quite novel and charming."[46] Music was one means of expressing the passion that she had been so sedulously schooled to suppress.

In the summer of 1857 Ned returned to the university to assist Gabriel in the decoration of the Oxford Union. He planned to be away for a few weeks, but ended up spending half a year slaving over his mural, while Georgie waited patiently in London. The subject he chose for his picture suggests that his romance was very much on his mind, if not altogether happily. He illustrated the story of Merlin the wizard and Nimue: Merlin, otherwise so confident of his extraordinary powers, falls in love with the beautiful Nimue and proceeds to teach her the secrets of enchantment as a way of proving his love. Eventually she wearies of him and, unable to discourage his attentions, resorts to using the secrets he has taught her to entrap him and free herself.

Ned returned to this subject at least five times in the years to come, which suggests that he found some profound truth for himself here. As a maker of enchantments, Merlin was much like an artist. Ned's infatuation with Gabriel showed that he wanted to learn the artist's

secrets, to take possession of that power for himself. But he also sensed a profound danger in that power, if it was not used wisely. Merlin was the devil's son; by taking the wizard as his totem, Ned acknowledged not only that he wanted to be an artist but that he understood that artistic power was born from the renegade side of the self, which might someday lead him to grief — through the agency of a beautiful but dangerous woman.

In his Oxford mural, Ned painted Nimue luring Merlin into the lake where she trapped him under a mighty stone for all time. The mistake that Merlin had made was loving too well; devotion to the woman of his dreams became an imprisonment. Ned had grown up with the tangible, daily evidence that great love had destroyed his father's happiness. He must surely have feared that he too might love a woman — might love Georgie — too much. At the same time he dreamed continually about such great love, and made it the subject of many of his paintings.

Ned was committed to finishing the mural, his first large, public piece of work, and he stayed at it long after Gabriel and the others had dispersed. Morris was still in Oxford, courting the strangely beautiful Jane Burden, but he had quit work. Only Spencer Stanhope remained painting beside Ned, whom he remembered as standing out from the others: "In spite of his high spirits and fun he devoted himself more thoroughly to his work than any of the others with the exception of Morris; he appeared unable to leave his picture as long as he thought he could improve it."[47]

When Ned finally returned to Red Lion Square in February 1858, he broke down altogether. According to Georgie, "the fictitious strength that had supported him through two years of mental and bodily strain suddenly failed, and scarcely knowing how it had happened, he became so weak that for a few days he was unable to raise his hand to his head."[48] Ned's collapses tended to follow a frightening pattern: first heart flutters, then fainting, followed by a long period of deep depression. In time Georgie learned to weather these spells, but this first episode terrified her. Within a few weeks he was up and around again, but he hadn't truly recovered, and that summer he fell dangerously ill. His depression and weakness were in part a reaction to Morris's engagement to Jane; he had thrived under his friend's exclusive attention and couldn't bear to give it up, despite his own imminent marriage.

The summer of 1858 was remembered as the season of the "great

stink," when the walls of Parliament had to be washed with chloride of lime in order to render the vile, polluted air from the river fit to breathe. For Ned the combination of heat and foul air was nearly unbearable. One hot afternoon he was visited by Sara Prinsep, the chatelaine of Little Holland House, who was renowned for her salon; Tennyson, Disraeli, Gladstone, Ruskin, Carlyle, Thackeray, Hunt, and Rossetti spent many a Sunday afternoon eating strawberries in her magnificent garden. Although she was a collector of celebrities, she was also a kindly and practical woman. Shocked by the sight of Ned's ghostly, sweating face and clammy hands, she packed up a handful of his things, put him in her carriage, and took him home, whereupon she immediately sent for a doctor. After examining this trembling young man, the doctor ordered complete bed rest for the indefinite future.

The Prinsep family cradled Ned with affection, and despite his weakness, he was soon cheerful. An even greater encouragement was the presence of George Frederick Watts, an older, established painter who had lived with the Prinseps for many years. Taking Ned under his wing, Watts began to teach him the importance of careful drawing, and the eager student soon realized that there was much to be learned beyond what Gabriel had taught him. Watts made Ned sit with a hard pencil and paper in front of a bunched-up towel and work at getting down all the folds and shadows in black and white. Ned took the point and never gave up the discipline, so that over many years he became a master draftsman.

He returned to Red Lion Square in the autumn. The household there was breaking up, for Morris was preoccupied with designing and building a beautiful new home for his bride-to-be. They were all sad to see this period in their lives come to an end; as Georgie wrote later: "I am surprised on employing the ruthless measure of weeks and months to find how short a time the brilliant days of Red Lion Square really lasted, for on looking back it seems so much longer. . . . every minute then contained the life of an hour."[49]

Ned began to search for new rooms, and eventually settled in Russell Place, right around the corner from the British Museum, where for the first time in his life he lived alone. Ford Madox Brown flattered him by asking him to assist in teaching Brown's class at the Working Men's College, and soon he became a great favorite among the students. Like Millais, he never condescended in the classroom, and long after he had become a highly esteemed painter he still said,

"No one knows how difficult it is to paint even a bad picture."[50] In a few months he had a class of his own.

<hr/>

At about this time Ned introduced Georgie to Brown and asked if he would be so kind as to give her some painting lessons. Brown was already teaching his daughters, Lucy and Katy, and Emily Seddon, and Georgie happily joined them in his studio. In his diary Brown noted: "This little girl seems to threaten to turn out another genius. . . . Her designs in pen and ink show real intellect."[51] Georgie was pathetically grateful for "his actually having allowed me to come and try whether I could handle a paint brush in his studio."[52]

In April 1859 Morris went on his honeymoon, and Georgie was left to console her lonely fiancé. Then, later that summer, the Macdonalds received word that they were being transferred to Manchester. As usual, Georgie's greatest concern was Ned's feelings, and she was pleased when he arranged to take a trip to Italy with Charles Faulkner and Val Prinsep. Transfixed by the beauty of what he saw there, he filled his notebooks with sketches of paintings by the Italian masters, while Georgie helped her family pack and move north.

Georgie wrote: "So now the Ruler of his life led him on this journey; and the cities that he saw during it, and the pictures in them, were such a fulfillment of his desire and such a revelation of what man could achieve that he ceased to be afraid of failure for himself."[53] For her, Ned's work as an artist was becoming a sacred enterprise, one that would tax him to the utmost limit of his abilities; she admired his courage and set herself the task of assisting in that work. Since she dismissed her own talent, she felt it appropriate that she should help him to create the beautiful paintings he dreamed of. Art replaced religion for both of them as a locus of value, and to her Ned would always be a kind of priest, celebrating the spirit by revealing its beauty through his work. When Ned returned from Italy, Georgie saw that her lover had changed in a profound way: "He had passed the pleasant wayside places where the labourer rests with his friends after a day's work, and had begun the world-long day of those who seek no rest or reward but that of contenting the rigour of the Judge Invisible."[54]

For all her genuine support of her beloved's work, Georgie was beginning to despair of ever becoming Mrs. Burne-Jones. She and Ned had been engaged for more than three years; now that she was

living in Manchester, her opportunities even of seeing him were few. Sympathizing with her dilemma, the Browns asked Ned in December whether he thought Georgie would like to come to London to visit them. When an invitation was issued for the month of April, Georgie began to count the days.

She very much enjoyed her visit, though later she looked back on it and cringed to think of the social and financial strains it must have put on the household. The Browns loved company, and Georgie was happy to sit at their table and watch the spectacle: "Who that was present at it could ever forget one of their dinners, with Madox Brown and his wife seated at either end of a long table, and every guest a welcome friend who had come to talk and to laugh and to listen? for listening was the attitude into which people naturally fell when in his company. He had so much to say and was so happy in saying it that sometimes he would pause, carving-knife in hand, to go on with his story, until Mrs. Brown's soft voice could be heard breathing his name from her distant place and reminding him of his duties." Brown's absent-mindedness and malapropisms were legendary among his friends, and Georgie broke up when he asked the company one evening if they had heard of a new novel called *The Mill on the Floss* by that brilliant Miss Atkinson. On another occasion, musing on the love life of Mary, Queen of Scots, Brown concluded: "There's no doubt that she had a real feeling for Boswell."[55]

But Brown was in no way woolly-minded when it came to the question of Ned and Georgie's love affair. Both he and Emma had been watching this young couple, and they had seen the dangers of delay all too clearly in the case of Lizzie and Gabriel. Brown sensed that Ned's hesitancy about sex was the chief stumbling block, even though money was the official reason for waiting. He believed that sex was healthy and brought balance into a man's life, and Emma agreed with him that Georgie would provide Ned with the sort of domestic stability and care that would foster steady artistic production. Georgie was delighted when the Browns convinced Ned that they should marry immediately.

Setting the date did not allay Ned's fears; in a letter written a few days before the ceremony, en route to Manchester, he warned Gabriel: "I shouldn't be surprised if I bolt off the day before and am never heard of again."[56] But he steeled himself and continued on. Respecting Georgie's parents' wishes, the couple were married in a quiet Methodist ceremony in the cathedral where Hannah and George Macdonald

had been married twenty-seven years earlier. Saturday, June 9, 1860, was the date — "Dante's own day," just as the young couple had promised each other.

Ned was overcome by laryngitis at Chester, their first stop on a honeymoon tour that was supposed to end in Paris, where they were going to join Lizzie and Gabriel, also honeymooning. Georgie had to inquire at the hotel desk for the name of a local physician. To hide their embarrassing newlywed condition, she left some half-used spools of thread lying about the room, along with a pair of worn-out boots. Either oblivious or kind, the doctor seemed to believe this fiction, and Georgie was very proud when he gave her directions for caring for the patient as if she had nursed him a dozen times before. But the wedding trip was ruined, and even the usually stoic Georgie could not hide her disappointment: "This illness was a sharp check, and we found ourselves shut up for some days in a dreary hotel in an unknown place."[57] When her long necklace caught on the bedpost and beads went flying around the room, so that she had to crawl around the floor to pick them up, the tears that she had not allowed herself to shed finally watered the carpet.

The newlyweds cut their honeymoon short and returned to Ned's rooms in Bloomsbury. The furniture that Ned had ordered had not yet arrived, and there was not even a chair to sit on, but they were so happy with their new home that they didn't care. Even their shortage of money did not worry Georgie. Ned had about thirty pounds to his name, and all she had brought with her by way of a dowry was a small deal table with a drawer that held her wood-engraving tools, with which she planned to engrave Ned's pictures so that their fame might be spread far and wide. The ever-generous Plint sent a check for twenty-five pounds, and Ned's aunt gave money to buy Georgie a piano.

Their rooms became a meeting place for friends who were attracted by their happiness and flocked to it as bees to honey. Swinburne lived nearby; "sometimes twice or three times in a day he would come in, bringing his poems hot from his heart and certain of welcome and a hearing at any hour."[58] The Rossettis were frequent visitors, as were the Morrises when they were in town. Georgie could offer few refreshments, mostly tea and cakes, but she and her new piano provided entertainment. She did some arranging of her own, fitting a new

poem of Gabriel's called "The Song of the Bower" to a waltz. Her choice of lyrics reveals a sensual undercurrent to her nature. The poem's speaker dreams of his lover, "My hand round thy neck and thy hand on my shoulder,/ My mouth to thy mouth as the world melts away."

Eight months after Georgie and Ned married, they were expecting a child. They were thrilled and terrified. Ned feared he would lose Georgie; they both worried that something might happen to the baby. Jane Morris's safe delivery in January 1861 gave them a bit of comfort, but then in May, when Georgie was in her fourth month, Lizzie Rossetti's baby girl was born dead, and in July the painter Joanna Wells died in childbirth. Ned was so worried that he couldn't even bring himself to talk about the child that was quite evidently on the way. In September he finally wrote to Crom, who was in Russia working as a tutor, that in about a month "either a little Ned or a little Georgie will appear," adding "don't tell, I keep it quiet for fear it should be a monster."[59]

Heedless of his parents' fears, baby Philip appeared in October 1861. Neither the doctor nor the nurse that had been engaged could be found, and Ned had to assist at the birth. Georgie was enormously proud of his self-possession in the crisis: "The arrival of our child, though not a 'monster,' brought us face to face with strange experiences. No one had told us any details connected with it essential for our guidance, the doctor and the wise woman were to arrange everything — but as neither of them happened to be at hand when wanted I doubt whether Edward or I had the more perturbed day. By his own energy, however, he guided the disjointed time and set it straight, for with him intellect was a manageable force applicable to everything."[60] When the nurse finally arrived, she found that she had three patients on her hands; understandably, Ned fell apart as soon as he was relieved of duty.

They adored Phil, although years later Georgie realized that "he remained a beloved toy far too long."[61] As an infant he was also the source of much anxiety and confusion, for Georgie felt that she didn't know how to take care of him.

Ned was working terrifically hard, not least because his patron Plint had died suddenly in the summer and he owed a great deal of work to the estate. By December he was worn out, and began to develop the sore throat, cough, and feebleness that Georgie had already come to recognize as the customary prelude to his nervous

collapses.* On Christmas Eve he decided to go to bed early, and Georgie kept him company as he lay coughing relentlessly. When he put his handkerchief to his mouth after one racking spasm, he took it away to find it soaked with blood. Georgie later recalled: "We looked at each other and the same thought passed through both our minds — that this was his death-warrant. We took and gave what comfort we could, trying to persuade ourselves in a flash of time that it was a thing of the commonest occurrence, that it happened to most people at some time in their lives, but — we had better see the doctor."

There was no ambulance to phone for, so Georgie rushed into the street in search of a cab and begged the driver to make haste to the home of Dr. Radcliffe in Henrietta Street. For her that short journey seemed to last forever: "Who does not know that threading of the streets in a hastily-summoned jolting cab, with the one haunting fear for companion?"[62] Radcliffe's house was all lit up, and as she crossed the threshold she heard the unmistakable sounds of a party in progress. The maid who answered her knock ushered her into the consulting room full of coats and hats dropped by the holiday revelers. When the doctor entered, she silently handed him the handkerchief. He promised to see Ned that night and sent her home to comfort her husband and wait. Later, after the doctor had examined the patient, he assured them that the hemorrhage was from the throat, not the lungs, and so was not a mark of consumption. This was Ned's first and last hemorrhage, most probably caused by severe bronchitis, but his "delicacy of chest" was always a worry. The winter continued to bring troubles. Phil too became sick, and almost died, and in February Lizzie Rossetti died.

Ned went back into the studio as soon as he recovered a fragment of strength, and this time Georgie felt herself shut out, stuck in the nursery with only an infant to talk to: "The difference in our life made by the presence of a child was very great, for I had been used to be much with Edward — reading aloud to him while he worked, and in many ways sharing the life of the studio — and I remember the feeling of exile with which I now heard through its closed doors

*During the course of their marriage, Georgie spent literally years nursing Ned. So many of his letters begin: "I have lost this summer through illness," or "Please forgive me I have been indoors all winter because the doctor insisted." Others might have given in to such debilitating weakness, but Ned never surrendered. He always returned to his studio at the first possible moment and kept drawing in bed whenever possible; it is truly remarkable how many paintings he produced despite his fragile condition.

the well-known voices of friends together with Edward's familiar laugh, while I sat with my little son on my knee and dropped selfish tears upon him as 'the separator of companions and the terminator of delights.' "[63]

Georgie tried to keep up her drawing and wood engraving, but before long they fell by the wayside. She never blamed Ned; she believed that it was her fault, that she did not have the fortitude to follow the terribly lonely path of an artist. At the same time she knew that a quick succession of pregnancies and a thousand household cares kept her too tired and busy; but she could not let herself rail against them, because to do so would have been to lay blame on the husband and children to whom she gave all her love and devotion. Occasionally she allowed herself to reflect on what she had lost, but almost always she checked her anger, bringing the responsibility for failure back to herself. (In fact Ned does not seem to have supported her in her efforts to work. He made no secret of the fact that he preferred his women lovely and passive: "I like women when they are good and kind and agreeable objects in the landscape of existence — give life to it and pleasant to look at and think about."[64])

With another mouth to feed, Ned felt the pressure to bring in more money. Fortunately, Brown had been right in guessing that Ned's work would gain by his marriage. Suddenly he was producing pictures one after the other. The fussiness of his juvenile paintings began to drop away, to be replaced with bolder, simpler designs. He was lucky in that he had enough patrons to take all his work; all he had to do was produce. He had a further precious cushion in that Morris let him use the newly formed design firm of Morris, Marshall, Faulkner & Company as a bank, from which he was allowed an unlimited overdraft. (Since Morris was the main source of capital for the firm, he had the power to extend credit.) Although Morris never begrudged him the money for a moment, Ned felt the weight of his debt always.

For a patron that Gabriel had sent to his studio, Ned returned to the story of Merlin and Nimue, hiring Fanny Cornforth to sit for the sorceress. In gouache, the heavy, opaque watercolors he favored, he painted Nimue in the foreground, holding a book of spells as she broods on the destruction she is about to wreak on her hapless teacher. Her face is at once regretful and intent; doubt may linger in her mind, but she is on the point of action. Behind her in the middle ground stands Merlin, the mighty magician of myth, painted as a thin, anxious, elfin young man. He wears a hood from which sprout little

wings or ears that immediately make one think of a devil. This Merlin seems fragile, but there is something malign about him. Both figures are sinister, and even without knowing their story, a viewer senses that their relation to each other must be sinister too.

By contrast Ned painted a picture of Georgie tending a rose trellis, innocent, tender, and pretty. He still adored her. Walking down Wardour Street one day, he idly stopped to look in a shop window and spotted a pocket watch encrusted with jade-green chrysolites. Unable to stop himself, he darted into the shop and spent what was virtually his last eight pounds to buy the watch for her.

In the summer following Phil's birth, Ruskin offered to take Ned and Georgie to Italy for a couple of months. Aggie came down from Manchester and carried Phil home to the Macdonalds for safekeeping, and the trio set off. They traveled well together, but at a certain point Ruskin tactfully took himself off so that Georgie and Ned could have some weeks alone. Ned loved showing his wife the treasures he had discovered on his first trip in 1859, and he delighted in her keen aesthetic sense, writing to Ruskin: "Georgie is growing an eye for a picture, she darts at a little indistinct thing hung away somewhere, and says timidly 'Isn't that a very nice picture?' and it generally ends in being a Bellini or Bonifacio."[65]

On their return home, Ruskin submitted his protégé's name for election to the Old Water-Colour Society, a prestigious institution that was a sort of first cousin to the Royal Academy. On this occasion the society rejected Burne-Jones, but he was accepted the next year, in 1864. At his first exhibition the press ripped into him. He was stung, but kept his sense of balance. One morning a friend, the potter William de Morgan, dropped in for a visit. Seeing a fresh canvas in the studio, he asked Ned if he was about to start a new picture. Laughing, Ned replied, "Yes, I am going to cover that canvas with flagrant violations of perspective and drawing and crude inharmonious colour." But de Morgan stayed on for dinner, and later in the evening some of Ned's pain leaked out. Returning to the subject, he said to his friend, "You know that was all gammon I was talking about perspective and drawing — I only do things badly because I don't know how to do them well; I do want to do them well."[66] Despite the critics' disdain, the artist acquired two enthusiastic and important patrons as a result of this exhibition, the Liverpool ship-

owner Frederick Leyland and William Graham, soon to be the Liberal MP for Glasgow.

That summer Georgie and Ned spent as many weekends as possible with the Morrises at Red House, their home in the Kent countryside. Red House was built to Morris's specifications; it embodied his dream of a medieval paradise. Happy in their new home, he and Jane offered the easiest, most generous sort of hospitality, and all their friends came eagerly to stay with them. Decorating the house became a group enterprise, and Ned was a key contributor, designing and painting murals for the drawing room and hallway. Meanwhile, Georgie and Jane were becoming good friends. Later Georgie looked back on the time they spent together at Red House as "one to swear by, if human happiness were doubted."[67] She and Ned were eagerly awaiting the birth of their second child.

At the end of the summer the Burne-Joneses, the Morrises, and Charley Faulkner and his mother and sister took a seaside holiday at Littlehampton together. For once Ned seemed really to relax. He made only one attempt to draw out-of-doors, a thing he hated, and after that he put his sketchbooks away and took Phil down to the beach every day instead. He built sandcastles, taught his boy to skip stones across the water, and was, Georgie said, "as near idle as I ever saw him."[68]

When they got home to Russell Place, Phil came down with a mild case of scarlet fever. The doctor said nothing about isolating the child, and Georgie also caught the fever. On October 28 the baby she was carrying was born prematurely. Georgie was so ill that she was delirious, unable to hold the infant or nurse him, and for the next eight days they both hovered on the point of death. Their friends clustered round Ned, except for Morris, who was very ill with rheumatic fever, and Gabriel, who was away in Paris with Fanny. Ruskin paid for the street to be laid with a deep carpet of sawdust so that the sound of horses' hooves would not jar Georgie. Swinburne called and wrote constantly, but took care that his notes should never add to Ned's burden: "I hope the girl was right in telling me of an improvement visible. Do not trouble yourself to answer this; I send it by my servant who will bring back word."[69] When the baby seemed to rally, his father named him Christopher, "because he had borne so heavy a weight as he crossed through the troubled waters of his short life,"[70] but three weeks and three days after his birth, the infant died.

As soon as Georgie gained a little strength Ned took her down to

Hastings to recuperate. She was weak for a year afterward, and her friends noticed that her pink cheeks had turned ashy. She felt that the illness had also ruined her memory. Before they returned from Hastings, Ned wrote to Morris to tell him that the months of illness had so emptied his wallet that he could not go forward with their plans to move to Red House, which Morris was going to enlarge so as to accommodate the Burne-Jones family. Morris sent back a letter headed "In bed, Red House": "As to our palace of art, I confess your letter was a blow to me at first, though hardly an unexpected one — in short I cried; but I have got over it now. As to our being a miserable lot, old chap, speaking for myself I don't know, I refuse to make myself really unhappy for anything short of the loss of friends one can't do without. Suppose in all these troubles you had given us the slip what the devil should I have done? I am sure I couldn't have had the heart to have gone on with the firm: all our jolly old subjects would have gone to pot — it frightens me to think of, Ned."[71]

Ned sent Georgie and Phil to Manchester for Christmas, while he rushed around London trying to find a house to rent. Memories of her delirium and her lost baby had made the room where she almost died "an incarnate terror" to Georgie, and he was determined that she should never have to enter it again. He found a small, pleasant house in Kensington Square, and Crom helped him with the move, so that after Christmas Georgie came back to a new house full of her old, familiar things, a kindness she never forgot. Even so, when she entered that house and looked round, she felt a sense of loss: "Something was gone, something had been left behind — and it was our first youth."[72]

In the months after their baby died, Georgie withdrew into her grief. Ned could not seem to comfort her, nor could he get the comfort from her that he badly needed himself. This death touched off fears and loneliness intimately derived from his own sad childhood. Unfortunately, Georgie, ordinarily so loving, was overwhelmed by her own misery, and perhaps by a sense that had she been more vigilant, she might have prevented the child's illness and death. Taught by her parents to hide depression and to smother anger, she had no satisfactory means of expressing her loss. Her husband, by contrast, was a man with a strong capacity and need to express his feelings — which was one of the reasons she had married him — but now, turning to

her for help, he was discouraged to find that she had withdrawn beyond his reach.

They both felt a mixture of joy and fear when Georgie found that she was pregnant again, ten months after Christopher died. This pregnancy seems to have gone smoothly, and on June 3, 1866, Margaret was born. (As Ned wrote: "So Phil's conjecture that it would be either a boy or a girl was not unfounded.")[73] At first Ned held himself aloof — babies didn't generally interest him — but before long he had utterly lost his heart to this child, who was as sunny and winning as Phil was nervous and demanding.

With two children to provide for, he set himself to work harder than ever, selling paintings as fast as he could finish them. By November 1866 he was able to hire Charles Fairfax Murray as an assistant to speed up production. His reputation was spreading, and as a consequence his social circle was also expanding rapidly — perhaps a little too rapidly. A friend of Gabriel's, the slippery but enticing Charles Howell, attached himself to them, sensing in Ned a tender heart and an easy mark. Better friends were George Howard, the future ninth earl of Carlisle, and his new wife, Rosalind. George was a serious amateur painter and a seriously rich man, and he commissioned many works from Ned over the years, including stained glass windows for the chapel at Castle Howard, his home in Yorkshire.

Around this time Ned obtained an introduction to the Ionides family, headed by Constantine Ionides, a Greek émigré who had built an enormous fortune based on his cotton import firm. Through the family, Ned and Georgie met a whole crowd of wealthy and cultured Greeks living in London. Among them was Euphrosyne Ionides Cassavetti, a strong-willed widow of not inconsiderable charm, who brought her daughter, Maria Cassavetti Zambaco, to Ned's studio and commissioned him to paint her portrait. Courtesy and common sense dictated that the artist should agree; the beauty of his subject was a bonus. Mary, as Ned called her in the English way, had long red hair, fine and tightly waved. It floated round her head like a cloud, setting off her almost phosphorescent white skin; hers was a beauty so unusual that it was hard not to stare. Ned began visiting the house regularly to sketch Mary, and she also came to his studio in Kensington Square to sit. The Cassavetti home was exotic, filled with treasures brought from Greece, and the women of the house were equally exotic to Ned, who was intrigued by their easy foreign manners. They were enormously wealthy; Mary had a personal fortune of eighty thousand pounds.

Mary also had a reputation as a wild and fascinating girl, but as Ned spent hours studying her face, he could not help but see the unhappiness written there. His first painting of her depicted Cupid rescuing Psyche, a choice of subject that now seems prophetic. As he worked he encouraged Mary to tell her story, and it came tumbling out. She grew up in Greece, but in 1858, when she was just fifteen, her father died and her mother brought her to England to live. Two years later, in 1860, she persuaded her mother to let her go to France to study sculpture. In Paris she met a much older man, a Greek doctor named Demetrius Zambaco, and married him too quickly. Children came — a son in 1864 and a daughter the following year — but by then the marriage had failed so badly that she packed up and left, returning home to her mother when her daughter was just a few months old. Caught in the awkward position of the married woman without a husband, she feared she had ruined her life.

Ned's heart went out to Mary; his drawings recorded every line of her sorrow with a tenderness that only increased as the years went by. For her part, Mary soon discovered his extraordinary faculty for friendship, and she thrived on his attention. Hungry for approval, she surrendered entirely to his charm. Before he quite realized what had happened she was deeply in love with him, and he found himself responding passionately. Feelings he had never known took him over. A new sort of romance unfolded before him, and the sexual desire that had terrified him as an adolescent now called to him like a siren. He was still afraid, but he was also older and more experienced. Georgie was his first beloved, the companion of his youth, the mother of his children, his domestic familiar; but she had never been the object of his passion, for he had needed to repress his passion during his fearful early years.

Ned had two choices before him, and he spent months agonizing about what to do. He could remain faithful to Georgie, preserve his honor and her trust, and as a consequence shut off a part of himself; or he could break faith with Georgie and have the chance to know a different kind of love, one that sometimes seemed far more compelling to him. At home, though, betrayal seemed out of the question, horrible. He would hold his baby and consider that he was letting her down, thinking perhaps of how he would feel if someday her husband gave her this pain. He made and broke resolutions to avoid Mary; his nerves shredded.

Ned confided his anguish to George Howard in a letter of September 1867, but held back from explaining its cause: "Georgie and all

babes are at a place that calls itself the seaside — I don't know why — I took them there a few days back, and fled home again, and here I am quite desolate. . . . I have tried everyone this year — if I could have pointed definitely to a heart disease or cancer or consumption or something clear and obvious it would have been bearable to my friends, but I have had no such luck — only I have felt intensely melancholy and depressed — the result of a good couple of years pondering about something and I have been a nuisance to everyone — and now I am very very much better and feel more likely to live and do good than I have for a year past — dear, I am not fickle — if I have seemed apathetic at any time I have been so weighed down with oppression that I have been intolerable even to Georgie."[74]

This resolution did not hold. He gave way, too hungry for the fragrant, seductive, delicious sensations Mary promised. This relationship was a great sexual and sensual awakening for him, just as he had dreamed it would be. Once he had begun, he could not turn away. He was in thrall to Mary and to the feeling of their bodies together. Mary's vulnerability made the bond stronger; he could not betray her trust by turning away from one who was so needy. As Georgie wrote: "Two things had tremendous power over him — beauty and misfortune — and far would he go to serve either; indeed his impulse to comfort those in trouble was so strong that while the trouble lasted the sufferer took precedence of everyone else."[75]

Meanwhile, Georgie was struggling at home, worn out by two small children and by dealing with what was for her the endless problem of managing servants. On the morning of November 28, 1866, she dashed off a note to Rosalind Howard canceling dinner: "I am so sorry, but I fear we shall not be able to come to you tonight. Our domestic plot thickens, and there was that in the eye of our temporary cook last evening which warns us we must not leave the house while she is here, for fear of finding her under the firegrate on our return. I am ashamed to send you and so late, but we made the discovery last night — too late for writing. My nurse, too, has tic doloreux so dolorously that I could not find in my heart to leave her. . . . Accept my love, and Edward's regrets — but he thinks it safer not to leave me to combat with a middle-aged female with a tendency to drink!"[76]

For a long time Georgie paid no heed to Ned's absences from home but accepted his explanations and excuses without hesitation. She attributed his distraction to difficulties with his work, a sort of preoc-

cupation with which she was familiar. His capacity to withdraw into his imagination was something she understood and even admired as essential to the life of the artist. Graciously accepting his imaginative life was one of the ways in which she could help him to create. Also she trusted Ned, and if she had any suspicions, she pushed them out of her mind as unworthy and ridiculous.

Life became more complicated when they discovered that they could not renew their lease at Kensington Square. The search for another house led them to the Grange, a large, wonderful, run-down old place in Fulham where Samuel Richardson had written *Pamela, Clarissa,* and *Sir Charles Grandison.* In those days Fulham was still more country than city, but even so the rent was so steep that the Burne-Joneses invited the Heeleys to share the house for a year. Ned was nervous about the responsibility, knowing that very soon he might leave this house in order to be with Mary. And how would he ever support such a place along with a second establishment? Would he be reduced to living off Mary's money? Trying to make light of his worries, he joked: "There is a madhouse next door, which is convenient, for I hate distant removes."[77]

Despite Ned's fears, he and Georgie signed the lease and threw an enormous party to celebrate. The housewarming went well, but disaster struck only hours after the guests had left: The ceiling in the studio fell in, dumping some seven hundred pounds of plaster onto the work that Ned had set out on display. Georgie was left with a huge mess to clean up, and Ned had to face the fact that he would have nothing to exhibit that year.

Once the Burne-Joneses were established at the Grange, Ned extended a standing invitation to Morris and to their close friend the architect Philip Webb to come every Sunday for breakfast. Webb came occasionally, but Morris and Ned spent almost every Sunday morning together until death intervened. After an elaborate breakfast downstairs, the two of them would go up to Ned's studio to work on various projects and to talk over everything under the sun. Georgie wrote: "They always either invited me to join them for a little while or else sallied forth from the studio to pay me a call: but it was their hour and power, and I did not proffer my company."[78] Their great collaborations were hatched here, and Ned drew illustrations for the poems that Morris wrote as they sat together. But the great men

also read aloud from a comic paper called *Ally Sloper* and giggled over it.

On the surface, life seemed to go on quite normally. Georgie's appointment diary records the usual round of visits and dinners and evening parties. In February 1868 she and Ned went to meet the novelist George Eliot at the Priory, her home by Regent's Canal. In May they attended a dinner party at the Morrises', where Georgie appeared quite "gay" in a "gorgeous yellow gown." But Ned must have wanted Georgie to find out his guilty secret; he left a letter of Mary's in his coat pocket, where Georgie happened upon it one day in June. The next months were for her an agony of mind.

Mary was pressing Ned to leave Georgie and elope with her, and he couldn't make up his mind what to do. A frail and unstable woman, Mary was made nervous by his indecision; there were times when she felt that she couldn't live without him. If they were to live together, they felt, they would have little choice but to leave England and settle somewhere in Europe. Mary could bring her children along with her, but Ned knew he would lose not only Georgie but Phil and Margaret, possibly forever.

Although his personal life was in turmoil, Ned's work was showing dramatic progress. In 1868 he started several major paintings using Mary as his model, and these are possessed of a new finish and grace. What he had learned from studying the Italian painters he loved, especially Mantegna, was beginning to show more and more strongly on his own canvases. Mary stimulated his imagination in a way that no one else ever had. Whether he admitted it to himself or not, he needed her for his work. He began a series of four paintings, commissioned by Mary's mother, depicting Pygmalion and the transformation of Galatea from statue to living being. The artist is shown not as a masterful sculptor carving a woman to his own design, but as a slim, tremulous young man who barely dares to touch his creation, preferring instead to kneel before her and worship her beautiful body with his eyes.

In February 1868 Georgie's sister Alice returned from India, where she had gone to live with her husband, John Kipling, and installed herself at the Grange to await the arrival of her second baby. When her first child, Rudyard, had been born, Alice had been in labor for six days and had almost died. This time she and her husband decided

that she should return to England for expert medical attention. Suddenly Mrs. Heeley announced that she too was pregnant, so Georgie had two women to nurse and the prospect of two more children to take care of.

Despite all the precautions, Alice Kipling's second delivery was almost as harrowing as the first. Finally the doctor had to wrestle out the baby, an eleven-pound girl who emerged with a black eye and a broken arm. For weeks afterward Alice and the baby, Trixie, required Georgie's constant attention. Then, just as the Kiplings prepared to decamp and it looked as if Georgie might get a rest, Harry Macdonald's wife, Caroline, wrote from America to say that she was arriving for her first visit to England and wanted to meet all the Macdonalds. Since Georgie was the only one who lived in London, Caroline quartered herself at the Grange, and Hannah Macdonald paid a rare visit to London to meet this new daughter-in-law. Georgie had a full house, just as it was becoming painfully apparent to her that her marriage was falling apart.

When the last Macdonald departed, she was overwhelmed by exhaustion. She and Ned decided that she should spend the month of September at Clevedon, the resort in Somerset where Lizzie and Gabriel had spent a happy holiday some years before. From Clevedon, Georgie wrote to Rosalind Howard that although she knew she desperately needed the rest, she hated being stuck out in the country, so far from her beloved husband. Although she didn't say so, she must have feared leaving him alone with Mary. In the same letter she said: "I am trying to etch, that I may etch Edward's designs, which would be nice for me."[79] She had always wanted to reproduce Ned's work to spread his fame to a larger audience; it was also a way to get closer to him. Unfortunately, she never succeeded in publishing any of her attempts.

Rosalind Howard was becoming an increasingly important resource for Georgie, but Georgie's reserve made a barrier. Although Rosalind sensed that something was wrong in her friend's marriage and pressed Georgie to open her heart, such revelation was impossible for her. She wanted to protect Ned and to preserve her own privacy as well. A further complication was that the temperamental Rosalind was always deeply disturbed by any sexual impropriety. Understanding this, Georgie may have hesitated to speak, knowing how upset and angry Rosalind would be if she got answers to all her questions.

More and more Georgie found herself turning to William Morris

for friendship and comfort. Since Morris was her husband's closest friend, she could expect a sympathy and discretion others might not offer. As angry as she must have been, Georgie was still — and always would be — protective of her husband. Morris had enough reserve to match hers; he would not pressure her, as Rosalind did, for confidences she did not want to make. Furthermore, Morris's own marriage had begun to sour and he too was in dire need of warmth and support.

He came round to the Grange in the evenings to sit with Georgie when Jane was away with her lover and Ned was out with Mary. Before long Morris felt himself drawn to Georgie, who offered so much that his wife refused to or could not provide: affection, approval, intellectual curiosity. His sense of honor stopped him from rushing in to take advantage of Georgie's vulnerability, but as time passed and Ned continued to pursue Mary, he grew to depend on her affection. Georgie needed Morris, but she was also afraid of what was happening. Her life seemed to be plunging into utter chaos. She still loved Ned; she was fearful of hurting Morris.

The cumulative strain seemed to be breaking Georgie's spirit. She wrote to her mother that she had spasms and severe headaches and was feeling altogether "very low and bad," which she would never normally have admitted; she hated to make a fuss about her health. At the turn of the year she wrote to her sister Louie one evening while she sat having "a lonely peck at my supper," and confessed that she dreamed of having another baby "but am not too sanguine."[80]

<div align="center">❧❀❧</div>

The crisis came a few days later. Mary's nerves snapped, and in her desperation she confronted Ned. Walking along the towpath by Regent's Canal late at night, she told him that she couldn't wait any longer — he had to leave Georgie immediately. He tried to put her off; he must have told her that he could not bring himself to abandon Georgie and the children. Just as they approached the Brownings' house, Mary raised the stakes by showing him a bottle containing enough laudanum for a double suicide. When he protested, Mary had to face the fact that he was not ready to die for her, as she was for him. Feeling utterly betrayed, she darted toward the canal. Ned made a grab for her; she resisted, and he had no choice but to wrestle her to the ground in order to save her. They rolled on the cobblestones, Mary struggling to escape his grasp and screaming. Alarmed by the noise, the Brownings summoned a constable to the scene.

In the confusion Ned wandered off and fainted. Eventually he returned home in the small hours of the morning, shattered and humiliated. Forced to a decision, Ned chose Mary, at least in part because he could not face the likelihood of her suicide. In a few days the two of them packed up and set out for the Continent. They didn't get far. Just as he had broken down on the day after his wedding, Ned now got so sick he could not make the Channel crossing. At Dover he came down with what was called brain fever and somehow or other made his way back home, where Georgie put him to bed, called the doctor, and once again took up her role as nurse. The scandal leaked out, and Gabriel wrote to tell Brown that "poor old Ned's affairs have come to a smash altogether."[81]

Rosalind Howard came to the Grange and tried to offer sympathy and help; by now she had heard gossip about Mary and knew that there was a crisis. But Georgie was unable to acknowledge what had happened or to speak about her feelings. Rosalind left, hurt because she had been repulsed. In apology Georgie wrote to her friend: "Dearest Rosalind, I am more touched by your kindness and thought for me than I can tell you — I do not know how to thank you. Forgive my reserve the other day when you came, but I am obliged to show it in time of trouble or I should break down. One day I hope I may be able to explain things better to you — meanwhile believe me I love you, and trust me." Unsatisfied, she put the letter to one side and took it up again that night, adding a postscript: "Thus far I wrote this morning, but Edward is so much better that I may now tell you that he is at home again, having been too weak to face the journey when he reached Dover. For two or three days he was so ill that we kept his being at home a secret, that the house might be quite quiet. The irritation of the brain however has decreased so very much that he is up and in his studio, but must still be kept very quiet. Forgive the little deceit it was meant only for good, and I did not like it even then."[82]

By the middle of February, Georgie decided to go away with the children. Ned apparently told her he needed to be by himself to think out what he wanted to do; at any rate, Georgie chose Oxford as her destination. Because it was between terms she was able to rent a student's rooms, and there she sat and read and thought about her life with her husband. Before she left London, Georgie had spoken a bit with Rosalind about Ned's affair. On February 18 she sent her friend a letter headed 16 Museum Terrace, Oxford, asking that her reticence be excused: "I hope you will be able . . . to bear with me

if I appear tiresomely reserved as ever on some subjects. I have made up my mind to this, long ago, and mean to keep to it. At the same time, please never be afraid of saying anything to me . . . for I need help. Indeed, my dear, I am no heroine at all — and I know when I come short almost as well as anyone else does — I have simply acted all along from very simple little reasons, which God and my husband know better than anyone — I don't know what God thinks of them."

Georgie's wisdom and her sympathy for her husband, for Mary, and for herself come through in this letter. Her reserve may have been tiresome and may have created problems, but in the long run it probably saved her marriage. If she had confided her troubles, the affair could easily have become an even greater scandal, and the pressure might have driven her and Ned apart. Instead, she preserved the connection between them by keeping quiet. She could also have retreated into blame and judgment, for which no one would have faulted her, but she insisted on looking at the complexity of the situation and acknowledging that she too might have contributed to their troubles. To Rosalind she wrote: "Be hard on no one in this matter, and [word unintelligible] no one — may we all come well through it at last. I know one thing, and that is that there is love enough between Edward and me to last out a long life if it is given us — and I tell you that because it will give pleasure to your kind heart. . . . I fear you may think much too well of me in many ways, and I don't want that — it makes me feel worse than I really am. If I did not know you loved me I should ask you to excuse this egotistic letter, as it is I don't."[83]

Six days later Georgie felt better. In a letter to Rosalind she described the days she had just passed in Oxford, putting a happier face on the time than it merited in order to reassure her friend: "We lead such a quiet life here, and there are a great many hours in every day, I assure you — more than usual, but they pass really not unpleasantly, and I can't tell you how good rest and quiet are. It feels funny sometimes when Phil is gone to bed and I sit down to read, as if I were the undergraduate to whom these rooms really belong, but it is snug and what I have often longed for of late. Edward will come down to us on Saturday if he can, and so I shan't have been alone long."[84] Despite the anger and confusion she must have felt, she missed her husband; whenever they were separated, even by her own choice, she always longed for him.

Back at home Ned was going through his own private hell, feeling

guilty toward Georgie and guilty toward Mary at the same time. Mary, who was also back in London, was in despair. She searched everywhere for Ned, who she quickly realized was hiding from her. As Gabriel put it, "the Greek damsel" was "beating up the quarters of all his friends for him and howling like Cassandra."[85] Those few friends who knew where he was closed ranks and refused to tell her, which only made her more despondent.

Ned finally broke down and told George Howard the whole story as they sat together after dinner at the Grange on the day Georgie left for Oxford, but the next morning he rushed to write a letter begging discretion: "What I spoke of last night . . . must be a profound secret — I mean nobody — really nobody — do not speak with Webb or anyone about me, but say I am out of sorts and no more. . . . I mean to go nowhere but really shut myself up from everyone — respect my decision and believe in my love for you." Terrified that Mary might turn up on his doorstep, he confessed: "I did not sleep at all in the night and tremble if a ring comes at the bell."[86] He concluded by asking George to burn the letter.

When Ned finally summoned his courage to visit Georgie in Oxford, he told her that he could not choose. He loved her, but he also loved Mary and would not stop seeing her. Georgie accepted his decision. One might think that she had no choice, since divorce was socially unacceptable, but Georgie was not a woman who led her life to please society. The one unalterable fact of her life was that she wanted Ned. She loved him, despite Mary, and resolved to hang on. Ned continued to go to Mary for at least three more years, and she was the subject of his major paintings for years beyond that, although he broke off their sexual connection, probably sometime in 1872. Their relationship did not really end until Mary at last gave up and turned away from him.

<center>❧❧❧</center>

As soon as Ned had recovered from this episode enough to go back to the studio, he turned his attention to finishing work in hand for the Old Water-Colour Society exhibition in the spring. One of the canvases he took up was the extraordinary *Wine of Circe*, a subject he had begun to develop as early as 1863. Now, as he rushed to finish the picture for exhibition, the Circe he painted distinctly resembled Mary.[87] For this work he chose a palette unusual for him — vivid yellows and scarlets and golds — as well as shapes and lines far denser

and more clearly defined than he normally employed. As a result, the painting leaps out as a significant and disturbing departure for him.

The canvas is dominated by Circe, who is measuring drops of an enchanted potion into an amphora of wine, which she will serve to Odysseus and his men, whose ships bob like bath toys on the sea in the background. With one hand Circe clutches the elaborate folds of her robe, giving the impression that her garment momentarily will fall open to reveal her voluptuous body. Stretched out next to her are two shiny black panthers that radiate fierce, aggressive energy; they are in league with her, agents of the destruction she wreaks.

Not surprisingly, the critics were repulsed by this painting. The *Art Journal* called it "altogether abhorrent to such minds as are not initiated in the sublime mystery of ugliness." Rossetti, however, recognized its ruthless, stunning power immediately, and wrote a sonnet in which he called the potion that Circe had devised to induce "rapture in Love's name" a mixture "distilled of death and shame." He may have understood more clearly than anyone the depths into which Ned was descending through Mary. He could also imagine the cost to her; his sonnet warns that Circe's rapture will not bring her fulfillment. In his poem her panthers can hope to enjoy only "a vain wail" on that shore where "the dishevelled seaweed hates the sea" — the sea that will carry Odysseus away on the morrow, loaded with new, bitter knowledge, but free.

<center>❧❦❧</center>

After the aborted elopement and Ned's subsequent collapse, Ruskin arranged for Charles Howell, whom he had hired as his personal secretary, to move into a house near the Grange to watch over Ned and comfort him. As well ask a tomcat to offer a mouse a slice of cheddar. In no time the devious but fascinating Howell was in Ned's studio several days a week, charming and being charmed. When he didn't stop by, Ned missed him and sent beseeching notes: "In all day if you are going to town peep at me" and "I want dreadfully to see you" and "I yearn for you."[88] He mocked his own dependency, but his need for Howell's reassuring presence was for a time boundless.

Howell became Ned's agent, soliciting buyers, making deals, bringing much-needed cash into Ned's bank account. His payoff came in the form of intrigue. Mary's mother colluded in prolonging her daugh-

ter's affair by commissioning more paintings from Ned, and Howell
delighted in the goings-on. He became an emissary to Mary, carrying
messages back and forth. He also made a good profit from a variety
of shady deals he was perpetrating without Ned's knowledge. Later
he got up a small but thriving trade in phony Burne-Joneses painted
by his mistress, Rosa Corder.

Georgie chose her friends more wisely. She sought out the company
of Marian Evans, known to the world as George Eliot. Mrs. Lewes,
as the novelist called herself, had lived for fifteen years with George
Henry Lewes, a philosopher, naturalist, and biographer of Goethe,
but they were not in fact legally married. Lewes could not obtain a
divorce from his wife because he had condoned her adultery by con-
tinuing to live with her after he knew that she had borne children by
another man. Georgie sensed that Marian Lewes's daring choice would
help her understand the complexity of her situation with Ned.

She continued to rely on Morris as well, but their relationship seems
to have become strained. Apparently Georgie retreated from Morris,
and he was hurt when he felt her push him away; he also felt how
much Ned needed him and found it difficult to respond to his friend.
He could not forgive Ned for betraying Georgie, nor could he speak
to him about his own growing devotion to her; it seems that the two
men chose silence as the only means of preserving their friendship
and protecting themselves. Only in his poetry could Morris describe
the awkwardness he felt:

> . . . shall I count the hours
> That bring my friend to me with hungry eyes
> Watch him as his feet the staircase mount
> Then face to face we sit? a wall of lies
> Made hard by fear and faint anxieties
> Is drawn between us and he goes away
> And leaves me wishing it were yesterday . . .

A note addressed to Georgie in the margin of Morris's manuscript
reveals his anguish over her reticence: "Poets' unrealities, tears can
come with verse, we two are in the same box and need conceal
nothing — don't cast me away — scold me but pardon me. What is
all this to me (say you) shame in confessing one's real feelings."[89]

Both Georgie and Morris were careful to obscure all traces of those
feelings. She destroyed the letters he sent her before 1876, including
all those from this volatile period. But there are in his poetry delicate

indications that he may once have pressed her to respond to his desire.

> She wavered, stopped and turned, methought her eyes,
> The deep grey windows of her heart, were wet;
> Methought they softened with a new regret
> To note in mine unspoken miseries,
> And as a prayer from out my heart did rise
> And struggled on my lips in shame's strong net,
> She stayed me, and cried 'Brother!' Our lips met,
> Her dear hands drew me into paradise.
>
> Sweet seemed that kiss till thence her feet were gone,
> Sweet seemed the word she spake, while it might be
> As wordless music — But truth fell on me
> And kiss and word I knew and, left alone,
> Face to face seemed I to a wall of stone.

For thirty years a beautiful maiden with crystal-clear light gray eyes like Georgie's appeared in Morris's poems as a bellwether, an embodiment of purity and loyalty.

In the late 1870s Morris turned to socialism and became an agitator, writing and delivering lectures on art and socialism all over Britain. He and Georgie and Ned agreed about many political questions: that home rule for Ireland was needed; that the empire had become a ravening maw, gobbling people and places unconscionably; that a violent class revolution within Britain was inevitable and necessary. But it grieved Ned that Morris seemed to be deserting art for politics, which he felt would surely end by disappointing him. Finally they came to a tacit understanding, in order to preserve their friendship, that they would not discuss politics. Ned felt guilty, calling it "the only time when I failed Morris."[90]

Georgie, in contrast, kept an open mind. She got herself a copy of *Das Kapital* and read it. She shared her questions and doubts with Morris in talk and in letters, asking him to engage with her, to hear her dissents, and respect her hesitations, which he did. Over the years they fought many points down to the ground; their letters show that both of them grappled with the theory of surplus value and mastered it.

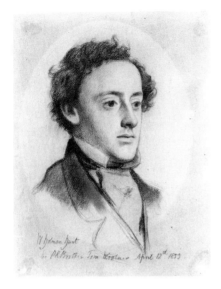

William Holman Hunt • *John Everett Millais*

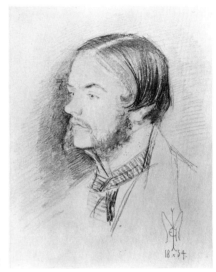

John Everett Millais • *William Holman Hunt*

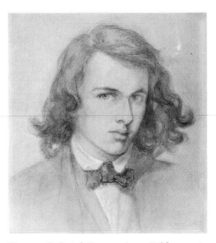

Dante Gabriel Rossetti • *Self-portrait*

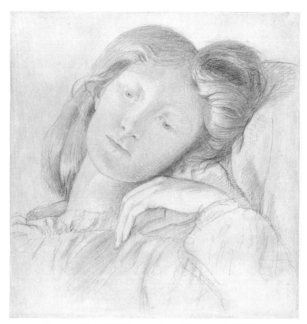

Dante Gabriel Rossetti · *Elizabeth Siddal*

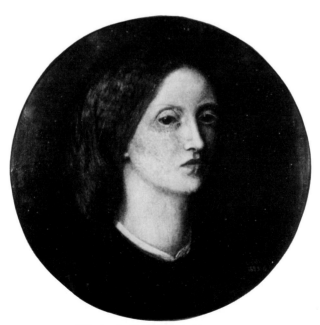

Elizabeth Siddal · *Self-portrait*

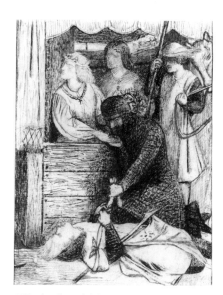

Elizabeth Siddal · *The Woeful Victory*

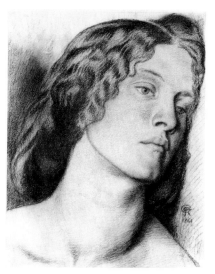

Dante Gabriel Rossetti
Study for *Fair Rosamund*
(Model: Fanny Cornforth)

Fanny Cornforth

John Everett Millais • *Hearts Are Trumps*

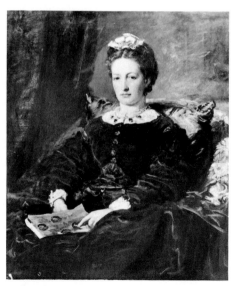

John Everett Millais • *Euphemia Millais*

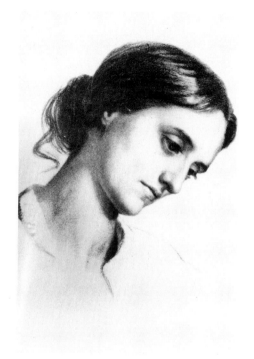

William Holman Hunt · *Edith Hunt*

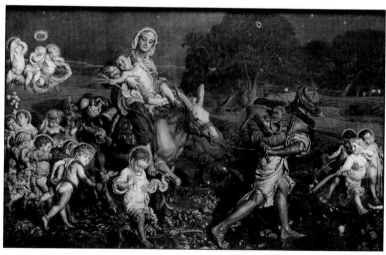

William Holman Hunt · *The Triumph of the Innocents*
(Model: Edith Hunt)

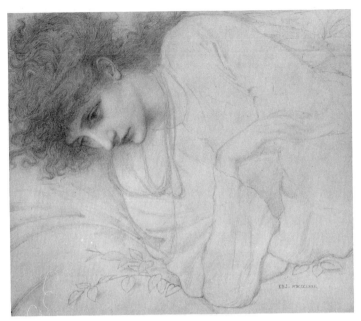

Edward Burne-Jones · *Maria Zambaco*

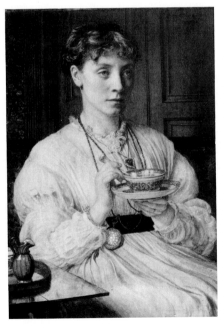

Edward Poynter · *Georgiana Burne-Jones*

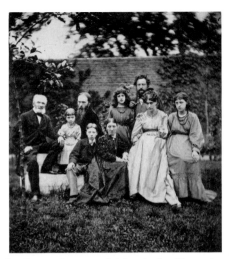

The Burne-Jones and Morris families, 1874
(Burne-Jones family on left)

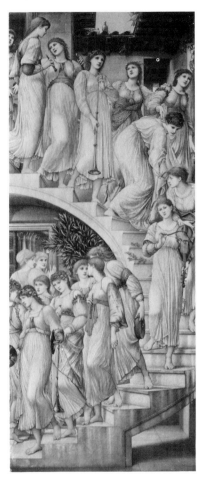

Edward Burne-Jones
*The Golden Stairs*

Edward Burne-Jones
with *The Star of Bethlehem*, c. 1889

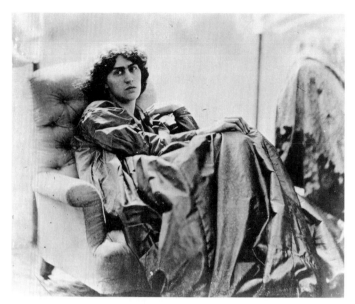

Jane Morris, c. 1865

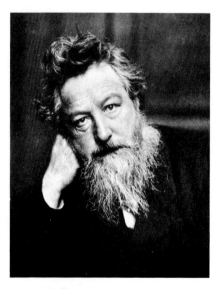

William Morris, c. 1887

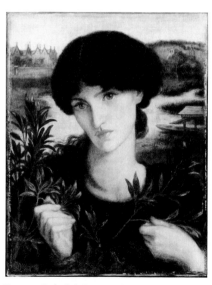

Dante Gabriel Rossetti · *Water Willow*
(Model: Jane Morris)

For a long time, however, Georgie could not accept Morris's strident brand of socialism. She confided to Charles Eliot Norton that Morris "is ever good and patient with me in my disagreements — but as time goes on I feel that . . . we are walking side by side it is in a kind of labyrinth, with a high wall between us. This often makes me unhappy. I take in his [socialist] paper, because I want to see what he is doing — saying publicly, but its tone jars and distresses me, and sometimes displeases so much that I don't think I can read it much longer. How I should like to talk to you about all this. On Edward the effect has been a kind of nausea of the whole subject, but then he has his own work to turn to — I have not any, and I 'worry' over it a great deal."[91] Despite her discomfort, Georgie persevered; she never stopped speaking with Morris on this subject so dear to his heart. Eventually she arrived at her own passionate brand of socialism.

<div align="center">✧◦✦◦✧</div>

In April 1870 Ned sent five paintings to the Old Water-Colour Society exhibition, the most fully realized of which was *Phyllis and Demophoön*. Phyllis was a queen of Thrace who hanged herself because her lover, Demophoön, failed to keep his promise to return to her. At her death she turned into an almond tree. Ned depicted the moment when Demophoön, returning too late, sees Phyllis reaching out to him from the beautifully fragrant flowering tree in which she has been condemned to dwell for eternity. Mary was his model.

The critics were savage; the *Times* remarked superciliously that the "idea of a love-chase, with a woman follower, is not pleasant." The picture caused such a problem that officials of the OWS politely asked Burne-Jones to remove it from the walls of the exhibition hall. He complied, but resigned from the society as soon as the show closed, explaining that "in so grave a matter as this I cannot allow any feeling except the necessity for absolute freedom in my work to move me."[92]

It is impossible to determine precisely why he was asked to remove the picture. Perhaps the OWS was simply disturbed by the fact that both lovers are nude. The woman has her arms locked tightly around the man, her face pressed up against his; her arm shields her breasts. Only the male genitals are on view, but this was certainly an unusual display for the time. A strand of drapery painted across Demophoön's upper thigh, just below his genitals, taunts the viewer, indicating that the artist could have raised the drape a bit and covered the man's sex

but that he chose not to do so.* This objection does not entirely satisfy, however, for other equally sexual pictures had appeared to less uproar.

Some biographers and art historians have suggested that the OWS's reason had more to do with the scandal of Burne-Jones's extramarital relationship. There was far too much embarrassing talk about the real-life story behind the art. The epigraph Ned gave his painting would have done nothing to dispel rumors: "Tell me what I have done, except to love unwisely?" The *Times* critic was right; this "love-chase" is disturbing. Phyllis's grief is writ large on her face; on Demophoön's we see anguish, guilt, and fear. The awkward pose of his body betrays just as plainly his urgent desire to escape her grasp. Such tortured feelings were not normally depicted in Victorian painting because the audience did not want to acknowledge that they existed; here they are all too nakedly displayed.

Why did Ned choose to portray his own desperation and Mary's misery for all the world to see? Perhaps he was far less aware of the picture's implication than we imagine, but it is hard to believe that such a brilliant man could blind himself so thoroughly. Why did he risk mortifying Georgie by offering his clandestine love up for public scrutiny? It could be that the painting was an attempt to tell Mary in this public forum that he was sorry, that he knew he had failed her. He may also have been silently begging her to let him go, showing her how frantic he was to escape their hopeless situation.

We have no way of knowing how Georgie felt, but she did seize a chance to get out of town when it came her way. Marian Lewes had taken George Lewes to Harrogate for the waters and wrote to say that they planned to continue on to Whitby; should Georgie care to join them, she need only inquire at the post office in Whitby for their address and she would be most welcome. On this slender reed Georgie launched a trip to the Yorkshire coast.

Whitby was a picturesque, red-roofed fishing village with a ruined

*Burne-Jones painted two versions of this picture. The second, painted in 1880, long after he had broken off the affair with Mary, is shown on the jacket of this book. Technically it is a stronger, more powerful painting, which shows the result of his careful study of Michelangelo during the 1870s. In the first version the bodies of both lovers are frail and Demophoön is more simply sad than the Demophoön of 1880, whose expression is a complex mixture of fear, guilt, and grief. In the later version the painter decided to drape the offending genitals, perhaps because he felt a need to hide where once he had insisted on a defiant display. The drape may also symbolize a desire to suppress the sexuality that had caused him so much anguish.

abbey on the hill above. During the day Georgie and Marian sat on the beach, talking and watching Phil and Margaret as they played on the sand and waded in the surf. In the evenings they continued their conversation late into the night, long after the children had been put to bed. Georgie felt free to talk with Marian, who was both wiser and far more tactful than Rosalind, and she was finally able to tell her whole story.

Once Marian had listened and considered, she counseled patience. She may have sensed that Ned's affair with Mary had begun to burn itself out; certainly she understood that Georgie loved Ned and wanted to preserve her marriage if at all possible. At the same time she encouraged Georgie to build up her own resources by seeking out some of the education she had longed for since she was a girl, and she promised to help Georgie read *Faust* in the original after they had both returned to London. For Marian, books had always been a refuge in time of trouble; she hoped they could become one for her troubled young friend.

Georgie stayed on at Whitby after the Leweses left, pondering what Marian had said and gathering her forces. She must have dreaded going home, where she knew that Ned was hard at work on a portrait of Mary, commissioned as usual by her mother. Even while he was struggling to finish this picture, however, Ned was missing his son and experiencing a tumultuous confusion of emotional allegiances. A lover, father, weary craftsman, and artist, he wrote to Phil: "I paint all day long and want to cry sometimes because after a long day no nice work has been done, and I have often spoiled my pictures for a time — then I want to be comforted with little arms about me; but often the work goes well and I feel proud — only I want you back, my little."[93]

When Georgie got home she followed her friend's prescription; over the next several years she applied herself to a study of German, French, and Latin, all languages in which Marian was fluent. She also treated herself to lessons on the organ, Marian's favorite instrument. This friendship sustained Georgie for many years. As a novelist Marian had to guard her working hours jealously, but she arranged her schedule so that Georgie could visit her every Friday afternoon, a practice they continued almost up until Marian's death in December 1880.

Back in London, Georgie celebrated her thirtieth birthday. To commemorate the occasion, Rosalind and George Howard commissioned

Edward Poynter to paint her portrait. Georgie put on a lovely white lace gown and dressed her hair in a fashionable fringe, but the woman who looks out from this picture is no lighthearted lady of fashion. Absently stirring her tea, she stares ahead impassively, ashen and drained, as if she has been left shell-shocked by years of turmoil and worry. The portrait must have brought Ned up short, so clearly does it document the havoc that marriage had wreaked on the young girl who had put her trust in him.

Morris had also planned a special gift for Georgie's birthday, a painted book bound in vellum. Inside he indited twenty-five poems, all but two of them his own work, in an open, casual calligraphic hand, and ornamented the borders with a garden of delicate flowers. The book became a workshop production: He did the lion's share of the work, but his manager, George Wardle, helped with the borders and Ned's assistant, Fairfax Murray, painted the pictures, a job for which Morris always engaged others because of his difficulty in rendering the human figure. As his contribution Ned painted a small picture to illustrate the first poem, which shows a young man and woman kneeling before each other in a pastoral setting. The woman has one hand extended toward the man; he reaches ardently toward her with both hands. Perhaps Ned was asking Georgie to forgive him.

By autumn Mary had seen that even though Ned might paint passionate pictures of her indefinitely, he was never going to leave Georgie. During this and the following year Mary experienced a major physical and mental breakdown. When she had recovered sufficiently she moved back to Paris, no doubt to remove herself from the scene of her torment.

From this time forward a slow mending began for Ned and Georgie. He turned back to her, and she accepted him. Their reconciliation was neither simple nor swift, and most of it remains hidden from our eyes. No more children came. Georgie turned to her studies and volunteered many hundreds of hours to fund and build a free gallery for the poor of South London; Ned buried himself in his work. For many years they did not vacation together; the excuse they gave was that one of them always had to be in the house to guard the paintings. The truth was that the distance between them could never be completely closed. Georgie's stoicism became a more prominent feature

of her character, remarked by family and friends alike. Ned turned inward to brood on his guilt and on the sacrifice he had made in giving up Mary.

Although an essential trust had been breached, they did rebuild from the broken pieces of their marriage. Their relationship changed into a companionship that deepened over the years. Georgie's devotion alone guaranteed its survival. She retained a strong sense that her task in life was to nurture and protect Ned so that he could produce the beautiful works of art that for her had a value beyond the small fact of her own happiness or unhappiness. In return, Ned acknowledged how much he depended on Georgie and cherished her for her integrity and her care.

Georgie's happiest hours were those she spent chatting or reading to Ned while he worked and in the evening when he came down from the studio, tired but hungry for the company of his family, "my three" as he called them. Friends often dropped in to visit: George Howard, Morris, and Ned's patron William Graham were regulars. While they chatted, Ned worked at designs for stained glass, which brought in small, steady sums of money. Georgie recalled: "He made the designs without hesitation; the result of incessant study from life showing itself in these large, free drawings, which came out upon the paper so quickly that it seemed as if they must have been already there and his hand were only removing a veil. The soft scraping sound of the charcoal in the long smooth lines comes back to me, together with his momentary exclamation of impatience when the stick snapped off short, as it so often did, and fell to the ground."*

Ned too loved the intimacy of these evenings; in fact, he hated for them to end, because he dreaded the nightmares that came to him. He preferred to lie on the couch and doze, lulled by the conversation, saying: "Don't stop, I love to hear the sound of voices — I wish there was no night and no bed — only to lie like this when one is tired and hear friends talking around one."[94]

In one of Ned's recurring dreams, Morris, his alter ego, betrayed a young girl who stood by a well "in that mournful twilight, which is the sky of dreams." She said, " 'Now listen to the noise of my heart,' and dropped a vast stone into the well, which boomed and

---

*The historian of Morris & Company's stained glass has calculated that during the years 1872–1878 Ned turned out a highly detailed cartoon every eight and a half days; during those quiet evenings in the drawing room he was becoming the greatest designer of stained glass in Britain in his century.

boomed till it grew into a roar unbearable."[95] At which point Ned would wake up, sodden with despair. His guilt was all-consuming; it felt bottomless as the well.

Over the next several years he was plagued by black depressions and repeated nervous collapses as he labored to accept the fact that his relationship with Mary was over and to figure out how to remake his life without her. He endeavored to hide his unhappiness because he felt he had no right to it. But Georgie, the lifelong student of his feelings, was not fooled for a moment as he threw himself into his painting in a vain attempt to work through his sense of grief and loss.

It was not just his great love that Ned had lost; other supports had also fallen away. He had broken with Howell (apparently because of some contretemps involving both Georgie and Mary),* and Gabriel had drifted off into drug addiction and mental illness, beyond Ned's reach. Gabriel refused invitations to the Grange; he didn't even show his work to Ned, who complained: "This is a letter of bitter reproach — you've finished a big picture and are sending it away today, and I do think it's shabby not to tell me and let me see it. Nobody anywhere in the world cares for your pictures as I do, and nobody understands them as well, and I ought to see them."[97]

The friendship with Ruskin also trailed off, though not without a bit of fireworks. Apparently disturbed by Ned's betrayal of Georgie, Ruskin wrote a lecture that sounds like a parable composed for Ned but was ostensibly a rumination on the repulsive, unforgivable carnality of Michelangelo's work. Ned had recently turned back to Michelangelo and Leonardo and found that he was able to make use of the riches they offered him; he was enormously excited about what he was learning from them, and both his draftsmanship and his painting technique began to show a new strength and definition. In his lecture, Ruskin seems to have been indicting both Ned's aesthetic enthusiasms and the conduct of his personal life. As soon as he had finished writing it, he invited Ned to his home so that he could read it aloud to an audience of one. Trudging back to the Grange, Ned

---

*One of the legends about Ned's relationship with Mary involves Howell arranging for Mary to take tea with Georgie at the Grange. Reportedly, the little tea party was going well and the ladies were making friendly conversation when Ned unexpectedly walked in. He collapsed in a dead faint and gashed his head on the mantelpiece as he fell, making a scar on his forehead that he carried for the rest of his days. The only source for this story, however, is Whistler, hardly the most reliable of narrators.[96]

was distraught: "As I went home I wanted to drown myself in the Surrey Canal or get drunk in a tavern — it didn't seem worthwhile to strive anymore if he could think it and write it."[98]

Ned was extremely productive during these years, as he wore himself out, painting some of his most powerful pictures. Between 1872 and 1874 he painted *Pan and Psyche,* a picture he had conceived in 1869, the year Mary tried to throw herself in Regent's Canal. Having tried and failed to drown herself, Psyche is being comforted by Pan, a wise old satyr who assures her that she will in time forget her pain. Ned's picture was not, however, so simply benevolent. It shows a muscular and supremely sensual satyr reaching down to stroke the head of the beautiful nude woman who kneels beneath him, begging with her eyes. (Her delicate profile is familiar as that of the suicidal queen in *Phyllis and Demophoön*.) Although he did not intend it, Ned had evoked the sexual power that held Mary in thrall for so long. The picture is disturbing because his Pan is so bluntly animal and his Psyche so human, frail and vulnerable.

In 1873 he was at work on *The Beguiling of Merlin,* six feet high and almost four feet wide — his last large painting about Mary and easily one of the most remarkable works he ever created. Mary reigns supreme and invincible in this return to the theme that had haunted Ned since youth. This time he painted with an understanding he had never had before, for now he had lived out the myth himself. A serpentine Nimue towers over Merlin just at the moment that she is casting her spell and trapping him in a hawthorn tree forever. The concentration of this composition is extreme: All that we see are Nimue and a feline Merlin with sunken, shadowed eyes, surrounded by a dense cloud of hawthorn blossoms.

In a letter written twenty years later, Ned tried to explain what he had wanted to do in this picture: "The head of Nimue was painted from the same poor traitor and was very like — all the action is like — the name of her was Mary. Now isn't that very funny as she was born at the foot of Olympus and looked and was primeval and that's the head and the way of standing and turning." Over the years he had recast this piece of his history; calling Mary a traitor gave her a large share in the responsibility for their betrayal of Georgie. Both the picture and his interpretation make it painfully clear how helpless he felt in the face of his attraction. In the letter he dropped all pretense and directly equated himself with Merlin, simply saying: "I was being turned into a hawthorn bush in the forest of Broceliande — every

year when the hawthorn buds it is the soul of Merlin trying to live again in the world and speak — for he left so much unsaid."[99] Perhaps he was hinting that if only he could have spoken about his love for Mary, the world would have forgiven him.

Ned collapsed when he finished this picture. After months in bed under Georgie's care, he was finally able to travel up to Naworth, the Howards' ancestral castle in Northumberland, for a rest. Georgie hoped that country air would make a difference; she was still desperately worried about him. "Please," she instructed his hostess, "without letting him notice it, dear Rosalind, treat him as you would a man recovering from a serious illness — don't make any plans or excursions for him, but let him wander about and breathe in fresh strength if the sweet air will give it him. I feel a ceaseless anxiety about him until he shows more decided improvement, so forgive me sending you this hint as to his state — he needs rest (if he can take it) and quiet at any price — two things impossible for him in this house, poor boy. He still has very bad nights, with bogie dreams and no doubt more painful thoughts in the waking times from them — you'll put him in a room not too far from fellow creatures, won't you?"[100]

Seeking an escape from the endless round of depression, Ned found a new distraction for himself, a diversion that seemed to arise naturally from his need for a supply of beautiful models. For ten years William Graham had been a loyal patron. Over that time he had become a trusted friend of Ned and Georgie's, and their financial adviser as well. He had built his own fortune by importing goods from India; until 1874 he had been the member of Parliament from Glasgow; he was also a voracious collector of all kinds of art. His daughter Frances Graham Horner remembered that the walls of every room in their townhouse in Grosvenor Place were lined with pictures from floor to ceiling. What didn't make it onto the walls was piled up on the floors and the chairs and the tables. Graham's collection was dominated by the Italian primitives and by the Pre-Raphaelites who were their spiritual descendants, including Millais, Rossetti, and Burne-Jones.

Graham devoted himself to his eight children just as passionately as he did to his pictures, for he was no bloodless aesthete. His favorite was Frances, a beautiful, lively, smart, socially precocious young

woman whose friends referred to her as "the Botticelli." Frances went everywhere with her father, who visited constantly in the Burne-Jones studio, and soon Ned became Frances's special friend. Who could have resisted a man who confided that only that morning, as he was laboring over a mermaid with a long, scaly tail, a model had come and asked him what the creature was and he had been forced to reply: "I couldn't help saying it was a portrait of the Dowager Countess of Dorking, and she quite believed it."[101]

Very quickly Ned discovered the treasures of imagination and sympathy Frances held out to him. By the mid-1870s he was having dinner with the Grahams in Grosvenor Place twice a week on the average, not least because it meant he could see Frances regularly. Sometimes Georgie accompanied him, but more often she stayed home. A correspondence grew up between Frances and Ned; she was as great a charmer as he, and their letters are full of fun and flirtation. She filled up part of the hole that Mary had left in Ned's life, but in a way that did not threaten his equilibrium. He knew now that he did not want to risk losing Georgie.

Frances was quick to see that Ned was depressed, that he didn't go out and make friends, that he tended to work too hard as a way of avoiding problems and people. She decided to take him on as a project. She brought amusing people to meet him; she saw that he was invited out; she led him back into the world. She encouraged him to open his studio on Sundays, a practice that was becoming fashionable and brought him into contact with all sorts, including new buyers. A little dubious about the whole undertaking, he was often "out" when visitors called, but servants showed them into the studio to see the paintings. Sometimes he hid so that he could hear their uncensored comments.

Ned was touched by Frances's care and grew to depend on her approval. She was worldly and feminine in ways that he loved and that in some part Georgie eschewed. Generally Georgie hated dinner parties; she felt that people talked twaddle and wasted one's time. Ned knew she was often right; the worst dinners reduced everyone "to a heap of ashes," he said. But he also loved the conversation and the jokes, and especially the pretty young women. Over the years, with Frances's help, he developed two lives: one in society, one at the Grange.

Through Frances he made a series of young female friends who came to tea, wrote to him when they were away, and paid him a

great deal of invaluable attention. They included Mary Gladstone, the daughter of the prime minister; Eva Muir; Laura Tennant; Olive and Violet Maxse; and Sally Norton, the daughter of Charles Eliot Norton. None of these friendships became sexual, but implicit in many of his charming little letters was a tender, teasing acknowledgment that he was a man and they were women. He longed for the exclusive attention of his young ladies; in fact, he had an insatiable desire for the company of women. When his favorites grew up and got engaged, he was distraught, just as he had been when Georgie's sisters had deserted him.

The fundamental innocence of these relationships is embodied in a painting Ned did during this period entitled *The Garden of Pan*. Pan is depicted as a slim boy piping on his reed by a little stream as two thoughtful young lovers listen to his song. This gentle representation makes a telling contrast with Ned's powerful, erotic *Pan and Psyche* of 1872.

Such friendships were more possible and far more common then than they would be now; sentimental friendship between men and women was an accepted and valued fact in a world where sex was so tightly controlled. This sort of interchange allowed sex at least to float in the air, providing some relief and, for young girls, some experience that they could not get in any other way. The young women sought it just as eagerly as Ned did when they found that he would give them so much without going too far. He was a bit like an uncle who relished their beauty and charm with greater ease and sophistication than the nervous young men they encountered. There was freedom in the fact that he was older and married; there was no need for a third person to hover about as a chaperone at every moment, because in the eyes of the world, *he* was the chaperon. If a young woman came to the Grange for Sunday lunch, he could escort her home. Nor did anyone think it shocking if she went for a walk with him in Kew Gardens, meeting in his favorite spot, the steamy Palm House, and taking tea afterward. The Victorians understood that there is an enormous distance between chastity and intercourse, and there are many pleasures along that road.

Georgie appears to have been genuinely comfortable with Frances and her friends. In her biography of Ned, she refers to Frances affectionately and quotes at length from letters that Ned wrote to her. The fact that Georgie welcomed these girls into her home argues that Ned didn't get carried away, but it may also mean that Georgie put

the brakes on by extending her own friendship to these young women. Then again, Georgie didn't go to Kew and she didn't read all the letters; there may have been passages of intimacy between Ned and his cadre that would have disturbed her had she known about them. There had to be, by our measurement, great denial on all sides for these friendships to be sustained over many years. The young women treated Ned as a dear friend or as an amusing older brother. Georgie treated them as close friends of the family. Ned called them his pets, his dears, his darlings. In his letters he acknowledged the intimacy of these relations, but he was also daring in his open declarations of affection for men friends.

Why did Ned seek out these young women? Why did he need Frances so badly? First and foremost, they were the raw material — real as well as psychic — for his painting. His fantasies about them were poured out on canvas after canvas. He drew them and painted them one after the other, treasuring every line and curve of their soft downy cheeks and foreheads and chins. With Mary Zambaco he had burst through the screen of repression behind which he had been trapped for so many years, and his painting had taken a dozen leaps forward. Now he was having a very hard time figuring out how to live in a world where sex was always on the verge of throwing his life into chaos once again. Sex and romance were the primary, necessary subjects of his art, so he crafted this strange compromise based on tea and sympathy with a dozen girls, no one of whom was allowed to dominate his affections for any length of time.

Another, deeper answer to the question must be rooted in his lonely childhood. Always trying to create what he had never had — the maternal affection that would have rendered him secure, sure that he was worthy of love — he wanted to make every appealing woman love him. It was as if he were continually in need of assurance that the mother and sister he had never known would have poured love onto him. For him, romance and maternity had become hopelessly confused; he was always starved for immoderate affection. Georgie gave him love and approval in a steady stream, but it was nowhere near enough.

Frances understood that Ned was also obsessed with what he perceived to be his hideous face and body. Photographs taken in middle age show a haunted, thoughtful, appealing face, by no means ugly. Surely the ugliness that dogged him was a reflection of some blemish, some deformation he perceived in his spirit. Try as he might, Ned

failed to heal himself; instead he kept on roving, searching for that one remarkable woman who would finally lay to rest his fear about himself. It seems unlikely that he really wanted to escape this pattern, for it afforded him too much erotic and emotional satisfaction. But the endless subtle betrayal of Georgie implicit in these friendships must have made him feel ill at ease, untrustworthy, insincere. By styling his young friends as little sisters or nieces, he helped himself allay that guilt.

Georgie undoubtedly sensed that these relationships had become a vital part of the delicate equation that sustained her marriage. At a deeper level, she may have felt she had no right to protest; in her childhood, she had had to content herself with the scraps of affection that her father offered in the moments when he allowed himself to leave his study to relax with his children. He had been loving, but only when available. What Georgie brought into adulthood was a model of a man who had to withhold in God's name. Now, when Ned secreted himself in the studio to draw one of his young ladies, he withheld in the name of art. When he had courted her he had seemed so different from her father — so open and expressive of his tenderness — but it turned out that he too held his essential self aloof.

In middle age Georgie developed a defense against Ned's remoteness, but it did not serve her well. Regretful that she could not win him with her beauty or her charm, she turned to another powerful weapon — her purity of heart. The artless, innocent spirituality that had first attracted Ned evolved into a grave, stern self-possession that felt like judgment to him. And so, perhaps, it was, informed by all the anger and disappointment she could not permit herself to express. Ned once mentioned that Georgie was "always unkind" in his dreams; she must have become a conscience for him, her absolute integrity an endless reproach, a standard he could never meet.

If it had all gone differently, if her husband had surrounded her with love and trust, Georgie might have been an easier, more relaxed woman. As it was, she was tense more with apprehension than with judgment, for she never knew which new girl would be another Mary Zambaco. Judgment became an instrument by which she could give moral instruction and so try to control Ned; unfortunately, it was precisely the weapon most perfectly designed to drive him further away from her. In time Georgie must have seen this, but it was too late.

This dynamic of betrayal, judgment, and guilt informed life at the

Grange and imbued it with a tension and a solemnity that even visitors sensed; the painter Graham Robertson described it as "an uncomfortable sensation of sitting up and balancing a biscuit on one's nose."[102] He added that as soon as he and Ned went upstairs and closed the door to the studio, Ned was restored to his usual lively, elfin self. Both Georgie and Ned would have liked to clear the air downstairs in the drawing room, but too many years had passed in uneasy silence; neither knew where to begin. Eventually Georgie came to understand what a price she had paid for holding back her anger; late in life, after Ned had died, she wrote to a friend: "I really thank Morris for the rages and tearings of the hair by which he expressed himself in early days, for though I can't imitate him I can say 'that's how I FEEL.' "[103]

After his resignation from the Old Water-Colour Society in 1872, Ned did not exhibit, and he felt as if the public had virtually forgotten him. Then, at the end of 1875, he and his friends began to hear rumors about a marvelous new gallery where pictures would be hung with plenty of space, in good light, as if in a private house. The author of this scheme was Sir Coutts Lindsay, an amateur artist, who placed advertisements in the newspapers announcing that he intended to take on the hidebound Royal Academy. Over the new few years Lindsay spent £150,000 (most of which was his wife's money) to build and maintain his splendid gallery.

Exhibition was by invitation rather than by competition. Gabriel and Brown were asked to exhibit at the opening, as was Ned. Brown refused straight off, but Gabriel seemed to mull over the question, then decided against. Lindsay pressed Ned to ask Gabriel to reconsider, but he wrote instead to let Gabriel know that he understood: "As to the Grosvenor Gallery, if you have made up your mind we won't talk about it. I should have liked a fellow-martyr — that's natural — as it is I shall feel very naked against the shafts. . . . I promised them to write you about it, and it's true I wish you would send, but that's all."[104]

There were no Rossettis to be seen at the opening, but Ned was joined by his early mentor G. F. Watts as well as by Whistler, Millais, Hunt, and a host of others. The main gallery was dominated at one end by Whistler, at the other by Burne-Jones. Ned had sent eight pictures, including *The Beguiling of Merlin*. On the first evening a lavish dinner was given for the Prince and Princess of Wales and "all

that London held of talent and distinguished birth." Two days later, on May 1, 1877, when the exhibition was opened to the public, seven thousand people came to see what the hullabaloo was about.

The Grosvenor Gallery was an instant hit with high society. It became one of the chic places to see and be seen, home ground for the aesthetes that Gilbert and Sullivan lampooned in *Patience*. Ned was not part of the aesthetic movement, but his elegant, sensuous colors and his dreamy, romantic subjects were catnip to the worshipers of decadence who flocked to see his work, those "greenery-yallery, Grosvenor Gallery, foot-in-the-grave young men."

Not everyone was so inclined. Many laughed at *The Beguiling,* and at least one viewer, the painter Elizabeth Thompson Butler, caught the scent of the new artistic fad straight off and was utterly repelled. A painter of horses and dramatic military scenes, Lady Butler described her reaction to the exhibit thus: "I felt myself getting more and more annoyed while perambulating these rooms, and to such a point of exasperation was I compelled that I fairly fled, and, breathing the honest air of Bond Street, took a hansom to my studio. There I pinned a seven foot sheet of brown paper on an old canvas and . . . flung the charge of *The Greys* upon it."[105] (Lady Butler would not have agreed, but she may have had Ned and Whistler to thank for the genesis of one of her best paintings.)

The critics did not indulge in any orgy of veneration either. Blinkers tightly in place, they viewed *The Beguiling* and focused on the fact that Nimue's head was too little. This obtuseness irritated Graham Robertson, who understood what Burne-Jones was up to: "The head obviously *was* too small, but did these clever folk really think that the painter did not know it? The [Nimue] of his picture is a Lamia, a Melusine, and as she puts forth her powers she is all serpent and in act to strike. The dull greenish garment, tightly clinging like a wrinkled skin, the curve of the lithe body, the narrow eyes *and* the small flat head all reveal the triumphant snake swaying slowly before the eyes of its helpless and mesmerised victim."[106]

Years later, Georgie saw that the opening of the Grosvenor Gallery had changed their lives: "From that day [Ned] belonged to the world in a sense that he had never done before, for his existence became widely known and his name famous."[107] Now his studio was packed every Sunday. Suddenly he had more patrons than he could handle, and as always, his imagination was spinning out a hundred pictures for every canvas he could finish. He hired more assistants, and came

close to realizing his dream of a medieval guild workshop where men labored together in harmony to produce one beautiful canvas after another.*

<div align="center">❧❦❧</div>

The 1880s opened with a series of losses that made both Ned and Georgie conscious that time was fleeting. George Henry Lewes had died during the winter of 1878, and they had grieved with Marian. Then, in May 1880, Georgie received a letter in which Marian announced awkwardly that she was about to marry John Walter Cross, a friend whom she had always tenderly called "nephew." He was forty; she was sixty. Georgie was shocked by the betrayal of Lewes's memory; she could not imagine Marian transferring her affections to another man any more than she could imagine remarrying if Ned died. She was also deeply hurt that after ten years of intimacy and all those dozens of Friday afternoon journeys she had made across London to visit Marian, her friend had been unable to bring herself to say that so momentous a change was taking place in her life. But Georgie's first impulse was to sit down at her desk and write to reassure Marian: "I cannot sleep till [your letter] is answered. Dear friend, I love you — let that be all — I love you, and you are *you* to me 'in all changes' — from the first hour I knew you until now you have never turned but one face upon me, and I do not expect to lose you now." And she signed it: "I am the old loving Georgie."[108] But something stopped her; she could not mail this note.

She and Ned did not judge Marian, but they did not know what to say or how to react to this marriage. Six weeks later Georgie wrote to her friend, asking for patience: "Give me time — this was the one 'change' I was unprepared for. . . . Forgive what would be an unpardonable liberty of speech . . . if you had not also looked closely into my life." She closed with: "Edward joins me in love, and I am always your loving Georgie."[109] Unfortunately, time was not to be granted her. On a Monday in December, just seven months after her marriage, Marian Cross went to bed with laryngitis. Georgie called

---

*His principal helper was Thomas Rooke, a skilled painter who so loved Ned that in the last years of his master's life he began keeping notes of his actual conversation. Most good talkers' conversation perishes with them; Ned was one of the lucky few to have both his silliest chat and his most thoughtful ruminations preserved. Rooke knew Ned would hate what he was doing, so he set himself to remember verbatim, taking only the odd surreptitious note.

late on Wednesday afternoon, but that same night John Cross had to take up his pen to tell her: "I must write one line to save you perhaps a greater shock of seeing the announcement in the papers. My great wife and your dear friend died tonight at 10 o'clock from failure of the powers of the heart."[110]

Less unexpected was the death of Gabriel. For years he had repulsed Ned's efforts to see him, allowing only a very occasional visit to his studio. Ned and Georgie knew how he had suffered and that death was a mercy for him, but they were nonetheless grieved to lose the friend of their youth.

Now in their forties, they were also continually plagued by their own afflictions. Georgie had spent months in bed with a bad back; Ned had had another frightening breakdown, not simply physical but not simply mental either. To guard against the respiratory infections that seemed to trigger his collapses, his doctor confined him to the house for months at a time, eventually for whole winters — a prescription that did little but make him more anxious because he was forced to be constantly aware of his frailty. However, when he was sick Georgie could nurse him, which he loved; this was the one ground on which they could come together in an easy and precious intimacy. She became simply the nurturing mother who guarded and petted her fragile boy; judgment did not come into it, and they were free to express their affection for each other. Georgie once wrote about Ned's amazing fortitude and grace in facing illness, that a visitor might well be surprised by the peals of laughter issuing from the sickroom. She was right: He wasn't a whiner, but he also got something out of illness — perhaps a respite from guilt.

Shut up in the house for a winter, Ned had nothing to do but work. For the Grosvenor Gallery in 1880 he painted a canvas nine feet high and four feet wide, showing a procession of eighteen beautiful virgins filing down an enormous staircase toward a door marking the threshold of their innocence. The faces of Frances Graham, May Morris, Laura Tennant, Mary Millais, and Margaret Burne-Jones can be seen in the picture, but Ned used his favorite professional model, Antonia Caiva, for all the bodies. As in so many Pre-Raphaelite paintings, the heads of upper-middle-class women are grafted to the body of a working-class woman — a perfect expression of Victorian society's attitude that ladies had only heads and that women were just mindless bodies.

Ned loved to work with Antonia; her beauty made him feel that

"she was like Eve and Semiramis and people at the beginning of the time."[111] But as *The Golden Stairs* progressed, she became little more than dozens of limbs and digits for him: "I have drawn so many toes lately that when I shut my eyes I see a perfect shower of them."[112] To work on the upper regions of the canvas he had to sit on a ladder, and toward the end of a day up there he sometimes grew afraid that he would faint and fall. Georgie felt it had become a race: "The picture is finished, and so is the painter almost."[113]

Despite his fatigue, he pressed on, and the next year began *The Sleep of King Arthur in Avalon,* the largest picture of his career at nine feet by twenty-one. It shows King Arthur on his deathbed, surrounded by a bevy of beautiful handmaidens and a field of flowers, and he would work on it until his own death stopped him.

To combat Ned's preoccupation with his work and build up his strength, Georgie started to search for a house by the sea where he could relax and get the benefit of the mild sea air. The ramshackle little place she bought in Rottingdean, a village near Brighton, became their haven, their refuge from the pressure of too many exhibitions, too many dinner parties, too many young ladies. They both loved it dearly and spent a great deal of time there, alone and together. Even their sanctuary could not provide absolute protection, though; one upheaval seemed to follow upon the heels of the next.

First Ned developed a problem with his vision. Then Phil left Oxford without his degree. At about this time, Ned's father suddenly decided to marry his (much younger) maid. After almost fifty years of devotion to the memory of his late wife, the old man suddenly found a replacement. All those childhood trips to the cemetery in Icknield Street came back to haunt Ned, even as he struggled to treat his father's new wife with dignity and courtesy. Perhaps even more disturbing to him, though, was the news that Frances, who had flirted with any number of young men over the years, had engaged herself to a wealthy barrister fifteen years her senior. Ned felt abandoned; in his heart he had always wanted Frances to be his sole treasure.

During these years Ned did a narrative picture about Georgie and himself called *King Cophetua and the Beggar Maid,* based on a well-known and much-loved Tennyson poem about a medieval king who searches far and wide for an utterly pure maiden to be his wife. With this picture Ned was exploring the painful enigma at the heart of his marriage: the fact that no matter how much he loved and respected Georgie, he could never find a way to bridge the distance between

them. He chose an enormous canvas — thirteen feet high and four feet wide — and on it he painted a pale, delicate maiden sitting on a high stair in a castle, with the king sitting humbly below looking up at her in wonder. She gazes into the distance, mournful, away from him; a sense of isolation lies like a pall over the immobile, separate figures. It is hard to imagine these lovers ever touching.

Georgie loved the picture, although she never hinted that it might have anything to do with her. Certainly, though, the painting suggests that while Georgie remained Ned's queen, she was for him unapproachable in her purity. He awarded her this place of honor as a reward for living with all his failures and indiscretions. But some of the sadness that comes through in the maid's face must have reflected his awareness of the difficult bargain they had struck. In one corner of her heart, Georgie must have wished that he had painted her instead as one of the beautiful sirens who called out to him.

In 1885, the year after *King Cophetua and the Beggar Maid* was exhibited to general acclaim, the Royal Academy finally decided that the time had come to redress their negligence, and Burne-Jones was elected to an associate membership. Such a possibility was so far from Georgie's mind that when the messenger arrived at ten o'clock in the evening, she thought it had to be a practical joke and sent him away. The next day her mistake was found out, and after much discussion Ned reluctantly decided to accept. Fame had become a nuisance to him, but he felt it would be graceless to refuse. He exhibited at the Royal Academy only once, in the following year, and finally in 1893 resigned from the institution, having never felt comfortable in its ranks.

As he grew older, personal concerns dwarfed public battles. Margaret's dawning maturity troubled him no end. In the summer of 1884, when she was just eighteen, he was commissioned by the dealer Agnew to paint a series of murals, an enormous project that gave him plenty of space in which to brood on the prospect of his daughter's sexual awakening. For his subject he chose the legend of the Sleeping Beauty.

In the *Briar Rose* series, the artist tells the story of the knight who has come to save the somnolent princess, but he makes sure to put countless obstacles in the young man's way, and nowhere does he suggest that the knight will actually succeed in his quest. In the first

panel the knight has just stumbled upon a group of sleeping knights, their bodies intertwined with a kind of deep languor as if after great exertion or sexual pleasure. They lie in a briar-rose forest, surrounded by thick branches studded with huge thorns. All the subsequent panels are similarly thorny; indeed, briars abound. The second panel shows the king's council chamber where the ancient, bearded ruler sits sleeping on his throne before a tangled group of sleeping courtiers. In the third, six maidens sleep the chaste, gentle sleep of girls; this is a world in which men and women live separately. And in the final panel the princess — Margaret was of course the model — sleeps stretched out on a bed that looks more like a bier, covered by a transparent blanket laid carefully upon her like a shroud. Her three attendants, one at her shoulder and two at her feet, sleep soundly. The knight stands at one end and Margaret awaits him at the other, but in between is a great and perilous distance that he must traverse in order to reach her. The nature of the danger is multifarious and symbolic: thorns that wound, a universal sleep that seems to verge on death. If the knight reaches the maiden and succeeds in awakening her, the entire kingdom might be saved. Yet if the princess awakes and begins to move, she will inevitably be pricked by a thorn, the significance of which is painfully obvious.

Certainly Ned dreamed about preventing any young man from ever reaching his maid. In a letter to Lady Leighton-Warren, a friend who lived in the country near Chester, he asked whether she would help him with his murals by sending him the fattest thorn branches in her garden from which to work; he was hopeful that "deep in some tangle there is a hoary, aged monarch of the tangle, thick as a wrist and with long, horrible spikes on it." Apparently someone had protested that the thorns he was sketching into his picture were too large to be realistic, and he wanted to prove that his imagination had not outrun nature: "I think I must have made my thorns too big, and yet, and yet — if it were only possible. . . . Such an hoary old creature might lurk under the leaves whose aspect would be terrible."[114] Such an hoary old creature as himself, who might succeed in scaring off any young blade who came to court his lovely daughter.

A week later he wrote again to thank Lady Leighton-Warren for her trouble: "The briars have come and are all my soul lusted for — how shall I thank you enough? The thick one is a superb one, of infinite use." Nonetheless, his unnamed critic had been right. He admitted that he was going to have to rework all the briars in his

picture, "for I had made all the thorns too big — too hooked and sharp — not the stems too thick, but the thorns were all amiss; and now my honour will be saved, and the Sleeping Beauty's honour, which is of more account."*[115]

The event that Ned had dreaded for so long finally came to pass in 1888, when Margaret, now twenty-one, became engaged to John W. Mackail, a friend of Phil's from Oxford. Her choice was irreproachable. Mackail, or Jack as his friends called him, was a brilliant, sensitive, quiet young Scotsman, a fellow of Balliol until he came to London to take a position as a civil servant in the Education Department. He was a ferociously hard worker who wrote scholarly articles and poems far into the night and in the early morning before he went to the office. It was apparent that Mackail would make a good husband and that they were very much in love, which did not make it any easier for Ned to accept the situation. In a letter to a friend he tried to make a joke of it: "Did you ever in this house see a man named Mackail? And should you from his face and expression have thought him capable of deep treachery to me?"[116] To Watts he wrote soberly: "My little Margaret is engaged. I haven't felt very good about it — I have behaved better than I felt. She looks very happy, and before he wanted her, and before I dreamt of any such thing, I thought him a fine gentleman through and through, and yet, look what he has done to me! I have known him for seven years, and always he seemed a grave learned man who came to talk to me about books — and it wasn't about books he came, and now where am I in the story? Send her a little blessing, for she loves you both — and say nothing consoling to me, for I have in me no bit of wisdom or philosophy, or ever had or shall have."[117]

Georgie tried to help Ned reconcile himself; she knew how lucky they were in Margaret's choice. To Swinburne she wrote in February 1888: "Edward and I want you to hear from ourselves [that Margaret is engaged] . . . by the kindness of heaven it is to the one man in the world we would have chosen for her if we might, what this means you will understand, and what a fresh life opens before us through it . . . he and Margaret shut their eyes to each other for a long time — during which Edward and I came to love him in an exceptional way —

---

*Curiously enough, this series, which brought him no peace of mind about Margaret, did bring him financial security; in 1890 Agnew paid him fifteen thousand pounds for it, fourteen thousand of which he invested. Finally he had sufficient capital to relax.

and then, when all was so made ready, suddenly they awoke and I never saw two people more blessed than they. . . . It never seemed possible that we could be made happy by a thing that meant she must leave us — but so it is. I hope you will be glad with us . . . so few, so very few seem to keep fire alive in their hearts so that the old ideals do not grow cold. See with what confidence I turn to you — it is I think even more because you are a poet than because you are one of our oldest friends. . . . Your eyes were almost the first that saw Margaret — I am sure they were good for her. Think what it is to see a poem lived."[118]

Margaret chose to be married on September 4 in the little village church at Rottingdean. The bride slept till her usual hour on her wedding day, but her father was up at the crack of dawn. The guest list was limited to eleven, and Margaret walked the short distance from the house to the church, with Georgie and Ned on either hand. They had tried to keep it secret, but somehow word got out in the village, and a little crowd formed at the door of the church. As they approached, four girls carrying huge baskets of rose petals came out of the church, and Ned thought that "it seemed to rain rose-leaves." The ceremony was brief, which was a mercy for Ned, who went home to his studio afterward and, to his surprise, felt for the first time in ages as if he could work.

Georgie's response to the fact that Phil and Margaret had grown up was to seek out work of her own outside the home. She volunteered many hundreds of hours to help a man named William Rossiter, who had been struggling for years to bring art to the working-class neighborhoods of London by means of exhibitions and free lectures. With Georgie's assistance, he raised £10,000 and built a gallery and a library in Camberwell that opened in 1891. The South London Art Gallery became so popular that within a few years it was drawing as many as three thousand visitors on a Sunday. Through her work Georgie not only brought pleasure to others, she acted on her conviction that the chance for every person to enjoy beauty was a fundamental step on the road to building a generous, decent society. Ned supported her in principle and loaned his paintings for exhibition, but he worried that she would make herself ill by overextending herself, which she frequently did. He was also a little jealous because she was no longer at his beck and call in the way she once had been.

The Mackails took a house in Young Street, a short walk from the Grange, and Ned often went round for a little visit in the early evening when the light failed and he had to stop painting. But even this ease of access to his precious daughter was not enough to satisfy him: "That seems a heavenly way the French have of living all together in a big house, within reach and within call, and I want it."[119]

A year later, distraught over Margaret's first pregnancy, Ned comforted himself by working at *The Star of Bethlehem,* an elaborate Nativity scene. Georgie was as nervous as her husband. The death of Christopher and the illness that had followed still haunted her; when one of Rosalind Howard's daughters lost a baby, Georgie wrote: "Will you please give her my love and tell her that I tenderly sympathize with her? I had a little shadowy babe before I knew you, that stayed with us three weeks, though I was too ill to know anything clearly about it — but as every year comes round I keep its birthday and death day, and a shadowy son of seven and twenty sometimes exists a moment for me."[120]

On January 30, 1890, Margaret's baby was born without mishap. At first Ned didn't pay her much mind and in fact resented her overweening supremacy: "The whole house is its abject slave."[121] But as little Angela began to take on a personality, he fell in love with her. He did literally hundreds of drawings for her amusement, and Angela always knew how lucky she had been: "When I woke up in the morning at North End House [Rottingdean] the first thing I saw was an angel, pulling away the curtain of darkness to let the daylight in. It was painted on the white-washed wall at the foot of my bed in our little attic night-nursery by my adoring grandfather."[122] Ned also painted a kitten playing with its mother's tail and a flight of birds in the corner where Angela was sent for punishment, so that she would have something to cheer her during these sessions. At the Mackails' house in Young Street, Ned kept a notebook of the finest drawing paper just so that he could do fresh drawings for his granddaughter. Indulging his own childhood penchant for the most ghoulish subjects, he bestowed upon her sketches of the Heath Horror, the Fen Ganger, the Seminary for More Advanced Dragon Babies, and the Tree that Weeps.

What had happened to Mary Zambaco in the years since she had fled to Paris, having given up all hope of life with Ned? The traces of her

life are very shadowy. She returned to London, and in 1879 Gabriel wrote a letter to Jane Morris in which he said that Mary was living very unhappily with another man, whom he didn't name, and that both of them "do nothing but work awfully hard at painting and produce Ned Joneses without number."[123] Mary kept on with her sculpture, and by 1888 she had taken a studio next door to the extra studio that Ned had rented across town in Campden Hill because his *Sleep of King Arthur in Avalon* was too large to fit into either of his two studios at the Grange. Of this arrangement we know nothing but the bare fact. It is possible that Ned and Mary resumed their affair, but it is far more likely that the grand passion of twenty years earlier had died down, and now they warmed their hands together over the embers of a sentimental companionship.

During the winter of 1890 Ned suffered a dangerous attack of influenza, an often fatal disease. Georgie felt that he never entirely threw off the results of this attack, and almost every winter for the rest of his life he had a recurrence, despite the fact that they took every precaution. (Georgie's health also became more precarious, although she made light of it.) In 1892, still weak from flu, he ventured out and fainted in the street, where he was almost crushed by a horse-bus. When his sight took a turn for the worse, an operation was performed right at the Grange; as he was being carried upstairs to the room that had been prepared as a makeshift operating room, he had an unfortunate glimpse of his doctors heating a wire to a red-hot glow. This tableau struck him as the handiwork of "mediaeval torturers," which does not sound far wrong.[124]

Frances, long since married but still his treasured friend, was dismayed by his growing feebleness and depression. In an attempt to cheer him up, she brought the lovely Helen Mary Gaskell to visit sometime in 1892. May, as she was always called, was a slim young woman with delicately waved hair and hollowed cheeks. She was married to a Captain Gaskell of the Ninth Lancers, by whom she had had three children; little is known of him beyond the fact that he was very rich, had a terrible temper, and was often away from home.

Ned proceeded to fall head over heels in love with May. Over the years he had been attracted to a dozen young women, but he had never fallen in this way, not since Mary. Yet it is not surprising that he opened himself up to May; he saw his own end coming and wanted

one last chance to satisfy his hunger for romance. We can discern from reading his letters that May returned something of his feeling, but it is hard to know just how far her affection went, for none of her letters to him survives.*

Between 1892 and 1895 Ned wrote to May virtually every day — sometimes several times a day. He may well have written her more than a thousand letters between that afternoon when Frances first brought her to visit and his death six years later. He would stop in the little intervals of painting and dash off another note, or continue a letter in progress: "You see I come from my painting and write a few lines, just to rest, and go back to it and am always turning to you, as I should if you were by, but always while I am working I am wanting you to like it or change it if you dislike it, and wondering what you will say."[125] Living completely in his love, he could not bear to lose hold of the intimacy that was broken off with each departure, but had to take up pen to continue the conversation on paper. Letters to May became his real life; the rest was like a dusty shadow. He told her that he wrote so often so that more of his life would seem real and nourishing to him: "I make it last as people on a raft make food last."[126]

The major events of his public life no longer affected him much one way or the other; he was too completely preoccupied with May and with finishing as many paintings as possible. When he was offered a baronetcy, he was torn about whether to accept it. Phil wanted it passionately, since he would inherit the title, but Georgie was appalled; it went against all her socialist convictions to bend the knee for royal oppressors. For himself, he told May: "I half like it and half don't care 2d."[127] Ultimately he did accept, for Phil's sake. To spare himself the embarrassment of being called Sir Edward, he told May he planned to slip Ralph, her butler, a fiver each year if he promised to announce him as Mr. Burne-Jones.

He could never get enough of May. In the early years especially he always needed more time, more attention, another letter from her, some further sign that she cared for him and would not turn away.

*In 1931, when May Gaskell was seventy-four years old, she reread all of Ned's letters and made a selection of a few hundred which she intended to give to the London Library, but which have ended up in the British Museum. She made a handful of brief notes in the margins. "Wonderful letter" certainly suggests that she treasured the memory of his ardor, and the fact that she wanted the letters to go to a public archive makes clear that she was proud of his love and wanted the world to know about it.

She kept definite limits on their relationship, seeing him most of the time only in society, at Frances's home or in her drawing room for a visit in the late afternoon when others might call. Twice she invited him to visit Beaumont Hall, her country home in Lancashire, for a few days; once he went by himself, once he took Georgie. May came to see him many times at the Grange; she would take tea with him and Georgie in the drawing room, then he would take her upstairs to his studio, where he drew her again and again. (In the Kelmscott Press edition of Chaucer's poetry, Ned's last and greatest collaboration with Morris, her face is everywhere.) He hated the fact that they rarely had time alone together, but he relished those chances that came his way. Once he took her to Hampton Court to see the Mantegnas he loved; an excursion with so aesthetic an intention could easily be justified. Later he recalled that they had had exactly three dinners alone together "in a pot-house" — in other words, in the sort of chophouse where a lady would not usually be seen, which had of course made those meals all the more delicious to him. In warm weather she took him out in her carriage, and he made the most of these jaunts, whispering the endearments he could not so easily speak at home.

Passages in his letters suggest that she had secrets to share with him too, that she also came to him with the urgency of a lover. In an early letter he apologized for his drawing room "that makes you say, 'Oh for God's sake take me out of this, the upstairs room is better.' "[128] The upstairs room was of course his studio, where they could talk in privacy. Nonetheless, in the beginning she was the one who pressed for concealment; he was forever reassuring her that he would not do anything unseemly that would give them away. When she had to go to Rome, where her mother was desperately ill, he wrote to comfort her but also to ask her dispensation to keep on writing: "May I send a letter now and then to you there — wherever it is — two in the week, full of public things — about registration of votes, and bimetallism and depreciation of the rupee — and the possible further lowering of the $2\frac{1}{4}$ percents — and when you come back I shall have done a lot of work and been happy and content all the time."[129]

He lived in terror that his all-consuming love would suffocate her or annoy her or force her to reject him, and he continually made gestures to reassure her and keep her by him. She needn't write often nor at length, he said; a line would do, even just "I am fat and well

and merry hearted."[130] He worried that his age and his ugliness would repulse her. (When they met she was thirty-five and he was fifty-eight.) He lamented, "I wish I wasn't so old for you — O I do so wish it — it's dreadful — and now the thought of that has made me sad and I want to write no more for a bit — it's dreadful for you — I know it is — how merciful you are to me."[131] At the bottom of the letter he drew a fetching little picture of himself as a plump bird hiding its head under its wing.

He feared that she inevitably would be drawn to younger suitors for her affections. "I'll never say a word of blame or reproach if you ever feel that too — and you must soon. Don't you think you shall? You will hide it from me I know and perhaps I shall never find out."[132] However, he never showed any jealousy toward Captain Gaskell; he must have known there was little feeling exchanged between this husband and wife.

Despite Ned's fears, May never did turn away from him. His utter delight in her pleased her; she certainly consented to bask in it. Even so, this obsession must have overwhelmed her at times, and there were periodic confrontations, serious talks about where their passionate alliance was heading. The tenor of Ned's letters makes it clear that she often pressed him to exercise self-control, but it seems as if she came close to breaking with him only once, at least insofar as he was aware. On July 23, 1894, he referred to "that fright" which would have caused him to lose her, adding "to lose your friendship would have killed me."[133]

The pressure on May was intense. Ned was forever reminding her that his happiness, even his very existence, hung by the thread of their relation. If she loved him, life was rich, happy, full; if she did not, he might not survive. Her health was delicate, and he worried incessantly that she might die. "Take care of yourself — constant care — if you die and I am here to see it I suppose grisly black hell will set in for me — and it oughtn't to be so very hard. Now let us be cheerful. For you are a heartrending thing to know."[134] Once he did acknowledge how great a drain on her energy he must be: "How you radiate life — and like a vampire I drink it in."[135] But he did not offer to leave off; as far as he was concerned, to stop meant death, or at best a return to the gray half-life he had lived for so many years before May appeared.

Ned reached a point where he felt that he could not bear living apart from her, nor even tolerate the hypocrisy of hiding his love.

He had been so ill through the winter of 1893 that he was unable to work for six months, and it seemed to him that there was little time left. Not being able to work always brought on depression. He had turned the problem of May over and over, not knowing what to do, guilty at the prospect of breaking Georgie's heart but convinced that he could not live without May. He finally decided to seek advice and turned to his friend and patron Arthur Balfour, the future prime minister.

Whatever Balfour said, he seems to have counseled against any dramatic break, and Ned reined himself in for the moment. That summer was a wretched, topsy-turvy time for him. Georgie was ill, and her sister Alice Kipling, with whom he did not get along, arrived from India and settled in for an indefinite stay at Rottingdean. He hid out in London much of the time, not only to avoid Alice but also because he feared that Georgie would sense his impatience with her sister and be hurt.

In August he learned that *Love Among the Ruins,* a large painting for which Mary Zambaco had modeled many years earlier, had been destroyed in the process of photogravure. Despite a careful warning affixed to the back, the technicians in Paris had washed it with white of egg and smeared it hopelessly, wiping Mary's face entirely away. Ned tried to force himself to be calm — "after all, this isn't to be named by illness of loved ones"[136] — but he seems to have lost his balance completely during this month.

On August 2 he wrote to May that he had made a bonfire of her letters because he feared that they would fall into the wrong hands someday, and he could not bear that prospect. On the fifth he wrote to say that he had not slept the night before, as "all my life scurried past me in an evil panorama — and I have come in scared and troubled to be with you a little. . . . Yes, my life has been too hard and bitter to remember and not be fevered."[137] Guilt and self-pity hopelessly intermingle in this letter. Over the next few days, however, he shed his guilt, suddenly bursting out: "Hadn't I better say I'm going to you — there must be a scene someday — I don't like to hurt — can't bear to hurt, but go to you I must — I think about it every moment — I see all the rooms — and I talk to you all day long."[138]

This letter sparked a confrontation when Ned paid a visit to Beaumont Hall. Painful words were exchanged, but he and May came to a resolution, and from this time forward the balance between them began to shift. A peacefulness crept into his letters. Back at Rotting-

dean for his birthday, Ned wrote: "It's sweet to have a vision of you moving about in that heavenly house."[139] Now he became the one who worried about concealment: "Phil gave me a can to keep your letters in. I only have two. I keep two till another comes, then I destroy them — it always hurts but it is best — write as often to me as you can especially now."

In this same letter, dated August 29, he explained that he had made a decision to stay with Georgie: "I have thought long and hard and there must be no change at all. . . . It is too deep now to be up-rooted — it would pull me up along with it."[140] Having teetered back and forth between extremes all summer, he finally understood that he had to stay put for his own sake. Now he wanted only a contin-uation of the passionate friendship that had grown up between them; at Beaumont he had received some assurance that he could trust May to stick by him. On April 17, 1895, he wrote to May recalling the wild turmoil of that visit to Beaumont as little more than a poignant memory. Then he had wished to die, but "now isn't life beautiful for me? If one can endure and be patient and wait and be humble and submit, not even hope is needful — I had none then — not the least little bit. And heaven's gates seemed tight shut, locked and barred, but I never left sitting at the gate, did I?"[141]

Looking back, he was grateful that this relationship had evolved into something less stormy and dangerous. Just a couple of weeks before he died, he and Thomas Rooke, his studio assistant, fell into a conversation about desire, and Ned commented: "Lust does frighten me, I must say. It looks like such despair — despair of any happiness and search for it in new degradation. . . . I don't know why I've such a dread of lust. Whether it is the fear of what might happen to me if I were to lose all fortitude and sanity and strength of mind — let myself rush downhill without any self-restraint . . ."[142] Glimpsing this prospect, he broke off, unable to travel any further down such an ugly road, even in imagination.

<center>❧❀❧</center>

By this time Ned's health had seriously deteriorated. His hand jerked and twitched sometimes, and his heart palpitations came with in-creasing frequency. He didn't tell Georgie for fear of worrying her, but confided in May. Georgie, however, had already divined what he did not say and instituted a policy of not bringing up emotional subjects for fear of bringing on an attack.

Both Ned and May had gone to great lengths to protect Georgie, but it is impossible that she had no inkling of what was going on. She had spent forty years studying her husband intently; she knew he was living at a great distance from her, indeed from almost everyone but May. But Georgie had learned to bide her time; she had seen the young ladies pass in and out of the studio, and she trusted that in time this one would pass too. Her true feelings will never be known; characteristically, she kept her own counsel. She did not confide in Rosalind Howard. Marian Lewes was dead. Letters to other close friends reveal nothing. If she said anything to any of her sisters, they took her secret to the grave. In her *Memorials of Edward Burne-Jones,* she mentioned "Mrs. H. Gaskell" as a "friend of these later years" and quoted from several of Ned's letters to May, from which we can conclude that she and May were sufficiently friendly for May to have loaned some part of the correspondence to her when she was writing the biography.[143] May was always welcome at the Grange.

Ned's letters to May give a grim reflection of Georgie's life during these years. In one he mused on whether he would go down to Rottingdean or not and decided that he would, because "it will please Georgie, and her pleasures are never many, and dwindle fast nowadays so I won't fail."[144] Perhaps the most telling passage comes in a note scribbled on the train as he and Georgie journeyed home to London in October 1894, after visiting the Gaskells at Beaumont: "Saturday between Crewe and London — wonder if I can write — at least it will help to pass the time — and Georgie is sound asleep, nor have I anything to say to her."[145] It is a sad, cold comment after thirty-four years of marriage. (May marked this letter "wonderful letter after last visit to Beaumont.")

It seems unlikely that Ned and Georgie ever openly discussed his relation with May. By now the habit of reticence was deeply entrenched. Indeed, Georgie's unwillingness to speak had become a great convenience for Ned, and she must have feared what would be revealed to her if she did press. She also knew that his dependence on her ran very deep; he admitted openly that he was terrified that she might die before he did.

Ned made sporadic efforts to cheer Georgie up, on one occasion buying her a pretty hat to replace the plain "Midland Counties Nonconformist hats and bonnets and frocks" she always wore now.[146] He seems to have forgotten the young Georgie who had wept on her honeymoon when her necklace broke, who had labored to sew herself

a splendid blue Chinese silk evening gown, who had appeared at a dinner party "gay in a gorgeous yellow gown." Georgie didn't buy those plain bonnets because she had no taste; she had simply become so discouraged about her attractiveness to her husband that she no longer saw any point in trying to adorn herself. Ned was either too stupid to see it or too ashamed to admit that he knew the truth.

Georgie never complained about Ned, but she did occasionally let herself comment on the unsatisfactoriness of woman's lot — a lot to which she nevertheless tried to content herself. To a friend she wrote: "I have nothing to report of myself. I seem always busy and never seem to have anything to show for it — which I believe ought to be woman's ambition, though I can't say it was mine to begin with. I feel a certain grasp of life though at present which is a sustaining thing. Does it come as one grows older I wonder as compensation for other things lost?"[147] Georgie never stopped reaching for that grasp of life, that understanding of the spirit; as she grew older it became a theme that ran through all her letters.

Despite her disclaimer, she did more than just keep busy. Her political activity increased during these years, in part perhaps to distract herself from what was happening at home. She was in the thick of her effort to transfer ownership of the South London Art Gallery to public authority, and she wore herself out doing the paperwork. When an act was passed in 1892 creating parish councils, for which women could both stand and vote, she decided to run as a candidate in Rottingdean. Ned was enormously proud of her candidacy and wrote to his old mentor Watts: "She is so busy — she is rousing the village — she is marching about — she is going like a flame through the village."[148] She won the election, and then set about campaigning to get the services she felt the village needed most: streetlighting, a fire brigade, water mains, garbage collection, garden allotments, public baths, and a district nurse. When taxpayers balked, she put up the money herself to buy a cottage for the new nurse. Perhaps by insisting on too much change too quickly, she ruffled quite a few feathers and was defeated the following year, but ran again and was re-elected in December 1896, having earned the grudging respect of some of the more hostile village voters.

Describing Ned during these years in her biography, Georgie wrote that he "worked harder than ever . . . patience too enlarged her borders in his mind, and scarcely anything seemed to irritate him, but he was much oftener depressed than he used to be."[149] She may have known the causes of his depression, but she had no intention of

revealing them to the world. She still loved him deeply; no one can read her book and doubt for an instant her devotion to him. A deep tenderness survived between them, although Ned discounted it in his letters to May.

Georgie knew that he saw death coming, and she may have been able to make the last, special allowances for him as he waited. She explained about his *Venus Concordia:* "He called this his 'panic picture', for he said he had suddenly waked up one night and thought what a bore it would be to Phil and Georgie to be left with such a lot of pictures that weren't finished!"[150]

Morris, in dangerously poor health, was their greatest worry. On February 23, 1896, Ned wrote: "No Morris to breakfast."[151] He never came again. On September 1 Morris wrote to Georgie in a feeble hand the briefest of letters: "Come soon. I want a sight of your dear face."[152] By October 3, Ned felt that either he or Georgie must visit their friend every day. Ned forced himself to stay with Morris right to the end, although he admitted how difficult it was: "He got to be such a shadow that he was no more than a glorious head on a crumple of clothes. . . . The strain of watching it was terrible to me sometimes, and I felt that I could hardly bear it. . . . I should have liked to rush off to Venice or somewhere, but of course if I *had* gone away I should have been still more miserable, and had had [sic] to come back again by the first train." At the end he and Georgie were in the house and Ned felt that "he died like a little child."[153]

Ned threw himself into work as the only way of managing his pain; the next day he started and finished two designs for stained glass. The subjects he chose were *David Lamenting the Illness of His Son Absolom* and *David Consoled,* as if he wished to compress all his grief into a single day. Even May faded from his mind; there are no letters to her in the three months following Morris's death.

Georgie and Ned needed each other now, perhaps more than they ever had. Georgie wrote to a friend, "We said to each other directly that it was no weeping matter." She knew what he had lost, but was not sure how close he wanted her to come now in her efforts to console him. "I am taking all the care I can of Edward — feeding as far as he will let me — companioning as far as may be. But his cry now was: 'I am quite alone now, quite, quite.' "[154] Sunday was always a hard day for them both, and it seemed to Ned as if 1897 were a particularly dark winter, with almost no good painting days.

Over the next year they drew very close together. In the winter

of 1898, when Georgie spent six weeks at Bordighera to build up her fragile health, Ned wrote to her every day but hid from her the fact that he had had another bout of influenza. He asked Georgie to write a biography of him — Jack Mackail had been asked to write one of Morris — for he knew that he could trust her to write with the discretion a stranger might not exercise. He still took his greatest comfort from his work. He was racing to finish his enormous painting about the death of King Arthur, and in 1898 he took up the problem of repairing *Love Among the Ruins,* which he had long despaired of. Experiment showed that the cloud left by the eggwhite could be wiped away by means of oxgall, and Ned was able to restore Mary's head.

On the night of June 16, Georgie and Ned were to go see a play that neither was terribly interested in, and they were relieved when it was put off. Georgie remembered: "By the kindness of God we were alone on this last evening: the theatre engagement that hung over our heads had been postponed. We played dominoes on the corner of the dinner table, and as we played he said he was tired and would write to tell Rudyard when he was coming to Rottingdean. I left him at his writing-table, and went into the drawing-room as usual. There a cloud descended upon me, of nameless fear. . . . Alone in my room upstairs, fear came upon me again, still with no warning of the side from which trouble would come. I was not afraid especially for him, nor for myself, but of something, and my sorely-laden spirit found relief in the cry 'Oh God, help us to bear it!' A speaking-tube connected Edward's room with mine, and in the night he called me and I went to him. Full and round as ever was the voice in which he spoke, splendid was his strength and courage against mortal pain; but a stronger than he was there, and the first severe shock of *angina pectoris* took his life."[155]

<center>❧✸❧</center>

There was a memorial service at Westminster Abbey, but Burne-Jones's ashes were interred in a wall of the little church at Rottingdean. Georgie's family watched her fight to resign herself to his death, but she wore mourning clothes for the rest of her life and was never without the pocket watch studded with chrysolites that he had bought her so many years before. She could never bring herself to throw out the plans for the addition to Red House which would have enabled the Morrises and the Burne-Joneses to live together in the Kent coun-

tryside all their days, and she meditated on how differently their lives might have gone if they had been able to achieve this close communion. For Georgie the happiest days were always those early ones, before Ned's affair with Mary rent their life in two.

It was painful for her to go into the studio now and see the canvases stacked up, gathering dust. Many of them were carried off to a death sale at Christie's that realized thirty thousand pounds. In the years that followed, Georgie went to great lengths to make sure that some of her husband's most important pictures would end up in the national collections. She decided to give up the Grange because it was too big for one person; as she was preparing to leave, the first days in the house came back to her: "I remember so well going up and down in it when we first went to live there, and saying to myself, 'What will happen to us in this house?' "[156] Now she made Rottingdean her home. There were plenty of visitors, especially Phil and Margaret and the grandchildren. The Rudyard Kiplings bought a house and settled in across the green. Georgie wrote to a friend: "You can imagine the difference it makes in my life to have them come in every evening, as they do."[157]

Georgie continued her political work. When at the end of the second Boer War the siege of Mafeking was lifted after 217 days, the rest of the village celebrated, but Georgie made a banner and hung it across the front of her house trumpeting the words "WE HAVE KILLED AND ALSO TAKEN POSSESSION."[158] A crowd collected and threatened to turn ugly, but her nephew Rudyard saw what was happening and rushed over to calm them.

Georgie's principal work during the years after Ned died was writing his biography. She went about it in a very professional manner, planning and organizing her research, canvassing friends, patrons, and family for letters and memories, studying her materials, checking dates and reviewing paintings. The result is an eloquent, accurate account of his life as a painter, as a friend, as a son and father; there are even glimpses of their romance and of the many years of marriage they shared. But much is left unsaid. Mary Zambaco is never mentioned by name; the only allusion to the havoc she and Ned had wreaked is the epigraph to the chapter that covers the years of the affair, enigmatic to those who know nothing of Mary: "Heart, thou and I are here, sad and alone."[159] May is described as just a dear friend — and so finally she was. A reader coming to the book without prior knowledge of Ned's or Georgie's life would conclude that they

had a simply rich and happy marriage. The reader who knows something of Mary or May wonders what price Georgie paid in sharing her husband with these women. In all she said little about herself; nonetheless, her readers learn indirectly how blessed Ned was to have a wife so wise, so generous, and so attentive, a mate who committed herself utterly to making his great labor possible.

Writing this book was a deep pleasure for Georgie. For the first time in her life she felt that she had serious work to sustain her, and when she had finished, after six years of unremitting effort, she felt both a sense of accomplishment and a sense of loss. On November 23, 1904, she wrote to Charles Eliot Norton: "I expect that you will understand the profound sadness which accompanies the fulfillment of my purpose, and how much I miss the daily labor at it — and how it seems to me that I have parted with something precious — almost lost it — by sharing it with everyone. I know, however, that it is not so — and that the deepest things of one's soul remain as great to one as before — if it were only for the reason that, try as one will, they cannot come to the surface and be expressed. The six years of steadily directed thought and quiet consideration have been a wonderful thing for me. . . . and often I think I should be a better companion to him for it if he came back."[160]

Georgie's struggles with the difficulties of being a woman and a wife emerged more clearly in these years; it was as if she felt freer to articulate them now that Ned was gone. When her friend Sydney Cockerell told her that he was going to marry a young woman who was a painter, she sent a letter of advice: "I do not imagine either of you will crowd up your life with unnecessary things, and so, as she is gifted, she may be able to be both a good worker and a good wife, which is much harder for her than you may think. . . . never think you have fathomed the depths of the nature of the dearest companion, but *believe* in it always, remembering that of many things it is impossible to speak — so at last one can only say, 'I would tell you if I *could* — nothing is purposely kept from you,' that is as near as one can get, with all one's striving. And it is enough for this life. To everyone this comes differently, but there is a silent freemasonry between those who have entered on it which gives me a tender feeling for all I know. It seems to me *the* Quest."[161]

Here Georgie articulated the faith that runs so clearly through her *Memorials* and makes them such a joy to read. She tells us that for her, marriage had been not a tragedy or a failure but a difficult and

sacred quest — in fact, the single most profound and exciting adventure on which a human being could embark. She acknowledged that her greatest hardship had been the difficulty of communicating her feelings; nonetheless, that silence had protected her and Ned and made it possible for their marriage to continue. Her pride in this "silent freemasonry" makes it clear that despite everything, her love for her husband was intact. We may be tempted to dismiss her pride as a grand illusion, but that is not within our purview. We simply can never know enough to make that judgment, although we are certainly free to brood on the contradictions and dilemmas inherent in this marriage, and to draw from them what wisdom we can. Georgie might have resented our prying, but she would have been glad to hear that others had found something useful in her experience.

She lived twenty-one years after Ned died, long enough to see the Great War and to play with her great-grandchildren. These years were useful, busy ones for her: She was always caring for someone, visiting Jane Morris to cheer her up, taking care of Margaret's brood, nursing her sisters as they lost their husbands and then came to her to die themselves. Georgie remained a center for her family and friends, a source of help, wisdom, and humor. Crom Price, too, came to her in his final illness. When Rudyard Kipling had to go to Canada, he entrusted his nine-year-old son to the tiny aunt who had saved his sanity when he was a boy and his own parents were in India.

World War I was a horror to her: "I feel as if the whole surface of the world at present was being turned over by a pitchfork."[162] Once it was finally over, she turned to her great-grandchildren, admitting to a friend: "I did not think it was possible to know such a fresh wellspring of love as they have opened to me."[163] She still thought of Morris every day and kept up a little conversation with him in her head. On March 20, 1918, for instance, she was reading Chaucer aloud and imagining that she could hear Morris laughing at her mistakes.

In January 1920 Georgie took rooms at 55 Holland Road to be near Margaret for the rest of the winter. She caught a chill that turned into bronchitis, and on February 2 sank quietly into death. Georgie had never been afraid to die, for as she had explained so casually in a letter to Sydney Cockerell a couple of years earlier: "I wish, by the way, that I knew who separated Time from eternity; there only seems one thing to me, and I always feel that I *am* in eternity."[164]

Seven

# PROSERPINE

ON A WARM EVENING in Oxford in the summer of 1857, Gabriel Rossetti, who loved this kind of silliness, asked Ned Burne-Jones to join him at a performance of the musical comedy *Ben Bolt*. There was no proper theater in Oxford at the time, so when the Drury Lane troupe came up from London each summer, they had to build a makeshift stage in a run-down gymnasium in Oriel Street. From the pit, which smelled of sweat and old socks, Gabriel surveyed the crowd in the cheap seats of the gallery. There he spotted two beautiful young girls. He couldn't tear his gaze from the more mysterious of the pair. Tall and elegant in her bearing, she had a luminous pallor that was heightened by her abundant, thick, tightly waved black hair. Imagining how he would paint her, Gabriel struggled to get the color of her skin right in his mind; later, after a dozen years' observation, he named it "dark pearl." With her sloe eyes set off by high, steeply angled cheekbones, she looked Greek, or perhaps gypsy. Features that should have spelled ugliness — a perilously long jaw, a large mouth, and a short upper lip — instead worked together to make an extraordinary, unforgettable face. Next to her, her sister's conventionally lovely looks provided a charming, cozy gloss to her weird beauty.

Gabriel alerted Ned, and when the curtain fell they rushed up the aisle to catch the girls before they drifted out and disappeared into the night. Gabriel explained that he and his companion were artists, invited by the university to paint murals in the new Oxford Union, and asked the strange sister if she would consent to come round to their rooms in George Street and model for them. Jane and Bessie

Burden, seventeen and fifteen, didn't know quite what to make of this overture, but Jane agreed to stop by the following day. She never showed up.

But Oxford was a small town, and Ned ran into Jane on the street just a few days later. He struck up a conversation and discovered that her parents objected to her modeling. Unwilling to lose such a prize, he and Gabriel paid a call at the Burden home in St. Helen's Passage, an alley running off Holywell Street. St. Helen's Passage was a wretched place beset by bad drains and the stench of raw sewage rising off rotting garbage heaps.[1] Jane's father, who worked as a groom in a stable, probably never made more than thirty pounds in a year, and in some years considerably less. Whether Jane's parents were swayed by the respectable address of the young men or by the prospect of some very badly needed shillings, they were soon won over — and Gabriel lost no time in laying claim to Jane.[2] He set to work, drawing her face for the enormous Guinevere in his mural. He had intended to use drawings he had made of Lizzie, but Jane caught his fancy, and the drawings of Lizzie were laid aside.

For her part, Jane was intensely curious about this artist, who was unlike anyone she had ever met. His dark olive skin, the bister shadows around his eyes that dramatized his melancholy, the beautifully formed hands that held the pencil and worked over the paper to bring forth a delicate rendering of her face — all this attracted her. Even more appealing was the gentle, caressing manner in which he asked her questions about herself. The sympathy with which he listened and responded was delicious to her, as to so many others. Usually shy, she was surprised to find herself almost garrulous. He wanted to know about her parents, why they had come to Oxford from the countryside in search of work. He asked about her brother, William, who was getting on as a messenger in one of the colleges and hoped to become a scout someday. He asked about Mary Ann, her older sister, who had died of tuberculosis. Most of all he cared to hear about her, savoring every detail, even about the little parish school she had attended, where girls were taught to read and write in the mornings, and to sew and iron in the afternoons, where they scoured a room every Saturday in preparation for the life of domestic service that most of them aspired to. Nothing seemed beneath his attention.*

---

*Jane may already have worked as a domestic by this time. There is no evidence either way, but at her age she would long since have taken a job if one had been offered.

Soon William Morris, a member of Gabriel's cortège in Oxford that summer, asked Jane to model for an oil painting. She agreed, happy to have the extra money and more at ease now that she knew modeling was light and pleasant work. Morris, however, was not as handsome as Gabriel, and nothing like as smooth. In fact he was quite bashful with women and had had little or no romantic experience; instead, he had spent untold hours dreaming and writing long ballads about medieval ladies and the knights who sought to earn their love. At Gabriel's urging, he had just quit the study of architecture for painting, and he felt enormously ignorant and uncomfortable standing before an easel.

Morris's childhood could hardly have been more different from that of Jane Burden. The son of a prosperous bill broker in London, he had grown up in a series of beautiful homes around Walthamstow on the edge of the city. Woodford Hall, the second, was a Georgian mansion with a park of fifty acres that bordered on Epping Forest. There, in the largest hornbeam forest in the world, one of the last wildernesses still unspoiled by urban or industrial incursions, he spent days by himself, riding his pony. Even as a boy he had a gift for extraordinary concentration, and he often sat for an entire day reading in a window seat. By the time he was seven he had read every one of Sir Walter Scott's novels; he was thrilled by their atmosphere of courage and chivalry, and as he rode his pony through the forest he imagined himself a knight on his charger. But his boyhood was no simple idyll. He felt sharp frustration in those early days too, and from the beginning he had a terrible temper, exploding in bursts of fury when his will was checked in a way that seemed to him unfair.

When Morris was twelve, his father died suddenly, and the next year he was sent away from the dreamy world of forest and pony to Marlborough College, a new public school. At Marlborough it seemed as if there was never enough to eat, and the teaching was poor; thrown together in a hurry to cash in on the abundant supply of sons in the affluent new middle class, the school hired masters who were so ill-prepared they failed even to organize the sports. Years later Morris was still bitter: "I learned next to nothing, for indeed next to nothing was taught."[3] He took advantage of the chaos to carve out his own routines, however, spending his time in the library reading about archaeology and church architecture. Out of school hours he explored the surrounding countryside, ranging over the Savernake forest and the downs, examining Roman ruins and stone circles and long bar-

rows. The other boys thought him a bit cracked but sought him out
as a source of endless, intricate, marvelous tales of knights and quests
and ladies and castles, which he spun out over the weeks of the term.

Young Morris created a life for himself that was interesting enough,
but he could not reconcile himself to the loss of home and most of
all to the loss of the companionship of his older sister, Emma. His
letters to her are filled with apologies for his homesickness: "It is now
only 7 weeks to the holidays, there I go again! Just like me! always
harping on the holidays, I am sure you must think me a great fool
to be always thinking about home always, but I really can't help it I
don't think it is my fault for there are such a lot of things I want to
do and say and see."[4]

A year after their father died Emma married a former curate at
Walthamstow and went with him to faraway Derbyshire. Apparently
Morris was never able to assimilate this loss and move beyond it.
Even in his earliest poems and stories a triangle appears again and
again: two men in love with one girl, who chooses one man and
spurns the other. The character with whom Morris identified was
always the rejected lover — not surprising, if this triad arose out of
his relationship with his adored sister.[5]

For his mural in the Oxford Union, Morris returned to this theme,
choosing as his subject "How Sir Palomydes loved La Belle Iseult
with exceeding great love out of measure, and how she loved not
him again but Sir Tristram." Then he portrayed Iseult in his painting,
using Jane as his model. In order to paint Iseult standing before her
richly canopied bed grieving for the absent Tristram, he set up a
background in his room in George Street. Amateur that he was, he
made the mistake of using his own bed as a prop, so for weeks he
had to sleep elsewhere so that the bedclothes could stay rumpled up
in exactly the same pattern as he tried to manipulate the tricky oil
colors. Jane came day after day, and though they sat silent much of
the time, exchanging stilted sentences at long intervals, Morris was
entranced by her beauty and her shyness. Falling swiftly, deeply in
love, he became doubly anxious, for he could not seem to manage
either his paints or his passion.

In an attempt to open up a more comfortable avenue of commu-
nication with this hesitant young girl, he offered to read her Dickens's
historical novel *Barnaby Rudge,* a pastime that would at least let him
spend many more hours in her company. His friends teased him
unmercifully about his droll conception of how to make love to a

stunner — but they failed to see the covert message in this novel. One of the book's young heroes, devastated by his lover's seeming indifference, marches off to fight in the American Revolution, where he loses an arm. Returning just in time to save his girl from rioters, he makes a tender but manly speech in which he offers himself as a friend for life. In the great Dickensian tradition of moral revelation, the young lady sees the error of her coquettish ways and offers him her constant love.[6] Morris, who always feared rejection, must have been trying to tell Jane that underneath his rough, clumsy exterior was a supremely vulnerable man worthy of her love.

In November Gabriel rushed off to Lizzie, who was ill and miserable, leaving his mural unfinished. The band of artists fell apart with the departure of their leader, but Morris hung on, unwilling to leave Jane. He could not get his painting to come right; according to legend, one day in desperation he scrawled on the back of this canvas, "I can't paint you, but I love you." No one knows how Jane responded, but at some point during that winter she agreed to marry him. She must have been nervous; she didn't know her future husband at all well, since his shyness only redoubled hers. However, her family must have been delighted. Morris was a very wealthy young man. At his majority he had inherited shares in copper mines in Devon that brought him an income of nine hundred pounds a year, a handsome sum, and Jane's parents knew that they would never have to fear the workhouse again.

If Jane was nervous, she was also eager. She had never seen London or the sea. As a little girl she had watched longingly as carefree undergraduates guided their punts upstream, not even dreaming that she might one day go on the river herself. Now she had a lover who not only was eager to take her boating but asked her whether she would enjoy a wedding trip on the Continent.

Morris, stunned by his good luck, threw himself into constructing a perfect life for himself and his bride. For him, that meant building a home of dreamlike beauty. Over the next year he bought an orchard of apple and cherry trees on Bexley Heath in Kent and commissioned his friend Philip Webb to design a house on the land. The locale appealed to Morris as suitably medieval; there was a ruined priory nearby, where Chaucer's pilgrims might well have spent a night on their way to Canterbury.

Morris wanted something simpler, more solid and honest than the

gloomy, pretentious villas he saw springing up all around London. He had become almost phobic about the soulless state of contemporary architecture, with its needless complication and shoddy workmanship. Webb gave him what he wanted. Red House, named for its red brick walls and red tile roof, is a massive, simple L-shaped structure.[7] Everything about the house is individual; even the choice of brick was daring at a time when stucco ruled. One fat, square tower nestles in the bend of the L, and a simple brick well on the lawn in the courtyard, with a steeply pitched little roof that echoes the angle of the house's roof, provided water. Today Red House looks like a dream, a fairy castle in a child's story, but the simplicity of its design and the lack of ornament make it quiet, almost austere, rather than sentimental or cute.

Morris wanted to create not just a dwelling but an entire world for the family he hoped to make with Jane, a world not unlike that of the medieval manor house, where the lord of the manor grew all his own vegetables, brewed beer, kept hens for eggs and cows for milk, and churned butter and made cheeses in his dairy. This vision was not as remote for Morris as it is for us; it was little different from the life he had lived as a boy at Woodford Hall.

He entered into every detail of the planning. The site was so carefully selected that scarcely a tree needed to be cut down; eventually it was possible to reach out a bedroom window and pick an apple from the close-hanging boughs. Morris laid out the gardens himself, making sure that there were fresh vegetables and flowers almost the year round. His knowledge of botany and horticulture was a legacy of his days in Epping Forest, when he had returned home full of curiosity and pored over Gerard's *Herbal,* and of the little garden plots that had been assigned to each of the Morris children. At Red House he made four small gardens, each enclosed by a fence covered thickly with roses, all four forming a single large square in the late medieval style. He dreamed that here Jane might reign as a happy Iseult, safe in a cheerful, fruitful little kingdom created by her adoring husband.

What was Jane doing during the year between her engagement and her marriage? Her biographer has speculated that she was being groomed for her new life — moved to respectable rooms in a boarding house and enrolled in a ladies' academy, much as Annie Miller had been.[8] This may well have happened, but there is no actual evidence.

What we do know is that Jane did educate herself. Over the years

she became a careful reader of poetry. Coleridge she found unsatisfying, but she studied Dante's *Vita Nuova* and once said that a much-loved poem "gives little snatches of pleasure in the saddest moments in quite unlooked for ways."[9] She became a devotee of the opera. Morris found it a bore, and in later years Philip Webb, who shared Jane's enthusiasm and liked her not a little, often escorted her to Covent Garden. She asked for a piano, and took lessons after her marriage. Somehow she also learned the manners and decorum necessary to negotiate the complicated social world into which she was being thrown. Perhaps she had no teacher; she may simply have been a close observer, eager for the education that would differentiate her from those she left behind. Many people remarked on her silence, which was bred at least in part by the need to watch intently everything that was happening around her, to figure out the codes and mores of the class into which her marriage moved her.

We also know that once Jane left St. Helen's Passage, she strove to suppress any reference to her origins, a reticence her friends sensed and respected.[10] After her marriage she rarely went back to Oxford and seems never to have invited her family to visit, with the exception of Bessie, who came to live with Jane and Morris after Mr. Burden died. She did not return to Oxford even for her mother's funeral in 1871. She once told Philip Webb that her childhood had not been a happy one, and when Morris's biographer Jack Mackail asked Jane if he could include an engraving of Holywell Street in the book, she refused adamantly — twice. She wanted to bury her past.

<div align="center">❦</div>

April 26, 1859, the Tuesday after Easter, Jane Burden married William Morris at Oxford in the little Norman church of St. Michael's near Carfax. She was nineteen and he was twenty-five. The guests were few: Jane's family, Ned Burne-Jones, and a handful of Morris's other friends. Among the missing were Gabriel Rossetti and all of Morris's family. Gabriel may have been jealous, but more likely he was just inattentive; he missed many weddings over the years. And perhaps Jane and Morris felt that it would be awkward for the two families to meet. Morris's mother was at odds with her mercurial son. She had dreamed that he would become a bishop, but instead he had spurned religion for art and taken up with a crowd of scruffy, willful painters in slouch hats. She may also have been shocked by his choice of a bride, but after the marriage she took an affectionate interest in Jane, and included her in holidays and family plans.

The newlyweds left for Dover, where they embarked on a six-week tour of the Continent. Returned to London, they set up house-keeping in furnished rooms at 41 Great Ormond Street, Bloomsbury, just a few blocks from Ned, while they waited for Red House to be built. One evening Ned brought his diminutive Georgie around to meet the majestic Jane, hoping that they would become friends. As an old woman, Georgie wrote of that first meeting: "Never shall I forget it — literally I dreamed of her again in the night."[11]

Georgie was only one of many who were struck by the power of Jane's appearance. The painter Graham Robertson, who did not meet Jane until her hair was graying, left us some wonderful clues to the nature of that power. Recalling her "lofty stature," her "long sweep of limb" and "neck like a tower," her "night-dark tresses" and "eyes of mystery," he explained that "Mrs. Morris required to be seen to be believed, and even then she seemed dreamlike. . . . Hers is one of the few World Faces, unique, yet each representative of a great type of which it is the supreme summary: for the moment I can only recall the Sphinx, [Mona] Lisa Gherardini and Napoleon, but to the list, however short, must certainly be added the name of Jane Morris."[12] Writing in the 1920s, Robertson was drawing on Jung's theory of archetypes, the images that Jung believed bring us messages from the unconscious. Such archetypes wield a power over which we have no control, a power beyond ordinary time and space and one that we ignore at our peril. Because of her beauty, Jane wielded such enormous power, which in time proved a burden to her as well as a threat to others.

For the moment the newlyweds seemed carefree. Possessed of wealth, beauty, and zest for life, they immersed themselves in the happy tasks of furnishing and decorating their magical house. To their delight, they discovered that they shared an interest in needlework. At college Morris had grown curious about embroidery and had taught himself by studying old pieces he bought. He had had a frame made and had sought out an old French artisan to dye him wools in beautiful colors he could not find commercially. He was a fine teacher, and eagerly demonstrated for his wife all that he had worked out.

Jane's happiness in the first days of her marriage shines through in her description of their collaboration: "The first stuff I got to embroider on was a piece of indigo-dyed blue serge I found by chance in a London shop. . . . I took it home and he was delighted with it and set to work at once designing flowers. These we worked in bright color in a simple rough way. The work went quickly and when

finished we covered the walls of the bedroom at Red House to our great joy."[13] They did not stop there; thousands more hours were devoted to reviving the exquisite, difficult art of embroidery: "Afterwards we studied old pieces and by unpicking etc. we learnt much, but it was uphill work, fascinating but only carried through by his enormous energy and perseverance."[14] Jane was justly proud of her husband's prodigious discipline and patience, but she passed off her own painstaking labor as if it were nothing.

By the summer of 1860 Red House was ready for them. Webb had even designed furniture, including a huge oak dining table. Wedding gifts made by friends were installed in places of honor. Ned had decorated a wardrobe with scenes from Chaucer's "Prioress's Tale," and Lizzie had painted a jewel casket for Jane.

The whole house was set up to receive friends, right down to the wine cellar, which was stocked with fine vintages. At the weekend guests tumbled out of the train, grateful for a chance to leave their city niches behind and spend a couple of days relaxing in the luxury of the Morrises' hospitality. The Burne-Joneses came almost every week, and the Rossettis were regulars, as were the Browns, Webb, and Charley Faulkner, an old friend from Morris's Oxford days.

If he was in town on business, Morris would meet Ned and Georgie at the train station in London, and the three of them would journey down to Abbey Wood Station together, where they were greeted by the stableman with the wagonette that would carry them the last three miles of their journey. This eccentrically decorated vehicle, resembling an old market cart, had been lined with cheery chintz hangings and emblazoned on the back with the Morris coat of arms. Its rich and romantic young owners were the subject of much amused speculation in the neighborhood, because they had spent so much money to build such a queer house and their carriage looked like the advance guard of a traveling show.

Standing in the porch, dressed in a simple serge gown with flowered collar and cuffs that Morris had designed and she had embroidered, Jane waited to make her guests welcome. She and Georgie quickly became good friends, just as their husbands had hoped. The business of the weekend was the decoration of Red House, and everyone joined in the work. Jane and Georgie painted tiles for the fireplace. The plaster walls begged for pictures. Ned planned to fill the drawing room with seven murals that told the story of Sir Degrevaunt, a favorite of theirs, but he only painted three of the series.

Morris and Jane had already painted patterns onto the ceiling of the drawing room, pricking the designs into the plaster to make them easier to repaint when they faded. Morris added a band of decoration below Ned's murals, with bushy trees and parrots and scrolls that he intended to inscribe with the motto he had chosen for himself: "If I can." Catching sight of those temptingly blank scrolls, Gabriel couldn't resist, and while Morris was away from the room he quickly began to fill them in, one after the other: "As I can't, As I can't, As I can't." When Morris got a look at the inscriptions, he flew into a rage, shouting and cursing at Gabriel, who gleefully cursed right back.

When work was put by in the late afternoon, the men assembled on the lawn to bowl on the green Morris had laid out, and the women sat in the shade and talked as twilight came on. Just before dinner Morris went down into his cellar and chose the vintages. Dinner was a long, delicious, leisurely meal, with good talk, good food, and a lot of silliness to salt the occasion.

Morris's friends loved to bait him. He tended to know more than any of them about almost everything, and it was considered great sport to catch him out. Georgie noted how Ned and Charley Faulkner enjoyed sending Morris to Coventry "for some slight cause and [refused] to exchange a word with him at his own table: it was carried on with an unflinching audacity that I cannot hope to describe, and occasionally reached the height of their asking Mrs. Morris if she would be good enough to communicate with her husband for them and tell him anything they wished to say — but a stranger coming in upon our merriment would never have guessed from the faces of the company who were the teasers and who the teased."[15] Jane loved their mischief, and Ned remembered her laughing "until, like Guinevere, she fell under the table."[16] Sitting at the head of his table, surrounded by dear friends in this house he had plucked from his private dream of the medieval past, Morris must have looked at his beautiful, laughing young wife, and imagined that he was truly living that dream, sharing bed and board with the enchanted maiden he had rescued from an unlovely life in a dirty alley. Ned made a drawing in red chalk of Jane standing behind her husband in her long medieval dress, wrapping her arms affectionately around his neck.

After dinner there were games and music in the drawing room. Hide-and-seek was a great favorite, as Georgie remembered: "I see that Edward, leaving the door open behind him, has slipped into an unlighted room and disappeared into its black depths for so long that

Mrs. Morris, who is the seeker, grows almost terrified. I see her tall figure and her beautiful face as she creeps slowly nearer and nearer to the room where she feels sure he must be, and at last I hear her startled cry and his peal of laughter as he bursts from his hiding place."[17]

❧❦❧

Jane, Lizzie, and Georgie became pregnant within the same year: Jane was the first, and her pregnancy appears to have been relatively easy and uneventful. She was already expecting when she moved into Red House with her husband, and all accounts of those first few months describe her participating fully and happily in the life there, painting the ceiling, fussing over her guests, flying around the countryside with Georgie in the comic little wagon.

Emma Brown, who had safely delivered three children and was pregnant once again, offered to come down to help Jane with the birth, which also seems to have gone smoothly. Jane Alice was born on January 17, 1861. The next day Morris wrote to Brown with that air of assumed casualness so characteristic of extravagantly proud first-time fathers: "My dear Brown, Kid having appeared, Mrs. Brown kindly says she will stay till Monday, when you are to come to fetch her, please. I send a list of trains in evening to Abbey Wood met by bus, viz., from London Bridge, 2.20 p.m., 4.20 p.m., 6.0 p.m., and 7.15 p.m. Janey and kid (girl) are both very well."[18]

Jenny, as she was called to distinguish her from her mother, was an easy, cheerful baby who was cared for by an excellent nurse, recommended by Morris's mother. All that Jane had to do was to enjoy the child, which she did, spending lots of time with her, disciplining her, and joining in her games. Motherhood gave Jane great satisfaction and seems to have come to her quite naturally. Nonetheless, she was dismayed to discover just five months after Jenny's birth that she was pregnant again. She and Morris wanted more children, but her body was still healing from the first birth.

The Morrises' second daughter, born on March 25, 1862, was named Mary but always called May. Because they were so close in age, Jenny and May were raised almost as twins. Friends thought of them as inseparable; they even received notes addressed to Jennian-may. Their parents were devoted to them, and later they both remembered a singularly happy, unclouded childhood.

Much as Jane loved her girls, however, she was determined not to

have a child every fourteen months. Her health began to fail early in her marriage, and although we have little information about her symptoms, she was more and more often too tired to enjoy life. Friends described her as too ill to join in, to attend a dinner party, or even to get up from the couch. The happy young woman who had waited eagerly in the porch was increasingly found laid up in bed. Her retreat to the sickroom may have been a means of evading marital relations, because some strain had arisen between her and her husband. The nature of their problems is hidden from us, but her first joy in their life together was marred.

<hr/>

When Jenny was on the way, the dividends from Morris's copper shares started to decline at an alarming rate, and he realized that he would have to figure out another way to make money. He had spent nearly four thousand pounds in creating Red House, which had seriously depleted his reserves. Painting was not going to be his career. It did not come naturally to him; his wild nervous energy made it hard for him to stand in front of an easel for hours at a time, and his difficulty with figure drawing made him irritable because frustrated. Working in the garden to try to get some apple blossoms down on canvas, he wore a hole in the grass by grinding his chair into the ground.

Furnishing Red House had given Morris a valuable clue to where his true genius lay. Disgusted with the hideousness of all things modern, he had discovered that he had to make everything anew. As Mackail wrote: "Only in a few isolated cases — such as Persian carpets, and blue china or delft for vessels of household use — was there anything then to be bought ready-made that Morris could be content with in his own house. Not a chair, or table, or bed; not a cloth or paper hanging for the walls; nor tiles to line fireplaces or passages; not a curtain or candlestick; nor a jug to hold wine or a glass to drink it out of, but had to be reinvented, one might almost say, to escape the flat ugliness of the current article."[19] This process thrilled Morris; designing and making a curtain or a candlestick that was simple, beautiful, and functional gave him a tangible sense of the usefulness of art that painting never had.

Out of excited discussions with Brown, Burne-Jones, and Rossetti grew the idea of a collective enterprise in which they would all contribute designs and share profits. They imagined that such a wealth

of talent in concert could change the history of decoration and design, and, grandiose as the notion sounds, they weren't entirely wrong. In partnership with Philip Webb, Charley Faulkner, and a friend of Brown's named Peter Paul Marshall, a skilled amateur painter who was probably invited to contribute his business skill, they created a firm. It was registered in April 1861, just three months after Jenny was born, as Morris, Marshall, Faulkner & Company, and it was capitalized on one of the shortest shoestrings in the history of commerce. On April 1 each partner paid in one pound for his share, and Morris's mother gave the group an unsecured loan for one hundred pounds. In January of the following year a further call of nineteen pounds a share was made on the partners.

The prospectus that they wrote and distributed dismissed the history of decoration in England as "crude and fragmentary." The undersigned company of artists, "having for many years been deeply attached to the study of the Decorative Arts of all times and countries," now planned to rescue English decoration by offering a complete range of integrated design: to include everything from murals for homes, churches, or public buildings, to carving for architecture, to stained glass, to metalwork of all kinds, to jewelry, furniture, embroidery, and even stamped leather.[20] Over time the range of beautiful objects they created went even beyond this ambitious list.

Space for manufacture and display was rented at 8 Red Lion Square. Morris was named general manager and allotted a salary of £150 a year; shortly afterward Faulkner was named business manager at the same rate of pay. Each artist was to be paid a fee for every design commissioned by the firm and would receive a share of the profits at the end of each year. A dozen workers were hired from surrounding neighborhoods.

The company's first large commissions grew out of Morris's architectural connections. The architect G. F. Bodley asked them to decorate two churches he was designing, St. Martin's in Scarborough and St. Michael's in Brighton. Ned, Gabriel, and Morris designed windows, and Morris chose the glass, a task that became his alone when it was discovered that he had a special gift for color. In no time family and friends were eagerly pitching in to help out. Jane, her sister Bessie, and Georgie Burne-Jones embroidered altar cloths and vestments; Georgie and Faulkner's sister Kate painted tiles.

The new company was a serious undertaking, since all concerned had a keen need for cash, but it was also a lark. Faulkner wrote to

Ned's friend Crom, who had gone to St. Petersburg as a tutor, about the meetings they held every Wednesday to discuss their affairs: "Beginning at 8 or 9 p.m. they open with the relation of anecdotes which have been culled by members of the firm since the last meeting — this store being exhausted, Topsy [Morris] and Brown will perhaps discuss the relative merits of the art of the thirteenth and fifteenth century, and then perhaps after a few more anecdotes business matters will come up about 10 or 11 o'clock and be furiously discussed till 12, 1, or 2."[21] Out of such evenings the group forged a determination to embody in their work the medieval ideals and fine handcraftsmanship that they esteemed. They also believed that if they could take joy in the creation of objects, those objects would be beautiful. If they achieved this goal, they would be able to present their culture with an alternative to the mechanical manufacture of rubbish. "Shoddy" had become Morris's mortal enemy, and he began to wage a lifelong battle against it.

One of their biggest problems at the start was that Morris had no flair for business. His concern was the quality of the work, and he drove a series of business managers almost mad by pitching out goods that did not meet his standards, tossing away profits at the same time. Years passed before a system for costing was firmly in place, and in the meantime the life of the company hung in the balance. In the early years the ink ran red at the end of the year at least twice. Nor did Morris have any knack for sales; it was no doubt hard for him, the privileged son of a wealthy man, to think of himself as a shopkeeper.

Val Prinsep dragged William Thackeray's daughter to the premises in Red Lion Square, and she captured perfectly Morris's haphazard approach to the customer at this period: "We came into an empty ground floor room, and Val Prinsep called 'Topsy' very loud, and someone came from above with hair on end and in a nonchalant way began to show one or two of his curious, and to my uninitiated soul, bewildering treasures. I think Morris said the glasses would stand firm when he put them on the table. I bought two tumblers of which Val Prinsep praised the shape. He and Val wrapped them up in paper, and I came away very much amused and interested, with a general impression of sympathetic shyness and shadows and dim green glass."[22]

Trying to learn how to be a businessman, manage his company, make designs, and put in place a number of different sorts of manufacture caused Morris intense physical and nervous strain. He thrived

on the challenge, but it left him severely drained. In addition, commuting between Red House and London ate up as much as two hours in each direction. In the autumn of 1864 he was felled by a dangerous attack of rheumatic fever. When he learned that the Burne-Joneses would not be able to move into Red House as they had planned, he broke down and cried.

Morris had to face the fact that he was spending a thousand pounds a year when his income was half that. To stave off disaster, he took emergency measures and sold some paintings and illuminated manuscripts. Furthermore, his perfect house had a perilous flaw: It was desperately cold in winter, and the doctor warned him against staying there in his frail state of health. Morris saw that he would have to move his family back to London if he wanted to make a go of the business and keep himself, his wife, and his children in any sort of security.

The firm had quickly outgrown the rooms at Red Lion Square, so he searched out a new building in Queen Square where he could set up larger workshops and house his family at the same time. For just £52 10s 6d a year he leased enough space to hold a store, a factory, and a home. The move proved good for business; in the next year, 1866, Morris, Marshall, Faulkner & Company was invited to decorate the Armoury and the Tapestry Room at St. James's Palace.

Both the Morrises were deeply saddened to leave their dream house behind for rooms above a shop in a grubby, sooty London square. Morris sold Red House outright and never went back to look at it; he could not bear to. The loss was not merely aesthetic. Jane was beginning to pull away from him. She was no longer a laughing girl at the other end of the table, but a tense, unsatisfied young woman whom he could not seem to please. Living close to each other day by day, they had not found it possible to sustain the high expectations they had both brought to the marriage: Jane had proved less romantic then Iseult; Morris, with his gusts of temper, was no Prince Charming; and now they had lost their castle.

The Morrises started out in their new home by hosting a weekly dinner for all those friends who had come down to the country on the weekends, but the strain proved too much for Jane, and the custom soon lapsed. The Burne-Joneses' house became the focus for hospitality in their circle, and Jane continued her retreat into invalidism. The dream Morris had tried to build was proving immaterial, as

dreams so often do, and all that remained to him were painful, fleeting images of the few pleasant years at Red House.

⁘⁙⁘

While Morris and Jane were grappling with their difficulties, Gabriel had been attempting to build a life for himself without Lizzie, who had died in 1862. A few weeks after her death he found a grand, gloomy mansion in Cheyne Walk, on the river, that captured his fancy, and by October he had moved into it. Swinburne, the novelist George Meredith, and Gabriel's brother William each agreed to pay a portion of the rent and share the house with him, but Gabriel was always lord and master. William slept there only on Mondays, Tuesdays, and Fridays, spending the rest of the week across town at home with his mother and sisters. Meredith proved a morose companion, and Swinburne set the others' teeth on edge with his penchant for orgiastic fitness routines, which culminated in a fast, naked slide down the main banister. The experiment did not work out. Meredith left in a huff, reportedly after Gabriel threw a cup of tea in his face during an argument at breakfast. Swinburne lasted a bit longer, but soon retreated to his parents' house.

As a means of distracting himself from the guilty thoughts of Lizzie that flooded his mind, Gabriel poured himself into decorating his new home, an enormous undertaking because of its size. He spent countless hours prowling antique stores and junk shops all over London, sometimes disguising himself in rags so as to strike a better bargain. He started his collection of precious blue-and-white Chinese porcelain, which he used at table, heedless of breakage. He ordered heavy velvet curtains, which shut out the light, and the dark paneled walls and staircases and the heavily carved Renaissance furniture he favored contributed to the brooding atmosphere. His bedroom was a cave; the dark mohair curtains covering the deeply recessed windows were never opened. He persuaded his mother to let him have the four-poster bed in which he had been born, and he hung it with seventeenth-century crewel bed-curtains that inexorably gathered dust.

The big, wild garden, almost an acre, was a more cheerful place, filled with plane trees and lime trees and an enormous mulberry tree that shed purple berries that stained everything. There were also fig and cherry trees, jasmine, roses and marigolds, thistles, Solomon's seal, daisies, blue iris, rhubarb, and weeds, weeds everywhere. Gabriel loved to entertain here in warm weather, and in the summer of 1863

he invited a photographer to come and take pictures of Jane Morris. Gabriel choreographed the session, directing Jane to sit this way, then that, to hold her hand against her face, to turn away from the camera. The results were extraordinary.

Into this urban jungle Gabriel brought a menagerie of animals, over the years building up a private zoo. At various times he owned peacocks, deer, armadillos, kangaroos, a wombat, a wallaby, three kinds of owls, a parakeet, a raven, pigeons, jackdaws, rabbits, a raccoon, hedgehogs, a woodchuck, mice, a mole, salamanders, squirrels, and various dogs, including an Irish wolfhound and the Pomeranian that he and Lizzie had acquired on their honeymoon and named Punch. Many of these creatures were given the run of the house as well as the garden, despite the fact that none of them were housebroken. Gabriel's favorite, the wombat, was even allowed to sleep on the table during dinner. When the wombat came to an untimely end, he had it stuffed and displayed it prominently in the entrance hall; he also designed a comic funeral card, which showed a fat little figure, unmistakably himself, weeping into a large handkerchief and kneeling by a huge dead wombat, stretched out on its back with its tiny paws curled.

The carnage his pets caused was at times quite startling, but Gabriel seemed to relish the bloodshed, remarking on one occasion: "Fancy, I had the loveliest little owl, a delightful ball of feathers, and my raven bit its head off. I had that devil executed."[23] At times their antics tried even his patience, though. When an armadillo went on a rampage, slaying chickens and pigeons, Gabriel got so angry that he fed it prussic acid. The beast confounded him by thriving on a diet of poison.

In order to pay for his lavish establishment, Gabriel had to work in earnest. A large sitting room that he fitted up as a studio was the envy of all his friends for its superb north light and great comfort. Twenty by thirty feet, it was lined with bookshelves and sofas that invited one to stretch out. Here he brought Fanny Cornforth and a host of others to pose for a series of large works in oil that proved very lucrative. He invited Annie Miller to model and painted her as a glorious, tempting Helen of Troy. He had finally hit on a formula that appealed to many wealthy patrons: On canvas after canvas he painted a single, large, erotic figure. These were the paintings that caused one critic to sniff that he was the "finest animal painter in England," a shot that stung.[24] But for the first time in his life Gabriel began to command the kind of prices he had always longed to charge.

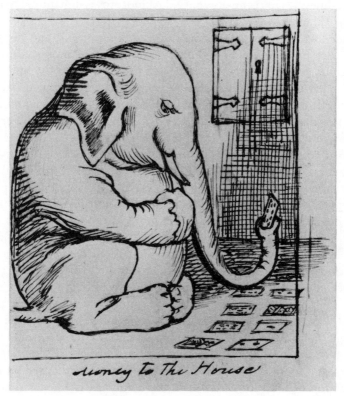

Dante Gabriel Rossetti • *Money to the House*

In April 1863, fourteen months after Lizzie's death, Fanny moved into Cheyne Walk, ostensibly as Gabriel's houskeeper. In fact her real contribution was made in his womblike bed, where she gave Gabriel the comfort, pleasure, and reassurance he desperately needed. If we had only the paintings to look at, we would imagine Fanny to have been a soulless courtesan, mindlessly sexual, appealing to some men, repellent to most women. But Gabriel's letters to her show another, far gentler side of the woman and of their relationship. They are filled with childlike jokes and endearments and domestic trivia. Her nickname was Elephant, earned for her growing girth, and he, expanding likewise, was Rhinoceros. These intimate little notes start out "Hullo Elephant" or "dear old Fan," and are sprinkled with silly little drawings of elephants at play. Most often he just wanted her company, and he could ask for it plaintively; with Fanny he felt free to show

his neediness: "Do come down. Old Rhinoceros is unhappy. Do come to old Rhinoceros."[25]

Fanny was not Gabriel's muse; she was his friend and his lover who stuck by him in the good times and the bad. Although she could be jealous and possessive, he respected her for her loyalty and loved her for loving him. When she grew truly fat, he stopped painting her, but he did not slough her off because she was no longer a stunner. He knew that her feelings were deeply hurt because he no longer used her as a model, and he did his best to cushion the blow.

It is hard to get glimpses of their life together because Fanny was relegated to that nether world occupied by mistresses, who could not be introduced to one's mother or sister. But it is painfully apparent that many of Gabriel's friends found Fanny appalling; her working-class manners and speech made the more fastidious among them ill at ease. William Allingham described a scene with Fanny and Gabriel in Cheyne Walk where Gabriel carried on about the color of Fanny's lips, tracing their outline with his finger as he explained: "Her lips, you see, are just the red a woman's lips always should be — not really red at all, but with the bluish pink bloom that you find in a rose petal." Fanny, embarrassed by all this attention to her body, rejoined, "Oh go along Rissetty!"[26] Something of a prig, Allingham was probably made uncomfortable by the attention Gabriel had drawn to the color and texture of Fanny's anatomy, but what he focused on in his recounting of the moment was Fanny's vulgar Cockney accent.

Some of Gabriel's friends distrusted her because they believed that she stole money and paintings from him.[27] During these years Gabriel had no bank account of his own but kept all his money at home in an unlocked drawer. Money slipped through his hands like water, and the household accounts were outrageously high. His servants stole him blind, and Fanny probably also took freely from the cash drawer. What Gabriel's friends could not see was that he truly did not mind. If he had ever put Fanny on salary as his housekeeper, her behavior might have been culpable, but he never did. He preferred to leave the arrangement casual; she was his lover, not his employee. He gave her paintings and drawings from time to time, first as keepsakes, later to sell so that she could support herself in comfort. He understood that as a woman she was singularly vulnerable. When he grew sick and feared he might die, he tried to put together money to buy Fanny a house so that she would have some security after his death. He felt she was his responsibility, even if his friends and his

brother could not credit it. In a letter he told her: "You are the only person whom it is my duty to provide for, and you may be sure I should do my utmost as long as there was a breath in my body or a penny in my purse."[28]

At first it appeared that Gabriel had begun to recover from Lizzie's death. He was working long hours almost every day, something he had never been able to do before. At Cheyne Walk he had made himself a home, and he entertained regularly, bringing artist friends and patrons together. The parties were gay, but an undercurrent of melancholy lingered. When the Millaises came to dinner and Effie complimented Lizzie's artwork, which was hung in the drawing room, Gabriel told her, "You see, if I didn't find traces of her all over the house I should surely die."[29]

His newfound equilibrium did not last. Indeed, the edges began to unravel very quickly. To Brown, Gabriel wrote on July 6, 1864: "I think it would be better not to bring Tennyson here just now. . . . I have no finished work to show at present, and have moreover so fallen out of the habit of seeing any but intimates, that I feel like a fool with others."[30] His world had begun to narrow; first he eliminated acquaintances, then he began to weed out close friends who committed any minor offense. Millais called twice, and was turned away both times. Eventually only a handful of friends were allowed to cross Gabriel's threshold.

Financial success had done nothing to quiet his fears of rejection and criticism, and he continued his self-destructive policy of refusing to exhibit. To his friend Frederic Shields he offered the following hollow rationalization: "I have adhered to my plan of non-exhibition because I think it is well to adopt early a plan of life and not lose time afterwards in giving second thoughts to it."[31]

In 1868 Gabriel wrote to Allingham in confidence that he suffered from "confusion in my head" and problems with his vision.[32] Since he feared that any hint of illness, physical or mental, might undermine his patrons' faith in his ability to carry out commissions, he begged Allingham to keep silent on the subject. He was already cranking out replicas instead of starting new subjects, and not only because he needed the money; his flow of inspiration had slowed to a trickle. Even *Beata Beatrix,* which he had painted in memory of Lizzie, was not sacrosanct. This curious figure carries some of the same erotic

kick as Bernini's statue of Saint Theresa in ecstasy, and so it was extremely popular with those patrons who liked their fervor draped in the cloak of religion. Over the years Gabriel churned out six copies of this picture. As time went by he left more and more of the work of replication to assistants, a fact that was never mentioned to buyers.

Eager for inspiration, he turned to Jane Morris, whose extraordinary face had haunted him ever since he first saw her sitting in the gallery of the theater at Oxford years before. He began a portrait of her, and on March 6, 1868, he wrote to ask her to come for a sitting. He had been working at this picture off and on for a couple of years, so he knew that Jane was an invalid, plagued by back pain; he suggested that if the trip from Queen Square sounded too arduous, she could come late on Friday for dinner only, no modeling, and sleep at Cheyne Walk in preparation for sitting on Saturday morning.

The finished portrait shows Jane dressed in a sumptuous deep turquoise silk dress (which she sewed herself to Gabriel's direction), resting her arms on a small table and staring pensively into the distance, lost in her own mysterious and melancholy thoughts. Her hands are folded elaborately just under her chin, right at the center of the picture. Gabriel found Jane's hands exquisitely beautiful; he designed this pose to give him the opportunity to show their every curve and hollow to full advantage.

When the picture was completed, it was hung in a place of honor in the drawing room at Queen Square. Gabriel inscribed it with a compliment to Morris, one to Jane, and one to himself: "JANE MORRIS A.D. 1868 painted by D. G. ROSSETTI. Famed by her poet husband and surpassingly famous for her beauty, now let her gain lasting fame by my painting." Vainglorious as his inscription was, it proved true; if Gabriel had not painted Jane again and again, we probably would never have heard of her.

Gabriel was unhappy, lonely, and vulnerable, and he did his best to make himself appealing to Jane in every way. Soon after he began his pursuit, he was courting her small daughters too. On a Thursday in April he sent them a gift accompanied by a winning little note: "Dear Jenny and May, Here come 2 little dormice to live with you — I know you will take great care of them and always give them everything they are fond of — that is, nuts, apples and hard biscuits. If you love them very much I daresay they will get much bigger and fatter and remind you of Papa and me. Your affectionate D. G. Rossetti."[33]

By May Gabriel had four pictures of Jane under way, and she spent much of the summer of 1868 at Cheyne Walk, modeling. Because she was so frail, she often stayed overnight rather than make the trip home by hansom. Gabriel made certain that Fanny was nowhere in evidence during these visits. Sometimes Morris came along; more often he came after work to join them for dinner. Gabriel and Jane were left alone together in his studio for days on end. It is not all that surprising that they fell in love.

<hr/>

For some time Jane had been steadily sealing herself off from her husband. Morris's poetry reveals that he felt her coldness as a profound and shattering rejection:

> But grief meseems is like eternity
> While our hearts ache and far-off seems the rest
> If we are not content that all should die
> That we so fondly once unto us pressed
> Unless our love for folly be confessed
> And we stare back with cold and wondering eyes
> On the burnt rags of our fool's paradise.

The deepest reasons for their estrangement are unknown, as they were silent on matters closest to their hearts. Still, it is possible to infer something about why the marriage broke down.

Jane was only nineteen when she married, with little if any experience of romance. As time passed and she learned more about the world and desire, she saw that she had not fallen in love with her husband but had been dazzled by all that he had to offer her. At the same time she did not see any possibility of leaving the marriage. Divorce was a social disaster for a woman of any class; for a woman from the working class, it might well mean sinking back into poverty. If she chose to leave the marriage in any fashion, even legally, the law would give her husband custody of the children she loved. Morris seemed to hold all the cards. Once she realized how trapped she was, Jane grew angry and resentful.

It has been argued that Morris's violent temper was largely responsible for the couple's estrangement, that it must have been difficult for Jane to live with someone who might put his fist through a door or throw a pot of stew out the window. But these outbursts were tempests of the moment, sudden surges of fury, with no grudge carried. Morris's blowups became a prime family joke; he once wrote

to May: "I suppose Harry has told you how beautifully I kept my temper last night and the night before."[34] Nevertheless, even Mackail, his official biographer, noted that he was sometimes guilty of "almost supernatural rudeness" toward both men and women.[35] Jane may well have felt ignored or neglected by his ability to shut her out and concentrate on his work to the exclusion of anything else.

Morris was, however, also capable of great tenderness and sympathy, and he never stopped loving Jane. He craved her love, and would certainly have made whatever efforts she asked to give their marriage a chance. One of his friends saw that Morris, who was "the Thor of the study and the workshop, where at times thundering was not unknown, was always the tender, devoted, worshiping husband. His attachment to home and family was a passion, not a routine observance."[36]

It was not Morris's anger that ate away at their marriage, but Jane's. Her fury was concealed, in the feminine way, and so outsiders jumped to the conclusion that Morris's visible, blustering temper was responsible. But Jane was infuriated less by Morris's temper than by his fantasies. By marrying her he had tried to seize hold of one of the medieval maidens he had been making up ever since he was a boy riding in Epping Forest. Into her beauty and her shy demeanor he had read grace, charm, uncanny wisdom, and sensitivity. But Jane felt she had proved all too human under the rough-and-tumble conditions of everyday life. She was insecure about her background; she wasn't particularly literate; she couldn't hold up her end with him in an intellectual discussion; she had her cranky days, her unkind moments. Jane dreamed of being as charming, brilliant, and appealing as he deemed her, but feared she would always fall short. The combination of her insecurity and scanty education overwhelmed her, even in the face of Morris's steady love.

Perhaps we can infer more about Jane's feelings about Morris by considering what she got from her attachment to Gabriel. Whereas Morris was often preoccupied, giving his full attention to his fledgling business, Gabriel gave his absolute attention to Jane, who in fact became his work. He told her explicitly that without her he could not make his great paintings. She was the raw material — physical and psychic — on which he depended, and he made her feel as if she were a goddess who ruled over him. From this time on he lived to paint her, to create solitary images of her. Although he used other models, he was careful to make it clear that he used them only for potboilers.

How flattering it must have been to be the object of such sustained, concentrated attention. Who could resist such a seduction? Jane, who felt so uncertain in the world into which marriage had thrown her, suddenly found a safe place where she reigned supreme, a well-lighted room by the river where every movement she made, every plane of her face, every word she uttered was treated as profoundly beautiful. Here she could never fail; indeed nothing was really asked of her. All she had to do was exist, and the fact of her existence was treated as a miracle. There was no pressure to talk; in fact, Gabriel could project his visions more successfully into the silence. William Rossetti understood that in Jane his brother had found an "ideal more entirely responsive than any other to his aspiration in art. It seemed a face created to fire his imagination, and to quicken his powers — a face of arcane and inexhaustible meaning. To realize its features was difficult; to transcend its suggestion, impossible."[37] And when the paintings were done they were praised to the heavens by those whom Gabriel allowed to see them, so that his friends and patrons also reflected back to Jane a sense of her consummate beauty.

From 1868 on Gabriel's strongest paintings show Jane and only Jane: Jane dressed in richly colored gowns, Jane surrounded by bits of greenery, Jane holding a cascade of flowers or a handful of theatrical props required to establish a story line about a goddess or a queen or an ancient beauty. She was his muse, the figure that recalled for him virtually every feminine archetype; in her, he saw femaleness in all its aspects. Over the years he painted her as Guinevere, the Virgin Mary, Mariana, Pandora, Beatrice, Mnemosyne, Proserpine, Astarte, and Desdemona.

Jane's health improved, and she seemed rejuvenated. Years later she said that in the earliest days of their relationship she was very much in love with Gabriel. He was still a prepossessing and appealing figure; despite the anxieties and fears that threatened to overwhelm him, he had not lost his charm or his ambition.

Feeling a great surge of new energy, Gabriel took up the largest canvas he ever attempted, seven feet by ten feet, and repeated in oil his watercolor subject of 1856, *Dante's Dream at the Time of the Death of Beatrice*. The actor Sir Johnston Forbes-Robertson, who posed for the head of Love in this painting, later wrote about the artist as he was in those hopeful days: "Let me try to describe him as I, a boy of 16, remember him at the age of 42. His face was pale, the colour of old

ivory as it were, but it glowed under excitement. His forehead was high-domed and broad, the brown eyes deep-sunk, lambent and sad, with the skin about them of a much darker tone than the rest of his face. His beard was black and slightly forked, and his hair was thick, black and curly. The lips were rather full and red, seen slightly through his mustache, which was not heavy. The face was very handsome, deeply striking, with its calm nobility and impressiveness — one of those rare faces, in short, that once seen are never forgotten. His voice was rich and deep, soft to ear as velvet to the touch. His frame was robust, thick-set and muscular. He stood, I should say, a little under 5 ft. 10 ins. but his whole appearance expressed his powerful personality."[38] (Actually Gabriel stood only five foot six or seven, but the power of his personality caused him to grow in people's minds.)

Gabriel inspired extravagant feeling in many who loved him. His charm was not superficial; his generosity went a long way toward justifying his friends' enthusiasm. For fifteen years he quietly supported a family in Boulogne with whom his father had been friendly. When the Blake scholar Alexander Gilchrist died unexpectedly of scarlet fever, Gabriel spent months helping his widow finish his biography of the poet, working for no salary or fee. Even when he was short of funds, there was always room at Cheyne Walk for a fellow artist in straits. Time and again his letters casually mention that a painter and sometimes his entire family had been in residence for months. When the painter James Smetham had a breakdown, Gabriel wrote dozens of encouraging letters to him, helped to sell his work, and asked friends to rally round. Balanced against his enormous preoccupation with himself was a remarkable capacity for caring.

He was not, however, without a capacity for cruelty. Seizing on Jane's quick response, he began to build a myth to justify their feelings for each other. Before he had even finished the first portrait, he started a narrative picture of her, drawing on the fifth canto of Dante's *Purgatorio* for the story of Pia de' Tolomei, a lady from Siena who was first imprisoned by her villainous husband and then poisoned by him.[39] In *La Pia de' Tolomei,* Gabriel shows Jane's head bowed by sadness, her gaze despairing, her face and body inexpressibly delicate and lovely. She is dressed in a gauzy overblouse whose drapery asks the viewer to imagine the rich, full curves of knee and arm and bosom beneath. Crowned by a ring of verdant fig leaves that suggest a ripe sensuality, she broods on her fate. Her rosary spills over the open pages of her missal, emblematic of her innocence and spirituality.

This painting must be read as the artist's statement about Morris and his treatment of Jane, but it could not have been painted without Jane's confidences and consent. Why did she agree to sit for a picture that was so obviously a slap at her husband? Whether she intended to or not, she must have been using Gabriel as a means of sending Morris a message so ugly that she could not tell it to him in person. By becoming involved with Gabriel she was breaking trust with her marriage, and she probably had to stoke her anger in order to justify her betrayal and the hurt that she would inflict on her husband, and even perhaps on her children.

Gabriel was also cruel to Morris by displaying his feelings for Jane in public. William Bell Scott described Gabriel's behavior at a dinner party he gave in November 1868: "I must say [he] acts like a perfect fool if he wants to conceal his attachment, doing nothing but attend to her, sitting sideways towards her, that sort of thing."[40] One can only imagine Morris's misery and humiliation as he watched his former mentor busily stealing his wife from under his nose.

Countless references in letters and memoirs attest to the fact that as time passed, Gabriel's attentions to Jane became increasingly embarrassing. One evening the literary critic Edmund Gosse was thrilled to observe this deliciously illicit couple at a party at the Browns', where Gabriel, grown "too stout for elegance," sat on a hassock at Jane's feet. Gosse felt that Jane, arrayed in a long ivory velvet dress that set off her raven hair to perfection, sat like an empress on the model's throne, content to be worshiped. Another acquaintance recorded a similar performance: "My most representative recollection of [Gabriel] is of his sitting beside Mrs. Morris, who looked as if she had stepped out of any one of his pictures, both wrapped in motionless silence as of a world where souls have no need of words." At a soirée given by the wife of a prominent solicitor, Gabriel was seen sitting in a secluded corner with Jane, holding a bowl of strawberries and carefully scraping the cream off each one — because, he explained, it was bad for her digestion — before feeding it to her from his spoon.[41] Intent on advertising a passion so sublime it existed in a realm beyond language, both Gabriel and Jane had lost sight of how absurd they might appear to anyone who existed outside their idyll.

Eventually, though, all three members of the triangle began to suffer, each in a characteristic way. Gabriel, emotionally the most precarious, was the first to break. In August 1868 he made a long-delayed trip

to Speke Hall near Liverpool to visit his patron Frederick Leyland, a fabulously wealthy shipowner. Charles Howell had agreed to accompany him because he could not bear to face alone the insufferable dullness of Speke Hall. Here Gabriel experienced his first outbreak of delusions, believing that he had fistula and a ruptured navel. Howell jumped into the breach, hiding Gabriel's true state from the Leylands, to whom the artist owed a great deal of work. By his own account Howell managed to talk Gabriel back to reality, but the fix was only temporary.

From Speke Hall Gabriel journeyed northward alone to visit William Bell Scott and his lover Alice Boyd at Penkill, Alice's ancestral castle in Ayrshire. Gabriel wrote to reassure his mother that he was coming along splendidly, claiming that long walks were giving him a respite from insomnia and that he was happily whiling away the evenings by reading aloud and playing the odd rubber of whist. To Howell he wrote the truth: "Had a bad night again last night. Whirling and flickering and something like approaching apoplexy has become the order of my nights — much worse than when at Speke."[42] Most likely he was suffering from anxiety rather than any physical disorder, but he fastened on his failing eyesight as the cause of his distress. (Over the next year not one but five of the finest doctors in London assured him that his eyestrain was nervous rather than organic in origin.)

Frightening everyone at Penkill, Gabriel announced that if his vision did not improve, he planned to kill himself. In an attempt to redirect his attention, his friends urged him to return to poetry, which even a blind man could write. He took the suggestion to heart and took up a cycle of sonnets about Jane which he called "The House of Life." Despite the devotion of his friends, though, there was to be no miraculous recovery. Scott found that he had to stay up night after night with Gabriel, to keep him company as he drank himself toward sleep with vast quantities of whiskey. In the small hours, after the ladies had retired, Gabriel trotted out the "fearful skeletons in his closet . . . for his relief and my recreation."[43]

Scott did not identify the skeletons, but it takes little imagination to guess that the bones that rattled the loudest were Lizzie's. Falling in love with Jane was such a profound betrayal of her memory that it threatened Gabriel's sanity. To allay his guilt he seemed to strike a bargain with Lizzie and God: If he committed suicide, he would suffer exactly as much as she had. But when he returned to London,

he pulled himself together and hid the full extent of his distress from Jane, not wanting to scare her off.

Morris had the most to lose, but he held up better than Gabriel and Jane. He poured his feelings into his poetry, writing as much as seven hundred lines in one day. He had started a cycle of tales he called *The Earthly Paradise,* a retelling in verse of the great love stories of the world. It was as if he hoped that by going over these stories and making them his own, he might discover some clue as to where his own love story had gone wrong — or even, if he was very lucky, a clue about how his love might be redeemed. He enlisted Ned to illustrate his tales, and the two of them spent dozens of Sunday mornings together in Ned's studio at the Grange discussing the stories, Morris writing and Ned drawing. Sadly, the project never came together, for they had not yet learned the skills they needed to print so complicated a book of pictures. But Ned's drawings furnished him with subjects for painting for the rest of his life, and so the work was not wasted.

Outside the studio all was not so calm. While Morris was confronting the threat to his marriage, Ned's involvement with Mary Zambaco was taking a deeper hold on him. Georgie and Morris found themselves alone together more and more often. Morris was drawn to Georgie, but guilt tied him up in knots, as his love for her conflicted with his love for Ned. He needed them both, but worried that he would have to choose. When Ned's attempt to elope with Mary failed and he collapsed, Morris found himself torn between sympathy and anger, for it pained him to watch Ned hurt Georgie. However, he could not bear to be at odds with his dearest friend, and when he did lose his temper he apologized immediately: "My dearest Ned I am afraid I was crabby last night, but I didn't mean to be, so pray forgive me — we seem to quarrel in speech now sometimes, and sometimes I think you find it hard to stand me, and no great wonder for I am like a hedgehog with nastiness — but again forgive me for I can't on any terms do without you."[44]

We don't know whether Jane sensed that her husband was turning toward Georgie in his despair. If she did, she may have been glad that he was finding comfort, for she was deeply caught up in her own problems; by the spring of 1869 her health had begun to break down alarmingly. She was never one to dilate on her symptoms, and her friends regarded her as a "singularly uncomplaining woman."[45] In fact, a very careful reading of her letters and those of her friends

reveals that she often suffered from crippling back pain, so severe at times that she was forced to lie flat on her back in bed.

With so little information, it is difficult to hazard a guess as to the reason for her affliction. Probably she transformed her anxieties into physical symptoms as so many others of her time did, because it was impossible to express them in any other way. Illness was the most acceptable means of retreating from problems that seemed overwhelming. Her health history reveals too many peaks and valleys; if she had suffered from a progressive organic disease, she would probably have had a concomitant steady decline in health, devoid of the numerous, if often short-lived, periods of relief and recovery that she enjoyed.

In 1869 her doctor was so worried that he ordered her to a spa in Germany to take a cure. The timing was not good, for Morris's business manager was warning him heatedly that if he did not cut his expenditures, the consequences would be dire.* But Jane's health was still his first consideration, so he dropped everything to take her to Bad Ems, where she could drink the waters and take the baths. She was loaded onto the train at Victoria like a piece of spun glass, but by the time they reached Ghent she was strong enough to go see Van Eyck's *Adoration of the Lamb* and to write to Gabriel about her delight in this masterpiece.

It might well have been pressure from Gabriel that caused Jane's back trouble to flare up so dramatically at this moment. He wanted her all to himself, even though it is not at all clear that he ever asked her to leave Morris and come live with him. Facing a dilemma with no possible happy outcome, Jane collapsed, realizing that she could not face the painful scandal that would ensue if she left Morris for Gabriel. By now it must also have been apparent to her that Gabriel's own psychic and physical health was so shaky that he could not be counted on to hold up under any public outcry. Nor was she willing to lose her daughters, whom she loved dearly.

It is possible that Jane engineered this private interlude with her husband, hundreds of miles away from Gabriel, as a means of renewing the marriage, but there is no evidence that such was the case. Morris still loved her, but he does not seem to have fooled himself

---

*Morris was a spendthrift; Jane tended to the other extreme. Even later, when their money problems were over, she still saved almost crazily. After one of her illnesses, Morris had to order her to take a cab from the train station instead of taking the circuitous suburban train journey she had planned to save a few shillings.

about the possibility that she might give up Gabriel, or turn back to him. His depression and sense of uselessness during the weeks at the spa argue that he had given up all hope. In a letter to Charles Eliot Norton he wrote: "I can't but consider my stay here as so many weeks of my life thrown away."[46]

The respite at Bad Ems gave Jane time to think about what she wanted to do with her life; she had literally hundreds of hours for contemplation as she lay in bed there. Her weakness was extreme. One day she would seem a little better; the next she would suffer a setback. The turning point in her cure came when the doctor prescribed a series of shower baths taken with spa water, rich primarily in salt and carbonate of soda. That she found relief in so simple a remedy suggests that Jane's ailment was not disease or dislocation of the spine but rather severe muscle spasms induced by anxiety, guilt, and depression. (The relief that Jane got from her course of showers did not last; curiously she seems to have abandoned them soon after she returned home. She continued to suffer with back pain on and off for many years, although it apparently abated after Morris died.)

A letter Jane wrote to Philip Webb from Ems offers one of the few clues to the meaning her illness held for her: "I have a sort of presentiment (though of course you don't believe in such things) that I may make a rapid turn — and feel myself well all of a sudden — and then I have another presentiment that should this change come — all those I now call my friends would also change — and would not be able to stand me."[47] Jane clung to her identity as an invalid because it offered her a vital shelter. So low was her self-esteem that she believed no one would love her if she were well. Even Gabriel's passionate worship had apparently failed to reassure her that she was worthy of love at all. This sense of her own worthlessness might explain why his attentions were so seductive as to tempt her to disrupt her entire life. Her suspicion that everyone would turn on her should she recover also suggests that Jane felt enormously guilty about her treatment of Morris. If she was not earning sympathy by virtue of her illness, she would have to face the consequences of her actions, which she imagined as dire. As long as she was truly ill, Morris could not abandon her or even chastise her.

During the time Jane was at Bad Ems, Gabriel pursued her with ardent letters. In his first he acknowledged her note of thanks for the

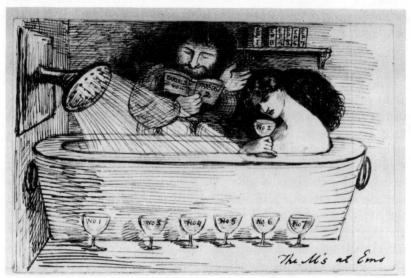

Dante Gabriel Rossetti  •  *The M's at Ems*

two garments he had given her as going-away gifts: "It delights me to know that the cloaks prove of service to you, and that you will be always wearing one of them."[48] His gifts were thoughtful but devious; intended to protect her from the cold and damp, they would also serve to remind Morris constantly of the giver.*

He pined for her, writing: "Absence from your sight is what I have long been used to; and no absence can ever make me so far from you again as your presence did for years. For this long inconceivable change, you know now what my thanks must be." Detecting a note of self-pity in what he had written, he apologized: "I have no right to talk to you in a way that may make you sad on my account when in reality the balance of joy and sorrow is now so much more in my favour than it has been . . . for years past."[49]

His jealousy of Morris betrayed itself in the savagely funny cartoons he sent to amuse Jane. In one, a lugubrious Jane sits naked in a bathtub

---

*In fact Morris did not begrudge Jane Gabriel's affection at this juncture. On August 9, when she felt too weak to write, he undertook to send Gabriel a note reassuring him that she was in no danger.

while a massive showerhead sprays the healing waters over her. Six numbered goblets are ranged on the floor in front of the tub; a seventh rests in Jane's hand. Number 1 is empty; Jane holds number 2, preparing to force its contents down; numbers 3 through 7 await her, full to the brim. In the background Morris is happily reading aloud volume two of his *Earthly Paradise* for Jane's entertainment, but apparently boring her to tears. Volumes one and three through seven are ranged behind him on a little bookshelf — ordeals awaiting the long-suffering wife.

On August 14 Gabriel went too far, though, when he sent Jane a drawing of a tiny, naked Morris trapped in a glass of spa water, pounding ferociously to be let out, plump breasts resting on a comically protruding belly. The joke was supposed to be that if Morris were truly grateful for Jane's recovery, he would show his "thanksgiving frame of mind by that act which is next to godliness."[50] (Morris was notoriously casual about dirt.) In his next letter, responding to a reproof from Jane, Gabriel made a half-serious apology for the "too naked truth of my last historical portrait."[51]

Gabriel had returned to Penkill for another holiday. Here he retreated to the lovely cool little cave he had discovered on one of his walks, where he tried to write new poems to fill out a projected volume. He described this nook to Jane as "the very place for Topsy to spin endless poetry in, and for you to sit in and listen to the curious urgent whisper of the stream." Jealous of Morris for spinning out thousands of lines of poetry seemingly without effort, he mocked himself for working "on what may be called the flea-bite principle."[52]

On this visit he produced one of the most frankly sexual sonnets written by a Victorian poet. At first he called it "Placata Venere," or "Venus Appeased," but later, to protect Jane's reputation, he changed the title to "Nuptial Sleep":

> At length their long kiss severed, with sweet smart:
>     And as the last slow sudden drops are shed
>     From sparkling eaves when all the storm has fled,
> So singly flagged the pulses of each heart.
> Their bosoms sundered, with the opening start
>     Of married flowers to either side outspread
>     From the knit stem; yet still their mouths, burnt red,
> Fawned on each other where they lay apart.

Sleep sank them lower than the tide of dreams,
   And their dreams watched them sink, and slid away.
Slowly their souls swam up again, through gleams
   Of watered light and dull drowned waifs of day;
Till from some wonder of new woods and streams
   He woke, and wondered more: for there she lay.

The confident sensuality in these lines is perplexing, for within days of their composition, Gabriel fell apart again, apparently because of his guilt about Lizzie. Perhaps the very ease with which he had been able to summon the delicious, traitorous memories that had inspired the verse triggered a dangerous wave of remorse.

He had, however, another good reason for feeling guilty. Before leaving London, he had authorized Charles Howell to arrange for the exhumation of Lizzie's coffin so that it could be opened and the notebook containing fair copies of all his early poems could be retrieved. Now he found that he could not forgive himself for this act, and thoughts of suicide returned to plague him. One afternoon Alice Boyd took Scott and Gabriel for a drive in the country. They reached the cliff above the Devil's Punchbowl, a treacherous whirlpool at the bottom of a waterfall, and climbed out of the carriage to take a closer look. While Scott stood on a precarious ledge of rock overlooking the maelstrom, he saw a spooky look come over Gabriel's face. At the same moment he and Alice realized what their friend was thinking: "One step forward and I am free!" With horror Scott realized that he could not reach Gabriel because of the slippery green lichen underfoot. Finally, however, Gabriel turned round and put his hand in Scott's. After they had backed away from the precipice, all three sat on the ground "without a word but with faces too conscious of each other's thoughts."[53]

A few days later, when Gabriel and Scott were out walking, a chaffinch settled on Gabriel's hand. Thinking of Lizzie and her pet finches, he felt sure that this uncanny visitor was her spirit, warning him of peril to come.

<center>❦❧❦</center>

The exhumation of Lizzie's body is one of the most ghoulish incidents in the history of poetry. From the start Gabriel feared what people would think if they learned of his willingness to dig up his wife's body in order to retrieve his youthful poems, and so he swore Howell

to secrecy. Despite his fear of revelation, Gabriel finished the letter on a shockingly cheerful and casual note, promising Howell his choice of the "swellest drawing conceivable" or a portrait of his wife if he succeeded in unearthing the manuscript.[54] To calm himself in the days before the grave was opened, he consulted a doctor about the probable state of Lizzie's corpse. As he told Swinburne later, "Had I not received medical assurance that all in the coffin would probably be perfect . . . I should not have had the courage to make the attempt."[55]

The grave was opened one night early in October. In attendance were Howell, a Dr. Llewellyn Williams of Kennington, and two workmen. To protect against infection, a great fire was built by the graveside, and its dancing flames served to light the proceedings. The notebook was removed, and Dr. Williams soaked it thoroughly in disinfectant and carried it home, where he set about the tedious task of separating and drying each leaf. Howell rushed back to his house, where Gabriel was waiting, to assure him that the notebook had been secured and that Lizzie was indeed still "perfect." Getting carried away, he theorized that laudanum had preserved her. He told Gabriel that her hair filled the coffin, still shining red and gold. *

On October 13 Gabriel wrote apologetically to William to inform him of the exhumation. He explained that he had already told Jane and Scott and his assistant, Dunn, and that Morris, Burne-Jones, and the solicitor Theodore Watts-Dunton had also heard. Although he had admonished Howell to tell no one else, he now realized that "the truth must ooze out in time."[57]

Two weeks later Gabriel wrote to advise Swinburne of what he had done, defending his action on the ground that "the truth is no one so much as herself would have approved of my doing this. Art was the only thing for which she felt very seriously. Had it been possible to her, I should have found the book on my pillow the night she was buried."[58] Gabriel also told Brown, to whom he confided that he was distressed because a worm had eaten a large hole right through the leaves of "Jenny," his early poem about a night with a prostitute. How he reconciled the supposed perfection of the corpse with the presence of worms he did not mention.

---

* Late in December Howell finally paid a bill dated October 5 "to two men attending at Highgate Cemetery to open and close coffin etc. Conveyance and driver, conveying men and tools to the cemetery. Paid men's expenses for refreshments tools etc. £2.2."[56]

Gabriel now began transcribing and reworking the poems so that he could send them to the printer as soon as possible. By November he was complaining of a constant shaking of the hands and other symptoms that he feared were the first signs of a paralysis. Jane was sitting for him regularly, but even her constancy wasn't enough to lift him out of his gloom. Every drawing and painting he did of her now seemed to him a failure. On January 30, 1870, he wrote: "Every new thing I do from you is a disappointment, and it is only at some odd moment when I cannot set about it that I see by a flash the way it ought to be done. Such are all my efforts. If I had had you always with me through life, it would somehow have got accomplished. For the last 2 years I have felt distinctly the clearing away of the chilling numbness that surrounds me in the utter want of you; but since then other obstacles have kept steadily on the increase, and it comes too late."[59] Gabriel seems never to have seriously considered that Jane might leave her husband and come to him. Instead, he continually wallowed in the "too lateness" of it all, never suggesting there might be any other issue of their dilemma. The very hopelessness of their situation gave it a powerful poignancy for him, a keen edge of pain that he enjoyed.

Even with the poems from the exhumed notebook, Gabriel had only 160 pages once the printer had set them in type. He needed at least another hundred to fill out the volume, so he set about grinding out poem after poem, a task that wore away his nerves. When his doctor advised a spell in the country, Barbara Leigh-Smith Bodichon offered him the use of a rustic four-room cottage she had built at Scalands, her father's estate. It had been fifteen years since he had paid a visit there with Lizzie and woven iris through her hair so that he could sketch her. Gabriel accepted the offer, for Scalands was less than twenty miles inland from Hastings, where Jane was staying for the sea air, just as Lizzie had done so many years before.

Gabriel ensconced himself in the cottage with William Stillman, an American friend, for company. He managed to alienate Stillman by spending carelessly on household expenses, but Stillman had his unwitting revenge when he suggested that Gabriel, an insomniac, try a marvelous new sleeping draft called chloral hydrate, which was fashionable because of its mildly hypnotic effect. Little if anything was known about the risks of this drug, and Gabriel became a pioneer, exploring its dangers.

While Stillman was still in residence, Gabriel invited the Morrises

to visit him for a few days. Then he asked Jane to pay a longer visit, after Stillman had gone. Although Morris could get away from London only occasionally, Jane wanted to accept the invitation. That the three of them managed to negotiate this awkward situation is remarkable, but they did so. On April 12 Morris brought his wife to Scalands and left her there, where she remained for almost a month, alone with Gabriel. By delivering Jane, Morris gave this visit his official approval, and the charade was so complete that Gabriel felt comfortable in writing to his mother: "Jane Morris is here and benefiting greatly. Top comes from time to time."[60] Soon Jane was strong enough to walk out with him in the fields. A sonnet that he wrote during this visit begins: "On this sweet bank your head thrice sweet and dear I lay, and spread your hair on either side," and continues: "So shut your eyes upturned, and feel my kiss/ Creep, as the Spring now thrills through every spray,/ Up your warm throat to your warm lips."

Jane's visit coincided with the triumphant publication of the long-awaited *Poems by D. G. Rossetti*. On April 26 Gabriel made a day trip to London to autograph presentation copies of the volume, and he arranged to meet Morris for a celebratory lunch. Morris wrote to Jane that afternoon, telling her that he had "just parted from Gabriel (and oysters) at Rules: he is pleased with his binding and so am I. The book seems selling well: 250 copies."[61] Indeed the volume did sell well. By the end of 1870 it had gone through six impressions and turned a handsome profit.

Gabriel orchestrated a symphony of favorable reviews by soliciting all his friends, even Morris, going to extraordinary lengths to protect himself from critical opprobrium. In his review of *Poems* for the Academy, Morris praised particularly the cycle of sonnets Gabriel called "The House of Life," a celebration of Jane, as "unexampled in the English language since Shakespeare's for depth of thought, and skill and felicity of execution." Although it hardly bears comparison with the work of the bard, there is no question but that "The House of Life" is one of the high watermarks of Victorian poetry, demonstrating an uncommon mastery of the sonnet form.

Morris's April 26 letter to Jane concluded with the news that he was about to go off to visit his friend Aglaia Coronio: "I am going to receive Aglaia's bland flatteries on my way to Neds this afternoon. I

do rather wish she wouldn't butter me so, if that isn't ungrateful so you needn't chaff me as one who can't see the fun of it; I shall certainly come down for day or two next week and fetch you up when you are ready to be fetched — do you want any more wine? I am with love Your loving WM."[62] Aglaia was the daughter of Constantine Ionides, patriarch of the Greek community in London, and she exerted herself to bring a great deal of business to Morris's firm over the years. At this time she was also pressing herself on Morris as a confidante, and he was coming to depend on her sympathy and companionship. Her urgent letters suggest that she wished for something more than intimate friendship, even though she was married, but Morris apparently did not.

There are those who argue that Morris was awkward with women, even oblivious of them. His intense, sustained friendships with several women, including Georgie Burnes-Jones, Aglaia Coronio, and Kate Faulkner, argue differently. Morris was not a man who wanted women to be dolls. The women he chose as friends were all intelligent, energetic, and sympathetic. In middle age he was no longer searching for a fairy princess; instead, he went to these women for the companionship and the emotional support he could not get from Jane. Many afternoons he slipped out of Queen Square to go next door for tea with Kate, who with his encouragement became a skilled designer and did a great deal of work for his firm. He also had a great deal of respect for Catherine Holiday, a brilliant needlewoman who embroidered for his company for many years; he treated her as a serious artist and a businesswoman. He may have been a failure at flattery, but these women looked forward eagerly to his letters and visits.

Georgie was his mainstay, and eventually Jane felt threatened by this friendship. Morris's secretary observed that Jane was jealous of the stimulating companionship her husband found with Georgie; no doubt she experienced it as further proof of her own inadequacy. But Jane did make a substantial contribution to her husband's business, by helping to supervise the embroidery section of the firm. Because there are few records pertaining to her work, it is hard to know how much or exactly what she did. It is clear that her collaboration with Morris brought her much pleasure. It seems sad that she did not get more involved in this work; Morris would certainly have been willing to teach her.

In November of this year, in the wake of an attack of sciatica and lumbago, Jane went to stay at Torquay on the south coast with

Morris's mother and sisters. Her choice suggests she felt a need to reaffirm ties to her husband and his family. Morris's letters to her imply that husband and wife had come together again, or at least come closer than they had in a long time. Humor bubbles up in a letter he dated November 25: "I went yesterday to order myself some new clothes; but was so alarmed at the chance of turning up something between a gamekeeper and a methodist parson, that I brought away some patterns in my hand to show Webb." He mentioned in the same note that he had finished writing *The Earthly Paradise,* a project that he had worked on for some six years, and felt "rather lost at having done my book." The letter ends with a bit of warm family news about the girls, who were with him in London: "Such a rumpus this morning. May enjoying a good tease and Jenny expressing herself in boo hoo — I am with best love Your loving William Morris."[63] In a letter of December 5 he promised to come and pick her up at Torquay, venturing to come a week early: "If my vanity doesn't deceive me, I think I might make it pleasanter for you by staying the week with you . . . I have now nothing special to keep me in town."[64] As always he had masses of work to keep him in town, but he was much more interested in whether his wife would welcome his company.

A letter of uncertain date, but probably written in early December, reveals an intimate level of communication and suggests that Jane had talked to Morris about her torment over Gabriel, and perhaps over her inability to make a decision about where she belonged. Morris made no bones about his preference — "I shall be glad of you dear, when you come home" — and extended the sheltering arm of his familiar protection. He went on to say: "As for living, dear, people like you speak about don't know either what life or death means, except for one or two supreme moments of their lives, when something pierces through the crust of dullness and ignorance, and they act for the time as if they were sensitive people — For me I don't think people really want to die because of mental pain, that is if they are imaginative people; they want to live to see the play played out fairly — they have hopes that they are not conscious of — Hillao! here's cheerful talk for you — I beg your pardon, dear, with all my heart."[65] As he sat writing the letter, Morris must have suddenly feared that he had gone too far, that she might think he was speaking only of his own pain, when what he wanted was to encourage her to hang on, to see the thing through, not to give in to despair.

No true reconciliation was forthcoming, however. Over the course

of the winter Jane gathered her courage and insisted on making a trial of life with Gabriel. Somehow Morris mastered his grief and fury and accepted the fact that Jane preferred his rival. A plan was concocted whereby Morris and Gabriel would rent a house together in the country so that Jane and Gabriel could live together for the summer, ostensibly with her husband's approval, far removed from the prying eyes of London.

Morris was the one who found the house: Kelmscott Manor, a beautiful, rugged, old Elizabethan-style manor house with a garden and sixty-eight acres of golden fields. It was situated in an obscure corner of Oxfordshire, and the rent was only seventy-five pounds a year. The village of Kelmscott was so isolated and unsophisticated that almost everything, even many food items, had to be ordered from London. The nearest train station was Faringdon, seven miles away, and a carter had to be paid for each delivery of goods brought up from the station. In the winter the Thames flooded the surrounding meadows, so the house was at times quite cut off — which meant that it would be only a summer residence; Jane and Gabriel could not settle in forever.

Morris took Jane and the children to Kelmscott in the spring, to see them safely settled, and then set out to realize one of his own dreams: to visit Iceland to see the sites of the heroic sagas he had been studying for years. This journey removed him from the scene, and Gabriel and Jane were able to enjoy the happiest, most carefree time that they had ever spent together. That summer it seemed as if they had found a way to enjoy their love without restriction. They thrived on a diet of sunshine and sweet air. Much time was spent sitting out in the garden, reading and drowsing. The river offered good fishing if it was wanted. Jane set up the household so that it ran smoothly and comfortably. She had become a superb housekeeper; her daughters' friends remembered the Morris home as a place where they could always be sure of a first-rate tea with a fresh homemade loaf and plenty of honey to slather on it.

Having endured the chaos and filth of Cheyne Walk, Gabriel was delighted to have a woman take all domestic worries off his hands. Lizzie had never taken an interest in housework; here was Jane putting up preserves from fruit she picked in the garden. The freedom enabled him to work at his easel many days that summer. He was happy drawing Jane, and he made many pencil sketches of her around the house and garden, full of the same kind of tenderness as those he had done of Lizzie.

When he grew tired at the end of the afternoon, he and Jane went for a walk through the fields or along the riverbank, venturing some days over a ramshackle bridge to a tiny island that invited them to lounge, to nap, to enjoy each other. Gabriel bragged about the improvement in Jane's health to Scott, claiming that she could take "five or six mile walks without the least difficulty." Even the girls, whom Gabriel had feared as the spoilers in his Eden, pleased him — they were "the most darling little self-amusing machines that ever existed."[66]

In the evenings, after the girls were in bed, the lovers read aloud to each other and discussed what they had read. Jane soaked up Gabriel's knowledge of poetry, but was now sufficiently confident to share her own opinions. The handful of her letters to Gabriel that survive show her to be an intelligent reader, with range and thoughtfulness. Jane's real education occurred not in those few months in Oxford before her marriage but during the thousands of hours she spent stretched out on the sofa nursing her back, when she passed time reading and reflecting on what she had read. When the pain was great she preferred light, amusing novels, but when she could, she set herself to study, and she and Gabriel discussed Shakespeare, Dante, Coleridge, Keats, Shelley.

By the end of August, Gabriel had written thirty new sonnets to expand "The House of Life" for a new edition of his *Poems,* and he had finished one of the most simple, touching paintings of his life. Called *Water Willow,* it is a tiny canvas, ten by thirteen inches, that shows Jane holding a willow branch and surrounded by Kelmscott: a minute manor house, a church, a little rowboat. This picture holds nothing theatrical, no melodrama, no exaggeration of features. Jane looks out at the viewer directly and tenderly, her eyes full of love and empty of tragedy or pathos.

Gabriel also wrote a wicked little story this summer that he called "The Cup of Water." A dashing king rides up to a cottage, where a maiden hands him a cup of water. The mere sight of her beauty makes him realize that he does not really love the princess to whom he has been pledged since boyhood. The king decides to give the maiden as a gift to one of his knights who has also fallen in love with her at first sight.

Ever revising his history with Jane, Gabriel was craftily building up a myth that he and she had loved each other even in the earliest days at Oxford, but that he, out of loyalty to Lizzie, had handed Jane over to Morris. This version is absurd, for as Ned said: "Nothing

pleased [Gabriel] more though, than to take his friend's mistress away from him."[67] If Gabriel had been in love with Jane, Lizzie would never have become her friend or visited Red House so constantly. Loyalty to Lizzie had not stopped Gabriel from sleeping with Fanny Cornforth and Annie Miller, nor would it have stopped him from seducing the young Jane. But by now Gabriel had a great stake in convincing both himself and Jane that he had always loved her. If it was true, then he had a seigneurial right to possess her, since he had been there first, in the days when he was king and Morris wished only to serve him.

In "The Cup of Water," when the knight claims the girl, she tells him that she will have the king or no one. Faithful to his sovereign, the knight tells his lord of the girl's preference. In an equally noble gesture, the king persuades the maiden to accept the knight as a favor to him. This thread of the story was also precious to Gabriel. If Jane had never cared for Morris but had married him only out of courtesy, then her love for Gabriel was a tragedy, not a betrayal.

While Gabriel and Jane were enjoying their idyll, Morris was off on his journey to Iceland. On July 6 he wrote from London to tell Jane that he was taking the night train to Edinburgh, the first stop on his route. He permitted himself to admit that he had had a hard time leaving Kelmscott — "How beautiful the place looked last Monday: I grudged going away so" — then pulled himself up short: "but I am very happy to think of you all happy there, and the children and you getting well."[68] He cannot have felt a simple happiness, but he must have believed that countenancing his wife's choice and even supporting it was necessary at this juncture to maintain any sort of connection to her.

The rugged trip to Iceland rejuvenated Morris. He had been studying Icelandic for several years in order to translate the Norse sagas, and he was fascinated by the heroes because they offered him models of detachment and courage, qualities he needed to meet the challenges in his own life. Visiting their country was a chance for him to imagine his heroes more vividly as well as to test his mettle on their ground. In a letter to Jane, he fairly crowed: "I am tremendous in health and in very good spirits, and enjoy the riding very much; the ponies are delightful little beasts, and their amble is the pleasantest possible means of traveling: everybody has behaved charmingly; even I have not lost my temper often. . . . I find sleeping in a tent very comfortable work even when the weather is very cold . . . last Tuesday week we had

a very bad day, riding over the wilderness in the teeth of a tremendous storm of snow rain and wind; it was an eight hours job but I was not a penny the worse for it next morning. You've no idea what a good stew I can make, or how well I can fry bacon under difficulties. . . . I am dirtier than you might like to see me: my breeches are a triumph of blackness."[69]

When he returned home in the autumn, he threw himself back into work with renewed vigor. He took down his beloved medieval herbals from the shelf, having decided to see whether he could use vegetable dyestuffs to color his own fabrics. For years he had been revolted by the harsh, ugly colors produced through the "abstract science of chemistry": To him they were just one more poisonous legacy of the industrial revolution. He also copied out his journal of the trip to Iceland as a gift, not for Jane but for Georgie, who he knew would treasure every word.

One can't help feeling a little sad that Morris and Georgie were never able to divorce and marry each other. They were so well suited: Both possessed a rock-hard integrity, each cared for the other deeply, and both were capable of such extraordinary self-containment and yet desired nothing so much as long-lived intimacy. Between them they had the makings of a remarkable marriage. But Georgie wanted Ned, and Morris could not turn away from Jane, in spite of his frustration and misery with her.

On the surface life returned to normal in the fall. Jane and the girls settled back into their domestic routine at Queen Square. But Gabriel was left distraught at the end of the summer. He wrote a sonnet mourning Jane's departure, called "Without Her," that begins: "What of her glass without her? the blank gray / There where the pool is blind of the moon's face." The queen of his night had gone, and he felt the loss to be final, complete. He told Jane over and over that he would never be able to return to Kelmscott; the place had been ruined for him. His insistence suggests that he had expected Jane to stay with him beyond the summer. Her return to Morris must have felt like a rejection, and rejection always cut him like a knife.

To deepen his misery, the critical hatchet that Gabriel had been dreading since the first tentative forays of the Pre-Raphaelite Brotherhood finally came down on his neck. On October 2 he wrote to Scott: "I see by advertisements I figure as the first victim in a series

(I presume) under the title of the 'Fleshly School of Poetry', in the *Contemporary Review* for October, but haven't seen it yet.''[70] The essay, signed Thomas Maitland, was a vicious attack on Rossetti and Swinburne, savage even by the standards of the day. Fleshliness was their crime; Maitland found sex everywhere in their verses, and set himself up as a sort of moral policeman, shouting with gleeful indignation every time he spied a hint of sensuality.

At first Gabriel saw the essay for the smug nonsense that it was and wrote to his publisher: "For once abuse comes in a form that even a bard can manage to grin at without grimacing.''[71] He suspected the author was pseudonymous and turned detective to prove that the piece had been written by a ninth-rate poet he despised named Robert Buchanan. To defend his honor, Gabriel began to write a lengthy reply to Buchanan, which, Scott said, "he read [aloud] over a hundred times, till the lives of his friends became too heavy to bear.''[72] Although William tried to persuade him not to dignify Buchanan's childishness with a response, Gabriel's retort, "The Stealthy School of Criticism," appeared in the December 16, 1871, issue of the *Athenaeum,* much watered down under legal advice.

Gabriel seemed to become more rather than less upset by Buchanan's venom as time passed, and his brother grew worried about him. Over the winter William kept an even closer eye on Gabriel than usual, calling constantly at Cheyne Walk. Gabriel admitted to him that he had been spitting blood on and off since the summer, but when William urged him to see a doctor, he shrugged off the advice.

Buchanan, who apparently could not leave vile enough alone, announced that he planned to expand his article and bring it out as a pamphlet, which he did in May 1872. Gabriel, who got hold of one of the first copies off the press, was horrified by what he read. His worst fears sprang off the page. Buchanan disdained the device that Gabriel had employed in some of his most erotic poems of speaking as from husband to wife: "Animalism is animalism, nevertheless, whether licensed or not; and, indeed, one might tolerate the language of lust more readily on the lips of a lover addressing a mistress than on the lips of a husband virtually (in these so-called 'Nuptial' Sonnets) wheeling his nuptial couch out into the public streets."

Gabriel read this as a mass of veiled charges. He suspected that Buchanan was alluding to his exhumation of Lizzie's grave, that Buchanan had found out that the use of "nuptial" was a blind, and that Jane was being humiliated. When Buchanan suggested snidely that

"The House of Life" was none other than the house of prostitution from which "Jenny" had operated, Gabriel jumped to the conclusion that Buchanan was telling the world that Jane was the real-life model for Jenny, little more than a commonplace whore. Gabriel's celebration of his faith that sexual love could be a transcendent experience, raising both lover and beloved out of the mundane into a realm of truly blessed communication, was dismissed as highfalutin folderol by Buchanan, who was too busy searching for the beast with two backs.

Over the next few weeks a series of blows rained down on Gabriel's head. On May 18 the *Echo* printed a review of Buchanan's pamphlet titled "Fleshing the Fleshly." Even though the piece was largely critical of Buchanan, Gabriel discerned in it a reference to himself as a coward. Although the word never appears in the article, William could not talk him out of his interpretation and had to dissuade him from challenging the writer or the editor to a duel.

On June 1 the *Saturday Review* weighed in for Buchanan, denouncing Swinburne, Rossetti, and their followers for their "emasculated delight in brooding over and toying with matters which healthy, manly men put out of their thoughts. . . . With Mr. Rossetti the shutters seem to be always closed, the blinds down. . . . One longs . . . to fling open a window and let in some honest daylight."

Brooding in the gloom at Cheyne Walk, Gabriel felt this thrust hit home. His fantasies now ran wild; William listened in pain as his brother expounded his theory of a cabal, a "widespread conspiracy for crushing his fair fame as an artist and a man, and for hounding him out of honest society."[73] On the second of June William recorded in his diary that he had been "all day with Gabriel at Chelsea — a day of extreme distress and anxiety on account of the nervous and depressed condition into which Gabriel has allowed himself to get worked."[74]

As a first line of defense, friends were organized to take Gabriel for a long walk every evening in an attempt to tire him out so he could get a little natural sleep. By this time he was utterly dependent on the combination of chloral hydrate and whiskey with which he drugged himself each night in an attempt to sleep. What he didn't understand was that the drug, which is effective in the short term, was now working against him. Chloral and alcohol are both depressants; worse, their effect is additive. Taken together in large amounts, they are a recipe for severe depression.

The side effects of the chloral complicated matters, bringing on

excitement, irritability, restlessness, and eventually delirium. All these may have stimulated Gabriel's fantasies in the early morning hours and led to some remarkable poetry and paintings, but he certainly did not get the sleep he needed. When he did sleep, the drug probably contributed to his nightmares, and then he awakened with a head-splitting hangover. Out of frustration he kept increasing the dose, perhaps inadvertently inducing psychosis; the incoherent, paranoid behavior he displayed over the next few months may well have been a result of the chloral. His doctors and his friends did not understand the effects of the drug as clearly as we do, but they knew that it was hurting him and worked to try to get him off it, with little success.

Gabriel's paranoia spiraled after June 5, when Robert Browning, a serious rival in poetry, sent him a presentation copy of a narrative poem he had just published called *Fifine at the Fair,* inscribed with an affectionate message. At first Gabriel cried, so touched was he by Browning's thoughtfulness, but as he read the poem he became convinced that its author had abused his trust and Lizzie's memory.

The speaker in *Fifine* takes his wife to a fair, where he sees a beautiful dancing gypsy named Fifine, who is far sexier and more vital than his spouse. It is apparent to the wife that her husband desires the gypsy, and the remaining two thousand lines of the poem are an elaborate attempt on his part to justify his attraction. The last fifteen lines are a bombshell: a sharp, ugly little scene in which the husband announces that he is going to see Fifine, on a flimsy pretext. With the last line he invites his wife to kill herself if she can't accept his choice: "Why, slip from flesh and blood, and play the ghost again!"

Gabriel jumped to the conclusion that Fifine was patterned after Fanny Cornforth. Worse, he decided that Browning had seized as the kernel of his poem the rumors that he and Lizzie had had a violent argument on the night she committed suicide because he was going to see Fanny. All the characters, even the speaker, are shadowy and indistinct, so it was easy for Gabriel to project himself and Lizzie into the roles of husband and wife. Those two thousand lines of rationalization echoed the eternal buzz inside his head, the endless mental conversation with Lizzie in which he tried but failed to shrive himself of guilt.

In fact Browning was actually struggling with his own ambivalent feelings about his dead wife, Elizabeth, whose memory he revered and rebelled against. Memory bade him be chaste, but his sexual needs still drove him, and the conflict of memory and desire was a secret torment. Unfortunately, there was no way for Gabriel to know

this, since officially Browning lived only to honor his dear departed spouse. If these two could have spoken to one another about the deep guilt they both felt, they might have found some relief. As it was, Browning had no idea that he might have echoed Gabriel and Lizzie's story; he was singularly proud of this poem as one of his most spontaneous creative achievements. A kindly man, he would never have sent Gabriel a copy if he had suspected it might hurt him in any way. Nonetheless, Browning became in Gabriel's mind a chief conspirator, intent on hounding him to death.

By now Gabriel was coming utterly to pieces. He embraced his enemies' view of him as an unhealthy, effeminate sort and proclaimed it to all who would listen. His friends were sickened as they heard him repeating over and over that he could not fight back because he had no manhood left. He insisted that he had no choice but to die in shame. Raving about the conspiracy, he swore that the walls of the house were inhabited by spies.

Doctors Thomas Hake and Henry Maudsley, an eminent specialist on mental illness, were called in to consult by Gabriel's long-time physician, John Marshall, and together they decided that he should be removed immediately from the dark, gloomy house in Cheyne Walk to neutral territory where he could be supervised closely. Hake offered to take him into his home and watch over him, but Gabriel insisted that they were all in league with the conspirators and refused to go. Finally he was persuaded to enter a cab and suffered a miserable journey to Hake's house in the company of his brother William, who by now felt quite desperate himself.

The next afternoon a crowd of merrymakers passed Dr. Hake's house on their way to Richmond Park, and Gabriel announced that the maypole they were carrying was a gibbet and that the mob was hell-bent on executing him in the park. He ran out of the house shouting and shaking his fists at the bewildered crowd. Hake and William rushed after him and dragged him back inside. After a long struggle, they got him into bed. Unable to sleep, Gabriel writhed on his bed, tormented by auditory hallucinations. All that William would say later was that Gabriel had twice heard a voice crying out a "term of gross and unbearable obloquy," but what that term was he did not say.[75] Whether the voice accused him of murder or adultery or some other equally horrible crime, Gabriel decided that the time had come to join Lizzie. Somewhere he found a bottle of laudanum and drank it all off.

The next morning Dr. Hake and William took turns looking in on the sleeping figure, assuming that he had simply worn himself out. Eventually they realized that his was not a natural sleep and called in a doctor from the neighborhood, who pronounced Gabriel beyond hope. William, who had been concealing the gravity of the situation from his family, rushed home to prepare his mother and Maria to attend a deathbed (Christina was herself ill, so could not come).

Almost twenty-four hours after Gabriel took his overdose, Ford Madox Brown summoned John Marshall, who administered massive doses of strong coffee. Caffeine was an effective antidote to opium poisoning, and Gabriel began to respond. While he hovered on the edge, his assembled doctors warned the family that if he survived, he might well show considerable brain damage. Gradually, however, he emerged from the coma, still full of delusions and suffering from paralysis of the hip, but by no means an idiot.*

<center>❧❦❧</center>

It seemed that Gabriel must be sent to an asylum, a prospect that his friends dreaded for him. Brown proposed an alternative: that they should work together to take him into the country and try to nurse him back to health themselves. Everyone rallied round. Graham offered the use of Urrard House, a lovely home he owned in Perthshire. Brown took Gabriel northward by invalid coach, and Scott promised to spell Brown soon, since he needed to get back to his studio. Dr. Hake's son George agreed to stay with Gabriel as a nurse-companion. (William, the obvious choice for this position, was so ill with anxiety that his doctor ordered him to stay behind in London.)

In desperation, Jane Morris was writing to anyone who might be able to tell her something of Gabriel's condition. Morris too was genuinely concerned about whether his old friend would survive; he even told Brown that he would be willing to stay with Gabriel for a few days if that would help. The rest of Gabriel's male friends, however, seemed to regard Jane as the cause or at least the catalyst of his

---

*Precisely what caused this mysterious paralysis is now unclear; perhaps Gabriel fell and traumatized the hip. He temporarily lost use of the leg, which he dragged around for some weeks, only gradually regaining control over it. Gabriel's father had had a series of strokes starting at about the same age, and after this Gabriel suffered more episodes during which he lost the use of an arm or a leg for some weeks or months, so it may be that there was a family history of malignant hypertension leading to stroke. Gabriel's father also sank into paranoid delusions at about this same point in his life.

crisis, and they determined to keep her from him, fearing a visit might harm him in some final, unspecified fashion.

His friends' fears unexpectedly link Fanny and Jane, two women so different in personality, appearance, character. Several of his male friends were convinced that his relationships with one or both women had damaged him profoundly: Fanny had cheated him, coarsened him, degraded him; contact with Jane was a psychic poison that might now well kill him. But if Jane watered the fine bloom of Gabriel's obsession with her by responding to his worship, she can hardly be said to have caused it. Obsessive attachment was a pattern that had shown itself in him long before he ever met her. Gabriel's friends did not understand — or preferred not to see — that Gabriel chose Jane, as he had chosen Fanny, because he wanted to paint her and to make love to her. Instead, they acted as if Jane had forced herself on him from the beginning. Jane was his muse, his lover, and his supporter, yet with all their good intentions his friends were intent on depriving him of her, a course that probably reflected their own fears about the power that women and sex wielded over them.

Whether or not their decision to exclude Jane was wrong, they did everything in their power to care for Gabriel. Scott's letters to Alice painstakingly chronicle their efforts to wean him both from his delusions and from the lethal chloral-and-whiskey combination. On June 29, just after they had moved Gabriel to Stobhall, another of Graham's properties in Perthshire, he wrote: "As to the very important matter of Gabriel's state, I fear no very encouraging account can be given. He is well in health, and the lameness is nearly gone, but the delusions remain and the sense of being mentally incapacitated. There are materials here for sketching, canvas and painting, but he simply refuses to do anything whatever, even to look about him or to read even a letter. He will simply sit and listen and think of things that he does not dare to speak of. He breathes a little heavy and his hand shakes a little so that if we could get him to try painting the result might be a disaster. Both Hake and Brown are discouraged, and have the impression that he is not better, and that the mania is becoming confirmed in some respects."[76]

When Scott tried to insist that Gabriel cut his consumption of alcohol, Gabriel pulled out all the stops, screaming that he would throw himself out the window if he did not have his whiskey. Scott held his ground, threatening him with the doctor and implicitly with the asylum, but afterward told Alice that he could not go through

such again: "The scene of fury was too painful to have repeated."[77] Gabriel was an alcoholic, as dependent on the whiskey as he was on the chloral, but he did accept a smaller ration. (Unbeknown to Gabriel, his caretakers had been watering his chloral for some time.)

In July the first small signs of improvement began to appear. At times Gabriel considered the possibility that some of his mad ideas were in fact delusory. On July 11 George Hake wrote to William that Gabriel's hip was better; he could now pull his own boots on and cross one leg over the other. By July 18 Scott reported that he was reading the newspapers; the most hopeful sign was that he had announced that "if there were any pretty peasant girls about here he would paint them."[78]

When Stobhall was needed by Graham's family, the company had to make a third move. This time they rented a modest new farmhouse. Dr. Hake had traveled up to join them, and when he found that Gabriel was worn out with sleeplessness he prescribed morphine. Hake may have felt that only morphine could ease Gabriel's agitation; he was probably also trying to stop the chloral, since morphine would ease the pangs of withdrawal. To William, helpless in London, the addition of a powerful narcotic sounded about as wise as handing a loaded gun to a desperate man, but Hake did in fact understand how to control the administration of the opiate, and Gabriel did not become addicted.

Throughout the summer Jane had been writing for news of Gabriel, but his friends had hidden this fact from him. Apparently it did not occur to them that he must have felt a keen sense of abandonment, since as far as he knew Jane had not even tried to find out how he was. As soon as he felt able, Gabriel wrote her a long letter, and after much debate with himself, Dr. Hake decided to mail it. He added a covering letter of his own, asking Jane to let him know if any of Gabriel's delusions had crept into the letter: "May I further take the liberty of asking you to be very guarded in your reply to him — telling him only amusing and cheerful facts, not noticing in the slightest degree his delusions if he has manifested any to you."[79] At Hake's request, Jane wrote to reassure William Rossetti that Gabriel's letter contained no suggestion of delusion and that she felt hopeful. She had had "many from his hand of a far more depressing kind."[80]

By the end of August Gabriel was feeling well enough to take up his brush again. On September 7 his assistant, Henry Dunn, arrived to replace Dr. Hake and to help him get back to work. The first task

Gabriel set himself was a replica of *Beata Beatrix,* for which Graham had already paid him nine hundred guineas. It is laudable that he wanted to clear his debt to Graham, who had shown him so much kindness during the summer, but there is something dreadful about his ability to grind out yet one more replica of his memorial to his wife, after all that had just taken place. More happily, his generosity was already reasserting itself: He started to search for a publisher for a novel Dr. Hake had written.

Despite the fact that he had told Jane he would never be able to return to Kelmscott, Gabriel now decided that it was the only place he could bear. Stopping briefly in London to reassure his mother and sisters, he and Dunn journeyed on to Kelmscott, arriving on September 25. Jane and the girls were there to greet him. Though he was shocked to find Jane in delicate health, for the moment Gabriel felt that he had come back from the dead and been restored to the Eden he and Jane had shared the summer before, which now seemed a lifetime away.

Needing cash badly and knowing that it was well nigh impossible for him to negotiate business from Kelmscott, Gabriel engaged Charles Howell as his agent in London. He was preparing for a long stay in Oxfordshire. Howell was eager to sign him up as a client and wrote to encourage him: "Your market is splendid paint what you like and there will be five men for each picture."[81] Since Howell was a flamboyant, perhaps pathological liar and his accounting procedures were all but nonexistent, it is impossible to know what percentage he actually took for himself, but he did sell enough paintings to keep Gabriel afloat. And despite the vagaries of his character, one develops a genuine sympathy for him when reading the letters Gabriel wrote to him over the next several years, in which Gabriel made literally hundreds of requests and demands, asking for everything from cash to clock repair to sweets.

Howell became much more than an agent. Gabriel took him over as a factotum, directing him to run countless errands for him all over London. Nothing was simple. For instance, in no fewer than two dozen letters Gabriel discussed the stationery that he wanted Howell to have printed for Jane. First he was unhappy because the cutting of the design, a pansy, was too crude; then he found the color of the paper garish, the quality wretched. Howell must have made innu-

merable trips to the printer. Next Jane got into the act, announcing that the silver paper Gabriel had settled on was impossible because everyone would think it was wedding paper. In the end the project was abandoned, but not for want of effort on Howell's part.

He searched and searched for the perfect shelves for Jane's new bedroom in London, at a house that Morris had rented in Turnham Green. He had been instructed by Gabriel that they must be inexpensive and yet the "most beautiful bookshelves that can be found," only to be told after a goodly length of time that Jane had changed her mind and decided she could use shelving she already owned.[82]

Howell put up with such shenanigans good-naturedly. The two men keenly enjoyed each other; they were both con men, and could appreciate each other's artistry. Howell hung in and hung in; no amount of profit could account for his heroic patience. No matter how vexed business matters became, he always looked forward to visiting Kelmscott, where the ease of life was so distinct from the atmosphere in starchier Victorian households: "What a comfort it is to stay in a house where one can wear slippers all day, and go to bed at anytime, and get up at reasonable hours."[83] He must also have enjoyed the meals arranged by Jane, which were, according to George Bernard Shaw, works of art.

Having almost lost Gabriel completely, Jane was grateful to have him restored to her, even though caring for him now entailed considerable responsibility. She and the children shuttled back and forth from London, which must have been a strain, but she seems to have been quite willing to nurse him in his convalescence. The chloral addiction was deeply entrenched, however, and its effects were steadily eating away at his health and judgment. Jane knew that he used chloral, but he hid from her the large quantities he was taking. She saw that despite her company, Gabriel was still dogged by depression. Even little May felt the weight of his sadness, later remembering the "rather broad figure tramping doggedly over the flat green meadows in search of exercise and air [and] returning after dark with the burden of weariness upon him. . . . Even the young child in pauses of happy playhours felt the loneliness of it."[84] Jane began to face the fact that Gabriel would never really get better; later she said: "That Gabriel was *mad* was but too true, no one knows better than myself."[85]

During this stay at Kelmscott he became preoccupied with a picture based on the legend of Proserpine, who was condemned to spend half of every year in hell with Pluto, the god of the underworld, and

who lost her true love, Adonis, to an early death. This painting gave Gabriel no end of trouble; in the end he painted it eight times, and no matter how hard he tried, he could not complete it to his satisfaction. A series of accidents also befell his canvases — so many in fact that the damage could hardly have been simple bad luck. That he didn't abandon the subject despite such setbacks shows how tightly he was bound up with the myth, and it is easy to understand why. In this tale lies the ultimate tragic version of Gabriel's triangle with Jane and Morris: In spite of her obligation to Morris, Jane will love the beautiful Gabriel eternally, long after he has been sacrificed to death.

Gabriel's obsession with this myth suggests also that he had come to see his own early death as inevitable. In the final version of the painting, Jane, dressed in a lugubrious turquoise velvet gown, holds a pomegranate and gazes mournfully into the distance. The flesh of the fruit has been cut, exposing the ruby-red seeds that symbolize her indenture to the god of the underworld. Like *La Pia de' Tolomei*, *Proserpine* shows Gabriel's continuing agony over Morris's possession of Jane, which, as far as he was concerned, condemned her to an elaborate death in life.

What is ironic is that Morris would have let Jane go if she had asked. There is no evidence that he ever really tried to stop her from going to Gabriel. In fact, he was far more forgiving than most husbands would have been; he allowed Jane to come and go as she chose, to flaunt her love for Gabriel, to return home when she wished. By this point his behavior had long since slipped over the border into masochism. His poetry shows that he was grieving for the loss of his wife and trying to figure out what he had done that had cost him her love, yet he continued to tolerate her repeated rejections. Just as Gabriel saw himself in the role of Adonis or Tristram or Lancelot, the lover or the usurper, Morris always cast himself as the despised lover, the cuckolded King Mark. Even as a youth he believed that he was destined to be the odd man out. In truth, though, it was Gabriel who had become Jane's Pluto, the king of night who threatened to drag her down into a confused, hellish underworld from which she would have to fight her way back to daylight and sane company.

On November 25 Morris wrote Aglaia Coronio that Jane had just returned from Kelmscott and was in good spirits, but that he had been feeling low: "I am afraid it comes from some cowardice or

unmanliness in me. One thing wanting ought not to go for so much: nor indeed does it spoil my enjoyment of life always, as I have often told you: to have real friends and some sort of an aim in life is so much, that I ought still to think myself lucky: and often in my better moods I wonder what it is in me that throws me into such rage and despair at other times: I suspect, do you know, that some such moods would have come upon me at times even without this failure of mine."[86] Some of Morris's biographers have interpreted this passage to mean that Morris had become impotent. If so, it is sad to see that he blamed himself rather than the devastating emotional bind he was in. But it seems at least as likely that his "failure" was the failure to hold Jane, to keep her love.

There were other reasons for his depression: "My intercourse with G[eorgie] has been a good deal interrupted not from any coldness of hers, or violence [?] of mine; but from so many untoward nothings: then you have been away so that I have had nobody to talk to about things that bothered me." He had also fretted over "another quite selfish business," which was that "Rossetti has set himself down at Kelmscott as if he never meant to go away; and not only does that keep me away from that harbor of refuge, (because it is really a farce our meeting when we can help it) but also he has all sorts of ways so unsympathetic with the sweet simple old place, that I feel his presence there as a kind of a slur on it." He no longer felt that he had to bite his tongue and be polite about Gabriel, though he up-braided himself for being petty: "O how I long to keep the world from narrowing on me, and to look at things bigly and kindly!" He hoped that he would be able to get away again to Iceland the following summer: "I know clearer now perhaps than then what a blessing and help last year's journey was to me; or what horrors it saved me from."[87] At long last he was prepared to admit that underneath his veneer of generosity and patience, he had suffered grievously and had grown to detest the friend who had stolen his wife.

<center>❧∽❧∽❧</center>

Morris did go to Iceland in the summer of 1873. With lots of time to think as his pony jogged over that lunar landscape day after day, he reached some resolutions about how he wanted to live the rest of his life. Back in London, he prepared to take control of the business he had built up so painstakingly over the years. It was absurd that his six partners should hold equal shares and receive equal profits

when he had done the lion's share of the work from the beginning; over the next year he framed a proposal to buy them out. When it was presented, Brown, whose fortunes were at a low ebb, flew into a rage; Marshall was unhappy; and Gabriel saw a unique opportunity to make Morris squirm.

For months hot letters flew back and forth. With the help of solicitors, an agreement was eventually hammered out whereby Morris would pay Brown, Marshall, and Gabriel one thousand pounds each in settlement. Ned, Webb, and Faulkner declined any payment. All of them would still be paid for any work that they did for the firm, just as they always had been. Privately Morris complained to his mother that three thousand pounds was a "deal of money to pay for sheer nothing."[88]

Brown couldn't bring himself to make up the quarrel with Morris for twelve years. Gabriel took his thousand pounds and put it into an annuity for Jane, so that she would have some spending money of her own each year. In this fashion he gave her a small measure of independence while appearing to return the money to Morris through a generous gift to his wife. (His own finances remained so precarious that at times he had to "borrow" the interest money from Jane to pay his bills.)

Acting on another of the decisions he had taken in Iceland, Morris told Jane and Gabriel that he would be relinquishing his half of the lease for Kelmscott. If Kelmscott were no longer her husband's house too, Jane would not be able to live there indefinitely without risking scandal. He was forcing her to choose.

<p style="text-align:center">◥◣◥◣◥◣</p>

Jane did not make a clear-cut choice, but she began to spend most of her time in London. She went to Kelmscott, but not so regularly as before, and she continued to model for Gabriel when he was at home in Cheyne Walk. In the summer of 1874, instead of settling in at Kelmscott with Gabriel, she joined Morris in taking Jenny and May, along with Phil and Margaret Burne-Jones, for their first trip abroad. As the train roared down the track toward Dover, the four children were so excited they were "squeaking with delight," and May remembered that her father "smiled across at Mother above the scrambling swarm and said with his heart and voice, 'It's worth anything to take the kids a treat, Janey, and see the little rascals enjoying it so.' "[89]

While the Morrises were in Belgium, Gabriel immured himself at Kelmscott. With only young George Hake for company, he sank back into his delusions. Walking down to the river one summer afternoon, he imagined that a group of men quietly fishing there hurled an outrageous insult at him. Suddenly these poor fellows found themselves under attack by a raving maniac. They shouted back, and George had to jump into the fray to prevent fists flying. This incident convinced Gabriel that he could no longer abide Kelmscott, and in short order he decamped for Cheyne Walk. (Without Jane, the place had lost its charm for him anyway. He visited Kelmscott only once again, very briefly, in 1877. Morris picked up the lease, sharing it with his publisher, and rejoiced in the recovery of his "sweet old place.")

Over the next year Gabriel sank into despondency. He worked at a picture called *La Bella Mano,* using the professional model he kept on a weekly retainer. This hideous painting of a lady washing her hands, attended by two cherubs, seems a caricature of his earlier works; the neck, lips, chin, bosom, hands are exaggerated so that the woman appears a grotesque giantess. Perhaps the years of chloral and alcohol addiction had begun to distort Gabriel's vision.

Depressed, discouraged, and unwell, he decided to get out of London in the fall of 1875, and he leased Aldwick Lodge, a dark barn of a place near Bognor Regis, two minutes' walk from a scrappy beach. The house was freezing and damp, hardly the ideal domicile for a man in poor health. Despite the chill, he invited Jane to come for a long visit.

Jane left her family and went down in November to model, but she returned home for Christmas with Morris and the girls. Gabriel's physical and mental state had deteriorated to the point that he frightened her. In his bedroom she found long rows of empty chloral bottles, and she asked him where they had come from. He told Jane the truth — that he had drunk their contents since his arrival — but she laughed and told him to stop joking. (It is believed that he took as much as twelve grams a night; ten grams is usually a lethal dose, and death has been reported with only four.) When it dawned on her that he actually *had* emptied them in just a few weeks, she was forced to face the fact that his addiction was hopeless, a permanent feature of his life for which she was no match. Later she looked back on this moment as the death knell of their relationship.

Gabriel had just negotiated a commission with a new patron who

was willing to pay the whopping price of two thousand guineas for a painting called *Astarte Syriaca,* a rendering of the ancient Middle Eastern goddess of love and war. Gabriel had enormous enthusiasm for this project, but *Astarte* looks like an image fresh from a nightmare, though he seems not to have realized it. The colors are vile: muddy mustard and a tawdry, uncomplementary turquoise. More disturbing is Astarte's expression: she stares out blankly, almost unseeing, as if she were drugged. And the pose is awkward: Astarte fingers a girdle at her hips and another just below her breasts, which would be sexy if the hands were not twisted in a stilted, unnatural fashion. In the background, the goddess's attendants look upward, their necks distended as if they are in pain.

Gabriel's worst fears were coming true; he was losing even his ability to draw. The picture is no doubt a reflection of his glassy mental state. He must have felt that his life was a bit of hell, but he kept scrambling along, writing to his patron to assure him that he was making progress on the picture.

Jane returned to Bognor to continue modeling for a fortnight in April, but while she was there she let Gabriel know that she could not come to him again. The rows of empty chloral bottles frightened her, and she felt that she could not go on exposing her daughters to such a bad influence. As gently as possible she signaled the end of the love affair. To protect Morris and especially her daughters, she extracted a promise that Gabriel would have all her letters to him burned at his death.

<hr />

Before Jane went down to Bognor, she seems to have confided something of her anguish to her husband, who wrote in response: "Wherein you are spiritless, I wish with all my heart that I could help you or amend it, for it is most true that it grieves me; but also, I must confess it, most true that I am living my own life in spite of it, or in spite of anything grievous that may happen in the world. Sometimes I wonder so much at all this, that I wish even that I were once more in some trouble of my own, and think of myself that I am really grown callous; but I am sure that though I have many hopes and pleasures, or at least strong ones, and that though my life is dear to me, so much as I seem to have to do, I would give them away, hopes and pleasures, one by one or all together, and my life at last, for you, for my friendship, for my honour, for the world. If it seems boasting

I do not mean it: but rather that I claim, so to say it, not to be separated from those that are heavy-hearted only because I am well in health and full of pleasant work and eager about it, and not oppressed by desires so as not to be able to take interest in it all. I wish I could say something that would serve you, beyond what you know very well, that I love you and long to help you: and indeed I entreat you (however trite the words may be) to think that life is not empty nor made for nothing, and that the parts of it fit one into another in some way; and that the world goes on, beautiful and strange and dreadful and worshipful."[90]

By now Morris had attained the detachment of his saga heroes, and he was proud of his achievement, but he had not grown hard at heart. Even so, Jane could have taken little comfort from this letter, which makes it clear that he had learned to live without her.

Morris was happy in his work. On Christmas Eve 1875 he had registered his first design for a carpet, and in March he had apprenticed himself at a factory in Leek, near Stoke-on-Trent, where the old methods of vegetable dyeing were still employed. He loved being a tyro, and was tremendously excited as he helped to set his first thousand-gallon vats of indigo dye. If conditions were not perfect, vast amounts of time, fabric, and money could be wasted, but good workmanship could produce the most extraordinarily beautiful blue he had ever imagined. In time he learned the technique so well that he began to think of producing his own fabrics. As a first step he imported a silk weaver from Lyons to set up a jacquard loom and teach his men the techniques of traditional silk weaving. Eventually he created materials dyed with his own extraordinary greens, yellows, reds, and browns, but the blue remained his favorite, and soft shirts of this shade became his personal trademark. The indigo was a powerfully permanent dye; he created a great deal of mirth by turning up at dinner parties bright blue to the elbows.

Jane's misery and Morris's joy were cut through this summer when their daughter Jenny suddenly had a series of violent seizures, which were almost certainly the symptoms of *grand mal* epilepsy. Morris's mother had a mild case of this disease, so he blamed himself for bringing it on his daughter. The doctors held out hopes of a cure, but these were dashed time and again. The seizures would ease up for a while, and Morris and Jane would begin to hope that the worst was over; then they would start up again, and the family would be plunged back into despair. The disease was ill understood; society

regarded it almost as a form of insanity. Slowly they began to realize that there would be no university for Jenny, nor any marriage.

This grief forged a new bond between husband and wife, as they struggled to do the best they could for their beloved child. Their first concern from now on was caring for Jenny. Jane tried to take on the entire burden herself, but eventually they saw that they would have to hire nurses to help during the worst periods. There were times when Jane's fear of Jenny's seizures was so great that Jane's doctors insisted that mother and daughter could not live together. Morris spelled his wife as often as he could; when he decided that the firm should try hand-knotting its own carpets, he turned the coach house and stable of their London house into carpet-weaving sheds so that he could oversee the work while staying home with Jenny.

After Jenny's illness began, Jane occasionally went to Cheyne Walk to model, but gradually her relationship with Gabriel was reduced to little more than letter writing. In its final years their correspondence was conducted from one sofa to the other, as the two invalids shared symptoms and remedies, cheered each other along, and more and more frequently sank into self-pity. They sounded like two ancients, though she was in her late thirties and he was just fifty. In the fall of 1878 Jane complained of insomnia, and Gabriel replied that he too was not sleeping a wink. Jane returned her sympathy: "I am grieved indeed to hear of your bad nights, mine are improving. I expect I am over-tired and anxious to get things straight, and moreover I have got used to the noise of the river-steamers which seemed at first to go on all night. Your affectionate Janey."[91] (The Morrises had just moved into a new home on the river at Hammersmith, and had christened it Kelmscott House.)

Much of Gabriel's production in these years was worked up from old sketches and drawings of Jane. When he hinted that he would like her to sit for one more picture, Jane declined: "As to sitting again, I should be but too happy to feel myself of use again to any human being, but it is scarcely likely that my back will improve with age. Still I will not despair yet, and you may be quite sure that if at all possible, I shall let you know."[92] In the past she had sat for him when her back was bad, propped up on pillows; now she used her illness as a reason for keeping away from Cheyne Walk.

While Jane and Gabriel lingered over their ailments, Morris was

pushing on with his work, always his first bulwark against the sadness at home. Deciding that he wanted the firm to try to weave tapestry, an art form he had loved ever since he had seen a fading gem at Queen Elizabeth's Lodge in Epping Forest when he was a boy, he started by paying a visit to the last remaining factories in France. Then, as he always did, he set himself the task of learning the craft before he asked his workers to undertake it. A tapestry loom was set up in his bedroom at Kelmscott House. Early in the morning, while the rest of the family slept, he put in a few hours at the loom as he watched the dawn break. His first effort was a design he called "Acanthus and Vine"; his notebook shows that he spent 516 hours on it between May 10 and September 17, 1879, an average of four hours each day.

Morris also developed a second, enormously demanding career that took him away from his family: He turned to radical political action during the second half of the 1870s. The role of upholsterer to the upper classes had begun to grate on his nerves and gnaw at his conscience, and he alienated more than one wealthy customer by explaining that he was fed up with "ministering to the swinish luxury of the rich." After much study and reflection, he concluded that socialism was the only ethical alternative.[93] He read Marx's *Kapital* so many times that his copy almost fell to pieces.

Soon, in an attempt to arouse and engage a working-class audience, he was writing lectures about the need for a class revolution and delivering them to anyone who would listen on a street corner of a Sunday morning — the only morning that working people had leisure. At first writing the speeches came hard — the "cursed words go to water between my fingers" — and public speaking was exquisitely uncomfortable.[94] But he overcame his awkwardness and at the height of his career regularly drew a crowd of a thousand to a hall in Manchester or Liverpool. To get the message out in print, he started a socialist newspaper, wrote many of the articles, and footed the bills. He also devoted hundreds of hours to meetings of various socialist organizations. Jane was sympathetic to his political beliefs and supported him, but she worried about the strain on his health, since he was now working far too hard. She also feared for his physical safety, and she had reason to worry. In a letter written after one tumultuous mass meeting, he asked Jenny to reassure Jane — "Tell your mother no policeman's hand touched my sacred collar."[95]

Taking a rare holiday in the summer of 1880, Morris rented a

houseboat so that the family could make a trip they had long dreamed of, all the way up the Thames from London to Kelmscott. The Morrises invited four guests, including their old friends Crom Price and William de Morgan, to join them. Morris did all the cooking, and Jane spent her days basking in the sun, for the weather was exceptionally fine. She stretched out on the deck with embroidery hoop in hand, and Morris enjoyed watching her enjoy herself. At Oxford she left the boat and went ahead to open up the house and get it ready to receive visitors. When the rest of the party reached Kelmscott after dark, they saw that Jane had lit every lamp in the house to greet them with a blaze of light.

Family life actually gave Jane far more pleasure than she was willing to let on to Gabriel. She never disparaged her husband to her daughters; on the contrary, she felt that "they have inherited from their Papa that precious gift of enjoyment . . . are they not merry little things?"[96] Many visitors to the Morris home saw contentment there rather than the desperation that Jane expressed to her lover. Morris's tutor in Icelandic, Eirikr Magnusson, who was often in the house, saw no misery; Jane was Morris's "truly charming wife" who was the "one unchanging delight of his inmost heart."[97] One of Jenny's friends from school loved to visit Kelmscott House because Mrs. Morris fascinated her: "To see Mrs. Morris reclining on a couch in all her strange beauty, her long pale hands moving deftly over some rich embroidery; to watch for the slow raising of her stone-grey eyes from under the brooding brows and listen for the delicious chuckling laugh with which she would greet our youthful extravagances — these were enough for me."[98]

By 1880, all that endured of Gabriel and Jane's grand passion were his dramatic avowals of attachment to her. On January 7 he wrote: "Dear suffering Janey, I have just kissed your handwriting, the most welcome thing in the world that I could have seen today. I am not *so very* low except on your account just now, but I had got so nervous and frightened about you that I don't know how I should have got through the night if I had not heard."[99] He now understood that his depressions made her unhappy, so he stayed out of her way much of the time. He told her of his "continual conviction that, if I make an appointment with you, I shall be far from being the only sufferer by my own gloom and blackness."[100] Jane tried to brace him up; one of her letters carries the brief postscript "no more jeremiads."[101]

One day in the early spring of 1881 the weather lifted, and so did

Gabriel's spirits, for Jane was coming to pose for *Desdemona's Death-Song*. She arrived at Cheyne Walk in time for lunch, and spent the afternoon modeling in the studio. For once Gabriel was in fine fettle, chatting away with all his old gusto. When they finished he gave her a delicious dinner and then insisted on escorting her home in a cab. To prolong the happy day, Jane cajoled him to come into the house, just for a moment, to see the girls, and he actually made it halfway up her walk before he lost his nerve. In defeat he turned and crept back to the cab for the journey home. They never saw each other again.

<p align="center">⚜</p>

Gabriel sensed that the end was coming. In early summer he grew deaf in the left ear. In December he suffered a stroke that paralyzed his left side, particularly the hand and arm; he never fully recovered. Death was no longer love's seductive twin, now that he was looking it in the face; instead, he saw only a horrifying descent into nothingness. Sensing his fear, family and friends gathered round to protect him.

Fanny was a casualty of their concern. Since Gabriel had rented a house for her in 1876, she had lived there much of the time, and in 1879 she had married again. Her husband was made to understand that Gabriel came first, and Fanny had continued to spend many evenings in Cheyne Walk, comforting Gabriel. But on November 27, 1881, Gabriel wrote her the briefest of notes: "Dear F. Such difficulties are now arising with my family that it will be impossible for me to see you here till I write again. D.G.R."[102] Cheyne Walk, which had been her province for almost twenty years, was now denied her.

Gabriel had enlisted a new nurse-companion, an ambitious young writer and journalist named Hall Caine, to replace the long-suffering George Hake, who had been summarily dismissed for imaginary insults in 1877. Caine had made himself indispensable, not least by convincing the Liverpool Corporation to pay £1550 for the enormous *Dante's Dream at the Time of the Death of Beatrice*. Caine was fiercely protective of Gabriel and jealous of Fanny, whom he was eager to shut out of Cheyne Walk.

Gabriel became so fragile that he could not bear the strain even of seeing friends. Denying Ned's request for a visit, he sent a line without salutation or signature: "Thanks, but I am very ill, and not well enough to see you. I can hardly write."[103] When Hunt asked to see him one last time, William Rossetti judged that Gabriel was too nervous and gently asked him not to come.

At the end of October John Marshall sent his best nurse, Mrs. Workman, to Cheyne Walk to try to get Gabriel off the chloral, but she failed. In December, after Gabriel had suffered the paralytic stroke, Marshall asked Dr. Maudsley, a nephew of the eminent specialist, if he would take on the challenge. Young Maudsley spent a month at Cheyne Walk administering injections of morphia under Marshall's direction, and finally Gabriel's addiction was checked. By now it was too late to help the patient much.

In February 1882 a friend offered Gabriel the use of his cottage in the village of Birchington-on-Sea, near Margate, and he accepted the offer. For some time he was alone in the cottage with only Caine, Mrs. Workman, and Caine's twelve-year-old sister, Lily, to talk to. Soon a stream of friends appeared; even his old patron Frederick Leyland cared enough to travel to this obscure village for one last visit. Howell swooped down, brushed Caine aside like a fly, and gave Gabriel one of his last light-hearted days, sitting by his bed regaling him with tales of his latest enterprise, selling horses for the king of Portugal. After he had gone, Gabriel spent the evening amusing Caine with wild stories of Howell's checkered past.

But many old close friends were missing, having been alienated over the years when Gabriel turned away from them as the madness came on and made him fearful even of his dearest comrades. One person who was conspicuously absent through these last months was Jane. She never came to visit, and if she wrote, her letters were destroyed. There is no evidence that Gabriel ever asked for her. Perhaps he did not want her to see him in his pitiable condition; perhaps she did not feel able to bear the sight.

In March Mrs. Rossetti and Christina came down to nurse Gabriel, who was now so weak that he rarely left his bed. At the beginning of April, Christina judged that the end was near and sent for William, who was shocked to find his brother "barely capable of tottering a few steps, half blind and suffering a great deal of pain."[104] Nonetheless, he kept on painting and writing poetry, even though he could spend only a quarter of an hour at his easel before he tired.

On the last morning of Gabriel's life, April 9, 1882 — Easter Sunday — he asked Caine in a thready voice: "Have you heard anything of Fanny?" Caine lied: "Nothing at all." Gabriel was suspicious. He trusted Fanny and knew that she cared for him. "Would you tell me if you had?" Caine bolstered his lie: "If you asked me — yes." "My poor Fanny," Gabriel murmured. Caine had the grace to be embarrassed, but neither the wit nor the courage to reverse himself and tell

the truth, though he knew there was precious little time left. "Unable to say anymore I went out of the room, feeling how poor and small had been our proud loyalty compared with the silent pathos of his steadfast friendship."[105] Elegant words, written long after the fact.

That evening Gabriel died, with his mother and sister sitting beside him. For all of them, especially William, the death came as a relief. As a last act of devotion to his friend, the highly strung Frederic Shields forced himself to sit by the bed and make a beautiful, careful sketch of Gabriel's face, calm now as if death had been a liberation.

The funeral was held at two o'clock on the following Friday. In accordance with his wishes, Gabriel was laid to rest not at Highgate, next to Lizzie's unquiet grave, but in the churchyard at Birchington. The death had been kept quiet to delay the onslaught of creditors, but fifteen of his friends who had been notified made the trip down. Graham, Leyland, Stephens, Boyce, and his Aunt Charlotte were there. Ned had started out but became ill and had to turn back halfway. Neither Jane nor Morris made the journey. Absent, too, was Swinburne, whom Gabriel had shut out; still confounded in his bitterness, the poet wrote: "To this day I am utterly ignorant and unable to conjecture why . . . he should suddenly have chosen to regard me as a stranger."[106] Many friends shared his perplexity. Also absent, but not by her own choice, was Fanny, who had written to William begging to be allowed to come to the funeral. He wrote a frosty letter to tell her that her request had come too late.

Many years after Gabriel's death, Ned was brooding about the significance of Gabriel's life one day in his studio, and he said to his helper: "I never knew anything that could encourage the superstition that some people had, that the gods were jealous of the possible achievements of great men, as much as in Rossetti's case. Everything was ready for the making of a glorious creature. The perfect hunger for romance that was spread abroad in the world at the time when he came into it. . . . It was lamentable to see the downfall, like the fall of a great Colossus, a great mountain. Down he went. We *all* suffer for it."[107]

<p style="text-align:center">❧❧❧</p>

Naturally it was William who had to clear up his brother's tangled affairs. Creditors came out of the woodwork; two chemists produced accounts amounting to a hundred pounds for chloral alone. A sale of household effects brought in almost three thousand pounds. After the

auction, Howell saw that Gabriel's unsold bed was about to go to the auctioneer's men for ten shillings; he opened his wallet and emptied it because he could not bear to see the bed taken by strangers.

Ned offered to touch up the background of *Found,* the "calf picture" of the prostitute and her village lover for which Fanny so many years ago had come to Gabriel's studio where " 'e put my 'ead against the wall and drew it for the 'ead."[108] Gabriel had tried and failed to finish this painting many times right up to the very end of his life. Now, out of love for his former master, Ned filled in a wash of blue sky, and William Graham finally received the picture he had paid for thirteen years earlier. A death sale of paintings and drawings held at Christie's yielded another £2800. After all debts had been paid, there was a small balance that, under Gabriel's will, went to William and his mother. Jane was given first pick of his paintings and of the jewelry he had collected to adorn his models.

Fanny had not been left a farthing, because Gabriel's mother and sister had been in the room while he was dictating his will. William was outraged when he learned that Gabriel had given Fanny, in addition to various paintings, £1100 in cash over the last seven years. When Fanny's new husband, John Bernhard Schott, produced an I.O.U. from Gabriel in the amount of three hundred pounds, William balked. Writing to Gabriel's friend and solicitor, Theodore Watts-Dunton, William admitted: "I know that you have always regarded her case as strong and mine as weak." Nonetheless, he argued, "perhaps we might terrorize [Fanny] a little" by hinting that she had stolen a portrait of Gabriel that she said he had given to her.[109] (He had in fact given it to her.) It seems that in the end William settled the debt for sixty-five pounds.

The whole family participated in the preparation of Gabriel's poems and letters for publication, a project that became almost an industry in William's hands during the next twenty-five years. Mrs. Rossetti was given the first right of censorship. On November 7 Christina sent William a package with this message: "Yesterday Mamma completed her look-thro' of Gabriel's letters. The accompanying parcel makes up the entire number she offers you to choose from (marked here and there with the monitory blue pencil)."[110] The attempt to clean up the unsavory Gabriel for posterity had already begun.

Morris was generous enough to recall that Gabriel had been "very kind to me when I was a youngster." Death did not, however, soften his view of the man who had helped to cleave his life in two; in fact,

it may have freed him finally to speak truthfully about him. In the same letter he wrote: "What a great man he would have been but for the arrogant misanthropy that marred his work, and killed him before his time."[111]

In a letter to Crom Price, Jane said that she was surprised by the weight of her grief for Gabriel, for she had imagined that she would feel only grateful when he was released from the torture of his mental pain. She thought her grieving had already been done long before, when she had had to break with him, but she had been wrong.

꧁ ꧂

At the time of Gabriel's death, Morris was immensely preoccupied with moving his business out of Queen Square. Needing more room, he had begun a search for a new factory. Eventually William de Morgan found him an old set of buildings near London at Merton Abbey on the River Wandle, which had been used to print calico. The setting was lovely, with an orchard, and the pure water of the river enabled Morris to set up his own dye works. He finally had room to install the machinery he needed to weave a serious amount of silk. In fact, on seven acres there was enough room to move the carpet making out of his home and consolidate all the work — stained glass, carpets, tapestry, and block printing — in one place. In the garden he laid out plots for his workers so that they could grow their own vegetables and flowers if they chose.

The only drawback was the distance: The journey from Kelmscott House took two hours on public transport in each direction. Morris kept a bed at Merton Abbey and slept there many nights in the hectic early days. By 1885 operations were running so smoothly that he had only to make the trip twice a week, but by then he was spending most of his time on socialist politics, which also took him from home, sometimes for weeks rather than days.

In the year after Gabriel died, Jane had found another lover to fill the gap he had left. Wilfrid Scawen Blunt, another poet, albeit a minor one, was in his own peculiar fashion also eager to worship her. Their meeting was no accident. Blunt asked Rosalind Howard to invite Jane for a visit to Naworth, the Howards' ancestral castle in Northumberland, so that he could make her acquaintance. Then he applied himself to the task of charming her. He read her his poetry in the garden. He talked casually of his bold travels in the desert, making light of life-threatening encounters with hostile Bedouin

tribesmen. He described his pink villa surrounded by apricot trees in Egypt. He dilated on his disgust with British oppression of the Irish. Having observed her carefully all the while and judged her sufficiently intriguing, he made sure that a thriving intimacy sprang up between the two of them almost overnight.

Certainly one of the most curious and extreme characters of his time, Blunt was a hopeless romantic, a raving egoist, a devotee of Catholicism and Mohammedanism, a self-styled ambassador without brief to Egypt and Ireland, almost a successful candidate for Parliament, a modestly gifted poet, a prodigious diarist, and above all a brilliantly successful seducer of young women, mostly chosen from the aristocracy or at least from among the very rich. He imagined himself a poet and lover in the tradition of his hero, Lord Byron, and from his early twenties until his death at the age of eighty-two he almost always had a mistress; often he was juggling two or more.

Blunt saved the letters Jane wrote to him (more than 130 in all), and it is clear that from the start Jane pursued him at least as avidly as he pursued her. In the first letter that has survived, written in July 1884, she made a polite inquiry about whether he would consider undertaking an article about Egypt for a socialist magazine her husband was interested in — but the heart of the matter was in her closing: "When are you coming to see me again?"[112]

Blunt did not let the grass grow. The next afternoon he was calling on Jane at Kelmscott House, where she received him in the drawing room that Morris had wanted to make the most beautiful room in England, filling it with glass, drapes, tapestry, and rugs he had designed and made in his own factory. What Blunt cared about were the portraits by Rossetti that hung there. He drew Jane out on the subject of Rossetti, who was in fact far more interesting to him than she was. As he made ready to leave, Jane took his hand in both of hers. Sensing that she was asking for a sign of affection, he kissed her fingers.

Nine days later on July 16, Blunt escorted Jane by train to his country home, Crabbet, for a visit. For four days he exerted himself to please and amuse her. In his diary he wrote that on the first afternoon they had a "curious conversation" with the "ghost of Rossetti" following them as they meandered through the garden. Jane confided that she had broken with Gabriel "on principle" and had regretted the break. By the time they parted, Blunt believed that Morris did not understand her. He summed up the visit in his diary, lamenting

only that Jane was too old for him: "If we had met ten years ago, it would have been still more interesting."[113]

At forty-four, ten months older than Blunt, Jane was a good twenty years older than most of the women he sought out. He perceived her as a fly caught in amber, trapped in the past where she had lived with Rossetti; she interested him "like a person risen from the dead."[114] Fortunately, in Blunt's view, Jane was aging very slowly; she had few wrinkles and little gray hair, and she had kept her figure. What Jane appreciated about Blunt was the fact that he didn't worship her from afar; instead he sat right next to her on the couch and kissed her hand, then invited her to bed. It is not clear exactly when they became lovers, but Blunt remarked in his diaries that their relation was "essentially physical and real and indulged as often as we met."[115]

It seemed only fitting to Blunt that he should be the one to console Jane for the loss of Rossetti, who had now superseded Byron as his hero. Having taken up Gabriel's position in Jane's bed, he consciously tried to recreate Gabriel's experience, hoping, apparently, to draw from the same well that had served to inspire his hero's poems. To Blunt, the affair seemed poignant, even elegiac; Jane was a "poor woman" who sat "under the portraits of her youth" in the drawing room that was "merely a tomb."[116]

By contrast, the affair made Jane feel more vital and alive than she had felt in years. The tables had been turned. Whereas Gabriel had pursued her eagerly, now she sought Blunt — and she did so with a great deal of confidence and zest. For Jane their assignations were a revelation. She opened herself to Blunt in a way that she never had to any other man.[117] A fevered note without salutation or signature read: "I can't write you a letter my soul is in too great a turmoil, whether it will ever calm down again Heaven only knows — Many many thanks for the poem."[118] Ten days later she was still drifting about house and garden in a haze of desire: "I move about in a sort of dream, as if a spell had been cast over me and the whole place. Are you sure you have brought no magic arts from Egypt, and have employed them against a poor defenceless woman?"[119]

Blunt offered Jane flattery and passion, but he also became a refuge from her grief about Jenny's illness. Often Jane felt as if she could not bear the strain of waiting for Jenny's next attack, but she had to hide her distress, for it scared Morris, who feared that Jenny would have to be sent to live in a sanatorium. For much of the winter of 1888 Jenny was almost out of her mind. Unable to talk freely to her

husband, Jane could write to Blunt about the cost of this illness to herself: "It has been a dreadful grief for us all, worse for me than for anyone, as I have been so constantly with her. I never get used to it, I mean in the sense of not minding. Every time the thing occurs, it is as if a dagger were thrust into me."[120] She hid nothing from him, telling him even about Jenny's frenzied attempt to kill herself by throwing herself out of a window, under the delusion that she had murdered her beloved father.

One afternoon when Blunt stopped in for tea, a seizure came over Jenny, and he watched aghast as she fell back against a cabinet so quickly that he could do nothing to save her. In an instant she had gashed the back of her head on the corner of a wardrobe. From that moment he had great sympathy for what Jane's daily life was like, and he was always conscious of the pain she endured.

In the fall of 1888 Blunt was invited down to Kelmscott Manor for the first of many visits. There he could really sink into his fantasy of connection to Rossetti, who seemed to him a "constant presence" in the house. Even the initials DGR on the napkins aroused him. In the evening, if Jane wanted him to come to her, she would leave a pansy in his room. Blunt was usually put in a guest room next to Morris's bedroom, where he listened quietly to the rhythm of his host's breathing until he judged that the latter had fallen into a deep sleep. Then he crept down the passage to Jane's room, enjoying every creak and groan of the floorboards: "Danger in love always acts with me as a physical stimulus, and passion is never so strong as when I am conscious of a tragedy approaching and hear its footsteps already in the next room."[121]

It was only in the privacy of Jane's bedroom that Blunt felt he truly came to know her. Although by her standards she confided a great deal in him, he still found her "so silent a woman," and he believed that "except through the physical senses we could never have become intimate." The two of them had by his lights "little really in common on the outside of things."[122] He delighted in what his senses told him, but even in bed he was obsessed with the way in which age had taken its toll: "In her prime she must have been the most beautiful woman conceivable — I do not mean her face."[123]

Blunt also used his visits to Kelmscott as a chance to get to know Morris better. As a matter of policy he cultivated the husbands of the women he seduced, believing that "the continuance of one's love for a married woman depends so often on the pleasant relations one

may establish with her husband." He regarded this practice as one of the "secrets of the heart which are not known even to our best novelists."[124] But Morris was not just a run-of-the-mill husband; Blunt admired him tremendously, as a poet, as a craftsman, and as a committed socialist, and was well aware that the range of Morris's intellect and learning far outstripped his own. He was fascinated by Morris's capacity for concentration on work and ideas, for it was a kind of forgetfulness of self he could not imagine. What confused him was that Morris kept his feelings to himself. Blunt imagined that because he did not display them, he simply didn't have any.

For his part, Morris tolerated Blunt, and even enjoyed sparring with him, but was careful to keep him at a distance. Blunt knew that Morris was suspicious of his relations with Jane: "More than once, after having left us alone together, I noted that he had returned suddenly on some pretence to the room where we were, blundering with loud footsteps and as if ashamed of a suspicion which he had not been able to control. Finding nothing, he was far too generous not to put the thought aside either with her or me. And yet there was reason."[125] Morris did not truly want to know what was happening, or he would have made it his business to catch them out. Instead, he was warning the pair that he was not oblivious of their intimacy.

Morris never completely stopped trying to close the distance between Jane and himself, but as part of his maturation as a socialist he had forced himself to contemplate the political realities of their failure at marriage. Writing to George Bernard Shaw in 1885, he had commented on the general problem of women's economic powerlessness, which he now understood had determined the course of Jane's life: "Nor do I consider a man a socialist at all who is not prepared to admit the equality of women. Also that as long as women are compelled to marry for a livelihood real marriage is an exception and prostitution or a kind of legalized rape the rule."[126] The statement shows how far Morris's socialist analysis had gone. He had read his Engels carefully; he had also grown through contact with women in the socialist movement, such as Eleanor Marx Aveling and Annie Besant. Unlike most of his contemporaries, he had the willingness and the courage to ponder what they said and not to flinch before it.

This insight must have been sharply painful for him, for it forced him to see that by marrying Jane he had compelled her to do something she might not herself have chosen. But it also restored to him a measure of comfort and dignity; by letting her go to Rossetti and

to Blunt, when other husbands would have constrained her, he had
allowed her her freedom rather than subject her to a lifetime of "le-
galized rape." As far as he was concerned, "copulation is worse than
beastly unless it takes place as the outcome of natural desires and
friendliness on both sides. So taking place there is something sacred
about it in spite of the grotesqueness of the act." In the world of
"real socialism," men and women would be free to enter into "gen-
uine unions of passion and affection." The present arrangement, in
which "once two people have committed themselves to one act of
copulation they are to be tied together throughout life no matter how
miserable it makes them, their children or their children's children,"
seemed foolish and cruel to him.[127]

<div align="center">⚜</div>

After the heady summers of 1888 and 1889, Jane's affair with Blunt
began to wane. Blunt was distracted by a stream of younger, livelier
women. Jane got lost in the shuffle, and she knew it. On October
18, 1890, she spent the day with Blunt, and he wrote in his diary that
it had been "the last I fancy in a quite intimate way — she felt this
and said it, and I did not contradict. I lunched with her and Jenny in
their melancholy house, and then we went out to see Burne-Jones
and talk over a design for the tapestry."[128]

The relationship trailed off slowly; that "last day" was not in fact
quite the last. Blunt made her a series of intimate farewells. On
September 30, 1891, he was down at Kelmscott to discuss the printing
of a book of his poetry by the Kelmscott Press, Morris's latest venture,
and "I made a little love to Mrs. Morris, poor woman, for quite the
last time."[129] On August 12, 1892, he was at Kelmscott again, where
"we slept together Mrs. M. and I" and talked of Rossetti.[130] Appar-
ently he simply couldn't think of anything else to do with her. Finally,
on a visit to Kelmscott in August 1894, Blunt rejected her outright.
Climbing the stairs to his room he found a pansy on the floor, but
he ignored it: "It is too late alas, and I slept soundly."[131]

It is difficult not to wonder how Jane could have been bored by
her husband and yet irresistibly drawn to Rossetti and then to Blunt,
both of whom were raving egotists and, where women were con-
cerned, moral dwarfs. Gabriel had the fascination of a weird sort of
genius to offer, but Blunt was memorable primarily by virtue of his
sexual stamina. They shared a gift for silver-tongued flattery, though,
and Jane seems to have had an almost boundless need for reassurance.

Taking enormous risks to satisfy it, she closed her eyes to a great deal, not least to the pain she caused her husband.

Those who met Jane diverged widely in their opinions of her. Some recognized her intelligence; others found her insipid. Jane showed only as much of herself as she chose. George Bernard Shaw found her the "silentest woman I ever met";[132] another acquaintance found her an "admirable talker" who was "interested in a thousand things" and "wholly without self-consciousness, always gracious, and in her person beautifully dignified."[133]

Part of Jane's problem was her great beauty, which conditioned the way in which people responded to everything else about her. Graham Robertson, who liked her immensely, thought that the role of beautiful, silent sibyl had been forced on her as a result of her extraordinary physiognomy: "I fancy that her mystic beauty must sometimes have weighed rather heavily upon her. Her mind was not formed upon the same tragic lines as her face; she was very simple and could have enjoyed simple pleasures with simple people, but such delights were not for her. She looked like the Delphic Sibyl and had to behave as such. She was a Ladye in a Bower, an ensorcelled Princess, a Blessed Damozel, while I feel sure she would have preferred to be a 'bright, chatty little woman' in request for small theatre parties and afternoons up the river. Brightness might equally have been expected from Deirdre of the Sorrows, chattiness from the Sphinx. She was Venus Astarte, 'betwixt the sun and moon a Mystery,' and there she had to stay."[134]

But Jane was by no means simple. Although she clearly took both pleasure and sustenance from Gabriel's and Blunt's adoring attentions, she was also straightforward, funny, and affectionate in her own right. Sydney Cockerell, a friend of the family and Morris's secretary for a time, said that Jane was truly "merry with her intimates."[135] Even Shaw somehow managed to discern that "she had a certain plain good sense which had preserved her sanity under treatment that would have spoiled most women."[136]

Graham Robertson came close to the heart of Jane's dilemma in his perception that appearance affects fate and an extreme appearance determines fate more absolutely; the lives of beautiful people follow a different course from those of the rest of us. Beauty confers great power, but it also imposes limitations. Virtually everyone responds to beauty first, whether out of desire or out of envy, and all because of an accident of birth. Beauties get the adulation we all think we

crave, but they also suffer a peculiar sort of isolation, for our judgment of them is so conditioned that we may not ever see through to their hearts and minds. If we do discern their thoughts or feelings, our response is still distorted by what their appearance means to us. Jane knew that if she had been born plain, Morris probably would never have been attracted to her, married her, or taken her out of St. Helen's Passage. Nor would Gabriel have painted her or lavished such extravagant attentions upon her. The knowledge that her face had been her ticket can only have reinforced her insecurity, for beauty is fragile and passing.

This was a woman who thought little of her real self, who felt that her background was shameful and that her physical feebleness made her worthless. She could not imagine any work of her own, anything worthwhile that she might do; her only identity was as the model and lover of men who were artists. When she found herself enjoying a brief period of good health late in 1888, she was scared by the prospect: "I shall have to find something to occupy my time if I keep as well as this," she wrote to Blunt. "I can think of nothing but novel-writing, one of my sisters-in-law suggested standing for a Poor Law Guardian. I wonder which I should do worst."[137] Several years later she admitted: "I am always inventing plots for novels, and if I ever find myself anywhere in peace I should develop them, but I daresay they would be bad and would not sell."[138]

Jane always fed Blunt's appetite for stories about Gabriel, and as their affair wound down she seems to have told Blunt more and more about herself and Gabriel, perhaps in an attempt to hold his interest. Or maybe he simply pressed her harder, intent on getting as much of the story as possible before his power over her faded along with their intimacy.

One winter afternoon in 1886, in the early days of their relationship, Blunt took Jane to visit the Grosvenor Gallery and then returned home with her to Kelmscott House for tea. There he drew her out on the subject of Rossetti. Later that day he entered in his diary a short summary of what Jane had told him, which is most interesting for what it tells us about how Jane saw Gabriel's life: "Rossetti's history seems to have been briefly this. Till his wife died, he led a virtuous and aesthetic life. But then, having an incurable melancholy, threw himself into debauchery. From this he was for a time converted

by his liaison with Mrs. Morris, but only for a time. She says she gave him up on account of his chloral drinking and because she could not leave her home and her children and after they separated he went steadily from bad to worse until he died."[139] Gabriel had clearly edited his story for Jane, erasing Annie Miller and Fanny Cornforth from the period before Lizzie's death. He also deleted Fanny from the years he spent with Jane, who believed that she had rescued him from debauchery by offering him a higher, more spiritual relationship — a fantasy that was in tune with Gabriel's own view of their affair.

Blunt went on to describe Jane: "She is more like a Spanish or Italian than an Englishwoman, in character: that is to say, she is kindhearted, physically passionate, but not a sentimental woman. She has an outside garment of romance, from having constantly lived with romantic people, and a certain outside knowledge of art, from having lived with artists. But none of this is natural to her, and she is essentially domestic and in its better sense commonplace. She attracts me however, perhaps on account of Rossetti."[140]

Four years later Jane told him that although she and Gabriel had corresponded before her marriage, "he never made love to her then." She confided that she had destroyed many of Gabriel's early letters, but that she still had ten years' worth — "love letters," she said, "and very beautiful ones." Worried that she might burn the rest, Blunt urged her to preserve them as intimate documents of a great artist. Jane admitted that she was ambivalent about their disposition; she did not want her husband and children to see them and be hurt by them. Sometimes she thought she would just brick them up into a wall at Kelmscott and let fate decide. Naturally, Blunt felt that the perfect solution to her dilemma was to bequeath them to him, the ideal guardian. Jane readily agreed, "for there is nobody now living," she said, "who knows me as you do."[141]

Blunt waited until 1892, when he had known Jane for almost ten years and their affair was definitely on the decline, before he dared to ask whether she had been in love with Gabriel. Her reply was curious: "Yes, at first, but it did not last long." Jane had been involved with Gabriel for at least eight years. His major breakdown came soon after their first idyllic summer at Kelmscott; perhaps afterward the joy went out of it for her. Or perhaps she was just flattering Blunt, making him feel grand because he had been her lover longer than his hero had been. Later Blunt added a notation in pencil: "It was very warm while it lasted."[142]

Now he pressed Jane to explain why she had broken with Gabriel. Again her answer is confusing: "When I found that he was ruining himself with chloral and that I could do nothing to prevent it, I left off going to him — and on account of the children."[143] Gabriel had been dangerously addicted to chloral for several years before Jane broke with him, and she had known he used the drug. But apparently she had denied the extent of the problem for years, as the families and lovers of addicts so often do, until she was confronted by the row of quart bottles in that frigid rented house in Bognor Regis. Furthermore, worried or not, she had kept her daughters with her every summer at Kelmscott, and had even brought them along when she went to see Gabriel immediately after his breakdown.

"I think I loved you for Rossetti's sake," Blunt said then, scaling new heights of insensitivity. "He is the one modern poet who interests me." Although he made no pretense that he had loved Jane for herself, she took this news in good part, replying: "If you had known him, you would have loved him, and he would have loved you — all were devoted to him who knew him. He was unlike other men."[144] Rising from the sofa, she drew Blunt over to the cabinet that Ned had given to her and Morris as a wedding present and opened the door so that he could see the picture of Lizzie that Gabriel had painted on the inside panel.

Whether Blunt's casual announcement that she had been only a means to an end wounded Jane, we do not know. She may have grown so accustomed to being no more than the catalyst and conduit for men's feelings and their art that it seemed natural to her, not something to fight or bemoan. She had been the damsel in Morris's castle; she had been the goddess of Gabriel's paintings. Perhaps the fact that she had become a sort of aesthetic trophy for Blunt did not shock her. Blunt had brought her a great deal of pleasure; maybe she felt they had made a fair trade.

<center>❧⚭❧</center>

While Blunt was drifting away from Jane, Jenny's condition was deteriorating, and in February 1891 she suffered an attack of "brain fever" (possibly cerebral meningitis) and almost died. Because there was no medication to control her seizures, they proceeded unchecked, and over the years the illness eroded her intelligence and her motor skills. Watching this inexplicable, inexorable tragedy take over their daughter's life was more than either Morris or Jane could bear. At

the end of 1892, Jane's doctor insisted that she must go abroad or risk "melancholia," and so she went to Bordighera.

In Italy Jane slowly healed herself, resisting the temptation to give way to her depression altogether, pulling round by what she had once described to Gabriel as "one of those gigantic efforts I have made so often to so little purpose."[145] This time there was great purpose; everyone needed her at home, even May. May had fallen wildly in love with George Bernard Shaw, who had seemed to return her feelings but then dropped her cold. On the rebound she had married a young socialist named Henry Halliday Sparling, whom both Morris and Jane thought a bad choice. Now Shaw had returned to haunt May. He was ill and his rooms were being redecorated, so May took him into her home to nurse him. At first her husband was perfectly willing to entertain May's friend, but as the winter progressed, it became painfully apparent to him that May and Shaw were in love. When the situation became uncomfortable for Shaw, he suddenly disappeared, leaving May distraught and alienated from her husband. Finally, in June 1894, Sparling left May and went to live in Paris.

Jane turned to Blunt once again: "May's married life has come to an end, and although we always expected some catastrophe or other in that direction, the blow is no less heavy now it has come. We have not spoken of it yet outside the family. . . . I feel at this moment as if I should never visit or see friends again, though I know that time cures much sorrow." There was no mincing of words; Jane placed the responsibility squarely on her daughter's shoulders: "May's position is this, she has been seeing a good deal of a former lover, and made her husband's life a burden to him, he refuses to bear it any longer."[146] Jane must have felt some sympathy for May, since she could not have refrained from thinking about what would have happened to her if Morris had refused to bear Gabriel any longer.

This year Jane also wrote to Blunt: "Always I have the anxiety of my husband's health."[147] A combination of gout and overwork had worn Morris out, but it was grief over Jenny that had finally stolen his hope and undermined his health. Despite a frightening loss of weight and increasing feebleness, he pressed on with his work, driving himself to complete as many projects as possible in the time he had left. As he spent more and more time in bed, Jane and May decided to embroider him a royal set of bed-curtains and coverlet. Jane spent hundreds of hours stitching the coverlet herself, with help from just one friend — an extraordinary labor to clothe the bed she had avoided

for so many years. What's more, it was a bed her husband could not occupy for long, since he was obviously dying. This effort suggests that she wanted to let him know through her art what she could not say aloud: that she honored and cared for him despite the distance that had grown up between them. She finished her work by signing one of the corners with her name and the motto *"Si je puis"* ("If I can"), the same motto Morris had chosen for himself in the early days at Red House.

For a long time he and Ned had planned to do an edition of Chaucer's poetry, which Ned would illustrate and Morris would publish at the Kelmscott Press. Now Ned felt that they were in a dead heat with death to finish the project. Out of love for Morris, he put his own work aside and bent over his drawing board to finish the illustrations so that the work at the press could go forward. To his surprise, the book was finished in time for Morris to glory in it, even if he was too frail to celebrate much. On June 24, 1896, the first fully bound copy, replete with eighty-seven illustrations, was delivered to Morris, and it seemed to them both that they had reached a goal they had been working toward all their lives, a crown to set on their collaboration and their love for each other. Ned wrote: "When Morris and I were little chaps at Oxford, if such a book had come out then we should have just gone off our heads, but we have made at the end of our days the very thing we would have made then if we could."[148]

To bolster their spirits, they immediately started planning a *Morte d'Arthur*, for which Ned was to do at least a hundred illustrations. No book and no work of art could, however, do more than put off the thought of death for a moment. By the winter of 1896 Morris had grown frighteningly ill. Jane was at her wit's end, and the doctors were at a loss to identify the problem. The symptoms of diabetes, tuberculosis, and kidney disease are apparent today, but at the time Morris's doctors could pin down for certain only nervous exhaustion and gout. Diabetes was finally diagnosed in the spring, by which time he was so weak that it taxed him to walk out to the garden, where he could lie in the sun and listen while Jane or Jenny or May read to him. Rest and sea air were prescribed, so Jane traveled by herself to Folkestone to search for rooms.

Life in a dreary hotel at Folkestone did nothing for their spirits. Morris continued to lose flesh, and Jane was anguished by the sight of him. She was worn out, but refused to hire a nurse. Georgie came

down and spent four days helping out and trying to amuse the patient, who was bored and irritable with inactivity. (Morris was no easy patient; when his doctor cut him back to one cup of tea a day, he got himself an enormous teacup.) A cruise to Norway was tried, to no avail.

In August a plan was made for Morris to go down to the country to Kelmscott, where Jenny was staying with her nurse, but he grew too weak to make the journey and had to write to tell the daughter who adored him that he would not be coming: "Dearest own child, I am so distressed that I cannot get down to Kelmscott on Saturday; but I am not well, and the doctors will not let me; please my own dear forgive me, for I long to see you with all my heart. I hope to get down early next week, darling. I send you my very best love and am Your loving father W.M."[149] He never saw Kelmscott again.

On September 1 Morris sent Georgie the last letter he ever wrote with his own hand, asking for a "sight of your dear face."[150] She and Ned came regularly to check up on the patient, as did many of his friends. When Graham Robertson came to visit, Jane chatted with him upstairs in the drawing room for a bit, and then conducted him downstairs to Morris's bedroom. As they descended the staircase he asked her how Morris was, and unable to speak, she fell against the wall and hid her bowed head in her hands. Even at this moment of grief she could not escape her burden as model and muse: Robertson excused himself, knowing his reaction was inappropriate, but he later admitted that "in spite of the realization of tragedy" his mind "involuntarily registered the thought — 'If Rossetti could have seen that grand, wild gesture, what a picture it would have drawn from him!' "[151]

Everyone tried to cheer Morris. Knowing he loved medieval music, a friend brought a virginal to the house and played his two favorite pieces, a pavane and a galliard by William Byrd. Afterward Morris asked him to play them both once more, but when he finished for the second time, Morris begged him to stop because he could not bear to hear any more. Another friend brought painted books from the Dorchester House library, but he had strength to look at them for only a few minutes at a time. His old friend and collaborator Eirikr Magnusson called, and when he heard the feeble voice in which Morris issued his customary hearty greeting — "How are you, old chap?" — it was all he could do to swallow his grief and feign cheerfulness. To Magnusson, Morris acknowledged that he was dying, bursting out, "But this is such weary work!"[152]

On October 2 Ned came to call. For the first time Morris kept to his bed during the visit, making no effort to get up and greet him. The next morning both Ned and Georgie came. Georgie was in the room and Jane was kneeling by the bed when Morris died.

Georgie broke the news to Blunt, writing: "Janie is her own dear unaffected self and sets a tone in the house of quiet and dignity which is a help to us all."[153] When Blunt came to pay his last respects, he was touched by the unfinished oak coffin with wrought iron handles, covered by a beautiful piece of old Broussa brocade that Morris had long treasured. Afterward he went into the drawing room, where "I found Mrs. Morris lying on the sofa upstairs just as usual, she was not in black and wore her usual blue shawl, her hair now quite white. I kissed her which I had not done for long and comforted her as well as I could. 'I am not unhappy,' she said, 'though it is a terrible thing for I have been with him since I first knew anything, I was eighteen when I married — but I never loved him.' "[154]

Surely the terrible thing was her denial, terrible for her as for him. Even at the moment of her husband's death, she needed to emphasize to her old lover that she had never loved her husband. Perhaps that cold statement expressed the one great fact of Jane's life and she needed to say it at that time so that there would be no pretense, no false sympathy for her as the loyal, broken widow. Or perhaps she was simply too shocked to know what she felt. Years later she wrote to Blunt to praise him for staying with a friend whose wife had just died. Recalling the time of her own loss, she said: "I know I was simply kept alive by what my friends did for me."[155] After the funeral, she never wore anything but black or white, though she loved rich, royal colors. And when Mackail finished his excellent biography of Morris, she complained to Blunt that the book had "just missed being first-rate — You see Mackail is not an artist in feeling, and therefore cannot be sympathetic while writing the life of such a man."[156]

Morris was buried in the churchyard at his beloved Kelmscott. A special train carried the coffin down to Lechlade; there it was transferred to a farmer's cart painted yellow with bright red wheels. To Ned that "little waggon with its floor of moss and willow branches broke one's heart it was so beautiful." A strapping shire horse pulled the cart over the lanes to Kelmscott churchyard, with a long procession of black carriages following. Overnight it had rained and the meadows had flooded; as the day advanced, the storm grew violent and wind and rain lashed the mourners. A short service was read out

to the assembled crowd of friends and admirers, socialists and artists who had traveled all the way down to this remote village in Oxfordshire to honor their friend and leader. Georgie was glad because the rain stopped for a few minutes at the graveside. Afterward Ned summed up the day: "There were no kings there — the king was being buried and there were no others left."[157]

<div style="text-align:center">❦</div>

A month later Jane finally made the trip she had long dreamed of to visit Blunt at his winter home in Egypt. Now, however, it was too late for an idyll. He set up Jane and May in the Pink House, a lovely little pavilion he had had built the year before to house his current grand passion. Unfortunately, the visitors seemed unhappy from the first, which made Blunt uncomfortable. On November 29 he wrote in his diary: "Mrs. Morris's visit has been rather a disappointment — her daughter May is an obstinately silent woman and Judith [Blunt's daughter] is bored by her and I fear they are likely to be bored by us. Neither of them ride, not even donkeys, though Mrs. Morris has made an attempt and life without riding here is impossible. One cannot walk on account of the heavy sand, so they sit indoors all day. I go see them twice a day, but with May it is impossible to keep up any conversation and I am at my wits' end how to amuse them for I cannot make love to either of them and what else is there to be done."[158]

What he did do was to take off, setting out on an expedition into the desert and leaving them to while away the hours as best they could in the Pink House. Despite the lack of amusements, Jane and May settled in for the winter and did not return home until April 5, 1897. Blunt noted their departure in his diary, adding that he had advised Jane to set up a dairy farm at Kelmscott "as old age without a hobby is sad."[159]

Now that Morris was gone, there was little to hold Jane in London, which she loathed. She sold the lease of their town home and moved to Kelmscott. (When she packed up the house, she made Blunt a gift of the massive oak table that Morris had had built for the dining room at Red House.) Morris's estate, left to her and the girls in trust, was valued at £55,000, so she had no financial worries. Jane took some of the money and built two cottages for workers in the village of Kelmscott as a memorial to her husband.

Without him, she had to bear the burden of caring for Jenny by

herself, a burden that increased as the years passed. Nurses lived in, and when Jenny became too ill they took her away to Leamington or another spa so that Jane could have a respite. Georgie visited Kelmscott regularly, and in 1901 she wrote: "Jenny is so much slower in speaking and apparently in thinking than she was a year ago. She never speaks without being spoken to or almost never and seldom smiles."[160] In 1907 she wrote: "A week in Jenny's company has made me understand Mrs. Morris's life as I never did before."[161]

Within a few years Jane's relationship with Blunt became little more than an occasional visit and letters at Christmas, although their affection for each other was apparent in these annual interchanges. In his diary entry for August 10, 1903, Blunt reported a conversation in which Jane looked back on her marriage; of Morris she had said, "Though selfish in little things, in great ones he was most magnanimous, the least selfish of men. After all . . . I suppose if I was young again I should do the same again."[162]

At the very end, Jane's beauty seems finally to have waned. When Georgie's sister Louie saw Jane at Bath during her last years, she was shocked. Writing to Georgie, she described how Jane had "put her dear long arms about me with my head on her shoulder and clasped me to her. I think she is looking horribly ill . . . She is very lonely . . . she looks such a sad woman, and O Georgie, where is the beauty that determined the course of her life!"[163]

Jane Morris died at Bath on January 25, 1914, at the age of seventy-four. Blunt was sorry to hear of her death, but he was "glad to remember" that on the occasion of their last meeting, a year and a half before, he "had stayed a moment behind . . . and kissed her when we said goodbye."[164] She was buried on January 29, next to Morris in Kelmscott churchyard, in the tomb that Philip Webb had designed for them.

# Epilogue

ANNIE MILLER outlived William Holman Hunt by fifteen years. She died at the age of ninety in 1925. If it were not for Hunt's granddaughter Diana, who spent years slowly piecing her story together, Annie might still be a shadow today, relegated to a sentence here and there in an obscure memoir.[1]

Soon after Gabriel Rossetti died, Fanny Cornforth rented a space in Bond Street, which she christened the Rossetti Gallery. There, with the help of her second husband, John Bernhard Schott, she exhibited and sold some of the pictures Gabriel had given her over the years. Fanny and Schott supported themselves by managing the Rose Tavern in Jermyn Street. When Schott died in 1891, he left Fanny an allowance, which by 1898 had been reduced to fourteen shillings a week. Fanny never had any children of her own, but she lived with her stepson, Fred Schott, whose letters show that he was genuinely fond of her. She died in 1905 in Brighton, aged eighty-one.

William Rossetti's late marriage to Ford Madox Brown's daughter Lucy was a source of unexpected happiness. Although he had known Lucy since she was seven years old, he did not marry her until 1874, when she was thirty-one and he was forty-five. They had five children, one of whom died in infancy.

After Gabriel's death, William kept busy by turning out one volume after another of memoirs and letters and essays devoted to Gabriel, Christina, Maria, Lizzie, and himself. He also continued to take care of his mother until her death in 1886, and of Christina, who died of breast cancer in 1894. He himself survived to see the end of the First World War, dying on February 5, 1919, at his home in St. Ed-

mund's Terrace. His daughter Helen Rossetti Angeli took up the job of family chronicler, writing a book about Gabriel and another about Charles Augustus Howell.

>When Howell died in 1890, the story went round that he had been found in a gutter with his throat cut and a sovereign between his teeth. In fact he died in a respectable nursing home from complications of influenza. On this occasion Graham Robertson received a note from his friend Ellen Terry, the actress, that read: "Howell is *really* dead *this* time! Do go to Christie's and see what turns up." Apparently Howell had already arranged so many trumped-up death sales of his goods that almost no one attended, and his things were knocked down at bargain prices.

>Ford Madox Brown spent the last fourteen years of his life carrying out a commission to decorate the Manchester Town Hall with twelve murals illustrating the history of the city. He survived Emma by three years and died in 1893.

>John Ruskin outlived Effie Millais, dying in 1900 at the age of eighty. For many years he suffered intermittent bouts of madness. The Queen, who had also caused Effie so much grief, died a year later.

>John Guille Millais not only wrote a biography of his father, he also became, with his father's blessing, a fine painter of landscapes and wildlife. Geoffroy, son of the current baronet, Sir Ralph Millais, has continued the family tradition by writing a book about the work of his great-grandfather.

>Philip Burne-Jones was a painter of real talent, but he never emerged from the shadow of his father, and remained a dilettante. He styled himself as a fashionable playboy, but just underneath his brittle charm lay an earnest, painful wistfulness. A bachelor, he died of a heart attack in 1926, just six years after his mother passed away.

>Margaret Burne-Jones's life was much happier. Her marriage to Jack Mackail was a long and fruitful one, and she lived into the 1950s. Her son Denis Mackail became a novelist, as did Ned's favorite, Angela, whom we know as Angela Thirkell, the writer of delightful romantic comedies.

>After her mother's death, May Morris took up the responsibility of looking after Jenny. During the First World War she sold her house in London and moved down to Kelmscott, where she spent the rest of her life with her devoted companion, Mary Frances Vivian Lobb. There she looked out for the villagers, seeing that cottages were

mended and opening a soup kitchen on Fridays, and prepared an edition of the collected works of her father, which scholars have relied on ever since. Jenny died in 1935; May died three years later, at which time Morris & Co. was shut down.

❧

As a movement in painting, Pre-Raphaelitism was quickly superseded by impressionism, which was almost its antithesis, and so in the history of art it remains a revolt rather than a revolution. Nonetheless, these painters and their models made many different contributions, some blatantly commercial, others of a more subtle, emotional, and aesthetic nature, that echo down through our lives.

By means of their business acumen, the Pre-Raphaelites helped to create the art market as we know it today. A number of factors came together to provide these young men with an extraordinary opportunity. The remarkable growth of capital in Britain during Victoria's reign created a flood of new buyers, hungry for bright, dramatic pictures with sentimental or erotic or romantic content. Art journalism grew with equal gusto, and that deluge of verbiage stoked the interest of potential patrons. A handful of brilliant dealers, including Gambart, came onto the scene. Add to this mix the young Pre-Raphaelites, afire with talent and ambition, and the art world changed completely. Before long these painters were demanding — and getting — higher prices than artists had ever dreamed of before. In the process they draped themselves and their work with a glamour and a mystique that still cling to the popular artist. They helped to establish the artist as a cultural hero and a celebrity — this last perhaps a dubious achievement, but one that is still very much with us.

Prices for some Pre-Raphaelite work remained high until World War I shocked people so deeply that romance and sentiment suddenly appeared to be pointless luxuries. After the war, the pictures dropped out of sight for a good while. The absolute nadir was an auction during the blitz in 1941, when Burne-Jones's enormous *Love and the Pilgrim* was bought in for twenty-one pounds.

One could still pick up fine Pre-Raphaelite work in the 1950s for a song, but that trend began to reverse itself when the art market went mad across the board. Today it is rare for a major work by one of these artists to come up for sale, because most of them have already found homes in museums. When one does, the competition is fierce. That would have gratified the artists, but they would have been even more pleased to see people willingly lining up for hours on end, week

in, week out, for the chance to look at their paintings, as they did when the Tate put on a comprehensive show of their work in 1984.

༂ೞೱ⌘ℰෳ

When I started this book, I assumed that many of the models longed to be artists, just as Elizabeth Siddal did, but were thwarted in this desire. Eventually I saw that I was wrong; aside from Lizzie, only Mary Zambaco worked as an artist. (Unfortunately, little is known of her actual productions or of how she felt about her work, despite the fact that she seems to have kept at it over many years.)[2] Georgie was the only other woman who actively wanted work of her own and sought it out.

I gradually realized that I was investigating the first generation of women in whom the idea that a middle-class woman might conceivably have a job, a profession, or a talent of her own began to break the surface, like a bulb planted deep that has just sent up its first tentative shoots. Work outside the home was a possibility that was just glimmering in the female imagination. A handful of women who possessed genius or fortitude or both figured out a way to realize their abilities — women such as George Eliot, Florence Nightingale, Barbara Bodichon, Elizabeth Thompson Butler, and Christina Rossetti — but they were the exceptions, and proved the rule by the very difficulty of their struggle.

When Georgie spoke on this subject, she was even more eloquent than usual. Since I first read the following passages in her *Memorials of Edward Burne-Jones,* I have never been able to get them out of my mind. Discussing the book of fairy tales that she and Lizzie planned to write and illustrate together, which never came to pass, she observed: "It is pathetic to think how we women longed to keep pace with the men, and how gladly they kept us by them until their pace quickened and we had to fall behind." Not "fell behind," but "had to fall behind." Georgie lived in a world where even a woman of her intelligence and courage saw such a fall as inevitable, a failure brought on by lack of education, the birth of children, and an absence of determination that she feared was inherent in women's nature. Speaking of her own efforts to learn wood engraving, she went on to say: "I stopped, as so many women do, well on this side of tolerable skill, daunted by the path which has to be followed absolutely alone if the end is to be reached." She could not quite envision a world in which women were strong enough to follow that path.

Reflecting on Lizzie's case, Georgie saw both difference and sim-

ilarity to her own situation: "With Mrs. Rossetti it was a different matter, for I think she had original power, but with her, too, art was a plant that grew in the garden of love, and strong personal feeling was at the root of it; one sees in her black-and-white designs and beautiful little watercolors Gabriel always looking over her shoulder, and sometimes taking pencil or brush from her hand to complete the thing she had begun." Georgie was right; in her painting Lizzie never broke free of Gabriel's influence. If he had married her sooner, or if her health had not limited her working days so severely, perhaps she would have developed an independent style. She would also have been helped if the Royal Academy Schools had been willing to admit her as a pupil.

Georgie points out to us that women of her time were free to operate only in the personal sphere, in the "garden of love." Her very choice of that phrase shows her ambivalence; she wished that her and Lizzie's efforts had not been "pathetic" and that they had been able to keep up the pace, but she also acknowledged how precious that private world was to her.

Reading through the letters and combing the stories of the rest of these women, one does not hear the passionate longing that Georgie felt; in fact, the subject is rarely mentioned. To insist that these women wanted work of their own is to impose our consciousness on theirs. Which is not to say that they did no work of any sort, but it was virtually all personal work, taking care of family. (Georgie and Edith and Effie and Jane were hardly simple Eves in their Edens; like God, they did the work of creating that "garden of love.") Nor does it mean that they would not have gotten pleasure from public work and achievement. Effie's relentless pursuit of social success was clearly, at least in part, a means of seeking recognition that she could not get in any other way. When Georgie was young, she could not see the point of women's suffrage and apologized to Rosalind Howard because she had no interest in working for the cause, but later, when the opportunity presented itself, she plunged in and ran for office.

Within the personal sphere, these women did distinguish themselves. They took risks that made other women tremble. They were not average; they all had the courage to model, and they chose to love and marry uncommon men, men who offered lives that promised to be challenging, uncertain, perhaps glamorous, but most assuredly not conventional.

Effie broke one of the most sacred taboos of her class and defied

even the Queen by leaving Ruskin and daring society to shut her out. By her efforts to win acceptance, she opened up a subject that had been little discussed. As a result of the long-running scandal she precipitated, many people were forced to consider whether a woman has a right to sexual experience and love in marriage. A flood tide of gossip was generated, but no doubt a good deal of reflection took place as well. The celebrity of both Ruskin and Millais made Effie's struggle far more public, more prolonged, and more painful than it would have been if she had been married to a manufacturer or a country gentleman.

Whereas Effie had the support of her parents, Edith Waugh was forced to bash another sacred Victorian cow, the absolute fealty that a child, particularly a daughter, owed to father and mother. At the same time that she defied her parents she took on the legal system and society's rigid definition of incest — a rather formidable task. During the years when Hunt was dithering about marrying her, common sense must have told her more than once to go back to her parents' house and beg their forgiveness, but she held her ground and waited Hunt out. Later her pride in being Mrs. Holman Hunt was so great that she probably felt only a little distant pity for those who condescended to her.

Jane ventured very far out on her particular limb. Living openly with a man not her husband took great boldness. In so doing, she risked causing pain to her husband and perhaps her daughters (although with Morris's help she apparently succeeded in avoiding the latter). Going to Rossetti was a gamble; Morris would have been well within his legal rights to turn her out and keep the girls, even to cut her off from seeing them. She was able to get away with such audacity because her husband did not seek revenge and because their circle was not a conventional one. As Georgie was fond of pointing out, they were different from the run of the middle class, and took pride in the ease, the frankness, and the generosity with which they treated each other. So it was possible to break new ground in this world of artists and models.

Effie, Edith, and Jane shared something else: All of them received encouragement and support from the men they loved. Hunt put off marriage to Edith, as he did so many other things (which showed marvelous self-absorption on his part), but he would have been happy to knock down anyone who dared to criticize her, and he expended extraordinary energies on the campaign for legislation to legitimize

their marriage, something he cared about not at all but felt was owed to his wife and children. Morris's efforts were silent but remarkable; fighting his pain and sense of rejection, subduing his pride, he tried to give Jane the freedom she needed in order to have her own chance at happiness. In the end she acknowledged his effort.

<p style="text-align:center">❧❧❧❧</p>

Were these hard-won marriages and relationships happy? Did the sacrifices they entailed bring these women and their husbands the fulfillment they sought? The answer is of course different in every case, but looking backward, we can see certain patterns. Courtship was the golden age for most couples. Georgie made no secret of it; for her, the first year of engagement was so intense that it seemed as if "every minute contained the life of an hour," and she always looked back to that time with longing.

The early years of marriage were often an extension of that first happiness, even a rebirth, as in the case of Lizzie and Gabriel; but as responsibilities piled up, happiness was often marred in one way or another. As it so often does, romance waned after children arrived. Georgie recalled vividly how she sat outside the studio with tiny Phil in her arms and wept because she felt shut out.

It cannot have been an accident that every husband stopped painting his wife within a few years of the wedding. Other models superseded her in the studio. Consciously, the artist was pleased that he could afford to pay professional models and free his wife from the drudgery of sitting, but subconsciously, no doubt, the wife became less desirable first as she grew familiar, later because she was aging. Perhaps without even noticing that he did so, the husband replaced her with younger women better suited to embody his fantasies — and those of the audience he had to please in order to sell paintings.

Among the hundreds of women depicted in the work of the Pre-Raphaelites, the number of old women can probably be counted on one hand, and they creep into story pictures just to fill out the tale, like the wrinkled old lady who sits next to the lovers at the banquet in Millais's *Lorenzo and Isabella*. Pre-Raphaelitism was a cult of youthful beauty. Jane Morris was the exception; because she appeared hardly to age at all, Gabriel continued to paint her well into her forties, and stopped only when she insisted that back pain prevented her from sitting. In this respect Gabriel and Jane might have had the longest sustained romance of any of these couples, if his madness and addiction had not driven them apart. His fascination with her never waned,

in or out of the studio. Unfortunately for both of them, his depressions and his fascination were entwined deep in his nature.

Great prices were paid in heartbreak and frustration. The tragedies leap out: Lizzie's death, Fanny's death. Rossetti's selfishness as he played with Lizzie like a cat with a mouse is stunning. Hunt's blithe casualness about Fanny's pregnancy is horrifying. In each case the man justified his behavior as a necessity, an outgrowth of his mission as an artist, which gave him a license not granted to other human beings. Ned needed Mary Zambaco's beauty like a drug; he felt compelled to paint her no matter what the cost, and painting her and making love to her were so intimately tied up that he couldn't sort them out. Georgie was left to hold her life together as best she could. In the long years after this affair, she must have felt a hundred hurts each time another pretty young woman came to the Grange to be drawn in the upstairs studio. Once again it was the painting that made these visits not only possible but necessary; those young girls were the inspiration without which he could not work. Georgie understood that it was not just the face but the spirit of a girl that animated her husband and made it possible for him to create the paintings she loved, and so she learned to share him — not without strain, but without bitterness and with a good deal of grace.

Models and wives were not the only ones who suffered. Hunt's nerves were worn to a frazzle, and his whole personality was deformed, by the fear of sex that controlled him for so long. Jane's attachment to Gabriel and the years she spent modeling for him in Cheyne Walk and living with him at Kelmscott cast a long, cold shadow over Morris's life and forced him to develop reserves of fortitude in order to sustain himself. He built up a wall of defense around himself so perfect that even Ned failed to see his loneliness, imagining that Morris needed no one.

To reduce any of these relationships to pain and disappointment, however, would be a mistake. In the beginning I expected to find little but emotional carnage; instead, I have been amazed to discover how often these men and women did touch and delight and amuse each other, despite their problems and illnesses and the endless anxiety of creation.

Once the tidal wave of romance had crested, they made adjustments, and some of those adjustments were surprisingly successful. Whereas we probably see a dozen points at which one or another marriage seemed ripe for dissolution, I doubt that those who actually lived them out would agree with our assessments; in fact, I suspect that they would mostly be astounded. It is true that all of them were to one

degree or another ruled by the cultural prohibition against divorce. However, they took satisfaction in seeing a marriage through. Because they stayed married, the emotional stakes were higher and the losses greater, but the rewards were also greater. Their lack of choice was not simply imprisoning; marrying for life had some benefits of which we have lost sight. Since they knew that they had made a lifelong commitment, they were very careful to preserve the trust and dignity of their relationships even when they were strained. In consequence, less damage was done, because people hesitated to speak to each other in haste, and they did not enshrine honesty above concern for each other.

Over the years, a husband and wife built up a history together that was precious to them both. Crises that we would regard as monumental dwindled away for them, appearing in retrospect as small blots that marred a large, rich tapestry they had woven together. That weight of history stopped Ned from announcing his attachment to May Gaskell, despite his utter desperation, and eventually helped him to let her go. Georgie's *Memorials of Edward Burne-Jones* leave no doubt that she loved Ned, regardless of all their difficulties and her compromises. Even at the crisis of her life, when the affair with Mary Zambaco still hung in the balance, she remained sure that there was "love enough between Edward and me to last out a long life."

There are other values that we have a hard time seeing. We condescend so utterly to the domestic sphere of life that we deem the labor performed there to be trivial. By contrast, Edith Holman Hunt perceived her role as an artist's wife to be a dramatic challenge. Caring for her home and family and making sure that Hunt could work peacefully in his studio brought her enormous satisfaction. Edith's ferocious energy may well have been an expression of her frustration — no doubt she glorified her role because it was the most exciting possibility open to her — but she made something quite splendid and eccentric out of it.

We would probably not choose to exchange places with these men and women, even if we could. Although we may be attracted by the civility, the privilege of talent, the vast stores of energy, the tenderness and passion that they felt for each other, we would not be willing to trade away the many psychic and social freedoms that have been so hard won in the intervening century. Nonetheless, we can still take pleasure in looking at the Pre-Raphaelites' remarkable paintings and reflecting on the stories behind them. As Georgie said, think what it is to see a poem lived.

NOTES
BIBLIOGRAPHY
INDEX

# Notes

The following abbreviations are employed for persons:
ACS — Algernon Charles Swinburne
CAH — Charles Augustus Howell
CEN — Charles Eliot Norton
CGR — Christina Georgina Rossetti
DGR — Dante Gabriel Rossetti
EBJ — Edward Burne-Jones
Ef — Effie Millais
EHH — Edith Holman Hunt
FGS — Frederic George Stephens
FMB — Ford Madox Brown
GBJ — Georgiana Burne-Jones
JEM — John Everett Millais
JM — Jane Morris
JR — John Ruskin
WBS — William Bell Scott
WHH — William Holman Hunt
WM — William Morris
WMR — William Michael Rossetti
WSB — Wilfrid Scawen Blunt

Manuscript collections and archives are identified in this manner:
Bembridge — Ruskin Galleries, Bembridge School, Isle of Wight
Bodleian — Bodleian Library, Oxford University
British Museum — British Library, Department of Manuscripts
Castle Howard — Archive Collection, Castle Howard, York
Cornell — Cornell University Library
Fitzwilliam — Fitzwilliam Museum, Cambridge University
Houghton — Houghton Library, Harvard University

Huntington — Huntington Library, San Marino, California
Leeds — Brotherton Library, University of Leeds
Morgan — Pierpont Morgan Library, New York
Princeton — Princeton University Library
Rylands — John Rylands University Library, Manchester
Tate — Tate Gallery, London
Texas — Harry Ransom Humanities Research Center, University of Texas at Austin
V&A — National Art Library, Victoria & Albert Museum, London
UBC — University of British Columbia, Vancouver
Wilmington — Samuel and Mary R. Bancroft Archive, Helen Farr Sloan Library, Delaware Art Museum
Yale — Beinecke Rare Book and Manuscript Library, Yale University

These abbreviations have been used to denote works:
Baldwin — A. W. Baldwin, *The Macdonald Sisters*
Boyce diary — Virginia Surtees (ed.), *The Diaries of George Price Boyce*
Bryson — John Bryson (ed.), *Dante Gabriel Rossetti and Jane Morris: Their Correspondence*
DHH — Diana Holman-Hunt, *My Grandfather, His Wives and Loves*
DHH2 — Diana Holman-Hunt, *My Grandmothers and I*
Faulkner — Peter Faulkner, *Jane Morris to Wilfrid Scawen Blunt*
FMB diary — Virginia Surtees (ed.), *The Diary of Ford Madox Brown*
G — Georgiana Burne-Jones, *The Memorials of Edward Burne-Jones*
HH — William Holman Hunt, *Pre-Raphaelitism and the Pre-Raphaelite Brotherhood*
JGM — John Guille Millais, *The Life and Letters of Sir John Everett Millais*
Mackail — J. W. Mackail, *The Life of William Morris*
MoL — Norman Kelvin (ed.), *The Collected Letters of William Morris*
OD — Oswald Doughty, *Dante Gabriel Rossetti: A Victorian Romantic*
RL — Oswald Doughty (ed.), *The Letters of Dante Gabriel Rossetti*
Rooke — Mary Lago (ed.), *Burne-Jones Talking*
Ru:Ro:PRsm — W. M. Rossetti (ed.), *Ruskin: Rossetti: Pre-Raphaelitism*

Where two or more quotations from a single letter or source appear in the same paragraph, I have used a single note at the end of the sequence to identify all passages. I have also used a single note to identify sequential quotations from one source about a single event.

## PROLOGUE

1. While I was writing this book, a marvelous volume that focuses specifically on the lives of the Pre-Raphaelite wives and models was published: Jan Marsh's *The Pre-Raphaelite Sisterhood*. The quality and range of Dr. Marsh's research are truly impressive, and her book is fascinating.

Readers who want to know more about these women and their relationships with the artists will want to read it.

I • THE PRE-RAPHAELITE BROTHERHOOD

1. JGM, I, 12.
2. HH, I, 29–30.
3. HH, I, 33.
4. HH, I, 35.
5. HH, I, 36, 57.
6. HH, I, 61.
7. HH, I, 67.
8. HH, I, 51.
9. HH, I, 83.
10. HH, I, 78.
11. However much Hunt wished to claim the wet white ground as his contribution to British painting, it is nonetheless true that Turner, Landseer, and Mulready had already experimented with it.
12. HH, I, 172.
13. HH, I, 73.
14. Ruskin, *Collected Works*, III, 624.
15. HH, I, 100.
16. HH, I, 99.
17. HH, I, 105.
18. HH, I, 105.
19. Taine, *Notes on England*, 31.
20. WMR, *Some Reminiscences*, I, 39.
21. FMB diary, May 9, 1855, 136.
22. Quoted in OD, 62.
23. HH, I, 128.
24. HH, I, 128–29.
25. Quoted in OD, 122.
26. HH, I, 139.
27. WHH quoted in Fleming, *Rossetti and the Pre-Raphaelite Brotherhood*, 88.
28. HH, I, 164.
29. Quoted in DHH, 52.
30. Angeli, *DGR: His Friends and Enemies*, 59.
31. HH, I, 174.
32. HH, I, 172.
33. JGM, I, 73.
34. HH, I, 204.
35. HH, I, 145.
36. HH, I, 231.
37. Quoted in DHH, 74.
38. DGR to WMR, July 1, 1850, RL, I, 90.

39. HH, I, 236.
40. HH, I, 249.
41. HH, I, 252.

2 · DANTE AND BEATRICE

1. G, I, 208.
2. There is only one book-length biography of Elizabeth Eleanor Siddal, Violet Hunt's *The Wife of Rossetti*. Ms. Hunt gives an extensive account of Lizzie's first visit to Deverell's studio, but I have resisted the temptation to draw on it because her book is an inconsistent and unreliable source. However, Ms. Hunt did some research; I have studied her papers in the Cornell University Library and made use of a handful of letters that she obtained from knowledgeable sources.
3. HH, I, 198–99.
4. FMB diary, March 10, 1855, 126. I have shamelessly stolen the wonderful phrase *madonna ex machina* from an article written by Michelle Green for *People Weekly,* December 3, 1984.
5. DGR to WMR, September 3, 1850, RL, I, 92.
6. DGR to John Lucas Tupper, October 25, 1850, RL, I, 94.
7. HH, I, 237.
8. DGR to John Lucas Tupper, October 25, 1850, RL, I, 94.
9. WMR, *PRB Journal,* December 7, 1850.
10. JGM, I, 144.
11. DGR to CGR, August 4, 1852, RL, I, 108–9.
12. WMR, *PRB Journal,* January 1853.
13. Ibid.
14. DGR to WMR, November 25, 1852, RL, I, 115.
15. DGR to Thomas Woolner, January 8, 1853, RL, I, 121.
16. DGR to WMR, June 20, 1853, RL, I, 146.
17. WMR quoted in OD, 139.
18. WBS quoted in OD, 138.
19. DGR to FMB, August 25, 1853, RL, I, 153.
20. Wey, *A Frenchman Among the Victorians,* 176.
21. Barbara Leigh-Smith to Bessie Parkes, undated, Princeton.
22. DGR to FMB, April 14, 1854, RL, I, 185.
23. DGR to Bessie Parkes, May 9, 1854, RL, I, 192.
24. Quoted in Weintraub, *Four Rossettis,* 79.
25. DGR to William Allingham, May 12, 1854, RL, I, 195–96.
26. DGR to FMB, May 23, 1854, RL, I, 200.
27. Ibid.
28. FMB diary, October 7, 1854, 100.
29. DGR to William Allingham, July 23, 1854, RL, I, 209.
30. FMB diary, October 7, 1854, 101.
31. FMB diary, August 6, 1855, 148.

32. FMB diary, December 2, 1854, 107.
33. WMR quoted in Procter, "Elizabeth Siddal: The Ghost of an Idea," 369.
34. DGR to William Allingham, March 17,1855, RL, I, 244.
35. FMB diary, March 10, 1855, 126.
36. Surtees, *Sublime and Instructive,* 115–16.
37. Quoted in Fleming, *Rossetti and the Pre-Raphaelite Brotherhood,* 14.
38. FMB diary, March 10, 1855, 126.
39. *Ru:Ro:PRsm,* 63.
40. DGR to FMB, April 13, 1855, RL, I, 249.
41. I am indebted to Pamela Gerrish Nunn for her superb analysis of Ruskin's treatment of Elizabeth Siddal and other female artists in "Ruskin's Patronage of Women Artists," *Woman's Art Journal* (Fall 1981/Winter 1982).
42. *Ru:Ro:PRsm,* 69.
43. *Ru:Ro:PRsm,* 76.
44. JR to Henry Acland, Spring 1855, quoted in OD, 174.
45. DGR to his mother, July 1, 1855, RL, I, 262.
46. *Ru:Ro:PRsm,* 106.
47. *Ru:Ro:PRsm,* 110, 107–8.
48. FMB diary, August 16, 1855, 149.
49. FMB diary, December 2, 1855, 157.
50. Alexander Munro to WBS, October 1855, RL, I, 278n.
51. *Ru:Ro:PRsm,* 110–12.
52. DGR to Elizabeth Siddal, February 15, 1856, RL, I, 289.
53. WMR, *Burlington Magazine,* vol. 1 (May 1903), 273.
54. FMB diary, July 16, 1856, 183.
55. FMB diary, July 10, 1856, 178.
56. DGR to William Allingham, late 1856, RL, I, 314.
57. DGR to FMB, February 27, 1857, RL, I, 320–21.
58. FMB diary, March 15, 1857, 196.
59. FMB diary, March 18–19, 196–97.
60. *Ru:Ro:PRsm,* 167.
61. G, I, 164.
62. Quoted in OD, 252.
63. Boyce diary, December 15, 1858, 25.
64. Boyce diary, July 23, 1859, 27.
65. Quoted in Nicoll, *Rossetti,* 125.
66. ACS to WBS, December 16, 1859, Lang, *Swinburne Letters,* I, 27.
67. DGR to his mother, April 13, 1860, RL, I, 363.
68. DGR to WMR, April 17, 1860, RL, I, 363–64.
69. DGR to FMB, April 22, 1860, RL, I, 364.
70. DGR to his mother, May 23, 1860, RL, I, 366.
71. DGR to William Allingham, July 31, 1860, RL, I, 371.
72. G, I, 208.

73. G, I, 220.
74. *Ru:Ro:PRsm,* 243–45.
75. DGR to William Allingham, September or October 1860, RL, I, 378.
76. DGR to William Allingham, postmarked November 29, 1860, RL, I, 384.
77. WBS, *Autobiographical Notes,* II, 64.
78. DGR to FMB, November 28, 1860, RL, I, 383.
79. G, I, 221.
80. ACS to WMR, December 4, 1895, British Museum.
81. DGR to FMB, May 2, 1861, RL, II, 397.
82. DGR to Mrs. John Dalrymple, May 2, 1861, RL, II, 397.
83. G, I, 222.
84. G, I, 228–29.
85. Troxell, *Three Rossettis,* 8.
86. Quoted in OD, 290.
87. WMR, *Some Reminiscences,* I, 196.
88. There are conflicting accounts of the note and of the wording of its message. In 1932 Violet Hunt contended that the note said: "My life is so miserable I wish for no more of it." This diction seems far more characteristic of Ms. Hunt than of Lizzie. William Rossetti's daughter Helen Rossetti Angeli initially denied that there had been a note at all; then, in her 1949 volume *Dante Gabriel Rossetti: His Friends and Enemies,* Mrs. Angeli revealed the closely guarded family secret that Lizzie's note had asked Gabriel to take care of Harry, which he did. I think this version is far more likely to be accurate. Although family secrets often become legends and are distorted in the process, Helen was the faithful daughter of the family's scrupulous chronicler. William omitted certain painful facts, but he did not lie or embroider. Unless she was certain of the existence and intention of the note, Mrs. Angeli would have had no motivation to tell a secret that could only bring her family pain.
89. G, I, 238.
90. Quoted in OD, 294.
91. WMR, *DGR: His Family Letters,* I, 222.
92. Quoted in OD, 302.
93. All excerpts from inquest at Bridewell Hospital are quoted in OD, 295–96.
94. Henderson, *Swinburne,* 55.
95. Caine, *Recollections of Dante Gabriel Rossetti,* 198.
96. G, I, 222.
97. WMR, *DGR: His Family Letters,* I, 225.
98. Soon after Lizzie died, Christina asked Gabriel whether she could include some of Lizzie's poems in a volume of her own. Gabriel sent his sister the manuscripts of Lizzie's poems, and after she read them through Christina wrote to him: "But do you not think that . . . beautiful as they are, they are almost too hopelessly sad for publication *en masse?"*

(WMR, *Rossetti Papers: 1862 to 1870,* 78.) The task of publication was left to William, the custodian and shepherd of the family's achievements. At the turn of the century, he arranged for five of them to be published in literary magazines. It was not until 1978 that Roger C. Lewis and Mark Samuels Lasner edited and published all of her surviving poems and many of her drawings and paintings in one slim, elegant volume.
99. DGR to Lady Cowper-Temple, March 26, 1871, Morgan.
100. Quoted in OD, 119–20.

### 3 • PYGMALION AND GALATEA

1. JGM, I, 119–20.
2. Susan Casteras, "Down the Garden Path: Courtship Culture and Its Imagery in Victorian Painting." Ph.D. dissertation, Yale University, 1977.
3. HH, I, 284–85.
4. HH, I, 290.
5. HH, I, 305.
6. HH, I, 346–47.
7. Layard, *Tennyson and His Pre-Raphaelite Illustrators,* 43.
8. HH, II, 430.
9. WHH to Thomas Seddon, August 15, 1853, Rylands.
10. HH, I, 365.
11. HH, I, 373–74.
12. HH, I, 382.
13. HH, I, 401.
14. HH, I, 490–91.
15. HH, I, 495.
16. FGS to WHH, April 10, 1854, Huntington.
17. Ibid.
18. Quoted in DHH, 150.
19. HH, II, 106–7.
20. HH, II, 141.
21. FMB diary, July 6, 1856, 181.
22. FMB diary, April 28, 1856, 172.
23. WHH to FGS, undated, Bodleian.
24. WHH to FGS, undated (probably December 5, 1857), Bodleian.
25. FGS to WHH, December 9, 1857, Bodleian.
26. WHH to FGS, December 10, 1857, Bodleian.
27. Boyce diary, January 21, 1858, 20.
28. FMB diary, January 25, 1858, 201.
29. WHH to Thomas and Martha Combe, February 26, 1859, Bodleian.
30. Boyce diary, January 21, 1858, 21.
31. WHH to FGS: undated (probably August 1859), Bodleian.
32. Boyce diary, December 22, 1859, 28.

33. HH, II, 189.
34. HH, II, 190.
35. HH, II, 192.
36. Quoted in Maas, *Gambart,* 119.
37. Quoted in Maas, *Gambart,* 120.
38. Quoted in Maas, *Holman Hunt and the Light of the World,* 91–92.
39. WHH to FGS, May 25, 1860, Bodleian.
40. WHH to FGS, Thursday night, Bodleian.
41. WHH to FGS, November 15, 1860, Bodleian.
42. WHH to FGS, November 22, 1860, Bodleian.
43. WHH to FGS, January 25, 1861, Bodleian.
44. WHH to FGS, January 25, 1861, Bodleian.
45. Quoted in DHH, 226.
46. WHH to FGS, February 15, 1861, Bodleian.
47. Clodd, "William Holman Hunt."

## 4 · AN ORDER OF RELEASE

1. Ef to her parents, August 1841, Morgan.
2. Ef to her mother, May 4, 1847, Morgan.
3. Ef to her mother, May 14, 1847, Morgan.
4. JR to Ef, November 1847, Morgan.
5. JR's father to JR, September 2, 1847, Bembridge.
6. JR to Ef, November 9, 1847, Morgan. These letters by Ruskin, along with scores of Effie's letters, are printed and analyzed in Mary Lutyens's fascinating trilogy chronicling the relations of the Ruskins, the Grays, and John Everett Millais. Anyone who is interested in learning more about Effie should turn to *The Ruskins and the Grays, Young Mrs. Ruskin in Venice,* and *Millais and the Ruskins.* They were an invaluable resource from the very beginning of this project.
7. Ef to her mother, April 29, 1848, Morgan.
8. Ef to her mother, July 20, 1848, Morgan.
9. JR to his mother, August 20, 1848, Yale.
10. JR to his father, September 4, 1848, Yale.
11. JR to his father, September 11, 1848, Yale.
12. JR to Ef, April 24, 1849, Morgan.
13. JR to Ef, April 27, 1849, Morgan.
14. JR to Ef, July 3, 1849, Morgan.
15. JR to Ef's father, July 5, 1849, Morgan.
16. Ef to her mother, December 22, 1849, Morgan.
17. Ef to George Gray, Jr., September 19, 1851, Morgan.
18. JR's father to JR, August 1851, Morgan.
19. JR to his parents, quoted in Effie's letter to her mother, February 24, 1850, Morgan.
20. Ef to her mother, February 3, 1850, Morgan.

21. Ef to her mother, February 8, 1852, Morgan.

22. Ef to her mother, February 1, 1852, Morgan.

23. JR to his father, December 28, 1851, Morgan.

24. Ef to her mother, February 8, 1852, Morgan.

25. Ef to her mother, June 27, 1852, Morgan.

26. Ef to her mother, postmarked February 25, 1853, Morgan.

27. Ef to her mother, March 20, 1853, Morgan.

28. Ef to her mother, May 3, 1853, Morgan.

29. Ef to her mother, July 10, 1853, Morgan.

30. JR to his father, July 8, 1853, Morgan.

31. JEM to WHH, July 3, 1853, Huntington.

32. Ef to Rawdon Brown, July 27, 1853, Morgan.

33. JEM to WHH, August 14, 1853, Huntington.

34. JR to his father, quoted in Lutyens, *Millais and the Ruskins,* 72.

35. JEM to WHH, October ?, 1853, Elizabeth Burt collection.

36. JEM to WHH, August 29, 1853, Huntington.

37. JR to his mother, October 16, 1853, Bembridge.

38. JR to WHH, October 20, 1853, Mary Lutyens collection.

39. JR's statement for his lawyer, April 1854, Morgan.

40. Ef to her mother, February 27, 1854, Morgan.

41. DGR to CGR, November 8, 1853, RL, I, 163.

42. JR's father to Ef's mother, November 3, 1853, Morgan.

43. JR to his father, November 6, 1853, Morgan.

44. JEM to Ef's mother, undated but inscribed in Mrs. Gray's hand "19th Dec$^r$/53 1st letter," Morgan.

45. JR to Ef's mother, December 1853, Morgan.

46. Ef to her mother, January 1, 1854, Morgan.

47. Ef to her mother, February 27, 1854, Morgan.

48. Ef to her mother, February 27, 1854, Morgan.

49. JEM to Ef's mother, March 3, 1854, Morgan.

50. Ef to her mother, February 27, 1854, Morgan.

51. Ef to her mother, March 3, 1854, Morgan.

52. Ef to her father, March 7, 1854, Morgan.

53. JEM to Ef's mother, March 15, 1854, Morgan.

54. Ef to her mother, March 23, 1854, Morgan.

55. Ef to her mother, March 30, 1854, Morgan.

56. Ef to her mother, April 1, 1854, Morgan.

57. Ef to her mother, April 6, 1854, Morgan.

58. Ef to her mother, April 10, 1854, Morgan.

59. JEM to Ef's mother, April 18, 1854, Morgan.

60. Ef to Rawdon Brown, April 27, 1854, Morgan.

61. John James Ruskin diary, April 25, 1854, Bembridge.

62. Ef to JR's mother, April 25, 1854, Morgan.

63. JEM to Ef's mother, April 27, 1854, Morgan.

64. FMB diary, July 13, 1855, 144.

65. Elizabeth Eastlake to Ef, May 3, 1854, Morgan.
66. Elizabeth Eastlake to Ef, April 29, 1854, Morgan.
67. Eleanor Vere Boyle to Ef, June 9, 1854, Morgan.
68. JEM to Ef's mother, May 10, 1854, Morgan.
69. JEM to Ef's mother, May 18, 1854, Morgan.
70. Rawdon Brown to Ef, May 1, 1854, Morgan.
71. Doctors' deposition (copy only; original records lost), Morgan.
72. JEM to F. J. Furnivall, May 23, 1854, Huntington.
73. JEM to Ef's mother, May 24, 1854, Morgan.
74. Ef to Rawdon Brown, July 15, 1854, Morgan.
75. Ef to Rawdon Brown, June 9, 1854, Morgan.
76. Decree of Nullity, Commissary Court of Surrey, July 15, 1854.
77. JR to Henry Acland, July 18, 1854, Bembridge.
78. JEM to Ef, July 21–22, 1854, Morgan.
79. Ef to Rawdon Brown, January 5, 1855, Morgan.
80. Elizabeth Eastlake to Ef, August 10, 1854, Morgan.
81. JR to JEM, December 11, 1854, Morgan.
82. JEM to JR, December 18, 1854, Morgan.
83. JR to JEM, December 20, 1854, Morgan.
84. FMB diary, April 12, 1855, 132.
85. JEM to WHH, May 22, 1855, Morgan.
86. Armstrong, "Sir John Everett Millais, bart."
87. JEM to WHH, May 22, 1855, Elizabeth Burt collection.
88. JR to F. J. Furnivall, June 3, 1855, Huntington.
89. JEM to Charles Collins, June 19, 1855, Morgan.
90. JEM to Charles Collins, July 3, 1855, Morgan.
91. Ef's diary, private collection.
92. Ef's diary, private collection.
93. JEM to Ef's father, July 11, 1855, Morgan.
94. JEM to Charles Collins, July 29, 1855, Morgan.
95. Ibid.
96. Ef to her mother, July 20, 1855, Morgan.
97. Ef to George Gray, Jr., July 27, 1855, Morgan.
98. JEM to Ef's father, July 11, 1855, Morgan.
99. JEM to George Gray, Jr., July 11, 1855, Morgan.
100. JEM to WHH, Elizabeth Burt collection.
101. JGM, I, 331.
102. JEM to Ef, April 11, 1856, Morgan.
103. JGM, I, 343.
104. JGM, I, 354.
105. Ef to Rawdon Brown, January 20, 1856, Morgan.
106. JEM to Charles Collins, November 18, 1856, Morgan.
107. Ef to Rawdon Brown, September 8, 1858, Morgan.
108. JEM to Ef, June 7, 1861, Morgan.
109. JEM to Ef, May 17, 1859, Morgan.

110. JEM to Ef, August 9, 1865, Morgan.

111. JEM to Ef, Fall 1867, Morgan.

112. JEM to Ef, August 6, 1890, Morgan.

113. JEM to Ef, December 4, 1891, Morgan.

114. Ef to her mother, April 29, 1861, Morgan.

115. JEM to Ef's mother, May 2, 1861, Morgan.

116. Ef to her father, September 19 [1864?], Morgan.

117. JGM, I, 287.

118. Ef to her mother, July 1867, Morgan.

119. Ef to Sophie Gray, February 10, 1865, Morgan.

120. JR to CEN, February 25, 1861, Houghton.

121. Rose La Touche diary, November 25, 1861? 68.

122. Maria La Touche to Ef, May 21, 1868, Morgan.

123. Maria La Touche to Ef, October 8, 1870, Morgan.

124. Ef to Maria La Touche, October 10, 1870, Morgan.

125. Maria La Touche to Ef, October 14, 1870, Morgan.

126. JR to Robert Horn, November 22, 1870, quoted in Derrick Leon, *Ruskin: The Great Victorian* (London: Routledge & Kegan Paul, 1949), 482.

127. JEM to Ef, November 18, 1859, JGM, I, 353.

128. Beatrix Potter diary, July 12, 1884, 97.

129. Ef to Duchess of Sutherland, May 2, 1874, Morgan.

130. JEM to Duchess of Sutherland, May 4, 1874, Morgan.

131. Thomas Biddulph to JEM, June 17, 1874, Morgan.

132. Quoted in Fleming, *That Ne'er Shall Meet Again,* 338.

133. Beatrix Potter diary, January 1886, 165.

134. JGM, II, 6.

135. EBJ to JEM, February 8, 1886, Morgan.

136. HH, II, 392.

137. HH, II, 372.

138. JGM, II, 356.

139. JEM to Ef, April 12, 1894. Morgan.

140. EBJ to HMG, February 22, 1896, British Museum.

141. Mary Millais to WHH, June 6, 1896, Huntington.

142. HH, II, 386–87.

143. JGM, II, 258.

## 5 • TRIUMPH OF THE INNOCENTS

1. WHH to FGS, July 20, 1864, Bodleian.

2. Ibid.

3. WHH to FGS, June 27, 1865, Bodleian.

4. Ibid.

5. WHH to FGS, July 11, 1865, Bodleian.

6. WHH to FGS, August 18, 1865, Bodleian.

7. WHH to FGS, September 28, 1865, Bodleian.

8. *The Habits of Good Society* (London: J. Hogg & Sons, 1859), 368.
9. *The Habits of Good Society*, 370.
10. C[ountess] of ••••, *Mixing in Society* (London: George Routledge & Sons, 1869), 224.
11. *The Habits of Good Society*, 372–73.
12. WHH to FGS, November 10, 1866, Bodleian.
13. WHH to FGS, January 19, 1867, Bodleian.
14. JEM to WHH, January 6, 1867, Bodleian.
15. WHH to FGS, January 19, 1867, Bodleian.
16. WHH to FGS, June 21, 1870, Bodleian.
17. WHH to JEM, December 7, 1869, Rylands.
18. WHH to WMR, October 9, 1870, Bodleian.
19. WHH to John Bradley, N.D., Princeton.
20. WHH to WBS, September 30, 1871, Princeton.
21. WHH to John Bradley, N.D., Princeton.
22. WHH to John Lucas Tupper, June 2, 1873, Huntington.
23. WHH to FGS, October 14, 1872, Bodleian.
24. WHH to FGS, May 2, 1873, Bodleian.
25. WHH to John Bradley, May 4, 1873, Princeton.
26. WHH to John Bradley, May 14, 1873, Princeton.
27. WHH to Clara Stephens, June 20, 1873, Bodleian.
28. WMR to FGS, N.D., Bodleian.
29. M. E. Durham to William Gaunt, November 27, 1942, Gaunt archive, Tate.
30. WHH to John Lucas Tupper, March 9, 1876, Huntington.
31. WHH to FGS, April 26, 1876, Bodleian.
32. HH, II, 344.
33. WHH to EHH, May 23, 1877, Rylands.
34. WHH to FGS, May 9, 1877, Bodleian.
35. WHH to EHH, May 11, 1877, Rylands.
36. EHH, N.D., Rylands.
37. WHH to EHH, May 12, 1877, Rylands.
38. WHH to EHH, May 13, 1877, Rylands.
39. WHH to EHH, May 18, 1877, Rylands.
40. WHH to FGS, May 28, 1877, Rylands.
41. HH, II, 331.
42. WHH to FGS, February 16, 1879, Bodleian.
43. WBS, *Autobiographical Notes*, II, 230–31.
44. HH, II, 343.
45. EHH quoted in DHH2, 42.
46. WHH to FGS, May 19, 1878, Bodleian.
47. M. E. Durham, William Gaunt archive, Tate.
48. Ibid.
49. Violet Hunt diary, May 6, 1882, Cornell.
50. Quoted in DHH2, 99.

51. WHH to Frederic Shields, February 25, 1892, Rylands.
52. WHH to Frederic Shields, N.D., Rylands.
53. HH, II, 380–81.
54. M. E. Durham, William Gaunt archive, Tate.
55. HH, II, 373.
56. HH, II, 334.
57. Quoted in DHH2, 40.
58. WHH to Frederic Shields, October 7, 1893, Rylands.
59. WHH to WMR, December 8, 1909, Rylands.
60. Quoted in Maas, *Light of the World,* 210.
61. Quoted in DHH2, 196.
62. Quoted in DHH2, 107.

## 6 • KING COPHETUA AND THE BEGGAR MAID

1. G, I, 8.
2. Rooke, 134.
3. G, I, 48.
4. G, I, 49–50.
5. Quoted in Cecil, *Visionary and Dreamer,* 99.
6. G, I, 64.
7. Readers who are curious to learn more about this extraordinary family will want to read Ina Taylor's superb biography *Victorian Sisters,* which has enriched my understanding by its brilliant analysis of the psychology of the Macdonald family.
8. Baldwin, 17.
9. Baldwin, 18–19.
10. Baldwin, 82.
11. G, I, 55.
12. G, I, 65–66.
13. G, I, 87.
14. G, I, 59.
15. G, I, 77.
16. G, I, 97–98.
17. For my understanding of this aspect of the Oxford tradition, I wish to thank the gifted critic and scholar Mary Ellmann, who lives in the city. The generosity and lively conversation of Dr. Ellmann and her late husband, Richard, the biographer of Joyce, Yeats, and Wilde, stimulated my imagination and intellect when I was just beginning to learn the craft of biography.
18. G, I, 105.
19. G, I, 112.
20. G, I, 105.
21. Quoted in Harrison, *Burne-Jones,* 17.
22. G, I, 109.

23. G, I, 108.
24. G, I, 99.
25. EBJ to George Howard, N.D. Castle Howard.
26. Quoted in Harrison, *Burne-Jones,* 14.
27. G, I, 111.
28. EBJ to HMG, May-June 1894?, quoted in G, I, 113–14.
29. G, I, 114–15.
30. G, I, 127.
31. G, I, 128–29.
32. G, I, 129.
33. G, I, 130.
34. G, I, 132.
35. G, I, 134.
36. Ibid.
37. G, I, 38.
38. G, I, 155.
39. Quoted in Harrison, *Burne-Jones,* 41.
40. G, I, 151.
41. G, I, 139.
42. G, I, 137.
43. G, I, 149.
44. G, I, 136.
45. G, I, 175.
46. Letitia Scott to WBS, N.D., quoted in WBS, *Autobiographical Notes,* II, 60.
47. Quoted in Harrison, *Burne-Jones,* 35.
48. G, I, 174.
49. G, I, 188.
50. G, I, 193.
51. FMB diary, January 25, 1858, 201.
52. G, I, 176.
53. G, I, 197.
54. G, I, 201.
55. G, I, 202–3.
56. EBJ to DGR, June 9, 1860, Princeton.
57. G, I, 204.
58. G, I, 215.
59. G, I, 229.
60. G, I, 230.
61. GBJ to Sydney Cockerell, June 20, 1918, V&A.
62. G, I, 233–34.
63. G, I, 236.
64. Quoted in Ina Taylor, *Victorian Sisters,* 72.
65. G, I, 245.
66. G, I, 260.

67. G, I, 208.
68. G, I, 280.
69. ACS to EBJ, November 1864, Fitzwilliam.
70. G, I, 282.
71. WM to EBJ, November 1864, MoL, I, 38.
72. G, I, 286.
73. G, I, 301.
74. EBJ to George Howard, September 1867, Castle Howard.
75. G, I, 309.
76. GBJ to Rosalind Howard, November 28, 1866, Castle Howard.
77. EBJ to George Howard, October 22, 1867, Castle Howard.
78. G, II, 5.
79. GBJ to Rosalind Howard, September 5, 1868, Castle Howard.
80. GBJ to Louisa Baldwin, January 5, 1869, Lance Thirkell collection.
81. DGR to FMB, January 23, 1869, RL, II, 685.
82. GBJ to Rosalind Howard, Wednesday [January 1869], Castle Howard.
83. GBJ to Rosalind Howard, February 18, 1869, Castle Howard.
84. GBJ to Rosalind Howard, February 24, 1869, Castle Howard.
85. DGR to FMB, January 23, 1869, RL, II, 685.
86. EBJ to George Howard, N.D., Castle Howard.
87. Ned used the gifted painter Rebecca Solomon as a model for Circe toward the end of work on this picture, which may mean that he and Mary had parted for a time or that he had promised Georgie he would not see Mary.
88. EBJ to CAH, various dates, Princeton.
89. Undated manuscript, British Museum.
90. G, II, 97.
91. GBJ to CEN, May 15, 1886, Houghton.
92. Quoted in Fitzgerald, *Burne-Jones,* 130.
93. G, II, 15.
94. G, II, 6.
95. EBJ to Frances Horner, N.D., Fitzwilliam (Burne-Jones Papers, XXVII, 41).
96. Cline, *The Owl and the Rossettis,* 9.
97. G, II, 51.
98. G, II, 18.
99. EBJ to HMG, January 1893?, British Museum.
100. GBJ to Rosalind Howard, July 31, 1874, Castle Howard.
101. G, II, 61.
102. Robertson, *Time Was,* 96.
103. GBJ to Sydney Cockerell, February 21, 1907, V&A.
104. G, II, 70.
105. Butler, *An Autobiography,* 186.
106. Robertson, *Time Was,* 48.
107. G, II, 75.

108. GBJ to George Eliot, May 6–7, 1880, *George Eliot Letters,* VII, 272.
109. GBJ to George Eliot, June 16, 1880, *George Eliot Letters,* VII, 299.
110. J. W. Cross to GBJ, December 22, 1880, *George Eliot Letters,* VII, 350.
111. EBJ to HMG, June 1893?, British Museum.
112. Quoted in Fitzgerald, *Burne-Jones,* 184.
113. G, II, 103.
114. G, II, 145.
115. Ibid.
116. EBJ to Sebastian Evans, February 3, 1888, Fitzwilliam.
117. G, II, 181–82.
118. GBJ to ACS, February 21, 1888, Leeds.
119. G, II, 199.
120. GBJ to Rosalind Howard, February 11, 1892, Castle Howard.
121. EBJ to Marie Stillman, September 6, 1891, Fitzwilliam.
122. Thirkell, *Three Houses,* 59.
123. DGR to JM, October 9, 1879, Bryson, 123.
124. EBJ to HMG, marked May-June 1894, British Museum.
125. EBJ to HMG, November 1, 1894, British Museum.
126. EBJ to HMG, September 25, 1894, British Museum.
127. EBJ to HMG, marked January-February 1894, British Museum.
128. EBJ to HMG, January 1893?, British Museum.
129. EBJ to HMG, March 9, 1893?, British Museum.
130. EBJ to HMG, October 26, 1894, British Museum.
131. EBJ to HMG, July 23, 1894, British Museum.
132. EBJ to HMG, March 27, 1895, British Museum.
133. EBJ to HMG, July 23, 1894, British Museum.
134. EBJ to HMG, N.D., British Museum.
135. EBJ to HMG, June 1893?, British Museum.
136. G, II, 238.
137. EBJ to HMG, August 5, 1894, British Museum.
138. EBJ to HMG, August 12, 1893, British Museum.
139. EBJ to HMG, August 27, 1893, British Museum.
140. EBJ to HMG, August 29, 1893, British Museum.
141. EBJ to HMG, April 17, 1895, British Museum.
142. Rooke, 187–88.
143. G, II, 208.
144. EBJ to HMG, August 1895, British Museum.
145. HMG inscribed EBJ letter of October 13, 1894, British Museum.
146. EBJ to HMG, Spring 1894, British Museum.
147. GBJ to Catherine Holiday, October 20, 1892, Huntington.
148. EBJ to G. F. Watts, 1894, quoted in Fitzgerald, *Burne-Jones,* 253.
149. G, II, 221.
150. G, II, 269.
151. G, II, 277.
152. Quoted in Fitzgerald, *Burne-Jones,* 269.

153. Rooke, 115.
154. G, II, 289.
155. G, II, 349–50.
156. GBJ to Charles Fairfax Murray, June 23, 1899, Rylands.
157. GBJ to Mary Gladstone, July 6, 1899, British Museum.
158. Baldwin, 154.
159. G, II, 1.
160. GBJ to CEN, November 28, 1904, Houghton.
161. GBJ to Sydney Cockerell, August 20, 1907, V&A.
162. GBJ to Sydney Cockerell, March 19, 1917, V&A.
163. GBJ to Sydney Cockerell, July 22, 1919, V&A.
164. GBJ to Sydney Cockerell, April 12, 1917, V&A.

## 7 • PROSERPINE

1. Virtually every bit of information that is known about Jane's childhood can be found in a ground-breaking article by Margaret Fleming called "Where Janey Used to Live" in the *William Morris Society Journal* 4, no. 3 (Winter 1981).
2. There are elements of guesswork in this scenario. I have tried to pick my way carefully through the legends that have grown up about how Jane came to meet the Pre-Raphaelites. Ned did run into Jane, but it is not absolutely certain whether or how he and Gabriel approached her parents, although this strategy is similar to that used with other models.
3. MoL, IIA, 227–28.
4. WM to Emma Morris, November 1, 1848, MoL, I, 3.
5. Even Morris's official biographer, J. W. Mackail, who suppressed a great deal out of respect for the family, saw this pattern and mentioned it in the biography. "The subject [of his mural] was one for which he felt a singular and almost a morbid attraction, that of the unsuccessful man and despised lover." Mackail, I, 119.
6. Many thanks to my friend Charles Hirshberg for reading *Barnaby Rudge* and alerting me to what this novel may have meant to Morris and Jane.
7. I thank Ray Watkinson and Peter Preston, Honorary Secretary of the William Morris Society, for helping me to check my description of Red House. Errors that remain are of course my own.
8. Jan Marsh's recent *Jane and May Morris* is the first full-length biography of Jane, and it is an invaluable and highly readable volume for anyone interested in this subject. Dr. Marsh has taken a fresh look at many aspects of Jane's life and dug out parts of it that most scholars had assumed were lost forever.
9. JM to WSB, June 22, 1885, Faulkner, 9.
10. Jan Marsh, "The Defence of Janey," *William Morris Society Journal* 7, no. 3 (Autumn 1987).
11. G, I, 195.

12. Robertson, *Time Was,* 93–95.
13. JM to May Morris, May 1910, British Museum.
14. JM to May Morris, about 1910, British Museum.
15. G, I, 211–12.
16. Quoted in Fitzgerald, *Burne-Jones,* 74.
17. G, I, 212.
18. WM to FMB, January 18, 1861, MoL, I, 33.
19. Mackail, I, 142–43.
20. Mackail, I, 150–51.
21. Mackail, I, 157.
22. Mackail, I, 155.
23. Prinsep, "A Chapter from a Painter's Reminiscences."
24. RL, IV, 1860n.
25. Various dates, Delaware Art Museum, Wilmington.
26. Quoted in OD, 316.
27. Rossetti's great modern biographer Oswald Doughty was not particularly fond of Fanny. Nonetheless, he found that there was "no real evidence" that Fanny had ever been an "expensive item" for Gabriel.
28. Quoted in Baum, *DGR's Letters to Fanny Cornforth,* 38.
29. Helen M. Madox Rossetti, *Ford Madox Brown,* 17.
30. DGR to FMB, July 6, 1864, RL, II, 514.
31. DGR to Frederic Shields, February 28, 1865, RL, II, 545.
32. DGR to William Allingham, September 30, 1867, RL, II, 636.
33. DGR to Jenny and May Morris, Thursday [April 1868], Bryson, 1–2.
34. WM to May Morris, October 26, 1887, British Museum.
35. Mackail, II, 344.
36. Eirikr Magnusson, obituary for WM, *Cambridge Review,* November 26, 1896.
37. WMR, *DGR: His Family Letters,* I, 244.
38. Forbes-Robertson, Johnston, "D. G. Rossetti, 1828–82," London *Times,* May 11, 1928.
39. There are two stories about how Pia de' Tolomei met her death: Some say she caught a marsh fever; others say she was poisoned. Dante must have believed the latter since he put her among those who did not have time to repent.
40. WBS to Alice Boyd, November 26, 1868, quoted in Lindsay, *William Morris,* 152.
41. All three incidents quoted in Lindsay, *William Morris,* 165.
42. DGR to CAH, August 21?, 1868, Texas.
43. Quoted in OD, 365.
44. WM to EBJ, May 25, 1869, MoL, I, 76.
45. WSB diary, October 14, 1892, Faulkner, 71.
46. WM to CEN, August 5, 1869, MoL, I, 82.
47. JM to Philip Webb, August 15, 1869, MoL, I, 89.
48. DGR to JM, July 21, 1869, Bryson, 5.

49. DGR to JM, July 30, 1869, Bryson, 11.
50. DGR to JM, August 14, 1869, Bryson, 22.
51. DGR to JM, August 23, 1869, Bryson, 24.
52. DGR to JM, August 30, 1869, Bryson, 26, 27.
53. WBS, *Autobiographical Notes,* II, 111–12.
54. DGR to CAH, August 16, 1869, RL, II, 712.
55. DGR to ACS, October 30, 1869, RL, II, 761.
56. Janet Camp Troxell Collection, Princeton.
57. DGR to WMR, October 13, 1869, RL, II, 752.
58. DGR to ACS, October 26, 1869, RL, II, 761.
59. DGR to JM, January 30, 1870, Bryson, 33.
60. DGR to his mother, April 18, 1879, RL, II, 848.
61. WM to JM, April 26, 1870, MoL, I, 118.
62. Ibid.
63. WM to JM, November 25, 1870, MoL, I, 126–27.
64. WM to JM, December 5, 1870, MoL, I, 129.
65. WM to JM, December 3?, 1870, MoL, I, 128.
66. DGR to WBS, July 17, 1871, RL, III, 954.
67. Rooke, 49.
68. WM to JM, July 6, 1871, MoL, I, 139.
69. WM to JM, August 11, 1871, MoL, I, 146.
70. DGR to WBS, October 2, 1871, RL, III, 1015.
71. DGR to F. S. Ellis, N.D., RL, III, 1017.
72. Quoted in OD, 495.
73. WMR, *DGR: His Family Letters,* I, 305.
74. *Diary of WMR 1870–73,* June 2, 1872, 205. For my account of Gabriel's breakdown in this year I have drawn extensively on William Fredeman's brilliant and painstakingly researched work "Prelude to the Last Decade: DGR in the Summer of 1872."
75. WMR, *DGR: His Family Letters,* I, 313.
76. WBS to Alice Boyd, June 29, 1872, Penkill Papers, UBC.
77. WBS to Alice Boyd, July 1, 1872, Penkill Papers, UBC.
78. Thomas Hake to WMR, July 18, 1872, Angeli Papers, UBC.
79. Thomas Hake to JM, August 13, 1872, Angeli Papers, UBC.
80. JM to WMR, August 15, 1872, Bryson, 184.
81. CAH to DGR, October 3, 1872, Texas.
82. DGR to CAH, January 9, 1873, Texas.
83. CAH to DGR, February 25, 1873, Texas.
84. May Morris, 1973, I, 229.
85. JM to Theodore Watts-Dunton, about 1884, British Museum.
86. WM to Aglaia Coronio, November 25, 1872, MoL, I, 171–73.
87. Ibid.
88. WM to his mother, March 25, 1875, MoL, I, 249.
89. May Morris, 1973, I, 288–89.
90. WM to JM?, March 22–April 6, 1876, MoL, I, 291. The salutation to

this letter has been lost, and so there is a possibility that it was written to another correspondent. However, its somber tone and unusual intimacy have led me to conclude that the recipient was almost certainly Jane.

91. JM to DGR, Tuesday [about October 1878], Bryson, 83.
92. JM to DGR, Thursday, Bryson, 100.
93. Morris's distaste for the "swinish luxury of the rich" was a legend among his friends. He is a key figure in the history of British socialism, and entire books have been written just about this aspect of his life, so it is ludicrous to summarize his involvement in a couple of paragraphs. Those who are interested in his political career will want to read E. P. Thompson's masterful biography *William Morris: Romantic to Revolutionary*.
94. Mackail, II, 67.
95. WM to Jenny Morris, August [9,] 1886, MoL, IIB, 561.
96. JM to Rosalind Howard, July 6, 1870, Castle Howard.
97. Eirikr Magnusson, obituary for WM, *Cambridge Review*, November 26, 1896.
98. Swanwick, *I Have Been Young*, 101.
99. DGR to JM, January 7, 1880, Bryson, 130.
100. DGR to JM, September 3, 1880, Bryson, 156.
101. JM to DGR, Thursday, Bryson, 100.
102. DGR to FC, November 27, 1881, RL, IV, 1942.
103. DGR to EBJ, October 1881, RL, IV, 1934.
104. Quoted in OD, 663.
105. Quoted in Baum, *DGR's Letters to Fanny Cornforth*, 114.
106. ACS to WBS, April 17, 1882, British Museum.
107. Rooke, 47–48.
108. Quoted in OD, 252.
109. WMR to Theodore Watts-Dunton, June 18, 1883, British Museum.
110. CGR to WMR, November 7, 1882, Princeton.
111. WM to WBS, April 27, 1882, MoL, IIA, 109.
112. JM to WSB, July 6, 1884, Faulkner, 2.
113. WSB diary, July 19, 1884, Fitzwilliam.
114. Ibid.
115. WSB diary, January 1914, Fitzwilliam.
116. WSB diary, January 3, 1885, Faulkner, 4.
117. On one occasion when Blunt was questioning Jane about her relationship with Gabriel, she said: "I never quite gave myself as I do now." Biographers have construed from this remark that Jane never slept with Gabriel. It seems to me impossible that their relationship remained platonic during all the years that they lived together. More likely Jane was saying delicately that she had been far more sexually timid when she was younger.
118. JM to WSB, August 11, 1889, Faulkner, 32.

119. JM to WSB, August 21, 1889, Faulkner, 32–33.
120. JM to WSB, August 9, 1888, Faulkner, 19.
121. Quoted in Longford, *Wilfrid Scawen Blunt,* 283.
122. WSB diary, May 7, 1891, Faulkner, 53.
123. WSB diary, May 13, 1890, Faulkner, 43.
124. Quoted in Longford, *Wilfrid Scawen Blunt,* 156.
125. WSB diary, Summer 1889, Faulkner, 30.
126. WM to GBS, March 18, 1885, British Museum.
127. WM to Charles Faulkner, October 16, 1886, Bodleian.
128. WSB diary, October 18, 1890, Faulkner, 47.
129. WSB diary, September 30, 1891, Fitzwilliam.
130. WSB diary, August 12, 1891, Fitzwilliam.
131. WSB diary, August 15, 1894, Fitzwilliam.
132. "Morris as I knew him," in May Morris, *William Morris,* xxiv.
133. Quoted in OD, 373.
134. Robertson, *Time Was,* 94.
135. Notes from Janet Camp Troxell conversation with Sydney Cockerell, September 12, 1950, Princeton.
136. "Morris as I knew him," in May Morris, *William Morris,* xxiv.
137. JM to WSB, December 28, 1888, Faulkner, 24.
138. JM to WSB, October 26, 1895, Faulkner, 93.
139. WSB diary, January 18, 1886, Fitzwilliam.
140. Ibid.
141. WSB diary, May 13, 1890, Fitzwilliam.
142. WSB diary, May 5, 1892, Fitzwilliam.
143. Ibid.
144. Ibid.
145. JM to DGR, 1880?, Bryson, 134.
146. JM to WSB, May 26, 1894, Faulkner, 87.
147. JM to WSB, December 15, 1894, Faulkner, 90.
148. G, II, 278.
149. Quoted in Lindsay, *William Morris,* 374.
150. WM to GBJ, September 1, 1896, Mackail, II, 332.
151. Robertson, *Time Was,* 276.
152. Eirikr Magnusson, undated notes, British Museum.
153. GBJ to WSB, quoted in WSB diary entry for October 4, 1896, Faulkner, 105.
154. WSB diary, October 5, 1896, Faulkner, 106. In fact Jane was nineteen when she married Morris, not eighteen as she claimed to Blunt.
155. JM to WSB, November 9, 1903, Faulkner, 119.
156. JM to WSB, May 6, 1899, Faulkner, 113.
157. EBJ to HMG, October 9, 1896, British Museum.
158. WSB diary, November 29, 1896, Faulkner, 107.
159. WSB diary, April 5, 1897, Fitzwilliam.
160. GBJ to Sydney Cockerell, August 13, 1901, V&A.

161. GBJ to Sydney Cockerell, July 23, 1907, V&A.
162. WSB diary, August 10, 1903, Faulkner, 119.
163. Quoted in Baldwin, 158.
164. WSB diary, January 1914, Fitzwilliam.

### EPILOGUE

1. Diana Holman-Hunt's biography, *My Grandfather, His Wives and Loves,* and her memoir, *My Grandmothers and I,* are a treasure-trove of information and insights about her eccentric and illustrious forebears. Both books make delightful reading, and are distinguished by the detachment and humor with which Holman-Hunt is able to survey her own family.
2. Mary had a cousin, Marie Spartali Stillman, who painted every day for most of her adult life and exhibited regularly. She lay just outside the confines of my study, but she would make a fine subject for a book. It is probably not accidental that both Maria Zambaco and Marie Stillman had substantial inheritances of their own, which gave them greater freedom than middle-class women had to pursue their own interests.

# Bibliography

Abse, Joan. *John Ruskin: The Passionate Moralist.* New York: Knopf, 1981.

Allingham, H., and D. Radford, eds. *William Allingham: A Diary.* Harmondsworth, England: Penguin, 1985.

Angeli, Helen Rossetti. *The Pre-Raphaelite Twilight: The Story of Charles Augustus Howell.* London: Richards, 1954.

Armstrong, Walter. "Sir J. E. Millais, bart." *Art Annual.* London: J. S. Virtue, 1885.

Auerbach, Nina. *Woman and the Demon: The Life of a Victorian Myth.* Cambridge: Harvard University Press, 1982.

Baldwin, A. W. *The Macdonald Sisters.* London: Peter Davies, 1960.

Banks, Joseph A. *Prosperity and Parenthood.* London: Routledge and Kegan Paul, 1954.

———."The Way They Lived Then." *Victorian Studies* 12, no. 2 (December 1968).

Battiscombe, Georgina. *Christina Rossetti: A Divided Life.* New York: Holt, Rinehart and Winston, 1981.

Baum, Paull Franklin. *Dante Gabriel Rossetti's Letters to Fanny Cornforth.* Baltimore: Johns Hopkins Press, 1940.

Bédier, Joseph. *The Romance of Tristan and Iseult.* Translated by Hillaire Belloc and completed by Paul Rosenfeld. New York: Vintage, 1965.

Beeton, Isabella. *Mrs. Beeton's Book of Household Management.* London: Chancellor, 1982.

Bell, Mackenzie. *Christina Rossetti.* London: Hurst and Blackett, 1898.

Bell, Quentin. *Victorian Artists.* Cambridge: Harvard University Press, 1967.

Bennett, Mary. *PRB Millais PRA.* Liverpool: Walker Art Gallery exhibition catalogue, 1967.

———. *William Holman Hunt.* Liverpool: Walker Art Gallery exhibition catalogue, 1969.

Benson, A. C. *Memories and Friends*. New York: Putnam's, 1924.

Best, Geoffrey. *Mid-Victorian Britain: 1851–75*. New York: Schocken, 1972.

Bignell, John. *Chelsea Seen from 1860 to 1980*. London: Studio B, 1978.

Birkenhead, Sheila. *Illustrious Friends*. New York: Reynal/William Morrow, 1965.

Bradley, Ian. *William Morris and His World*. New York: Scribner's, 1978.

Bryson, John, and Janet Camp Troxell, eds. *Dante Gabriel Rossetti and Jane Morris: Their Correspondence*. Oxford: Clarendon, 1976.

Burd, Van Akin. *John Ruskin and Rose La Touche: Her Unpublished Diaries of 1861 and 1867*. Oxford: Clarendon, 1979.

Burne-Jones, Georgiana. *The Memorials of Edward Burne-Jones*. New York: Macmillan, 1906.

Burton, Hester. *Barbara Bodichon*. London: John Murray, 1949.

Butler, Elizabeth. *An Autobiography*. Boston: Houghton Mifflin, 1923.

Byron, May. *A Day with Rossetti*. New York: Hodder and Stoughton, n.d.

Caine, T. Hall. *Recollections of Dante Gabriel Rossetti*. Boston: Roberts Brothers, 1898.

Callen, Anthea. *Women Artists of the Arts and Crafts Movement: 1870–1914*. New York: Pantheon, 1979.

Carr, J. Comyns. *Coasting Bohemia*. London: Macmillan, 1914.

Casteras, Susan. *Images of Womanhood in Victorian Art*. Rutherford, N.J.: Fairleigh Dickinson University Press, 1987.

———. *The Substance or the Shadow: Images of Victorian Womanhood*. New Haven: Yale Center for British Art, 1982.

Cecil, Lord David. *Visionary and Dreamer: Two Poetic Painters: Samuel Palmer and Edward Burne-Jones*. Princeton: Princeton University Press, 1969.

Cecil, Russell L., and Robert F. Loeb. *A Textbook of Medicine*. 9th ed. Philadelphia: W. B. Saunders, 1955.

Champneys, Basil, ed. *Memoirs and Correspondence of Coventry Patmore*. 2 vols. London: George Bell and Sons, 1901.

Chapel, Jeannie. *Victorian Taste*. London: Zwemmer, 1982.

Cline, C. L. *The Owl and the Rossettis*. University Park: Pennsylvania State University Press, 1978.

Clodd, Edward. "William Holman Hunt, 1827–1910" *Fortnightly Review* (new series) 100 (1916).

Conner, Patrick. *Savage Ruskin*. Detroit: Wayne State University Press, 1979.

Conway, Moncure D. *Autobiography*. 2 vols. London: Cassell, 1904.

Crane, Walter. *An Artist's Reminiscences*. New York: Macmillan, 1907.

Crow, Duncan. *The Victorian Woman*. New York: Stein and Day, 1972.

Cunnington, Phyllis. *Costumes for Births, Marriages and Deaths*. London: Adam and Charles Black, 1972.

Dobbs, Brian and Judy. *Rossetti: An Alien Victorian*. London: Macdonald and Jane's, 1977.

Doughty, Oswald. *Dante Gabriel Rossetti: A Victorian Romantic*. New Haven: Yale University Press, 1949.

————, and J. R. Wahl, eds. *The Letters of Dante Gabriel Rossetti.* 4 vols. Oxford: Oxford University Press, 1965–67.

Du Maurier, George. *The Young George du Maurier: A Selection of His Letters, 1860–67.* Edited by Daphne du Maurier. London: Peter Davies, 1951.

Dunn, Henry Treffry. *Recollections of Dante Gabriel Rossetti and His Circle.* London: Elkin Mathews, 1904.

Ehrenreich, Barbara, and Deirdre English. *For Her Own Good: 150 Years of the Experts' Advice to Women.* New York: Anchor/Doubleday, 1979.

Ellmann, Mary. *Thinking About Women.* New York: Harcourt Brace Jovanovich, 1968.

Elzea, Rowland. *The Correspondence Between Samuel Bancroft, Jr. and Charles Fairfax Murray, 1892–1916.* Occasional Paper No. 2. Wilmington: Delaware Art Museum, February 1980.

————. *Samuel and Mary R. Bancroft, Jr. and Related Pre-Raphaelite Collections.* Wilmington: Delaware Art Museum, 1978.

Faulkner, Peter. *Jane Morris to Wilfrid Scawen Blunt.* Exeter: University of Exeter, 1986.

————. *Wilfrid Scawen Blunt and the Morrises.* London: William Morris Society, 1981.

Fennell, Francis L., ed. *The Rossetti-Leyland Letters.* Athens: Ohio University Press, 1978.

Fitzgerald, Penelope. *Edward Burne-Jones: A Biography.* London: Michael Joseph, 1975.

Fleming, G. H. *Rossetti and the Pre-Raphaelite Brotherhood.* London: Rupert Hart-Davis, 1967.

————. *That Ne'er Shall Meet Again.* London: Michael Joseph, 1971.

Fleming, Margaret. "Where Janey Used to Live." *William Morris Society Journrnal* 4, no. 4 (Winter 1981).

Fothergill, Brian. *Nicholas Wiseman.* London: Faber and Faber, 1963.

Fredeman, William E. "Prelude to the Last Decade: Dante Gabriel Rossetti in the Summer of 1872." *Bulletin of the John Rylands Library* 53, nos. 1 and 2 (Autumn 1970, Spring 1971).

————. *Pre-Raphaelitism: A Bibiliocritical Guide.* Cambridge: Harvard University Press, 1965.

Freeman, Sarah. *Isabella and Sam: The Story of Mrs. Beeton.* New York: Coward, McCann and Geoghegan, 1978.

Garrison, Fielding H. *An Introduction to the History of Medicine.* 4th ed. Philadelphia: W. B. Saunders, 1961.

Gaunt, William. *Victorian Olympus.* London: Cardinal, 1975.

Gay, Peter. *The Bourgeois Experience: Victoria to Freud.* Vol. 1, *Education of the Senses.* New York: Oxford University Press, 1984.

————. *The Bourgeois Experience: Victoria to Freud.* Vol. 2, *The Tender Passion.* New York: Oxford University Press, 1986.

Gernsheim, Allison. *Victorian and Edwardian Fashion: A Photographic Survey.* New York: Dover, 1981.

Glynn Grylls, Rosalie. *Portrait of Rossetti*. London: Macdonald, 1964.

Goodman, Louis S., and Alfred Gilman. *The Pharmacological Basis of Therapeutics*. 3rd ed. New York: Macmillan, 1965.

Graves, Algernon. *Art Sales from Early in the Eighteenth Century to Early in the Twentieth Century*. 3 vols. New York: Burt Franklin, 1970.

Greer, Germaine. *The Obstacle Race*. New York: Farrar, Straus and Giroux, 1979.

Haight, Gordon S. *George Eliot: A Biography*. New York: Oxford University Press, 1968.

———, ed. *The George Eliot Letters*. 9 vols. New Haven: Yale University Press, 1954.

Hake, Thomas Gordon. *Memoirs of Eighty Years*. 2 vols. London: Richard Bentley and Son, 1892.

Haley, Bruce. *The Healthy Body and Victorian Culture*. Cambridge: Harvard University Press, 1978.

Haller, John S., and Robin M. Haller. *The Physician and Sexuality in Victorian America*. New York: W. W. Norton, 1977.

Harding, James. *The Pre-Raphaelites*. New York: Rizzoli, 1977.

Harding, M. Esther. *Woman's Mysteries*. New York: Harper and Row, 1971.

Harrison, Fraser. *The Dark Angel: Aspects of Victorian Sexuality*. New York: Universe, 1978.

Harrison, Martin, and Bill Waters. *Burne-Jones*. London: Barrie and Jenkins, 1973.

Hemstedt, Geoffrey. "Painting and Illustration." In *The Victorians,* edited by Laurence Lerner. New York: Holmes and Meier, 1978.

Henderson, Philip, ed. *Letters of William Morris to His Family and Friends*. London: Longmans, 1950.

———. *Swinburne: Portrait of a Poet*. New York: Macmillan, 1974.

Hess, Thomas B., and Linda Nochlin. *Woman as Sex Object: Studies in Erotic Art, 1730–1970*. London: Allen Lane, 1973.

Hiley, Michael. *Victorian Working Women: Portraits from Life*. Boston: Godine, 1980.

Hollander, Anne, *Seeing Through Clothes*. New York: Viking, 1978.

Holman-Hunt, Diana. *My Grandfather, His Wives and Loves*. London: Hamish Hamilton, 1969.

———. *My Grandmothers and I*. New York: W. W. Norton, 1961.

Holme, Thea. *Chelsea*. New York: Taplinger, 1971.

Horner, Frances. *Time Remembered*. London: Heinemann, 1933.

Hunt, John Dixon. *The Wider Sea: A Life of John Ruskin*. New York: Viking, 1982.

Hunt, Violet. *The Wife of Rossetti*. New York: Dutton, 1932.

Hunt, William Holman. *Pre-Raphaelitism and the Pre-Raphaelite Brotherhood*. 2 vols. New York: AMS, 1967.

Ionides, Luke. "William Morris and Richard Wagner." *Transatlantic Review* 1, no. 2 (February 1924).

James, William, ed. *John Ruskin and Effie Gray*. New York: Scribner's, 1947.

Johnson, Diane. *Lesser Lives*. New York: Knopf, 1972.

Johnson, Wendell Stacy. *Living in Sin: The Victorian Sexual Revolution*. Chicago: Nelson-Hall, 1979.

Kelvin, Norman. *The Collected Letters of William Morris*. Vols. 1 and 2: 1848–1888. Princeton: Princeton University Press, 1984.

Kohfeldt, Mary Lou. *Lady Gregory*. New York: Atheneum, 1985.

Lago, Mary, ed. *Burne-Jones Talking*. Columbia: University of Missouri Press, 1981.

Lambert, Angela. *Unquiet Souls*. New York: Harper and Row, 1984.

Landow, George. *William Holman Hunt and Typological Symbolism*. New Haven: Yale University Press, 1979.

Lang, Cecil Y., ed. *The Swinburne Letters*. 6 vols. New Haven: Yale University Press, 1959–1962.

Layard, G. S. *Tennyson and His Pre-Raphaelite Illustrators*. London: Elliot Stock, 1894.

Lewis, Roger C., and Mark Samuels Lasner. *Poems and Drawings of Elizabeth Siddal*. Wolfville, Nova Scotia: Wombat, 1978.

Linder, Leslie, ed. *The Journals of Beatrix Potter from 1881–1897*. London: Frederick Warne, 1966.

Lindsay, Jack. *J. M. W. Turner: His Life and Work*. New York: New York Graphic Society, 1966.

———. *William Morris: His Life and Work*. New York: Taplinger, 1979.

Longford, Elizabeth. *Eminent Victorian Women*. New York: Knopf, 1981.

———. *A Pilgrimage of Passion: The Life of Wilfrid Scawen Blunt*. London: Weidenfeld and Nicolson, 1979.

Lowndes, Susan, ed. *Diaries and Letters of Marie Belloc Lowndes: 1911–47*. London: Chatto and Windus, 1971.

Lutyens, Mary. *Letters from Sir J. E. Millais, bart. and William Holman Hunt, O.M. in the Henry E. Huntington Library*. Walpole Society, vol. 44, 1972–1974.

———. *Millais and the Ruskins*. New York: Vanguard, 1967.

———. "Millais–La Touche Correspondence." *Cornhill Magazine*, no. 1051 (Spring 1967).

———. "Portraits of Effie." *Apollo* 87, no. 73 (March 1968).

———. *The Ruskins and the Grays*. London: John Murray, 1972.

———. "Smallpox at the Grand Hotel." *Cornhill Magazine*, no. 1055 (Spring 1968).

———. *Young Mrs. Ruskin in Venice*. New York: Vanguard, 1965.

Lutyens, Mary, and Malcolm Warner, eds. *Rainy Days at Brig O'Turk*. Westerham, Kent: Dalrymple, 1983.

Maas, Jeremy. *Gambart: Prince of the Victorian Art World*. London: Barrie and Jenkins, 1975.

———. *Holman Hunt and the Light of the World*. London: Scolar, 1984.

———. *Victorian Painters*. New York: Putnam's, 1969.

Macht, David, and Nellie L. Gessford. "The Unfortunate Drug Experiences

of Dante Gabriel Rossetti." *Bulletin of the Institute of the History of Medicine* 6, no. 1 (January 1938).

Mackail, J. W. *The Life of William Morris.* London: Benjamin Blom, 1968.

McLaren, Angus. *Birth Control in Nineteenth-Century England.* New York: Holmes and Meier, 1978.

McMullen, Roy. *Victorian Outsider: A Biography of J. A. M. Whistler.* New York: Dutton, 1973.

Malory, Thomas. *Le Morte d'Arthur.* Edited by Janet Cowen. 2 vols. Harmondsworth, England: Penguin, 1984.

Marcus, Penelope. *Burne-Jones.* London: Arts Council of Great Britain exhibition catalogue, 1975.

Marcus, Steven. *The Other Victorians.* New York: Bantam, 1967.

Marsh, Jan. *Jane and May Morris.* London: Pandora, 1986.

——. *The Pre-Raphaelite Sisterhood.* New York: St. Martin's, 1985.

Mayhew, Henry. *London Labour and the London Poor.* 4 vols. New York: Dover, 1968.

Millais, Geoffroy. *Sir John Everett Millais.* London: Academy Editions, 1979.

Millais, John Guille. *The Life and Letters of Sir John Everett Millais.* London: Methuen, 1899.

Mills, Ernestine. *Life and Letters of Frederic Shields.* London: Longmans, 1912.

Mitchell, R. J., and M. D. R. Leys. *A History of London Life.* London: Longmans, Green, 1958.

Moore, Katharine. *Victorian Wives.* London: Allison and Busby, 1985.

Morris, James. *Heaven's Command: An Imperial Progress.* New York: Harcourt Brace Jovanovich, 1973.

Morris, May. *Introductions to the Collected Works of William Morris,* edited by Joseph Dunlap. 2 vols. New York: Oriole Editions, 1973.

——. *William Morris: Artist, Writer, Socialist.* 2 vols. Oxford: Basil Blackwell, 1936.

Morris, William. *A Book of Verse: A Facsimile of the Manuscript Written in 1870.* New York: Clarkson N. Potter, 1981.

——. *The Collected Works of William Morris.* London: Longmans, Green, 1910–1915.

——. *News from Nowhere.* Edited by James Redmond. London: Routledge and Kegan Paul, 1970.

——. *The Novel on Blue Paper.* Edited by Penelope Fitzgerald in *Dickens Studies Annual,* vol. 10. New York: AMS, 1982.

Mullins, Edwin. *The Painted Witch.* New York: Carroll and Graf, 1985.

Nicoll, John. *Dante Gabriel Rossetti.* New York: Macmillan, 1975.

Noakes, Vivien. *Edward Lear: The Life of a Wanderer.* London: Fontana/Collins, 1979.

Nochlin, Linda. *Realism.* New York: Penguin, 1975.

——. "Why Are There No Great Women Artists?" In *Woman in Sexist Society,* edited by Vivian Gornick and Barbara K. Moran. New York: New American Library, 1972.

Nunn, Pamela Gerrish. "Ruskin's Patronage of Women Artists." *Woman's Art Journal* 2, no. 2 (Fall 1981/Winter 1982): 8–13.

Packer, Lona Mosk. *Christina Rossetti.* Berkeley: University of California Press, 1963.

———. *The Rossetti-Macmillan Letters.* Berkeley: University of California Press, 1963.

Parry, Linda. *William Morris Textiles.* New York: Viking, 1983.

Pearsall, Ronald. *Public Purity, Private Shame.* London: Weidenfeld and Nicholson, 1976.

———. *The Worm in the Bud.* Harmondsworth, England: Penguin, 1983.

Pedrick, Gale. *No Peacocks Allowed: Dante Gabriel Rossetti and His Circle.* London: Macdonald, 1964.

Pike, E. Royston. *Human Documents of the Victorian Golden Age.* London: Allen and Unwin, 1974.

*The Pre-Raphaelites.* Tate Gallery exhibition catalogue. London: Tate Gallery/Penguin, 1984.

Prinsep, Val. "A Chapter from a Painter's Reminiscences: The Oxford Circle: Rossetti, Burne-Jones and William Morris." *The Magazine of Art* (1904).

Procter, Ida. "Elizabeth Siddal: The Ghost of an Idea." *Cornhill Magazine,* no. 990 (Winter 1951/52).

Reitlinger, Gerald. *The Economics of Taste: The Rise and Fall of Picture Prices.* 3 vols. New York: Hacker, 1982.

Robertson, David. *Sir Charles Eastlake and the Victorian Art World.* Princeton: Princeton University Press, 1978.

Robertson, W. Graham. *Time Was.* London: Quartet, 1981.

Rose, Phyllis. *Parallel Lives.* New York: Knopf, 1983.

Rossetti, Christina. *The Complete Poems of Christina Rossetti.* Edited by R. W. Crump. Vol. I. Baton Rouge: Louisiana State University Press, 1979.

Rossetti, Dante Gabriel. *The Early Italian Poets.* Berkeley: University of California Press, 1981.

———. *The Works of Dante Gabriel Rossetti.* Edited by William Rossetti. London: Ellis, 1911.

Rossetti, Helen M. Madox. *Ford Madox Brown.* London: De La More, 1901.

Rossetti, William, ed. *Dante Gabriel Rossetti: His Family Letters with a Memoir by William Michael Rossetti.* 2 vols. New York: AMS, 1970.

———. "Dante Rossetti and Elizabeth Siddal." *Burlington Magazine* I (March–May 1903).

———. *The Diary of William Michael Rossetti 1870–73.* Edited by Odette Bournand. Oxford: Clarendon, 1977.

———. *The P.R.B. Journal.* Edited by W. E. Fredeman. Oxford: Clarendon, 1975.

———. *Preraphaelite Letters and Diaries.* London: Hurst and Blackett, 1900.

———. *Rossetti Papers: 1862 to 1870.* London: Sands, 1903.

———. *Ruskin: Rossetti: Preraphaelitism.* New York: AMS, 1971.

Ruskin, John. *Life, Letters and Works of John Ruskin*. Edited by E. T. Cook and A. Wedderburn. 39 vols. London: Allen, 1900–1911.

Scott, William Bell. *Autobiographical Notes of the Life of W. Bell Scott and Notices of His Artistic and Poetic Circle of Friends, 1830–82*. Edited by W. Minto. 2 vols. New York: Harper, 1892.

Sewter, A. Charles. *The Stained Glass of William Morris and His Circle — A Catalogue*. 2 vols. New Haven and London: Yale University Press, 1975.

Shonfield, Zuzanna. *The Precariously Privileged: A Professional Family in Victorian London*. Oxford: Oxford University Press, 1987.

Shorter, Edward. *A History of Women's Bodies*. New York: Basic, 1982.

Sitwell, Sacheverell. *Narrative Pictures*. London: B. T. Batsford, 1969.

Smith, Charles Eastlake, ed. *Journals and Correspondence of Lady Eastlake*. 2 vols. London: John Murray, 1895.

Sonstroem, David. *Rossetti and the Fair Lady*. Middletown: Wesleyan University Press, 1970.

Sontag, Susan. *Illness as Metaphor*. New York: Farrar, Straus and Giroux, 1978.

Spalding, Frances. *Magnificent Dreams: Burne-Jones and the Late Victorians*. New York: Dutton, 1978.

———. *Vanessa Bell*. New Haven: Ticknor and Fields, 1983.

Stephens, F. G. *Dante Gabriel Rossetti: Painter and Poet*. London: Seeley, 1894.

Stillman, W. J. *The Autobiography of a Journalist*. Boston: Houghton Mifflin, 1901.

Strachey, Lytton. *Queen Victoria*. New York: Harcourt, Brace, 1921.

Strasser, Susan. *Never Done: A History of American Housework*. New York: Pantheon, 1982.

Strouse, Jean. *Alice James*. Toronto: Bantam, 1982.

Surtees, Virginia. *The Artist and the Autocrat: George and Rosalind Howard: Earl and Countess of Carlisle*. Wilton, Salisbury, Wiltshire: Michael Russell, 1988.

———. *The Diary of Ford Madox Brown*. New Haven: Yale University Press, 1981.

———. *The Diary of George Price Boyce*. Norwich, England: Real World, 1980.

———. *The Paintings and Drawings of Dante Gabriel Rossetti (1828–1882): A Catalogue Raisonnée*. Oxford: Clarendon, 1971.

———, ed. *Sublime and Instructive: Letters from John Ruskin to Louisa, Marchioness of Waterford, Anna Blunden and Ellen Heaton*. London: Michael Joseph, 1972.

Surtees, Virginia, et al. *Dante Gabriel Rossetti, Painter and Poet*. London: Royal Academy of Arts exhibition catalogue, 1973.

Swanwick, Helena M. Sickert. *I Have Been Young*. London: Gollancz, 1935.

Symons, Arthur. *Studies in Strange Souls*. London: Charles J. Sawyer, 1929.

Taine, Hippolyte. *Notes on England*. Edited by Edward Hyams. London: Thames and Hudson, 1957.

Taylor, Ina. *Victorian Sisters*. London: Weidenfeld and Nicholson, 1987.

Thirkell, Angela. *Three Houses*. London: Robin Clark, 1986.

Thompson, E. P. *William Morris: Romantic to Revolutionary*. New York: Pantheon, 1976.

Treuherz, Julian. *Pre-Raphaelite Paintings from the Manchester City Art Gallery*. London: Lund Humphries, 1980.

Trevelyan, Raleigh. *A Pre-Raphaelite Circle*. Totowa, N.J.: Rowman and Littlefield, 1978.

Troxell, Janet Camp. *Three Rossettis*. Cambridge: Harvard University Press, 1937.

Vicinus, Martha. *Suffer and Be Still*. Bloomington: Indiana University Press, 1973.

Viljoen, Helen. *Ruskin's Scottish Heritage*. Urbana: University of Illinois Press, 1956.

Warner, Malcolm. *The Drawings of John Everett Millais*. Bolton Museum and Art Gallery exhibition catalogue (Arts Council of Great Britain), 1979.

Watson, Francis. *The Year of the Wombat. England: 1857*. New York: Harper and Row, 1974.

Watts-Dunton, Theodore. *Old Familiar Faces*. London: Herbert Jenkins, 1916.

Weintraub, Stanley. *Four Rossettis*. New York: Weybright and Talley, 1977.

Wey, Francis. *A Frenchman Among the Victorians*. Translated by Valerie Pirie. New Haven: Yale University Press, 1936.

Whitehouse, J. Howard. *Vindication of Ruskin*. London: Allen and Unwin, 1950.

Wohl, Anthony, ed. *The Victorian Family: Structure and Stresses*. London: Croom Helm, 1978.

Woodham-Smith, Cecil. *Florence Nightingale*. New York: McGraw-Hill, 1951.

Woolner, Amy, ed. *Thomas Woolner, R.A., His Life in Letters*. New York: Dutton, 1917.

# Index